Women
Artists

Women Artists

The Linda Nochlin Reader

Edited by
Maura Reilly

230 illustrations

Thames & Hudson

Twenty-eight of the thirty essays in this book have been
previously published over a period of forty-five years.
While the author and editor have resisted the temptation
to correct errors of fact or interpretation, it has not always
been possible to include all of the illustrations that
originally accompanied the essays.

Women Artists: The Linda Nochlin Reader © 2015 Thames & Hudson
Essays © 2015 Linda Nochlin
Preface © 2015 Maura Reilly
Interview Linda Nochlin by Maura Reilly © 2015 Linda Nochlin
and Maura Reilly

First published in 2015 in hardcover in the United States of
America by Thames & Hudson Inc., 500 Fifth Avenue, New York,
New York 10110

thamesandhudsonusa.com

Library of Congress Catalog Card Number 2014952399

ISBN 978-0-500-23929-2

Printed and bound in China by C & C Offset Printing Co. Ltd

Contents

Preface

There are few art historians who have been as influential, provocative and prolific as Linda Nochlin, the Lila Acheson Wallace Emerita Professor of Modern Art at the Institute of Fine Arts, New York University.

Since the late 1960s, Nochlin has written and edited seventeen books and countless articles—many of which have been translated into other languages—as well as curated several groundbreaking exhibitions, from *Women Artists, 1550–1950* (co-curated with Ann Sutherland Harris) to *Global Feminisms* (co-curated with Maura Reilly). She is perhaps best known for her landmark 1971 article in *ARTNews*, "Why Have There Been No Great Women Artists?," a dramatic feminist rallying cry, in which she assessed the socio-cultural structures—access to art education, definitions of genius and greatness itself—that impacted not only the art produced by women historically but also their professional and art-historical status, as well. This canonical essay precipitated a paradigm shift within the discipline of art history, and as such her name has become inseparable from the phrase, "feminist art," on a global scale.

Nochlin's anthologies to date have tended to reproduce her essays about the representation of women by canonical male artists—Courbet, Seurat, Van Gogh, Degas, Manet, Géricault, Pissarro, and so on. Over the last five decades, however, she has consistently written and lectured about women artists. Most of these texts are scattered in journals, exhibition catalogues, and books, or were presented as lectures, or have not been published at all. For the first time, *Women Artists: The Linda Nochlin Reader* brings together thirty of these essays about women artists and feminist art, dating from 1971 to the present.

The anthology begins with a dialogue between Nochlin and editor Maura Reilly, in which they discuss her childhood, early years at Vassar College, curated exhibitions, favorite women artists, definitions of feminist art, the status of women artists today, and tasks for the future. The essays are organized by publication date. Omitted are monographic essays on Dorothea Tanning, Kate Millet, Grace Hartigan, Malvina Hoffman, Catherine Murphy, Judy Pfaff and others, as well as a few thematic investigations. *Women Artists*, therefore, is not intended to be exhaustive, or to cover the entire field in any sense. The authors have left the essays as they originally appeared, despite the strong temptation to correct any errors of fact or mistakes of interpretation. The collection, then, hardly constitutes a "grand finale"; some of them will appear dated, as is inevitable for essays written at certain moments and in response to specific problems and situations that may no longer seem as urgent. So be it: that is the fate of most art history and art criticism, feminist or not. The authors hope these pieces can still be read with pleasure and profit, and will encourage some readers to reshape their views of women artists and their art.

A Dialogue with Linda Nochlin, the Maverick She

Maura Reilly: In 1988, you argued that "feminist art history is there to make trouble, to call into question, to ruffle feathers in the patriarchal dovecotes."[1] You have spent your entire professional career doing just that, making trouble, embodying the position of the maverick she, using it as a decided advantage. You have continually questioned academic assumptions in/around issues of gender, race and class—and, as such, have transformed not only the discipline of art history, but academic investigations in general. You have examined afresh the work of French painter and provocateur Gustave Courbet; redefined realism as an artistic style, from the 19th century to the present; revised art history to include women artists, and the analysis of representations of women by male canonical artists; have contributed enormously influential thematic essays—most spectacularly, your essay, "Why Have There Been No Great Women Artists?"; and have produced countless monographic texts on women artists, most of which we've reproduced here. Among these many scholarly contributions, you have also curated several milestone exhibitions, including the landmark *Women Artists, 1550–1950* in 1976 [Los Angeles County Museum of Art], and, more recently, *Global Feminisms* in 2007 [Brooklyn Musem], among others. You have been unceasingly bold, intrepid, inspiring and influential. Your scholarship has been consistently transgressive, irreverent, and anti-establishment. What I want to know, is where did this all begin? How did you come to be someone with such an intellect, strong opinions, belief in yourself and in your voice—especially as a woman growing up in 30s/40s America, a period marked by overt sexism and strict gender roles. Shall we start with your childhood, growing up in Brooklyn, as an only child within a close-knit Jewish family?

Linda Nochlin: Yes, I grew up in a secular, leftist, intellectual Jewish family, like so many in the neighborhood of Crown Heights in Brooklyn. Intellectual achievement, creation or appreciation of the arts—literature, music, painting, dance—were considered the highest goals, along with social justice. I understood that before I understood anything else. My father worked and my mother stayed home to raise me, but it was hardly "stereotypically patriarchal." I was an only child and my mother shared all her intellectual and esthetic interests with me: she loved modern dance and we danced together; she was engaged with modern literature and read to me aloud from James Joyce's *Portrait of the Artist* when I was quite young. She listened to and played classical music and I listened with her. In some ways, I grew up in an extended family: my grandparents

and aunts and uncles played a big role in my formation. I was expected to participate in discussions of Gogol and Dostoyevsky when I was in high school, because that was what they found interesting. In no sense was I forced to read anything I didn't want to. Indeed, the whole idea of the "tiger mother" is repugnant to me. I engaged with art and literature because that was what the people around me were interested in.

MR: As a child, were there women whom you admired? And if so, who, and what was it about them specifically? What were your aspirations as a child/teenager?

LN: Yes, of course there were women whom I loved and admired, like my mother and my grandmother, my father's mother, who drove a car, did serious gardening, and was a deep-sea fisherwoman. But much as I loved and admired them, I knew quite early that I didn't want to stay at home and be only a wife and mother. You can love and admire someone without wanting to model your life on theirs: that's where I think the idea of a "role model" is deceptive. I admired Eleanor Roosevelt, certainly, and Martha Graham, but I don't think I necessarily wanted to be like them. My aspirations as a teenager were vague: I wanted to be a poet, a writer, an artist, a dancer—something like that. I never thought of being a scholar or an academic.

MR: At what point in your life, or at what age, did you realize that there was such a thing as inequality between the sexes?

LN: I think I realized that there was inequality quite early—and my reaction was outrage. In fact, I remember vividly my first act of proto-feminist critique in the realm of the visual. I must have been about six years old when I performed this act of desecration. Slowly and deliberately, I poked out the eyes of Tinker Bell in an expensively illustrated edition of *Peter Pan*. I still remember my feeling of excitement as the sharp point pierced through those blue, long-lashed orbs. I hoped it hurt, and I was both frightened and triumphant looking at the black holes in the expensive paper. I hated Tinker Bell—her weakness, her sickening sweetness, her helplessness, her wispy, evanescent body—so different from my sturdy plump one—her pale hair, her plea to her audience to approve of her. I was glad I had destroyed her baby blues. I continued my campaign of iconoclasm with my first-grade reader—*Linda and Larry*, it was called, and Larry was about a head taller than Linda and always the leader in whatever banal activity the two were called on to perform. "See Larry run. See Linda run. Run, Larry, run. Run, Linda, run…" etc. I successfully amputated Larry's head with blunt scissors on one page of the reader and cut off his legs in another: now they were equal and I was satisfied. (Freudians can make of this what they will!) These very deliberate acts of destruction were propelled not so much by rage as by a fierce sense of injustice. Why were women depicted as poofy, pretty, helpless weaklings, men as doughty leaders and doers? I read these stories and fairy tales with some pleasure, but also with a certain annoyance.

MR: Well, there is without doubt too much dependence on male saviors in fairy tales—be it the woodsman in "Red Riding Hood" or the handsome prince who rescues Cinderella or Sleeping Beauty, who are relatively passive figures wholly dependent on their beauty for happiness.

LN: Yeah, I guess I knew that my foot (already large) would never fit into that glass slipper! I liked children's books with feisty heroines who did interesting things. Do not imagine that I was a precocious man-hater, or boy-hater: far from it. Among my favorite books were Booth Tarkington's *Penrod* series and the wonderful *Otto of the Silver Hand*, written by Howard Pyle and illustrated by him with shady Dürer-esque engravings. I read Mark Twain's *Life on the Mississippi*, with its strictly male cast of characters, three times in a row. What I hated was not men—my beloved grandfather was the one who most encouraged me in my intellectual and artistic pursuits—but rather the visual putting down of girls and women vis-à-vis a power situation in both high and popular culture, and I resorted to extreme measures when confronted by it.

MR: Nevertheless, fairy tales have remained a longstanding fascination—that is, you've written extensive texts about the tales in the work of Kiki Smith, Miwa Yanagi, and Natalie Frank—all of which are included in this book. Now, moving on in your chronology...from 1947 to 51 you attended Vassar College, which was then an all-girls' school, where you received a BA in philosophy (with a minor in Greek and art history). What were those undergraduate student years like for you?

LN: Yes, I graduated from Vassar in 1951. I had decided to go to an all-women's college because all the smart women I knew (who could afford it or get a scholarship) went to Ivy League schools, mainly the so-called "Seven Sisters": Vassar, Smith, Wellesley, Bryn Mawr, Radcliffe, Barnard, Mount Holyoke. Vassar was an eye-opening experience. The Vassar faculty was comprised of old-time lefties and feminists but, as a whole, my first-year teachers were not very good. But I learned a lot, anyway. I wrote a term paper for my introductory history class on Beatrice Webb and Fabian socialism, which I suppose was the first "feminist" text I ever produced.

MR: Moving from Crown Heights in Brooklyn to a quasi-suburban college campus in Poughkeepsie must have been quite a culture shock, I imagine.

LN: Actually, the big culture shock was some of the girls in my class. They were not Jewish, not "intellectual," not from New York—and were quite waspy and only interested in dating. They knitted Argyle socks for their boyfriends, played bridge, and went to football games. They all wore gold bobby pins and camel-hair coats and Bermuda shorts. Some of them made debuts. This was truly another world for me. But I made

wonderful, interesting friends, was politically active, supporting Henry Wallace's presidential campaign with like-minded young women, wrote and published poetry, and met others who did the same. I went to a stimulating conference on the contemporary arts, organized partly by Phyllis Bronfman (later Lambert), where I saw Merce Cunningham perform with John Cage on the prepared piano. (I had seen Merce with Martha Graham in my high-school days, but this was something new and different.) I was asked to design sets for an early (American) performance of Bertolt Brecht's *The Good Woman of Setzuan*. Gradually, we all sorted ourselves out and I found good, great and inspiring teachers, some of them men but many of them women. The good thing about a women's college at the time was that women had a chance to do everything. I got onto the editorial board of the liberal newspaper, I participated in the theater, where women did lighting, carpentry and, of course, acting and directing. We were the heads of student government. We were not pushed to the margins because there were no gendered margins, so to speak; we were all there was.

MR: In a way, then, having grown up in a household in which your voice and intellect were encouraged, where you were quite coddled, you would have found the strong and independent women you met at Vassar quite "normal," right? I recall your telling me that there were no male chairs in the art history department until your husband [in 1975], and that you always thought that women ran the show at Vassar. However, you also said that you were often told that you "think like a man," as if women couldn't think, that women were fluttery and emotional. So at what stage did you realize that life outside of Vassar truly was a "man's world," that there was a glass ceiling, that there were firm societal expectations set upon most women?

LN: In the 1940s, Vassar was an institution with a serious feminist past and a history of brilliant, creative, and politically activist students like Elizabeth Bishop and Mary McCarthy. But in the late 1940s it succumbed to the postwar demand that women return to "Kinder, Küche, Kirche" [German slogan meaning "children, kitchen, church"]. Then, a well-publicized survey team of sociologists, psychologists and educational authorities known as the Mellon Committee came to Vassar and blighted the ambition of the women students, as well as denigrated women's potential for achievement, by declaring the college a "homosexual matriarchy" and women who dared to use their minds in competition with men as "overachievers." Yet here again, contradiction—fortunately—abided. In the classroom, our teachers—the better ones, male and female—encouraged us to strive, to excel, to explore, even if nothing much awaited most of us after graduation but marriage, parenthood, and membership of the Junior League of St. Louis or Scranton. For a term paper in my junior year social psychology course, I wrote a so-called "content analysis" paper about the women's magazines of the period—*Good Housekeeping, Ladies Home Journal,* and *The Woman's Home Companion*—thereby enabling myself to read

in good conscience what I usually felt guilty about as time-wasting. (Parenthetically, I must admit that then, as now, this feminist enjoys the occasional wallow in the sluttish pleasures of popular culture: *US*, *In Touch*, *OK*, *Star*—I don't buy them, but if they are around, like *Vogue*, or *Elle* or *Allure*, I certainly will flip through them, by no means entirely uncritically but with a certain delicious, clandestine enjoyment.) My analysis uncovered the double message women's magazines of the 40s sent to their readers: on the one hand, there were the serious articles about major women activists and achievers like Eleanor Roosevelt or Dorothy Thompson or Amelia Earhart, presumably calculated to encourage their readership to do likewise. But the fiction they offered up for female consumption told a different story: in all cases, without exception, women who pursued careers, who didn't pay full attention to husbands and children and domestic affairs, were doomed and punished. Career girls who wanted to keep on working, who dared to compete with male partners, were cast into outer darkness—either they remained "old maids," or lost their mates to more properly domesticated women. The message was clear, and cast in the guise of fiction it appealed more to the emotions or even the unconscious fears and doubts of the female audience at stake. Such fiction, like women's films at the time, reinforced the doxa of the day, and no doubt helped sell more houses, more washing machines and more table linen to the would-be model housewives and helpmeets that these magazines catered to. This project also opened my eyes to my still-hypothetical future. Although not yet a card-carrying feminist—and who was in those days, besides some shapeless, tweedy, old left-over suffragettes among the emeritae?—I knew from that time onward that I was not going to be one of those model domestic women. I despised and pitied them, and vowed inwardly that I would be different. Of course, there were other models for heterosexual women on view at the college—bohemian wives and mothers, or, in rare cases, married female instructors—but their fate was almost too awful to contemplate: women trying to finish their dissertations, write their poetry, or paint their pictures amid a shambles of urine-soaked diapers, unwashed dishes, and uncontrollable children. No, indeed.

MR: No, indeed! Instead, you decided to continue your education, attending Columbia in 1952 [Master's in English literature, 17th century, thesis on poet Richard Crashaw and Baroque imagery] and then, from 1953 to 63, you commuted to the Institute of Fine Arts to pursue your doctorate in art history, while also teaching part-time at Vassar, raising your daughter Jessie as a single mother after your husband, Philip Nochlin, died in 1960. During that time you also had a crucial Fulbright year in Paris, working on your dissertation, and writing a novel titled *Art and Life*, still unpublished, in your spare time. You were doing it all! As to your dissertation topic, why Gustave Courbet? I imagine that his unique combination of stylistic innovation and political engagement must have played a part—combined with, of course, a lifelong love of realism and painting.

LN: I first got involved with Courbet when I wrote a paper on French artists and the 1848 revolution at the Institute of Fine Arts [New York University] in the early 1950s. I had also taught early Netherlandish painting—Jan van Eyck, Rogier van der Weyden—at Vassar. I loved realist styles from the gut, as it were, because they refused the rhetoric of grandeur, the perfection and unity of the High Renaissance, in favor of a different kind of magic, that of the detail, the additive, the allure of the specific. Paradoxically, I also was drawn to Italian art of the 15th century—Fra Angelico, Pollaiuolo, Ghirlandaio, above all Piero— for different but related reasons, Piero because of my modernist proclivities. (What is good about art history is that it can support inconsistencies: you don't have to look down on Jan van Eyck if you love Piero della Francesca, and vice versa.) Then, later, I became interested in contemporary New Realism—Pearlstein, Alice Neel, Sylvia Mangold, Sylvia Sleigh, Rackstraw Downes, and so on—and curated a show of their work at Vassar called *Realism Now*, in 1967. My interest in realism sprang from multiple motivations—political, formal, personal; it culminated in a two-part article I wrote for *Art in America* in 1974: "The Realist Criminal and the Abstract Law." My interest in realism has never waned. I've taught several seminars on the subject, and have written extensively about women realists, including most recently a text on Ellen Altfest, included in this book.

MR: Tell me a bit about the years from 1963, the year you finished your doctorate, to 1970—which is to say, prior to your writing of "Why Have There Been No Great Women Artists?" I know you married architectural historian Dick Pommer (in 1968), and had your second daughter, Daisy, in 1969, but what were you working on during that stage— in terms of scholarship?

LN: I was, first of all, writing *Mathis at Colmar*, a slim volume about the Isenheim Altarpiece which I subtitled "a visual confrontation," published by the Red Dust Press in 1963. This was ekphrasis rather than art history. (See my piece on Sophie Calle in this volume for more about ekphrasis and art.) Then I was busy collecting, editing and, in some cases, translating, the material for the "Sources and Documents" series edited by my professor, Peter Janson. I ended up with two volumes of readings on art by such 19th-century writers as Baudelaire, Mallarmé, Fénéon, and many others, including the writings of the artists themselves: *Realism and Tradition in Art, 1848–1900* and *Impressionism and Post-Impressionism, 1874–1904*, both published in 1966. I then went on to write *Realism*, a volume in the Penguin series, "Style and Civilization," of which I am still proud, if not entirely satisfied. And it was then that I met my inspiring future editor at Thames & Hudson, Nikos Stangos, who was involved in almost all my future publications with that house, to which I still remain faithful.

I also published several articles during that period starting with a controversial review of Joseph C Sloane's *Paul Marc Joseph Chenavard*, which appeared in *The Art Bulletin* in 1964. My study of Courbet's *Burial*, "Innovation and tradition in Courbet's *Burial at*

Ornans," appeared in *Essays in Honor of Walter Friedlaender* [Marsyas, Supplement II], published by New York University, Institute of Fine Arts, in 1965. In the same year, I published "Camille Pissarro: the unassuming eye" in *ARTnews*, and in 1967, "Gustave Courbet's *Meeting*: A Portrait of the Artist as a Wandering Jew," in *The Art Bulletin*; the latter won the Kingsley Porter Prize of 1948 for the best article in that publication by a writer under forty. In 1968, I curated the exhibition *Realism Now* at Vassar, with the help of my undergraduate students, and wrote the catalogue; both got some notice in the New York press, and artists and critics came up to Poughkeepsie to see the show. Finally, I published "The Invention of the Avant-Garde: France, 1830–1880," in *The Avant-Garde, Art News Annual XXXIV* in 1968, and then went on to do the research, and write, a long historical article about the birth and later vicissitudes of the museum. Titled "The Inhabitable Museum," it appeared in *ARTnews* in January 1970.

MR: And exactly one year later, in January 1971, you published "Why Have There Been No Great Women Artists?", also in *ARTnews*. It was intended for publication in one of the earliest scholarly texts of the feminist movement, *Women in Sexist Society*,[2] in which it was published under a different title, "Why Are There No Great Women Artists?" But it appeared first as a richly illustrated article in a pioneering and controversial number of *ARTnews* (vol. 69, January 1971), dedicated to women's issues.

LN: The text was written during the early days of the Women's Liberation movement, and was at least partially based on research carried out the previous year when I had conducted the first seminar, at Vassar College, on women and art, in 1970.

MR: To put this into context, you taught the first class on women and art at Vassar, as you say, and then taught the course again that same year at Stanford, where you met Judy Chicago and Miriam Schapiro for the first time. You also saw *Womanhouse* while in California, and, as you make clear in your "Starting from Scratch" essay, included in this volume [p. 188], had mixed feelings about it. On a wider scale, also in 1970, the US underwent drastic political and cultural changes, all in favor of the women's movement—with events such as the ERA (Equal Rights Amendment) passing in the US House, the 50th Anniversary celebrations of the 19th Amendment, Bella Abzug's election to the House, and the publication of major feminist texts like Robin Morgan's *Sisterhood is Powerful*, Germaine Greer's *The Female Eunuch*, Shulamith Firestone's *The Dialectic of Sex* and *Our Bodies Ourselves*, as well as the founding of the Ad Hoc Women Artists' Committee, and the Feminist Art Program at Fresno. Again, all of this in 1970. It must have been beyond exhilarating!

LN: Yes, it certainly was...and when I embarked on "Why Have There Been No Great Women Artists?" in 1970, there was no such thing as a feminist art history: like all other

forms of historical discourse, it had to be constructed. New materials had to be sought out, a theoretical basis put in place, a methodology gradually developed.

MR: Your essay "Starting from Scratch" captures beautifully what appeared to be a sense of urgency on the part of liberated women like yourselves, as you sought to intervene in and alter history itself. But was there a specific incident around that time that inspired you to write that essay?

LN: I wrote "Why Have There Been No Great Women Artists?" as the direct result of an incident that took place at a Vassar graduation in 1970. Gloria Steinem was the graduation speaker...she had been invited by my friend Brenda Feigen, who was then a graduating senior. Her brother Richard Feigen was there. He was a famous gallery person, the head of the Richard Feigen Gallery. Anyway, afterwards, Richard turned to me and said, "Linda, I would love to show women artists, but I can't find any good ones. Why are there no great women artists?" He actually asked me that question. I went home and thought about this issue for days. It haunted me. It made me think, because, first of all, it implied that there were no great women artists. Second, because it assumed this was a natural condition. It just lit up my mind. I am sure it was the catalyst that enabled me to put together a lot of things I had been thinking about, and stimulated me to do a great deal of further research in a variety of fields in order to "answer" the question and its implications, but his initial question started me off.

MR: Prior to this incident, had you ever asked yourself a similar question—as to why there were no "great" women artists—or musicians, or writers, for that matter?

LN: No, I hadn't. The thing about Vassar was that we'd always known there were women artists. Works by Georgia O'Keeffe, Kay Sage, Florine Stettheimer, Veira da Silva, Agnes Martin, and Joan Mitchell hung in the gallery. There were also women artists like Rosemary Beck teaching painting at Vassar; our sculpture teacher, Concetta Scaravaglione, who had been active in New Deal projects, was a woman, and a lot of contemporary women artists were invited to campus for lectures. I remember attending gallery talks by Loren MacIver, Irene Rice Pereira, and Grace Hartigan in the early 1950s, and they were memorable. As a sophomore I had thrust a poem into the hands of MacIver, and as a young teacher I remember being bowled over not just by Hartigan's work, but also by her tough, bohemian, unconventional persona. Even earlier, though, in my teens, my mother had shared with me her enthusiasm for women writers like Virginia Woolf, Katherine Mansfield, Rebecca West, and Elinor Wylie. So I certainly knew that there were women artists. But I wasn't thinking in terms of men or women; I just included women in the group of people who made art. I just thought, there they were.

MR: So ultimately, then, it was the word "great" in Richard's sentence that started you thinking about the historical circumstances of women as artists, prompting you to ask that intentionally provocative question. Did you have any idea at the time that the essay would ring down like a clarion call, or that it would challenge each new generation to assess changes and improvements in the conditions under which women artists work?

LN: I knew I had done something important. I wrote it under a kind of heady inspiration that was based on a great deal of previous thinking and knowledge, all of which surfaced as I wrote; each new element led me on to further investigation in a wide variety of fields; each discovery demanded further research. I hesitate to use the term "dialectical thinking" loosely, but I think of it as such; it was a truly exciting experience. I might tone down the rhetoric a little if I were writing a similar piece today, but somehow, at the time, it was necessary to the project.

MR: Around the same time that you were writing "Why Have There Been No Great Women Artists?" in the early 1970s, you were also writing about Miriam Schapiro, Sylvia Sleigh, Dorothea Tanning, as well as thematic texts like "Some Women Realists" [p. 76], and "How Feminism in the Arts can Implement Cultural Change."[3] You also participated in a controversial forum titled "What is female imagery?," in *Ms. Magazine* in 1975, along with Lucy Lippard, Arlene Raven, Joan Snyder, Eleanor Antin, and others—in which you were asked if women's art was different from men's. To which you argued against the concept of a "feminine sensibility," postulating that women's art was no more alike than men's art, and that we should speak instead "of female styles, always in the plural"[4]—a position you have maintained till today. Simultaneously, you were organizing with Ann Sutherland Harris one of the most important exhibitions in the history of feminism, that is, *Women Artists: 1550–1950*, which was the first large-scale museum exhibition in the US dedicated exclusively to women artists from a historical perspective. The exhibition presented more than 150 works by eighty-four painters, from 16th-century miniatures to modern abstractions. In Ann Sutherland Harris' acknowledgments in the catalogue, she describes the genesis of the show, explaining that the initial impetus came from a group of women artists in California. The process, as she describes it, is well worth repeating:

> The idea for this exhibition emerged during the course of some informal after-dinner speeches following the symposium organized in connection with another exhibition, "Caravaggio and His Followers," held at the Cleveland Museum of Art in 1971. Kenneth Donahue told the story of women artists who came to the Los Angeles County Museum of Art demanding gallery space and exhibition time for women equal to that being given to male artists. During the course of subsequent meetings, when the work of distinguished women artists of the past

was discussed, they proposed a comprehensive exhibition devoted to Artemisia Gentileschi, a suggestion that Mr. Donahue greeted with enthusiasm. Athena Tacha...urged me to respond. I rose and welcomed the suggestion too, but noted that there were many other neglected women artists worthy of exhibition. The audience responded warmly to both our statements, and Mr. Donahue came over immediately to ask me if I would be interested in being a Guest Curator for such a show. Of course, I said yes...and in the course of the conversation the idea of a historical survey of major women artists emerged. ...As soon as it became a serious possibility, I urged Mr. Donahue and his coordinator of exhibitions, Jeanne D'Andrea, to invite Professor Linda Nochlin and they quickly agreed with this suggestion. Her participation was crucial for she is the only scholar who has been working for a long time on this subject.[5]

LN: Yes—this, in succinct form, tells how I got involved in the show. The research began shortly after that time. Needless to say, it took a long time, a great deal of work, and a lot of traveling. It was certainly difficult, but at the same time, very exciting: we were, to quote the title of my article included in this volume about the early days of the women's art movement, "Starting from Scratch." Of course, we had a single important museum, Los Angeles County, that really wanted the show, right from the start, so that was encouraging, and other museums in this country took it on, including the University Art Museum of Austin, Texas, the Carnegie Institute in Pittsburgh, and, most important

Women Artists exhibition, 1977, Brooklyn Museum

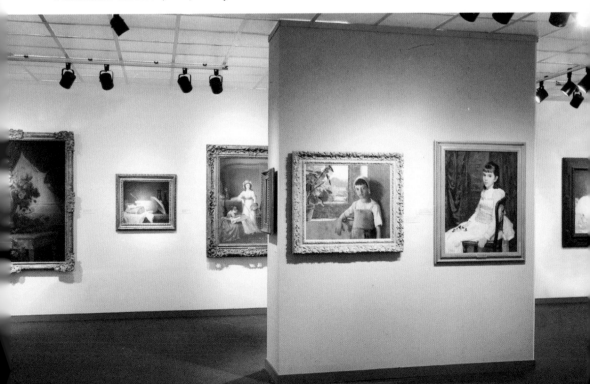

for me, since I was born and brought up in Brooklyn, the Brooklyn Museum. Some museums were receptive to the idea of the show, but many were not. Some curators and directors in Europe thought we were wasting our time, as they reluctantly dragged women's works out of storage; some even laughed. But then again, other curators, like the wonderful Richard Morphet at the Tate, were extremely enthusiastic and helpful, providing much-needed information and revealing works by major women artists that were eventually lent to the show.

MR: The exhibition had a considerable and immediate impact on the art-historical paradigm against which it was working. It was then, and continues to be, regarded as a landmark event in the history of feminism and art. Art critic John Perrault, writing in 1977, declared in his review of the exhibition, "The history of Western art will never be the same again."[6] After an exhibition such as this, Perrault continued, the occlusion of women from art history "can never happen again, for their research has proved that there have been women artists of great accomplishment all along." And Robert Hughes, writing for *Time* magazine, called *Women Artists* "one of the most significant theme shows to come along in years."[7] Quite the compliments!

LN: Yes, the exhibition was very well received. Perhaps more indicative of its impact at the time is the fact that museums lending to the exhibition began exhibiting their works by women artists more regularly once they had returned from the tour. It also spawned countless articles, monographs, and dialogue about the importance of women's artistic production as a whole.

MR: At the time, you explained to Grace Glueck in a *New York Times* review that *Women Artists* was "like doing the whole history of art with a feminist cast."[8] What a remarkable feeling that must have been! When I teach this exhibition in my museum studies courses, I present it as the most significant curatorial corrective in the 1970s to the occlusion of women as cultural contributors from the larger historical record—insofar as its central aim was the reclamation of women artists and their insertion back into the traditional canon of art history from which they had been lost, or forgotten, or simply dismissed as insignificant, because female. It was unprecedented in the historiography of exhibitions. I also explain that the strategy of discovery and analysis employed in *Women Artists* was part and parcel of a larger project of "reclamation" employed by feminists at this time—as is perhaps most visible in an installation like Judy Chicago's *The Dinner Party*, which commemorates 1,038 women from history. Or one could also mention exhibitions like *Old Mistresses: Women Artists of the Past* (Walters Art Gallery, Baltimore, 1972) and *Women Artists of America, 1707–1964* (Newark Museum, 1965), or the first survey texts of women artists from that time period by Eleanor Tufts, Germaine Greer, and Elsa Honig Fine.[9] Clearly, reclamation and excavation were important

feminist strategies at the time—and your involvement in *Women Artists* testifies to your belief in this. Therefore, I must broach a difficult subject. In "Why Have There Been No Great Women Artists?" [pp. 42–68], written five years prior to the opening of the exhibition, you were critical of feminists whose first reactions were "to swallow the bait, hook, line and sinker, and to attempt to answer the question as it is put: i.e., to dig up examples of worthy or insufficiently appreciated women artists throughout history; to rehabilitate rather modest, if interesting and productive careers; to 're-discover' forgotten flower-painters or David-followers and make out a case for them..."[10] You argued that while such attempts were certainly worth the effort, they did nothing "to question the assumption behind the question, 'Why have there been no great women artists?' On the contrary, by attempting to answer it, they tacitly reinforce its negative implications."[11] You continued: "The fact of the matter is that there have been no supremely great women artists, as far as we know, although there have been many interesting and very good ones who remain insufficiently investigated or appreciated...The fact, dear sisters, is that there are no women equivalents for Michelangelo or Rembrandt, Delacroix or Cézanne, Picasso or Matisse, or even, in very recent times, for de Kooning or Warhol, any more than there are Black American equivalents for the same."[12] It was statements such as these that precipitated a maelstrom of criticism from feminists. I know that you later modified these statements. But can you explain how you worked through this contradiction at the time?

LN: Yes, I did later modify these statements. On the one hand, I knew I was taking a position that directly contradicted my stance in "Why Have There Been No Great Women Artists?" Yet it seemed to me that, after digging around in the basements and reserves of great European museums and provincial art galleries, there had indeed been many wonderfully inventive, extremely competent, and, above all, unquestionably interesting women artists; some of these artists had been cherished and admired on their own native turf, even if they could not be considered so-called international superstars. This work and its historical import, without question, deserved to be shown and, even more important, deserved to be thought about and seriously analyzed within the discourse of high art. In other words, in "Why Have There Been No Great Women Artists?" I said that I thought that simply looking into women artists of the past would not really change our estimation of their value. The whole point of the first big *Women Artists: 1550–1950* exhibition, however, was precisely to see what women as artists had done over the years despite prejudice, marginalization, and stereotyping. We weren't claiming to find some neglected Michelangelos. For a variety of socially constructed reasons, there had really never been a female equivalent for Michelangelo or Van Eyck, or Poussin, for that matter. Our goal for this enterprise was not primarily to prove that women really had an art history as successful as that of the men, despite overwhelming odds, a history silenced by male conspiracies. Rather, I was interested to see what women had achieved

and not achieved within specific historical circumstances and particular sorts of social refusal and permission. In "Why Have There Been No Great Women Artists?" I said that I thought that simply looking into women artists of the past would not really change our estimation of their value. Nevertheless, I went on to look into some women artists of the past and I found that my own estimations and values had in fact changed.

MR: *Women Artists* ended in 1950—which is to say, prior to the women's movement in the US and the development of feminism as an artistic practice. It is interesting to contemplate whom you might have included had you brought the exhibition to the present. I know you had a particular aversion to the concept of a female esthetic or central core imagery, and that you were writing about Sleigh and Schapiro, but what other sorts of work by women were you drawn to in the 1970s?

LN: Well, there was other equally memorable if less overtly political women's work on view in the early 1970s that I really liked. I am thinking particularly of pieces by Lynda Benglis that I encountered in the innovative 1971 exhibition at Vassar College, where I was teaching. Titled *26 × 26*, the show itself, curated by a brilliant former student, Mary Delahoyd, was intrepid in its choices: it included, besides the Benglis pieces, poured work by Marjorie Strider, and a "performance" piece by Gordon Matta-Clark, which involved living suspended in a net in the trees for several days. Dazzling! I would really like to go into the Lynda Benglis contribution in some detail, because for me it extended the whole notion of what a feminist intervention into the contemporary art doxa—Minimalism, for the most part—might be, both in terms of structure and medium. At the same time, it made me revise the very notion of what sculpture itself might be. It was the total rejection of sculptural work as permanent, stable, firmly based on the ground, and monumental, that was at stake in Benglis' pieces for the show, as it was in the concurrent work by Marjorie Strider in the Vassar show. This innovation had, of course, been vital to the creative output of Eva Hesse, as well: Hesse's *Contingent* (1969), made of impermanent materials, poured or extruded from the wall (in Strider's case, poured down the stairs or even out the window!) rather than standing on the ground or a traditional base; Benglis' "pours" engaged with space and temporality more boldly than any sculptor since Bernini, and his off-balance, metamorphosing *Daphne* in the 17th century.

MR: Yes, absolutely, Benglis, Strider, Hesse (and Hannah Wilke, as well) were doing something entirely new, and irrevocably connected with contemporary feminism in its refusal of the general standards of sculptural decorum.

LN: Benglis herself remembers the Vassar piece, *For and Against (For Klaus)*, as crucial. In a recent letter to me, Benglis affirms that the Vassar piece was of particular importance in the development of her early oeuvre. Although it was the second in the series of

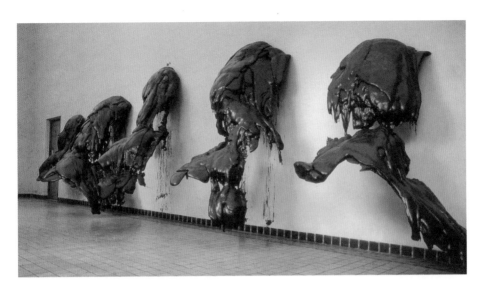

Lynda Benglis, *For and Against (For Klaus)*, 1971.
Pigmented (iron oxide black) polyurethane, 11 × 32 × 11 ft (33.5 × 107.2 × 33.5 m) (destroyed).
Installed at Vassar College Art Gallery, Vassar College, Poughkeepsie, NY in the exhibition *26 × 26*,
May 1–June 6, 1971

large-scale polyurethane pour pieces that she made over the course of eight months in 1971, it was the first in which she realized that the form could emerge solely from the wall and float in space without touching the ground for support. It was in making the Vassar work that she first understood that she could produce a deep cantilever of up to a dozen feet or more. She also informed me that a new wall had recently been constructed in the Poughkeepsie space just prior to Lynda's arrival, and she recalls that she was very careful to include elements of both the old and new walls as she was pouring. At the same time, Benglis was very clear that she was not interested in responding to the architecture of the space, as did Marjorie Strider in the staircase and window pieces in the same exhibition. On the contrary, she felt she was choosing in a formal and structural way, recognizing the development of form within a chosen context that did not have to do with allusions to specific architectural elements.[13] Yet if the dynamic thrusts and drips extruded from the wall with sinister bravado made a mockery of traditional art itself, desecrating the building in which traditional art was taught and presumably sanctified, nevertheless, contradictorily, the dripping folds of polyurethane themselves recalled past traditions, like Bernini's swirling, dynamic, dramatic drapery folds, themselves so different from both classical placidity and the contemporary Minimalist doxa.

MR: In the context of the early 1970s, this inventive and independent rejection of Minimalism constituted a forceful feminist gesture.

LN: Yes, and it reminds us that art assumes social or political meaning only within a context: to create this drippy, dynamic, extrusive, "impure" "sculpture" in an art world

that supported Minimalist purity, clarity and control had political meaning. It stood, to us who were participants in what was called the "women's movement in art," for the rejection of a kind of intellectual oppression that we felt neither accepted us nor gave us a chance to express ourselves. At a crucial moment within the burgeoning feminist movement, these solidified "pours," as they came to be called, literally flowed with the sheer energy of women's liberation.

Now I must make a personal confession. My husband and I walked off with a small fragment of one of the polyurethane pieces, a precious relic of the pieces on view, when it was broken off after the show was over and just lying around. Were we stealing art? Nobody raised the question. Somebody probably just said, "Do you want to take this?", and we said, "Sure!", and took it and put it on our back porch; it looked good out there. Of course, it disintegrated within about a year: I mean, rain, snow, dog...all those things... time, erosion. It vanished, got smaller and smaller, less and less, until finally it was just a little blackish nub and we put it in the garbage. We were very sad, of course, but we accepted it, the way you have to accept death after life: I mean that's what happens—why shouldn't art die? Does all art have to last? Does it have to be permanent and monu-mental—and valuable? This is something the work of certain women artists, like Hesse, Benglis, Bourgeois and others, makes us think about. Benglis made many varieties of "pours," many in brilliant intermingled colors, some suspended from walls, flowing down or just spreading out freely on the floor, all of them implying free movement of molten material, rejecting stasis as a necessary condition of the sculptural process.

Of course, it wasn't just women who were rejecting traditional modernist and post-modernist form at the time. Willem de Kooning also vehemently opposed sculptural traditions old and new in the series of thirty-three bronzes he created in the early 1970s. In *Clam-Digger* or *Cross-Legged Figure* of 1972, de Kooning, unlike Benglis or Hesse, or Bourgeois at times, retains the human figure, rendering it grotesque by melting and twisting it out of shape, certainly, but still keeping it perfectly recognizable as a human figure. And it's a large-scale human figure, formless and un-sculptural though it may be, a human figure cast in the traditionally noble and enduring material of bronze. De Kooning wasn't fooling around; he wasn't making stuff in polyurethane or beeswax or wire mesh, he was making sure it was cast in bronze and that it was going to be there a long, long time (and, parenthetically, be worth more and more over time), drippy, formless and grotesque though it might be.

I don't want to dwell only on innovative work from the beginning of the women's movement, in my continual quest for imagery that changed my ideas about what art could be. Sometimes, as recently as last year, it could be a piece that so thoroughly deconstructs/reconstructs a traditional theme like "motherhood" that I can never look at a Madonna-and-child image in the same way again. I am thinking of a work I encountered recently in a show of women's art in Buffalo at the Albright-Knox Gallery, a large color photograph. Janine Antoni's *2038* (2000)[14] is a startling variation on the

time-honored theme of motherhood: a parodic but deep reversion to the topos of the nursing mother. The basic animality of this act of nurturance, an act which neverthe-less can be sublimated into the highest virtue of which the female body is capable, is literally inscribed in *fin-de-siècle* artist Giovanni Segantini's ever-popular *Le Due Madri* (The Two Mothers, 1889), with its sentimental juxtaposition of two pairs of nursing mothers: cow and calf and peasant woman and baby in the shadowy interior of a barn.

MR: And Christian art—as exemplified by Artemisia Gentileschi's 17th-century version of the Madonna and Christ-child theme—had elevated this act of nursing into the most sacred function of the female body, almost but not quite making up for the original sin of Eve. Mary Cassatt also brought the theme up to date, and in doing so secularized it to the point that it became a theme of that everyday life so central to Impressionist iconography.

LN: Antoni's abject mother, lying in a rusty trough with an anonymous milk-giver of a different species at her breast is certainly not a scene of "daily life." Surrealist in its uncanny revision of who gives milk for whom, it is in some sense an updated Madonna of Humility, a popular theme in the Renaissance and before, where the Virgin sits humbly on the ground instead of being elevated on a chair or throne. I would like, however, to turn from the history or meaning of the theme to an exploration of the actual, immediate experience of Antoni's photograph itself, for it is the immediate experience that is so memorable, for a variety of reasons. As an image, it appeals not only to sight but to the haptic sense, the sense of touch so often disdained by artists and theorists as a lower sense. Sight and hearing were traditionally considered the higher and more rational senses, as opposed to those of touch, smell and taste, which were considered gross, primitive, and childish. Here though, it is touch that conveys

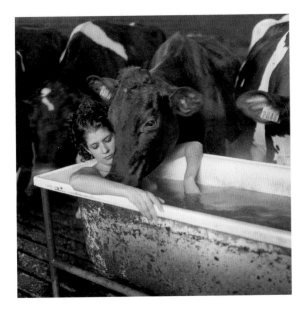

Janine Antoni,
2038, 2000.
C-print,
20 × 20 in.
(50.8 × 50.8 cm)

the mystery of the flesh: the preternatural softness of the cow's muzzle against the soft, female breast; the contrastingly rougher, emergent texture of its dark coat against her delicate arms; the urgent sheen of its slanted eye against her peacefully closed ones. The murky fluid of the bathwater plays against the rough, rusty surface of the trough (not a proper bathtub) in which the woman, Antoni, is half submerged. It is the haptic sense, then, that both constructs and responds to the mysterious *tendresse* of the image, its shocking yet oddly soothing provocation.

MR: Of course, Antoni's *2038* is not merely an investigation of motherhood and its limits, but also of cows!

LN: Yes, an investigation into what one might call, tongue-in-cheek "bovinity!" Poetic but straightforward, the image recalls the text of one of our major young prose writers, Lydia Davis, in a long, elegiac, exhaustive, deadpan piece, "The cows": "They are a deep, inky black. It is a black that swallows light. Their bodies are entirely black, but they have white on their faces. On the faces of two of them, there are large patches of white, like a mask. On the face of the third, there is only a small patch on the forehead, the size of a silver dollar...."[15] And, of course, when I think of women and cows, I think of women and camels and I am back in 1971 again and mingling with the entirely original work of Nancy Graves, the first camel-bone pieces, which again made me revise my notions of what a work of art might be. The camel-bone pieces (the "bones" completely constructed by Graves herself) hung in a remarkable installation in the early 70s at Vassar. There is a picture of me kneeling in their midst with my little daughter, as though in a jungle. Graves' film about the camel market in Isy Boukir of 1971, filmed in the Sahara in the course of eighteen days—just camels, camels moving, writhing, looking, bending, running—so enchanted me that I wrote a piece that was simply all that I saw and could grasp in writing as I watched the movie. I was not the only admirer of *Isy Boukir*. Roger Greenspun, the critic of the *New York Times* said: "...Ms. Graves' film is precise and wonderfully particular, and as appreciative of its camels as of the controlled rhythms of their surges across the screen, the slight shifting of their legs, the curves of their extended necks. It is altogether beautiful, rich, assured, tactful and intensive filmmaking."[16]

MR: In your catalogue essay for that Vassar exhibition, you compare Graves' "Camel series" (1968–69) to the radical gestures of Duchamp's readymade: as re-creations of found objects re-presented anew. Her innovation and difference, of course, is that, if she'd wanted to pull a Duchampian gesture, she would have, as you state, "bought a stuffed camel from a taxidermist, signed it, and wheeled it into an art gallery."[17]

LN: One could never mistake one of Graves' camels for a "real" camel! Rather, they exist as compelling simulacra.

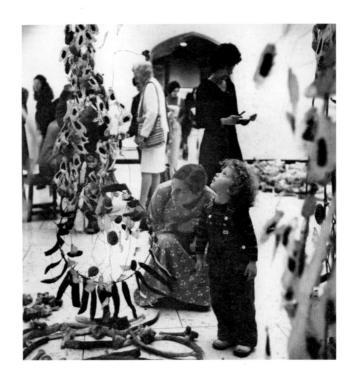

Linda Nochlin
and daughter,
Daisy Pommer,
Vassar College
Art Gallery,
Poughkeepsie, NY,
Nancy Graves
exhibition,
October 17–
November 7, 1971

MR: Do you happen to know if Graves identified as a feminist? Is her work "feminist"? How important is intentionality when discussing feminist art? I'm thinking, I suppose, of an artist like Lee Bontecou, who became a feminist icon in the 1970s, despite her own opinion to the contrary, as a result of Chicago and Schapiro's famous article, "Female imagery," written in 1973 (*Womanspace Journal*), in which one of her sculptures was used to illustrate a central core image. Or Frankenthaler, who one hesitates to call feminist because she was opposed to any suggestion of her sex or feminism being an issue in her work. Or Joan Mitchell, Elaine de Kooning...This brings us, yet again, to the question of "What is feminist art?" And who can be called a feminist artist?

LN: The question is a complicated one, and is harder to answer than it was in the 1970s, when a group of women artists set out, passionately motivated by the Women's Liberation movement, to create a new feminist art, a project that would engage with politics, including the politics of the art world, and at the same time innovate in the realm of style and iconography. It was by no means a question of simply painting images of The Great Goddess or feisty females knocking out their male opponents. Abstract artists like Miriam Schapiro and Joyce Kozloff understood the importance of stylistic context in the invention of a feminist imagery. At a time when 'reduction', 'cool', 'simplification' were the watchwords of the vanguard Minimalists, pattern and decoration could be understood as feminist protest, among other things. Some women artists felt that painting itself had a patriarchal heritage and abandoned it for conceptual art, performance, installation, video or photography-based forms of expression.

MR: While others held on to the tradition of painting quite steadfastly, producing "space" within it, forging alternatives, often in a quest for a female esthetic, many women artists in the US were working with abstract vocabularies, exploring the geometric schema of the grid, revisiting this modernist, Minimalist emblem with a vengeance, while others were parodying the signature abstract expressionist "drip." An artist like Joan Snyder was slicing through her canvases with large vaginal slits; Louise Fishman was cutting up her Minimalist paintings and stitching them back together; and Mary Heilmann was teasing out the formal esthetics of color-field painting by deliberately integrating what she called "girly" colors, much like Chicago had done with *Rainbow Pickett*, or Benglis with her *Blatt*. These were all consciously feminist strategies. But what you're saying, I think, is that in the 1970s there were divisions and differences among women artists purporting to support feminism in their work. Weren't those the same sort of issues that (male) artists had already been dealing with vis-à-vis the place of utilitarian political "messages" in high art or its equivalent?

LN: Yes, the prime exemplar is, of course, the case of Ad Reinhardt, a committed radical in politics, but totally, and self-consciously, non- or even anti-political in his work. In his black paintings, totally abstract, he sought for purity, reduction, "art-as-art," as he put it. In his cartoons, widely published in leftist periodicals like *PM*, he openly, and with considerable wit, expressed his political beliefs, including his beliefs about art itself, in series like "How to look at art," about modern art and its viewers. For Reinhardt,

Lynda Benglis creating
Blatt, 1969

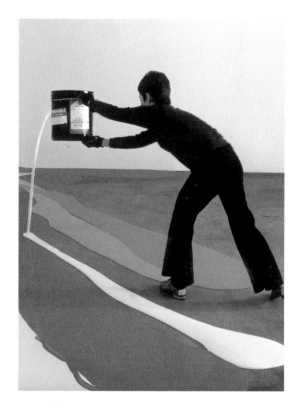

art—high art—and politics were separate realms, and to make art into a utilitarian weapon, no matter how important the cause, was to besmirch it, to misunderstand what art was about. Reinhardt is, of course, an extreme case, but one can certainly imagine that there might be a feminist artist who was a feminist in her political engagement, who joined feminist demonstrations for larger representation of women artists in museums, who fought for more women curators, who demanded more shows for women artists, and yet in her work rejected all visible signs of feminist (i.e. political) engagement.

MR: Yet, there is another aspect of feminist art/feminist artists. There are some women artists whose work is imbued with the issues promulgated by feminism, yet who don't necessarily refer to feminist issues directly.

LN: Yes, and in some instances, the feminist "agenda" is simply, sometimes subtly, sometimes blatantly, there. Feminism is, in other words, a necessary but not a sufficient condition for their creative innovations, an ever-present substratum of their art. I am thinking specifically of three major artists of our time who happen to be women: Louise Bourgeois, Cindy Sherman, and Kara Walker. Louise Bourgeois joined in some of the earliest mass meetings of Women's Liberation; I know because I was there with her at one of them, I think in Washington. But aside from this, her burning antagonism to patriarchy underlay her constructive and deconstructive strategies in much of her most powerful work. It is most apparent, of course, in such overtly named major works as *The Destruction of the Father* of 1974, but it underpins both style and iconography in many others. She herself, in her many autobiographical writings, attributes this to her specific relationship to her own father, her life-long resentment of his betrayal of her mother and herself in an affair with her governess, and no doubt there is some truth in this personal account. It also makes a good heart-rending story to account for her decided antipathy to male authority in the realm of art. But the larger issue suggested by works like *The Destruction of the Father*, the series of giant (female) spiders, the late works in cloth, and many others, is the feminist one of ensuring parity for women, of refusing to bow to centuries of male-dominated tradition. One might go so far as to say that the whole floppy, horizontal, multipartite, irregular, suggestively but ambiguously erotic totality of *The Destruction of the Father* is the Other of traditional sculpture, which was, until recently, vertical, tightly controlled, unambiguously gendered male or female, wrought of some permanent, noble material like stone or bronze. Bourgeois' piece is, in some sense, the anti-David by Michelangelo, with its beautiful marble surface and overwhelming masculine power; the anti-Greek god with his carefully balanced contrapposto; the anti-Matisse *Back* with its formalist perfection (and calculated imperfections). And it is a denial of the unstated assumption of masculine authority, which each of these works presumes and projects, which is the very basis of their aura, in the Benjaminian sense of the term.

MR: Agreed. Bourgeois' late works, crudely sewn out of coarse fabric, again undermine millennia of male-dominated tradition. Turning deliberately to ignoble, impermanent material and debased subject matter—sexual but not sensual in the usual sense of the term—they reject both skill and the requirements of high art in favor of the *matière* of children's toys or cheap bathrobes. Dangling or splayed out rather than standing, incorporating real elements like leg braces or sharp knives, they mingle the innocent and the vicious with startling grotesquerie.

LN: And the fact that they are stuffed and sewn, rather than modeled or carved, again calls attention to aspects of feminist demands for respect for the "low" arts of stitchery, for women's traditional crafts, but with a difference. For Louise Bourgeois in her old age rejects all the niceties associated with female craftsmanship, with children's dolls, with the cloth arts, and transforms them into something more virulent, more aggressive, more, paradoxically, anti-patriarchal than even some of her own previous work; she turns the materials of women's craft toward more brutal, destructive ends, even parodying some her earlier pieces like *Arch of Hysteria* (1993) by creating a clumsy, dangling, ill-sewn cloth version. Can one say that the late Louise turns against all authority, even her own, because once a move is accepted, becomes part of the doxa, it is, by definition, patriarchal? In the case of Cindy Sherman, one of the outstanding artists of today, male or female, I would say that all her representations of female subjects are underlain by feminist rejection of woman's position in the world, and in consciousness itself. Take the early film stills of seductive "starlets" in come-hither poses. It doesn't take more than a minute to realize that these black-and-white self-images are parodies, subtle or blatant, of everything Hollywood has imposed upon its young women would-be actresses. Far from being "seductive" or "hot," they are as cold as ice, lacking in overt sexual appeal. It is impossible to imagine any tinseltown publicity agent in his/her right mind using these "film stills" to publicize a client. In other words, they deliberately "don't work," and in so doing lose their apparent reason for being and assume another position, very different from their obvious one. That is to say, they reveal to the viewer the whole oppressive, time-worn, debasing apparatus of female seductiveness, forced not only on Hollywood starlets but on women in general: one thinks of Simone de Beauvoir's time-honored assertion, "One is not born a woman, but rather becomes one." There is not a single photographic series by Sherman that is conceivable without the impact of feminism. By this, I do not at all mean to imply that they are based on some specific doctrine or are instruments of propaganda—far from it. I am saying the series only becomes meaningful within a social context, a psychoanalytic field that feminism has infiltrated, whether this be the images of horror and violence toward women—whether self-wrought or done by others, replete with vomit, garbage, and nameless revolting substances: a fantasy on a bulimic theme, or dismembered body parts chaotically installed on a horizontal field in token of innumerable, highly publicized images of

Cindy Sherman,
Untitled #465, 2008.
Chromogenic color
print, 64⅕ × 58 in.
(163.8 × 147.3 cm),
edition of 6

the savage violation of the female body in the press or on screen; or the horrifically grotesque figures with weird and enlarged sex-prostheses displaying their monstrosity to the public, porn so far over the top that it becomes something worse. But most of all, we are made aware of the feminist consciousness underpinning the gut-wrenching pathos of Sherman's series that highlight the coming of age and women's desperate attempts to nullify it, to stave off the inevitable traces of time on flesh.

In *Untitled #465* (2008), signs of both class and age collaborate in the construction of the parodic role-playing involved. The "subject," played, as always, by Sherman herself, turns her haughty glance at us, over her shoulder, in a time-honored pose of upper-class condescension. The ill-concealed wrinkles, sags and scratches etched into her skin below the cheek bone (a good dermatologist never uses Botox on the lower part of the face!) are echoed by the uneven double strand of pearls about her throat and contrasted with the perfection of the glowing pearl globe in her earlobe. Our attention is carried upward by the noble flight of steps behind her and the indications of poshness in the classical motifs at the sides of the flight. The implications are clear: this babe, despite her age-reddened eyes, her unevenly applied eyebrows, her unconvincingly matte black hair, and the non-coincidence of her lips and lipstick, has class—or thinks she does. And she is trying to stave off that time-honored class enemy—old age—as hard as she can. Naturally, she is failing: that's where the pathos comes in. Though we may dislike her, even envy her, we can't help feeling sorry for her at the same time; or, if we are a certain age ourselves, empathizing. And of course, on another level, we can't help admiring the brilliance of Sherman's (not totally successful) masquerade itself. There are many other variations in Sherman's work on the coming-of-age theme, all different

Cindy Sherman,
Untitled #474, 2008.
Chromogenic color
print, 90¾ × 60 in.
(230.5 × 152.4 cm),
edition of 6

and carefully individuated: the aging art collector surrounded by examples of her booty, her face a painted, lifted mask hovering between arrogance and despair (*Untitled #474*, 2008); the pathetic, mink-caped creature clutching her arms about herself protectively, standing before a luxury apartment, expensively ill-clad, her sad face puffed, asymmetrical and line-incised; and many others. All bear witness to the fact that there is no winning the contest with death. Sherman, in her many disguises makes this as clear as any medieval dance-of-death of Renaissance *memento mori*. Indeed, these works shift toward the allegorical.

MR: Sherman's whole project eloquently testifies that "feminist" art is not necessarily an invigorating call-to-arms but, on the contrary, may be a more complex revelation of specific identities that are part of a broader set of issues involving femininity and its representations. And all of these are implicated in the position—commercial, physical, psychological—of the masquerade of femininity in the contemporary world. Since, in Sherman's work, it is always the same woman who plays all the roles, the undeniable implication is that femininity (or "womanliness," as it used to be called) is itself a masquerade imposed on women, as Joan Riviere pointed out so many years ago.[18]

LN: Cindy Sherman's entire output literally embodies "womanliness as masquerade," since it is always the artist herself that plays the widely differing roles. And it is a masquerade maintained with increasing difficulty with the passage of time, hence the

pathos of the revelatory images of the later stages of women's lives, when the masquerade, despite all the holding efforts and the expense, begins to fail, leaving only the grotesque evidence of that failure behind. No wonder old women have traditionally been shunned or demeaned as hags, crones or witches, or even as face-lifted, super-maquillaged society dames: they all predict, dangerously, and for men as well as women, loss of potency, enfeeblement, and, ultimately, the threat of the grand finale, the end of both masquerade and its failure: death.

MR: In regards to your contention that there are some women artists whose work is imbued with feminist issues yet don't necessarily refer to the issues directly, you had referred earlier to Kara Walker. Can you explain what you mean by that?

LN: Yes, but what interests me about Kara Walker's work is that the issue of race unequivocally constitutes the manifest content. This imagery, wrought in a newly sophisticated version of the archaic, popular medium of the silhouette (I have one of my mother as a teenager created when she visited Atlantic City in the first quarter of the 20th century), clearly represents the evils imposed upon people of color by slavery, imperialism, colonialism, and, more recently, by bias and prejudice. Yet such a representation equally depends, for its language and power, on the issues of gender imbricated in the racial ones. Sexual domination, the white male's privileged access to the black woman, rings out as a reiterated theme, in the muted, ironically black medium of the silhouette. Daring in its blatant outrageousness yet delicate in its manipulation of elegant contours, a major, large-scale silhouette installation like *Gone: An Historical Romance of a Civil War as it Occurred b'tween the Dusky Thighs of One Young Negress and Her Heart*, created in 1994, depends on the representation of gender exploitation to make its point. An acerbic riff on the romanticized stereotypes of race relations in the pre-Civil War South, as set forth by popular favorites like Margaret Mitchell's *Gone with the Wind*, and still current today, *Gone* begins and ends with male and female coupled figures. To the left, a perky, hoop-skirted young lady tilts forward on tiptoes to kiss an elegantly booted and jacketed young army officer, his sword pricking up behind him, their hands intertwined in stereotypical Hollywood fashion. But look again, and you see that this romantic encounter is enabled by the skinny legs of a little black girl, peeking out beneath the ruffled border at the rear of the young lady's voluminous skirt. These legs perhaps belong to the little girl gripping a drowned goose in the next element of the installation, a folkloric interval featuring the old folksong, "Aunt Rhody."[19] To the far right, the same "white master" carries off the wonderfully detailed figure of an old mammy, complete with pipe, broom, spindly legs, and ragged skirt that completely envelops his head and shoulders. What is the white guy up to? Nothing good. And gender exploitation begins young in Walker's incisive iconography: in the middle of the composition, raised to prominence on an island hill, the little black girl, in profile,

Kara Walker, *Gone: An Historical Romance of a Civil War as it Occurred b'tween the Dusky Thighs of One Young Negress and Her Heart*, 1994. Cut paper on wall, approximately 156 × 600 in. (396.2 × 1524 cm)

sucks off a little white boy in a sailor suit as he raises his hands in triumphant ecstasy. The whole composition is a marvel of exquisite detail and decorative elegance, featuring a graceful pitcher, strands of vegetation, and a kind of pseudo-Rococo perkiness throughout. It is blatant, ugly exploitation of black women that lies at the heart of the darkness pilloried here.

MR: Her cut-paper silhouettes harness genteel 19th-century imagery to highlight the vestiges of sexual and physical exploitation bred by slavery—as do her animations, which equally portray views of the antebellum South, offering up scenes of defecation, rape, decapitation, among other atrocities. However, she is also interested in issues of class, as another form of injustice. I'm thinking in particular of her most recent work from 2014, produced for Creative Time at the Domino's Sugar Factory in Brooklyn, a storage shed in Brooklyn built in 1927 to house the mountains of raw sugar due for whitening. Walker's work, in response to this setting, is an oversized sphinx wearing a mammie's kerchief, titled *A Subtlety, or the Marvelous Sugar Baby* [...]. The work pays homage to the passing of blue-collar America, at the same time that it criticizes the process of turning brown into white sugar, as if the former were "impure" to start with. What's interesting to me, of course, is that, at first glance, one might not view this work as "feminist" *per se*. And yet, like many of the works in our *Global Feminisms* exhibition, it is a less subtle, or, as I like to call it, "subterranean" feminism.

LN: Yes, it is. That's why I believe that much of the most interesting feminist art is being created by women from non-Western settings. This has nothing to do with primitivism or nature, but rather with specific situations: women artists in Asia, Africa, Latin America and Australia, in touch with the most contemporary media, sophisticated theory, and international art production, are creating new kinds of visual languages to embody new meanings, new interpretations of the situation of women in different

cultures—complex, acerbic, vivid, contrarian, and often—dare I use the word?—beauti-
ful. In a way, one might say that for many women artists worldwide today, their situation
as women simply cannot be avoided: one might almost speak of a feminist unconscious
in the work of some of the most brilliant contemporary women artists: a critical force
that has nothing to do with the woman/nature nexus or vaginal imagery, but with
ambiguity, androgyny, contrarianism, rejection of the clichéd categories of women-
hood, experimentation with the body and its metamorphoses and exploitation of all
the various media of contemporary art-making.

MR: I'm really proud of *Global Feminisms*. It was the largest exhibition of international
feminist art to date, and included works by eighty-eight women artists from sixty-six
countries. It was an unwieldy number, for sure, but I think our enthusiasm for the
subject precluded us from eliminating any of the women. The critical reception of *Global
Feminisms* interests me greatly. While smart feminist scholars and curators like Helena
Reckitt, Eleanor Heartney, Michele Kort, and Dena Muller understood the curatorial
mission behind *Global Feminisms*, others seemed to miss the point altogether. In her
New York Times review of *Global Feminisms*, for instance, Roberta Smith wrote that the
exhibition was "like a false idea, wrapped in confusion," and questioned whether there
is, in fact, such a thing as "feminist art." Is this criticism justifiable, in your opinion?

Kara Walker, *A Subtlety, or the Marvelous Sugar Baby, an Homage to the unpaid and overworked Artisans
who have refined our Sweet tastes from the cane fields to the Kitchens of the New World on the Occasion
of the demolition of the Domino Sugar Refining Plant* (installation view). A project of Creative Time
Domino Sugar Refinery, Brooklyn, NY, May 10–July 6, 2014

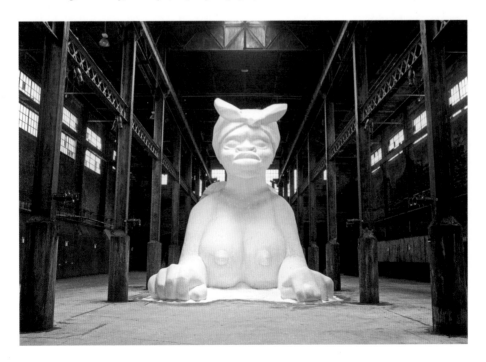

LN: No. I think Roberta, whose criticism I often admire and agree with, was totally mistaken about *Global Feminisms*. Because it was organized for the opening of the Elizabeth A Sackler Center for Feminist Art at the Brooklyn Museum, we had to include not just art by women, but art by women that conveyed a sense of political or social critique. I think that was what some critics and viewers didn't understand. The artists had to be critical of a certain status quo, whatever or wherever it was, and this had to manifest itself in some way. For instance, I don't think Ghada Amer is like Shahzia Sikander, or Sarah Lucas is like Tracey Moffatt. It wasn't as if just one kind of art and one kind of critique were represented in the show. Some of it was humorous, some of it was savagely serious, and some of it was estheticized. So I don't think it was confused, I think it was varied, according to the situations in the different cultures from which the women came, representing a wide range of styles and esthetic positions.

MR: Yes, *Global Feminisms* was certainly not a feminist-lite exhibition—it wasn't meant to be. It was not a "boiled-down" or consumable version of feminism. Either way, some of the reactions were downright angry. Retrospectively, I think that was a good thing. Successful exhibitions should push people's assumptions as to what constitutes "good" art, and in this case feminist art. Our exhibition was one of many major feminist events in 2007, including the founding of The Feminist Art Project, *Wack! Art and the Feminist Revolution* (MOCA, Los Angeles), the "Feminist Futures" symposium at MoMA, and so forth. Indeed, the year 2007 in the United States has been hailed by many in the art world as the Year of the Feminist. All of this activity bore witness to the fact that feminism in the visual arts appeared to be alive and flourishing, despite rumors to the contrary, and that all this should be a cause for unmitigated rejoicing among feminist art historians and critics like ourselves. What was your feeling at the time?

LN: Yes and no. Or rather, that the rejoicing should be mixed with a certain amount of skepticism, or at least a problematizing of the situation of women artists and feminist criticism. Such was the position of Carol Armstrong, in her *Artforum* preview of *Global Feminisms* and *Wack!*:

> I applaud their focus on art by women and recognize that the MOCA show's self-prescribed targeting of "second wave" feminism is historically justified in this regard. But I am leery of a correspondence that may be set up between women's art and feminist art, for it suggests, first, that only women can be feminists, and second, that women artists must be concerned with feminist themes, which must in turn be women's themes. That would be a double disservice both to women and feminists, a proclamation that feminism is only of interest to women and that women are a class apart from the human. Surely the feminist revolution has shown us the fallacy of both ideas. So we hope that

"Wack!" and "Global Feminisms" will provide openings toward a future in which male artists may be feminists and female artists may concern themselves with whatever engages them.[20]

Certainly, one hopes for a future in which male artists can be feminists—so far, however, I have not seen too much evidence of "male feminism," despite the fact that feminist art practice has had, and continues to have, a profound influence on the shape of art since the 1970s. Nor do I think that most women artists engaged with feminism by any means think that "women are a class apart from the human"—on the contrary, it is the misogynists of the world who propagate such a belief. And certainly, women artists should be and are free to explore whatever dimensions of art and experience they wish. Often, in my opinion, the most interesting feminist practice is not consciously or intentionally "political" but speaks out, subtly, humorously, originally, sardonically, of critical gender issues from different frames of reference. I cannot imagine forcing some clichéd, boring politically correct agenda on a woman artist, any more than on a male one.

MR: Agreed. Our lack of inclusion of males in our *Global Feminisms* show irked several critics, Armstrong among them. I recall that at the beginning we did consider the inclusion of male artists. But, in the end, it was a numbers game. If the exhibition included eighty-eight artists and twenty of them were men, then that would have been twenty fewer women we could represent! Now, feminist critics like Armstrong are certainly entitled to their opinions. And, of course, feminists should be free to criticize and make judgments about women artists and writers rather than condescending to them by refraining from value judgments. Unconditional praise is always suspect.

LN: More worrisome to me than criticism of specific feminist projects is the institutionalization of feminist practice and theory within the museum and the university. A triumph to be sure, but, like many triumphs, a mixed blessing. What does the institutionalization of feminist practice and theory imply? What does the substitution of "gender studies" for "feminist studies" imply? Is it the neutralization of feminist critique into a kind of even-handed study of chosen artists, like the analysis of 19th-century "great" male painters in books such as Charles Harrison's intelligent but infuriatingly revisionist *Painting the Difference: Sex and Spectator in Modern Art* (2005)?—actually an excuse to rescue certain exceptional works by exceptional male artists from the putative clutches of feminist critique. Of course, feminist art historians have, for the most part, never totally rejected Manet, Degas or Cézanne, as Harrison implies. On the contrary, they have revivified them and the study of 19th-century art in general by showing them in a new light, revealing formal and expressive qualities, and theoretical models, good and bad, which were never considered before feminist art history brought them to light.

MR: True. And on a related note, what happens when feminism becomes a course rather than a cause? When gender studies are institutionalized as simply another item in the curriculum? And what happens, on the contrary, within institutional settings, either museums or universities, when feminist critique is abandoned in favor of an uncritical celebration of women artists and their work in shows or courses devoted to the subject? Or when token women are inserted into the world art canon?

LN: Yes. Or when essentialism creeps into what I profoundly believe must always be considered the social construction of the entity "woman"? "One is not born a woman, but rather becomes one," declared Simone de Beauvoir, still the mother of us all, theoretically speaking. The socially constructed entity, woman, if she is an artist, faces a different world of experience and challenge than a male artist does. Difference, if always different and changing, exists. The forms that difference takes in art are obviously multiple, uncharted and, in the future, unchartable.

MR: And it is for that reason that shows of women artists, courses disseminating the feminist critique of art, and understanding and appreciation of the many directions, kinds of imagination, creative invention, and critical intelligence of women, need to be encouraged and rewarded. However, I do worry that such single-sexed exhibitions and spaces run the risk of ghettoization, and that they are unwittingly reproducing the segregation they aim to challenge. While women-only shows and spaces should be celebrated—as much as, say, the Jewish Museum, the Studio Museum in Harlem, El Museo del Barrio—I worry that, to the extreme, they can be separatist, and that perhaps the programming at these spaces is preaching only to the converted? In other words, who is receiving this information, and therefore how impactful is it, ultimately? Are these types of exhibitions still necessary?

LN: I don't think we should worry about the "impact." I think it is still important that various groups and sub-groups should be accorded their place in the sun. And even more important, that women artists, like those of other categories, should be seen in shows that are intelligently curated, bringing out new ideas even in connection with familiar work. I am thinking of the recent Cassatt/Degas exhibition in Washington (National Gallery of Art, 2014) as an example, where Cassatt and Degas are presented, with evidence, as creative partners rather than as leader and disciple. So, do I think that women-only and specialized spaces are still necessary today? Not in the same way, I suppose. I think at times it makes for an interesting show, if other aspects are specified, such as geographic or historical contexts. A show about women muralists of the New Deal, or Mexican women artists, or 19th-century women photographers, can always be made interesting and revealing, and not just to women. Other kinds of shows can also be invigorating and good for our morale, like *Women Choose Women* (New York Cultural Center, 1973).

What I feel is even more important today is to make sure women make an appearance and an impact in whatever context they are shown: this is not always the case. When it happens, it is an important occasion and should be noted. I just saw a terrific modern Latin-American photography exhibition at the Fondation Cartier in Paris (*América Latina 1960–2013*, 2014). It was a revelation because of the innovative quality of the works, the often-subtle political undercurrents, and for the fact that a large proportion of the work was by women photographers. In case one didn't realize the fact, there was an excellent film accompanying the work where many women spoke out about their experience.

MR: There is certainly more work to be done in this regard; however, for me, one of the most pressing issues today is how best to address the canon of art history, as it still needs to be radically re-conceptualized. It's one thing to "add" neglected or excluded artists to the traditional canon of art history; but it's an entirely different project to completely overhaul it, to challenge the entire notion of canonicity itself as a problematic and antiquated paradigm. In 1990 you chaired a session at CAA [College Art Association] called "Firing the Canon: Feminism, Art History, and the Status of the Canonical," which addressed these issues, asking questions such as: "Should feminist art historians and critics reject the canon and focus instead on 'minor' and 'marginal' figures? Should they attempt to add women artists to the canon? Or should feminist art historians and critics call into question the very notion of the canon itself by demonstrating how it works to maintain existing relations of power between men and women?"[21] It's amazing to me how relevant and prescient these questions are twenty-five years later. Where are we with all of this today? What are our options vis-à-vis the canon of art history? Throughout your career, for instance, you have often employed a revisionist approach, paying homage to canonical works, often by major male artists, but with a difference: critically rather than reverentially, or with the intention of pointing out gendered significations in works previously understood to be universal in their significance. In an essay from 1974, titled "How Feminism in the Arts Can Implement Cultural Change," you asserted that feminists needed to develop a revisionist art history that could "bring about re-evaluation, making us look again at pictures which have been cast aside and really rethink the implications of this rejection, making us ask what elements exist within the work of art that one might look at from a feminist viewpoint."[22] Revisionism: this is one option. If the canon of art history cannot be abolished altogether, then what sorts of counter-hegemonic tactics besides revisionism can we employ against and within it? Of course, I'm referring to the historical canon, not the current art system.

LN: One can start with the premise that any canon, narrowly construed, is an obstruction both to complex thought and to open examination of the historical situation itself. Certainly, the closer we get to the present, the more the dead weight of the

"canonical" obstructs objective examination of art and the art world more broadly conceived. Certainly, one is entitled to believe, and demonstrate, that some works of art are richer and more interesting than others. But to go from there to constructing a canon is counterproductive.

MR: Throughout your scholarship of the 1970s, you maintained that, in addition to the development of a revisionist art history, there were several fundamental issues that needed to be addressed before feminism in the arts could truly implement cultural change. The first, of course, was the notion of "greatness," which itself must be redefined as something other than white, Western, and unmistakably male. Have we achieved this?

LN: I think the whole idea of "greatness" is out of date, as far as contemporary art is concerned, and rightly so. And so are single standards, as far as I am concerned. Was there ever a single standard? Michelangelo thought Jan van Eyck was a painter for old ladies and nuns, and Roger Fry and Clement Greenberg shared this opinion, although they stated it more elegantly. Blake thought Rembrandt and Sir Joshua Reynolds were negligible daubers, and many 19th-century critics, as we all know, were scathing about the work of Manet and the Impressionists. I happen to think that women are doing the most interesting and innovative work at present; and it is all quite different! No sign of a "female style"; no centralized imagery or necessary pattern and decoration, as some essentialist feminist art critics believed at the beginning of the women's movement. A wide range of media, genres and styles marks women's work today. To me, this is what is important. Women can do what they want, the way they want.

MR: Since "genius has no sex" (according to Madame de Staël!), then the "problem," you've earlier argued, lies not in our hormones, as women, but in our institutions and education. How much have these two things in particular changed since the 1970s?

LN: I think it is undeniable that both institutions and education have changed a great deal. MFA programs are now comprised of sixty per cent women students. There are courses on feminism and art, contemporary women artists, etc., at major institutions of learning. This would have been unheard of in my day. And yet it is perhaps arguable that, even today, women have to struggle harder to get to the top, whatever the top is. Certainly, there are more shows by women artists in museums, especially university museums, than there used to be. But men still command the top prices at auctions and in general. But do I think top prices are the equivalent of important, interesting art? Jeff Koons costs more than Courbet; what does that tell us about relative value? But I have a feeling the art market is going to be biased for a long time, despite the heartening progress that 20th- and 21st-century women artists have made. The art market is in

many ways still a boys' club, with men competing with other rich men to see who can pay the highest prices. Can we really judge the value of art, by men or women, by the crazy logic of the market? Is some of the stuff that goes for millions really "worth" that amount? This is a complicated question.

MR: Yes, the art market is certainly an arena where gender inequality is thrown into high relief—and certainly begs the question of value versus worth. As of this year (2014), for instance, the highest price paid to date for a living woman artist is $6.6 million, for a Cady Noland sculpture, in comparison with an editioned one by Jeff Koons, which sold for $58.4 million. Likewise, the most ever paid to date for a dead woman artist is $11.9 million for a gorgeous Joan Mitchell, versus $142.4 million for a Francis Bacon triptych. These are enormous discrepancies! It's not looking so great elsewhere either. The recent Association of Art Museum Directors' 2014 Gender Gap Report testifies to continued inequity, concluding that female museum directors earn seventy-nine cents for every dollar earned by male museum directors; and the wonderful, continuously expanding art project called Gallery Talley, spearheaded by artist Micol Hebron, makes evident that, as of 2014, women artists make up only 30% of the gallery stables in the US. Solo exhibition histories and permanent exhibition displays at places like MoMA and LACMA (Los Angeles County Museum of Art) reveal abysmal figures, and the ratio of male to female artists at major biennials, like Documenta and Venice, is consistently low. (The last Venice Biennale, curated by art star Massimiliano Gioni, was 73% male.) Now, to put the latter in perspective, it helps knowing that the 1995 edition featured male artists 92% of the time. So, we have witnessed a marked improvement over the last few decades, but we still have quite a battle ahead of us.

LN: I don't think that battling is the only thing. How would you battle the art market and how would you force collectors to buy women's work? I, for one, would stop focus-ing so heavily on the art market and prices of works, which tell you little or nothing about the quality of the work in question, only about the state of the market itself. If a Picasso goes for less than a Jeff Koons, does that immediately signify that the Koons is the "better" work? No, it means that some rich and powerful people are competing to see who can spend more on a Koons. Yes, it's a screwy situation, but let's just look at it as the grotesque economic situation it is; I don't see what can be done about it directly. I think that $11.9 million is a good price for a splendid work of art: it's not a grotesquely inflated price, to be sure. Certainly press coverage and textbook representation could be enlarged, but I don't see this as a "battle" as much as an intellectual project.

MR: How so? Are you arguing, as you did in 1974, that the most effective way to combat injustice is "through thought, through the pursuit of truth, and through the constant questioning and piercing through of our so-called 'natural' assumptions"?[23] In other

words, I think you're saying that the only way to effect real change is not to "fight" it directly, but rather to "attack" it intellectually?

LN: Yes. What I don't mean is throwing tomatoes at a Sotheby's auction, much as one might like to! Regarding the term "fight," remember William Blake's wise words: "I shall not cease from mental fight/Nor shall my sword sleep in my hand." All metaphorical, of course, except the mental fight – that's real.

MR: On several occasions throughout your career, you've cautioned feminists about getting too excited about certain advances, like by the fact that feminist critique (and allied critiques such as colonialist studies, queer theory) has entered into mainstream discourse itself (albeit perfunctorily), and as an integral part of a new, more theoretically grounded and socially contextualized art historical practice. You warned us that while it might seem, at times, as though feminism is "safely ensconced in the bosom" of one of the most conservative of the intellectual disciplines, this is far from being the case.

> There is still considerable resistance to the more radical varieties of the femi-
> nist critique in the visual arts, and its practitioners are accused of such sins as
> neglecting the issue of quality, destroying the canon, scanting the innate visual
> dimension of the art work, reducing art to the circumstances of its produc-
> tion—in other words, of undermining the ideological and, above all, esthetic,
> biases of the discipline. All of this is to the good: feminist art history is there
> to make trouble, to call into question, to ruffle feathers in the patriarchal dove-
> cotes. It should not be mistaken for just another variant of or supplement to
> mainstream art history. At its strongest, a feminist art history is a transgressive
> and anti-establishment practice, meant to call many of the major precepts of
> the discipline into question.[24]

Your scholarship has certainly succeeded in doing just this, and has inspired gen-erations of scholars to follow in your wake. In addition to these words of wisdom, as a closing statement, what can you leave us with?

LN: At a time when certain patriarchal values are making a comeback—as they always do during times of war and stress—it is well to think of women as refusing their time-honored role as victims or supporters. It is time to rethink the bases of our position and strengthen them for the fight ahead. As a feminist, I fear this moment's overt reversion to the most blatant forms of patriarchy—a great moment for so-called "real men," like football players and politicians, to assert their sinister dominance over "others": women and people of color, primarily: the return of the barely repressed. Masculine dominance in the art world fits into this structure, and we need to be aware of it. But I think this

is a critical moment for feminism and women's place in the art world. Now, more than ever, we must be aware of the dangers lying ahead, as well as the achievements of the past. We need to deploy all our intelligence and energy in order to ensure that women's art is seen, women's voices heard, women's excellence rewarded. And we must work to create an art world in which high qualities, rather than high prices, are the touchstones of success, for men and women equally.

Notes

1 "[F]eminist art history is there to make trouble, to call into question, to ruffle feathers in the patriarchal dovecotes. It should not be mistaken for just another variant of or supplement to mainstream art history. At its strongest, a feminist art history is a transgressive and anti-establishment practice, meant to call many of the major precepts of the discipline into question." Linda Nochlin (1988), "Introduction," in *Women, Art and Power*, New York, NY: Harper & Row, p. xii, and quoted in Nochlin (2006), "Why have there been no great women artists? Thirty years after," see p. 320 in this volume.

2 Vivian Gornick and Barbara Moran, eds (1971), *Women in Sexist Society*, New York: Basic Books.

3 "How Feminism in the Arts can Implement Cultural Change (1974), *Arts in Society* 2, nos 1–2, Spring–Summer, pp. 80–89.

4 "What is Female Imagery?" (1975), *Ms. Magazine*, no. 11, May, pp. 81–82.

5 Ann Sutherland Harris (1976), "Acknowledgments," *Women Artists: 1550–1950*, Los Angeles County Museum of Art, p. 8.

6 John Perrault (1977), "Women Artists," *The SoHo Weekly News*, October 13, p. 40.

7 Robert Hughes (1977), "Rediscovered—Women Painters," *Time*, January 10.

8 Grace Glueck (1977), "The Woman as Artist: Rediscovering 400 Years of Masterworks," *New York Times Magazine*, September 25, p. 50.

9 Eleanor Tufts (1974), *Our Hidden Heritage: Five Centuries of Women Artists*, New York, NY: Paddington Press; Elsa Honig Fine (1978), *Women and Art: A History of Women Painters and Sculptors from the Renaissance to the Present Day*, G. Prior; Germaine Greer (1979), *The Obstacle Race: The Fortunes of Women Painters and Their Work*, London: Secker and Warburg.

10 Linda Nochlin (1971), "Why Have There Been No Great Women Artists?," *ARTnews*, January; see p. 43 in this volume.

11 Ibid., see p. 44 in this volume.

12 Ibid., see pp. 45–46 in this volume.

13 Lynda Benglis and Sarita Dubin, Letter to Linda Nochlin, August 2014.

14 The title comes from the ear-tag identifying the cow in the image.

15 From Lydia Davis (2014), "The Cows," *Can't and Won't: Stories*, New York, NY: Farrar, Straus & Giroux, Loc. 906 ff.

16 Roger Greenspun (1972), "Screen: Palette of Art," *New York Times*, April 14.

17 Linda Nochlin (1986), "Nancy Graves: the Subversiveness of Sculpture," *Nancy Graves: Painting, Sculpture, Drawing, 1980–1985*, Poughkeepsie, NY: Vassar College Art Gallery.

18 See Joan Riviere (1929), "Womanliness as a Masquerade," *International Journal of Psychoanalysis*, vol. 10, pp. 303–13.

19 "Go tell Aunt Rhody, Go tell Aunt Rhody/Go tell Aunt Rhody, the Old Grey Goose is dead/ She died in the mill pond, she died in the mill pond/She died in the mill pond, a-standin on her head." This song is not associated with black cultural history and probably originated among white people during colonial days.

20 Carol Armstrong (2007), "Global Feminisms," *Artforum*, January, p. 87.

21 "Firing the Canon: Feminism, Art History, and the Status of the Canonical," College Art Association, annual conference, 1990.

22 Linda Nochlin (1974), "How Feminism in the Arts Can Implement Cultural Change," p. 85.

23 Nochlin, "How Feminism in the Arts Can Implement Cultural Change," p. 89

24 Nochlin, *Women, Art and Power*, p. xii, see p. 320 in this volume.

1

Why Have There Been No Great Women Artists?

ARTnews, January 1971

While the recent upsurge of feminist activity in this country has indeed been a liberating one, its force has been chiefly emotional—personal, psychological and subjective-centered, like the other radical movements to which it is related, on the present and its immediate needs, rather than on historical analysis of the basic intellectual issues which the feminist attack on the status quo automatically raises.[1] Like any revolution, however, the feminist one ultimately must come to grips with the intellectual and ideological basis of the various intellectual or scholarly disciplines—history, philosophy, sociology, psychology, etc.—in the same way that it questions the ideologies of present social institutions. If, as John Stuart Mill suggested, we tend to accept whatever *is* as natural, this is just as true in the realm of academic investigation as it is in our social arrangements. In the former, too, "natural" assumptions must be questioned and the mythic basis of much so-called "fact" brought to light. And it is here that the very position of woman as an acknowledged outsider, the maverick "she" instead of the presumably neutral "one"—in reality the white-male-position-accepted-as-natural, or the hidden "he" as the subject of all scholarly predicates—is a decided advantage, rather than merely a hindrance or a subjective distortion.

In the field of art history, the white Western male viewpoint, unconsciously accepted as *the* viewpoint of the art historian, may—and does—prove to be inadequate, not merely on moral and ethical grounds, or because it is elitist, but on purely intellectual ones. In revealing the failure of much academic art history, and a great deal of history in general, to take account of the unacknowledged value system, the very *presence* of an intruding subject in historical investigation, the feminist critique at the same time lays bare its conceptual smugness, its meta-historical naïveté. At a moment when all disciplines are becoming more self-conscious, more aware of the nature of their presuppositions as exhibited in the very languages and structures of the various fields of scholarship, such uncritical acceptance of "what is" as "natural" may be intellectually fatal. Just as Mill saw male domination as one of a long series of social injustices that had to be overcome if a truly just social order were to be created, so we may see the unstated domination of white male subjectivity as one in a series of intellectual distortions which must be corrected in order to achieve a more adequate and accurate view of historical situations.

It is the engaged feminist intellect (like John Stuart Mill's) that can pierce through the cultural–ideological limitations of the time and its specific "professionalism" to reveal biases and inadequacies not merely in dealing with the question of women, but in the very way of formulating the crucial questions of the discipline as a whole. Thus, the so-called woman question, far from being a minor, peripheral and laughably provincial sub-issue grafted onto a serious, established discipline, can become a catalyst, an intellectual instrument, probing basic and "natural" assumptions, providing a paradigm for other kinds of internal questioning, and in turn providing links with paradigms established by radical approaches in other fields. Even a simple question like "Why have there been no great women artists?" can, if answered adequately, create a sort of chain reaction, expanding not merely to encompass the accepted assumptions of the single field, but outward to embrace history and the social sciences, or even psychology and literature, and thereby, from the outset, to challenge the assumption that the traditional divisions of intellectual inquiry are still adequate to deal with the meaningful questions of our time, rather than the merely convenient or self-generated ones.

Let us, for example, examine the implications of that perennial question (one can, of course, substitute almost any field of human endeavor, with appropriate changes in phrasing): "Well, if women really *are* equal to men, why have there never been any great women artists (or composers, or mathematicians, or philosophers, or so few of the same)?"

"Why have there been no great women artists?" The question tolls reproachfully in the background of most discussions of the so-called woman problem. But like so many other so-called questions involved in the feminist "controversy," it falsifies the nature of the issue at the same time that it insidiously supplies its own answer: "There are no great women artists because women are incapable of greatness."

The assumptions behind such a question are varied in range and sophistication, running anywhere from "scientifically proven" demonstrations of the inability of human beings with wombs rather than penises to create anything significant, to relatively open-minded wonderment that women, despite so many years of near-equality—and after all, a lot of men have had their disadvantages too—have still not achieved anything of exceptional significance in the visual arts.

The feminist's first reaction is to swallow the bait, hook, line and sinker, and to attempt to answer the question as it is put: i.e., to dig up examples of worthy or insufficiently appreciated women artists throughout history; to rehabilitate rather modest, if interesting and productive careers; to "re-discover" forgotten flower-painters or David-followers and make out a case for them; to demonstrate that Berthe Morisot was really less dependent upon Manet than one had been led to think—in other words, to engage in the normal activity of the specialist scholar who makes a case for the importance of his very own neglected or minor master. Such attempts, whether undertaken from a feminist point of view, like the ambitious article on women artists which appeared in the

1858 *Westminster Review*,[2] or more recent scholarly studies on such artists as Angelica Kauffmann and Artemisia Gentileschi,[3] are certainly worth the effort, both in adding to our knowledge of women's achievement and of art history generally. But they do nothing to question the assumptions lying behind the question "Why have there been no great women artists?" On the contrary, by attempting to answer it, they tacitly reinforce its negative implications.

Another attempt to answer the question involves shifting the ground slightly and asserting, as some contemporary feminists do, that there is a different kind of "greatness" for women's art than for men's, thereby postulating the existence of a distinctive and recognizable feminine style, different both in its formal and its expressive qualities and based on the special character of women's situation and experience.

This, on the surface of it, seems reasonable enough: in general, women's experience and situation in society, and hence as artists, is different from men's, and certainly the art produced by a group of consciously united and purposefully articulate women intent on bodying forth a group consciousness of feminine experience might indeed be stylistically identifiable as feminist, if not feminine, art. Unfortunately, though this remains within the realm of possibility it has so far not occurred. While the members of the Danube School, the followers of Caravaggio, the painters gathered around Gauguin at Pont-Aven, the Blue Rider, or the Cubists may be recognized by certain clearly defined stylistic or expressive qualities, no such common qualities of "femininity" would seem to link the styles of women artists generally, any more than such qualities can be said to link women writers, a case brilliantly argued, against the most devastating, and mutually contradictory, masculine critical clichés, by Mary Ellmann in her *Thinking about Women*.[4] No subtle essence of femininity would seem to link the work of Artemisia Gentileschi, Mme. Vigée Le Brun, Angelica Kauffmann, Rosa Bonheur, Berthe Morisot, Suzanne Valadon, Käthe Kollwitz, Barbara Hepworth, Georgia O'Keeffe, Sophie Taeuber-Arp, Helen Frankenthaler, Bridget Riley, Lee Bontecou or Louise Nevelson, any more than that of Sappho, Marie de France, Jane Austen, Emily Brontë, George Sand, George Eliot, Virginia Woolf, Gertrude Stein, Anaïs Nin, Emily Dickinson, Sylvia Plath and Susan Sontag. In every instance, women artists and writers would seem to be closer to other artists and writers of their own period and outlook than they are to each other.

Women artists are more inward-looking, more delicate and nuanced in their treatment of their medium, it may be asserted. But which of the women artists cited above is more inward-turning than Redon, more subtle and nuanced in the handling of pigment than Corot? Is Fragonard more or less feminine than Mme. Vigée Le Brun? Or is it not more a question of the whole Rococo style of 18th-century France being "feminine," if judged in terms of a two-valued scale of "masculinity" vs "femininity"? Certainly, though, if daintiness, delicacy and preciousness are to be counted as earmarks of a feminine style, there is nothing fragile about Rosa Bonheur's *Horse Fair* [p. 66], nor dainty and introverted about Helen Frankenthaler's giant canvases. If women have

Élisabeth Vigée Le Brun, *Portrait of the Artist's Daughter*, 1789. Oil on canvas, 17¼ × 13¾ in. (43.8 × 34.9 cm)

turned to scenes of domestic life, or of children, so did Jan Steen, Chardin and the Impressionists—Renoir and Monet as well as Morisot and Cassatt. In any case, the mere choice of a certain realm of subject matter, or the restriction to certain subjects, is not to be equated with a style, much less with some sort of quintessentially feminine style.

The problem lies not so much with the feminists' concept of what femininity is, but rather with their misconception—shared with the public at large—of what art is: with the naïve idea that art is the direct, personal expression of individual emotional experience, a translation of personal life into visual terms. Art is almost never that, great art never is. The making of art involves a self-consistent language of form, more or less dependent upon, or free from, given temporally-defined conventions, schemata or systems of notation, which have to be learned or worked out, either through teaching, apprenticeship or a long period of individual experimentation. The language of art is, more materially, embodied in paint and line on canvas or paper, in stone or clay or plastic or metal—it is neither a sob-story nor a confidential whisper.

The fact of the matter is that there have been no supremely great women artists, as far as we know, although there have been many interesting and very good ones who remain insufficiently investigated or appreciated; nor have there been any great Lithuanian jazz pianists, nor Eskimo tennis players, no matter how much we might wish

there had been. That this should be the case is regrettable, but no amount of manipulating the historical or critical evidence will alter the situation; nor will accusations of male-chauvinist distortion of history. The fact, dear sisters, is that there *are* no women equivalents for Michelangelo or Rembrandt, Delacroix or Cézanne, Picasso or Matisse, or even, in very recent times, for de Kooning or Warhol, any more than there are Black American equivalents for the same. If there actually were large numbers of "hidden" great women artists, or if there really should be different standards for women's art as opposed to men's—and one can't have it both ways—then what are the feminists fighting for? If women have in fact achieved the same status as men in the arts, then the status quo is fine as it is.

But in actuality, as we all know, things as they are and as they have been, in the arts as in a hundred other areas, are stultifying, oppressive and discouraging to all those, women among them, who did not have the good fortune to be born white, preferably middle class and, above all, male. The fault, dear brothers, lies not in our stars, our hormones, our menstrual cycles or our empty internal spaces, but in our institutions and our education—education understood to include everything that happens to us from the moment we enter this world of meaningful symbols, signs and signals. The miracle is, in fact, that given the overwhelming odds against women, or blacks, that so many of both have managed to achieve so much sheer excellence, in those bailiwicks of white masculine prerogative like science, politics or the arts.

It is when one really starts thinking about the implications of "Why have there been no great women artists?" that one begins to realize to what extent our consciousness of how things are in the world has been conditioned—and often falsified—by the way the most important questions are posed. We tend to take it for granted that there really is an East Asian Problem, a Poverty Problem, a Black Problem—and a Woman Problem. But first we must ask ourselves who is formulating these "questions," and then, what purposes such formulations may serve. (We may, of course, refresh our memories with the connotations of the Nazi's "Jewish Problem.") Indeed, in our time of instant communication, "problems" are rapidly formulated to rationalize the bad conscience of those with power: thus the problem posed by Americans in Vietnam and Cambodia is referred to by Americans as "the East Asian Problem," whereas East Asians may view it, more realistically, as "the American Problem"; the so-called Poverty Problem might more directly be viewed as the "Wealth Problem" by denizens of urban ghettos or rural wastelands; the same irony twists the White Problem into its opposite: a Black Problem; and the same inverse logic turns up in the formulation of our own present state of affairs as the "Woman Problem."

Now the "Woman Problem," like all human problems, so-called (and the very idea of calling anything to do with human beings a "problem" is, of course, a fairly recent one) is not amenable to "solution" at all, since what human problems involve is reinterpretation of the nature of the situation, or a radical alteration of stance or program

on the part of the "problems" themselves. Thus women and their situation in the arts, as in other realms of endeavor, are not a "problem" to be viewed through the eyes of the dominant male power elite. Instead, *women* must conceive of themselves as potentially, if not actually, equal subjects, and must be willing to look the facts of their situation full in the face, without self-pity, or cop-outs; at the same time they must view their situation with that high degree of emotional and intellectual commitment necessary to create a world in which equal achievement will be not only made possible but actively encouraged by social institutions.

It is certainly not realistic to hope that a majority of men, in the arts, or in any other field, will soon see the light and find that it is in their own self-interest to grant complete equality to women, as some feminists optimistically assert, or to maintain that men themselves will soon realize that they are diminished by denying themselves access to traditionally "feminine" realms and emotional reactions. After all, there are few areas that are really "denied" to men, if the level of operations demanded be transcendent, responsible or rewarding enough: men who have a need for "feminine" involvement with babies or children gain status as pediatricians or child psychologists, with a nurse (female) to do the more routine work; those who feel the urge for kitchen creativity may gain fame as master chefs; and, of course, men who yearn to fulfill themselves through what are often termed "feminine" artistic interests can find themselves as painters or sculptors, rather than as volunteer museum aides or part time ceramists, as their female counterparts so often end up doing; as far as scholarship is concerned, how many men would be willing to change their jobs as teachers and researchers for those of unpaid, part-time research assistants and typists as well as full-time nannies and domestic workers?

Those who have privileges inevitably hold on to them, and hold tight, no matter how marginal the advantage involved, until compelled to bow to superior power of one sort or another.

Thus the question of women's equality—in art as in any other realm—devolves not upon the relative benevolence or ill-will of individual men, nor the self-confidence or abjectness of individual women, but rather on the very nature of our institutional structures themselves and the view of reality which they impose on the human beings who are part of them. As John Stuart Mill pointed out more than a century ago: "Everything which is usual appears natural. The subjection of women to men being a universal custom, any departure from it quite naturally appears unnatural."[5] Most men, despite lip-service to equality, are reluctant to give up this "natural" order of things in which their advantages are so great; for women, the case is further complicated by the fact that, as Mill astutely pointed out, unlike other oppressed groups or castes, men demand of her not only submission but unqualified affection as well; thus women are often weakened by the internalized demands of the male-dominated society itself, as well as by a plethora of material goods and comforts: the middle-class woman has a great deal more to lose than her chains.

The question "Why have there been no great women artists?" is simply the top tenth of an iceberg of misinterpretation and misconception: beneath lies a vast dark bulk of shaky *idées reçues* about the nature of art and its situational concomitants, about the nature of human abilities in general and of human excellence in particular, and the role that the social order plays in all of this. While the "woman problem" as such may be a pseudo-issue, the misconceptions involved in the question "Why have there been no great women artists?" points to major areas of intellectual obfuscation beyond the specific political and ideological issues involved in the subjection of women. Basic to the question are many naïve, distorted, uncritical assumptions about the making of art in general, as well as the making of great art. These assumptions, conscious or unconscious, link together such unlikely superstars as Michelangelo and Van Gogh, Raphael and Jackson Pollock under the rubric of "Great"—an honorific attested to by the number of scholarly monographs devoted to the artist in question—and the Great Artist is, of course, conceived of as one who has "Genius"; Genius, in turn, is thought of as an atemporal and mysterious power somehow embedded in the person of the Great Artist.[6] Such ideas are related to unquestioned, often unconscious, meta-historical premises that make Hippolyte Taine's race-milieu-moment formulation of the dimensions of historical thought seem a model of sophistication. But these assumptions are intrinsic to a great deal of art-historical writing. It is no accident that the crucial question of the conditions *generally* productive of great art has so rarely been investigated, or that attempts to investigate such general problems have, until fairly recently, been dismissed as unscholarly, too broad, or the province of some other discipline, like sociology. To encourage a dispassionate, impersonal, sociological and institutionally oriented approach would reveal the entire romantic, elitist, individual-glorifying and monograph-producing substructure upon which the profession of art history is based, and which has only recently been called into question by a group of younger dissidents.

Underlying the question about woman as artist, then, we find the myth of the Great Artist—subject of a hundred monographs, unique, godlike—bearing within his person since birth a mysterious essence, rather like the golden nugget in Mrs. Grass' chicken soup, called Genius or Talent, which, like murder, must always out, no matter how unlikely or unpromising the circumstances.

The magical aura surrounding the representational arts and their creators has, of course, given birth to myths since the earliest times. Interestingly enough, the same magical abilities attributed by Pliny to the Greek sculptor Lysippos in antiquity—the mysterious inner call in early youth, the lack of any teacher but Nature herself—is repeated as late as the 19th century by Max Buchon in his biography of Courbet. The supernatural powers of the artist as imitator, his control of strong, possibly dangerous powers, have functioned historically to set him off from others as a godlike creator, one who creates Being out of nothing. The fairy tale of the Boy Wonder, discovered by an

older artist or discerning patron, usually in the guise of a lowly shepherd boy, has been a stock-in-trade of artistic mythology ever since Vasari immortalized the young Giotto, discovered by the great Cimabue while the lad was guarding his flocks, drawing sheep on a stone; Cimabue, overcome with admiration by the realism of the drawing, immediately invited the humble youth to be his pupil.[7] Through some mysterious coincidence, later artists including Beccafumi, Andrea Sansovino, Andrea del Castagno, Mantegna, Zurbarán and Goya were all discovered in similar pastoral circumstances. Even when the young Great Artist was not fortunate enough to come equipped with a flock of sheep, his talent always seems to have manifested itself very early, and independent of any external encouragement: Filippo Lippi and Poussin, Courbet and Monet are all reported to have drawn caricatures in the margins of their school-books instead of studying the required subjects—we never, of course, hear about the youths who neglected their studies and scribbled in the margins of their notebooks without ever becoming anything more elevated than department-store clerks or shoe salesmen. The great Michelangelo himself, according to his biographer and pupil, Vasari, did more drawing than studying as a child. So pronounced was his talent, reports Vasari, that when his master, Ghirlandaio, absented himself momentarily from his work in Santa Maria Novella, and the young art student took the opportunity to draw "the scaffolding, trestles, pots of paint, brushes and the apprentices at their tasks" in this brief absence, he did it so skillfully that upon his return the master exclaimed: "This boy knows more than I do."

As is so often the case, such stories, which probably have some truth in them, tend both to reflect and perpetuate the attitudes they subsume. Despite any basis in fact of these myths about the early manifestations of Genius, the tenor of the tales is misleading. It is no doubt true, for example, that the young Picasso passed all the examinations for entrance to the Barcelona, and later to the Madrid, Academy of Art at the age of fifteen in but a single day, a feat of such difficulty that most candidates required a month of preparation. But one would like to find out more about similar precocious qualifiers for art academies who then went on to achieve nothing but mediocrity or failure—in whom, of course, art historians are uninterested—or to study in greater detail the role played by Picasso's art-professor father in the pictorial precocity of his son. What if Picasso had been born a girl? Would Señor Ruiz have paid as much attention or stimulated as much ambition for achievement in a little Pablita?

What is stressed in all these stories is the apparently miraculous, non-determined and a-social nature of artistic achievement; this semi-religious conception of the artist's role is elevated to hagiography in the 19th century, when both art historians, critics and, not least, some of the artists themselves tended to elevate the making of art into a substitute religion, the last bulwark of Higher Values in a materialistic world. The artist, in the 19th-century Saints' Legend, struggles against the most determined parental and social opposition, suffering the slings and arrows of social opprobrium like any Christian martyr, and ultimately succeeds against all odds—generally, alas, after his

death—because from deep within himself radiates that mysterious, holy effulgence: Genius. Here we have the mad Van Gogh, spinning out sunflowers despite epileptic seizures and near-starvation; Cézanne, braving paternal rejection and public scorn in order to revolutionize painting; Gauguin throwing away respectability and financial security with a single existential gesture to pursue his Calling in the tropics, or Toulouse-Lautrec, dwarfed, crippled and alcoholic, sacrificing his aristocratic birthright in favor of the squalid surroundings that provided him with inspiration, etc.

Now no serious contemporary art historian takes such obvious fairy tales at their face value. Yet it is this sort of mythology about artistic achievement and its concomitants which forms the unconscious or unquestioned assumptions of scholars, no matter how many crumbs are thrown to social influences, ideas of the times, economic crises and so on. Behind the most sophisticated investigations of great artists—more specifically, the art-historical monograph, which accepts the notion of the Great Artist as primary, and the social and institutional structures within which he lived and worked as mere secondary "influences" or "background"—lurks the golden-nugget theory of genius and the free-enterprise conception of individual achievement. On this basis, women's lack of major achievement in art may be formulated as a syllogism: if women had the golden nugget of artistic genius then it would reveal itself. But it has never revealed itself. QED women do not have the golden nugget of artistic genius. If Giotto, the obscure shepherd boy, and Van Gogh with his fits could make it, why not women?

Yet as soon as one leaves behind the world of fairy tale and self-fulfilling prophecy and, instead, casts a dispassionate eye on the actual situations in which important art production has existed, in the total range of its social and institutional structures throughout history, one finds that the very questions which are fruitful or relevant for the historian to ask shape up rather differently. One would like to ask, for instance, from what social classes artists were most likely to come at different periods of art history, from what castes and sub-groups. What proportion of painters and sculptors, or more specifically, of major painters and sculptors, came from families in which their fathers or other close relatives were painters and sculptors or engaged in related professions? As Nikolaus Pevsner points out in his discussion of the French Academy in the 17th and 18th centuries, the transmission of the artistic profession from father to son was considered a matter of course (as it was with the Coypels, the Coustous, the Van Loos, etc.); indeed, sons of academicians were exempted from the customary fees for lessons.[8] Despite the noteworthy and dramatically satisfying cases of the great father-rejecting *révoltés* of the 19th century, one might be forced to admit that a large proportion of artists, great and not-so-great, in the days when it was normal for sons to follow in their fathers' footsteps, had artist fathers. In the rank of major artists, the names of Holbein and Dürer, Raphael and Bernini, immediately spring to mind; even in our own times, one can cite the names of Picasso, Calder, Giacometti and Wyeth as members of artist-families.

As far as the relationship of artistic occupation and social class is concerned, an interesting paradigm for the question "Why have there been no great women artists?" might well be provided by trying to answer the question: "Why have there been no great artists from the aristocracy?" One can scarcely think, before the anti-traditional 19th century at least, of any artist who sprang from the ranks of any more elevated class than the upper bourgeoisie; even in the 19th century, Degas came from the lower nobility—more like the haute bourgeoisie, in fact—and only Toulouse-Lautrec, metamorphosed into the ranks of the marginal by accidental deformity, could be said to have come from the loftier reaches of the upper classes. While the aristocracy has always provided the lion's share of the patronage and the audience for art—as, indeed, the aristocracy of wealth does even in our more democratic days—it has contributed little beyond amateurish efforts to the creation of art itself, despite the fact that aristocrats (like many women) have had more than their share of educational advantages, plenty of leisure and, indeed, like women, were often encouraged to dabble in the arts and even develop into respectable amateurs, like Napoleon III's cousin, the Princess Mathilde, who exhibited at the official Salons, or Queen Victoria, who, with Prince Albert, studied art with no less a figure than Landseer himself. Could it be that the

By Sofonisba Anguissola, member of a noble family of Cremona, *Philip II, King of Spain*, c. 1580. Oil on canvas, 72½ × 41 in. (184.2 × 104.1 cm)

little golden nugget—Genius—is missing from the aristocratic make-up in the same way that it is from the feminine psyche? Or rather, is it not, that the kinds of demands and expectations placed before both aristocrats and women—the amount of time necessarily devoted to social functions, the very kinds of activities demanded—simply made total devotion to professional art production out of the question, indeed unthinkable, both for upper-class males and for women generally, rather than its being a question of genius and talent?

When the right questions are asked about the conditions for producing art, of which the production of great art is a sub-topic, there will no doubt have to be some discussion of the situational concomitants of intelligence and talent generally, not merely of artistic genius. Piaget and others have stressed in their genetic epistemology that in the development of reason and in the unfolding of imagination in young children, intelligence—or, by implication, what we choose to call genius—is a dynamic activity rather than a static essence, and an activity of a subject *in a situation*. As further investigations in the field of child development imply, these abilities, or this intelligence, are built up minutely, step by step, from infancy onward, and the patterns of adaptation–accommodation may be established so early within the subject-in-an-environment that they may indeed *appear* to be innate to the unsophisticated observer. Such investigations imply that, even aside from meta-historical reasons, scholars will have to abandon the notion, consciously articulated or not, of individual genius as innate, and as primary to the creation of art.[9]

The question "Why have there been no great women artists?" has led us to the conclusion, so far, that art is not a free, autonomous activity of a super-endowed individual, "influenced" by previous artists, and, more vaguely and superficially, by "social forces," but rather, that the total situation of art making, both in terms of the development of the art maker and in the nature and quality of the work of art itself, occur in a social situation, are integral elements of this social structure, and are mediated and determined by specific and definable social institutions, be they art academies, systems of patronage, mythologies of the divine creator, artist as he-man or social outcast.

The question of the nude

We can now approach our question from a more reasonable standpoint, since it seems probable that the answer to why there have been no great women artists lies not in the nature of individual genius or the lack of it, but in the nature of given social institutions and what they forbid or encourage in various classes or groups of individuals. Let us first examine such a simple, but critical, issue as availability of the nude model to aspiring women artists in the period extending from the Renaissance until near the end of the 19th century, a period in which careful and prolonged study of the nude model was essential to the training of every young artist, to the production of any work with pretentions to grandeur, and to the very essence of history painting, generally accepted

as the highest category of art: indeed, it was argued by defenders of traditional paint-
ing in the 19th century that there could be no great painting *with* clothed figures, since
costume inevitably destroyed both the temporal universality and the classical ideali-
zation required by great art. Needless to say, central to the training programs of the
academies since their inception late in the 16th and early in the 17th centuries was life
drawing from the nude, generally male, model. In addition, groups of artists and their
pupils often met privately for life drawing sessions from the nude model in their studios.
In general, it might be added, while individual artists and private academies employed
the female model extensively, the female nude was forbidden in almost all public art
schools as late as 1850 and after—a state of affairs which Pevsner rightly designates as
"hardly believable."[10] Far more believable, unfortunately, was the complete unavailabil-
ity to the aspiring woman artist of *any* nude models at all, male or female. As late as 1893,
"lady" students were not admitted to life drawing at the Royal Academy in London, and
even when they were, after that date, the model had to be "partially draped."[11]

A brief survey of representations of life-drawing sessions reveals: an all male cli-
entele drawing from the female nude in Rembrandt's studio; men working from male
nudes in 18th-century representations of academic instruction in The Hague and
Vienna; men working from the seated male nude in Boilly's charming painting of the
interior of Houdon's studio at the beginning of the 19th century; Mathieu Cochereau's
scrupulously veristic *Interior of David's Studio*, exhibited in the Salon of 1814, reveals
a group of young men diligently drawing or painting from a male nude model, whose
discarded shoes may be seen before the models' stand.

The very plethora of surviving "Academies"—detailed, painstaking studies from the
nude studio model—in the youthful oeuvre of artists down through the time of Seurat
and well into the 20th century, attests to the central importance of this branch of study
in the pedagogy and development of the talented beginner. The formal academic
program itself normally proceeded, as a matter of course, from copying from drawings
and engravings, to drawing from casts of famous works of sculpture, to drawing from
the living model. To be deprived of this ultimate stage of training meant, in effect, to
be deprived of the possibility of creating major art works, unless one were a very ingen-
ious lady indeed, or simply, as most of the women aspiring to be painters ultimately
did, to restrict oneself to the "minor" fields of portraiture, genre, landscape or still-life.
It is rather as though a medical student were denied the opportunity to dissect or even
examine the naked human body.

There exist, to my knowledge, no representations of artists drawing from the nude
model which include women in any role but that of the nude model itself, an interesting
commentary on rules of propriety: i.e., it is all right for a ("low," of course) woman to
reveal herself naked-as-an-object for a group of men, but forbidden to a woman to par-
ticipate in the active study and recording of naked-man-as-an-object, or even of a fellow
woman. An amusing example of this taboo on confronting a dressed lady with a naked

Marguerite Gérard, *Portrait of the Artist Painting a Musician, c.* 1803.
Oil on panel, 24 × 20.5 in. (61 × 52 cm)

man is embodied in a group portrait of the members of the Royal Academy in London in 1772, represented by Zoffany as gathered in the life room before two nude male models: all the distinguished members are present with but one noteworthy exception—the single female member, the renowned Angelica Kauffmann, who, for propriety's sake, is merely present in effigy, in the form of a portrait hanging on the wall. A slightly earlier drawing of *Ladies in the Studio,* by the Polish artist Daniel Chodowiecki, shows the ladies portraying a modestly dressed member of their sex. In a lithograph dating from the relatively liberated epoch following the French revolution, the lithographer Marlet has represented some women sketchers in a group of students working from the male model, but the model himself has been chastely provided with what appears to be a pair of bathing trunks, a garment hardly conducive to a sense of classical elevation; no doubt such license was considered daring in its day, and the young ladies in question suspected of doubtful morals, but even this liberated state of affairs seems to

have lasted only a short while. In an English stereoscopic color view of the interior of a studio of about 1865, the standing, bearded male model is so heavily draped that not an iota of his anatomy escapes from the discreet toga, save for a single bare shoulder and arm: even so, he obviously had the grace to avert his eyes in the presence of the crinoline-clad young sketchers.

The women in the Women's Modeling Class at the Pennsylvania Academy were evidently not allowed even this modest privilege. A photograph by Thomas Eakins of about 1885 reveals these students modeling from a cow (bull? ox? the nether regions are obscure in the photograph), a naked cow to be sure, perhaps a daring liberty when one considers that even piano legs might be concealed beneath pantalettes during this era (the idea of introducing a bovine model into the artist's studio stems from Courbet, who brought a bull into his short-lived studio academy in the 1860s). Only at the very end of the 19th century, in the relatively liberated and open atmosphere of Repin's studio and circle in Russia, do we find representations of women art students working uninhibitedly from the nude—the female model, to be sure—in the company of men. Even in this case, it must be noted that certain photographs represent a private sketch group meeting in one of the women artists' homes; in the other, the model is draped;

Angelica Kauffmann, *Cornelia, Mother of the Gracchi, Pointing to Her Children as Her Treasures, c.* 1785. Oil on canvas, 40 × 50 in. (101.6 × 127 cm)

and the large group portrait, a co-operative effort by two men and two women students of Repin's, is an imaginary gathering together of all of the Russian realist's pupils, past and present, rather than a realistic studio view.

I have gone into the question of the availability of the nude model, a single aspect of the automatic, institutionally maintained discrimination against women, in such detail simply to demonstrate both the universality of the discrimination against women and its consequences, as well as the institutional rather than individual nature of but one facet of the necessary preparation for achieving mere proficiency, much less greatness, in the realm of art during a long stretch of time. One could equally well examine other dimensions of the situation, such as the apprenticeship system, the academic educational pattern which, in France especially, was almost the only key to success and which had a regular progression and set competitions, crowned by the Prix de Rome which enabled the young winner to work in the French Academy in that city—unthinkable for women, of course—and for which women were unable to compete until the end of the 19th century, by which time, in fact, the whole academic system had lost its importance anyway. It seems clear, to take France in the 19th century as an example, a country which probably had a larger proportion of women artists than any other—that is to say, in terms of their percentage in the total number of artists exhibiting in the Salon—that "women were not accepted as professional painters."[12] In the middle of the century, there were only a third as many women as men artists, but even this mildly encouraging statistic is deceptive when we discover that out of this relatively meager number, *none* had attended that major stepping stone to artistic success, the École des Beaux-Arts, only 7% had received any official commission or had held any official office—and these might include the most menial sort of work—only 7% had ever received any Salon medal, and *none* had ever received the Legion of Honor.[13] Given that women were deprived of encouragements, educational facilities and rewards, it is almost incredible that a certain percentage did persevere and seek a profession in the arts.

It also becomes apparent why women were able to compete on far more equal terms with men—and even become innovators—in literature. While art-making traditionally has demanded the learning of specific techniques and skills, in a certain sequence, in an institutional setting outside the home, as well as becoming familiar with a specific vocabulary of iconography and motifs, the same is by no means true for the poet or novelist. Anyone, even a woman, has to learn the language, can learn to read and write, and can commit personal experiences to paper in the privacy of one's room. Naturally this oversimplifies the real difficulties and complexities involved in creating good or great literature, whether by man or woman, but it still gives a clue as to the possibility of the existence of Emily Brönte or an Emily Dickinson, and the lack of their counterparts, at least until quite recently, in the visual arts.

Of course we have not gone into the "fringe" requirements for major artists, which would have been, for the most part, both psychically and socially closed to women, even

if hypothetically they could have achieved the requisite grandeur in the performance of their craft: in the Renaissance and after, the great artist, aside from participating in the affairs of an academy, might well be intimate with members of humanist circles with whom he could exchange ideas, establish suitable relationships with patrons, travel widely and freely, perhaps engage in politics and intrigue; nor have we mentioned the sheer organizational acumen and ability involved in running a major studio-factory, like that of Rubens. An enormous amount of self-confidence and worldly knowledgeability, as well as a natural sense of well-earned dominance and power, was needed by the great *chef d'école*, both in the running of the production end of painting, and in the control and instruction of the numerous students and assistants.

The lady's accomplishment

In contrast to the single-mindedness and commitment demanded of a *chef d'école*, we might set the image of the "lady painter" established by 19th-century etiquette books and reinforced by the literature of the times. It is precisely the insistence upon a modest, proficient, self-demeaning level of amateurism as a "suitable accomplishment" for the well-brought-up young woman, who naturally would want to direct her major attention to the welfare of others—family and husband—that militated, and still militates, against any real accomplishment on the part of women. It is this emphasis which transforms serious commitment to frivolous self-indulgence, busy work or occupational therapy, and today, more than ever, in suburban bastions of the feminine mystique, which tends to distort the whole notion of what art is and what kind of social role it plays. In Mrs. Ellis' widely read *The Family Monitor and Domestic Guide*, published before the middle of the 19th century, a book of advice popular both in the United States and in England, women were warned against the snare of trying too hard to excel in any one thing:

It must not be supposed that the writer is one who would advocate, as essential to woman, any very extraordinary degree of intellectual attainment, especially if confined to one particular branch of study. "I should like to excel in something" is a frequent and, to some extent, laudable expression: but in what does it originate, and to what does it tend? *To be able to do a great many things tolerably well, is of infinitely more value to a woman, than to be able to excel in any one. By the former, she may render herself generally useful; by the latter, she may dazzle for an hour. By being apt. and tolerably well skilled in everything, she may fall into any situation in life with dignity and ease—by devoting her time to excellence in one, she may remain incapable of every other.*

So far as cleverness, learning, and knowledge are conducive to woman's moral excellence, they are therefore desirable, and no further. *All that would occupy her mind to the exclusion of better things, all that would involve her in the mazes of flattery and admiration, all that would tend to draw away her thoughts from others and fix them on herself, ought to be avoided as an evil to her, however brilliant or attractive it may be in itself.* [my italics][14]

Lest we are tempted to laugh, we may refresh ourselves with more recent samples of exactly the same message cited in Betty Friedan's *Feminine Mystique*, or in the pages of recent issues of popular women's magazines.

This advice has a familiar ring, of course: propped up by a bit of Freudianism and some tag-lines from the social sciences about the well-rounded personality, preparation for woman's chief career, marriage, and the unfemininity of deep involvement with work rather than sex, it is still the mainstay of the Feminine Mystique. Such an outlook helps guard man from unwanted competition in his "serious" professional activities and assures him of "well-rounded" assistance on the home front, so that he may have sex and family in addition to the fulfillment of his own specialized talent and excellence at the same time.

As far as painting specifically is concerned, Mrs. Ellis finds that it has one immediate advantage for the young lady over its rival branch of artistic activity, music—it is quiet and disturbs no one (this negative virtue, of course, would not be true of sculpture, but accomplishment with the hammer and chisel simply never occurs as a suitable accomplishment for the weaker sex); in addition, says Mrs. Ellis, "it [drawing] is an employment which beguiles the mind of many cares...Drawing is, of all other occupations, the one most calculated to keep the mind from brooding upon self, and to maintain that general cheerfulness which is a part of social and domestic duty...It can also," she adds, "be laid down and resumed, as circumstance or inclination may direct, and that without any serious loss."[15] Again, lest we feel that we have made a great deal of progress in this area in the past 100 years, I might bring up the remark of a bright young doctor who, when the conversation turned to his wife and her friends "dabbling" in the arts, snorted: "Well, at least it keeps them out of trouble!" Now as in the 19th century, amateurism and lack of real commitment, as well as snobbery and emphasis on chic, on the part of women in their artistic "hobbies" feeds the contempt of the successful, professionally committed man who is engaged in "real" work and can, with a certain justice, point to his wife's lack of seriousness in her artistic activities. For such men, the "real" work of women is only that which directly or indirectly serves the family; any other commitment falls under the rubric of diversion, selfishness, egomania or, at the unspoken extreme, castration. The circle is a vicious one, in which philistinism and frivolity mutually re-enforce each other.

In literature, as in life, even if the woman's commitment to art was a serious one, she was expected to drop her career and give up this commitment at the behest of love and marriage: this lesson is, today as in the 19th century, still inculcated in young girls, directly or indirectly, from the moment they are born. Even the determined and successful heroine of Mrs. Craik's mid-19th-century novel about feminine artistic success, *Olive*, a young woman who lives alone, strives for fame and independence and actually supports herself through her art—such unfeminine behavior is at least partly excused by the fact that she is a cripple and automatically considers that marriage is denied to

her—ultimately succumbs to the blandishments of love and marriage. To paraphrase the words of Patricia Thomson in *The Victorian Heroine*, Mrs. Craik, having shot her bolt in the course of her novel, is content, finally, to let her heroine, whose ultimate greatness the reader has never been able to doubt, sink gently into matrimony, "Of Olive, Mrs. Craik comments imperturbably that her husband's influence is to deprive the Scottish Academy of 'no one knew how many grand pictures.'"[16] Then as now, despite men's greater "tolerance," the choice for women seems always to be marriage *or* a career, i.e., solitude as the price of success *or* sex and companionship at the price of professional renunciation.

That achievement in the arts, as in any field of endeavor, demands struggle and sacrifice, no one would deny; that this has certainly been true after the middle of the 19th century, when the traditional institutions of artistic support and patronage no longer fulfilled their customary obligations, is undeniable: one has only to think of Delacroix, Courbet, Degas, Van Gogh and Toulouse-Lautrec as examples of great artists who gave up the distractions and obligations of family life, at least in part, so that they could pursue their artistic careers more single-mindedly. Yet none of them was automatically denied the pleasures of sex or companionship on account of this choice. Nor did they ever conceive that they had sacrificed their manhood or their sexual role on account of their singleness and single-mindedness in order to achieve professional fulfillment. But if the artist in question happens to be a woman, 1,000 years of guilt, self-doubt and objecthood have been added to the undeniable difficulties of being an artist in the modern world.

Louise Bourgeois,
Noir Veine, 1968.
Black marble,
23 × 24 × 27 in.
(58.4 × 61 × 68.6 cm)

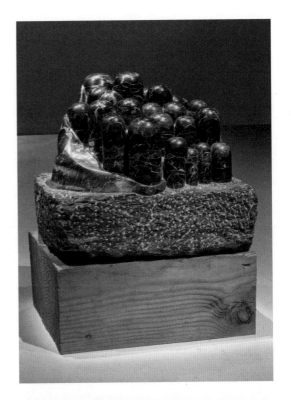

Emily Mary Osborn, *Nameless and Friendless*, 1857.
Oil on canvas, 32½ × 40⅞ in. (82.5 × 103.8 cm)

Maurice Bompard, *Un début à l'atelier*, 1881.
Oil on canvas, 88⅝ × 166⅛ in. (225 × 422 cm)

As an example of the unconscious aura of titillation that arises from a visual representation of an aspiring woman artist in the mid-19th century, Emily Mary Osborn's heartfelt painting, *Nameless and Friendless*, 1857, a canvas representing a poor but lovely and respectable young girl at a London art dealer, nervously awaiting the verdict of the pompous proprietor about the worth of her canvases while two ogling "art lovers" look on, is really not too different in its underlying assumptions from an overtly salacious work like Bompard's *Un début à l'atelier*. The theme in both is innocence, delicious feminine innocence, exposed to the world. It is the charming *vulnerability* of the young woman artist, like that of the hesitating model, which is really the subject of Miss Osborn's painting, not the value of the young woman's work or her pride in it: the issue here is, as usual, sexual rather than serious. Always a model but never an artist might well have served as the motto of the seriously aspiring young woman in the arts of the 19th century.

Successes

But what of the small band of heroic women, who, throughout the ages, despite obstacles, have achieved pre-eminence, if not the pinnacles of grandeur of a Michelangelo, a Rembrandt or a Picasso? Are there any qualities that may be said to have characterized them as a group and as individuals? While we cannot go into such an investigation in depth in this article, we can point to a few striking characteristics of women artists generally: they all, almost without exception, were either the daughters of artist fathers, or, generally later, in the 19th and 20th centuries, had a close personal connection with a stronger or more dominant male artistic personality. Neither of these characteristics is, of course, unusual for men artists, either, as we have indicated above in the case of artist fathers and sons: it is simply true almost *without exception* for their feminine counterparts, at least until quite recently. From the legendary sculptor, Sabina von Steinbach, in the 13th century, who, according to local tradition, was responsible for South Portal groups on the Cathedral of Strasbourg, down to Rosa Bonheur, the most renowned animal painter of the 19th century, and including such eminent women artists as Marietta Robusti, daughter of Tintoretto, Lavinia Fontana, Artemisia Gentileschi, Elizabeth Chéron, Mme. Vigée Le Brun and Angelica Kauffmann—all, without exception, were the daughters of artists; in the 19th century, Berthe Morisot was closely associated with Manet, later marrying his brother, and Mary Cassatt based a good deal of her work on the style of her close friend Degas. Precisely the same breaking of traditional bonds and discarding of time-honored practices that permitted men artists to strike out in directions quite different from those of their fathers in the second half of the 19th century enabled women, with additional difficulties, to be sure, to strike out on their own as well. Many of our more recent women artists, like Suzanne Valadon, Paula Modersohn-Becker, Käthe Kollwitz or Louise Nevelson, have come from non-artistic backgrounds, although many contemporary and near-contemporary women artists have married fellow artists.

Artemisia Gentileschi, *Judith Slaying Holofernes*, c. 1614–20.
Oil on canvas, 78⅜ × 63¾ in. (199 × 162 cm)

It would be interesting to investigate the role of benign, if not outright encouraging, fathers in the formation of women professionals: both Käthe Kollwitz and Barbara Hepworth, for example, recall the influence of unusually sympathetic and supportive fathers on their artistic pursuits. In the absence of any thoroughgoing investigation, one can only gather impressionistic data about the presence or absence of rebellion against parental authority in women artists, and whether there may be more or less rebellion on the part of women artists than is true in the case of men or vice versa. One thing however is clear: for a woman to opt for a career at all, much less for a career in art, has required a certain amount of unconventionality, both in the past and at present; whether or not the woman artist rebels against or finds strength in the attitude of her family, she must in any case have a good strong streak of rebellion in her to make her way in

the world of art at all, rather than submitting to the socially approved role of wife and mother, the only role to which every social institution consigns her automatically. It is only by adopting, however covertly, the "masculine" attributes of single-mindedness, concentration, tenaciousness and absorption in ideas and craftsmanship for their own sake, that women have succeeded, and continue to succeed, in the world of art.

Rosa Bonheur

It is instructive to examine in greater detail one of the most successful and accomplished women painters of all time, Rosa Bonheur (1822–1899), whose work, despite the ravages wrought upon its estimation by changes of taste and a certain admitted lack of variety, still stands as an impressive achievement to anyone interested in the art of the 19th century and in the history of taste generally. Rosa Bonheur is a woman artist in whom, partly because of the magnitude of her reputation, all the various conflicts, all the internal and external contradictions and struggles typical of her sex and profession, stand out in sharp relief.

The success of Rosa Bonheur firmly establishes the role of institutions, and institutional change, as a necessary, if not a sufficient cause of achievement in art. We might say that Bonheur picked a fortunate time to become an artist if she was, at the same time, to have the disadvantage of being a woman: she came into her own in the middle of the 19th century, a time in which the struggle between traditional history painting as opposed to the less pretentious and more freewheeling genre painting, landscape and still-life was won by the latter group hands down. A major change in the social and institutional support for art itself was well under way: with the rise of the bourgeoisie and the fall of the cultivated aristocracy, smaller paintings, generally of everyday subjects, rather than grandiose mythological or religious scenes were much in demand. To cite the Whites: "Three hundred provincial museums there might be, government commissions for public works there might be, but the only possible paid destinations for the rising flood of canvases were the homes of the bourgeoisie. History painting had not and never would rest comfortably in the middle-class parlor. 'Lesser' forms of image art—genre, landscape, still-life—did."[17] In mid-century France, as in 17th-century Holland, there was a tendency for artists to attempt to achieve some sort of security in a shaky market situation by specializing, by making a career out of a specific subject: animal painting was a very popular field, as the Whites point out, and Rosa Bonheur was no doubt its most accomplished and successful practitioner, followed in popularity only by the Barbizon painter Troyon (who at one time was so pressed for his paintings of cows that he hired another artist to brush in the backgrounds). Rosa Bonheur's rise to fame accompanied that of the Barbizon landscapists, supported by those canny dealers, the Durand-Ruels, who later moved on to the Impressionists. The Durand-Ruels were among the first dealers to tap the expanding market in movable decoration for the middle classes, to use the Whites' terminology. Rosa Bonheur's naturalism and

ability to capture the individuality—even the "soul"—of each of her animal subjects coincided with bourgeois taste at the time. The same combination of qualities, with a much stronger dose of sentimentality and pathetic fallacy to be sure, likewise assured the success of her *animalier* contemporary, Landseer, in England.

Daughter of an impoverished drawing master, Rosa Bonheur quite naturally showed her interest in art early; at the same time, she exhibited an independence of spirit and liberty of manner which immediately earned her the label of tomboy. According to her own later accounts, her "masculine protest" established itself early; to what extent *any* show of persistence, stubbornness and vigor would be counted as "masculine" in the first half of the 19th century is conjectural. Rosa Bonheur's attitude toward her father is somewhat ambiguous: while realizing that he had been influential in directing her toward her life's work, there is no doubt that she resented his thoughtless treatment of her beloved mother, and in her reminiscences, she half affectionately makes fun of his bizarre form of social idealism. Raimond Bonheur had been an active member of the short-lived Saint-Simonian community, established in the third decade of the 19th century by "Le Pére" Enfantin at Menilmontant. Although in her later years Rosa Bonheur might have made fun of some of the more far-fetched eccentricities of the members of the community, and disapproved of the additional strain which her father's apostolate placed on her overburdened mother, it is obvious that the Saint-Simonian ideal of equality for women—they disapproved of marriage, their trousered feminine costume was a token of emancipation, and their spiritual leader, Le Père Enfantin, made extraordinary efforts to find a Woman Messiah to share his reign—made a strong impression on her as a child, and may well have influenced her future course of behavior.

"Why shouldn't I be proud to be a woman?" she exclaimed to an interviewer. "My father, that enthusiastic apostle of humanity, many times reiterated to me that woman's mission was to elevate the human race, that she was the Messiah of future centuries. It is to his doctrines that I owe the great, noble ambition I have conceived for the sex which I proudly affirm to be mine, and whose independence I will support to my dying day..."[18] When she was hardly more than a child, he instilled in her the ambition to surpass Mme. Vigée Le Brun, certainly the most eminent model she could be expected to follow, and he gave her early efforts every possible encouragement. At the same time, the spectacle of her uncomplaining mother's slow decline from sheer overwork and poverty might have been an even more realistic influence on her decision to control her own destiny and never to become the slave of a husband and children. What is particularly interesting from the modern feminist viewpoint is Rosa Bonheur's ability to combine the most vigorous and unapologetic masculine protest with unabashedly self-contradictory assertions of "basic" femininity.

In those refreshingly straightforward pre-Freudian days, Rosa Bonheur could explain to her biographer that she had never wanted to marry for fear of losing her independence—too many young girls let themselves be led to the altar like lambs to the sacrifice,

she maintained. Yet at the same time that she rejected marriage for herself and implied an inevitable loss of selfhood for any woman who engaged in it, she, unlike the Saint-Simonians, considered marriage "a sacrament indispensable to the organization of society."

While remaining cool to offers of marriage, she joined in a seemingly cloudless, lifelong and apparently Platonic union with a fellow woman artist, Nathalie Micas, who evidently provided her with the companionship and emotional warmth which she needed. Obviously the presence of this sympathetic friend did not seem to demand the same sacrifice of genuine commitment to her profession which marriage would have entailed: in any case, the advantages of such an arrangement for women who wished to avoid the distraction of children in the days before reliable contraception are obvious.

Yet at the same time that she frankly rejected the conventional feminine role of her times, Rosa Bonheur still was drawn into what Betty Friedan has called the "frilly blouse syndrome," that innocuous version of the feminine protest which even today compels successful women psychiatrists or professors to adopt some ultra-feminine item of clothing or insist on proving their prowess as pie-bakers.[19] Despite the fact that she had early cropped her hair and adopted men's clothes as her habitual attire, following the example of George Sand, whose rural romanticism exerted a powerful influence over her imagination, to her biographer she insisted, and no doubt sincerely believed, that she did so only because of the specific demands of her profession. Indignantly denying rumors to the effect that she had run about the streets of Paris dressed as a boy in her youth, she proudly provided her biographer with a daguerreotype of herself at sixteen years, dressed in perfectly conventional feminine fashion except for her shorn head, which she excused as a practical measure taken after the death of her mother; "Who would have taken care of my curls?" she demanded.[20]

As far as the question of masculine dress was concerned, she was quick to reject her interlocutor's suggestion that her trousers were a symbol of emancipation. "I strongly blame women who renounce their customary attire in the desire to make themselves pass for men," she affirmed. "If I had found that trousers suited my sex, I would have completely gotten rid of my skirts, but this is not the case, nor have I ever advised my sisters of the palette to wear men's clothes in the ordinary course of life. If, then, you see me dressed as I am, it is not at all with the aim of making myself interesting, as all too many women have tried, but simply in order to facilitate my work. Remember that at a certain period I spent whole days in the slaughterhouses. Indeed, you have to love your art in order to live in pools of blood...I was also fascinated with horses, and where better can one study these animals than at the fairs...? I had no alternative but to realize that the garments of my own sex were a total nuisance. That is why I decided to ask the Prefect of Police for the authorization to wear masculine clothing.[21] But the costume I am wearing is my working outfit, nothing else. The remarks of fools have never bothered me. Nathalie [her companion] makes fun of them as I do. It doesn't bother her at all

to see me dressed as a man, but if you are even the slightest bit put off. I am completely prepared to put on a skirt, especially since all I have to do is to open a closet to find a whole assortment of feminine outfits."[22]

Yet at the same time Rosa Bonheur is forced to admit: "My trousers have been my great protectors…Many times I have congratulated myself for having dared to break with traditions which would have forced me to abstain from certain kinds of work, due to the obligation to drag my skirts everywhere…" Yet the famous artist again feels obliged to qualify her honest admission with an ill-assumed "femininity": "Despite my metamorphoses of costume, there is not a daughter of Eve who appreciates the niceties more than I do: my brusque and even slightly unsociable nature has never prevented my heart from remaining completely feminine."[23]

It is somewhat pathetic that this highly successful artist, unsparing of herself in the painstaking study of animal anatomy, diligently pursuing her bovine or equine subjects in the most unpleasant surroundings, industriously producing popular canvases throughout the course of a lengthy career, firm, assured and incontrovertibly masculine in her style, winner of a first medal in the Paris Salon, Officer of the Legion of Honor, Commander of the Order of Isabella the Catholic and the Order of Leopold of Belgium, friend of Queen Victoria—that this world-renowned artist should feel compelled late in life to justify and qualify her perfectly reasonable assumption of masculine ways, for any reason whatsoever, and to feel compelled to attack her less modest trouser-wearing sisters at the same time, in order to satisfy the demands of her own conscience. For

Rosa Bonheur, *The Horse Fair*, 1852–55.
Oil on canvas, 96¼ × 199½ in. (244.5 × 506.7 cm)

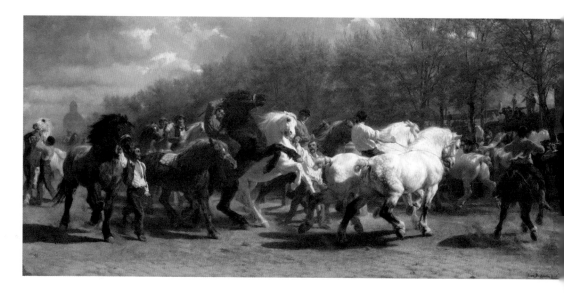

her conscience, despite her supportive father, her unconventional behavior and the accolade of worldly success, still condemned her for not being a "feminine" woman.

The difficulties imposed by such demands on the woman artist continue to add to her already difficult enterprise even today. Compare, for example, the noted contemporary, Louise Nevelson, with her combination of utter, "unfeminine" dedication to her work and her conspicuously "feminine" false eyelashes: her admission that she got married at seventeen despite her certainty that she couldn't live without creating because "the world said you should get married."[24] Even in the case of these two outstanding artists—and whether we like *The Horse Fair* or not, we still must admire Rosa Bonheur's achievement—the voice of the feminine mystique with its potpourri of ambivalent narcissism and guilt, internalized, subtly dilutes and subverts that total inner confidence, that absolute certitude and sell-determination, moral and esthetic, demanded by the highest and most innovative work in art.

Conclusion

We have tried to deal with one of the perennial questions used to challenge women's demand for true, rather than token, equality, by examining the whole erroneous intellectual substructure upon which the question "Why have there been no great women artists?" is based; by questioning the validity of the formulation of so-called "problems" in general and the "problem" of women specifically; and then, by probing some of the limitations of the discipline of art history itself. Hopefully, by stressing the *institutional*— i.e. the public—rather than the *individual,* or private, pre-conditions for achievement or the lack of it in the arts, we have provided a paradigm for the investigation of other areas in the field. By examining in some detail a single instance of deprivation or disadvantage—the unavailability of nude models to women art students—we have suggested that it was indeed *institutionally* made impossible for women to achieve artistic excellence, or success, on the same footing as men, *no matter what* the potency of their so-called talent, or genius. The existence of a tiny band of successful, if not great, women artists throughout history does nothing to gainsay this fact, any more than does the existence of a few superstars or token achievers among the members of any minority groups. And while great achievement is rare and difficult at best, it is still rarer and more difficult if, while you work, you must at the same time wrestle with inner demons of self-doubt and guilt and outer monsters of ridicule or patronizing encouragement, neither of which have any specific connection with the quality of the art work as such.

What is important is that women face up to the reality of their history and of their present situation, without making excuses or puffing mediocrity. Disadvantage may indeed be an excuse; it is not, however, an intellectual position. Rather, using as a vantage point their situation as underdogs in the realm of grandeur, and outsiders in that of ideology, women can reveal institutional and intellectual weaknesses in general,

and, at the same time that they destroy false consciousness, take part in the creation of institutions in which clear thought—and true greatness—are challenges open to anyone, man or woman, courageous enough to take the necessary risk, the leap into the unknown.

Notes

1 Kate Millett's (1970) *Sexual Politics*, Garden City, NY: Doubleday & Co, Inc., and Mary Ellmann's (1968), *Thinking about Women*, New York, NY: Harcourt Brace Jovanovich, Inc., provide notable exceptions.

2 "Women Artists" (1858), review of *Die Frauen in die Kunstgeschichte* by Ernst Guhl in *The Westminster Review* (American Edition), LXX, July, pp. 91–104. I am grateful to Elaine Showalter for having brought this review to my attention.

3 See, for example, Peter S Walch's excellent studies of Angelica Kauffmann, or his unpublished doctoral dissertation, "Angelica Kauffmann" (1968), Princeton, NJ, on the subject; for Artemisia Gentileschi, see R Ward Bissell (1968), "Artemisia Gentileschi—A New Documented Chronology," *Art Bulletin*, L (June), pp. 153–68.

4 Ellmann, *Thinking about Women*.

5 John Stuart Mill (1966), "The Subjection of Women" (1869), in *Three Essays by John Stuart Mill*, London: Oxford University Press, p. 441.

6 For the relatively recent genesis of the emphasis on the artist as the nexus of esthetic experience, see MH Abrams (1953), *The Mirror and the Lamp: Romantic Theory and the Critical Tradition*, New York: WW Norton, and Maurice Z Shroder (1961), *Icarus: The Image of the Artist in French Romanticism*, Cambridge, MA: Harvard University Press.

7 A comparison with the parallel myth for women, the Cinderella story, is revealing: Cinderella gains higher status on the basis of a passive, "sex-object" attribute—small feet—whereas the Boy Wonder always proves himself through active accomplishment. For a thorough study of myths about artists, see Ernst Kris and Otto Kurz (1934), *Die Legende vom Künstler: Ein geschichtlicher Versuch*, Vienna: Krystall Verlag.

8 Nikolaus Pevsner (1940), *Academies of Art, Past and Present*, Cambridge: Cambridge University Press, p. 96f.

9 Contemporary directions—earthworks, conceptual art, art as information, etc.—certainly point *away* from emphasis on the individual genius and saleable products; in art history, Harrison C and Cynthia A White's (1965) *Canvases and Careers: Institutional Change in the French Painting World*, New York: John Wiley & Sons, opens up a fruitful new direction of investigation, as did Nikolaus Pevsner's pioneering *Academies of Art*. Ernst Gombrich and Pierre Francastel, in their very different ways, always have tended to view art, and the artist, as part of a total situation rather than in lofty isolation.

10 Female models were introduced in the life class in Berlin in 1875, in Stockholm in 1839, in Naples in 1870, at the Royal College of Art in London after 1875 (Pevsner, *Academies of Art*, p. 231). Female models at the Pennsylvania Academy of the Fine Arts wore masks to hide their identity as late as about 1866—as attested to in a charcoal drawing by Thomas Eakins—if not later.

11 Pevsner, *Academies of Art*, p. 231.

12 White, *Canvases and Careers*, p. 51.

13 Ibid., Table 5.

14 Sarah Stickney Ellis (1844), *The Daughters of England: Their Position in Society, Character, and Responsibilities* (1842), in *The Family Monitor*, New York: HG Langley, p. 35.

15 Ibid., pp. 38–39.

16 Patricia Thomson (1956), *The Victorian Heroine: A Changing Ideal*, London: Oxford University Press, p. 77.

17 White, *Canvases and Careers*, p. 91.

18 Anna Klumpke (1908), *Rosa Bonheur: sa vie son oeuvre*, Paris: E Flammarion, p. 311.

19 Betty Friedan (1963), *The Feminine Mystique*, New York: WW Norton, p. 158.

20 Klumpke, *Rosa Bonheur*, p. 166.

21 Like many cities even today, there were areas that had laws against impersonation.

22 Klumpke, *Rosa Bonheur*, pp. 308–9.

23 Ibid., pp. 310–11.

24 Cited in Elizabeth Fisher (1970), "The Woman as Artist. Louise Nevelson," *Aphra*, I, Spring, p. 32.

2

Miriam Schapiro: Recent Work

Arts Magazine, November 1973

In her most recent works, paintings and large-scale collages of great richness and complexity, Miriam Schapiro raises the issue of feminism and art: more specifically, of feminism in relation to abstract art. At the same time, these works, in their impassioned yet controlled sensuous extremism, their deliberate juxtaposition or interweaving of seemingly contradictory pictorial strategies, constitute a daring way out of the reductive corner into which mainstream abstraction has painted itself in the last few years. Taken as a group, these works constitute a radical statement of Schapiro's identity as an artist working in the vanguard of contemporary abstraction and, at the same time, as a feminist struggling with other women to create a valid imagery of women's consciousness. In the collages, the artist's private delight at Bloomingdale's remnants counter, her sympathy with the patient ad hocism of patchwork quilts, her responsiveness to the delicate patterns of Persian miniatures are set in fruitful tension with the bold brushwork of gestural painting and the rigorous formal articulation of illusionistic abstraction. Schapiro's collages serve to remind us that enrichment—the sanctioning of previously "unacceptable" realms of substance or experience to inclusion within the kingdom of High Art—has been a strategy of avant-garde innovation as significant as reduction and exclusion; and that collage has been a major vehicle of enrichment. At once a technique and a weapon, part self-revealed artifice, part self-confessed reality, collage has over and over again forced a testing of previously established strictures of form and content by confronting the supreme esthetic value of the canvas with the esthetic non-value of newspaper or oilcloth, ticket stubs and waste paper, rubber tires, or, in this case, fabric scraps. Too often, the implications of collage material as a meaningful *content*, activated rather than supressed by its new context, have been neglected. But as we shall see, the implications of the introduction of patterned fabric—patchwork—into works of imposing scale and major ambition are central to Schapiro's intention and achievement.

While these may be characterized as feminist works, there is nothing pastel or passive—i.e. stereotypically "feminine"—in the collages, in which Schapiro has placed the raw material of everyday domesticity—chintzes, checks, cretonnes—in the novel ambience of bold, often disturbing, abstract structure; frameworks at times stringently geometric, at others, explosive, in which the innocently displaced drygoods spring to unsettling new life.

In some of the smaller works and in the large *Lady Gengi's Maze*—and the very title is significant in its evocation of the oriental, the feminine and the formally complex—there are references to the sophisticated exoticism of Persian miniatures, their proliferation of patterning contained within firm linear boundaries, the evocative mystery of their deep yet surface-oriented domestic spaces, of sensuous energy contained by formal convention. Yet at the same time, the very scale of *Lady Gengi's Maze* (72 × 80 in.) immediately differentiates it from the miniature, as does the tension generated by the opposition between the rich, multifarious textures of the three hovering carpet or quilt-like forms and the austerity of the symmetrical linear or asymmetrical black and gray elements which suggest powerful yet equivocal spatial existence in front and in back of them. In addition, the three framed forms are differentiated among themselves, progressing from the brushy, overly painterly surface of the left-hand square, two corners of which establish the spatial ambiguity of the composition by equating the *literal* boundary of the canvas at the upper left with the *figurative* limit established by the linear edge of the foreground enclosure, to the splendid patchwork exuberance of the central diamond shape, down to the more muted colors, smaller, less assertive patterns and

Miriam Schapiro, *Lady Gengi's Maze*, 1972.
Acrylic and fabric collage on canvas, 72 × 80 in. (182.9 × 203.2 cm)

Miriam Schapiro, *Big OX No. 2*, 1968.
Acrylic on canvas, 90 × 108 in. (228.6 × 274.3 cm)

more ragged, shapeless swatches of the lowest "carpet." Brilliantly framed in gold, this form is pierced at its center by a jagged hole-shape, an evocative formal wound revealing the steps behind, which, at the same time, can be read as part of the surface of the sinking rectangle itself. The latter configuration with the central hole more forcefully asserted as a spatial penetration, a gap torn in the fragile tapestry of interwoven textiles surrounding it, serves as the motif of the related *Flying Carpet*.

Mysterious evocation, a sense of content created by powerful spatial effects in which bold foreshortening and perspective illusion is constantly contradicted by the equally powerful surface reinforcement of brilliant color has been a characteristic of Schapiro's style since the middle sixties. In *Big OX No. 2* of 1968, for instance, the literal power of the splayed word-image formed by the interpenetrating "O" and "X", heightened by enormous scale and the vivid opposition of bright red-orange figures against silver background, is countered by the tender pink recessive planes of the inner lining of the central image. Here, the pathos and mystery of the hole, with its implications of hidden depths and organic vulnerability, are tellingly played against the cool authority of the contemporary central image grounded in the literalness of the surface. The expressive and formal potentialities of this mode, which Barbara Rose characterized as Abstract Illusionism, reached their climax in Schapiro's series of paintings created in

collaboration with the computer in 1970–71. To make these paintings, the artist fed the programmed drawing, a simple figure "rather like a new letter in an imaginary alphabet," into the computer, which could produce a theoretically limitless series of variations—or literally, of viewpoints—of the original drawing. Several of these "viewpoints," those most in accord with the artist's projected vision, would then be selected for transformation into large-scale work. At this stage, the artist's choice and feeling would dictate which portions of the computer-projected permutations of an individual image would be selected, which rejected, which portions strengthened by color, which merged with the background of the canvas, which elements treated as flat planes and which as recessive orthogonals. Works from this series like *Keyhole* or *The Palace at 3:00 A.M.* demonstrate the artist's uncanny ability to create anthropomorphic or architectural analogies by means of purely abstract relationships of form and color. In at least one of this series, *Iris* (*Homage to Georgia O'Keeffe*), the reference, both to organic forms and to the Women's Movement, is explicit.

In the fall of 1971, Miriam Schapiro joined Judy Chicago as a co-director of the Feminist Art Program at the California Institute of the Arts. The explicit aim of the Program was "to help women restructure their personalities to be more consistent with their desires to be artists and to help them build their artmaking out of their experiences as women." This intention found its concrete expression in the communally created art project, *Womanhouse*, an environment created for and by women in an abandoned house on Mariposa Street in Hollywood in 1971–72. In the context of the Feminist Art Program and *Womanhouse*, Schapiro worked in modes and on imaginative levels which, on the surface of it, would seem utterly different from those embodied in the large-scale, powerfully complex abstractions of her almost contemporary computer series. On first glance it would seem that the little *Dollhouse* that Schapiro created for *Womanhouse* in collaboration with Sherry Brody, with its miniature scale, its profusion of rich, decorative materials, the literalness of its cozy spaces and the concreteness of its references to woman as maker of the home, might constitute a rejection of contemporary abstraction as alien to the woman artist's deepest needs and desires. But not at all: on closer inspection, *Dollhouse* reveals of range of complexity and contradiction far beyond the reach of little girls' toys or stereotyped notions of woman's place. Each lovingly furnished room is disturbed by some impinging menace: a rattlesnake is curled up on the parlor floor, a grizzly bear stares through the nursery window at the tiny monster in the crib; mysterious men lurk outside the kitchen window. Above all, this dollhouse is specified as the home of a women *artist*, complete with doll-sized studio and a male nude model, accompanied by a postage stamp-sized replica of one Schapiro's large-scale abstractions. Far from constituting a rejection of her identity as an artist, more specifically as

Miriam Schapiro with Sherry Brody (Assistant), *Dollhouse*, 1972.
Wood and mixed media, 79¾ × 82 × 8½ in. (202.6 × 208.3 × 21.6 cm)

an abstract artist, *Dollhouse* is a conscious and artful articulation of the rich imaginative substratum from which artmaking, specifically woman's artmaking and, even more specifically, Miriam Schapiro's artmaking, can arise.

It is within this context of consciously feminist art activities that the insistent introduction of patchwork into Schapiro's collages assumes its full significance. The patchwork quilt has recently become a burning issue in certain feminist art circles. On the one hand, the existence of these brilliant stitched creations seems to offer proof of women's ability to create a valid art form apart from the male-dominated institutions of high art: indeed, one spokeswoman for the quiltmakers, Pat Mainardi, in a provocative article in the *Feminist Art Journal*, asserts that women quiltmakers anticipated recent developments in abstract art by more than a century. On the other hand, quilts may be viewed more as tokens of women's traditional ability to triumph over adversity, to make the best of things in the face of continual oppression: denied the means of access to historical significance and major stylistic innovation in the art of the past, women fulfilled their esthetic potentialities within the restricted, safely ahistorical areas of the decorative and the useful.

Schapiro shapes the multiple implications of patchwork to a variety of formal and expressive ends. In *Mimi's Flying Patches*, one is overwhelmed by the sheer exuberance of the scraps of fabric as they burst forth from the implicit "art" boundaries of the silver interior frame, at times smothering it with a welter of burgeoning pattern, at times playfully draping themselves over its edge to form the artist's nickname. In one of the larger works, *Window on Montana*, the mood is more somber, weightier. A certain sense of depth, both physical and psychic, is created by the contrast of the window-shaped configuration of lighter, more delicate and flowery fabrics in the center and the darker, more ominously paint-streaked patches at the peripheries of the work. A mood of nostalgia is evoked, too, by the deliberate dimming of the brightness of colors in some areas, reminding us that the passage of time has its effects on calico and chintz, that patchwork is, after all, like art, a part of history. In *Euridice*, larger shapes of fabric both define and in turn are defined by the suggestively expressive brushwork of the rose-colored central veil—a reference to Schapiro's own artistic past, perhaps, as well as to the revival of fifties pictorial values in the present—with its overtones of the lightness of air, the warmth of fire. And perhaps nowhere are the claims and counterclaims of hard-edge, expressive brushstroke and patchwork made more explicit than in the aptly titled *Explode*, where the angular fragments of brilliantly patterned textile literally burst out upon us from the light-colored, red-framed "picture space" in an aggressive assault upon the actual space of the word, a kind of patchwork liberation.

Not all women artists are feminists; not all feminist artists wish to incorporate their feminist identity into their art works and, certainly, even if some of them do, none will do it in the same way. Miriam Schapiro's collages are unique and deeply personal statements: they are by no means programmatic or didactic in their intentions or

Miriam Schapiro, *Explode*, 1972.
Acrylic and fabric collage on canvas, 80 × 72 in. (203.2 × 182.9 cm)

their effects. They do, however, in their splendor and novelty, suggest one of the many possible modes of interaction between feminism and art, in which the woman artist's consciousness of her identity can function with the same force and validity as did the abstract expressionists' awareness of their identity as Americans in the forties and fifties. The impact of the Women's Movement has already made itself felt in the art world in a variety of significant ways: it is predictable that in the seventies, women, freed from the demands of traditionally feminine roles and the compulsion to react against them by adopting equally stereotyped masculine stances, or perhaps by operating in an area of creative tension generated by the very consciousness of opposing options, will play an increasingly dominant role in the shaping of art.

3
Some Women Realists: Part 1

Arts Magazine, February 1974

Women artists have turned to realism since the 19th century, through force of cir-
cumstance if not through inclination. Cut off from access to the high realm of history
painting, with its rigorous demands of anatomy and perspective, its idealized classical
or religious subjects, its grand scale and its man-sized rewards of prestige and money,
women turned to more accessible fields of endeavor: to portraits, still life and genre
painting, the depiction of everyday life, realism's chosen arena.

Like the realist novel—another area in which women have been permitted to exercise
their talents since the 19th century—genre painting, and realist art generally, has been
thought to afford a more direct reflection of the woman artist's specifically feminine
concerns than abstract or idealized art, because of the accessibility of its language. Yet
one must be as wary of reading "feminine" attitudes in, or into, realist works as into
abstract paintings. While being a woman—like being an American or being a dwarf or
having been born in 1900 rather than in 1940—may be a variable, even an important
variable, in the creation of the artwork, little can be predicted on its basis. That a given
artist is a woman constitutes a necessary but by no means a sufficient condition of her
choice of a given style or subject: it is one element along with others, like her nationality,
her age, her training, her temperament, her response to available modes of expression,
or her priorities of self identification.

For the woman realist, like the woman artist in general, the sense of the creative self
as a woman may play a greater or a lesser role in the formulation of pictorial imagery. In
the past few years, with the rise of a powerful and articulate women's movement, this
sense of conscious feminine identification has become a more dominant factor in the
work of many women artists, who have begun to define themselves more concretely *as*
women, and to identify their feelings and interests with those of other women in the
realms of art and politics, and in their private realms of imagination as well.

It is, of course, difficult to separate unconscious or half-conscious motives from
conscious intentions in the choice of a given realist motif or vantage point. Does a
woman choose to depict her living-room floor, the Virgin of the Macarena, or mothers
and children, rather than trucks, motorcycles, and pin-ups out of conscious feminist
principles, or the promptings of the unconscious, or because such material is familiar to
her and easily available, or for a combination of such reasons? To what extent does the

depiction of close-up, large-scale views of fruit or flowers, a fairly popular motif among current women realists, depend on some sort of archetypal imprinting of the female psyche, and to what extent on the fact that a major woman artist, Georgia O'Keeffe, made such imagery her trademark? To what degree should realist works be read as iconological symbols—that is, conveyors of unconsciously or semi-consciously held attitudes or ideas and, more specifically, as conveyors of unequivocally feminine world views? These issues all come into play in a consideration of the work of some women realists.

I. Social realists

To a 19th-century English genre painter like Emily Osborn, realism (with a small "r"), if she thought about it at all, meant what it did to most of her contemporaries and has continued to mean to most of the public ever since: subject matter from the contemporary world; a tone which is didactic and moralizing; and a style which is clear, representational, and often richly detailed in its delineation of locale, type, and situation.

Osborn surely must be considered a proto-feminist artist: her major works deal with the problems facing the women of her time: *The Governess*, exhibited at the Royal Academy in 1860 and bought by Queen Victoria herself, constituted a bitter pictorial indictment of the "practice of treating educated women as if they were menial servants," to borrow the words of a contemporary reviewer; other works, like *For the Last Time*, *Half the World Knows Not How the Other Half Lives*, or *God's Acre*, touch on timely issues of poverty and social oppression specifically as they affect the lives of women. Her best-known work, *Nameless and Friendless* (1857) [p. 60] is one of the rare 19th-century paintings to deal directly with the lot of the woman artist.

It is a painting that was meant to be read and interpreted rather than to be appreciated for its not inconsiderable visual qualities alone. Such a work necessarily employed some of the strategies of the novel, the theater, or the sociological treatise to achieve its ends, and often seems to prophesy the silent film in its emphasis on accurate, significant detail and meaningful gesture. Yet it is wrong to dismiss such examples of Victorian realism as *Nameless and Friendless* as merely "photographic" or "literary" simply because they do not accord with today's established canons of pictorial decorum. They should, on the contrary, be considered a different but equally legitimate and viable mode of visual structure and expression. While it is richly detailed and full of social and psychological information, a work like *Nameless and Friendless* is paradoxically not at all photographic, in the way the work of many present-day realists may be said to be so. Victorian narrative painting, in the complexity of its organization, the explicitness of its social and moral implications and its dramatically meaningful condensations is at the furthest pole of expression, in its approach to the raw material of experience, from the diffidence and objectivity characteristic of the photographic sensibility. Osborn's work,

77

rather than constituting an apparently random slice through time, like a photographic image, is a carefully constructed palimpsest of significant temporal incidents from which a complex message may be distilled.

Such a didactic and socially meaningful type of realist expression has had its adherents among women artists of the 20th century. In our own country, during the 1930s, the art programs of the New Deal offered an opportunity to artists of both sexes to create works which commented on the social issues of the day, and which were located on the walls of those public institutions where their messages might reach an appropriate public. In several cases, women artists working on government-sponsored commissions took the opportunity to comment, in large-scale wall-paintings, on those social issues which particularly concerned women or in which women constituted the critical motif.

Such was the case in Lucienne Bloch's ambitious mural, now lost, for the Women's House of Detention in New York, of 1936. Bloch chose a theme relevant to the female audience—the cycle of a woman's life—and placed it in a context familiar to the women prisoners, a city playground in a working-class district. A certain didactic overtone is perceptible in the iconography, in that black and white children mingle and share toys and food while their mothers chat companionably; an unintentionally darker note is struck by the fact that a cityscape of factories, skyscrapers, and gas tanks quite literally closes off the horizon. Bloch was quite straightforward about her attempt to program social significance and utility into her art: first of all, she felt that the prison context itself created "a crying need for bright colors and bold curves to offset [the] drabness and austerity." Second, she wanted to combat the inmates' suspicion of art "as something highbrow...severed from the people and placed upon a pedestal for the privilege of museum students, art patrons, and art dealers," by relating her own work to their lives as closely as possible. "Since they were women and for the most part products of poverty and slums, I chose the only subject which would not be foreign to them— children—framed in a New York landscape of the most ordinary kind." Finally, the artist discovered that her actual presence making the mural had a quite concrete, if not traditionally esthetic, impact on the women inmates: "...They wholeheartedly enjoyed watching me paint. The mural was not a foreign thing to them. In fact, in the inmates' make-believe moments, the children in the mural were adopted and named."[1]

The social idealism and public concern of the New Deal even made its impact on such a private and idiosyncratic realist style as that of Florine Stettheimer. Her *Cathedrals of Wall Street* of 1939 [p. 145], one of a series of cathedrals of New York, is a loving but subversive homage to Eleanor Roosevelt, who occupies the center stage, elegant in Eleanor blue, with Mayor LaGuardia dancing attendance and Franklin relegated to inanimate glory as a sort of Pantocrator on the flattened white-and-gold facade of the Stock Exchange, flanked by a gorgeous golden George Washington. This record of democratic pageantry is couched in a language of such light-hearted decorative

Lucienne Bloch, *The Cycle of a Woman's Life*, 1936.
Mural, House of Detention for Women, New York.

prolixity that it deftly undermines, at the same time that it reflects, the more pompous
and pretentious large-scale monuments of social significance of the time.

Interestingly enough, many of the women artists who choose to comment on the
social issues of the day in their art at the present moment—Mac Stevens comes to mind,
or Faith Ringgold—tend to turn to more abstract or decorative pictorial languages,
perhaps feeling that social concern or political protest are more forcefully conveyed by
symbolic rather than descriptive means today.

II. Evocative realism

What Cindy Nemser has called "the close-up vision"—"the urge to get up close, to zero
in, to examine details and fragments"—has played a major role in the imagery of many
contemporary women realists.[2] This kind of realism is at a far remove from the social
variety, with its emphasis on the concrete verities of setting and situation.

It was, of course, a woman artist, Georgia O'Keeffe, who first severed the minutely
depicted object—shell, flower, skull, pelvis—from its moorings in a justifying space or
setting, and freed it to exist, vastly magnified, as a surface manifestation of something
other (and somehow deeper, both literally and figuratively) than its physical reality on
the canvas. One can think of the work of O'Keeffe and of such contemporary painters
of relatively large-scaled, centralized, up-front realistic images of fruit, flowers or seed-
pods as Buffie Johnson, Nancy Ellison, or Ruth Gray as "symbolic" in their realism as
long as we are very explicit about the nature of the symbolism involved.

O'Keeffe's *Black Iris* of 1926 like Ruth Gray's iris in *Midnight Flower* of 1972, or Nancy Ellison's cut pear in *Opening* of 1970, or Buffie Johnson's *Pomegranate* of 1972, is a hallucinatingly accurate image of a plant form at the same time that it constitutes a striking natural symbol of the female genitalia or reproductive organs.

The kind of symbolism implicit to these women's imagery—O'Keeffe's iris, for example—is radically different from that of more traditional symbolism, like the so-called hidden symbolism of the 15th-century Flemish realists.[3] In the case of the latter, the depicted object—the "vehicle" of the pictorial metaphor, to borrow a term from literary criticism—refers to some abstract quality, shared by itself and the subject, or "tenor" of the metaphor, which it serves to convey. The irises in the vase in the foreground of Hugo van der Goes' *Portinari Altarpiece*, far from being sexual symbols, refer to the future sorrow of the Virgin at the Passion of Christ. The significance may have been suggested by the notion of the sword-shaped leaves of the flower "piercing the Virgin's heart," an implication made even more obvious in the name of the closely related gladiola, which is derived from the Latin word for sword. But the meaning of the flower is hardly visually self-evident. In the older work, the symbolic relation between the minutely rendered irises and the abstract suffering of the Virgin obviously depends on a shared context of meaning—the iconography of the Nativity: it is something the spectator is supposed to know, not something that strikes him or her the minute he or she sees the flower in its vase.

In O'Keeffe's *Black Iris* or Gray's *Midnight Flower*, on the contrary, the connection "iris–female genitalia" is immediate: it is not so much that one stands for the other, but rather that the two meanings are almost interchangeable. The analogy is based not on a shared abstract quality, but rather upon a morphological similarity between the physical structure of the flower and that of woman's sexual organs—hence on a visual, concrete similarity rather than an abstract, contextually stipulated relation. In the same way, Johnson's pomegranate suggests woman as a fruitful being—it is morphologically similar to the uterus; the richness of female fecundity—the seeds well up from inside the pomegranate; and her reproductive expandability—the fruit splits under the pressure of its own ripeness—without ever being anything other than a carefully observed and described, if large-scale, pomegranate. (The fruit's mythological significance in the story of Proserpine may or may not play a role in the metaphorical significance of the work, but knowledge of the myth is certainly not essential to our response to its other implications.)

Such morphological metaphors were particularly attractive to the Surrealists, for they tend to be apprehended intuitively rather than depending on previous information, to make their appeal on the level of fantasy and imagination, perhaps even, of unconscious association, rather than to the intellect. As such, they lend themselves admirably to that imagery of metamorphosis on which the Surrealists relied to upset the uneasy boundaries between thing and thing, substance and substance, perception

Georgia O'Keeffe,
Black Iris, 1926.
Oil on canvas,
36 × 29⅞ in.
(91.4 × 75.9 cm)

and hallucination or dream. Yet neither O'Keeffe's, Johnson's nor Ellison's work can be considered "surreal." Their images are simply realist analogues, suggesting and evoking a feminine content—realist images suspended in a suggestive void. If a contemporary artist puts the iris back into a context, O'Keeffe's suggestive aura still plays its role: an interesting, witty new set of implications accrues to the flower in Carolyn Schock's *The Iris* of 1972. Now the irises, desexed and casual, have been put back into a still-life setting of deliberate artifice, like a studio set-up; but the feminist implications of O'Keeffe's iris as icon are nicely made into a dilemma by situating the vase between a (masculine?) hammer and a (feminine?) fan. The artist has at once desacralized and at the same time reactivated the feminist, or feminine, implications of the flower.

III. Literal or thing-in-itself realism

Some women realists today are distinguished precisely because of their choice of unevocative motifs. Artists like Sylvia Mangold, Yvonne Jacquette [p. 82], Susan Crile, or Janet Fish are really pictorial phenomenologists. In their awareness of the picture surface, their concern with scale, measurement, space or interval, their cool, urban tone,

81

Yvonne Jacquette, *James Bond Car Painting*, 1967.
Acrylic on masonite, 46 × 46 in. (116.8 × 116.8 cm)

their often assertive and sometimes decorative textures, they tend to affirm the artwork as a literal fact which, while it may have its referent in the actual world, nevertheless achieves its true effectiveness in direct visual experience, not evocation. Certainly, their subjects—floors, windows, ceilings, rugs, jars, bottles—count for something, but for what? Perhaps these are better considered motifs rather than subjects, but with none of the arty overtones that have accrued to this term since the 19th century. The images of these painters, neither symbolic, metaphoric, nor suggestive, are, in the rhetoric of pure realism, either metonymic—one thing next to another thing next to another—or synecdochic—a part of something standing for a larger whole.

Janet Fish, with her batallions of jars, honey-pots, glasses, and bottles, traffics in the objecthood of ordinary transparent containers. Their mass-produced curves, their patient, coarse-grained refractions, their elegant or graceless labels are simply there, on the shelf or table. What, after all, can one coke bottle remind you of besides another coke bottle? If, in confronting the human figure the realist artist or certain photographers, as Susan Sontag has recently suggested, somehow violate an implicit moral sanction by cooly transforming human subjects into visual objects, Janet Fish, the painter of glassware or packaged supermarket fruit, need face no such accusation. If anything, through over life-sized scale and attentive handling, she confers an unprecedented

dignity upon the grouped jelly jars or wine-bottles that she renders with such deference. The glassy fruit-or-liquid-filled volumes confront us with the hypnotic solemnity of the processional mosaics at Ravenna, and a similar, faceted, surface sparkle.

Sylvia Mangold, in an oeuvre at once austere and profligate, has devoted herself to exhaustive probing of the phenomenology of the floor: one would guess it is the floor of her own apartment. No photograph would care so much, could be as ostentatiously lavish in its documentation as this dedicated artist; not Walker Evans, not James Agee in his poignant litany of walls and floors and shingles in *Let Us Now Praise Famous Men*, not even Nathalie Sarraute in her thirty-page contemplation of the environs of a door-knob at the beginning of *La Planetarium*, goes farther than Sylvia Mangold in *Floor II*.

"Bareness and space (and spacing) are so difficult and seem to me of such greatness that I shall not even try to write seriously or fully of them," says Agee in *Let Us Now Praise Famous Men*[4]—although of course he has been doing just that all along. Mangold might have said much the same thing, but without the final demur. The floor for Mangold is an absolute, its limits not the horizon but the actual boundaries of the canvas itself. In *Floor with Laundry #2* this surface is interrupted by the gratuitous spatial markers of dropped clothing: the ordinary, stretched to a hypothetical infinity, is measured by carefully delineated, brutally shapeless, exquisitely individuated cast-offs.

In 1968, when Mangold created *Floor II*, within the context of dominant hard-edge abstraction, color-field, and Pop, what did it mean to paint a floor with methodical seriousness—straight? What was—and is—the significance of such a choice (*not such a subject*), of such a procedure? While the painting may look simple, the reasons for its

Sylvia Plimack Mangold, *Floor with Laundry #2*, 1970.
Acrylic on canvas, 36 × 46 in. (91.5 × 116.8 cm)

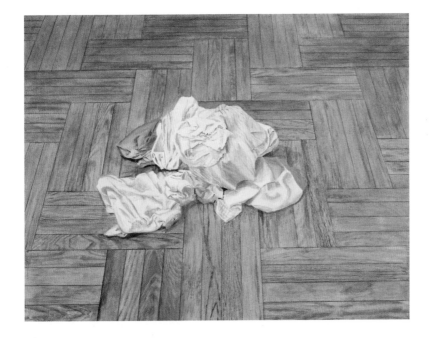

being the way it is or for its being at all are probably not. It is both related to and yet at the same time constitutes a subversion of the abstract art of the time. Of course, the very existence of non-relational abstraction gave the artist permission to consider something as nebbish as a stretch of floor a plausible motif. But if *Floor II* is at once absolutely pure of conventional meaning or "content," like an abstract motif, at the same time it is a representation of an irrevocably concrete *gegeben* out there: it is appropriation, not invention. *Floor's* challenge of abstraction is vividly demonstrated by the identification of the *recession* of the floor with the *surface* of the canvas. Are we looking through or at the picture plane? And from where?

Mangold's mode of approach is a detachment so passionate that, taken as a state of mind, it might well be considered obsession. Her mood may find antecedents in the methodological obsessiveness of certain Surrealists like Ernst in his wood-grain *frottages* or Magritte in that deadpan literalism of texture particularly characteristic of his wood surfaces. But the Surrealists' textural obsessions were always located in a supportive setting of ambiguity or hysteria: they were not simply direct statements of how it is if you look down at the living-room floor for a long time, with or without the help of a photograph. Very 1960s, perhaps, is that sense of an intensely personal vantage point, which is at the same time very cool and non-committal. If *Floor II* is anti-poetic and anti-evocative, yet it is a reminder that there is such a thing as a deliberately anti-poetic poetry, and that the innovative force of the French New Novel, which tried to use prose to erase its own significance, reached its zenith in the sixties. The extraordinarily muted yet rapier-sharp realist imagery of an artist like Vija Celmins offers, perhaps, the best parallel with Robbe-Grillet's attempt to abolish significance in literature: is her *Eraser* of 1970 a sly reference to the French writer's *Les Gommes*, as well as being a self-evident Pink Pearl by Eberhard Faber and nothing more?

Nothing but what is, the thing in itself: that seems to be what Mangold is after. Floors have always been *in* paintings. Jan van Eyck and Ingres seem to have enjoyed them, and the 19th-century realist Gustave Caillebotte was positively gaga about one in his prophetically literal, high-horizoned *Floor-Scrapers* of 1875, but they have always been a background incident in the work, not, as in Mangold's paintings, the whole subject of it.

But, by implication, Mangold's floor must be part of a larger whole, too: the orthogonals must meet somewhere. The feminine variable, a single strand in the weaving together of possible intentions and motivations, may be worth considering in this larger context, the world beyond the floor. If a woman is hemmed in by the domestic scene, if floors, toys, and laundry are her daily fare, she can still turn adversity into advantage, constructing out of the meanest, most neglected aspects of experience an imagery horizonless and claustrophobic, yes, but concrete, present, unchallengeable in its verisimilitude. The very mode of approach—part by part, methodical, a little at a time, like folding the laundry, like knitting, like cleaning a floor very very carefully, as opposed, say, to the explosive spontaneity, the all-over conquest of a Pollock—has its roots in a

social reality. Someone said of Chardin in the 18th century: "Nothing humiliates his brush"; in the 20th century we have to go farther to search out that nothing, and it is *her* brush that is not humiliated; or perhaps creates a triumph of self-imposed humility.

Yvonne Jacquette did a floor, the *James Bond Car Painting*, in 1967 [p. 82]. Here, the domestic vantage point is more explicitly spelled out, the dimensions of quotidian reality measured by an overflowing wastebasket, the bottom of a desk, the foot of a music stand, a toy train, and the James Bond car itself. The painting was part of a series concerning space between objects, according to the artist, and this issue of spaces between things has continued to inspire Jacquette in an art of greater range but perhaps less intensity than that of Mangold. For Jacquette, space is a function of glimpses—up, out, down, around—of clouds through windows, of light fixtures on ceilings, of a fraction of shingled barn against the sky. This is not the movement-suggesting Impressionist glimpse of the fleeting moment, but the casting of a colder, more fixative eye. Once again, one is tempted to view these diffident cut-off views as synecdoches pointing to a larger whole: women may be stuck with glimpses for their visual nourishment, yet the pictorial tensions generated by the interplay between space and the things that interrupt its freedom are, after all, what makes art interesting or what makes art art; and this is the case whether the space in question is the living-room floor and the interruption the children's toys, or the Sistine Ceiling and the interruption the hand of God.

Some Women Realists: Part 2

Arts Magazine, May 1974

Painters of the figure

That fear of content, of the transgression of experienced reality into the *hortus conclusus* of the image, which has marked the most extreme phases of the modern movement in recent years, is at least in part responsible for the demise of the portrait as a respectable field of specialization. That is not to say that advanced artists of the 20th century have not tried their hands at this time-honored genre: there is Picasso's portrait of Gertrude Stein, Kokoschka's of Dr. Tietze and his wife, or Matisse's of Mlle. Landsberg, to name only a few. In the last few years, realists like Alex Katz, Philip Pearlstein, and Chuck Close have helped revive the genre; and of course, photographic portraits have always been accepted, indeed, at times, encouraged, as somehow appropriate for a mechanical medium rather than a truly creative one like painting. Yet there is surely nothing to compare, in the 20th century, with the enormous and inventive achievement

of major portraitists of the past, like Rembrandt, Hals, or Velázquez, who devoted their best efforts to the field. Even in the 19th century, a self-appointed custodian of the grand tradition like Ingres exhibited a haughty reluctance to waste the valuable time he might have been devoting to history painting on mere portraiture, despite the fact that high society was willing to pay well for the privilege.[5] And while it is quite true that the Impressionists and Post-Impressionists were highly responsive to the visual appearance of the contemporary world in the shape of their own circle of family and friends, on the one hand, and to the claims of intensified response to human subjects on the other, it is equally true that the modernist attitude to such works has been to play down their status as portraits and to emphasize the formal inventiveness of paintings like Manet's *Zola*, Van Gogh's *Woman of Arles* (*Mme. Ginoux*), of Cézanne's *Vollard*, as though there were some necessary contradiction between responsiveness to the picture-plane and to human character. In short, one might say that portrait painting has been peripheral to the central concerns of much of the advanced art of our times.

In the field of portraiture, women have been active among the subverters of the natural laws of modernism. This hardly seems accidental: women have, after all, been encouraged, if not coerced, into making responsiveness to the moods, attentiveness to the character-traits (and not always the most attractive ones) of others into a life-time's occupation. What more natural than that they should put their subtle talents as seismographic recorders of social position, as quivering reactors to the most minimal subsurface psychological tremors to good use in their art? For the portrait is implicated, to some degree at least—whether artist, sitter or critic wish to admit it or not—in "that terrible need for contact" to which Katherine Mansfield makes such poignant reference in the pages of her *Journal*. Unlike any other genre, the portrait demands the meeting of two subjectivities: if the artist watches, judges the sitter, the sitter is privileged, by the portrait relation, to watch and judge back. In no other case does *what* the artist is painting exist on the same plane of freedom and ontological equality as the artist her or himself, and in no other case is the role of the artist as *mediator* rather than dictator or inventor so literally accentuated by the actual situation in which the artwork comes into being. This is particularly true of the representations or relatives, friends or kindred spirits—rather than commissions—and of course, of self-portrayal—characteristic of the best 20th-century portraiture.

The number of women painters for whom the portrait and self-portrait have been important, or even major, concerns within the last 100 years is large, even if we exclude highly competent professional specialists in portrait commissions like Cecilia Beaux: their ranks include such artists as Mary Cassatt [chapter 11], Paula Modersohn-Becker, Romaine Brooks, Florine Stettheimer [chapter 5], and, in more recent years, a woman who has devoted an entire oeuvre of great variety and inventiveness almost exclusively to the portrait: Alice Neel [chapter 19]. Neel is just now coming into her own after forty years of painting, with a retrospective at the Whitney Museum and several magazine

articles, the most important of which, by Cindy Nemser, however, appeared—signifi-
cantly enough—*not* in an art journal but in the feminist publication, *Ms.*⁶ Why, one
wonders, was Neel for so long refused serious consideration, or, even more insidiously,
was her work relegated to consideration as the pictorial equivalent of *vers de société*,
her achievement equated with skillful social satire, always with the implication that
"real" art had better things to do? (One remembers, of course, that Manet was regret-
fully written off by his academic teacher Couture as "nothing more than the Daumier
of his times.") Neel's portraits, far from being merely witty or clever—although to be
so is itself no mean achievement—form a consistent, intensely serious and innovative
body of work: she has, progressively over the years, invented an idiosyncratic structure
of line, color and composition to body forth her vision of unmistakably contemporary
character. Twenty or thirty years hence, looking back at the exposed thighs, the patent
leather polyphony of the shoes, the world-weary individualism of the *Gruen Family*
(1970) or the casual yet somehow startling *rapprochement* of self-exposure and self-
containment—of post, color scheme, and personality—achieved in *Gregory Battcock
and David Bourdon* (1971), we will be forced to admit, sighing, blushing or wincing as
the case may be, "so *that's* the way we were!"

One thinks of Van Gogh's Neunen period portraits of peasants, weavers, railway
workers and also of his intention to be an "illustrator of the people" when confronted
by the dark, brooding, unrelenting intensities of Neel's early representations of the
people of Spanish Harlem, where she lived during the forties. There is the same delib-
erate brutalizing of the means to achieve more penetrating pictorial ends, the same
refusal to rely upon stereotype or sentimentality, the same inability to patronize one's
subjects or to see them as mere picturesque generalizations for the human condi-
tion. Neel's later works, too, like *Dorothy Pearlstein* of 1969, *Vera Beckerhoff* of 1972, or
Nancy and Her Baby of 1967 may also call to mind precedents by Van Gogh: the single
portraits recall the stiff, dignified, almost Épinal awkwardness of his *Postman Roulin*;
the mother and child of his *Mother Roulin and Her Baby* with its disquieting interlac-
ing of maternal and childish forms. Facing the terrible portrait of *Andy Warhol*, livid,
bandaged, trussed, sewn, and scarred, visibly dropping yet willing himself to a ghastly
modicum of decorum after his near-assassination, one is reminded somehow of Van
Gogh's intention, in painting the melancholy Dr. Gachet, to record "the heart broken
expression of our time." There is no question of derivativeness in any of her work: it
is simply a fact that few of her subjects have escaped the inroads of contemporary
anxiety—a peculiarly New York brand of it—each, of course, in his or her own particular
fashion. Nobody is ever quite relaxed in a Neel portrait, no matter how suggestive of
relaxation the pose: some quivering or crisping of the fingers, some devouring patch
of shadow under the eyes or insidious wrinkle beneath the chin, a linear quirk, a stra-
tegic if unexpected foreshortening dooms each sitter-victim to premonitory alertness
as though in the face of impending menace.

This lurking uneasiness is not something Neel reads into her sitters; rather, it has to do with her peculiar phenomenology of the human situation. It is how Neel sees us, how we actually exist for her, and so it is there. Or rather, at times, she doesn't so much *see* it that way as record it, in the same way that Courbet once, without realizing what he was painting, is said to have recorded a distant heap of faggots by simply putting down what he saw until the paint strokes revealed themselves to be what they were. Recently, when I was sitting for her, Neel said to me, "You know, you don't *seem* so anxious, but that's how you come out," genuinely puzzled. Of course, one might say that a person's exterior, if it is keenly enough explored and recorded with sufficient probity, will ultimately give up the protective strategies devised by the sitter for facing the world. Neel felt genuine regret, perhaps, that this was the case; nevertheless, since it was, to paint otherwise would have been merely flattering rather than truthful.

The nude portrait is a subcategory of portraiture that seems to have appealed to certain women artists perhaps because of the subversive nature of the contradiction it implies: the generalization of the nude juxtaposed with the specificity of the portrait. This jarring conjunction was perhaps, as the art historian Eunice Lipton has suggested, a significant factor in the hostility aroused by Manet's *Olympia* when it was shown in Paris more than 100 years ago. The nude—even Cubist or Surrealist—is somehow supposed to be timeless, ageless, and, above all, anonymous, not someone you might meet on the street, shake hands with, or bump into at a cocktail party. Here again, Neel has challenged tradition, both old and new, not least in choosing male nudes as her subjects. As early as 1933, she portrayed a frontal and thrice-endowed Joe Gould, recognizable in every respect, and more recently a no less totally individuated John Perrault, languid and hairy, stretched out on a couch [both p. 287]. Neel's nude portraits of pregnant women are particularly incisive: the reclining *Pregnant Woman* of 1971, with her ballooning, brown-lined belly and distended nipples, but also the less well-known but no less interesting, seated *Pregnant Betty* of 1968. In the latter portrait, the subject, although naked, is firmly rooted in a precise time and place both by her own stylishness and the artist's style, as well as by the exactly recorded, extreme, degree of her pregnancy. No rhetorical generalizations are predicated upon the sitter's condition. Neel has deliberately contraverted the primitive or archetypal clichés associated with incipient motherhood—earth mother or fertility goddess—by dwelling on its very *unnaturalness* for this sophisticated, individuated, urban woman. She plays the force of the temporarily swollen, turgid, bulging breasts and belly (nature's realm) against the fashionable delicacy of the arms and legs, the up-to-dateness of the ravaged coiffure, the painted artifice of make-up and toe-nail polish, welding these contradictions into an uneasy union predicated upon self-exposure, discomfort, and a wary isolation, defiantly unassimilable to the comforting mystique of childbearing.

Exposure, or self-exposure, has surely been one of the chief motivations behind an even more specialized sub-category of portraiture: the nude, or partially nude,

self-portrait. An element of masochism, defiance and self-humiliation at once, seems implicit in the male artist's literally "bearing his breast"—and even mine—to the public. In the case of female artists the implications of the nude self-portrait are quite different: while we are culturally conditioned to expect the *subject* of a self-portrait to be male, we do not expect him to be nude; in the case of a woman, our expectations are reversed: while we certainly expect her to be *nude*, we do not expect her to be the subject of a self-portrait. (How many "Portraits of the artist as a young woman" can one readily call to mind?). Paula Modersohn-Becker led the way with her delicate yet powerful nude *Self-Portrait* of 1906, in which the paradisiacal felicities of Gauguin's exotic Eves or Liliths are called into question by the brooding Teutonic seriousness of the flower-wreathed head, the weary sag of the heavy shoulders. More recently, Jane Kogan has posed for herself in an equally paradisiac if far more provocative situation in her *Interiorized Self-Portrait*. Here, the artist's aggressively womanly body merges with and emerges from an equally aggressively mannish suit; her head-on, spectacled glance is shaded by a no-nonsense derby; and she grasps a flower in one hand and a cat-o-nine-tails in the other.

A still further refinement on the nude, female self-portrait theme is the double portrait in which the female member of the pair rather than the male—(one might think of *Rembrandt and Saskia* as the more traditional prototype)—is the artist, and the male is reduced—or elevated, depending on how we look at it—to the role of companion-model. Sylvia Sleigh made this sex-role reversal quite explicit in her *Philip Golub Reclining* of 1971 [p. 90], where she represented herself as the clothed, active artist, in the process of recording the nude, passive, male model before her. Quite different in mood but similar in its pictorial reversal of customary expectations is Marcia Marcus' *Double Portrait I* of 1972–73. The artist has represented herself standing before the Lion Gates of Mycenae, alert and self-contained, clad in a transparent nightgown: potential energy is suggested by the crinkly expansiveness of her hair, its linear tensions reiterated by the wiggly intricacy of the lace insert over her breasts. Her figure is backed up by the towering, masculine yet gently dropping image of a tender, fair-haired flower-child, whose brilliantly patterned pants evoke the innocent world of Gauguin's islanders, and whose eyes are exactly the same, pristine shade of blue as the Greek sky in the background.

It is Sylvia Sleigh, perhaps, who most pointedly raises the issues involved in the female artist's representation of the male nude. While not overtly political in intention, works like her *Nude Portrait of Allan Robinson* (1968), *Paul Rosano Seated, Nude* (1973), *Nick Tischler Nude* (1973), as well as her large-scale group compositions like *The Court of Pan (After Signorelli)* (1973) or *The Turkish Bath* (1973) [p. 221] are certainly political in effect, if we accept sexuality as one of the major political arenas of our day. It seems apparent that many of the ostensibly *formal* criticisms levelled at Sleigh's work— "awkward" or weak drawing, too loose or too tight brushwork, "incorrect" or "labored" perspective, "mechanical" or "disjointed" composition, etc.—are actually reactions to

Sylvia Sleigh, *Philip Golub Reclining*, 1971.
Oil on canvas, 42 × 62 in. (106.7 × 157.5 cm)

the underlying political implications of her work: her male nudes force a questioning of what is "natural," "acceptable," or "correct" in the realm of feeling or being, as well as in the realm of art. Similar accusations of formal weakness, technical insufficiency, or even willful distortion were, of course, leveled at Courbet, Manet and even at the young Ingres, at least in part because the underlying polities of their art affronted "normal"— i.e. unconscious or ideological—expectations.

"Both celebratory and ironic," in the words of Leon Golub, father of one of Sleigh's favorite young models, these nudes suggest that to a contemporary woman painter, male nudity need be no more heroic, no less voluptuous than the female variety. The problem of gentling the male without destroying his—at least potential—potency is connected with the difficulty of creating an up-to-date imagery of male sensuality with a predominantly female audience in mind. Individuation is perhaps the key to Sleigh's response to this problem. She, like Martha Edelheit, another interesting painter of male nudes, refuses to consider her naked subjects as anonymous models. Sleigh's male nudes are all portraits, and, so to speak, portraits all the way, down to the most idiosyncratic details of skin tone, configuration of genitalia or body-hair pattern. (Sleigh has stated that her interest in male fur and its infinite variety, while partly due to delight in its sheer decorative possibilities, was also determined by a reaction against the idealizing depilation of the nude body decreed in the academic training of her youth.)

As did Manet in his *Olympia* or his *Déjeuner sur l'herbe*, Sleigh often relates her nudes to the Great Tradition, both as an assertion of continuity in scope and ambition, and, at the same time, as a witty and ironic reminder of what values have been rejected, or in her case, deliberately stood on their heads. At the same time, her reinterpretations of traditionally female nude group scenes, like *The Turkish Bath* [p. 221], permit her to carry her responsiveness to the generic appeal of male sensuality; and, at the same time to each man's distinctive type of physical or psychological attractiveness to its ultimate pictorial fulfillment. In this large painting, freely based on prototypes by Delacroix and Ingres, the wonderful pink and blond tenderness of Lawrence Alloway's recumbent form is played against the piercing blue intelligence of his glance, and his horizontal image against the swarthy, svelte romantically aquiline verticality of the adjacent figure of Paul Rosano. In the same fashion, the richly hair-patterned torso of the dreamily relaxed John Perrault is nicely paired off with the stiffer, more frontal glabrousness of that of Scott Burton kneeling beside him, and the delights of these contrasts themselves are set off by the richness and coloristic brilliance of the decorative patterns against or upon which they are placed.

The ironies of her work of course reveal the reality of the sexual situation. If we compare Sleigh's male harem scene with Ingres' *Turkish Bath* we see that she has actually dignified her male sitters by stipulating through portrait heads and distinctive physiques that they are differentiable human beings. The faces of Ingres' women are as close to being bodies as they can possibly be without suffering a complete metamorphosis, like Magritte's body-head in *Rape*: they are as devoid of intelligence or energy as breasts or buttocks. This depersonalization is a prime strategy of what Susan Sontag has called the pornographic imagination; indeed, a token of its success in sexualizing all aspects of experience and rejecting anything that might divert from his single-minded goal. Sleigh's wit is at once a weapon and a token of her humanity: instead of annihilating individuality, she envisions it as an essential component of erotic response: instead of depersonalizing the heads of her sitters, she not only accepts their uniqueness but goes still further and intensifies the uniqueness of their bodies as well.

It is an interesting commentary on the inextricability of moral or political judgments from esthetic ones that so many female observers of Sleigh's paintings experience them as successful, and pictorially accomplished, the subjects as sensually appealing and physically attractive—rather in the same terms that art historians or critics, generally male or trained by men, have responded to the overt erotic appeal of nudes by Watteau, Goya or Ingres—whereas heterosexual males are often turned off by her works. They feel that the figures are "effeminate," the tone "campy," the drawing "weak," "distorted," or "incorrect," perhaps trying to dissociate themselves from what might be a threatening reversal of the power structure, or to rationalize their quite genuine distress and anger about being turned into languid creatures of the bedroom rather than active, privileged visual consumers of centuries of esthetically-certified erotic art products. The liberties

taken with the female figure by male artists have always been justified on the grounds of the increased esthetic and sensual pleasure afforded by such deviations from current canons of academic correctness. Donald Posner, for example, in his recent study of Watteau's nude *Lady at her Toilet*, counters 18th-century criticism of the anatomical deficiencies of Watteau's drawings for this work by admitting that, while such criticisms are not wholly unfair, they are completely beside the point "because the drawings do not aim to articulate the structure and mechanics of bone and muscle, but attempt to capture the voluptuousness of the female body as it surrenders to relaxation, stretches and turns, or curls itself up. In achieving this, these sketches are unsurpassed."[7] Change the adjective before "body" to "male" and one sees the point of Sleigh's interpretation of the nude male form. While the canons of drawing, or of artistic quality, seem quite properly to be relatively flexible and determined by quite specifiable goals or situations, the ideological contexts in which these judgements of quality are formulated, since they are generally hidden or unconscious, are less amenable to change or even to rational consideration. The imagery of contemporary women realists like Neel, Sleigh and many others may demand that we raise these ideological assumptions to the level of conscious attention and face the larger implications of what have previously seemed to be purely esthetic questions of quality.

Notes

1 Lucienne Bloch (1973), "Murals for Use," in Frances V O'Connor, ed., *Art for the Millions: Essays from the 1930s by Artists and Administrators of the WPA Federal Art Project*, Greenwich, CT: New York Graphic Society, pp. 76–77.

2 Cindy Nemser (1972), "The Close-up Vision—Representational Art, Part II," *Arts Magazine*, May, p. 44.

3 See Goran Hermeren (1969), *Representation and Meaning in the Visual Arts*, Lund (Lund Studies in Philosophy, I), pp. 77–101, for an excellent discussion of iconographical symbolism, including the hidden variety.

4 James Agee and Walker Evans (1960), *Let Us Now Praise Famous Men*, orig. pub. 1939 and 1940, Boston, MA: Houghton Mifflin, p. 55.

5 Robert Rosenblum (1967), *Jean-Auguste-Dominique Ingres*, New York, NY: Harry N Abrams, p. 33.

6 Cindy Nemser (1973), "Alice Neel: portraits of four decades," *Ms*, October, pp. 48–53.

7 Donald Posner (1973), *Watteau: A Lady at Her Toilet*, New York, NY: Viking, p. 62.

4

Women Artists after the French Revolution

Women Artists: 1550–1950, 1976

Why should people prone to pregnancy and passing indispositions be barred from the exercise of rights no one would dream of denying those who have gout or catch cold easily?

<div align="right">LE MARQUIS DE CONDORCET, 1790</div>

For women artists, as for women in general, the French revolution appears to have been a mixed blessing, opening up some doors, shutting others, exhilarating in theory but often exclusive and repressive in practice. While it is certainly true that some of the *philosophes*, Marquis de Condorcet above all, paved the way for revolutionary feminism, others, like Jean Jacques Rousseau, made it abundantly clear that marriage and mother-hood—and little else besides—were woman's "natural" vocation.

Condorcet, in 1787, had made the first attempt to incorporate the case for the civil equality of women into the liberal political ideology of the Enlightenment.[1] He maintained that if women were to be taxed, they should be able to vote; that domestic authority should be shared; that the professions and, most importantly, educational opportunity should be opened up to the female sex.[2] In essence, Condorcet provided a political theory that justified the principle of equality before the law for everyone, regardless of sex, thus including females in the general term *mankind* for the first time in history.[3]

During the revolution itself, feminist pamphlets and various proposals for the betterment of women's condition appeared, and women began sending delegations to the government and using the political clubs as a platform. In 1791 Olympe de Gouges, one of the major feminists of the French revolution, enunciated her "Declaration of the Rights of Women": "All women," she declared, "are born free and remain equal to men in rights.... Law is the expression of the general will: all female and male citizens have the right to participate personally or through their representatives in its formation." She also demanded equality of opportunity in public employment, the right to paternity suits, and a general end to male domination.[4] Yet despite the sensational activism of feminists like Olympe de Gouges, Etta Palm, and Théroigne de Méricourt, and a feminist program (rather piecemeal, it is true) of educational, economic, political, and legal

change, women were eventually systematically excluded from most revolutionary benefits, including the right to vote. Their political clubs were outlawed in the Fall of 1793.

Although politically advanced, the revolution was in many ways socially conservative: along with middle-class ideals of political liberty and economic opportunity it espoused the equally middle-class ideal, recently developed at that, of the happy nuclear family, the family as a secure nest offering shelter from the brutality of public or professional life. The Rousseauan notion of woman as the "natural" guardian of the home militated strongly against her achievement of status as an independent being, in the arts as elsewhere.

It is symptomatic of revolutionary hostility toward the advancement of women that the first act of the Société Populaire et Républicaine des Arts (successor to the earlier Commune des Arts), established in 1793, was to exclude women from its meetings. The arguments raised by the members of the Society in coming to this decision are worth examining in detail, since they were to provide the basis for similar exclusionary decisions in the future. The members decided to close the door to women artists because women were "different from men in every respect." Since the Society, it was maintained, had as its goal the cultivation of the arts rather than politics, and since the law forbade women to assemble and deliberate for any reason, to admit them would be to go against the law. In response to one member's feeble protest that the Jacobin Society had admitted a woman member, another *sociétaire* stoutly maintained that among Republicans, women must absolutely give up the jobs destined to men. Although admitting that for his own satisfaction, he would be happy to live with a woman who was talented in the arts, still, to do so would be to act against the laws of nature. "Among savage people," he asked (rhetorically, to be sure), "those in consequence who are closest to the state of nature, are women ever seen doing the work of men?" The whole issue was blamed on the "Citizeness le Brun" (Mme. Vigée Le Brun), who exhibited great talent for art and had thereby inspired a horde of other women who "wished to busy themselves with painting although they should only occupy themselves with embroidering the swordbelts and caps of the police." The proposal that only female citizens recognized for their talent and exemplary character should be admitted was countered with the assertion that other popular societies would be angered by the admission of women to the Société des Arts. Finally, despite the fact that their rules made no such stipulation, the Society voted "purely and simply that female citizens would not be admitted."[5]

Yet despite such overt exclusion of women artists from the institutions governing their profession; despite the fact that they were to be denied admission both to the École des Beaux-Arts and the prestigious Class of Fine Arts of the Institute until almost the end of the 19th century;[6] and despite the fact that they had to study their craft apart from their male colleagues and under far less favorable conditions, women artists nevertheless made progress, as a group and as individuals, in the years following the revolution. Whether it was because of the less restricted access to the Salons or the greater emphasis

on portraits and genre rather than history painting (despite lip service to the latter),[7] increasing numbers of women painters participated in public exhibitions in the early 1800s. In the 1801 Salon, out of a total of 192 painters exhibiting, about 28, or 14.6%, were women; in 1810, out of 390 painters exhibiting, about 70, or 17.9%, were women; in 1822, out of 475 painters exhibiting, about 67, or 14.1%, were women; and in 1835, out of 801 painters exhibiting, about 178, or 22.2%, were women. Thus, both in terms of percentages and even more dramatically in terms of absolute numbers (since the Salons themselves expanded), the statistical position of women painters improved in the Salons of the first third of the 19th century.

Yet such statistics, of course, tell us little about the kind of work women were exhibiting or the attitudes toward women's painting revealed by critics, patrons, and public. It is naturally difficult to generalize about such a varied group of painters; still, one would be safe in saying that the relatively unprestigious genre of the portrait was the most popular among women artists; indeed, critics early in the century recognized the "happy fecundity" of women painters as portraitists.[8] Another type of painting particularly popular with women artists, as indeed it was with many of their male contemporaries, was what might best be termed "sentimental genre": intimate, often domestic, scenes of heart-warming pleasure or, less frequently, heart-breaking minor tragedy, often with moralizing overtones. It must be emphasized that women had no monopoly on this sort of painting, most often associated with Greuze in the 18th century and with Boilly, Drolling, and Léopold Robert in the 19th; a painting like Ingres' *Henry IV Playing with His Children* (current location unknown)[9] of 1817 is certainly a prime example of the genre under its historical aspect. Nevertheless, in the early 19th century, women artists like Marguerite Gérard [p. 96], Pauline Auzou, Constance Mayer, Eugenie Servières, Elisabeth Chaudet, and Antoinette Haudebourt-Lescot must certainly be said to have staked out a considerable claim in this popular if not highly respected territory.

Some of these women artists even developed specializations within this already restricted domain as a way of establishing a clearer identity in a highly competitive field, a ploy not uncommon with painters of both sexes before or since. Mme. Haudebourt-Lescot, for example, specialized in—and may even be said to have invented—Italian genre subjects, like *Dancing the Saltarello* or *The Marionette Theater in Rome*, with an emphasis on scenes of woman's daily life. Mme. Chaudet, although she did attempt an antique subject in the Salon of 1810—the now-vanished *Dibutade*—specialized in the genre subcategory of children with animals, a choice well suited to her modest talents, according to Charles Landon.[10] She established her reputation in the Salon of 1799 with a *Little Girl Trying to Teach Her Dog to Read*. *A Young Girl Feeding Her Chickens* appeared in the Salon of 1802 and *A Young Girl Mourning the Death of Her Pigeon* (Musée d'Arras) in the Salon of 1808.[11] A more dramatic variant of this popular child-and-animal theme by Mme. Chaudet, *A Child Asleep in His Cradle Guarded by a Brave Dog* of 1801

Marguerite Gérard, *An Architect and His Family*, c. 1787–90. Oil on wood panel, 12 × 9½ in. (30.5 × 24.1 cm)

(Musée de Rochefort), in which the sleeping infant seems to have been saved from a serpent by his faithful canine companion, evidently set a precedent. The next year Mme. Villers presented the even more heartrending *Baby in Its Cradle Carried Off by the Floods of the Year X*, in which the little victim is accompanied by a faithful dog who paddles along beside the floating cradle—a theme of canine life-saving that ultimately reaches its apotheosis in the English artist Landseer's *Saved* of 1856, in which a giant Newfoundland is represented after having rescued a drowning child.

Yet not all women artists felt themselves restricted to portraits or to genre scenes at the beginning of the 19th century: far from it. Nanine Vallain (dates unknown), for example, was a pupil of David's and of Suvée's who exhibited in the Salons from 1793 to 1810. Although she did paint a *Young Woman Seated with a Lamb on Her Lap* in 1788, early in her career, as well as the requisite portraits, she also turned to classical, allegorical, and religious themes. In the Salon of 1793 she showed two Ovidian subjects—*Ceyx and Alcyone* and *Acontius and Cydippe*—both on an ample, if not extravagant, scale. In 1795 she showed a *Spartan Woman Giving a Sword to Her Son*; in 1806, *Sappho Singing a Hymn to Love*; in 1808, *Cain Fleeing with His Family after the Death of Abel*; and in 1810, *Tirzah, Wife of Abel, Crying on the Tomb of Her Spouse and Imploring Mercy*. Most interesting

of all, because of its high quality and because it reveals the artist's sympathies with and possible participation in the French revolution—sympathies rarely embodied in the surviving work of women artists—is Vallain's *Liberty* of 1793–94, now undergoing restoration in the Louvre. This painting, seized after the closing of the Jacobin Club on 9 Thermidor, 1794,[12] represents an allegorical figure of Liberty dressed in a blue tunic and dark yellow skirt over a red-trimmed white undergarment, holding a red Phrygian cap on a pike in her left hand, the Declaration of the Rights of Man in her right. On the ground at her feet are a symbolic fallen crown and chains as well as the fasces, ancient emblem of authority. The commemorative function of the painting is suggested by an urn to the left, inscribed, "To our brothers who died for her..." as well as by the pyramidal cenotaph that looms behind the seated figure. Vallain's work may well be compared favorably with other revolutionary depictions of the figure of Liberty, such as the one in Jean-Baptiste Regnault's *Liberty or Death*, which appeared in the Salon of 1795.[13] Certainly the ambition and scope of her oeuvre and the high quality of the few known works by her hand make Vallain far more than a minor genre specialist or a painter of "women's subjects" in the derogatory sense of the term.

Other women, mainly David's pupils or followers, turned their hands to historical, classical, or allegorical subjects at the beginning of the 19th century. Sophie Guillemard (1780–?), a student of Regnault's, exhibited an *Alcibiades and Glycerion* in the Salon of 1802 and a *Joseph and Potiphar's Wife* a year later. Even more ambitious was Angélique Mongez (1775/76–1855), a pupil of David's and Regnault's, who won a first-class gold medal in the Salon of 1804. She painted a *Ulysses Finding Young Astyanax at Hector's Grave*, with life-size figures in the classical style of David, as well as a large-scale *Alexander Weeping at the Death of the Wife of Darius*. In 1806 she showed a *Theseus and Pirithous Cleansing the Earth of Brigands*, a painting with symbolic overtones, and in the 1808 Salon exhibited a complex allegory featuring Orpheus and Euridice with thirteen life-size figures. Still other classical subjects shown by this "art-amazon" were *The Death of Adonis* (1810); *Perseus and Andromeda* (1812); and, in 1814, a much-admired *Mars and Venus*, now in the Musée d'Angers. Mme. Mongez, whose later years were spent in poverty, had a mixed press: although some critics admired her work, others felt that her colors were cold and her style somewhat too obviously dependent on David's.[14] Yet while these criticisms may indeed have been well taken, one suspects that beneath the specific cavils lurks a more inclusive one: condemnation of a woman artist for hubris, for reaching beyond her "natural" sphere and "limited" ability. This is overtly stated by "Le Pausanius Français" in 1805, á propos of Mongez' *Theseus and Pirithous*: "Long ago, someone said: nobody has ever heard of a woman who succeeded in writing a tragedy or in painting a great history painting. Mme. Mongez will at least have the honor of having made the attempt...and it may be said of her: ...*Magnis lamen excidet ausis* [She was overcome by the grandeur of the task].... When you follow the footsteps of men in an art like painting, and above all, those of the history painter, where one must rise

above all the petty details which can disturb talent and destroy the work, either you must abandon these great subjects to our sex, or content yourself with sweet, tender subjects, or finally, paint portraits and landscapes."[15]

In a similar way, Mme. Haudebourt-Lescot was tactfully admonished by Landon when she attempted a canvas of unusually large scale, *François Premier and Diane de Poitiers* of 1819, a work that was 6 feet by 3 feet 6 inches. "We believe," declared this critic, "that this [weakness] is not the fault of the painter, whose talent cannot be doubted, but that of the proportions that she has adopted, the use of which demands a more serious and profound command of the brush than that which she has effected up to this time.... It is thus to small easel paintings, to charming but popular subjects that Mlle. Lescot should continue to devote her exclusive attention...."[16] Another woman artist, Mme. Benoist, evidently abandoned history painting completely in 1795 after having received adverse criticism, although she continued to draw antique subjects in her sketchbooks.

Still another woman who turned to history painting as well as to the more usual portraits and sentimental subjects was Pauline Auzou.[17] She showed a *Daphnis and Phyllis* in the Salon of 1795 and *Dinomache, Mother of Alcibiades* in 1796. Yet Auzou is interesting from another standpoint as well: like many other artists of her time, some of them women, she was an active participant in what one might call the great Napoleonic pictorial propaganda machine, an enterprise in which Mesdames Godefroid, Benoist, and Chaudet were also involved, as the official portraits of Napoleonic women and children in the Empire galleries at Versailles testify. Indeed, Mme. Benoist was one of the artists (whose ranks included Antoine Gros, François Gérard, Charles Thévenin, and Pierre Prud'hon) who received an annual stipend of from 2,000 to 4,000 francs from the Napoleonic government.[18] Auzou, however, played a major role in a particularly delicate Napoleonic propaganda campaign: the justification of the emperor's marriage to Marie Louise of Austria and, necessarily, of his controversial divorce from Josephine and alliance with France's former enemy. Many artists were summoned to this task. After the final defeat of Austria at Austerlitz, when Napoleon was already planning to marry the Hapsburg princess, Baron Gros was asked to paint the meeting and implied reconciliation of the two emperors on the battlefield. Shortly after, the same artist was commissioned to create a historical precedent for the Austro-French reconciliation by depicting the Holy Roman Emperor Charles V being cordially welcomed by François I at St. Denis (Paris, Louvre).[19] The talents of Marie Louise, the eighteen-year-old pawn in Napoleon's political maneuvers, were celebrated by Alexandre Menjaud in his *Empress Marie Louise Painting the Emperor's Portrait* (Versailles, Musées Nationaux) in the Salon of 1810.[20] This despite the fact that, in the words of one unfriendly historian, "up to the time of her marriage, Marie Louise possessed but one social talent on which she prided herself not a little—the power of moving her ears without stirring a muscle of her face."[21] The elaborate wedding ceremony of the royal pair in the chapel of the Louvre

WOMEN ARTISTS AFTER THE FRENCH REVOLUTION

was recorded by David's pupil and assistant, Georges Rouget. The ultimate political purpose of the marriage—the production of an imperial son and heir, the little King of Rome—was duly glorified by both Rouget and Menjaud, as well as by Baron Gérard in his splendid *Marie Louise and the King of Rome* (Versailles, Musées Nationaux).

But it was Pauline Auzou, in her first attempt at painting contemporary history, who made two of the most original contributions to the iconography of Marie Louise and the Austrian marriage in a pair of works now in Versailles: *The Arrival of the Archduchess Marie Louise in the Gallery of the Château de Compiégne, 28 March 1810*, from the Salon of 1810, and *Marie Louise, at the Time of Her Departure from Vienna, Distributing Her Mother's Diamonds to Her Brothers and Sisters, March, 1810*, from the Salon of 1812. In an effective and quite appropriate way Auzou has muted the pompous rhetoric of history painting with the intimacy of sentimental genre, especially in the farewell scene, in which that *topos* of feminine virtue, the giving up of jewels, is called into play to celebrate the generosity and family feeling of the young empress-to-be. Although the *Arrival of Marie Louise* is dignified by symbolic bas-reliefs in the background, the work retains a good deal of the freshness and naïveté of Auzou's sentimental scenes: the new empress, who had only met her husband a few hours before (they had been married by proxy in Vienna), is greeted by an excited band of charming white-clad maidens bearing flowers and wreaths. Despite the obvious differences in style, scale, and ambition between Auzou's *Arrival of Marie Louise* and a grandiose work like Rubens' *Arrival of Marie de Medici at Marseilles*—the comparative modesty, restraint, awkwardness, and lack of

Pauline Auzou, *The Arrival of the Archduchess Marie Louise in the Gallery of the Château de Compiégne, 28 March 1810*, 1810. Oil on canvas, 45⅛ × 60¼ in. (114.5 × 153 cm)

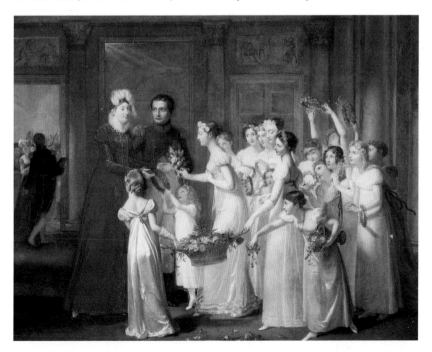

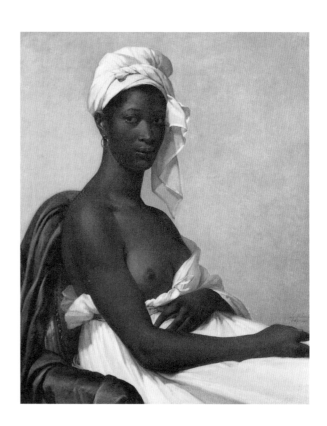

Marie Guillemine Benoist,
Portrait of a Negress,
1799–1800. Oil on canvas,
31⅞ × 25⅝ in. (81 × 65 cm)

plastic exuberance of the Auzou work in comparison with the Rubens are obvious—it is nevertheless interesting to find a woman artist, like the 17th-century master, participating in that public, ceremonial celebration of the deeds of rulers or the construction of a suitable iconography for the non-events in the lives of the politically prominent, which has been one of the important functions of artists over the centuries.

Yet the relative prominence of women artists in the revolutionary and Napoleonic art world should not blind us to the obstacles that often stood in their way. These difficulties were not merely the obvious ones of second-rate training or patronizing criticism that attempted to keep females in their "proper" place by discouraging ambition and praising minor accomplishment. Women artists of the period, like their counterparts before and since, were also impeded in the conduct of their professional lives by the more general social restrictions that hedged in well-brought-up women. The case of Mme. Benoist is revealing. A distinguished pupil of both Vigée Le Brun's and David's, Mme. Benoist (née Leroulx de la Ville) is perhaps best known for her compelling *Portrait of a Negress*, which made her reputation when it appeared in the Salon of 1800. This work, which may well be considered a black equivalent of David's portrait of Mme. Trudaine (*c.* 1791, Paris, Louvre), may have been intended as a pictorial manifesto of the 1794 decree abolishing slavery, similar in effect to Girodet's *Portrait of the Deputy Belley* (Château de Versailles) of 1797, in which a distinguished black sitter is also brilliantly represented.[22]

Despite Mme. Benoist's successes and her evident devotion to her profession; despite her reception of a gold medal in 1804 and the numerous commissions she had received from Napoleon; and despite the fact that she had been granted a yearly stipend by the government, at the very peak of her career she was deprived of the opportunity to exhibit in the Salons—a requisite of artistic viability at the time—because of the strictures of feminine propriety. When, after the fall of Napoleon, her husband, Pierre-Vincent Benoist, received the high post of Conseiller d'Etat in the Restoration government, the price was the sacrifice of his wife's career. His position as a high government official required that his wife withdraw from all further public exhibitions of her work. The letter that Mme. Benoist wrote to her husband in reply to his demand is a cry from the heart, and one that was to be repeated—or repressed—by many women artists in years to come when asked to give up their life's work for the sake of their husbands' careers. After asking her husband to forgive her for "sulking and complaining" Mme. Benoist continues: "Don't be angry with me if at first my heart bled at the course I was forced to take—and ultimately, to satisfy a prejudice of society to which one must, after all, submit. But so much study, so many efforts, a life of hard work, and after that long time of testing—successes; and then to see them almost an object of humiliation—I could not bear that idea. All right, don't let's talk about it any more; I am reasonable… my self-respect was wounded too brusquely. Let's not talk about it any more or the wound will open up once more."[23]

France was not the only country in which women artists could receive official recognition at the beginning of the 19th century. The small courts and cities of Germany offered them what was perhaps greater security if less wide-reaching reputation. Barbara Krafft (1764–1825), whose father had been a pupil of Anton Raphael Mengs and who herself became a member of the Vienna Academy, painted for the church in Prague and won local fame as a portraitist in Salzburg; she eventually became the Painter to the City of Bamberg, where she had moved in 1812.[24] Of greater interest is the career of Marie Ellenrieder (1791–1863), certainly the foremost woman painter of Germany in the early 19th century. Born in Constance, Ellenrieder was granted admission to the Munich Academy through the intervention of a sympathetic bishop and studied there, mainly with Peter von Langer, from 1813 to 1816. While a student, she became interested in old German art, then a source of inspiration for many of her most progressive contemporaries. From 1822 to 1824 she worked in Rome, where she became closely associated with Overbeck and the Nazarenes, Germanic forerunners of the Pre-Raphaelite movement engaged in recapturing the formal purity and moral innocence characteristic of Italian art before the High Renaissance. After completing a *Stoning of St. Stephen* for the high altar of the Church of St. Stephen in Karlsruhe, she was named Bavarian court painter in 1829. Her patron, Grand Duchess Sophie of Baden, gave her numerous commissions for portraits and religious works, of which the most appealing for contemporary viewers are perhaps the least ambitious: the sensitive *Self-Portrait*

of 1818, the unabashedly sentimental *Young Girl Picking Flowers* of 1841, both in the Karlsruhe Staatliche Kunsthalle, where many of her works survive. Yet Ellenrieder's religious paintings are certainly not without charm, and her drawings—fresh, direct, both literal and idealized at the same time—certainly deserve consideration as valid works of art in the Nazarene tradition.

The case of Ellenrieder raises an interesting issue associated with women artists, although not irrelevant to many male artists as well: the extent to which women artists must be "discovered" by contemporary art historians. Why do women artists so often seem inaccessible? Obviously that question is closely related to the larger issue of provinciality and to the fact that some artists, many of them women, preferred, or were confined to, local success and reputation rather than activity in the artistic centers of their times. Ellenrieder is an interesting case of the painter who is both "known" and "unknown" at the same time: known, that is, to art lovers in Karlsruhe[25] and in Constance, where she returned in the 1840s, yet virtually unknown elsewhere.

The nineteenth century: England, France, and the United States

It cannot be denied that to the average young woman, the study of drawing is a detrimental one. Art is a severe taskmistress, and demands unceasing sedentary toil, giving but grudging rewards in return for drudgery.

ELLEN C CLAYTON, 1876

In England, women artists participated in imposing, and increasing, numbers in the public exhibitions of the 19th century, despite the fact that they were denied membership of the Royal Academy and often had an extremely difficult time getting serious instruction. "In those days," reported a distinguished woman artist of the period, Eliza Bridell-Fox, referring to her student days in the middle of the century, "no advantages whatever were offered in the Government schools to those female artists who desired to attain proficiency in any branch of art, except decorative art. No models were then allowed, no draperies or other accessories. The 'Figure Class' as it was pompously, if ironically, designated, was 'instructed' in one small room, containing a few casts from the antique, the instruction being imparted during one daily visit from the lady superintendent."[26] According to this source, the only decent academy open to women in the early part of the century was Sass's School, about which little is known. In the middle of the century, Bridell-Fox took the unprecedented step of starting an evening class, with an undraped female model, for other women artists, "The class excited intense interest, with different opinions, among lady artists and girl students," declares Ellen C Clayton, author of the major study of English women artists of the 19th century. "Perhaps," she continues, "there is no more vexed subject, or one more difficult of satisfactory solution, than this matter of drawing from the life by ladies studying figure

painting."[27] Certainly the lack of adequate opportunity to draw from the nude model presented a grave obstacle to serious women art students during a period when the most esteemed genres of art depended to a large extent on the ability to depict the human body convincingly.

It was at least partly for this reason that, by 1859, women art students started to storm the very citadel of academic art instruction, the Royal Academy. Although young women by this time had their own "Government School of Art for Females" in Gower Street, they nevertheless sought access to the superior prestige and far more serious instruction offered by the Royal Academy. In April 1859 a memorial was forwarded to each member of the Royal Academy by thirty-eight professional women artists, soliciting their influence "to obtain for women a share in the advantage of the study from the Antique and from Nature, under the direction of qualified teachers, afforded by the Schools of the Royal Academy. But," as William Sandby, the mid-19th-century historian of the Royal Academy, points out, "as this request would necessarily have involved a separate Life School, the Royal Academy could not entertain the proposal in the space to which their schools are at present confined."[28] By 1862, however, five female students were permitted to study in the Antique Schools, following the accidental admission of one of Eliza Bridell-Fox's students, Laura Herford, who had submitted her work identified by her initials alone. Apparently there had never been any specific ruling prohibiting women's entry into the Schools; it was simply, according to Sandby, that none had ever applied before.[29]

Nevertheless, it was slow going for women students, and their admission was marked by considerable ambivalence. By the end of 1863 or the beginning of 1864, a group of female art students from the South Kensington and other art schools was again protesting the Royal Academy's exclusionary policies. They sent a printed memorial to the members petitioning for the right to compete at the Royal Academy examinations, which had been open to women for some years past and then closed to them in June 1863. The text of this boldly phrased memorial makes it clear that the underlying issues were economic even more than esthetic; at stake was women's right to prepare themselves for self-supporting careers on the same basis as men:

"...The current opinion and feeling of late years, on the part of the educated public, has been strongly in favor of the introduction of women to such callings and pursuits as are, or seem to be, suitable to their sex, capacities and tastes, although the same may have been previously for the most part, or altogether, monopolized by men.... One channel which in modern times [has] been opened for the enterprise of women, is the pursuit of the Arts of Sculpture and Painting, and...many women have availed themselves of that opening and are at present earning their livelihood as artists, and many other young women are preparing themselves by study and practice to follow their example.... It is well known that the schools of the Royal Academy are of a much higher standard than the other art schools of the kingdom, and are in every way more suitable

for advanced students; they are also the only free art schools in this country which is a consideration of moment to some of your memorialists.... Your memorialists therefore pray that liberty may be restored to female students to compete for admission into the schools of the Royal Academy, upon the same terms and conditions, in all respects, as are granted to, or imposed upon, male students."[30]

Despite this heartfelt and eminently reasonable plea, by 1868 only thirteen women were matriculated, although there had been numerous applications; in 1876, there were ninety-two, and in 1879, 130. As late as the 1880s, discriminatory rules were still in effect. In 1881 it was resolved "that the Male and Female Students work in different Painting Schools,"[31] and in 1888 the rules stated that at the end of Probation, that is, at the end of the second term, the male student was obliged to submit a painting of an entire figure from life, whereas a female student was required to submit a head only. Victorian prudery continued to hedge in women students at the Royal Academy until the end of the century. In 1891, although both men and women were working from live models, women in the School of Painting had to work from the "Draped Living Model" while men worked from the "Nude Living Model." In 1893, after constant petitioning, women students finally were allowed a nude male model—almost nude, that is, for precautions were carefully stipulated in the decision to grant this request: "It shall be optional for Visitors in the Painting School to set the male model undraped, except about the loins, to the class of Female Students," states the relevant passage from the Royal Academy Annual Report of 1894. "The drapery to be worn by the model to consist of ordinary bathing drawers, and a cloth of light material 9 feet long by 3 feet wide, which shall be wound round the loins over the drawers, passed between the legs and tucked in over the waistband; and finally a thin leather strap shall be fastened round the loins in order to insure that the cloth keep its place."[32] Not until 1903 were mixed classes instituted, and even then a separate class of life drawing for females was maintained. And of course, it must be added, the final achievement of equality in art school did little to alleviate the continuing social pressures—the demands of marriage, family, and domesticity—militating against women's achievement in the realm of art. To get a sense of this ultimate impediment one has only to read the reminiscences of Augustus John—hardly a notable feminist despite his great admiration for his sister, Gwen—about the Slade School in the early 20th century: "...In what I have called the Grand Epoch of the Slade," says John, "the male students cut a poor figure; in fact they can hardly be said to have existed. In talent, as well as in looks, the girls were supreme. But these advantages for the most part came to nought under the burdens of domesticity which...could be for some almost too heavy to bear."[33]

The situation of women in relation to the Royal Academy has been investigated in detail here because it is paradigmatic, with minor variations, of situations obtaining elsewhere during the same period. The United States, or at least the Pennsylvania Academy, was relatively progressive in this respect, despite the various difficulties

women students experienced in gaining access to the nude model. By 1868 the Academy had established a Ladies' Life Class with a female model, a class charmingly depicted by Alice Barber Stephens ten years later in what is perhaps the earliest representation of women artists working from the nude.[34] Nevertheless, it had taken women art students years to achieve this relative equality, and male models were evidently not in regular use until 1877. As late as 1882, and even after, the board of directors of the Academy still received irate letters from those upholders of decency who were horrified that the students' "feelings of maidenly delicacy" were violated by contact with the "persons of degraded women and the sight of nude males in the stifling heat of the Life Class."[35] And of course, according to legend, it was because Thomas Eakins removed the loincloth from a male model in the Ladies' Life Class that he was asked to resign from his position as professor at the Academy.[36]

Nineteenth-century French paintings of women's art classes[37] are invariably striking for the absence of what is always the focus of attention in the conventional art school scene of male art students: the nude model. In Paris the only serious class offered to women was at Julien's studio, and according to Marie Bashkirtseff, nude male models were evidently available to women students there by 1877—whether with or without drapery is not specified. Nevertheless, she complained in her journal that the quality of instruction in the women's class was not as high as in Julien's men's class on the floor below, and nowhere near as thorough as that offered by the École des Beaux-Arts, from which women were completely excluded.[38]

Yet, to return to the situation in 19th-century England, the difficulties women artists had in receiving adequate training did not by any means discourage them from participating in the exhibitions of the period. Although their names appear in exhibition records far less frequently than those of their male colleagues, it is nevertheless true that thousands and thousands of women showed their works publicly, many of them participating in the highly esteemed annual exhibitions of the Royal Academy. There are no accurate statistics on the number of women artists represented in the Royal Academy shows of the 19th century, but the alphabetical record of Royal Academy exhibitors compiled by Algernon Graves suggests how many there were.[39] Under the letter A we find (including Honorary Exhibitors but excluding miniaturists) at least fifty-nine women painters listed, and under the letter C at least 215. Granted that some of these women exhibitors showed only one or two flower paintings and that few women equaled the astounding productivity of their more prolific male contemporaries, it is nevertheless true that women artists were very much in evidence at the Royal Academy shows as well as in other, somewhat less important British exhibitions of the time.[40] Many of these women were solid professionals from every standpoint: Mrs. Sophie Anderson, who contributed steadily and substantially to the Royal Academy shows from 1855 to 1896, making her debut with a *Virgin and Child*, contributing a scene of torture in 1876 and a classical *"Evoe, evoe Bacche!"* in 1883; Emily Osborn, who submitted forty-three serious

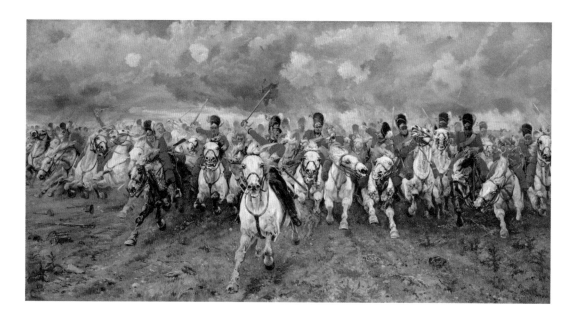

Lady Elizabeth Butler, *Scotland for Ever*, 1881.
Oil on canvas, 40 × 76½ in. (101.6 × 194.3 cm)

contributions between 1851 and 1884; and Elizabeth Thompson, later Lady Elizabeth Butler, who was widely acclaimed for her ambitious and accurate military paintings, of which she showed twenty-two between 1873 and 1903, as well as many more in the 20th century.

Lady Butler was one of those striking anomalies among 19th-century women artists, a woman for whom being female was in many ways an advantage. Like Rosa Bonheur, with whom she was sometimes compared, Lady Butler was astonishing. A woman battle-painter, like a woman animal-painter on the heroic scale, was something out of the ordinary, and the ferocious energy, the "masculine" forcefulness, and the manifest accuracy of their works not only stilled the usual patronizing criticism of women's art, but actually made some die-hard critics—even those as opinionated as John Ruskin— eat their words. "I never approached a picture with more iniquitous prejudice against it than I did Miss Thompson's," admitted Ruskin at the beginning of his panegyric of the artist's *Quatre Bras* of 1875, "partly because I have always said that no woman could paint; and secondly, because I thought what the public made such a fuss about *must* be good for nothing." In the end, the former doubter outdid himself in admiration, maintaining that the righthand corner of the canvas, "where the cuirassier is catching round the neck of the horse as he falls...is wrought, through all the truth of its frantic passion, with gradations of color and shade which I have not seen the like of since Turner's death."[41] In many ways, the intrepid Lady Butler's approach to her work—like that of many of her popular male contemporaries—may remind us more of Cecil B De Mille than of Cézanne. Like the filmmaker, she deployed casts of—if not

106

thousands—at least hundreds of figures. And since higher truth was equated with material veracity, she, like De Mille, spared no pains to achieve accuracy of detail: cloth was specially woven and costumes recreated; rye fields were purchased and trampled down (this for *Quatre Bras*, where the encounter depicted had taken place "in a field of particularly tall rye," according to Siborne's *Waterloo Campaign*); horses were made to fall down not once but many times; regiments were sent into action; cannons were fired. Butler's apparently boundless self-assurance, her easy assumption of authority, her unfailing energy, and her passion to control everything down to the smallest detail may remind us of similar qualities in another Victorian superwoman of similar upper-middle-class background: Florence Nightingale. And certainly her privileged background, like Florence Nightingale's, helped her to achieve her chosen goal. Lady Butler's mother had been a noted pianist and a talented painter whose watercolors had captured the attention of a younger Ruskin. Her father, Thomas James Thompson, was a connoisseur, a man of exceptional culture, extraordinary sensitivity, and, of course, an adequate private income. He was firmly committed to women's self-development and devoted much of his life to the education of his two unusual daughters. Lady Butler's sister was the distinguished writer and critic Alice Meynell, a feminist, socialist, and Catholic who wrote discerningly about Mary Wollstonecraft in the *Spectator* as early as 1879, admired Jane Austen, disliked the notion of "feminine style," and contributed to the *Catholic Suffragist*.[42]

It is perhaps the more modest, more intimate works of the Victorian period, like those by Emily Osborn or Edith Hayllar, that excite greater sympathy today than Lady Butler's battle pieces, both for their esthetic quality and for the insights they afford into the actual experience of women at the time. Equally important, a re-examination of the relatively modest domestic scenes by women artists in the 19th century, particularly those painted in England, may lead us to question some of the often unstated assumptions underlying art historical judgments. In confronting a work as complex and interesting as Osborn's *Nameless and Friendless* of 1857 [p. 60], one might well ask why the iconography of 15th- or 16th-century religious or allegorical art is explicated with such care and subtlety by scholars, while that of 19th-century genre painting— often equally intricate and challenging—is so often dismissed as merely "literary" or "sentimental," irrelevant to the major, generally formal, issues raised by the art of the period. Osborn's *Nameless and Friendless* is one of the rare 19th-century paintings to deal directly with the lot of the woman artist.[43] Osborn was keenly aware of the economic dimensions of this problem, so often stressed in women's demands for more adequate academic training. For the Royal Academy Exhibition of 1857 she subtitled her work with a verse from Proverbs (10:15): "The rich man's wealth is his strong city, The poverty of the poor is their ruin."

Nameless and Friendless is a fine example of English narrative painting, a mode of expression that Hogarth had made popular in the 18th century and that continued to

flourish during the 19th. The whole point of narrative painting is to tell a story—generally a story with a moral and with clear psychological overtones—within a realistically detailed setting that underscores the implications of the theme as it establishes the social position of the characters. The pictorial elements available to the narrative painter—line, shape, color—are, of course, the same ones available to the staunchest advocate of pure painting; it is just that for the narrative painter, like Emily Osborn, these elements are viewed as means rather than as ends in themselves.

A painting like *Nameless and Friendless* was meant to be "read" rather than merely looked at, to arouse moral feeling rather than simple appreciation of its visual qualities. Indeed, it may remind us of an episode—visually condensed—from a 19th-century novel, which English women above all others excelled at writing. Such a work necessarily employs some of the strategies of literature, or of the theater, or of the sociological study. And, in its emphasis on significant details and meaningful gestures, and in its focus on the "dramatic" moment, it foreshadows similar elements in early films. The heroine occupies the center of the stage, emphasized by the sharp vertical of the shop window and the pallor of the prints behind her, as well as by the light falling on her face and hands. The pathos of her situation—social, financial, professional, and sexual—is clearly established by both the larger elements of the composition and the smaller details of her surroundings. That she is an unmarried orphan is indicated by her black dress and ringless left hand; that she is poor, by her worn-out clothes, unfashionable shawl, and shabby dripping umbrella; that her social position is low is brought out by the eloquent emptiness of the chair against which the umbrella is propped: had she been a wealthy lady client rather than a nameless and friendless woman painter, she would naturally have been sitting down rather than standing up. With downcast eyes and fingers twisting the string from her packet, she awaits the verdict of the dealer, whose skeptical gesture is tellingly contrasted with her nervous one. At the same time, the skepticism or indifference of the dealer and his assistants is contrasted with the insolent, obviously sexual interest aroused in the two wealthy clients to the left, who, in the arrogant nonchalance of their poses and the flashy elegance of their dress, offer a contrast both to the genteel poverty and modest demeanor of the girl and to the more "commercial" appearance and bearing of the shop personnel.[44]

Distinctions of class, wealth, and sex—perhaps the last above all—are thus clearly indicated through the imagery of Osborn's painting. It is certainly significant—or would have been to the mid-19th-century viewer—that the two connoisseurs ogling the vulnerable heroine are looking up from a print of a scantily clad dancing girl: obviously their interest in art, like their attention to the young artist, is motivated more by prurience than esthetic concern. And while the rainy weather is, perhaps, simply a realistic depiction of English climate, it also helps to suggest the hard life that an unprotected young woman must endure in the city. How different from the mood of Edith Hayllar's *A Summer Shower*, in which the rain only emphasizes the cosiness of the home that

shelters the players. Implicit in both of these works is the conventional 19th-century view of the young lady; a creature safe only in the protected environment of home and family, a being immensely vulnerable once she ventures into the jungle-world of commerce. Although women artists may indeed have been a fact of life in the 19th century—and there was simply no way that their presence could be ignored—they were nevertheless to be kept in their place. Both the general rules governing the conduct of women and the critics saw to that, even in the somewhat more relaxed climate of France. During the Second Empire, even quite liberal thinkers like Jules Simon—in his socially progressive study, *The Working Woman*, published in 1861—condemned women to merely reproductive and repetitive tasks in design and industry, because of their obvious incapacity for any work demanding initiative or imagination.[45] In the same vein, Léon Legrange, in an important article published in the *Gazette des beaux-arts* in 1860, condescendingly delegates to women pastels, porcelains, miniatures, and flower painting: "What more delicate hand could decorate the fragile porcelains with which we love to surround ourselves? Who else could so well reproduce on an ivory cameo, and with a more exquisite feeling of natural tenderness, the features of a beloved child?" demands this author. "And who else but women would have the careful patience to hand-color botanical plates, pious images, and prints of all kinds?" he continues.

Separate but unequal is the leitmotif often repeated in such discussions of the woman artist's accomplishments: "Male genius has nothing to fear from female taste," declares Legrange. "Let men conceive of great architectural projects, monumental sculpture, and the most elevated forms of painting, as well as those forms of the graphic arts which demand a lofty and ideal conception of art. In a word, let men busy themselves with all that has to do with great art. Let women occupy themselves with those types of art which they have always preferred, such as pastels, portraits, and miniatures. Or the painting of flowers.... To women, above all, falls the practice of the graphic arts, those painstaking arts which correspond so well to the role of abnegation and devotion which the honest woman happily fills here on earth, and which is her religion."[46] Julie Victoire Daubié, a French feminist and the first woman to present herself for the baccalaureate examination, protested vigorously against this sort of hypocritical rationalization of injustice. In her remarkable study, *La Femme pauvre au XIXe siècle* (The Poor Woman in the 19th Century) of 1866, she demanded complete equality in the education of women artists, including access to the École des Beaux-Arts and even to the competition for the Prix de Rome. Like her English contemporaries she based her argument on sheer economic reality: the fact that women artists, granted inferior compensation because of their limited access to education and competition, were thereby denied a living wage.[47]

But bold statements like Daubié's were generally ignored. By the 1970s and 80s, women art students from all nations were flocking to Paris in search of instruction in private studios, most notably the one run by the former prizefighter M Julien (or Julian, as it is often spelled), where they could work from models and receive criticism from

such eminent academic artists as Tony Robert-Fleury or the somewhat more "advanced" Jules Bastien-Lepage. Yet they were still hemmed in by the restrictions governing feminine behavior. Cecilia Beaux's cousin suggested that Cecilia would be "quite *déclassé* if she accepted the invitation of an American friend to escort her to the Salon";[48] and the rebellious Marie Bashkirtseff repeatedly deplored the lack of freedom and opportunity that, she felt, had invidious effects upon her—and all women's—art. "I wrote to Colignon [E Collignon (1822–1890), a minor artist?] that I wished I were a man," she records in the pages of her journal; "I know that I should become somebody; but with skirts—what can one do? Marriage is the only career for women; man has thirty-six chances, woman has but one, the zero like the Bank. But the Bank gains in any case; we pretend that it is the same with woman; but that is not true."[49] At another time she complains that the men students at Julien's class have three artists to criticize their work while the women have only one;[50] later she angrily inveighs against her lack of opportunity as a woman: "...We went to the École des Beaux-Arts. It is enough to make one cry with rage. Why can not I go and study there? Where can I get instructions as complete as there?"[51]

The strictures placed on the freedom of women artists, as well as the overt denial to them of the professional opportunities, rewards, and institutional legitimization offered to their male colleagues, can only be understood in the broader context of women's position during the 19th century. To the preservers of the status quo, women's demands for professional equality were often equated with wider assaults on the social framework, with atheism, anarchism, socialism, and free love. Not only were professional women seen as threatening competitors, but their very existence was viewed as inimical to the sanctity of the family, to woman's "God-given" or "natural" destiny as wife, mother, and guardian of the home. The constant references to the woman artist's inborn delicacy and refinement of feeling, the repeated attempts to protect her from exposure to nudity or the hazards of "coarsening" competition, and the establishment of specific restrictions to prevent fully qualified women from being accepted into the most prestigious professional organizations—all of these were responses to what were felt to be very real threats to the status, power, and, not least, the convenience of the men who controlled the various "Establishments." Nor was hostility to women's self-development or professional achievement by any means confined to the ranks of the politically conservative, as a glance at Daumier's lithograph series *The Blue-Stockings* of 1844 or his *Socialist Women* of 1849 will reveal. Seen in this light, the constant solicitude for women's weakness, their sexual purity, their social vulnerability, can be understood as a lightly veiled threat, a way of keeping them in their place by "protecting" them from serious achievement—and independence.

The result of such discriminatory attitudes—whether veiled or overt—was often achievement at a level of competent mediocrity by those women artists tenacious enough to pursue professional careers. The names of Louise Breslau (1858?–1928),

Louise Abbéma (1858–1927), and Virginie Demont-Breton (1859–1935), once quite well known, have sunken into oblivion. While one can certainly blame changes in taste for this current neglect, a neglect that until recently obscured even the career of the extraordinarily successful Rosa Bonheur (and of course, those of many of these women's male contemporaries), it must be admitted that women artists were rarely—with the notable exceptions of Berthe Morisot and Mary Cassatt—among the most daring or innovative painters of the period. Simply being persistent enough to devote a lifetime of effort to being a serious artist was a considerable accomplishment for a 19th-century woman, when marriage and its concomitant domestic duties so often meant the end of even the most promising careers.

Perhaps better than any statistical or sociological study, two novels, one English and one American, cast light on the situation of the woman artist in the 19th century. They are interesting not merely for what their authors consciously recount, but for the

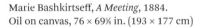

Marie Bashkirtseff, *A Meeting*, 1884.
Oil on canvas, 76 × 69⅝ in. (193 × 177 cm)

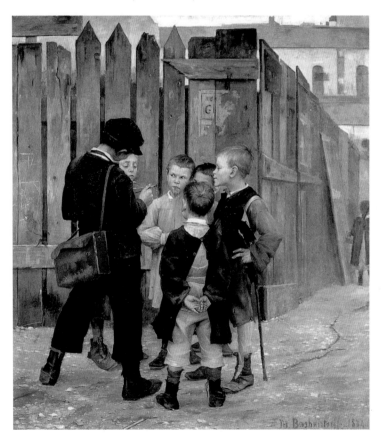

unconscious attitudes—the ideological assumptions—they unwittingly reveal. In the more conventional of the two—*Olive*, by Dinah Maria Craik—the fact that the young painter-heroine lives alone, strives for fame and independence, and actually supports herself through the sale of her art is at least partially justified by the fact that she is crippled, and thus automatically considers herself ineligible for woman's "natural" destiny. Yet the book has a "happy" ending nevertheless—happy, that is, by 19th-century standards. In the end, to paraphrase Patricia Thomson's discussion of *Olive* in her provocative study, *The Victorian Heroine*, Mrs. Craik, having shot her bolts in the course of the novel, is content to let her heroine, whose ultimate greatness the reader has never doubted, sink gently into matrimony. "Of Olive," Thomson states, "Mrs. Craik comments imperturbably that her husband's influence is to deprive the Scottish Academy of 'no one knew how many grand pictures'."[52]

Elizabeth Stuart Phelps' *The Story of Avis*, published in 1877, is a darker, more unconventional vision. It chronicles the tragic life of a brilliant young woman artist, whose early promise is destroyed, as inevitably as that of any hero in Zola or Dreiser, by the interplay of biological and social forces.[53] Although the novel is often awkward, overwritten, and melodramatic, it nevertheless still has the power to move and convince. The message of *The Story of Avis* is that the life of the artist and that of the wife and mother are utterly incompatible; in short, that marriage destroys for women any possibility of creative achievement. Avis, a young woman of New England, has recently returned from brilliant successes in Paris, where she had been encouraged to pursue her calling by the great Couture himself. She is determined to dedicate her life to art—great art, this is—to become, in fact, a vestal virgin of painting. In a moment of exaltation, she envisions a mighty mural of feminine experience: "Instantly, the room seemed to become full of women. Cleopatra was there, and Godiva, Aphrodite and St. Elizabeth, Ariadne and Esther, Helen and Jeanne d'Arc, and the Magdalene, Sappho, and Cornelia—a motley company. These moved on solemnly, and gave way to a silent army of the unknown. They swept before her in file, in procession, in groups. They blushed at altars; they knelt in convents; they leered in the streets; they sang to their babes; they stooped and stitched in black attics; they trembled beneath summer moons; they starved in cellars; they fell by the blow of a man's hand; they sold their souls for bread; they dashed their lives out in swift streams; they wrung their hands in prayer. Each, in turn, these figures passed on, and vanished in an expanse of imperfectly defined color like a cloud, which for some moments she [Avis] found without form and void to her.... In the foreground the sphinx, the great sphinx, restored. The mutilated face patiently took on the forms and hues of life: the wide eyes met her own; the dumb lips parted; the solemn brow unbent. The riddle of ages whispered to her. The mystery of womanhood stood before her, and said, 'Speak for me'."[54] Alas for the mystery of womanhood, poor Avis is destined never to speak for it, nor for herself, through her art at all. Forced against her better judgment into a disastrous marriage with a weakling and failure, she is gradually weighed

down with the increasing demands of motherhood and housework and brutalized by economic hardship. After the tragic death of her ne'er-do-well husband, when she at last attempts to return to her art—a tired, middle-aged woman—she finds herself no longer capable of anything but the lowest hackwork: her powers have disappeared along with her youth.

Significantly, at the same time that *The Story of Avis* was being written, another young American woman artist was studying in Paris and sending her work to the Salon, but, unlike Avis, feeling increasingly dissatisfied with the conventional ideals of academic art. In the very year that Elizabeth Stuart Phelps' tragic novel was published, Mary Cassatt, whose work had been rejected for the Salon of 1877, was invited by Degas to join a group of "Indépendants." She quickly accepted his invitation, later confiding to her biographer: "At last I could work with absolute independence without considering the opinion of a jury. I had already recognized who were my true masters. I admired Manet, Courbet, and Degas. I hated conventional art—I began to live."[55] Certainly the most important woman artist of the 19th century, she is also worthy of consideration as the most significant American artist, male or female, of her generation. Capable of turning her hand to oils, pastels, murals, and, above all, to brilliant printmaking; dedicated to her work throughout a long and productive lifetime; independent in her art, though hardly unconventional in her personal behavior, Cassatt offers the happy example of a 19th-century woman artist who bypassed both competent mediocrity and the relatively rare popular notoriety of painters like Bonheur or Butler to reach genuine achievement. Unlike the heroines of *Olive* and *The Story of Avis*, she never married.

The 20th century: issues, problems, controversies

> If we must reject the empty fetishes of "The Eternal Feminine," or of "Feminine nature," we must nevertheless recognize the fact that there are women, and that the fact of being one puts one into a special situation.
>
> SYLVIE LE BON, 1975

In the face of the enormous range and variety of paintings by 20th-century women, it would indeed be futile, if not impossible, to talk of a "women's style" or a "feminine sensibility." There certainly seems to be no mysterious essence of femininity relating Liubov Popova's sharply abstract *Architectonic Painting* of 1917 to Florine Stettheimer's wittily decorative *Family Portrait II* of 1933, nor connecting Paula Modersohn-Becker's monumental *Mother and Child* of 1906 with the staccato audacities of Hannah Höch's *Cut with a Kitchen Knife* of 1920. And surely Gabriele Münter's *Man in an Armchair (Paul Klee)* of 1913 [p. 114], like her other works of this period, can be compared more profitably with those by other members of the Blue Rider group, male and female, than with

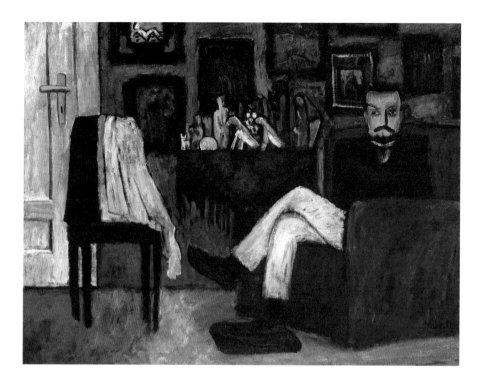

ABOVE
Gabriele Münter,
*Man in an Armchair
(Paul Klee)*, 1913.
Oil on canvas,
37⅜ × 49⅜ in.
(95 × 125.5 cm)

RIGHT
Frida Kahlo,
*Frieda and Diego
Rivera*, 1931. Oil on
canvas, 39⅜ × 31 in.
(100 × 78.7 cm)

those by contemporary yet stylistically disparate women artists like the French Marie Laurencin or the Canadian Emily Carr.

Yet to discard obviously mystificatory, essentialist theories about women's "natural" directions in art is by no means to affirm that the fact of being a woman is completely irrelevant to artistic creation. That would be tantamount to declaring that art exists in a vacuum instead of in the complex social, historical, psychological, and political matrix within which it is actually produced. The fact that a given artist happens to be a woman rather than a man counts for something: it is a more or less significant variable in the creation of a work of art, like being an American, being poor, or being born in 1900. Like any other variable, little can be predicted on its basis in isolation from the specific context in which it exists.

The artist's sense of the creative self as a woman—her concentration on what is generally considered woman's realm of experience, either because of social pressures or personal choice—may play a greater or a lesser role in women's work, depending on the circumstances. There have been women artists like Gwen John who deliberately restricted herself to a rather narrow range of female subjects, or like Frida Kahlo, who turned to herself and her own peculiarly feminine obsessions and dilemmas for subject matter. At times when the issues of women's rights, status, and identity have been critical—at present, for example, and in the late 19th and early 20th centuries—this sense of the creative self as a woman could play an important role, not merely in choices of subject matter, but in more subtle pictorial variations, as it seems to have done in the work of Paula Modersohn-Becker and Käthe Kollwitz. At other times the presence of allegedly "feminine" elements of form or content in the work of art is ambiguous, often, as in the case of Georgia O'Keeffe's flower paintings, hotly affirmed by both admiring and disparaging critics, and as hotly denied by the artist herself.[56] Given the complexity and richness of this field of investigation, it seems wise to restrict the present discussion to a few of the many issues raised by the work of women artists in the first half of the 20th century: the relation of women artists to the decorative arts; the question of national variation in relation to women's achievement; and the issue of "feminine" subject matter and style.

Women and the decorative arts

The feminine presence in the field of the decorative arts, more specifically, those related to textiles—weaving, embroidery, stitchery—is a time-honored one. Indeed, women have continued to make significant contributions in this area through the 19th and 20th centuries. For example, exhibits—rather conventional ones, to be sure—of lace, embroidery, tapestry, and needlework were prominent among the works illustrated in the official publication of *Art and Handicraft in the Woman's Building of the World's Columbian Exposition* in Chicago in 1893. Later, the leading weavers and tapestry makers

at the Bauhaus—Anni Albers, Ruth Consemüller, Gunta Stölzl, Otti Berger, Benita Koch-Otte—were women.[57] Nevertheless, this traditional relation, or perhaps relegation, of women to the decorative arts was complicated by a variety of social and economic as well as ideological factors at the turn of this century. One complicating factor was the ambiguous status and prestige accorded to the decorative arts themselves, especially in relation to the so-called high arts of painting and sculpture. Another was the complex relationship of the decorative arts to the evolution of abstract painting and the subsequent development of an abstruse mystique to differentiate the latter from the former. Still another factor was the social, political, and moral implications associated with the promotion of the handicrafts and with education in design, especially in Great Britain during the latter part of the 19th century.

Have women simply been shunted off into the so-called minor or decorative arts because these were considered less demanding and were certainly less prestigious? It is undeniable that English women were admitted to the Schools of Design, both the Branch Schools and their own Female School in London, long before they were admitted, in any significant numbers, to the teaching facilities of the Royal Academy. The ranks of these schools were swelled not merely by the working-class girls for whom this sort of training, aimed primarily at industrial design, was originally intended, but by vast crowds of impoverished young ladies who were in desperate straits trying to find employment in the arts, primarily as governesses.[58] Even earlier, in France, Mme. Frere de Montyon, a student of Restout's, had founded the École Gratuite de Dessin pour les Jeunes Personnes, a school established in 1805 to help penniless young women become self-supporting, an enterprise perhaps intended as much as an aid to public morals as to encourage artistic ability. The École Gratuite de Dessin was brought under government jurisdiction in 1810.[59]

The democratizing effort to extend knowledge of the applied arts to the lower classes—and to women—was carried further in subsequent attempts to break down completely the barriers between high art and the decorative arts. The attempt reached a climax in Great Britain during the late 19th century with the program of social transformation proposed by John Ruskin and, especially, by William Morris. Interestingly enough, women seem to have served little more than a purely inspirational function for Morris and his followers, although both Janey and May Morris produced embroidery for the cause of arts and crafts. Women in late 19th-century England certainly made contributions to porcelain painting, textiles, embroidery, and, often anonymously, to patchwork and other forms of stitchery, and of course Kate Greenaway was active as an illustrator and tile-designer, influencing Gauguin and many other painters. Nevertheless, women as a group were not prominent in the English Arts and Crafts Movement. In Scotland, however, two unusually gifted and productive sisters, Frances Macdonald (1874–1921) and Margaret Macdonald (1865–1933) made major contributions in design. Margaret later married the innovative architect and designer Charles

Rennie Mackintosh, and as members of his circle both sisters created imaginative curvilinear designs for architectural ornaments, metalwork, embroideries, and stained glass, as well as watercolors that often hover on the brink of abstraction.

Although the effort to overthrow the hegemony of "high art" by merging it with the "minor" arts, an effort that has characterized one current of vanguard ideology from Synthetism to Constructivism, is by no means a feminine invention, the extent to which the decorative arts, especially those involving textiles, have played a role in the careers of advanced women artists is striking. Yet even though their achievements in these realms are often brilliant, the fact that painters like Natalia Goncharova, Alexandra Exter, Liubov Popova, and Varvara Stepanova; Sophie Taeuber-Arp and Vanessa Bell; Marguerite Zorach and Sonia Delaunay were involved in textile design, weaving, tapestry making, and costume design nevertheless has equivocal implications. On the one hand, for a woman artist to "return," as it were, to her traditional role in the minor arts, generally less conducive to fame and fortune than a career in painting or sculpture, can be viewed as a retrograde step. Yet from another vantage point, we can say that advanced women artists involved in the decorative arts in the early 20th century were contributing to the most revolutionary directions—both social and esthetic—of their times.

Marguerite Zorach may indeed have turned from painting to embroidering tapestries after the birth of her second child, when she "no longer had the hours of uninterrupted concentration that she required to work out her personal views on canvas,"[60] and Sonia Delaunay may have moved from monumental Orphist canvases to fabric and dress design in order to support her husband and herself after the loss of her private income following the Russian revolution. Nevertheless it is also true that Zorach's needlework, in many ways more original and interesting than her paintings, received more exposure and critical attention than her canvases during the 1920s and 30s,[61] and that Delaunay had had considerable success in the applied arts before the loss of her income[62] and continued to make some of her most original contributions in this area throughout her career. Certainly the experiences of Sophie Taeuber-Arp and Vanessa Bell in the decorative arts exerted a progressive influence on their "high art" creations. Taeuber-Arp, who began as a textile specialist and taught weaving and embroidery at the Arts and Crafts School in Zurich, may well have influenced her husband, Jean Arp, in the direction of greater abstraction as a result of the embroidery and weaving they did together at the time of the First World War. Indeed, it was probably precisely because of her background in the decorative arts that Taeuber-Arp was one of the first artists to think of abstraction as a natural point of departure rather than the end of a long process of evolution from representation. Vanessa Bell's participation from 1913 to 1919 in Roger Fry's Omega Workshops, for which she designed screens, textiles, and mosaics, seems to have intensified her penchant for abstract colorism and bold surface treatment which had already been stimulated by contact with the Fauves and Cubists.

For many of the Russian avant-garde artists of the early 20th century, dedication to the applied arts constituted a revolutionary challenge to the whole mystificatory, reactionary ideology of traditional "high art." "Under pressure from the revolutionary conditions of contemporaneity, we reject the pure forms of art. We recognize self-sufficient easel art as being outmoded and our activity as mere painters as being useless.... We declare productional art to be absolute and Constructivism to be its only form of expression." Thus the group of avant-garde artists, including Alexandra Exter, Liubov Popova, and Varvara Stepanova, who met at the Moscow Institute of Artistic Culture in 1921, announced their entry into the world of industrial design—more specifically, in the case of the women artists, into that of innovative clothing and textile design.[63] Artists like Goncharova, Olga Rozanova, and Kseniya Boguslavskaya had made semi-abstract and Suprematist contributions to textile and dress design in the years preceding the Russian revolution,[64] and both Exter and Mukhinn had created more individualistic and elegant fashions and theater costumes in the early 1920s. But Popova and Stepanova, probably the first women artists to be employed as professional designers in the Russian textile industry, attempted even more boldly to adapt mass-produced clothing and fabrics to the new demands of a revolutionary society. Both worked on various kinds of "stereotype" garments: clothing designed to the specification of different jobs or situations—comfortable, functional, and devoid of unnecessary decoration. In so doing, they managed to bring about the extension of art into life that was the leitmotif of the revolutionary art theory of their times, creating fabrics and costumes that still look attractive and contemporary.

A similar impulse to break down the barriers between art and life motivated Russian-born Sonia Delaunay in the creation of her famous *robe simultanée* ("simultaneous dress") of 1914, her collaboration in innovative book-design with the poet Blaise Cendrars in the same year, her creation of avant-garde theater costumes in the early 1920s and of designs for commercially produced fabrics and dresses throughout the 1920s. During the same decade Delaunay also turned to furniture design and interior decoration, even having a Citroën automobile painted in colorful rectangles after one of her textile patterns to serve as an appropriate background for the Jacques Heim turnouts executed from her designs.[65] Among her more recent works is an important group of monumental, abstract tapestries.[66]

In attempting to evaluate women artists' contributions to the decorative arts, much depends on one's attitude toward the relative importance of the "high" versus the "applied" arts. If we consider painting the ultimate form of esthetic expression, then it will be a foregone conclusion that Sonia Delaunay made a sacrifice by neglecting her monumental abstract canvases to produce fabrics and fashions, while her husband, Robert Delaunay, was permitted to continue his calling as a painter and, perhaps even more important, as a theorist of abstract art. If, however, we take a less conventional view of what constitutes value in the avant-garde production of the 20th century, we can

see that women artists, by remaining faithful to their time-honored role as decorative artists, have advanced the cause of abstraction and, at the same time, spread its message beyond the walls of the studio, museum, and gallery into the realm of daily life—a goal devoutly sought by artists—whether "high" or "applied," male or female—from the time of Ruskin and Morris to the Russian revolution, the Bauhaus, and afterwards.

Women artists and the question of national origin

Why have women artists as a group seemingly flourished in certain national situations and not in others? What, for example, accounts for the appearance of a remarkable group of innovative women artists in Russia at the beginning of the 20th century or for the unusual number and productivity of women in the New Deal art programs of the United States?[67]

To study the case of the Russian women—Goncharova, Exter, Popova, Udaltsova, Rozanova, Stepanova, Serabriakova, and others—one must leave the realm of art history and turn to an investigation of the unusually important role played by women in the intelligentsia and the related radical political movements in 19th-century Russia. Among left-wing intellectuals of that period, women were generally accepted as complete equals by male colleagues or co-conspirators; among conservatives, women students were viewed as particularly pernicious enemies of the Establishment. With many ups and downs, it is true, determined Russian women pursued professional education in the second half of the 19th century, going abroad in relatively substantial numbers when prevented by a nervous and inconsistent bureaucracy from pursuing their studies at home. For example, in the summer term of 1873, there were ninety-six Russians among the 110 women students at Zurich University, mainly studying to be doctors.[68] Russian women students differed from Western European feminists in that they were almost completely integrated with the radical political movements of their time and were primarily motivated in their search for knowledge and power by a desire to serve the people. From the 1860s on, they began to fill not only universities but prisons and fortresses.[69]

The *kursistka*, or woman student, was a recognizable revolutionary type, in fact the very personification of radical activism, and was painted several times by Nikolai Iaroshenko (1846–1898); his most important version of this subject, exhibited in 1883, aroused a good deal of political controversy. The major 19th-century Russian realist, Ilya Repin (1844–1930), painted *A Woman Revolutionary in Prison Awaiting Execution* in about 1884, a subject later identified with a well-known revolutionary martyr, Vera Figner, who had become the leading member of the terrorists' Executive Committee following the execution of another woman "regicide," Sophia Perovskaya. Repin had originally intended to make the exemplary figure of a political dissident returning from exile in his *They Did Not Expect Him* of 1884–88, a young woman, a *kursistka*

figure to be precise, representing both the men and women of the new, revolutionary generation.[70]

Among the great pre-revolutionary heroes were many important heroines, often living in communal quarters with their male counterparts, "going among the people," suffering and making sacrifices on a completely egalitarian basis. In the first of the great political trials of 1877, for instance—the so-called "Trial of the Fifty"—almost half of the accused were women, dubbed the "Moscow Amazons." The names of Sophia Bardina, Lydia and Vera Figner, Betty Kaminskaya, Catherine Breshkovskaya, Sophia Perovskaya, Vera Zasulich, and Ludmila Volkenstein, as well as many others, are pre-eminent in the annals of 19th-century Russian revolutionary history. Indeed, one of the Czarist ministers of the 1870s attributed the success of the revolutionary propaganda campaign chiefly to the surprisingly large number of women among the conspirators.[71] Some women, like Valentina Semonovna Serova (1846–1924), mother of the artist V Serov, were active in both politics and the arts. This talented and energetic woman, an associate of many of the leading cultural figures of her day, including Tolstoi, Turgenev, Repin, Tchaikovsky, and Wagner, wrote five operas that she termed "ideological," one dealing with the condition of the peasantry, another based on the events of the revolution of 1905.[72]

Against this background, the vigor, independence, and iconoclastic daring of the Russian women artists of the early 20th century seem less unprecedented if no less dazzling. Natalia Goncharova, for instance, seems to have been on a level of complete equality with her avant-garde male colleagues, especially with Mikhail Larionov (1881–1964), with whom she worked closely. At first glance her work seems devoid of any particularly "feminine" qualities that would distinguish it from the work of the vanguard male painters of her time and place. Indeed, the impassioned catalogue preface to her one-woman show of 1913 reveals that Goncharova was far more concerned with establishing her identity as a modernist and a Russian than as a woman.[73] The "masculine" subject of electrical equipment—at that time the very quintessence of the progressive and dynamic—seems to have particularly fascinated her. Canvases like *The Machine's Engine* (1913, Paris, Galerie Loeb), *Electricity, Dynamo Machine*, and *Electric Lamp*,[74] created during her productive Cubo-Futurist phase, express this preoccupation. Interestingly enough, Sonia Delaunay, Russian-born although working in Paris, created her enormous light- and color-filled abstract canvas entitled *Electric Prisms* in 1914. One recent scholar, Marina Tsvetaïeva, has claimed that Goncharova was the first artist to introduce the mechanical into painting; certainly she was the first to treat mechanical objects as though they had a life of their own, maintaining that "the principle of movement in a machine and in a living being is the same, and the joy of my work is to reveal the equilibrium of movement."[75]

Still, it is interesting to notice how often within the sexually neutral, or even "masculine," and always vigorously avant-garde imagery of Goncharova intrude

references—sometimes ironic or rather subversive—to the artist's gender. *The Laundry* (London, Tate Gallery) of 1912 may illustrate the "machine esthetics," but it does so in terms of a traditionally feminine familiarity with hand-irons, laces, shirts, and collars, and *The Street Wall (Ostrich Plumes and Ribbons)* of 1912, with its elegant ladies' accoutrements, is also provocatively "feminine" in its iconography, compared to similar paintings by male artists.[76] One wonders, too, if it was mere chance that led Olga Rozanova to create *Workbox* of 1915, a brilliantly inventive collage—oil, paper, and lace on canvas—using women's traditional sewing materials as both iconography and substance.[77] Like Goncharova, she was concerned chiefly with machine themes at this time, and by *c.* 1916, like Popova and Exter, had moved on to pure abstraction of the most architectonic and non-referential sort.

In the case of the remarkable efflorescence of women artists in our own country during the 1930s, the issue is not so much that of radical stylistic innovation as of the sheer numbers of women involved and the range and variety of their pictorial expression. In this case, too, the status of women artists can be properly appreciated only within the larger context of the New Deal art programs and, to a lesser degree, in relation to American women's status in the professions. Just the fact that a 1935 survey of professional and technical workers on relief showed that about 41% of all artists receiving assistance were women suggests their relative importance in the field. Women were also prominent among the professional administrators of the federal art programs, women like Juliana Force, who became the regional director of the Public Works of Art Project, and Audrey McMahon, who acted as director of subsidized art production in New York State throughout the 1930s.[78] As KA Marling has pointed out, many of the women involved in the Federal Art Project and other government programs had achieved high positions even before the establishment of the New Deal agencies of patronage. Nevertheless, the "gender-blind" consideration of aspiring artists under the New Deal programs not only created an often exhilarating *esprit de corps*—perhaps an unfortunate expression under the circumstances, but still apt—that united artists of both sexes, but at the same time did much to meet the demands of women artists for two kinds of rights: the right to participate and the right to be judged on the same basis as men. In Marling's words: "The catastrophe of the Great Depression, by placing art under the jurisdiction of government for nearly a decade, answered both demands. The art projects sanctioned and consolidated the gains of a century of women's struggles for access to training, and for professional recognition, by coming to the rescue of artists to whose skills and cultural contributions sexual labels were no longer germane. Clearest proof of women's attainment of the right to dispassionate judgment appears in the procedural guidelines followed by the federal Section of Fine Arts. The Section, a non-relief patronage program charged with providing American mural decoration of the highest available quality for public buildings, awarded commissions on the basis of 'anonymous competitions.' Artists were instructed to submit their sketches unsigned.... Government

juries were not alerted to the gender of the competitors...."[79] The government art programs did not, of course, encourage the highest type of creative endeavor, although, on the whole, they did not stand in its way if it should appear. What they did do was create a relatively democratic, fair—and by implication, fair-to-women—system of supporting and encouraging the arts in this country, a system that managed to patronize artists as different as Marion Greenwood (1909–1970), who created massive Riveraesque murals, and Doris Lee (1905–1983), with her chirpy regional genre scenes, and as different as Lee Krasner and Isabel Bishop. Indeed, the impact of the New Deal can be seen even in the style and subject matter of women artists who were not really connected with its art programs because they did not need them, like Florine Stettheimer, who nevertheless reveals a decidedly New Dealish social consciousness in her *Cathedrals of Wall Street* (1939) [p. 145], featuring Mrs. Roosevelt and Mayor La Guardia.

The ultimate impulse behind the creation of greater opportunities for women artists through the New Deal art programs seems to have been not so much feminism as egalitarianism: an ideal perhaps largely mythic, like that of America as a great "melting pot," yet partly effective, too, if only in eliminating a certain *overt* sexual bias in the distribution of largesse. In any case, feminist consciousness does not seem to have played a major role in the conceptions of many of the well-known women artists who participated in the New Deal programs.[80] One can discern occasional references to women's status and condition when these seem appropriate to the circumstances, as in Lucienne Bloch's mural *Cycle of a Woman's Life* (1936, destroyed) [p. 79] for the New York House of Detention for Women, in which she depicted the stages of a woman's life with an integrated cast of characters or, more ambivalently, in Minna Citron's highly satirical "Feminanities" series of 1935, in which the artist, in her own words, attempted "to hold a mirror to the unlovely facets of a woman's mind."[81] Both works are simply individual instances in widely varied oeuvres; few of the major women artists of this period, with the possible exception of Isabel Bishop, seem to have dedicated themselves to themes particularly relevant to women. For most women artists on the Public Works of Art Project, like Agnes Tail, it was the American scene, or, even more accurately, as Marling has put it, "an interest in distinctly American forms of artistic expression and a desire to view American art and life in a broader human and historical context"[82] that was the motivating force behind their creations.

The issue of "women's imagery"

The notion that woman's experience *as* woman affords her a special vision of reality and unique imaginative insights, thus providing a source of specifically "feminine" pictorial imagery, is an issue that has been and continues to be hotly debated. Although it would seem obvious from this exhibition that there are no particular stylistic features associated with the work of women artists—"delicate brushwork," for example, or

Rachel Ruysch, *Still-Life with Fruit and Insects*, 1711.
Oil on panel, 17⅜ × 23⅝ in. (44 × 60 cm)

"pastel" colors—it is also clear that in specific historical situations women artists have been encouraged to turn to certain areas of activity more than others: in 19th-century England, for example, they were certainly directed more toward the modest realm of flower painting than the ambitious one of the heroic mural. Indeed, flower painting seems to have been favored by both amateur and professional women artists from the 17th century down through the 19th and even afterwards. Usually one suspects that the reasons are quite practical and unmysterious ones, including accessibility of the subject and demand by the market. Yet even in this case it is obvious that historical and local factors play a greater role in determining style than does the sex of the artist. Rachel Ruysch's flower paintings look far more like those of her male Dutch contemporaries than they do like the flowers painted by Maria Sibylla Merian or by Georgia O'Keeffe, which in turn are clearly related to the stylistic context of their own time and place.

The issue of "feminine imagery" and its complexities may conveniently be examined in the work of two of the strongest German women artists of the early 20th century: Paula Modersohn-Becker and Käthe Kollwitz. A comparison of their work is revealing precisely because the two painters are so close in time and place, because both are women, and because in addition both created an iconography clearly centered about women and women's experience. Yet what strikes one about these two nearly contemporary artists, both women, both German, and both devoted to the themes of women

and children, is the difference in their interpretation of these subjects. This difference is even more striking in that both artists depicted proletarian women, the poor and the outcast, a subject which, in the traditional language of 19th-century realism, had been used to convey a deep sense of fatalism, uncomplaining acceptance of a hard destiny.[83]

By the end of the 19th century the peasant woman had become the very embodiment of fatalistic conservatism, her major virtue that of endurance—a creature inescapably bound to the unchanging cycles of nature and completely divorced from the dynamic forces of history. Modersohn-Becker's representations of old peasant women, like her *Old Woman from the Poorhouse* of 1903, are a kind of ultimate distillation of this imagery, couched in an original language sparked by contact with the French vanguard—Van Gogh, Cézanne, and Gauguin—in which expressive color and daring simplifications of contour become formal equivalents for the awkward, almost animal-like endurance of her sitters. The old peasant woman—passive, immobile, unprotesting—is literally at one with her natural selling.

Nothing could offer a greater contrast to this image of static acceptance than Käthe Kollwitz's etching of 1907, *Losbruch* [Revolt], from her series *The Peasant War*, created between 1902 and 1908.[84] A political activist living among the poor in Berlin and profoundly committed to radical social change, Kollwitz envisioned the anonymous peasant woman as a dynamic force, who galvanizes her fellow oppressed into action. Evidently Kollwitz conceived the protagonist of *Losbruch* from reading Zimmermann's classic *Peasants' War*, which gave the account of the peasant woman "Black Anna," who incited her fellow peasants to action. As a young woman, Kollwitz had responded to August Bebel's *Woman under Socialism*, first published in 1883,[85] which connected the struggle for social democracy with women's fight for justice. In four out of the seven prints of *The Peasant War* a woman figures as the protagonist.

Representations of the political activism of women—real women, that is, and not female allegorical figures—and especially of proletarian women, are relatively rare in the painting of the 19th century, although Kollwitz's conception is reminiscent of some of Goya's graphic images of fiercely struggling peasant women in the *Disasters of War*. There did exist a popular, folkloric tradition of the proletarian, female activist—aside from the saintly Joan of Arc, who, significantly, is hardly ever represented in actual combat. The heroines of Auguste Le Barbier's *Jeanne Hachette at the Siege of Beauvais* (1781, now destroyed but known through engravings) and of Horace Vernet's *Scene of the French Campaign of 1814* (1826) are such figures. Going back even further, there is Pieter Bruegel's representation of the legendary Mad Meg (*The Dutle Grier, c.* 1562–64), a virago who has completely thrown off the yoke of male dominance and who, armed with helmet, cuirass, sword, and a kitchen knife, confronts the devil himself with her savage, unleashed energy, at the head of her brigade of women. And indeed, there is something diabolic, like Mad Meg—that not-so-mad embodiment of sexual and social revolt—in the shadowy, sinewy female figure of Kollwitz's *Whetting the Scythe*, another

RIGHT
Paula Modersohn-Becker,
Old Peasant Woman,
c. 1905–6. Oil on
canvas, 29¾ × 22¾ in.
(75.6 × 57.8 cm)

BELOW
Käthe Kollwitz,
Losbruch, 1907,
from *The Peasant
War* series (1902–8).
Etching.

plate from the *Peasant War* series, a figure whose intense concentration on the business at hand contrasts so strongly with the quiet passivity of the old peasant woman by Modersohn-Becker.

Similar contrasts are revealed by Modersohn-Becker's and Kollwitz's approach to the perennially popular subject of motherhood. Maternity is certainly one theme from the neoclassical epoch down to the age of Surrealism that can be said to have captured the attention of women artists—those, of course, who have drawn on the experience of their own lives and those of their fellow women for inspiration. This is not to say, of course, that this subject has not appealed to men artists as well or that women artists are in any way "instinctively" drawn to such themes: the whole tenor of this essay argues consistently against such "innate" or "essential" proclivities on the part of women artists, or indeed against the existence of any specifically feminine tendencies whatever, apart from specific historical contexts. That motherhood should have played such an important role in women artists' iconography is hardly remarkable: historically it has been the central life experience for most women, cutting across barriers of class, period, and nationality. Yet even in the case of this most universally popular of subjects, the variations on the theme are more striking than the similarities.

For women artists belonging to and identifying with the cultivated upper-middle classes, like Berthe Morisot or Mary Cassatt, the theme of the mother and child is approached directly and concretely, but with a certain reserved delicacy, a deliberate avoidance of the extremes both of spirituality—i.e., overt references to the traditional Virgin and Child image—and of animal physicality—i.e., Modersohn-Becker. In the work of Cassatt and Morisot, one is made acutely aware of the precise level of elegance and refinement of these mothers and their lovely offspring: indeed, part of the charm of these canvases lies in the subtle but undeniable self-consciousness of distinction of form and of subject they convey to the spectator.

That Käthe Kollwitz's interpretation of maternal feeling should be radically different from Cassatt's or Morisot's is hardly surprising. Less expected, perhaps, is the striking difference between her conception of the theme and that of Paula Modersohn-Becker, a contrast even more surprising in that both of these artists concentrated upon the motherhood of the poor.

Like the old peasant woman, the lower-class mother had been a standard character in the repertory of humanitarian realists during the second half of the 19th century. The nursing mother as an image of the life force, of existence sustained at the most primitive level and under the most reduced circumstances—this image was powerfully embodied by Daumier in his Michelangelesque drawing, *The Soup* (*c.* 1860–70). It was given more exaggerated expression, at times verging on the ludicrous or the grotesque, in the work of late 19th-century Italians like Giovanni Segantini (1858–1899) in his *The Two Mothers* (1889), in which a peasant mother and child are visually associated with a cow and calf, or Teofilo Patini (1840–1906) in his *Mud and Milk* (1883), in which the ragged mother, a

proletarian madonna of humility, nurses her infant while sitting in a stubble-covered field, protected by a battered umbrella. The imagery of the nursing mother was certainly favored by an artist like Fritz Mackensen, painter of *The Nursing Infant* (1892) and a member of the same Worpswede art colony where Modersohn-Becker worked and lived. In a canvas like *Mother and Child* (*c.* 1903), Modersohn-Becker has reduced the theme to its pictorial essentials, and by removing the theme of maternal nourishment from history or social circumstance has implied that motherhood is an instinctive—rather than a social—female function. On the other hand, Käthe Kollwitz, in her etching *Poverty* (1897), by portraying the poor mother who *cannot* feed her child has inserted motherhood into the bitterly concrete context of class and history. Both these women artists conceived of motherhood and the nurturing of children as the natural destiny of their sex. But Kollwitz set forth the material circumstances that prevent the working-class mother from fulfilling this natural destiny, thereby transforming her into the very personification of the proletarian victim of history. Modersohn-Becker, especially in her extraordinary late works, probably created while she herself was looking forward to motherhood, transforms the mother into a being entirely transcending time or place, a dark, anonymous goddess of nourishment, paradoxically animal-like, bound to the earth and utterly remote from the contingencies of history or the social order. While in some ways reminiscent of Gauguin's Tahitian women, which Modersohn-Becker knew and admired, these late mother and child paintings are actually starker, more reduced to pure function, more boldly divested of any kind of conventional beauty or softening appurtenances than any of Gauguin's female figures.

The dramatic but drastically simplified conception of feminine power expressed in Modersohn-Becker's paintings had a powerful hold on the German imagination in the late 19th and early 20th centuries.[86] One of its most explicit and elaborate formulations was that by the scholar and would-be anthropologist, Johann Jakob Bachofen, who in his book *Mother Right*, published in 1861 but not popularized until the 1890s and then revived in the 1920s, claimed that women had originally dominated during the pre-historic stages of social evolution, when the Divine Mother had been the central cult image, the body had prevailed over the mind, and "the eyes of humanity had been fastened on the earth." Maternity, Bachofen declared, the central feature of this primeval stage of human development, pertained to the physical side of humanity, the only side he felt that humans actually shared with the animals.[87]

Such theories identifying women with the realm of nature and reducing them to their purely sexual dimension had wide dissemination in the early years of the 20th century. DH Lawrence is perhaps their major promulgator in the literature of the English-speaking world, but his is simply the most convincing and coherent voice among many. In the visual realm, it would seem that Georgia O'Keeffe, in her vastly magnified, frontal flowers, like her *Black Iris* of 1926 [p. 81][88] or her suggestively closed and open clamshells of the same year is making similar claims for the unity of the feminine

and the natural order. In such imagery, the forms of nature, while never losing their own integrity, exist at the same time as strong schematic metaphors of female sexuality, universalized by their separation from any sort of concrete locale or visual context. As such, like Modersohn-Becker's similarly isolated and powerful maternal images—and analogous to the sexually awakened, intuitive heroines of DH Lawrence's fiction—they function as potent and vastly attractive mythic projections of essentialist notions of femininity.[89] Such images of female sexuality were basically apolitical if not outright conservative: woman, reduced to her sexual being, conceived of as a part of Nature, was the very antithesis of historical action. Paradoxically, however, in the context of today's feminist activism, such imagery has acquired potent political implications, for woman's control over her sexual destiny is now seen as a central issue in her struggle for self-determination. Nothing could better demonstrate the complexity, and the basic ambiguity, of the issue of what constitutes a valid "feminist imagery" than the recent transformation of the placid iris into a fighting symbol. Having begun this discussion of women artists with one revolution, it is perhaps appropriate that we end it with another, the feminist revolution of today, which, in a sense, has brought into being a new history—a more valid, complex, expansive interpretation of the past—in art, as in every other realm of human experience.

Notes

1 KB Clinton (1975), "Femme et Philosophe: Enlightenment Origins of Feminism," *Eighteenth-Century Studies*, VIII, no. 3, Spring, p. 295.

2 See especially Condorcet's "Lettres d'un bourgeois de New Haven à un citoyen de Virginie," in his *Oeuvres* (1847), F O'Connor and MR Arago, eds, VIII, Paris, pp. 15–19. For an excellent summary of feminism and the French revolution, see J Abray (1975), "Feminism in the French Revolution," *American Historical Review*, LXXX, February, pp. 43–62.

3 Clinton, "Femme et Philosophe," pp. 295–96 and 298–99.

4 Abray, "Feminism in the French Revolution," pp. 48–49.

5 H Lapauze, ed. (1903), *Procès-Verbuax de la Commune Générale des Arts et de la Société Populaire et Républicaine des Arts*, Paris, pp. L–LI and 183–85.

6 See A Boime (1971), *The Academy and French Painting in the Nineteenth Century*, London, pp. 3–8, for the basic structure, and restructuring, of these institutions.

7 See A Schnapper (1974), "Painting During the Revolution, 1789–1799," in *French Painting 1774–1830: The Age of Revolution*, catalogue, Paris: Grand Palais, pp. 109–10.

8 G Wildenstein (1963), "Table des portraits exposés à Paris au Salon entre 1800 et 1826," *Gazette des beaux-arts*, LXI, p. 10.

9 Wherever possible, current locations of works are given. Those not provided are not available.

10 CP Landon (1808), *Annales du Musée et de l'école moderne des beaux-arts*, II, Paris, p. 16.

11 See Schnapper, "*Painting during the revolution*," no. 20.

12 M Furcy-Raynaud (1912), *Nouvelles archives de l'art français*, Paris, p. 294.

13 See Schnapper, "Painting During the Revolution," no. 150, p. 137.

14 See GK Nagler (1835 and 1914), *Neues allgemeines Kunstler-Lexikon*, 25 vols, Munich and Linz, Germany, for a long discussion of Mme. Mongez and her work.

15 PJB Chaussard (1808), *Le Pausanius Français: ou Description du salon de 1806*, pp. 200 and 203. I am grateful to Sally Wells-Robertson for having brought this passage to my attention.

16 CP Landon (1819), *Annales du Musée*, p. 63.

17 The career of Auzou is now being investigated by Vivian P Cameron, a doctoral candidate at Yale University.

18 RB Holtman (1950), *Napoleonic Propaganda*, Baton Rouge, LA: Louisiana State University Press, p. 164.

19 For a discussion of these works and the political context in which they were undertaken, see F Haskell (1971), "The manufacture of the Past in Nineteenth-Century Painting," *Past and Present,* no. 53, November, pp. 109–20.

20 Marie Louise evidently took painting lessons from Prud'hon, and some works by her hand still survive. See, for example, her *L'Innocence*, executed while the empress was studying with Prud'hon (oil on canvas, 22¹⁄₁₆ × 18⅛ in., now in the depository of the Musée de Besançon).

21 F Masson (1894), *Napoleon and the Fair Sex*, London, p. 268.

22 See *The Age of Neo-Classicism* (1972), London: The Royal Academy and Victoria and Albert Museum, no. 26 for Benoist, no. 106 and p. 11 for Girodet's portrait.

23 Letter from Mme. Benoist to her husband, October 1, 1814, in MJ Ballot (1914), *Une Éleve de David. La Comtesse Benoist, "L'Emilie de Demoustier," 1768–1826*, Paris, p. 212.

24 See *The Age of Neo-Classicism*, no. 173, p. 45a, for an example of Krafft's work.

25 Several of her paintings are hung in the galleries of the Staatliche Kunsthalle in Karlsruhe, and her works are fully catalogued by this museum. See *Katalog Neuere Meister 19, and 20. Jahrhundert* (1971), Staatliche Kunsthalle Karlsruhe, 2 vols. In addition, at least three monographs have been devoted to Ellenrieder: K Siebert (1915), *Marie Ellenrieder*, Karlsruhe; M Zundorff (1940), *Marie Ellenrieder*, Konstanz; and FW Fischer and SV Blankenhagen (1963), *Marie Ellenrieder, Leben und Werk der Konstanzen Malerin...mit einem Werkverzeichnis*, Konstanz/Stuttgart.

26 In Ellen Creathorne Clayton (1876), *English Female Artists*, vol. II, London, p. 148.

27 Ibid., p. 83.

28 W Sandby (1862), *The History of the Royal Academy of Arts*, II, London, p. 272.

29 Ibid., and SC Hutchison (1968), *The History of the Royal Academy, 1768–1868*, London, p. 118.

30 JN Anderson, Papers, Royal Academy, xxvi. I am grateful to Professor Albert Boime for having brought this document to my attention.

31 Hutchison, *The History of the Royal Academy*, p. 143.

32 Cited in ibid.

33 A John (1958), obituary notice of Lady Smith, *The Times*, February 1, cited in M Holroyd, (1974), *Augustus John: The Years of Innocence*, p. 62, footnote.

34 See *Held in Trust* (1973), Philadelphia: Pennsylvania Academy of the Fine Arts, pp. 4 and 17.

35 Letter signed "R. S." to the president of the Pennsylvania Academy, April 11, 1882. Cited in *Held in Trust*, introduction by CJ Huber, p. 21.

36 See G Hendrix (1974), *The Life and Works of Thomas Eakins*, New York: Grossman, pp. 137–45, for a full account of Eakins' resignation, the position of women art students, and their angry reaction to Eakins' departure.

37 See also the painting by Adrienne Grandpierre-Deverzy, *The Studio of Abel Pujol in 1822*, 1822, Musée Marmottan, Paris.

38 A Theuriet, ed. (1887), *Le Journal de Marie Bashkirtseff*, 2 vols, Paris, pp. 334–35, 351, 407. Accounts of Julien's women's class are also given by Anna Klumpke (1908), *Rosa Bonheur: sa vie son oeuvre*, Paris: E Flammarion; Cecilia Beaux (1930), *Background with Figures*, New York and Boston, pp. 117–24; and Mary Breakell (1907), "Marie Bashkirtseff. The reminiscence of a fellow-student," *Nineteenth Century and After*, London, lxii, pp. 110–25. A thorough study of women students at Julien's and other women's art classes in the late 19th century in Paris is now being undertaken by Judith Stein of Temple University.

39 A Graves (1972), *The Royal Academy of Art: A Complete Dictionary of Contributors and Their Work from its Foundation in 1769 to 1904* (originally published 1905, 1906), New York.

40 See, for example, the impressive number of women artists included in Graves (1901), *Dictionary of Artists Who Have Exhibited Works in the Principal London Exhibitions from 1760 to 1893*, 3rd ed. (reprinted Bath, 1970), which covers not merely the exhibitions of the Royal Academy, but those of the British Institution, the Society of British Artists, the Royal Watercolour Society, the Grosvenor Gallery, the New Gallery, and various other exhibitions.

41 J Ruskin (1904), "Academy Notes, 1875," in
 ET Cook and A Wedderburn, eds, *The Works
 of John Ruskin,* London, xiv, p. 309.

42 AK Tuell (1925), *Mrs. Meynell and Her Literary
 Generation*, New York: EP Dutton & Co.,
 pp. 5–7, 136, and *passim.*

43 The painting is now in the collection of
 Sir David Scott. For a good reproduction
 of the original, see J Maas (1969), *Victorian
 Painters*, London: Barrie & Rockcliff, p. 121.
 Another 19th-century treatment of this rare
 subject, perhaps known through engravings
 to Osborn, is Mme. Haudebourt-Lescot's
 The Second-Hand Dealer of Paintings (Salon
 of 1824), a work almost identical in theme
 to Osborn's, now known to us only through
 line engraving. I am grateful to Sally Wells-
 Robertson for having brought this work to my
 attention.

44 *Nameless and Friendless* has recently been
 misinterpreted as "A gentlewoman reduced
 to depending upon her brother's art," by
 S Macdonald (1970), in *The History and
 Philosophy of Art Education*, New York:
 American Elsevier Press, fig. 9., p. 96. I am
 grateful to Judith Stein for having brought
 this significant misreading to my attention.

45 CR Baldwin (1973–74), "The Predestined
 Delicate Hand: Some Second Empire
 Difinitions [sic] of Women's Role in Art
 and Industry," *Feminist Art Journal*, II, no. 4.
 Winter, p. 14.

46 L Legrange (1860), "Du rang des femmes dans
 les arts," *Gazette des beaux-arts*, October 1,
 pp. 30–43, cited by Baldwin, "The Predestined
 Delicate Hand," pp. 13–14.

47 JV Daubié (1866), *La Femme pauvre aux XIXe
 siècle*, Paris: Guillaumin, pp. 292–93. I am
 grateful to Priscilla Robertson for calling my
 attention to this book.

48 Advice that Beaux evidently ignored. See
 her *Background with Figures*, p. 130 (note 38
 above).

49 The entry is from 1878, see A Theuriet,
 Le Journal de Marie Bashkirtseff, p. 402.

50 Ibid., p. 351.

51 Ibid., p. 407.

52 Patricia Thomson (1956), *The Victorian
 Heroine: A Changing Ideal, 1837–1873*,
 London: Oxford University Press, p. 77.
 Also see E Showalter (1975), "Dinah Muloch
 Craik and the Tactics of Sentiment," *Feminist
 Studies*, II, no. 2/3, pp. 15–17.

53 For an interesting and illuminating analysis
 of Elizabeth Stuart Phelps and this work,

 see Christine Stansell (1972), "Elizabeth
 Stuart Phelps: A Study in Female Rebellion,"
 Massachusetts Review, XIII, pp. 239–56. Zola's
 well-known study of a doomed (male) artist,
 Claude Lantier, in the novel *L'Oeuvre*, was not
 finished until 1886.

54 Elizabeth Stuart Phelps (1877), *The Story
 of Avis*, Boston, MA: James R Osgood & Co.,
 pp. 149–50.

55 A Segard (1913), *Mary Cassatt, un peintre des
 enfants et des mères*, Paris, p. 8. Translated in
 Mary Cassatt, 1844–1926 (1970), Washington,
 DC: National Gallery of Art, introduction by
 Adelyn Breeskin, p. 13.

56 O'Keeffe not only refused to permit any
 of her flower pieces to be included in this
 exhibition, but even refused to have them
 reproduced in the catalogue, presumably
 for fear they would be misinterpreted in the
 context of a show of women artists.

57 MH Elliott edited the *Art and Handicrafts*
 publication of 1893. A sense of the
 achievement of women textile designers
 may be gained from a visit to the Bauhaus
 archives in Berlin. Although women may have
 traditionally been involved in hand-weaving
 and art weaving, this is by no means true as
 far as industrial or mass-production of cloth
 is concerned, as E Sullerot (1968), *Histoire et
 sociologie du travail féminin*, Paris, p. 90, has
 pointed out: "The industrial revolution was
 at first characterized by the transfer into the
 hands of men of almost all the productions
 which until that time had been feminine."
 Later, of course, women and children, at
 considerably lower salaries, to be sure,
 followed men into the textile mills.

58 Q Bell (1963), *The Schools of Design*, London,
 pp. 135–37. KA Marling deals with the
 relation of American women to arts and crafts
 and social uplift in the introduction to the
 exhibition catalogue, *7 American Women: The
 Depression Decade* (1976), Poughkeepsie, NY:
 Vassar College Art Gallery, pp. 10–11.

59 Rosa Bonheur's father, Raymond, took over
 the directorship in 1848, and his daughter
 took over the following year, after his death.
 The school, called the École speciale de
 Dessin pour les Demoiselles and, later, the
 École Imperiale, was headed by Mlle. Nelly
 Marandon de Montyel after 1860. I am
 grateful to Professor Albert Boime for much
 of this information.

60 *Marguerite Zorach: The Early Years, 1908–
 1920* (1973), introduction by RK Tarbell,

Washington, DC: National Collection of Fine Arts, p. 50. The artist was joined briefly in her tapestry work by her husband, the sculptor William Zorach (p. 57).

61 Ibid., p. 57.

62 A Cohen (1975), *Sonia Delaunay*, New York, p. 77

63 For a complete discussion of the remarkable contribution of women artists to Constructivist clothing and textile design, see John Bowlt (1976), "From Pictures to Textile Prints," *The Print Collector's Newsletter*, VII, no. 1, March–April, pp. 16–20.

64 Ibid., p. 17.

65 J Damase (1971), *Sonia Delaunay: Rythmes et couleurs*, Paris, pp. 214–15

66 See the catalogue, *Sonia Delaunay Tapestries* (1974), New York: Aberbach Fine Art Gallery. For the fabric designs, see *Sonia Delaunay: Etoffes imprimées des années folles* (1971), Mulhouse: Musée de l'Impression sur Etoffes.

67 The question has been investigated in the realm of women's literature, especially in the field of the novel, more thoroughly than in that of the arts. See, for example, most recently, Ellen Moers' (1976) interesting and provocative study, *Literary Women*, Garden City, NY: Doubleday. The situation of Russian women artists of the 20th century has been discussed in the context of Russian art of the period by John Bowlt (1988), *Russian Art of the Avant-Garde: Theory and Criticism, 1902–1934*, New York: Thames & Hudson, and Camilla Gray (1962), *The Great Experiment: Russian Art, 1863–1922*, London: Thames & Hudson, and is at present being investigated by graduate students like Ronnie Cohen, who is working on Alexandra Exter at the New York University, Institute of Fine Arts, and Margaret Betz at the CUNY Graduate Center. The situation of women artists and the New Deal has recently been illuminated by an exhibition organized by KA Marling and HA Harrison, with their informative catalogue *7 American Women: The Depression Decade* (1976).

68 FW Halle (1933), *Woman in Soviet Russia*, London: Routledge, p. 36.

69 Ibid., p. 40.

70 This painting was not exhibited until 1896, although it had been painted earlier. See Alison Hilton (1978), "The Revolutionary Theme in Russian Realism," in H Millon and L Nochlin, eds, *Art and Architecture in the Service of Politics*, Cambridge, MA: MIT Press.

71 Halle, *Woman in Soviet Russia*, p. 50.

72 I am grateful to Alison Hilton for material on Serova.

73 This preface has been translated by John Bowlt (1988), *Russian Art of the Avant-Garde*, pp. 54–60.

74 M Chamot (1972), *Goncharova*, Paris, p. 58.

75 Cited by Chamot, ibid.

76 See ibid., p. 51, for a reproduction of *The Laundry*; p. 53 for *The Street Wall (Ostrich Plumes, and Ribbons)*. It would be interesting to compare Goncharova's *Picking Apples* of 1909 (Gray, *The Great Experiment*, fig. 66) with its formal poses and feminine cast of characters, to Mary Cassatt's vanished mural with this subject at its center, created for the Woman's Building of the Chicago World Fair of 1893.

77 See Bowlt, *Russian Art of the Avant-Garde*, p. 104.

78 Marling, *7 American Women*, pp. 12–13.

79 Ibid., p. 14.

80 Ibid., p. 5.

81 For a reproduction of the Bloch mural, see ibid., p. 22. For one of Citron's paintings from the "Feminanities" series, *She Earns "An Honest Living,"* of 1934, see ibid., p. 26.

82 Marling, *7 American Women*.

83 For a general discussion on the theme of the peasant in French art of the second half of the 19th century, see RL Herbert (1970), "City vs. Country, the Rural Image in French Painting from Millet to Gauguin," *Artforum*, viii, February, pp. 44–55.

84 See O Nagel, *Käthe Kollwitz: Die Handzeichnungen, Berlin*, p. 50

85 See A Bebel (1971), *Woman under Socialism*, introduction by Louis Coser, New York: Schocken, for Kollwitz's source of inspiration.

86 For a discussion of the impact of this and related ideas, especially as they pertain to the work of DH Lawrence, see Martin Green (1974), *The von Richthofen Sisters: The Triumphant and the Tragic Modes of Love*, New York: Basic Books, Inc., particularly pp. 73–100, but also *passim*.

87 According to Bachofen, the more recently evolved paternal and spiritual principle belonged, on the contrary, to human beings, more specifically to male human beings, alone—ultimately, patriarchal civilization. Father Right, the division of labor, the domination of spiritual effort, of change and aspiration—in short, civilized, male-dominated culture, as we

know it—triumphed; but features of the old, female-dominated realm of nature—immutable instinct and attachment to the forces of the earth—still endure in woman, a creature, he maintained, essentially defined by her instinctive sexual and maternal role. This is a brief and, admittedly, incomplete summary of Bachofen's notions; see JJ Bachofen (1967), *Myth, Religion, and Mother Right: Selected Writings of J. J. Bachofen*, R Manheim, trans., Princeton, NJ: Princeton University Press. Also see Green, *The von Richthofen Sisters*, pp. 81–84, on Bachofen. For radically contrasting conclusions based on similar anthropological, or pseudo-anthropological, material (much of it contributed by the American anthropologist Lewis Henry Morgan, whose *Ancient Society* had appeared in 1877), see Bebel's *Woman under Socialism*, and Friedrich Engels (1972), *The Origin of the Family, Private Property and the State*, introduction by EB Leacock, New York: International Publishers, first published in 1884. For an excellent critique of mythologizing, pseudo-scientific matriarchal theories, including Bachofen's, see the review by A Hackett and S Pomeroy of Elizabeth Gould Davis (1971), *The First Sex,* Baltimore: Penguin Books, entitled "Making History: *The First Sex*" (1972), *Feminist Studies*, I, no. 2, Fall, pp. 97–108.

88 For a reproduction, see *Georgia O'Keeffe* (1970), catalogue by Lloyd Goodrich and Doris Bry, New York: Whitney Museum of Art, p. 40. For a more detailed discussion of the iconography of the iris, see L Nochlin (1974), "Some Women Realists: Part I," *Arts Magazine*, February, pp. 47–49.

89 It would seem more than a mere coincidence that O'Keeffe painted *The Lawrence Tree* (1929, collection the artist, Goodrich and Bry, *Georgia O'Keeffe*, no. 61) shortly after her first arrival in New Mexico, and that one of her admirers, the New Mexican by-adoption, Mabel Dodge Luhan, was also one of DH Lawrence's most fervent disciples. In the deserts of New Mexico, perhaps O'Keeffe—like Lawrence, like Mabel Dodge Luhan, who married a Navaho Indian, and like many other artistic personalities—was also seeking that primordial truth, that dark, timeless unity with and acceptance of nature, which seemed for Lawrence and for Luhan, at any rate, inseparably bound with what they considered "true femininity," and as inalterably opposed to the rationality, mutability, and restless ambition of what they thought of as "masculine" civilization. See, for example, Mabel Dodge Luhan (1932), *Lorenzo in Taos*, New York: Knopf, and the same authors' (1931) "Georgia O'Keeffe in Taos," *Creative Art*, vii, June, pp. 407–10. For a recent discussion of the New Mexican art ambience, see S Schwartz (1976), "When New York Went to New Mexico," *Art in America*, July–August, pp. 93–96.

5
Florine Stettheimer: Rococo Subversive

Art in America, No. 7, September 1980

It is admittedly difficult to reconcile the style and subject matter of Florine Stettheimer with conventional notions of a socially conscious art.[1] The Stettheimer style is gossamer light, highly artificed and complex; the iconography, refined, recondite and personal in its references. In one of her best known works, *Family Portrait No. 2* of 1933, we see the artist in her preferred setting: New York, West Side, feminine, floral, familial. The family group includes her sister Ettie, whom she had portrayed in an equally memorable individual portrait ten years earlier, sitting to the artist's right. Ettie was a philosopher who had earned a doctorate in Germany with a thesis on William James, but later turned

Florine Stettheimer, *Family Portrait No. 2*, 1933.
Oil on canvas, 46¼ × 64⅝ in. (117.4 × 164 cm)

to fiction. She wrote two highly wrought novels, *Philosophy* and *Love Days*, publishing under the pseudonym "Henrie Waste,"[2] novels which would certainly by today's standards be considered feminist in their insistence that woman's self-realization is incompatible with romantic love, and, in the case of *Love Days*, in the demonstration of the devastating results of the wrong sort of amorous attachment.

To the far right is her sister, Carrie, also subject of an earlier individual portrait, hostess of the family parties and creator of the doll house now in the Museum of the City of New York. This last project was the work of a lifetime, complete with miniature reproductions of masterpieces by such artist-friends of the Stettheimers as Gaston Lachaise and William and Marguerite Zorach, as well as a thumbnail version by Marcel Duchamp of his *Nude Descending a Staircase*. Off center, hieratically enshrined in a shell-like golden mandorla, is the matriarch, Rosetta Walter Stettheimer. She is here shawled in lace, Florine's favorite fabric, which Ettie and Carrie are shown wearing as well.[3] The artist herself, however, is clad in the dark painting suit that served as her work outfit, although this relatively sober turn-out is here set off by sprightly red high-heeled sandals. The whole world of the Stettheimers, set aloft amid Manhattan's significant spires, with the blue waters surrounding the island visible below, is guarded by a stellar Statue of Liberty and domesticated by the exuberant baldaquin of 182 West 58th Street (the Alwyn Court, their dwelling place). The scene is at once distanced and brought to the surface of the canvas by the resplendent three-part bouquet that dominates the composition. Perhaps each flower is meant as a reference to a sister; perhaps the willow-like frond binding them all together is meant to refer to their mother.[4] In any case, the stylish floral life of the bouquet dwarfs and overpowers the human life in the painting. One may choose to see that bouquet, and indeed, the painting as a whole, as a kind of testimonial offered by the artist to her family, her city, and to the very world of vivid artifice she created with them. "My attitude is one of Love/is all adoration/for all the fringes/all the color/all tinsel creation," she wrote.[5]

Certainly the mature style of Florine Stettheimer is based on highly idiosyncratic responses to a wide variety of sources, ranging from the later effusions of Symbolism (including the American variety recently brought to focus by Charles Eldredge in an exhibition at the Grey Gallery) to the decorative style of Henri Matisse and the set designs of the Russian Ballet—projects by Bakst, Benois, and Goncharova—which the artist encountered in Paris before the First World War. More specifically, she seems to have been influenced by her friend Adolfo Best-Maugard, the Mexican artist and theorist, who playfully juggles the seven basic forms of his esthetic system in his hand in Stettheimer's 1920 portrait of him. Best-Maugard's *A Method of Creative Design*, first published in 1926, systematizes various vanguard notions of the time into decorative, linear, at times quite witty configurations. His illustrations to the book—"Curtains," "Rosettes and Flowers" or "Modern Surroundings," for example—share many characteristics of Stettheimer's treatment of the same themes, yet can hardly be considered

Florine Stettheimer,
Portrait of Myself, 1923.
Oil on canvas, mounted
on composition board,
40 × 26 in. (101.6 × 66 cm)

a unique source. On the contrary: Stettheimer had acquired a thorough knowledge of the European art tradition during her years on the Continent; as a student abroad, she had commented on artists, artwork and collections at considerable length and often with great astuteness in the pages of her diary.[6] At the same time, she was well aware of the most advanced currents of the art of her own period, and was closely allied through friendship and mutual interest with the people who made it. The Stettheimers' circle of friends included Marcel Duchamp, whose portrait Florine painted in 1923, Elie Nadelman, Albert Gleizes, Gaston Lachaise, William and Marguerite Zorach, and many others. Primitive and folk art seem to have played a role in the formation of the artist's style as well—as did, perhaps, the elegant and incisive graphic stylishness of contemporary *Vanity Fair* cartoons. A comparison of Stettheimer's *Natatorium Undine* of 1927 and *Divers, Divers*, a cartoon of the same year by the witty and feminine Fish,[7] gives some indication of just how far-ranging Stettheimer's eye actually was.

Often, just when we think she is being her most naively "uninfluenced," Stettheimer is in fact translating some recherché source into her own idiom. Such is the case with the *Portrait of Myself* (1923), which draws upon the eccentric and visionary art of William Blake, whose reversal of natural scale, androgynous figure style and intensified drawing seem to have stirred a responsive chord in Stettheimer's imagination. Blake's

illustration for his *Song of Los*, with the figure reclining weightlessly on a flower, seems to have been the prototype for Stettheimer's memorable self-portrait, and indeed it had been published in Laurence Binyon's *Drawings and Engravings of William Blake* in 1922. Certainly, the artist was conversant with the literature of art: "I think she must have read everything concerning art published in English, French and German...," wrote her sister Ettie in the introduction to Florine's posthumously published poems in 1949.[8]

But as much as Stettheimer's evolved style depends on resourceful borrowing and translation, even more does it depend, like all original styles, on a good deal of forceful rejection. In order to arrive at her own idiosyncratic language of form, she had to turn away not only from traditional formal values like those embodied in the academic nudes she painted around the turn of the century (while studying with Kenyon Cox at the Art Students' League), but also those of modernist abstraction. In any case, no matter what its derivations or its novelties, Stettheimer's style, at first glance, hardly seems an appropriate vehicle for the rhetoric of social message.

Nor do the subjects of many of the artist's more "documentary" works, like *Studio Party* of 1915 or *Sunday Afternoon in the Country* of 1917 seem to have that public character, that easy accessibility characteristic of a public art of social consciousness. The social character of these works is of a very private kind. The sitters are the privileged denizens of a most exclusive world, the world of the Stettheimers' entertainments, soirées and picnics. In *Studio Party*, along with Florine herself, that world is seen to include the Lachaises, Albert Gleizes, Avery Hopwood, and Leo Stein; in *Sunday Afternoon*, those enjoying themselves in the elaborately cultivated garden of André Brook, the Stettheimers' place in the country, are Marcel Duchamp, Edward Steichen, Adolph Bolm, the dancer, and Jo Davidson, the sculptor. And—an additional touch of esthetic distancing—Stettheimer herself seems to have seen these gatherings as justified by her transformation of them into works of art. In a poem of about 1917, recorded in her diary and later published in the *Crystal Flowers*, she says: "Our Parties/ Our Picnics/ Our Banquets/ Our Friends/ Have at last—a raison d'être/ Seen in color and design/ It amuses me/ To recreate them/ To paint them."[9]

Indeed, far from looking like an art of social purpose, Stettheimer's paintings seem as though they might best be considered an expression of camp sensibility at its highest—the figures weightless, sinuous and androgynous; the settings unswervingly theatrical; the inherent populism or even vulgarity of some subjects, like *Beauty Contest, to the Memory of P. T. Barnum*[10] of 1924 or *Spring Sale at Bendel's* of 1922, mediated by a pictorial structure fantastically Rococo, distanced by decorative reiteration. And camp sensibility, defined by Susan Sontag in her seminal article of 1964 as "a certain mode of aestheticism," of seeing the world in terms of a degree of artifice, of stylization[11] (a definition which serves admirably to sum up Stettheimer's pictorial expression), is explicitly contrasted by Sontag with artistic attitudes of deep social concern and awareness. She

Florine Stettheimer, *Beauty Contest, to the Memory of P. T. Barnum*, 1924.
Oil on canvas, 50 × 60 in. (127 × 152.4 cm)

sees camp sensibility as opposing both the moralism of high culture and the tension between moral and esthetic passion which she finds characteristic of avant-garde art; it is, in her phrase, "wholly esthetic."[12] "It goes without saying," she asserts, "that the Camp sensibility is disengaged, depoliticized—or at least apolitical."[13]

Yet in insisting on the explicitly *social* impulse behind Stettheimer's art while pointing out its overtly camp qualities, I am not being merely paradoxical. Rather, it seems to me that events and shifts of ideological position in the more than fifteen years since "Notes on 'Camp'" appeared—above all, that striking redefinition of what is generally considered to be social and political in import rather than private or even esthetic, a change effected, largely by public and militant activism of blacks, women and gays (the very territory of camp itself, from *Prancing Nigger* to the present)—have made us far more aware of an actively subversive component inherent to camp sensibility itself. This subversiveness may be quite validly viewed as social or political commitment in its own right.

In 1980, there is justification for seeing camp—in many ways a fiercer and more self-assured continuation of the half-petulant, half-parodic foot-stamping poses of *fin-de-siècle* decadence—as a kind of permanent revolution of self-mocking sensibility against the strictures of a patriarchal tradition and the solemn, formalist teleology of vanguardism. This recent transformation of the ideological implications of camp is itself a good reason for taking seriously a notion like that of the "social consciousness" of Stettheimer.

When we get down to looking at the artist and her work concretely and in detail, however, we might do better to view her reconciliation of social awareness and a highly wrought camp vision of life as simply one of a number of paradoxes inherent to her nature and her situation. First of all, she was both an insider and an outsider: comfortably wealthy, a giver of parties, a friend of many interesting and famous people, but Jewish (and, as the pages of her diary reveal, very aware of it); and, although an artist, a very private artist, known only to a rather special group of admirers, and a woman artist at that. Secondly, she was a determined feminist, yet equally determined to be feminine in the most conventional sense of the term: her bedroom was a dream-construction of lace and cellophane, her clothing and demeanor ladylike; yet at the same time, she was capable of voicing in her poetry a quite outspoken and prickly antagonism toward male domination. One such poem, published in the posthumous volume of her verse, *Crystal Flowers*, is an ironic musing on models: "Must one have models/ must one have models forever/ nude ones/ draped ones/ costumed ones/ 'The Blue Hat'/ 'The Yellow Shawl'/, 'The Patent Leather Slippers'/ Possibly men painters really/ need them—they created them."[14] Still another, titled "To a Gentleman Friend," begins, quite startlingly: "You fooled me you little floating worm ...";[15] while another, more poignant and untitled, sums up bitterly the self-muting deception forced on women by the men who admire them: "Occasionally/ A human being/ Saw my light/ Rushed in/ Got singed/ Got scared/ Rushed out/ Called fire/ Or it happened/ That he tried/ To subdue it/ Or it happened/ He tried to extinguish it/ Never did a friend/ Enjoy it/ The way it was/ So I learned to/ Turn it low/ Turn it out/ When I meet a stranger—/ Out of courtesy/ I turn on a soft/ Pink light/ Which is found modest/ Even charming/ It is a protection/ Against wear/ And tears/ And when/ I am rid of/ The Always-to-be-Stranger/ I turn on my light/ And become myself."[16]

Self-contradictions abound in the Stettheimer personality and outlook. She was a snob but an ardent New Dealer, a fanatic party-giver who in her diary complained of a particularly spectacular party given in her honor that "it was enough to make a socialist of any human being with a mind." Some of these contradictory stances are admittedly trivial; others are less paradoxical than they seem. For a woman, for instance, the boundaries between subjective preoccupation and social awareness are by no means absolute; at times they effectively coincide. Then again, both the snob and the social activist share a highly developed sensitivity to the defining characteristics of class and milieu. And finally, and perhaps most important in separating apparent contradiction

from the real variety, although Florine Stettheimer may have gloried in *artifice*—that is to say, the authentic and deliberate creation of fantasy through suitably recondite means— she absolutely loathed *phoniness*, that pretentious public display of false feeling she associated with the high culture establishment. Two of the most significant poems in the *Crystal Flowers* make this distinction perfectly clear, and, at the same time, together, are a perfect paradigm of the loves and hates of camp sensibility. One the one hand, "I hate Beethoven": "Oh horrors!/ I hate Beethoven/ And I was brought up/ To revere him/ Adore him/ Oh horrors/ I hate Beethoven// I am hearing the/ 5th Symphony/ Led by Stokowsky/ It's being done heroically/ Cheerfully pompous/ Insistently infallible/ It says assertively/ Ja-Ja-Ja-Ja/Jawohl—Jawohl/ Pflicht—!—Pflicht!/ Jawohl!/ Herrliche!/ Pflicht!/ Deutsche Pflicht/ Ja-Ja-Ja-Ja/ And heads nod/ In the German way/ Devoutly—/ affirmatively/ Oh—horrors."[17]

Pomposity, dutifulness, the heavy, automatic response to an implicitly patriar- chal infallibility—such are the things which fill Florine Stettheimer with horror. What inspires her with delight is the very opposite of all that is heavy, dutiful, solemn or imposed by authority; she articulates her loves in a hymn to lightness, lace, feminine sensibility and the goddess of it, her mother; a paean to the adored textures, sounds and *objets d'art* of childhood: "And Things I loved—/ Mother in a low-cut dress/ Her neck like alabaster/ A laced up bodice of Veronese green/ A skirt all puffs of deeper shades/ With flounces of point lace/ Shawls of Blonde and Chantilly/ Fichues of Honeton and Point d'Esprit/ A silk jewel box painted with morning glories/ Filled with ropes of Roman pearls/ ...Embroidered dresses of while Marseilles/ Adored sash of pale watered silk/ Ribbons with gay Roman stripes/ A carpet strewn with flower bouquets/ Sèvres vases and gilt console tables/ Mother reading us fairy tales/ When sick in bed with childhood ills—/ All loved and unforgettable thrills."[18] Mother, lace and fairy tales belong to the cherished world of dream-artifice; Beethoven, German solemnity, and hollow affirma- tion to that of dreary falsehood: nowhere is she more forthright about the distinction.

With that distinction in mind, one might well raise some questions about conven- tional notions of an art of social concern itself, especially as these have recently been articulated in our own country. Must a public art of this kind be solemn, pompous and alienated? Or can it, on the contrary, be personal, witty and satirical? Can one's friends and family be seen as participants in history, and, conversely, can the major figures of history be envisioned as intimates, as part of one's own experience? Is it possible for imagination and reality to converge in a lively, problematic image of contemporary society? Must history, in other words, be conceived of as something idealized, distant and dead that happened to other people, or is it something that involves the self? And what, precisely, are the boundaries between the public and the private? Why has such a distinction been made in the creation of art? All these issues are raised, although hardly resolved, by the art of Florine Stettheimer.

On the simplest level of historical awareness and political conviction there is Florine Stettheimer's lifelong admiration for America and Americanness: her own kind of patriotism. Both *West Point of* 1917, now at the US Military Academy, and *New York* of 1918, in the collection of Virgil Thomson, offer examples of it warmed by the glow of the expatriate recently reunited with her birthplace—the Stettheimer sisters and their mother had returned to New York from Europe at the outbreak of the First World War. *West Point*, commemorating a visit of August 29, 1917, is a pictorial record—a topographically accurate continuous narrative—of the Stettheimers' trip to the Military Academy by Hudson Dayliner, by car, and on foot. The composition features the symbolic flag and eagle, and places George Washington—a lifelong idol of Florine's and perhaps, as father of her country, an apotheosis of the missing Stettheimer *père*—at the heart of the composition in the form of a bronze copy of the 1853 Union Square equestrian portrait by Henry Kirke Brown (which had recently been obtained by Clarence P Towne and dedicated in 1915). In *New York*, Washington plays a relatively minor role as a tiny statue in front of the Subtreasury, at the end of a long vista, but the painting is really an homage to another symbol of American grandeur: the Statue of Liberty. The painting, inspired by Woodrow Wilson's visit to the Peace Conference of 1918, is minutely detailed, and the historic implications of the panorama are underscored by the palpability of the statue, built up in relief of putty impasto covered with gold leaf, so that, literally as well as figuratively, Liberty stands out.[19]

Although Stettheimer can hardly be counted among the ranks of notable activists in the cause of racial equality, it is nevertheless true that black people figured quite regularly in her work, from the time of *Jenny and Genevieve* of about 1915 to that of *Four Saints in Three Acts*, the Gertrude Stein–Virgil Thomson opera for which she designed the sets and costumes in 1934. Her sympathy for black causes can, in addition, be inferred not merely from her work but from her close friendship with one of the staunchest supporters of black culture, the music critic, belle lettrist and bon vivant, Carl Van Vechten. One of the most ambitious and complex of all Florine Stettheimer's social investigations of the 1920s is devoted to a black environment, the segregated beach of *Asbury Park South*, now in the collection of Fisk University. The subject, which also inspired a poem,[20] may well have been suggested by Van Vechten, whose portrait she did in 1922, and who figures in the reviewing stand to the left in *Asbury Park South*.[21] An extraordinarily active promoter of black cultural interests, Van Vechten spent most of his free hours in Harlem literary salons and night clubs during the 20s. He loved and publicized jazz, which he maintained in his capacity as a music critic in 1924, was "the only music of value produced in America." The black writer James Weldon Johnson said in the early days of the negro literary and artistic renaissance that Carl Van Vechten, by means of his personal efforts and his articles in journals, did more than anyone else in the country to forward it. Walter White, founder of the NAACP (National Association for the Advancement of Colored People), was a close friend, as were literary figures

ABOVE
Florine Stettheimer,
Asbury Park South,
1920. Oil on canvas,
50 × 60⅛ in.
(127 × 152.7 cm)

RIGHT
Florine Stettheimer,
*Portrait of Carl Van
Vechten*, 1922. Oil on
canvas, 30½ × 26 in.
(77.5 × 66 cm)

like Langston Hughes, Countee Cullen and Zora Neale Hurston. In his later avatar as a photographer, Van Vechten created an extensive gallery of portraits of blacks prominent in the arts: he received an honorary doctorate in 1955 from Fisk University, to which he donated his collection of black musical literature and where he established the Florine Stettheimer Collection of Books on the Fine Arts.

The extent of Van Vechten's involvement with black culture was noted in the pages of *Vanity Fair* in the form of a caricature of the music critic in blackface by his friend Covarrubias, the Mexican draftsman; and a popular song of about 1924, "Go Harlem," advised its listeners to "'go inspectin' like Van Vechten." Van Vechten's parties were famous for their heady mixtures of blacks and celebrities; Bessie Smith might be found rubbing shoulders with Helena Rubinstein. Florine noted in the pages of her diary meeting Paul Robeson and Somerset Maugham at one of Carl and Fania's parties.[22] In 1926, Van Vechten published *Nigger Heaven*, a brilliant, poignant, unstereotyped and sexy novel about various social circles in Harlem, in which the author reveals the richness and authenticity of black culture and, at the same time, the tragedy that might ensue for the more educated members of Harlem society when they tried to enter the white world.[23] Van Vechten dedicated this work to the Stettheimer sisters, and Florine thanked him for her copy with a poem: "Darling Moses/ Your Black Chillun/ Are floundering/ In the sea/ /Gentle Moses/ / The waves don't part/ To let us Travel free/ / Holy Moses/ Lead us on/ To Happyland/ We'll follow/ Thee/ Dear Carlo, this is to you in admiration of your courage. Florine, West End August 1st, 1926."[24]

The impact of Van Vechten's passion for all aspects of black cultural expression was felt not only by Florine but also by his friend, Covarrubias, whose impressions of night life in Harlem appeared in *Vanity Fair* in the 1920s and were published as *Negro Drawings* in 1927. Certainly, these drawings offer stylistic parallels to the figure style of *Asbury Park South* in their sinuous compression and simplication of form, which Parker Tyler, in the case of Stettheimer's painting, has likened to Paleolithic art or Rhodesian rock paintings.[25] We may feel that works such as Covarrubias' or Stettheimer's are demeaning or caricatural, but at the time, they were viewed by both blacks and whites as homages to black elegance, grace and energy.[26] Florine's vision of blacks—campy, satirical and admiring at once, idiosyncratic, clearly a vision of high life and high times rather than of a worthy but unjustly treated proletariat—is very different melting pot, which informs the iconography of a work like Lucienne Bloch's mural *The Cycle of a Woman's Life* [p. 79], completed for the New York Women's House of Detention in 1936 under the New Deal. In some ways, today's sensibility is the way it stresses racial uniqueness and self-identification rather than brotherhood at the expense of authentic ethnicity, but here again, the issue of public versus private impression comes into question: Stettheimer's work is intended for a relatively restricted and, of course, voluntary audience. It does not preach or offer solace. The other is meant for a public place—a prison at that—and is therefore fated to uplift and to promulgate a consoling mythology.

But perhaps the most consistent and ambitious expressions of Stettheimer's social consciousness are the four *Cathedrals*, a series that engaged her intermittently from approximately 1929 until her death in 1944. All of them are in the Metropolitan Museum; all are large-scale—about 60 by 50 inches—and packed with incident. In these, her masterpieces, she ingeniously and inextricably mingles the realms of reality and fantasy observation and invention. The *Cathedrals* are grand, secular shrines dedicated to the celebration of American life, as exemplified in its most cosmopolitan, expansive, yet for Stettheimer, most intimately known city—New York. She subdivides this celebration of urban excitements into four major categories: the world of theater and film in the case of *Cathedrals of Broadway*, 1929 [p. 144]; the world of shops and high society in *Cathedrals of Fifth Avenue*, c. 1931; the world of money and politics in *Cathedrals of Wall Street*, c. 1939 [p. 145]; and finally, the world of art—her own particular world within New York—in the unfinished *Cathedrals of Art*. The compositions are centralized and hieratic, as befits secular icons presided over by contemporary cult figures, yet this centralization is never ponderous or static, but, on the contrary, airy and mobile, energized by fluid, swirling rhythms, animated by a weightless, breezy sort of dynamism. The iconography of the *Cathedrals* is both serious and lightheartedly outrageous, giving evidence of the artist's view that admiration and social criticism are far from mutually exclusive. The color is sparkling, the drawing soft and crackling at the same time. Each *Cathedral*, in addition to celebrating a permanent aspect of New York life, at the same time commemorates a particular event—in the case of *Cathedrals of Broadway*, for instance, the shift from silent films to talkies. In the center, golden Silence is roped off beneath a newsreel-gray image of Jimmy Walker opening the New York baseball season, while the blazing marquees of the Strand and the Roxy to left and right proclaim the advent of the talking film. The *Cathedrals of Fifth Avenue*, besides celebrating a society wedding and the glories of Hudnut's, Tiffany's, B Altman's, Maillard's and Delmonico's, is also a commemoration of Lindbergh's flight—the hero can be seen parading in an open car in the background to the left. In all of the *Cathedrals*, Florine, her sisters and her interesting friends figure prominently; they are part of New York's ongoing life, participants in historic occasions. In the *Cathedrals of Fifth Avenue*, for instance, above the hood of the car decorated with a dollar sign on the right, appear the artist and her sisters; between the family group and the wedding party are Charles Demuth, with Mrs. Valentine Dudensing and her daughter in front of him and Muriel Draper leaning on Max Ewing to his left. Arnold Genthe is photographing the ceremony, and Mrs. Walter Rosen stands next to him in yellow.[27]

Florine's celebration of her city finds close parallels, once more, in her poetry. Not only do several poems explicitly deal with the varied joys of the city, but in one untitled work the very explicitness of that loving celebration is reiterated: "My attitude is one of Love/ is all adoration/ for all the fringes/ all the color/ all tinsel creation/ I like slippers gold/ I like oysters cold/ and my garden of mixed flowers/ and the sky full of towers/

and traffic in the streets/ and Maillard's sweets/ and Bendel's clothes/ and Nat Lewis hose/ and Tappé's window arrays/ and crystal fixtures/ and my pictures/ and Walt Disney cartoons/ and colored balloons."[28]

Yet the *Cathedrals* depend upon more than mere affection and a sense of personal participation for their striking unity of feeling and design. Their complex yet highly readable structure may, indeed, strike a familiar chord. Despite basic differences of attitude too deep to go into, there is a strange and, as it were, distilled reminiscence of the murals of Diego Rivera in these works. A comparison with the revolutionary murals of the Mexican artist may seem farfetched or even perverse; nevertheless, the Ministry of Education frescoes in Mexico City were published in this country in 1929,[29] the year of the earliest of the *Cathedral* paintings, and certain common features may be observed to exist in Rivera's *The Billionaires* or his *Song of the Revolution* and Stettheimer's *Cathedrals of Broadway* or *Cathedrals of Wall Street*. It might also be kept in mind that both Stettheimer and Rivera had made extensive art-tours of Europe and had returned to their native lands thoroughly familiar with both traditional European artistic culture and the new pictorial experiments of the avant-garde. Both were highly responsive to the popular culture and folk art of their own nations. Both regarded their

Florine Stettheimer, *Cathedrals of Broadway*, 1929. Oil on canvas, 60⅛ × 50⅛ in. (152.7 × 127.3 cm)

native lands with critical and loving eyes, and both felt free, for the purposes of their message—and because both folk and vanguard art encouraged it—to incorporate verbal elements into the pictorial fabric of their works, a procedure which Stettheimer plays to the hilt in *Cathedrals of Fifth Avenue*, where "Tiffany's" is spelled out in jewels, "Altman's" in household furnishings and drygoods.

The third of the series, *Cathedrals of Wall Street*, signed and dated 1939 but probably finished after that date, is worth studying in considerable detail, partly because a good deal of material relating to its genesis is available, partly because it unites in a single, scintillating image so many of Stettheimer's responses to the social issues of her time, as well as her political commitments—in her own terms, of course. In *wall Street* big business confronts popular pageantry; the historic past confronts contemporary American life; her beloved New York shelters the major representatives of her equally beloved New Deal. The painting then is a satiric icon—almost Byzantine in its symmetry, frontality and golden effulgence—but an icon up-to-date and jazzy in its staccato rhythms and concrete detail; presiding over this icon are the Father, Son and Holy Ghost of a patriotic Trinity: Washington, Roosevelt and the American Eagle.

Florine Stettheimer, *Cathedrals of Wall Street, c.* 1939. Oil on canvas, 60 × 50 in. (152.4 × 127 cm)

Cathedrals of Wall Street is an homage to Mrs. Roosevelt, elegant in an Eleanor-blue gown in the center of the piece. She is escorted by Mayor LaGuardia, and is about to be thrilled by the "Star-Spangled Banner" intoned by Grace Moore, who stands to the right center. Among the other identified figures are Michael Ericson in an American Legion uniform; Michael J Sullivan, a Civil War veteran; Claget Wilson, and an Indian chief.[30] Yet perhaps primarily, *Cathedrals of Wall Street* is dedicated to the memory of George Washington; the artist herself is depicted offering his statue a bouquet inscribed "To George Washington from Florine St." at the far right. Stettheimer's affection for the father of her country was longstanding, going back at least as far as the outbreak of the First World War. The sitting-room in her Beaux-Arts apartment included a bust of Washington enshrined in a niche. The pages of her diary make reverent reference to painting the figure of Washington in *Cathedrals of Wall Street* on the anniversary of his birth. She notes: "Feb. 22. *Washington's Day* 1939—I put lots of gold on Washington"; on February 22, 1940: "Washington's day—Painted all day—Washington in the painting."

As far as the Roosevelts were concerned, her affections, though of more recent vintage, were not less fervent. Evidently, she wanted Van Vechten to introduce her to Mrs. Roosevelt because she so admired her, and of course, wished to put her into her painting, but Van Vechten evidently did not know the First Lady.[31] Florine was an ardent supporter of FDR. In her diary she notes: "Nov. Fifth 1940—Have just registered my vote for Roosevelt;" on the 6th: "I took off my tel. receiver at seven A.M.—'Roosevelt' said the voice instead of 'good morning'"; on January 2, 1941: "Inauguration Day—Thank goodness it came off—heard oath and speech...." On October 24, 1940, she had noted with dismay: "McBride and Clagg [Clagget Wilson] for Wilkie oh horrors! Showed them Cathedrals of Wall Street and Clagg in marine uniform in it."

The date inscribed on the painting suggests still further and even more concrete memorial connections. Nineteen-thirty-nine was the year dedicated to celebrating the 150th anniversary of George Washington's inauguration in New York. In *George Washington in New York*, a far less ambitious work which, done in the same year, may well be related to *Cathedrals of Wall Street*, Stettheimer makes her point by simply juxtaposing a bust of George with the New York skyline. The inauguration had taken place just where she set her Wall Street painting, on the steps of the old Subtreasury building, then Federal Hall, at Wall and Nassau Streets, a site marked by John Quincy Adams Ward's 1883 bronze statue of Washington, so prominently featured in the painting. The major civic event of 1939, the New York World's Fair, like *Cathedrals of Wall Street*, was planned to commemorate this momentous occasion, and, like the painting, was intended as a tribute to the father of our country, as the cover of the special "World's Fair Supplement" to the *New York Times* magazine section clearly indicates.

The first diary notations about *Cathedrals of Wall Street* occur in 1938, when plans for various First Inaugural commemorations, and, of course, for the New York World's

Fair, the biggest celebration of Washington's inauguration of all, were well under way. On April 18 of that year, Florine makes reference to putting Grace Moore singing "The Star Spangled Banner" into *Wall Street*, and to meeting the celebrated singer at Rose Laird's beauty salon. On April 19, she notes: "Started to stain the outlines of my new painting 'Cathedrals of Wall Street.'" She was evidently still working on it well into 1940, when, according to notations in her diary, she went to visit the Stock Exchange and had her friend, the lawyer Joseph Solomon, bring her ticker tape to copy. The date 1939 inscribed on the painting, then, refers to the event it commemorates rather than the year the painting was actually completed.

All during the period preceding the inauguration celebrations, sources of inspiration for the artist's project offered themselves in the press. For example, although it is not specifically related to the Washington festivities themselves, a major illustrated article by Elliot V Bell titled "What is Wall Street?," which ran in the *New York Times* of January 2, 1938, almost sounds like a description of the subject and setting of Stettheimer's painting. The writer discusses the new focus of attention which has shifted to Wall Street in order to counteract the business depression, and includes what might be considered a verbal equivalent of major features of the canvas: "The geographical center of the district lies at the intersection where Broad Street ends and Nassan Street begins. Here on one corner stands the Stock Exchange, on another J. P. Morgan's and on a third the moded temple of the old United States Subtreasury upon which the statue of George Washington stands with lifted hand to mark the site where the first President on April 30, 1789, took the oath of office...."[32] On April 30, 1938, the *New York Times* ran an illustrated account of "A patriotic ceremony in Wall Street," subtitled "A view of the exercises in front of the Subtreasury Building yesterday commemoring the inauguration of George Washington as the first President of the United States." The report went on to describe the representatives of many patriotic organizations, military and naval groups with their massed color which had joined the previous day in commemorating the first inauguration which had taken place 149 years ago. The accompanying photograph is remarkably similar to the right-hand portion of Stettheimer's painting.[33]

In April of the following year, 1939, the 150th anniversary of the occasion, an eight-day reenactment of Washington's celebrated trip from Mount Vernon to New York took place, with the participants decked out in 18th-century costume, traveling from Virginia to New York in a 160-year-old coach and crossing from New Jersey to Manhattan by barge. On April 30, Inauguration Day itself, there was a ceremony in front of Federal Hall during which wreaths like the ones in Stettheimer's painting were reverently laid at the feet of Washington's statue; all the patriotic societies paraded, and, according to the *New York Times* report, "the nearly empty financial district...echoed and reechoed the blaring music of military bands."[34] Denys Wortman, as artist and cartoonist who took the part of Washington, was received by Mayor LaGuardia at City Hall.[35]

None of these celebrations could, however, match in elaborateness or scale the climatic event of the eight-day journey—the reenactment of the First Inaugural. The reconstructed ceremony took place beneath the colossal 68-foot-high statue of the Father of Our Country on Constitution Mall as part of the opening day festivities on April 30 of the New York World's Fair; Denys Wortman and his costumed entourage were whisked from Manhattan to Flushing Meadows by speedboat for the occasion.[36]

All these events must have struck an answering spark in the breast of someone who admired Washington as much as Florine Stettheimer did, and many of the reports and announcements of these happenings were illustrated with drawings and photographs which may well have added fuel to the fire. One can imagine Stettheimer's enthusiasm for a commemoration which united her favorite historic personage with her favorite contemporary entertainment—George Washington with the World's Fair. And she adored the Fair, visited it almost daily during the spring and summer of 1939, and, according to her sister Ettie, hoped to be asked to commemorate it in her art, a hope which remained unfulfilled. *Cathedrals of Wall Street* must then serve by proxy as her pictorial tribute to the exuberance and optimism—alas, ill founded—with which the Fair approached the future.

At the same time, *Cathedrals of Wall Street* hardly seems to call down unmixed blessings on the present-day republic. George Washington seems a bit startled by the presence of Bernard Baruch, John D Rockefeller and JP Morgan in the pediment of the Stock Exchange. The ubiquity of gold seems to have more than Byzantine implications; it impinges on the very rays of light infiltrating the floor of the Exchange. And the juxtaposition of Salvation Army and Stock Exchange offers a trenchant pictorial paraphrase of George Bernard Shaw's pointed question from the end of *Major Barbara:* "What price salvation?" Washington is both the guardian of, and admittedly a bit peripheral to, the modern world of drum majorettes and high finance.

Stettheimer's final work in the *Cathedrals* series celebrated that aspect of New York achievement with which she was most intimately connected—the world of art. *Cathedrals of Art*, dated 1942 but left unfinished at the time of her death in 1944, is her ultimate pictorial statement about the inextricable connection between public and private, between the friends she cherished and the works of art to which they dedicated their lives. The grand, three-part setting, dominated by the red-carpeted main staircase of the old Metropolitan Museum, clearly distinguishes art *in* America, the province of the Museum of Modern Art (to the left), from *American* art, the realm of the Whitney Museum (to the right), with the Metropolitan Museum itself providing that overarching tradition which—spatially as well as chronologically—lies behind both. On the crossbar of the stretcher, in 1941, Florine identified the work as "Our Dawn of Art." And indeed, in the foreground, baby Art—based on a recently acquired statue of Eros, depicted here as born drawing—is being photographed by George Platt Lynes in a blaze of light,

while being worshiped by a female art-lover to his right.[37] Baby Art ascends the stairs, hand-in-hand with the Metropolitan's director, Francis Henry Taylor, to join curator of paintings Harry B Wehle, standing at the top of the stairs with a young woman holding a clearly labeled "prize." The red-carpeted staircase is flanked by museum directors, critics and art-dealers; perhaps a certain reminiscence of Raphael's *School of Athens* gives added resonance to the composition. Among the art-world notables present are Alfred Stieglitz on the staircase to the left, grandly cloaked and turning his profile upward to follow youthful Art's progress; A Everett (Chick) Austin Jr., enterprising director of the Wadsworth Atheneum, standing with folded arms at the base of the left-hand column inscribed "Art in America"; his counterpart at the base of the right-hand column, inscribed "American Art," is Stettheimer's friend and supporter, the critic Henry McBride, with "Stop" and "Go" signs in his hand.

In the center of the composition, Francis Henry Taylor leads the infant to the high altar of the Cathedral of Art in the form of a portrait, perhaps reminiscent of Mrs. Stettheimer, by one of the artists whom Florine most admired, Frans Hals. This sedate and portly figure from the past is set in opposition to a sprightly and up-to-date young female figure, also directly on central axis, labeled "cocktail dress"—perhaps meant to represent the modern feminine ideal as opposed to the more traditional one.[38]

In the left-hand "panel" of what might well be considered a triptych, Art plays hop-scotch on a Mondrian laid out at the feet of Alfred Barr Jr., seated most appropriately in what looks like a Corbusier chair before two striking Picassos. Immediately beneath Barr, the two *Women on the Beach* break loose from their canvas in front of the Douanier Rousseau's lion. In the upper part of the right-hand "panel," dedicated to the Whitney Museum, stands Juliana Force in front of a sculptured figure by Gertrude Vanderbilt Whitney, guarded by an American eagle. To the lower right and lower left foreground, isolated by a screen and a white-and-gold lily-topped canopy respectively, stand Robert Locher (an old friend), and Stettheimer herself, as *compère* and *commère* of the specta-cle—an idea, incidentally, that the artist probably derived from *Four Saints in Three Acts*. The two figure as patron saints or intercessors between the world of art and its audience. *Cathedrals of Art*, then, is not only a tribute to art but to New York's art institutions and to the people who run them. The only other painting about art that is as original in both its richness of allusion and its sense of intimate personal involvement is of course Courbet's *Painter's Studio*. Like Courbet's *Studio*, *Cathedrals of Art* is an *allégorie réelle*, an allegory that takes its terms from experienced reality, and as such, like Courbet's work, it emphasizes the role of friendship, of mutual support and of contemporary inventiveness in sustaining a living art.

In "Public Use of Art," an important article which appeared in *Art Front* in 1936, Meyer Schapiro inveighed against the public murals of the New Deal, seeing in "their seemingly neutral glorification of work, progress and national history the instruments of a class"—the dominating class of the nation. "The conceptions of such mural

paintings," Schapiro maintained, "rooted in naïve, sentimental ideas of social reality, cannot help betray the utmost banality and poverty of invention."[39] While one may feel that Schapiro is too sweeping in his condemnation of the public art of his day, and that Stettheimer's playful, and in many ways, arcane creations hardly offer a totally viable alternative to the mural programs sponsored under the New Deal, his criticism is nevertheless relevant to Stettheimer's art. Her ideas of social reality, if idiosyncratic, are neither naïve nor sentimental, her pictorial invention the opposite of "banal" or "poor." Nor is her vision, in *Cathedrals of Art*, totally affirmative.

Beneath the glowing admiration for American institutions and personae in this work, as in the other paintings of the *Cathedral* series, exists a pointed and knowing critique of them as well. The *Cathedrals*, as I have indicated, are by no means pure affirmations of American, or even New York, values. The most effective revelations of social reality are not necessarily either intentional or from the left, as both Engels and Georg Lukács have reminded us. Balzac, upholder of monarchy, was in fact the most acute and critical analyst of the social reality of his time. Look again at *Wall Street*; or look again at the *Cathedrals of Art*, with each little chieftain smugly ensconced in his or her domain, the dealers feverishly waving their artists' balloons or clutching their wares, the critic with his mechanical signals, the avid photographers—and the blinded, worshipful public.

Florine Stettheimer, the artist, existed in this world, it is true, but still somewhat apart from it—as her painting exists apart from the major currents of her time. She knew herself to be, as an artist, a peripheral if cherished figure, unappreciated and unbought by the broader public. She may indeed, in her discreet way, have felt rather bitter about this larger neglect. After a disastrous exhibition at Knoedler's in 1916, although she would often show a work or two at group shows at the Whitney, the Carnegie Institute or the Society of Independent Artists, she never had a major retrospective until 1946, after her death.[40]

In a poem from *Crystal Flowers*, Stettheimer succinctly sums up the position of art in a capitalist society: "Art is spelled with a capital A/ And capital also backs it/ Ignorance also makes it sway/ The chief thing is to make it pay/ In a quite dizzy way/ Hurrah—Hurrah—."[41] Here, certainly, is social consciousness about art if ever there was.

Notes

1 The major sources of information about Florine Stettheimer are the exhibition catalogue, *Florine Stettheimer* (1946), Henry McBride, ed., New, York: Museum of Modern Art; and Parker Tyler (1963), *Florine Stettheimer: A Life in Art*, New York: Farrar, Strauss & Giroux. In addition, the Florine Stettheimer archive in the Beinecke Rare Book and Manuscript Library of Yale University contains a manuscript (unfortunately mutilated by her sister Ettie's scissors) of Florine's diary, as well as typed and manuscript versions of her poetry. Recent publications include the exhibition catalogues, *Florine Stettheimer: An Exhibition of paintings, Watercolors, Drawings* (1973), New York: Low Memorial Library, Columbia University; *Florine Stettheimer: Still Lifes, Portraits and Pageants 1910 to 1942* (1980), Boston, MA: Institute of Contemporary Art;

and an article by Barbara Zucker (1977), "Autobiography of visual poems," *ARTnews*, February, pp. 68–73.

2 *Philosophy/An Autobiographical Fragment* was originally published in 1917; *Love Days* in 1923. Both were republished along with a group of short stories and an English translation of her doctoral dissertation, written in 1907 for Freiburg University, on William James' "The Will to Believe," in Ettie Stettheimer (1951) *Memorial Volume of and by Ettie Stettheimer*, New York: Alfred A Knopf.

3 Stettheimer also painted an individual *Portrait of My Mother* (1925), her best work in the opinion of Henry McBride (MOMA catalogue, 1946, p. 39).

4 For a somewhat different interpretation of the significance of the bouquet, see Tyler, *Florine Stettheimer*, p. 15.

5 Florine Stettheimer (1949), *Crystal Flowers*, New York. This edition of Florine's verses was published after her death by her sister Ettie, who also provided an introduction.

6 All references to the diary refer to the manuscript in the Beinecke Rare Book and Manuscript Library, mentioned in note 1 above. Her comments range from remarks on the Aegina Pediment in Munich, and her ideas and feelings about the old masters viewed on visits to Italian churches, museums and palaces in 1906, to comments on a Rodin exhibition in 1910 and on some Franz von Stücks seen at the Munich Secession. In 1912, she notes, on a trip to Madrid, that "the beauty of the Titian Venus and the Danae" is "intoxicatingly beautiful," and that *Las Meninas*, to her surprise, "had the quality of realism attributed to it by those who write about it." In Toledo, she admits that she doesn't think El Greco so marvelous. In Paris she exclaims: "I can't bear Carpeaux. His Hugolin [sic] is stupid...," and declares Regnault's *Salome*, now in the Metropolitan Museum, "an abomination." She admires Manet and declares Monet's "new Venice painting the most attractive thing he has done so far." Her reaction to Gustave Moreau's work is measured. In 1913, she notes a very good loan show of Van Gogh flowers.

7 Miss Fish was an extremely popular cartoonist for the cognoscenti, who read *Vanity Fair*. A full-page advertisement for her *High Society: A Book of Satirical Drawings* (1920), which appeared in *Vanity Fair*,

November, p. 24, claimed that "'High Society' is the smartest book of the season," and that "...the patterns of the flappers' frocks are like laces and hangings by Beardsley." There has been an exhibition of Miss Fish's work in New York recently, but I have been unable to locate a reference to it.

8 Stettheimer, *Crystal Flowers*, introduction, p. iii.

9 MS version, Beinecke Library, dated *c*. 1917.

10 For a fuller discussion of *Beauty Contest*, see Ann Sutherland Harris and Linda Nochlin (1976), *Women Artists: 1550–1950*, catalogue, Los Angeles, CA: Los Angeles County Museum of Art, p. 267.

11 Susan Sontag (1966), "Notes on 'Camp'" (1964), in *Against Interpretation and Other Essays*, New York: Farrar, Strauss & Giroux, p. 277.

12 Ibid., p. 287.

13 Ibid., p. 277. For a more recent and equally provocative discussion of camp and associated issues, see Brigid Brophy's (1973) *Prancing Novelist: A Defence of Fiction in the Form of a Critical Biography in Praise of Ronald Firbank*, New York: Barnes & Noble, especially pp. 171–73; but also 406–7 for the social subversiveness of Wilde and Firbank's fictions, their emancipation of women and proletarians: and pp. 551–59 for Firbank's *Prancing Nigger*.

14 Stettheimer, *Crystal Flowers*, p. 78. Florine did not intend her poems for publication. This assumption of privacy may have something to do with their remarkable frankness.

15 Ibid., p. 43.

16 Ibid., p. 42.

17 This version of the poem and its punctuation are taken from the MS in the Beinecke Library, IV–VI.

18 MS, Beinecke Library, VII–IX.

19 For a poem related to this painting, beginning: "Then back to New York...," see Stettheimer, *Crystal Flowers*, p. 79.

20 MS, Beinecke, IV–VI. "Asbury Park" begins: "It swings/it rings/it's full of noisy things..."

21 Other friends present are: Van Vechten's wife, the actress, Fania Marinoff, Marcel Duchamp, Avery Hopwood, Paul Thenevaz.

22 Most of the information about Van Vechten is obtained from Bruce Kellner's (1968) excellent *Carl Van Vechten and the Irreverent Decades*, Norman, OK: University of Oklahoma Press. For a different, far more critical view of Van Vechten's relationship to

Harlem and black culture, see Nathan Irvin Higgins (1971), *Harlem Renaissance*, Oxford and New York: Oxford University Press, pp. 93–118. Not surprisingly, Van Vechten was not only an aficionado of black culture, but also the major promoter of Ronald Firbank in the US (Higgins, *Harlem Renaissance*, p. 95). It was Van Vechten who convinced Firbank to change the title of his *Sorrow in Sunlight* to *Prancing Nigger* when it was published in the US (Higgins, *Harlem Renaissance*, p. 112).

23 Sec Kellner, *Carl Van Vechten*, p. 202.

24 MS, Beinecke, VII–IX. Evidently, Carl Van Vechten typed up copies of Florine's letters to him—those about his books—and sent them, after Florine's death, to her sister Ettie.

25 Tyler, *Florine Stettheimer*, p. 131.

26 See, for instance, the introduction to Miguel Covarrubias (1927), *Negro Drawings*, New York: Alfred A Knopf, by Frank Crowninshield, in which it is claimed that Covarrubias is "the first important artist in America...to bestow upon our Negro anything like the reverent attention...which Gauguin bestowed upon the natives of the South Seas." (np).

27 These identifications appear in the Stettheimer archives in the Metropolitan Museum, New York. They seem to follow those established by Henry McBride (1946), MoMA catalogue, table of contents.

28 Stettheimer, *Crystal Flowers*, p. 23.

29 See *The Frescoes of Diego Rivera* (1929), introduction by E Evans, New York: Harcourt Brace & Co.

30 Identifications from McBride, *Florine Stettheimer*, p. 48, and Stettheimer archives, Metropolitan Museum, New York. I have been unable to discover any account, in either newspapers or biographies of the First Lady, of a visit by Mrs Roosevelt to Wall Street at the time the painting was begun. Perhaps further investigation will reveal such a visitation; until then, one might best consider it an invention of Stettheimer's.

31 Tyler, *Florine Stettheimer*, p. 107.

32 *New York Times Magazine*, January 2, 1938. The piece begins with a consideration of government credit expansion, "tried to the tune of $20,000,000,000." Could this figure be a clue to the meaning of the "19,000,000,000" inscribed to the left and right of Roosevelt's

head in the painting? It is close, if not exact. The article continues with a description of the "...blackened spires of Trinity Church," as opposed to the "sun lit docks of the East River...," and refers to the "...itinerant preachers [who] often take their stand outside the Bankers' Trust at the corner of Wall and Nassau Streets, exhorting the noon-time crowds of clerks and office boys to forsake Mammon and return to God...," in roughly the same spot that Stettheimer placed her Salvation Army "Glory Hole."

33 *New York Times*, April 30, 1938, p. 3.

34 *New York Times*, May 1, 1939, p. 8.

35 See such articles as "Reenactment..." (1939), *New York Times*, April 25, p. 3, and "In Washington's footsteps" (1919), by HI Broch, *New York Times Magazine*, April 30, p. 6, as well as accounts in *New York Times*, May 1, 1939, p. 8.

36 *New York Times*, May 1, 1939, p. 8, with a photograph of the ceremony.

37 Once more, the identifications are from McBride (1946), MoMA catalogue, p. 53, and the Metropolitan Museum archive. For a lengthier discussion, see Tyler, *Florine Stettheimer*, pp. 74–78.

38 I have not been able to run down any specific incident which may be said to have "inspired" the *Cathedrals of Art*. There are, however, several possibilities that may have contributed to its genesis: for example, the recent appointment of Francis Henry Taylor as director on January 8, 1940; the reinstallation of the paintings in almost all the galleries, a project nearing completion in August 1941 (*Bulletin of the Metropolitan Museum*, August 1941, pp. 163–65); or a contemporary costume show, held in the museum shortly before the artist began her painting, which featured a "cocktail dress like the one that figures so prominently in her work." (Tyler, *Florine Stettheimer*, p. 74).

39 Meyer Schapiro (1936), "Public Use of Art," *Art Front*, November, p. 6. I am grateful to Dr Greta Berman for calling this article to my attention.

40 A third exhibition, *Flowers of Florine Stettheimer*, organized by Kirk Askew Jr, was held at Durlacher Brothers, New York, in 1948.

41 Stettheimer, *Crystal Flowers*, p. 26.

6

Nancy Graves:
The Subversiveness of Sculpture

Nancy Graves: Painting, Sculpture, Drawing, 1980–1985,
Vassar College Art Gallery, 1986

Nancy Graves once said, in the context of a discussion of her sculpture, "...I try to subvert what is logical, what the eye would expect." This subversive impulse seems to me central to Graves' achievement, her achievement as a painter as well as a sculptor, I might add.

The enterprise of modern art has, of course, involved and invited subversion since early in the 20th century; in its strongest manifestations, this subversive impulse has constituted itself as anti-art. The question to ask in this strategy of subversion is often "What if...?" Marcel Duchamp, in 1917, asked: "What if I claim that a urinal is art because I sign it R. Mutt, call it 'Fountain', show it in a gallery, and say it is art?" In so doing, he revealed the arbitrary status of all art. Picasso asked a different question about the relationship between art and object in a work like his 1951 *Baboon and Young*. "What if I say a child's car is a baboon's head and that, through this metamorphosis, it constitutes an element of sculpture?" Picasso's subversive strategy, in this case, is the opposite of Duchamp's: through his transformation of a mere toy into sculpture, he has revealed the arbitrary status of non-art. Even earlier, at the beginning of the 20th century, vanguard artists had asked a related, subversive question, about what we now think of, and admire, as "primitive" art: "What if...these musty artifacts, these idols, footstools, canoe paddles, war-clubs, and totems, crowded together helter-skelter in the display cases of the ethnographic museum or the Museum of Natural History...what if these bizarre objects were, in fact—Art"? This question was, of course, "decided" early in the 20th century, when Derain, Picasso, Braque, Matisse, etc., revised the status of the "primitive" object by incorporating its strategies into their own work, thereby moving it from the dusty shelves of the natural history museum to the more inviting spaces of the art gallery.

In the late 1960s, Nancy Graves in effect asked the question: "What if...I took a camel out of the Museum of Natural History and put it into an Art context...but..." (and here she added to the complexity of the subversion, in a way *cancelling* the initial impulse) "...what if I actually *made* the camel from start to finish?" From the very beginning, Graves' art reveals its foundations in current conceptual discourse, one of

its great strengths, I believe. In the case of the *Camels* series, the move from a natural history context to a high art context, by then an established move in the repertory of 20th-century subversive strategies, is then itself undermined by the willed, long-term productive process of the artist, a process that involved learning about anatomy and archaeology; research in libraries and museums, in slaughterhouses and in the desert; and the deliberate acquisition of a certain technology, involving the study of carpentry and the final, painstaking construction of the beasts on wooden armatures filled with polyurethane and burlap, upholstered with actual animal hides, transformed into art-materials by cutting and the application of oil paint.

Now obviously, if Graves had wanted to pull the old Duchampian trick of demonstrating the arbitrariness of the category of high art, she could have easily bought a stuffed camel from a taxidermist, signed it, and wheeled it into an art gallery. With the same gesture, and without providing the sculptural object, she could have attempted to demonstrate (as the early primitivists had at the beginning of the century), the opposite claim: that what had previously been assigned to the category of "non-art" in the Natural History Museum, in this case, a stuffed camel, if properly responded to in terms of its formal and expressive qualities, deserved to be considered a valuable work of art. In other words, a taxidermist's creation could, through the power of the enlightened gaze, be transformed into an esthetic object.

But Nancy Graves rejected both these subversive strategies, which indeed had outworn their subversiveness in the context of American vanguard sculpture of the late 1960s. Instead, we might pose her camel question as follows: "What if...I constructed a sculptural object that on the one hand relates to reality and illusion like

Nancy Graves, *Camels, VI, VII, VIII*, 1969.
Wood, steel, burlap, polyurethane, animal skin, wax, oil paint,
VI: 90 × 144 × 48 in. (228.6 × 365.8 × 121.9 cm), *VII*: 96 × 108 × 48 in. (243.8 × 274.3 × 121.9 cm), *VIII*: 90 × 120 × 48 in. (228.6 × 304.8 × 121.9 cm)

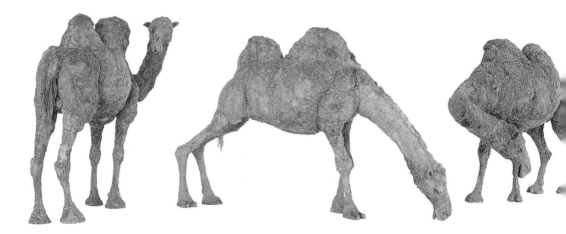

a representational work, but, on the other hand, is produced and constructed, and relates to the spatial and conceptual situation of the gallery like an abstract work?" What, then, is the status of a piece which ultimately bodies forth, in the most concrete terms possible, not the representation of any particular camel, but the more abstract category of "camelness"? Graves' constructed camels are, paradoxically, more camel-like than any individual camel might be. On the other hand, after a moment or two of contemplation, no one could possibly mistake a Graves *Camel* for a "real" stuffed camel: her works clearly exist as compelling simulacra, but simulacra which, in their insist-ent illusionism *and* their equally insistent assertion of their status as volume, surface, shape and texture, call into question the very opposition between a so-called "art" and a so-called "reality."

The subversiveness of Graves' *Camels* seems to me to lie in the fact that their status can never be satisfactorily resolved: they can never be defined as clearly art or as non-art; or by assigning them unequivocally to the category of representation or that of abstraction. Their relation to science or natural history is equally ambiguous: it is a relationship that is there but not there at the same time. Or rather, the boundaries between the activities of science—observation, research, systematic investigation, archaeological reconstruction—and those of art—invention, creation, construction, imaginative play—are purposely left undefined and open.

Indeed, one might go on to say that the subversiveness in all Graves' work lies in a determination to refuse boundaries, to undefine or blur and make ambiguous what had previously appeared to have clear categorical status; to refuse what appeared to be "obvious" exclusions or contradictions. They must, finally but not unequivocally, be considered conceptual works in the broadest sense of the term.

Graves' involvement with process is another aspect of her refusal of boundaries. There is a continuity in her work which has nothing to do with the superficial charac-teristics of style and everything to do with the generation of one set of investigations out of another. Refusing the customary boundaries between the organic-natural and the esthetic-constructed, she quite logically went on to make works based on camel bones between 1969 and 1971. In so doing, she was at the same time articulating a *formal* problem about the nature of the armature as support. She constructed the bone-forms out of wax on top of a steel armature and colored them with marble dust. But then Graves went on to question the very status of armature-as-support by scattering, hanging or propping the camel bones around the gallery space. In a work like *Fossils* [p. 156] of 1970, bones are scattered on the floor, calling into question still another assumption of high art: the relation of the spectator to the work and the traditional positioning of the viewer, the confrontation of a work on a base as a unique object. She goes still further in boundary-testing in relation to the support system of sculpture in *Calipers* of 1970 [p. 156], in which she now uses the quarter-steel rods which had previously functioned as armature as the sculptural forms themselves, the skeleton of the skeletons, as it

LEFT Nancy Graves, *Fossils*, 1970. Plaster dust, marble dust, acrylic and steel, 36 × 300 × 300 in. (91.4 × 762 × 762 cm)

BELOW Nancy Graves, *Calipers*, 1970. Hot-rolled steel, 12 × 120 × 180 in. (30.5 × 304.8 × 457.2 cm)

Nancy Graves, *Shaman*, 1970.
Latex on muslin, wax, steel, copper, aluminum wire, gauze, oil paint, marble dust and acrylic,
167¾ × 167¾ × 143¾ in. (426 × 426 × 365 cm)

were. The rods are scattered so that they overlap on the floor, like the camel bones they served as support for; yet they are, as the title suggests, related to the abstract function of measurement. When the rods rusted, they left rust marks on the floor, reminding Graves of *shadow*, measurement and drawing at once, which she in turn used in her next works, transformed into physical concretion. Such a work is *Cast Shadow Reflecting from Four Sides*. At the far end of process, the shadows might take off from the ground and assume the status of fragile, totemic, sometimes anthropomorphic forms, as in *Shaman* of 1970. All these works seem to bear an evolutionary relationship to the camel pieces, despite the fact that they are empirically or stylistically quite different from them.

One of the climaxes of this "camel" period is certainly the cinematic work Graves devoted to this theme: *Goulamine* of 1970 and *Izy Boukir* of 1971. Made in Morocco, these films record every movement and feature of camels, filmed singly and in groups. But again, speaking of these films as "recording" camels, as though this were a scientific, ethnographic study of camel behavior, would be a mistake, although no doubt the student of camel physiology or camel behavior would appreciate them. Here again, Graves is concerned not merely with recording but with recording-as-making and

making as a process of creating. One might consider, for example, the way a relatively abstract pattern of repeated similarities is marked out by a structure of equally apparent differences; the way some partly taxonomical, partly esthetic quality of "camelness" is distilled from the endless and endlessly fascinating concrete data offered by a series of images of individual, even idiosyncratic camels. As is the case in her sculpture, Graves, in her films is concerned neither with gathering together pure information nor with creating pure form but with a *process* of making which is both and neither: in which the boundaries are open.

Making the films opened up further directions of exploration for Graves in her sculpture, and in work on paper as well. A work like *Variability and Repetition of Similar Forms II* of 1979, which consists of thirty-six freestanding, life-size camel legs, suggests, in three-dimensional, skeletal form, the underlying patterning and variability of movement offered by the camels in the films. The systems of information-exchange related to the logistics of camel-transportation are the subject of the schematic, and witty, drawing entitled *Signs Exchanged Between Ireteba, Sub-Chief of the Mojave, and Major Beale, Aboard the 'General Jessup', While Ferrying 16 Camels (Property of the U.S. Government) Across the Colorado River Near Needles, California, January, 1858.* In this

Nancy Graves, *Variability and Repetition of Similar Forms II*, 1979.
Bronze and COR-TEN steel, 72 × 192 × 144 in. (182.8 × 487.6 × 365.7 cm)

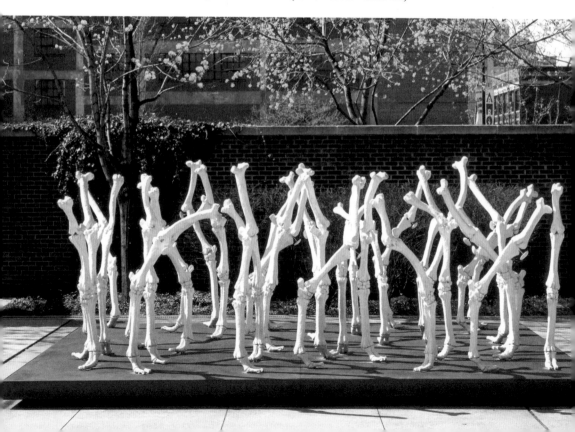

work—almost parodic in its evocation of precise historic specificity—a kind of chart indicating the hand signals for such essential elements of communication as "yes," "center," and "tobacco," the word "camel" never appears: the "real" camel is suggested as the unseen referent generating the whole system of sign-language which constitutes the work.

In her most recent pieces, Nancy Graves has been engaged in subverting the logic of modernist sculpture, at the same time that she extends the possibilities inherent in its discoveries. Using the method of direct casting, in which no mold is used and the cast object itself is "burned out" or destroyed in the kiln, Graves literally inserts the realm of the organic, the "thing-in-itself" into the realm of abstract shapes and forces that constitutes classical modernist sculptural practice. Yet the inserted plants, sardine skeletons, or net bags lose their original logic of meaning within the novel context provided by monumental sculpture, and assume a new, more lyrical and ambiguous life as relational terms in a complex, invented three-dimensional structure. Each form, of course, retains its individual character: the fans, the enormous leaves, the bubble-wrap, the lotus-pods are discernible beneath the brilliantly painted bronze surfaces. They are not meant to disappear completely, to be transformed out of existence as organic or manmade entities. Rather, Graves' work suggests, sculptural presence may come into being through the uninhibited intercourse, the imaginative recombination, of elements derived but liberated from their status as things in the world. The organic and the constructed again hang together in uneasy but invigorating proximity.

Issues of weight and balance seem to play a primary role in creating that sense of vital riskiness characteristic of Graves' recent sculpture. This riskiness, it seems to me, has to do with challenging the basic concepts of sculpture from Matisse through Calder and David Smith, while nevertheless making constant references to the tradition that is being called into question. The very notion of inscribing instability and ambiguity in bronze, the most traditional, weighty, and enduring of sculptural media, is unsettling, as is the notion of coloring its surfaces in a way that is patently, outrageously, pictorial, and therefore denies the weight and solidity of the medium.

In much of the recent sculpture, it is as though Graves is working toward disequilibrium: toward impossible systems of balance. The dynamic implications of a recent piece like *Trambulate* of 1984 [p. 160] depend chiefly on the unsettlingly centrifugal organization of the sculptural elements. It seems as though these assembled fans, sardine skeletons, chains and convoluted, snaky swirls of polychrome bronze cannot possibly maintain their precarious equilibrium; the wheeled form, pushing off to the right increases this sense of stimulating instability, as does the brilliant, painterly, weight-denying color of the surfaces. The arm-like, branch-like, wing-like element at the top reaches rashly upward and outward, as though poised for flight, or flying apart. Process, mobility, the potential for taking off into space are suggested by the very title, *Trambulate*, with its overtones of ambulation, tram-travel, and tramping; but, like the

Nancy Graves, *Trambulate*, 1984.
Bronze and carbon steel with polyurethane paint and baked enamel,
86½ × 71 × 38 in. (219.7 × 180.3 × 96.5 cm)

ordinary objects which have lost their original functions within the new situation of the
sculpture, these very concepts are themselves transformed into a new, imaginative sig-
nification: "trambulation," perhaps. As was the case in her earlier work, Nancy Graves'
recent sculpture calls into question the very possibility of the sculptural in the process of
transforming the natural world into the language-system of art. Playing against gravity,
against solemnity, against fixed, rigid categories of what constitutes sculpture; playing
equally against triviality, unmotivated whimsy or novelty for the sake of novelty, Nancy
Graves is playing for very high stakes indeed.

160

7

Morisot's *Wet Nurse*: The Construction of Work and Leisure in Impressionist Painting

Women, Art and Power and Other Essays, 1988

Tant de clairs tableaux irisés, ici, exacts, primesautiers....

<div align="right">STÉPHANE MALLARMÉ[1]</div>

Berthe Morisot's *The Wet Nurse and Julie* of 1879 [p. 162] is an extraordinary painting.[2] Even in the context of an oeuvre in which formal daring is relatively unexceptional, this work is outstanding. "All that is solid melts into air"—Karl Marx's memorable phrase, made under rather different circumstances, could have been designed for the purpose of encapsulating Morisot's painting in a nutshell.[3] Nothing is left of the conventions of pictorial construction: figure versus background, solid form versus atmosphere, detailed description versus sketchy suggestion, the usual complexities of composition or narration. All are abandoned for a composition almost disconcerting in its three-part simplicity; a facture so open, so dazzlingly unfettered as to constitute a challenge to readability; and a colorism so daring, so synoptic in its rejection of traditional strategies of modeling as to be almost Fauve before the fact.[4]

Morisot's *Wet Nurse* is equally innovative in its subject matter. For this is not the old motif of the Madonna and Child, updated and secularized, as it is in a work like Renoir's *Aline Nursing* or in many of the mother-and-child paintings by the other prominent woman member of the Impressionist group, Mary Cassatt. It is, surprisingly enough, a work scene. The "mother" in the scene is not a real mother but a so-called *seconde mère*, or wet nurse, and she is feeding the child not out of "natural" nurturing instinct but for wages, as a member of a flourishing industry.[5] And the artist painting her, whose gaze defines her, whose active brush articulates her form, is not, as is usually the case, a man, but a woman, the woman whose child is being nursed. Certainly, this painting embodies one of the most unusual circumstances in the history of art—perhaps a unique one: a woman painting another woman nursing her baby. Or, to put it another way, introducing what is not seen but what is known into what is visible, two working women confront each other here, across the body of "their" child and the boundaries of class, both with claims to motherhood and mothering, both, one assumes, engaged

<div align="right">161</div>

Berthe Morisot, *The Wet Nurse and Julie*, 1879.
Oil on canvas, 19¾ × 24 in. (50 × 61 cm)

in pleasurable activity which, at the same time, may be considered production in the literal sense of the word. What might be considered a mere use value if the painting was produced by a mere amateur, the milk produced for the nourishment of one's own child, is now to be understood as an exchange value. In both cases—the milk, the painting—a product is being produced or created for a market, for profit.

Once we know this, when we look at the picture again we may find that the openness, the disembodiment, the reduction of the figures of nurser and nursling almost to caricature, to synoptic adumbration, may be the signs of erasure, of tension, of the conscious or unconscious occlusion of a painful and disturbing reality as well as the signs of daring and pleasure—or perhaps these signs, under the circumstances, may be identical, inseparable from each other. One might say that this representation of the classical topos of the maternal body poignantly inscribes Morisot's conflicted identity as devoted mother and as professional artist, two roles which, in 19th-century discourse, were defined as mutually exclusive. *The Wet Nurse and Julie*, then, turns out to be much more complicated than it seemed to be at first, and its stimulating ambiguities may have as much to do with the contradictions involved in contemporary mythologies of work and leisure, and the way that ideologies of gender intersect with these paired notions, as they do with Morisot's personal feelings and attitudes.

Reading the *The Wet Nurse and Julie* as a work scene inevitably leads me to locate it within the representation of the thematics of work in 19th-century painting, particularly that of the woman worker. It also raises the issue of the status of work as a motif in Impressionist painting—its presence or absence as a viable theme for the group of artists which counted Morisot as an active member. And I will also want to examine the particular profession of wet-nursing itself as it relates to the subject of Morisot's canvas.

How was work positioned in the advanced art of the later 19th century, at the time when Morisot painted this picture? Generally in the art of this period, work, as Robert Herbert has noted,[6] was represented by the rural laborer, usually the male peasant engaged in productive labor on the farm. This iconography reflected a certain statistical truth, since most of the working population of France at the time was, in fact, engaged in farm work. Although representations of the male farm worker predominated, this is not to say that the female rural laborer was absent from French painting of the second half of the 19th century. Millet often represented peasant women at work at domestic tasks like spinning or churning, and Jules Breton specialized in scenes of idealized peasant women working in the fields. But it is nevertheless significant that in the quintessential representation of the labor of the female peasant, Millet's *Gleaners*, women are represented engaged not in productive labor—that is, working for profit, for the market—but rather for sheer personal survival—that is, for the nurturance of themselves and their children, picking up what is left over after the productive labor of the harvest is finished.[7] The *glaneuses* are thus assimilated to the realm of the natural— rather like animals that forage to feed themselves and their young—rather than to that of the social, to the realm of productive labor. This assimilation of the peasant woman to the position of the natural and the nurturant is made startlingly clear in a painting like Giovanni Segantini's *Two Mothers*, which makes a visual analogy between cow and woman as instinctive nurturers of their young.

Work occupies an ambiguous position in the representational systems of Impressionism, the movement to which Morisot was irrevocably connected; or one might say that acknowledgment of the presence of work themes in Impressionism has until recently been repressed in favor of discourses stressing the movement's "engagement with themes of urban leisure."[8] Meyer Schapiro, above all, in two important articles of the 1930s, laid down the basic notion of Impressionism as a representation of middle-class leisure, sociability, and recreation depicted from the viewpoint of the enlightened, sensually alert middle-class consumer.[9] One could contravene this contention by pointing to a body of Impressionist works that do, in fact, continue the tradition of representing rural labor initiated in the previous generation by Courbet and Millet and popularized in more sentimental form by Breton and Bastien-Lepage. Pissarro, particularly, continued to develop the motif of the peasant, particularly the laboring or resting peasant woman, and that of the market woman in both Impressionist and Neo-Impressionist vocabularies, right down through the 1880s. Berthe Morisot herself

turned to the theme of rural labor several times: once in *The Haymaker*, a beautiful preparatory drawing for a larger decorative composition; again, in a little painting, *In the Wheat Field*, of 1875; and still another time (more ambiguously, because the rural "workers" in question, far from being peasants, are her daughter, Julie, and her niece, Jeanne, picking cherries) in *The Cherry Tree* of 1891–92.[10] Certainly, one could point to a significant body of Impressionist work representing urban or suburban labor. Degas did a whole series of ironers;[11] Caillebotte depicted floor scrapers and house painters; and Morisot herself turned at least twice to the theme of the laundress: once in *Laundresses Hanging out the Wash* of 1875, a lyrical canvas of commercial laundresses plying their trade in the environs of the city, painted with a synoptic lightness that seems to belie the laboriousness of the theme; and another time in *Peasant Girl Hanging Clothes to Dry* of 1881, a close-up view where the rectangularity of the linens seems wittily to reiterate the shape and texture of the canvas, the laundress to suggest the work of the woman artist herself. Clearly, then, the Impressionists by no means totally avoided the representation of work.

To speak more generally, however, interpreting Impressionism as a movement constituted primarily by the representation of leisure has to do as much with a particular characterization of labor as with the iconography of the Impressionist movement. In the ideological constructions of the French Third Republic, as I have already pointed out, work was epitomized by the notion of rural labor, in the time-honored, physically demanding, naturally ordained tasks of peasants on the land. The equally demanding physical effort of ballet dancing, represented by Degas, with its hours of practice, its strains, its endless repetition and sweat, was constructed as something else, something different: as art or entertainment. Of course this construction has something to do with the way entertainment represents itself: often the whole point of the work of dancing is to make it look as though it is not work, that it is spontaneous and easy.

But there is a still more interesting general point to be made about Impressionism and its reputed affinity with themes of leisure and pleasure. It is the tendency to conflate *women's* work—whether it be her work in the service or entertainment industries or, above all, her work in the home—with the notion of leisure itself. As a result, our notion of the iconography of work, framed as it is by the stereotype of the peasant in the fields or the weaver at his loom, tends to exclude such subjects as the barmaid or the beer server from the category of the work scene and position them instead as representations of leisure. One might even say, looking at such paintings as Manet's *Bar at the Folies-Bergère* or his *Beer Server* from the vantage point of the new women's history, that middle- and upper-class men's leisure is sustained and enlivened by the labor of women: entertainment and service workers like those represented by Manet.[12] It is also clear that these representations position women workers—barmaid or beer server—in such a way that they seem to be there to be looked at—visually consumed, as it were— by a male viewer. In the *Beer Server* of 1878, for example, the busy waitress looks out

Berthe Morisot, *Peasant Girl Hanging Clothes to Dry*, 1881.
Oil on canvas, 18⅛ × 26⅜ in. (46 × 67 cm)

alertly at the clientele, while the relaxed male in the foreground—ironically a worker himself, identifiable by his blue smock—stares placidly at the woman performer, half visible, doing her act on the stage. The work of café waitresses or performers, like those represented by Degas in his pastels of café concerts, is often connected to their sexuality or, more specifically, the sex industry of the time, whether marginally or centrally, full time or part time. What women, specifically lower-class women, had to sell in the city was mainly their bodies. A comparison of Manet's *Ball at the Opera*—denominated by the German critic Julius Meier-Graefe as a *Fleischebörse*, or flesh market—with Degas' *Cotton Market in New Orleans* makes it clear that work, rather than being an objective or logical category, is an evaluative or even a moral one. Men's leisure is produced and maintained by women's work, disguised to look like pleasure. The concept of work under the French Third Republic was constructed in terms of what that society or its leaders stipulated as good, productive activity, generally conceived of as wage-earning or capital production. Women's selling of their bodies for wages did not fall under the moral rubric of work; it was constructed as something else: as vice or recreation. Prostitutes (ironically, referred to colloquially as "working girls" today), a subject often represented by Degas, like the businessmen represented in his *Members of the Stock Exchange*, are of course engaging in a type of commercial activity. But nobody has ever thought to call the prints from Degas' monotype series of brothel representations "work

scenes," despite the fact that prostitutes, like wet nurses and barmaids and laundresses, were an important part of the work force of the great modern city in the 19th century, and in Paris, at this time, a highly regulated, government-supervised form of labor.[13]

If prostitution was excluded from the realm of honest work because it involved women selling their bodies, motherhood and the domestic labor of child care were excluded from the realm of work precisely because they were unpaid. Woman's nurturing role was seen as part of her natural function, not as labor. The wet nurse, then, is something of an anomaly in the 19th-century scheme of feminine labor. She is like the prostitute in that she sells her body, or its product, for profit and her client's satisfaction; but, unlike the prostitute, she sells her body for a virtuous cause. She is at once a mother—*seconde mère, remplaçant*—and an employee. She is performing one of woman's "natural" functions, but she is performing it as work, for pay, in a way that is eminently not natural but overtly social in its construction.

To understand Morisot's *Wet Nurse and Julie*, one has to locate the profession of wet-nursing within the context of 19th-century social and cultural history. Wet-nursing constituted a large-scale industry in France in the 18th and 19th centuries. In the 19th century, members of the urban artisan and shop-keeping classes usually sent their children out to be nursed by women in the country so that wives would be free to work. So large was the *industrie nourricière* and so patent the violations of sanitation, so high the mortality rate and so unsteady the financial arrangements involved that the government stepped in to regulate the industry in 1874 with the so-called Loi Roussel, which supervised wet nurses and their clients on a nationwide basis.[14] Members of the aristocracy or upper bourgeoisie such as Berthe Morisot, however, did not have to resort to this "regulated" industry. They usually hired a *nourrice sur lieu*, or live-in wet nurse, who accompanied the infant, took it to the park, and comforted it—but was there mainly to provide the baby with nourishment.[15] The omnipresence of the wet nurse in the more fashionable purlieus of Parisian society is indicated in Degas' *At the Races in the Countryside*, where the Valpinçons, husband and wife, are accompanied by their dog, by their son and heir, Henri, and by the veritable star of the piece, the wet nurse, depicted in the act of feeding the baby.[16] A foreign painter like the Finnish Albert Edelfelt, when depicting the charms of Parisian upper-class life, quite naturally included the wet nurse in his *Luxembourg Gardens*, a painting of 1887 now in the Antell Collection in Helsinki; and Georges Seurat incorporated the figure, severely geometrized, into the cross section of French society he represented in *A Sunday on the Island of La Grande-Jatte*.

The wet nurse was, on the one hand, considered the most "spoiled" servant in the house and, at the same time, the most closely watched and supervised. She was in some ways considered more like a highly prized milch cow than a human being. Although she was relatively highly paid for her services, often bringing home 1,200 to 1,800 francs per campaign—her salary ranked just under that of the cordon bleu chef[17]—and was often

Edgar Degas, *At the Races in the Countryside*, 1869.
Oil on canvas, 14⅜ × 22 in. (36.5 × 55.9 cm)

presented with clothing and other valuable gifts, her diet, though plentiful and choice, was carefully monitored and her sex life was brought to a halt; and of course, she had to leave her own baby at home in the care of her own mother or another family member.[18]

The wet nurse was always a country woman, and generally from a specific region of the country: the Morvan, for instance, was considered prime wet-nurse territory.[19] Wet-nursing was the way poor country women with few valuable skills could make a relatively large sum of money: selling their services to well-off urban families. The analogy with today's surrogate mothers makes itself felt immediately, except that the wet nurse was not really the subject of any moral discourse about exploitation; on the contrary: although some doctors and childcare specialists complained about the fact that natural mothers refused to take nature's way and breastfeed their children themselves, in general they preferred a healthy wet nurse to a nervous new mother. Few upper-class women in the later 19th century would have dreamed of breastfeeding their own children; and only a limited proportion of women of the artisan class, who had to work themselves or who lived in crowded quarters, had the chance to do so. If Renoir proudly represented his wife nursing their son Jean, it was not because it was so "natural" for her to do so, but perhaps because, on the contrary, it was not. Renoir's wife, in any case, was not of the same social class as Berthe Morisot; she was of working-class origin. Berthe Morisot, then, was being perfectly "natural" within the perimeters of her class in hiring a wet nurse. It would not be considered neglectful and certainly would not have to be excused by the fact that she was a serious professional painter: it was simply what people of her social station did.

The wet nurse, in various aspects of her career, was frequently represented in popular visual culture, and her image appeared often in the press or in genre paintings dealing with the typical trades or professions of the capital. A forgotten painter of the later 19th century, José de Frappa, in his *Bureau de Nourice* depicted the medical examination of potential wet nurses in an employment bureau. Husband, mother-in-law, and doctor evidently participated in the choice of a candidate. Wet-nursing was frequently the subject of humorous caricatures right down to the beginning of the 20th century, when sterilization and pasteurization enabled mothers to substitute the newly hygienic bottle for the human breast—and thereby gave rise to cartoons dealing with the wet nurse attempting to compete with her replacement.[20] With her ruffled, beribboned cap and jacket or cape, she was frequently depicted in illustrations of fashionable parks, where she aired her charges, or in those of upper-class households. Her characteristic form could even serve to illustrate the letter *N*—for *nourice*—in a children's alphabet. Degas, like Seurat, was evidently struck by the typical back view of this familiar figure and sketched it in one of his notebooks.

Morisot is not, of course, in her paintings of her daughter and her wet nurse[21] creating a sociological document of a particular kind of work or even a genre scene of some engaging incident involved in wet-nursing. Both Julie and her wet nurse serve as motifs in highly original Impressionist paintings, and their specificity as documents of social practice is hardly of conscious interest to the creator of the paintings, who is intent on creating an equivalent for her perceptions through visual qualities of color, brushwork, light, shape—or the deconstruction of shape—and atmosphere. Nor do we think of Morisot as primarily a painter of work scenes; she was, indeed, one of those artists of the later 19th century—like Whistler and Manet, among others—who helped construct a specific iconography of leisure, figured by young and attractive women, whose role was simply to be there, for the painter, a languid and self-absorbed object of esthetic contemplation—a kind of human still life. Her *Portrait of Mme Marie Hubbard* of 1874 and *Young Girl Reclining* of 1893 are notable examples of this genre. Morisot is associated, quite naturally, not with work scenes, however ambiguous, but rather with the representation of domestic life, mothers, or, more rarely, fathers—specifically her husband, Eugène Manet—and daughters engaged in recreation. This father-and-daughter motif is, like the theme of the wet nurse, an unusual one in the annals of Impressionist painting. Male Impressionists who, like Morisot, turned to the domestic world around them for subject matter, painted their wives and children as a matter of course. Here is a case where being a woman artist makes an overt difference: Morisot, in turning to her closest relatives, paints a father and child, a rather unusual theme in the annals of Impressionism, and one with its own kinds of demands. She depicts her husband and daughter doing something concrete—playing with a boat and sketching or playing with toy houses—and with a vaguely masculine air.

Despite the fact that scenes of leisure, languor, and recreation are prominent in

Berthe Morisot, *Eugène Manet and His Daughter in the Garden*, 1883.
Oil on canvas, 23⅝ × 28⅞ in. (60 × 73.5 cm)

Morisot's oeuvre, there is another way we might think of work in relation to her production. The notion of the work of painting itself is never disconnected from her art and is perhaps allegorized in various toilette scenes in which women's self preparation and adornment stand for the art of painting or subtly refer to it.[22] A simultaneous process of looking and creating are prime elements of a woman's toilette as well as picture-making, and sensual pleasure as well as considerable effort is involved in both. One could even go further and assert that in both—maquillage and painting—a private creation is being prepared for public approbation.

Painting was work of the utmost seriousness for Morisot. She was, as the recent exhibition catalogue of her work reveals to us,[23] unsparing of herself, perpetually dissatisfied, often destroying works or groups of works that did not satisfy her high standards. Her mother observed that whenever she worked, she had an "anxious, unhappy, almost fierce look," adding, "This existence of hers is like the ordeal of a convict in chains."[24]

There is another sense in which Morisot's oeuvre may be associated with the work of painting: the way in which the paintings reveal the act of working which creates them are sparkling, invigorating, and totally uneffortful-looking registers of the process of painting itself. In the best of them, color and brushstroke are the deliberately revealed point of the picture: they are, so to speak, works about work, in which the work of looking and registering the process of looking in paint on canvas or pastel on paper assumes an importance almost unparalleled in the annals of painting. One might

almost say that the work of painting is not so strongly revealed until the time of the late Monet or even that of abstract expressionism, although for the latter, of course, looking and registering were not the issue.[25]

Even when Morisot looked at herself, as in her 1885 *Self-Portrait with Julie*, boldly, on unprimed canvas, or in her pastel *Self-Portrait* of the same year, the work of painting or marking was primary: these are in no sense flattering or even conventionally penetrating self-portraits: they are, especially the pastel version, working records of an appearance, deliberate in their telling asymmetries, their revelation of brushwork or marking, unusual above all for their omissions, their selective recording of a motif that happens to be the author's face. The pastel *Self-Portrait* is almost painfully moving. It is no wonder that critics sometimes found her work too sketchy, unfinished, bold to the point of indecipherability. Referring to two of her pastels, for example, Charles Ephrussi declared: "One step further and it will be impossible to distinguish or understand anything at all."[26]

In her late *Girl with a Greyhound (Julie Manet)*, a portrait of Julie with a dog and an empty chair, painted in 1893, Morisot dissolves the chair into a vision of evanescent lightness: a work of omission, of almost nothingness. Compared with it, Van Gogh's famous *Gauguin's Chair* looks heavy, solid, and a little overwrought. Yet Morisot's chair

Berthe Morisot, *Girl with a Greyhound (Julie Manet)*, 1893.
Oil on canvas, 26¾ × 31½ in. (73 × 80 cm)

is moving, too. Its ghostliness and disembodiment remind us that it was painted shortly after her husband's death, perhaps as an emblem of his absent presence within the space of his daughter's portrait. And perhaps for us, who know that she painted this at the end of her life, it may constitute a moving yet self-effacing prophecy of her own impending death, an almost unconscious means of establishing—lightly, only in terms of the work itself—her presence within an image representing, for the last time, her beloved only child.

In insisting on the importance of work, specifically the traces of manual activity, in Morisot's production, I am not suggesting that Morisot's work was the same as the onerous physical labor involved in farm work or the routine mechanical efforts of the factory hand—nor that it was identical with the relatively mindless and constricted duties of the wet nurse. We can, however, see certain connections: in a consideration of both the work of the wet nurse and that of the woman artist the element of gender asserts itself. Most critics, both then and now, have emphasized Morisot's gender; her femininity was constructed from an essentialist viewpoint as delicacy, instinctive-ness, naturalness, playfulness—a construction implying certain natural gendered lacks or failures: lack of depth, of substance, professionalism or leadership, for instance. Why else has Morisot always been considered as somehow a secondary Impressionist, despite her exemplary fidelity to the movement and its aims? Why has her very flouting of the traditional "laws" of painting been seen as a weakness rather than a strength, a failure or lack of knowledge and ability rather than a daring transgression? Why should the disintegration of form characteristic of her best work not be considered a vital ques-tioning of Impressionism from within, a "making strange" of its more conventional practices? And if we consider that erosion of form to be a complexly mediated inscrip-tion of internalized conflict—motherhood versus profession—then surely this should be taken as seriously as the more highly acclaimed psychic dramas of male artists of the period: Van Gogh's struggle with his madness; Cézanne's with a turbulent sexuality; Gauguin's with the countering urgencies of sophistication and primitivism.

I would like to end as I began, with Karl Marx's memorable phrase: "All that is solid melts into air." But now I would like to consider the whole passage, from the *Communist Manifesto*, from which I (and Marshall Berman, author of a book titled by that passage) extracted it. Here is the whole passage: "All fixed, fast-frozen relations, with their train of ancient and venerable prejudices and opinions, are swept away, all new-formed ones become antiquated before they can ossify: All that is solid melts into air, all that is holy is profaned, and men at last are forced to face...the real conditions of their lives and their relations with their fellow men."[27]

I am not in any sense suggesting that Morisot was a political or even a social rev-olutionary—far from it. But I am saying that her strange, fluid, unclassifiable, and contradiction-laden image *Wet Nurse and Julie* inscribes many of those characteristic fea-tures of modernism and modernity that Marx is of course referring to in his celebrated

passage—above all, modernism's profoundly deconstructive project. Sweeping away "all fixed and frozen relations with their accompanying prejudices and opinions"—this is certainly Morisot's project as well. And in some way too, she is in this picture, being forced to face, at the same time that it is impossible for her fully to face, the real condition of her life and her relations with a fellow woman. Thinking of Marx's words, looking at Morisot's painting, I sense these real conditions hovering on the surface of the canvas, a surface as yet not fully explored, untested but still potentially threatening to "ancient and venerable prejudices and opinions"—about the nature of work, about gender, and about painting itself.

Notes

1 Preface to the catalogue of the posthumous exhibition of Berthe Morisot's paintings, Durand-Ruel Gallery, Paris, March 5–23, 1896.

2 The painting was exhibited under the title *Nourrice et bébé* (Wet Nurse and Baby) at the Sixth Impressionist Exhibition of 1880. It is also known under the title *La Nourrice Angèle allaitant Julie Manet* (The Wet Nurse Angele Feeding Julie Manet) and *Nursing*. See the exhibition catalogue, *The New Painting: Impressionism, 1874–1886* (1986), Fine Arts Museums of San Francisco and National Gallery of Art, Washington, DC, no. 110, p. 366; and Charles F Stuckey and William P Scott (1987–88), *Berthe Morisot: Impressionist*, catalogue, National Gallery of Art Washington, DC; Kimbell Art Museum, Fort Worth, Texas; Mount Holyoke College Art Museum, fig. 41, pp. 89 and 88.

3 Karl Marx's statement may be found in Robert C Tucker, ed. (1978), *The Marx–Engels Reader,* New York: Norton, p. 476.

4 The critic Gustave Geffroy responded to the *Wet Nurse*'s unique qualities when he reviewed Morisot's work from the Sixth Impressionist Exhibition in *La Justice* of April 21, 1881, by waxing lyrical: "The forms are always vague in Berthe Morisot's paintings, but a strange life animates them. The artist has found the means to fix the play of colors, the quivering between things and the air that envelops them... Pink, pale green, faintly gilded light sings with an inexpressible harmony." Cited in *The New Painting: Impressionism, 1874–1886*, p. 366.

5 Indeed, one might suspect that the unusual sketchiness and rapidity of the brushwork may have had something to do with Morisot's haste to complete her painting within the course of a single nursing session. Nevertheless, she obviously did not consider the painting a mere preparatory study, since she exhibited it in public as a finished work.

6 Robert Herbert (1970), "City vs. Country: the Rural Image in French Painting from Millet to Gauguin," *Artforum* 8, February, pp. 44–55.

7 See Jean-Claude Chamboredon (1977), "Peintures des rapports sociaux et invention de l'éternel paysan: Les deux maniéres de Jean-Francois Millet," *Actes de la recherche et sciences sociales*, nos 17–18, November, pp. 6–28.

8 Thomas Crow (1983), "Modernism and Mass Culture in the Visual Arts," in Benjamin HD Buchloh, Serge Guilbaut and David Solkin, eds, *Modernism and Modernity: The Vancouver Conference Papers*, Nova Scotia: The Nova Scotia College of Art and Design, p. 226.

9 See Meyer Schapiro (1936), "The Social Bases of Art," in *Proceedings of the First Artists' Congress against War and Fascism*, New York, pp. 31–37, and "The Nature of Abstract Art" (1937), *Marxist Quarterly* I, January, pp. 77–98, reprinted in M Schapiro, *Modern Art: The Nineteenth and Twentieth Centuries* (1978), New York: George Braziller, especially pp. 192–93.

10 For an illustration of *The Haymaker*, see Stuckey and Scott, *Berthe Morisot: Impressionist*, pl. 93, p. 159; for *In the Wheatfield*, see Kathleen Adler and Tamar Garb (1987), *Berthe Morisot*, Ithaca, NY: Cornell University Press, fig. 89; and *The Cherry Tree, Berthe Morisot: Impressionist*, pl. 89, p. 153.

11 For a detailed discussion of Degas' ironers and laundresses, see Eunice Lipton (1986), *Looking into Degas: Uneasy Images of Women*

and Modern Life, Berkeley, CA: University of California Press, pp. 116–50.

12 For the role of the barmaid in French 19th-century society and iconography, see TJ Clark (1984), *The Painting of Modern Life: Paris in the Art of Manet and His Followers*, Princeton, NJ: Princeton University Press, pp. 205–58, and Novalene Ross (1982), *Manet's "Bar at the Folies-Bergère" and the Myths of Popular Illustration*, Ann Arbor, MI: University of Michigan Press.

13 For information about government regulation of prostitution, see Alain Corbin (1978), *Les Filles de noce: Misère sexuelle et prostitution aux 19e et 20e siècles*, Paris: Aubier Montaigne; for the representation of prostitution in the art of the later 19th century, see Hollis Clayson (1912), "*Avant-Garde* and *Pompier* Images of 19th Century French Prostitution: the Matter of Modernism, Modernity and Social Ideology," in F Frascina, T Garb, N Blake, B Fer and C Harrrison (1993), *Modernity and Modernism, French Painting in the Nineteenth Century*, New Haven, CT and London: Yale University Press, pp. 43–64. Meier-Graefe uses the term "Fleischborse" in *Édouard Manet* (1912), Munich: Piper Verlag, p. 216.

14 For the Roussel Law of December 23, 1874, see George D Sussman (1982), *Selling Mothers' Milk: The Wet-Nursing Business in France: 1715–1914*, Urbana, IL: University of Illinois Press, pp. 128–29 and 166–67.

15 For an excellent examination of the role of the wet nurse in the 19th century, focusing on the *nourrice sur lieu* and including an analysis of the medical discourse surrounding the issue of maternal breastfeeding, see Fanny Fay-Sallois (1980), *Les Nourrices à Paris au XIXe siècle,* Paris: Payot.

16 I am grateful to Paul Tucker for pointing out the presence of the wet nurse in this painting.

17 Fay-Sallois, *Les Nourrices à Paris*, p. 201.

18 For the figures of the wages cited, see Sussman, *Selling Mother's Milk*, p. 155, and for the salary of the live-in wet nurse and her treatment generally, see Fay-Sallois, *Les Nourrices à Paris*, pp. 200–39.

19 Sussman, *Selling Mothers' Milk*, pp. 152–54.

20 See, particularly, the vicious cartoon depicting a wet nurse attempting to boil her breast in emulation of bottle sterilization, published by Fay-Sallois in *Les Nourrices à Paris*, p. 247. Other interesting cartoons featuring wet-nursing and the practices associated with it appear on pp. 172–73, 188 and 249 of this work, which is amply illustrated.

21 There are at least two other works by Morisot representing her daughter, Julie, and her wet nurse: an oil painting, *Julie with Her Nurse*, 1880, now in the Ny Carlsberg Glyptotek, Copenhagen, is reproduced as fig. 68 in Adler and Garb, *Berthe Morisot*; and a watercolor entitled *Luncheon in the Country,* of 1879, in which the wet nurse and baby are seated at a table with a young boy, probably Morisot's nephew Marcel Gobillard, as pl. 32, p. 77, in Stuckey and Scott, *Berthe Morisot: Impressionist*.

22 See, for example, *Woman at Her Toilette*, *c.* 1879, in the Art Institute of Chicago, or *Young Woman Powdering Her Face* of 1877, Paris, Musée d'Orsay.

23 Stuckey and Scott, *Berthe Morisot: Impressionist*.

24 Ibid., p. 187.

25 See, for example, Charles Stuckey's assertion that, in the case of *Wet Nurse and Julie*, it is difficult to think of a comparably active paint surface by any painter before the advent of abstract expressionism in the 1950s. Stuckey and Scott, *Berthe Morisot: Impressionist*, p. 88.

26 Cited in ibid., p. 88.

27 Cited in Berman (1982), *All That Is Solid Melts into Air: The Experience of Modernity*, New York: Simon and Schuster, p. 21.

8

Zuka's French Revolution: A Woman's Place is Public Space

Feminist Studies, Autumn 1989

At last—a woman artist who dares to take possession of history and to position women as active participants within the historical process itself! Zuka's series of exuberant paintings and cutouts, *The French Revolution through American Eyes*, is revolutionary in at least two ways. First of all, it is revolutionary in its novel construction of the French revolution itself, a novelty in which the fact that the artist happens to be a woman plays an important part. Second of all, the series is revolutionary in the position it accords to women within its construction of the French revolution. The prominence of women in revolutionary action has not often been marked in high art. Zuka's series redresses this omission, in both commemorating the place of specific women in revolutionary history and, equally important, the omnipresence of anonymous women in all aspects of revolutionary action—from hauling cannons to participating in the gigantic revolutionary festivals that were such an integral part of the revolutionary process itself.

The representation of major political events in the visual arts is generally thought of as pompous, solemn, and frozen: conservative in the worst sense of the word. One thinks of the faded potboilers that hung in the schoolrooms of our youth, commemorating long-dead historical incidents with deadly pseudo-accuracy, neatening up and prettifying the often messy contingencies of the past like an undertaker painting a corpse. Above all, the conventional representation of the Great Historical Event was serious: there was no room for high spirits or low comedy in the creaky rhetorical machinery of the conventional historical painting. The Great Man rode his white horse without a mishap over the Saint Bernard pass into immortality; Washington crossed the wintry Delaware imperturbably: there were never any pratfalls on the high road to destiny according to the average *machine de salon*.

Nothing could be further from Zuka's spirited take on the French revolution. Like all good historians—and all original artists—she knows that the past can only come to life in terms of the present. Although she has looked long and hard at the documents of the French revolution and appropriated a wide cross section of its visual imagery, she has brought the revolution to life in terms of her own experience of it in the 20th century, and through a language in which wit, playfulness, modernist irreverence, and awareness of the deflationary possibilities inherent to the formal means of art itself are

Zuka, *Vigée Le Brun Paints Germaine de Staël's Portrait in the Presence of Benjamin Constant*, 1988. Oil on linen, 76¾ × 51⅛ in. (195 × 130 cm)

fused by pictorial energy to create a vision of history that is at once idiosyncratically contemporary yet historically accurate.

The omnipresence of women was one of the most striking, indeed, startling aspects of the French revolution, often noted at the time, sometimes complained of—an aspect often forgotten, or more accurately, repressed. For the 19th-century historian Michelet, one of the revolution's major virtues was to have finally inserted women and their children—the heart of a heartless world—into public life. Zuka has deliberately emphasized the importance of women in every phase of revolutionary activity as no other artist before her. In so doing, she has acted not merely as a feminist, but as a responsible historian, bringing to light and visually rearticulating a lost reality. Mona Ozouf, the great present-day historian of the revolutionary festivals, for example, has stressed the overwhelming importance of women's place within them, figured as Liberty or

175

as the Goddess of Reason, or simply in groups—white-clad, wreathed, bearing green branches or flowers in their arms, signifying the peaceful communion of all the people, women and children included, under the beneficent aegis of the revolution. Zuka has represented a group of such garlanded, joyous, white-clad women in the foreground of her decorative canvas, *Street Celebration, July 14*; others, wearing symbolic tricolor sashes, participate in the ceremonial planting of a Tree of Liberty; and women play a major role in her most ambitious canvas, a diptych of the *Fête of the Supreme Being on the Champs-de-Mars*.

Here, at the base of the artificial mountain erected for the festival, men and women of the people celebrate the event in a wild, emotionally unbridled *carmagnole*; to the left, women dressed in Grecian robes create a restrained frieze in the official, classical style of the pageant. Thus, women function to set forth the violent contrasts between reason and passion inscribed at the heart of revolutionary theory and practice itself.

Women play an even more active role—as indeed they did, historically—in Zuka's pictorial interpretation of the *Women's Hunger March to Versailles*. The women marchers, decked out in brilliantly colored dresses and coiffed in the characteristic puffy white bonnet of the times, hold branches, and, more menacingly, scythes and muskets, as well as a revolutionary trophy—the scale of Justice topped with the *bonnet rouge*. One of their number, in a red, white, and blue striped skirt, beats vigorously on a drum and seems to be calling her sisters to action. The vitality of the women's action is under-scored by the unexpected color relationships in the canvas, in which a long procession of smaller figures forms a decorative border. The red, white, and blue stripes are, perhaps, expected, but there are also large areas of lighter and darker violet, subdued salmon pink, black, mulberry, and olive green that serve to "defamiliarize" the scene and add to its vividness a certain sense of menace. Equally activist are the women in a multipartite cutout who march to the beat of a woman drummer or strain under the weight of the cannon they pull, their great balloon-like white hats creating a formal continuity and rhythm among the scattered elements of the piece. Nor has Zuka neglected the more traditional role of women during the revolution: gaily clad prostitutes are depicted plying their customary trade in the courtyard of the Palais Royal, their habitual garish color schemes considerably enhanced by the tricolor sashes and ribbons they sport as part of their up-to-date revolutionary chic.

The individual women revolutionaries rediscovered by feminist historians also play their role in this series. Zuka has represented the social theorist and activist, Olympe de Gouges, three times: once with a symbolic frieze of putti, muskets, and the guillotine; another time in a more conventional portrait of a lively and intelligent-looking woman; and a third time, when Olympe de Gouges is depicted as the revolutionary, feminist activist she was, vigorously orating and turning out pamphlets. The latter work com-memorates the courage and tenacity of the woman who wrote her own *Declaration of the Rights of Woman* a year after the appearance of the more celebrated *Declaration of the*

Rights of Man. The artist has also celebrated the other well-known woman activist of the revolution, Théroigne de Méricourt, in a large canvas. De Méricourt, who wanted to go to the front and fight alongside the men, is appropriately represented wearing military dress—a red redingote over a red, white, and blue dress and a three-cornered hat with a tricolored cockade perched on her head. She holds up a gold sword in her hand and is surrounded by a group of rather skeptical-looking soldiers. The more tragic heroines—or perhaps, more accurately, anti-heroines—of the revolution also make their appearance on the stage of history, as Zuka portrays it. The painter David excluded Charlotte Corday from his memorable representation of Marat assassinated, but Zuka makes her the star of the event, in a powerful close-up, looking out at the spectator behind the grotesquely shriveled corpse of the bleeding revolutionary martyr [p. 178]; and in a second, even more horrifying canvas, with the crowd screaming in the background, framed by the mechanical scaffolding of the guillotine and the anonymous back of her executioner. That tragic and silly queen, Marie-Antoinette, also appears several times: in a light-hearted portrait, framed by dancing putti; as a shepherdess, wearing a splendid hat, in a large-scale collage; and finally, as the "Veuve Capet," stripped of her ornaments, her dignity, and even her wig, being led to execution in a horse-drawn cart [p. 179].

Zuka, *Théroigne de Méricourt at the Front*, 1987. Acrylic on linen, 51⅛ × 38¼ in. (130 × 97 cm)

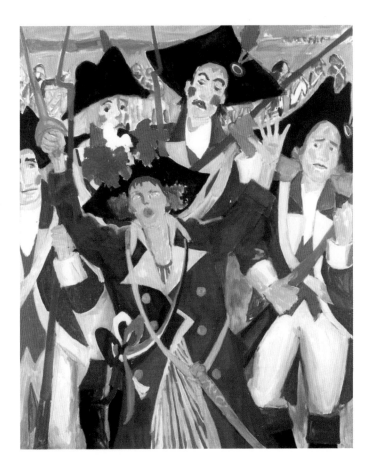

"For me," says Zuka, "history always explains what goes on now. When I see a younger person on the Paris Métro with purple hair, cut shorter in the back, longer in the front, I think of the 'incroyables' at the end of the Revolution, young people who wore their hair the same way—very short at the back—to accommodate the guillotine. In the same way, experiences in the present, or the recent past, help me recapture the vividness of history. Anyone who lived through the events of 1968 in Paris understands the excitement, the extremes of joy and anger of the Revolution—and knows that the Revolution must have been, among other things, well—fun." It is this sense of the revolution as a celebration, a performance, a series of transformatory actions and tableaux vivants, a combination of order and chaos, that Zuka captures with exemplary fidelity, appropriating the imagery of the past and animating it with the expressive wit of the present.

> When I started to paint pictures with the French Revolution as my subject, six years ago, there were no women in the French Revolution except Marie-Antoinette and Charlotte Corday. Nothing much was said about the latter except that she'd assassinated Marat. The imagery showed harridans on the street, ugly violent creatures storming Versailles or knitting at the guillotine. I was pretty sure this wasn't so. After digging around in everything I could find and then starting to read the research that has been done by historians, writers, and philosophers on women in the French Revolution, mostly by women both American and French, I see a parallel world to that described in most history books. I see a world of courageous, inventive, talented women, women of the streets, marginals, eccentrics who lived a passionate adventure full of hope and discoveries. It lasted but a few years and ended very badly. Setback and repression for all French women for over a hundred years was the outcome.

Zuka, *Charlotte Corday Assassinates Marat*, 1987. Oil on linen, 39⅜ × 39⅜ in. (100 × 100 cm)

Zuka, *Marie-Antoinette escortée à la guillotine*, 1987. Oil on linen, 76¾ × 51⅛ in. (195 × 130 cm)

My two favorites are Olympe de Gouges and Théroigne de Méricourt. De Gouges was an original, creative, witty, flamboyant political thinker and author of theater plays. She ended on the guillotine, leaving behind intelligent, talented works that have been totally ignored. She wrote the *Declaration of the Rights of Woman* one year after the *Rights of Man* had been written.

De Méricourt was a pretty Belgian peasant girl arriving in Paris at the beginning of the events. Enflamed by the French revolution and the possibilities opened to women suddenly and unexpectedly, she became the Passionaria of the Parisian scene.

Both were calumniated outrageously in their time. In the 19th century, their stories were distorted even more than ignored and forgotten.

The paintings and collages presented in this essay formed part of the exhibition, *The French Revolution through American Eyes*, which was shown in Paris and five cities in the US in 1988–89, and included painted bas-reliefs and large and small canvases with historiated frames.

9

Pornography as a Decorative Art: Joyce Kozloff's Patterns of Desire

Patterns of Desire, 1990

In one of Joyce Kozloff's exuberant decorative inventions, two separate pairs of exotic lovers enjoy their amorous pursuits amid the rich entanglements of vines and flowers decorating a Renaissance vestment. The maharaja from Nepal in the top image carries a dagger and hatchet in his belt (weapons are a common feature of the erotic iconography of some cultures); the bottom pair engage in sexual yoga, the artifice of their poses matching that of the conventionalized floral backdrop against which they are placed. In another painting, frolicking putti from black Pompeian frescos are interspersed with scenes derived from a medieval bath-and-bordello miniature (cleanliness was definitely *not* associated with godliness back then), an image borrowed from a present-day gay pornographer, an 18th-century Indian lovemaking scene...and a Reginald Marsh lithograph of Parisian prostitutes dancing more or less naked in a brothel. These descriptions provide some sense of the range and inventiveness of the series of watercolors in which the artist engages the erotic with the ornamental.

By recasting pornography as a form of decorative art, Kozloff has been transgressive on several counts: first of all, in the realm of subject matter, a realm in which outspoken representation of the sexual act has always, in Western art at any rate, served to signify the presence of the transgressive. Secondly, she has been subversive on the level of formal practice, treating the copulating bodies that punctuate the aggressively patterned fields of the picture plane as simply another decorative element, no more significant than the stylized borders or highly ornamental backgrounds against which their provocative forms languish, twist, or nestle. The fact that the artist happens to be a woman and a feminist raises still other disturbing issues. How can her strong belief in women's subjecthood and their right of self-determination be reconciled with a form of representation that, by definition, objectifies women's bodies and transforms them into passive vehicles of masculine specular pleasure? How, to put it bluntly, can a feminist engage with porn?

I have, of course, been speaking as though pornography were a simple, unitary concept, a pre-existing, fixed entity, easy to define and thus to regulate and contain. And yet, although almost everyone seems to know just what pornography is and to have a very certain opinion about it, about its viewers, and about whether or not it should be

generally available, there are widely divergent views about the values inscribed in the pornographic representation, and more specifically, its effects and effectiveness vis-à-vis its readers or viewers.

Susan Sontag, on the one hand, in her now classic article "The Pornographic Imagination" of 1967, devoted to the literary variety, defends pornography as a specific attainment of the imagination in which the "full" human being, male or female, has no place. "What pornographic literature does," asserts Sontag, "is precisely to drive a wedge between one's existence as a full human being and one's existence as a sexual being.... Normally we don't experience...our sexual fulfillment as distinct from or opposed to our personal fulfillment. But perhaps in part they are distinct, whether we like it or not. Insofar as strong sexual feeling does involve an obsessive degree of attention, it encompasses experiences in which a person can feel he is losing his 'self'."[1] Going further to specify the characteristics of the literary pornographic imagination, Sontag lays emphasis on energy and absolutism: "The books generally called pornographic are those whose primary, exclusive, and overriding preoccupation is with the depiction of sexual 'intentions' and 'activities.'...The universe proposed by the pornographic imagination is a total universe. It has the power to ingest and metamorphose and translate all concerns that are fed into it, reducing everything into the one negotiable currency of the erotic imperative."[2]

Monique Wittig, the contemporary French feminist, on the other hand, conceptualizes pornography not merely as a construction of the imagination but as a form of discourse, which is at the same time a "performative act." Says Wittig: "The pornographic discourse is part of the strategies of violence which are exercised upon [women]: it humiliates, it degrades, it is a crime against our 'humanity.' As a harassing tactic it has another function, that of a warning.... [The] experts in semiotics...reproach us for confusing, when we demonstrate against pornography, the discourses with the reality. They do not see that this discourse *is* reality for us, one of the facets of the reality of our oppression. They believe that we are mistaken in our level of analysis."[3]

Neither Sontag's nor Wittig's specifications of the pornographic quite do justice to Kozloff's take on erotica. For it is precisely as a genre that she approaches pornographic imagery, a genre that, for all its differences and specificities of style, iconography, and cultural contextualization, cuts across barriers of nationality, time, and geography, to concentrate on a narrow if intense range of human experiences. The representation of sexual intercourse, in all its varieties and permutations, is what the pornography appropriated by Kozloff focuses on: intercourse, foreplay, aftermath, and preliminary stimulation. There is not a "soft" image in the lot: this is hard-core stuff.

In a paradoxical sense, however, the series does not belong in the category of pornography at all. The juxtapositions that Kozloff establishes between the sexually charged images and their totally non-illusionistic settings cancel out that compelling realism so often associated with pornographic visual representation in our culture, especially

since the advent of photography, that supreme medium for the mass distribution of porn almost since the time of its invention. This ready-made realism, cheap, democratic, seductively illusionistic, called forth a strong reaction. As early as the second half of the 19th century, a major artist like Edgar Degas, in his series of brothel monotypes, by juxtaposing realistic representations of sexually explicit poses and incidents—splayed legs, pubic hair, drooping breasts, vulgar gestures, copulating couples, etc.—with the emphatic marks of the graphic medium—odd angles of vision, splashes or splotches of ink, scratched and striated surfaces, fingerprints and bare white paper—called into question the "performative" aspect of visually produced porn: its transparent appeal to masculine desire. To put it another way, Degas was already setting up a distinction between two kinds of pleasure: the pleasure of viewing a naturalistically depicted erotic scene and the pleasure of experiencing the nuances of an inventively manipulated esthetic surface.

Yet Kozloff's project raises a further issue with respect to the pornographic intention. Should a Kozloff watercolor be taken as "pornography" in the strict sense of the term, or is the artist using erotic images appropriated from a variety of national traditions to create a quite different genre, in which the sexual charge must of necessity fizzle, discharge, or misfire because of its inappropriate or contradictory new context? This aspect of Kozloff's work seems aimed particularly at the woman viewer, traditionally excluded from or ambiguously positioned in relation to conventional erotic imagery, which is designed with the male heterosexual in mind. Perhaps the female viewer would do best to relate to Kozloff's constructions in terms of oscillation, a situation in which the viewer's position moves back and forth between engagement and critique, between identification and distancing. The making strange, the defamiliarization of the familiar vocabulary of visual arousal certainly plays an important role in Kozloff's construction of the erotic/decorative image.

Again, it is the female viewer who takes most pleasure in the transgressive possibilities these works offer in both their demystification of the sacrosanct wickedness of the pornographic image, and, at the same time, their free play with the sacred texts of all cultures: their disrespectful but often affectionate playing around with the cultural patrimony—*patrimony* to be taken in the literal sense of "that which is inherited from the father."

What does it mean to the feminine, more specifically the feminist, viewer of these images that, for example, the space provided for the coupling of stylized Egyptian figures is a page from *The Book of Kells*, a surface inscribing with obsessive decorative energy a sacred Christian text and resanctified by the esthetic authority conferred on it by more recent, art-historical canonization? Kozloff doubly desanctifies this page by means of the dual visual scandals of sexual representation and artistic appropriation. Both the Koran and a Hebrew scroll of the Book of Esther serve the same sort of function; in the case of the former, juxtaposed with a Japanese, a Greek, and a Beardsley

Joyce Kozloff, *Pornament is Crime Series #9: Celtic Couplings*, 1987.
Watercolor on paper, 22 × 22 in. (55.9 × 55.9 cm)

image of fantastically exaggerated phallic prowess, as well as a Persian representation of an elegant, turbaned man having sex with an ecstatic donkey; in the case of the latter, embellished with Chinese and French scenes of prostitution. That texts so closely linked with sexual prohibition and repression should serve literally as a stage for the performance of the rituals of sexual arousal and satisfaction at this historical moment, the moment of an ominous turning toward censorship of sexual expression in the arts and elsewhere, constitutes "performative discourse" indeed. More accurately, in the present climate of mounting repression, such representations constitute a political discourse of the most intrepid and challenging sort.

But Kozloff's project involves more than mere blasphemy. I find it satisfying that she refuses to rely on just one set of strategies, that the goals of her sensual satire are multiform. In *Revolutionary Textiles* [p. 184], for example, it is a Soviet fabric pattern, up-to-date in the extreme, that provides the decorative foil, sandwiched between human figures drawn from Greek vase painting and Japanese prints. The erotic elements in both cases are stylized and conventionalized but in very different ways, as indeed are the representational elements—airplanes and factories—in the Soviet textile. How

Joyce Kozloff,
*Pornament is
Crime Series #12:
Revolutionary
Textiles*, 1987.
Watercolor on
paper, 22 × 22 in.
(55.9 × 55.9 cm)

does the viewer react to this unexpected conjunction of the sexual and the decorative? Does she or he have to eradicate one reading in order to experience the other? Or does the kind of perceptual oscillation to which I have already made reference take place, a psycho-visual vibration in which response to shape, color, and contour, on the one hand, and to sexual arousal, on the other, displace each other in rapid succession? And how would one go about distinguishing between the decorative intentions of the Soviet fabric designer and those of the ancient Greek vase painters, who, after all, were also practicing decorative artists as well as being skilled, and inventive, pornographers? Issues of abstraction versus representation; high art versus low, or mass-produced, art; and cultural ownership and appropriation all are addressed here but without resort to the sensory—and sensual—deprivation characterizing more theoretical expositions of such trendy dilemmas.

The *Patterns of Desire* series is, on some level, always about pleasure, that most desirable and elusive of experiences. In these images, three kinds of pleasure are at issue, perpetually figuring and refiguring themselves in a variety of ways: the pleasure of the artist, the viewer, and the figures represented in the images. The pleasure of those figures is a given of the pornographic imagination, despite, or perhaps because of, the generally deadpan expressions of the enactors of the pornographic scenario in almost all kinds of visual porn. In a way, this lack of specific expression is a token of the intensity

of the experience itself, which is represented as engaging the body in isolation without self-consciousness or ambivalence. The expressionlessness of most of the participants in these erotic games indicates unequivocally to the viewer that what we are looking at and being aroused by are fleshly, not spiritual, exercises.

The pleasure of the artist has to do with both the sexual and the decorative aspects of the production. "I wanted to swing back and forth between architecture, the decorative arts, popular culture, and landscape, between flat and deep space," Kozloff declares, "I chose only sources that I love. After all, the series was to be about pleasure."

For the viewer, pleasure may arise from a variety of factors. The unexpectedness of the juxtapositions is one potent source: elephants humping above, people in elephantine positions below (in *Khajuraho Dijonnaise*); Giulio Romano's illustrations for Pietro Aretino's sonnets and 1930s Hollywood movie stills (in *Classical Stations*); an expressionist set from *The Cabinet of Dr. Caligari* and expressionless copulators from a Chinese pillow book (in *Alan's Bedroom*). Sometimes the sheer plenitude of the image

Joyce Kozloff, *Pornament is Crime Series #16: Classical Stations*, 1987.
Watercolor on paper, 22 × 22 in. (55.9 × 55.9 cm)

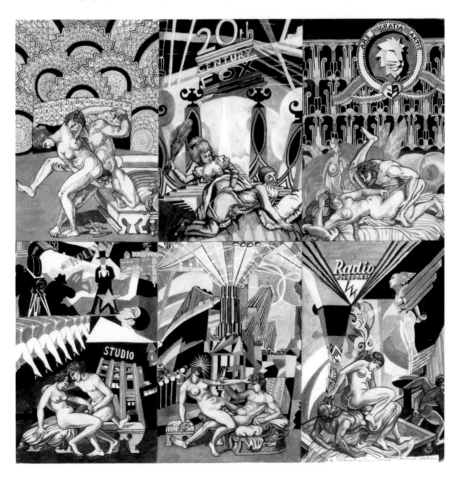

Joyce Kozloff, *Pornament is Crime Series #26: Xtatic Night Blooms—or Rosebud*, 1988.
Watercolor on paper, 22 × 22 in. (55.9 × 55.9 cm)

provides plenty of visual satisfaction. This seems to be the case in *Xtatic Night Blooms—or Rosebud*, in which there are an incredible number of erotic objects and a dazzlingly intricate setting enmeshing them, and the 18th-century English chintz field of action is as sensuous and charged with energy as the tumbling, straddling, clutching figures that adorn it. Richness of color, texture, and pattern adds to the sensual enjoyment of the pictorial texts throughout the series; so does a certain, deliberate denial of richness from time to time—a pleasurable respite from the demands of decoration—provided by works like *Big Boys: Palladio, Veronese, Picasso et al*, with its classically austere Palladian enfilade, and the bizarre architectonic symmetry of *Lequeu's Legions*.

Joyce Kozloff,
*Pornament is
Crime Series #11:
Mackintosh–
MacDonald
Tea Room*,
1987 (detail).
Watercolor on
paper, 22 × 22 in.
(55.9 × 55.9 cm)

In conclusion, I must admit that Kozloff's watercolors settle none of the controversies raging about the pornographic object—or the pornographic imagination. On the contrary, they tend to unsettle any previous notions that the viewer may have entertained, especially about the inevitable seriousness of the erotic experience. Sex, in many of its manifestations, is bizarre or seems so when looked at from outside; at times it is outright funny. It is especially funny when it takes place in the wrong setting—and almost all of Kozloff's settings are "wrong" from the point of view of spatial, temporal, and visual logic. It is, in a way, just this wrongness that makes them so right. Masturbation in the monastery; the maharaja fucking in the Mackintosh–MacDonald tea room; George Grosz jerking off in an Utamaro landscape. This is a *déréglement des sens*, perhaps, a liberation of the erotic fantasy from the bonds of time and place, a free flight into a crazy, untrammeled garden of earthly delights. Yet at the same time, the *Patterns of Desire* series draws our attention to the logic, the persistent mechanics, as it were, of erotic production, and by doing so, reveals the limitations of the genre with its endless repetitions, its all too systematic repleteness. By tearing the erotic out of its expected contexts and providing other, less expected and more visually competitive sites for the representation of the explicitly sexual, Kozloff foregrounds both the achievements and the inevitable lacks of the pornographic imagination.

Notes

1 In Susan Sontag, *Styles of Radical Will*, New York, 1981, pp. 58–59.

2 Ibid., p. 66.

3 "The Straight Mind" (1890), *Feminist Issues*, no. I, Summer, p. 106. I am drawing here on Tania Modleski's suggestive reading of Wittig's analysis in terms of JL Austin's notion of the "performative" statement, in "Some Functions of Feminist Criticism, or the Scandal of the Mute Body" (1989), *October* 49, Summer, pp. 3–24, especially p. 18.

Starting from Scratch: The Beginnings of Feminist Art History

The Power of Feminist Art, 1994

In 1969, three major events occurred in my life: I had a baby, I became a feminist, and I organized the first class in Women and Art at Vassar College. All these events were, in some way, interconnected. Having the baby—my second daughter—at the beginning of the Women's Liberation Movement gave me a very different view of motherhood than I had had back in the middle 1950s when I had my first child; feminism created a momentous change in both my personal life and my intellectual outlook; organizing that first class in feminist art history irrevocably altered my view of the discipline and my place in it, so that all my future production was touched by this originating moment of insight and revision.

It is hard to recapture the sheer exhilaration of that historical moment, harder, perhaps, to remember the concrete details of a conversion experience which, for many women of my age and position, was rather like the conversion of Paul on the road to Damascus: a conviction that before I had been blind; now I had seen the light. In my case, the light had been provided by a friend—just an acquaintance, really—who, shortly after my return from a year in Italy with husband and baby to my familiar job in the Vassar art history department, showed up in my apartment with a briefcase full of polemical literature. "Have you heard about Women's Liberation?" she asked me. I admitted that I hadn't—political activity in Italy, although vigorous, had not been noteworthy for its feminist component—but that in my case it was unnecessary. I already was, I said, a liberated woman and I knew enough about feminism—suffragettes and such—to realize that we, in 1969, were beyond such things. "Read these," she said brusquely, "and you'll change your mind." So saying, she thrust her hand into her bulging briefcase and brought forth a heap of roughly printed, crudely illustrated journals on coarse paper. The pile included, I remember, *Redstockings Newsletter*, *Off Our Backs*, *Everywoman*, and many other publications, including special editions of radical news sheets run by men which angry women had taken over for the explicit purpose of examining the conditions of their exploitation. I started reading and I couldn't stop: this had nothing to do with old-fashioned ideas about getting the vote for women and getting men out of the saloons. This was brilliant, furious, polemical stuff, written

from the guts and the heart, questioning not just the entire position of women in the contemporary New Left and anti-Vietnam movements (subordinate, exploited, sexually objectified) but the position of women within society in general. And these articles—which touched on every area in which women were involved, from repression at the workplace to oppression at home, from art production to housework—were above all striking in their assertion that the personal was political, and that politics, where sex roles and gender were concerned, began with the personal. That night, reading until two a.m., making discovery after discovery, cartoonish light bulbs going off in my head at a frantic pace, my consciousness was indeed raised, as it was to be over and over again within the course of the next year or so. Or perhaps the right figure of speech is a spatial one: it was as though I kept opening doors onto an endless series of bright rooms, each one opening off from the next, each promising a new revelation, each moving me forward from a known space to a larger, lighter, unknown one.

A few weeks later, or maybe it was a few months, after a certain amount of thought but not much specific research outside of a thorough rereading of Simone de Beauvoir, I posted the following notice on the bulletin board in the art history office at Vassar (I reproduce the announcement and the tentative syllabus exactly as they appeared at the time):

Art 364b

November 25, 1969

I am changing the subject of the Art 364b seminar to: *The Image of Women in the 19th and 20th Centuries*. I have become more and more involved in the problem of the position of women during the course of this year and think it would make a most interesting and innovative seminar topic, involving materials from a variety of fields not generally included in art historical research. This would be a pioneering study in an untouched field. Among fields and areas to be included might be:

1. Woman as angel and devil in 19th-century art
2. The concept of the nude through history with special emphasis on 19th and 20th century (anatomy; must a nude be a female? What is shown and what is not shown)
3. Pornography and sexual imagery
4. The social significance of costume
5. Social realities and artistic myths (i.e. women working in factories and the *Birth of Venus* in the Salons)
6. Advertising imagery of women
7. The theme of the prostitute

8. The Holy Family and the joys of domesticity (imagery of the secular family as nexus of value in bourgeois art in the 19th century)

9. Socially conscious representations of lower class women (almost always in "low" art rather than "high")

10. Freudian mythology in modern art; Picasso and surrealism

11. Matisse and the "harem" concept of women

12. Women as artists

13. The Vampire woman in art and literature (in relation to social, psychological and economic factors)

14. Women in Pre-Raphaelite painting and Victorian literature

Most of this territory—and a great deal more—has never been touched. It would involve work in history, sociology, psychology, literature, etc.

<div align="right">LINDA NOCHLIN POMMER</div>

Looking back from the vantage point of almost a quarter of a century, I am struck by the remarkable combination of ambition and naïveté characterizing the project. Did I really think we could cover all those topics in the course of a single semester? Why did I confine "women as artists" to a single class? (Actually, there were several sessions on women artists in the class as it was taught.) And why was I so fixated on the Vampire woman? Alas, since I have never kept a diary and only minimal evidences of that first seminar remain in my keeping, I cannot answer specific questions about what I had in mind. My fuzziness about these issues is a poignant reminder to historians about the unreliability of witness accounts, especially when the witness is identical with the historian in question. Nevertheless, I am struck by the fact that many of these topics have continued to be of major importance to feminist art historians and critics, and, equally, that they have served as the basis for much of my own work in years to come. Even more amazing, we did, as a class, "cover" all these issues and more, admittedly not with the nuance and wealth of information marking subsequent efforts in these areas, but with a lot of passion, a sense of discovery, and with the knowledge that whatever we did counted; for everything, quite literally, remained to be done. We were doing the spadework of feminist art history, and we knew it.

I say "we" because, in this undergraduate seminar, we were "we": a committed group of feminist or proto-feminist researchers tracking down the basic materials of our embryonic discipline. Although as teacher of the group I had a certain priority in directing the inquiry, I was in many ways as ignorant as my students as far as bibliography or background was concerned: everything had to be constructed from the beginning. We were both inventors and explorers: inventors of hypotheses and concepts, explorers of the vast sea of undiscovered bibliographical material, the underground rivers and streams of women's art and the representation of women. As far as bibliography

was concerned, the reading list had to be constructed as we went along. There were no textbooks, no histories of women artists, no brilliantly theorized examinations of the representation of prostitution, no well-illustrated analyses of pornography from a feminist point of view. The concept of the gaze insofar as it related to the visual representation of women had yet to be articulated. Yes, to be sure, there were some outdated and rather patronizing "histories" of women artists like Walter Shaw Sparrow's *Women Painters of the World* (1905), interesting because of its sheer anachronism, serving as raw material for analysis rather than as valid documentation. For raw information, not always accurate, about the 19th century and earlier, there was Mrs. Elizabeth Ellet's *Women Artists in all Ages and Countries* (1858), Clara Erskine Clement's *Women in the Fine Arts* (1904), and Ellen C Clayton's *English Female Artists* (2 vols, 1867), none of them illustrated. And luckily for us, since Vassar had been a women's college, there was a rich repository of materials on individual women and their achievements—in the arts as well as in other areas—and a great deal of material about the social position and the problems of women historically. Vassar had had a feminist, as well as a purely feminine, history although this aspect of its past was decidedly low-keyed during the 1950s and 60s, especially since, at the very moment when the Women's Movement was getting off the ground, the college itself was switching from being a single-sex institution to a coeducational one.

Yet in a certain sense, given the specific nature of my own experience of Vassar, where I had been a student (class of 51) and teacher for many years by the time I taught my first class in women and art, I had always been a feminist, albeit a partly unconscious and often confused one. Certainly I believed that I was as intelligent and capable as most of the men I knew, although constantly riven by the self-doubts and pangs of guilt that afflicted smart and ambitious women in those days. I, like most intellectual women at the time, thought my problems were my own, unique, the products of neurosis or disorganization, not social problems afflicting all women of my sort. Neurosis, not the double message of high achievement coupled with sacrifice of self for husband and family conveyed to intelligent women by the ideological structures controlling gendered behavior, was the reason we were so mixed up, I thought, so often incapable of focusing on intellectual work without pain and conflict. I was exhausted so often, I believed, because I wasn't well-organized enough to juggle housework (admittedly rudimentary, but necessary nevertheless), childcare, husband, teaching, and graduate studies, while also commuting from Poughkeepsie to New York, part time. My graduate "program" consisted of whatever was given at the Institute of Fine Arts on Wednesday afternoon and Saturday morning. If I couldn't manage such a full life (which also included poetry writing, giving and going to fairly lively parties, taking in vanguard theater and dance performances in New York, and playing the recorder with an ancient music group), with sufficient calm and expertise, I felt it was because I somehow hadn't figured things out properly. I didn't consider the fact that organized childcare arrangements were

nonexistent and that women were supposed to run the household singlehanded even if they were professionals. If I had to correct papers, I felt guilty about not doing research for a seminar report at the Institute; if I worked on the seminar report, I felt haunted by shopping I was neglecting; if I shopped, I felt I wasn't paying enough attention to my child. There was no system of moral or practical support for women like me at that moment in history—just unbounded personal energy and a will to persist under difficult circumstances.

At the same time, however, my Vassar education and my years of teaching gifted women there had given me a profound sense of what women could do, even if they weren't encouraged to do much but Little League and family after graduation. My own work was respected and rewarded, my energy and passionate commitment admired. And in some ways, I had always been interested in the achievements, and problems, of talented women. After all, the first paper I had written in freshman history—awarded the history prize that year—had been about the Fabian socialist Beatrice Webb. In social psychology, I had produced a "content analysis" of women's magazines, demonstrating their contradictory message about women's roles. I discovered after months of reading *Ladies' Home Journal* and *Good Housekeeping* that despite the fact that achieving women like Mrs. Roosevelt and Dorothy Thompson were featured in their high-minded articles, the fiction section told a different tale: in these emotionally charged stories, professional women were inevitably punished for their ambition and wives and mothers who dedicated themselves to husband and family were always rewarded for their sacrifice as well as winning the readers' sympathy. Then too, the head of the art history department, Agnes Rindge Claflin, had always encouraged women artists. I remember visits and gallery talks from Loren MacIver, Irene Rice Pereira, and Grace Hartigan in the early 1950s, and they were memorable: as a sophomore I had thrust a poem into the hands of MacIver, and as a young teacher I remember being bowled over not just by Hartigan's work, but by her tough, bohemian, unconventional persona. Works by Georgia O'Keeffe, Kay Sage, Florine Stettheimer, Veira da Silva, Agnes Martin, and Joan Mitchell hung in the gallery; a lively woman sculptor, Concetta Scaravaglione, taught sculpture in the studio. Even earlier, in my teens, my mother had shared with me her enthusiasm for women writers like Virginia Woolf, Katherine Mansfield, Rebecca West, and Elinor Wylie.

At Vassar, women were my teachers, respected scholars and intellectuals in their own right. While most of them were a little too tweedy and unglamorous to serve as *exempla* in any sphere but the academic, some, like Agnes Claflin, were elegant, worldly, sophisticated, and a bit wicked as well as brilliant—all characteristics that charmed me, and continue to do so today. All in all, one might have called me a "premature feminist" in many ways before 1969 and my discovery of Women's Liberation. And now my time had come: what I had felt, confusedly, partially, individually, had become a mass movement, passionately articulated in speeches, articles, books, and meetings by ever-increasing

groups of women, taking inspiration and gaining power from each other, sharing their feelings, their ideas, and their indignation.

By the time Art 364b, "Woman and Art" got underway in January of 1970, there were a few changes and additions to the course: topics became more specific and a rudimentary bibliography had come into being. The reading list was decidedly interdisciplinary and included not only Robin Ironside and John Gere's *Pre-Raphaelite Painters* (1948), Lister's *Victorian Narrative Paintings* (1966), Theodore Reff's "The meaning of Manet's *Olympia*" (1964), Alfred Barr's *Matisse: His Art and his Public* (1951), and Françoise Gilot's *Life with Picasso* (1964), but Gertrude Himmelfarb's *Victorian Minds* (1968), Havelock Ellis's *Studies in the Psychology of Sex* (1942), Mary Wollstonecraft's *A Vindication of the Rights of Women* (1792), and Mrs. Sarah Ellis's *The Education of Character with Hints on Moral Training* (1856). The seminar included a crash course on 19th- and 20th-century cultural history, sexual ideologies and feminist, as well as feminine, notions of what constituted women's place and identity. Nor was "low" art neglected: the bibliography included Gibbs-Smith's *The Fashionable Lady in the Nineteenth Century* (1960), James Laver's *English Costume of the Nineteenth Century*, Emily Burbank's *Woman as Decoration* (1917), as well as several books devoted to advertising and film: E Jones's *Those Were the Good Old Days: A Happy Look at American Advertising* (1959), De Vries's *Victorian Advertisements* (1969), and Alexandra Walker's pioneering *Sex in the Movies* (1966).

Although it is hard to recall the specific features of the class, much less specific students after the passage of time and the repetition of the seminar in various forms in subsequent years, I do remember with great clarity the general air of excitement and enthusiasm that characterized each of its sessions. Students literally fought to give not merely one or two but as many as three class presentations. Discoveries were rife, especially when it came to class presentations on women artists: Frida Kahlo, then relatively unknown to all but a small group of cognoscenti, came to light, as did Meret Oppenheim, known only as the author of the notorious *Fur-Lined Tea Cup* at the Museum of Modern Art, but not known to be a *woman* artist by most of the class. I remember that Donna Hunter, now an art historian at the University of California at Santa Cruz, sent away to Sweden for a recent but obscure exhibition catalogue of Oppenheim's work and revealed to us the richness, variety, and genuine marvelous-ness—in the Surrealist sense—of her production. "I had thought," Donna wrote to me in her memoir of the class, "with a first name like Meret, that Oppenheim was a man... What different interpretations spring to mind when one knows that a woman, in the preponderantly male and male chauvinist world of Surrealism, lined a tea-cup and spoon, symbols of ladylike afternoon rituals, with fur!"

Susan Casteras, another memorable member of the class, now curator of paintings at the Yale Center for British Art, remembers that the "tremendous sense of intel-lectual excitement and expectation that was generated was quite palpable, and those in the class...all shared this unspoken and heightened awareness." This was Donna's

impression, too: "What I remember most about the seminar was the atmosphere in the room, the high level of energy and enthusiasm—a buzz. Everyone was aware that this was a first: that we as women were working with a woman professor on women artists...." "In retrospect," Susan Casteras explained, "it was a feeling of vicarious empowerment and pride that particularly enthralled us—the idea that women mattered as creators of art and that their efforts, whether frustrated, failed, or successful, were worthy topics to study...." She recalls in the same letter "that several undergraduate presentations were outstanding, and the list of areas covered—demonic and angelic images of women, the concept of the nude, pornography, women workers, prostitution, harems, women artists, the vampire/femme fatale and Pre-Raphaelite feminine prototypes—now reads like a prophetic list of some of the central concerns of scholars of 19th century art in the last 20 years."

In the case of her own work in the class, Casteras, the author of several important books and organizer of at least two major exhibitions about the representation of Victorian womanhood, remembers that one of her reports, "a focus on Victorian court-ship imagery, proved to be the germ of my doctoral dissertation and much subsequent iconological research and writing...." Another of her presentations "concentrated on Mary Cassatt and her *Modern Woman* mural (pendant to Mary MacMonnies' *Primitive Woman*) for the Woman's Building at the World's Columbia Exposition of 1893," and resulted in a long senior essay and later, an important article. That senior essay, which I still have on my shelf as a reference work, is an outstanding piece of research about what was then a little-known major achievement of Cassatt's, lost after the exhibition. Donna Hunter has taught courses on art history and feminism and is now working on a project involving a gendered reading of the visual and verbal imagery of the Terror, the martyrs of the revolution in particular.

But it was not merely the discovery of women artists and their achievements that was exciting. Looking at old themes in new ways was equally revealing: the imagery of the family, especially of mothers and children, was seen in a new light: a comparison of Mary Cassatt's *The Bath* or Berthe Morisot's *The Cradle* with Renoir's *Portrait of Mme. Renoir Nursing Pierre* revealed that it was the male artist's image that was more senti-mental, traditional, and clichéd, the women's more emotionally distanced and formally avant-garde. And Dorothea Tanning's hallucinatory image of 20th-century motherhood, bleak, isolated, preternaturally silent, shredded the myth of essentialist nurturance and benignity entirely, leaving it in Surrealist tatters. Work by such modernist masters as Picasso and Matisse was examined in ways that called into question the whole formalist apparatus of art criticism and demanded a more critical view of what had formerly been seen as relatively gender-neutral territory. It was not just the iconography of works like the *Demoiselles d'Avignon* or Matisse's harem women that was called into question, but the whole position of the female nude within Western pictorial culture itself. Why were there so few male nudes by women artists and so many female ones by males? What

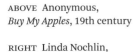

ABOVE Anonymous,
Buy My Apples, 19th century

RIGHT Linda Nochlin,
Buy My Bananas, 1972

did that say about power relations between the sexes, about who was permitted to look at whom? About who was objectified for whose pleasure?

These issues were pursued at greater length in the introduction I gave to a session on "Eroticism and the Image of Woman in 19th-century Art" at the College Art Association Meetings in San Francisco in 1972. It was subsequently published as "Eroticism and Female Imagery in Nineteenth-century Art" in *Woman as Sex Object*, edited by Thomas Hess and myself in the same year, where it was illustrated with the now-notorious photograph of a bearded male nude coyly holding a tray of fruit at penis level, entitled *Buy My Bananas*, created as a pendant to a 19th-century female version of the topos called *Buy My Apples*. Today, such critiques may seem obvious, but in 1969 and 1972, when whole lectures or classes could go by without any reference to the specifically sexual qualities of nudes like *Olympia* or Goya's voluptuous naked Maja, discussions of the sexual politics of paintings were anything but self-evident.

I gave the course again in the spring term of 1971, this time in conjunction with one given by Professor Elizabeth Daniels in the English department on women in Victorian literature, a course which again bore fruit (not bananas this time!) in my own work. When I was asked to give the Walter Cook Alumni Lecture at my graduate school

alma mater, The Institute of Fine Arts, I decided on a feminist theme, incorporating both the French art, which had always been my field of interest, and the Victorian painting with which I had recently become involved. In this lecture, "Holman Hunt's *Awakening Conscience*: the Theme of the Fallen Woman in Nineteenth-century Realism," I attempted to reconstruct sexual ideologies through a critical analysis of formal structure as well as iconography in the work of Manet and the Pre-Raphaelites; the talk was unequivocally feminist in its viewpoint. It included not only "fallen women" images from the work of Degas and Hogarth, Augustus Egg and Cézanne, as well as the two featured paintings of the lecture, Hunt's *Awakening Conscience* and Manet's *Nana*, but it juxtaposed misogynistic texts by the Goncourts with feminist ones by John Stuart Mill.

"Woman and Art" surfaced again in a new incarnation at Stanford University during the summer term of 1971. Now the course outline was more complex in its material and more rationalized in its organization; the reading list grouped texts thematically for each class session. There was, in fact, beginning to be a feminist literature in art history and criticism, as well as in many other fields. Looking back, one can see that a discipline, a discourse, and a field of scholarly inquiry was in the making, and one can watch ideas in the process of formulation. Among the texts, some of which were fairly standard art-historical ones, were included such specifically feminist works as: Naomi Weisstein's "Psychology Constructs the Female" from *Women's Liberation and Literature* (1971); my own "Why Have There Been No Great Women Artists?", published that January in *ARTnews* and simultaneously in *Women in Sexist Society* (1971); interviews with Judy Chicago, Miriam Schapiro, and Faith Wilding in *Everywoman*; *The Victorian Woman: A Special Issue of Victorian Studies*; Lucy Komisar's "The Image of Woman in Advertising," also from *Women in Sexist Society*; and Alex Shulman's "Organs and Orgasms," from the same volume. Students, of course, contributed additional bibliography to the reading list as they prepared their presentations.

The two introductory sessions were devoted to a discussion, based on the reading and slides of the interrelated issues of women in art and women as artists; the third class dealt with the theme of woman in 20th-century high art: Matisse and the harem conception of women; Picasso, Surrealism, and Freudian mythologies of woman; de Kooning's brutal tactics in his *Women*; women in pop art; pornokitsch. The fourth class was dedicated to 19th-century imagery of women. The fifth class, however, struck out in relatively new territory, or at least considerably expanded on what had previously been a minor issue—women in low or popular art: advertising, TV, movies, costume, women's magazines, and the relation of such imagery to high art. One woman in the class, I remember, brought her grandmother's lacy bloomers and petticoat as objects worthy of art-historical scrutiny and social analysis. For the next session, women as sex, which included pornography and sexual imagery, class members went down to the famous porn shops of San Francisco, where the habitués were evidently shocked speechless by the spectacle of proper young female students avidly paging through

the most explosive merchandise. The final reports were on women artists: such 19th-century heroines as Bonheur, Cassatt, Morisot, the women sculptors of Rome (the so-called White Marmorean Flock), and 20th-century ones: O'Keeffe, Romaine Brooks, Frankenthaler, Bontecou, and, as a bow to the local talent, Julia Morgan, a San Francisco architectural pioneer who had created Hearst's San Simeon, among other achievements.

But perhaps most interesting of all was a final session with Miriam Schapiro and Judy Chicago, up from *Womanhouse* in Los Angeles, full of ideas and fresh from recent innovations in the actual making of art and the empowering of women artists. While I strongly disagreed with their assertion that there was an innate "feminine" style, signified by centralized imagery or circular forms and existing apart from history and the historically conditioned institutions of art, I agreed just as strongly with their ideas about supporting the work and the working lives of contemporary women artists. The students were enthralled and participated actively in the discussion that followed Schapiro and Chicago's presentation. Among those attending the class was a Stanford graduate student, Paula Harper, who herself was to take a leading role in the early development of feminist art history. In 1971, Paula taught a course at the California Institute of the Arts pioneering Feminist Art Program—a seminar on the history of women artists—and then went on to participate in the organization of the Women's Caucus at the College Art Association and to chair the first CAA session devoted entirely to women's art history in 1973 in New York. This session included memorable presentations by Eunice Lipton on Manet; Susan Casteras on Susan Eakins; and June Wayne on the "feminized" position of artists in general in American society.

Needless to say, I later made the trip to *Womanhouse* and found it exciting and provocative, inspiring and controversial. In the works on view in the rackety, "domestic" setting, the aggressive emphasis on the representation of women's bodies as well as the sense of the unrelenting oppressiveness of women's lives was novel and disturbing: the unforgettable *Menstruation Bathroom* with its wall-to-wall Kotex and vivid red-and-white decor was an outstanding case in point. Yet as a Vassar woman and a seasoned professional, I was a bit surprised at the unremitting fascination with domesticity and sexuality that marked the work on view and surprised to find that women art students actually needed so much support and encouragement simply to do their work: we, as students, after all, had taken it for granted that we could produce plays, do the lighting, paint sets, make frescoes and be articulate, independent, and feisty. My one-day experience at *Womanhouse* made it clear that this was hardly the case universally. Then too, I had always had interesting and brilliant women professors as mentors, in art as well as in more scholarly realms, and took it for granted that other women had had the same opportunity. *Womanhouse* made it obvious that for many women, authority figures were masculine by definition and having teachers of one's own sex who were openly conscious of their femininity was indeed a radical innovation.

At that point in the women's art movement, contemporary art making and the history of art insofar as it concerned women and their representation were mutually stimulating and interrelated. Once again, excitement was in the air, time seemed to be too short for all we wanted to investigate, critique, discuss, and argue about. The class attitude at Stanford was decidedly *engagé*, and yes, I think that California made a difference.

It was shortly after the California summer that Ann Sutherland Harris and I embarked on a major enterprise in the early history of women's art history: the preparation of the exhibition *Women Artists: 1550–1950* and its accompanying catalogue. The exhibition came into existence at least in part through the persistent activism of women artists and the progressive spirit of the Los Angeles County Museum of Art. During the course of preparing the show, Ann and I traveled extensively in Europe and in this country, encountering every possible attitude on the part of museum curators, ranging from bemused curiosity to patronizing contempt to genuine and enthusiastic support for our project. Open-minded and knowledgeable curators, like the Tate Gallery's Richard Morphet, were rare and greatly appreciated. One museum official actually went so far as to ask me why there had never been any great women artists! Needless to say, some of the very same curators who had sneered or begrudgingly made us a few meager loans were showing women artists themselves a few years later. Working on *Women Artists* was one of the most difficult, and yet ultimately one of the most rewarding, tasks of my life. On the one hand, I knew I was taking a position that directly contradicted my stance in "Why Have There Been No Great Women Artists?" Yet it seemed to me that, after digging around in the basements and reserves of great European museums and provincial art galleries, there had indeed been many wonderfully inventive, extremely competent, and above all, unquestionably interesting women artists; some of these artists had been cherished and admired on their own native turf, even if they could not be considered so-called international superstars. This work and its historical import, without question, deserved to be shown and, even more important, deserved to be thought about and seriously analyzed within the discourse of high art. The show had other effects as well—both simpler and more direct. Even today, women sometimes come up to me, women artists or workers in the art field, and say something like this: "That show changed my life. I never knew before that I, as a woman artist or art-worker, had a history. After that show, I knew I was part of a long tradition and it gave me the courage to go on."

Nothing, I think, is more interesting, more poignant, and more difficult to seize than the intersection of the self and history. Where does biography end and history begin? How do one's own memories and experiences relate to what is written in the history books? Can one complain of "distortion" in historical writing when, inevitably, with the passage of time, our own memories of events and experiences become confused, filmy, uncertain? I have been drawn to the topos of self and history since the age of twelve,

when I wrote a long blank verse poem called "The Ghosts of the Museum," inspired by my spiritual home-away-from-home, the Brooklyn Museum. Here, in this poem, I attempted to communicate with an Egyptian princess; I brought museum objects, like mummies and cherry-wood cradles, to articulate life in terms of my own, unique, present-day experience of them; and I predicted dolefully that our own cigarette lighters and coffeepots, our radios and necklaces would soon find their place "in the vast, dusty halls of the museum." Later, when I was considerably older and more sophisticated, I wrote a poem entitled "Matisse/Swan/Self" in which I contemplated a photograph of Matisse sketching a swan in the Bois de Boulogne in 1931, the very year I was born, and meditated on the coincidence of totally unrelated events which nevertheless could be interpreted as meaningfully integrated on some transcendent level. Yet in 1969 and the years that followed, the intersection of myself and history was of a different order: it was no mere passive conjunction of events that united me to the history of that year and the ones that followed, but active engagement and participation, a sense that I, along with many other politicized, and yes, liberated, women, were actually intervening in the historical process and changing history itself: the history of art, of culture and of institutions, and of consciousness. And this knowledge even today, almost twenty-five years later, gives us an ongoing sense of achievement and purpose like no other that I know of.

11

Mary Cassatt's Modernity

Representing Women, 1999

Mary Cassatt's *Lady at the Tea Table* (1883–85) is one of the most remarkable American portraits of the 19th century. A subtle combination of strength and fragility, the painting represents Mrs. Mary Dickinson Riddle, Cassatt's first cousin once removed. The sitter, who had a reputation as a great beauty, in fact rejected the work, apparently because she and her daughters felt it was not flattering enough. And indeed, it is not a flattering portrait, in the sense that John Singer Sargent's almost contemporary portrait of *Lady Agnew of Lochnaw* (1892) is. The pose is far more rigid, the costume and decor more severe; the tell-tale signs of age, especially about the mouth and chin, are observed, if not exaggerated; the wonderfully quirky nose's sharp tip is enhanced by a dab of white highlight; the horizontal flare of the nostril is anything but classic in its idiosyncratic structure. What Mrs. Riddle has is *character*, something as different from the slightly

Mary Cassatt,
*Lady at the Tea
Table*, 1883–85.
Oil on canvas,
29 × 24 in.
(73.7 × 61 cm)

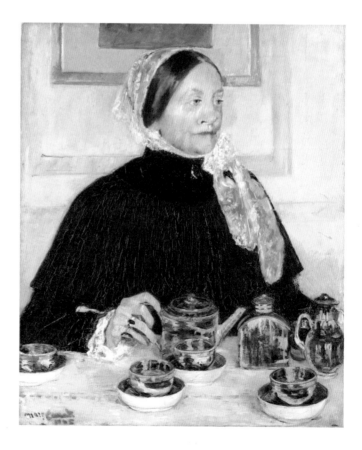

vapid elegance of Sargent's sitter as it is from the explosive primitivism of an almost contemporary portrait like Vincent van Gogh's *La Mère Roulin* (1889).

Cassatt has been criticized for paying attention to the lives of only a very restricted circle of women: a privileged circle, like that represented by Mrs. Mary Dickinson Riddle, women who could afford to spend their days enjoying genteel accomplishments, mutual entertainment, and mild, leisure activities; women who did not have to work, and who, on the whole, did not engage in the arts on a *professional* rather than an amateur level. Cassatt herself was divided about this: she aspired unswervingly toward professionalism and the serious work it entailed but nevertheless honored the feminine sphere of activity, those "spaces of femininity"[1] so aptly named by Griselda Pollock, that private sphere of family, friends and decorous sociability which engaged most women of Cassatt's time and class.

The taking of tea with elegant accoutrements seems to have attracted her more than once, as the painting *The Cup of Tea* (1880) demonstrates. Perhaps it seemed paradigmatic to her of that other kind of "work" or more accurately, art, that leisure-class women engaged in, in addition to running fairly complicated, large-scale households: the art of organizing domestic ceremonies. Tea is here represented as a sort of ritual occasion in the feminine, what Yeats has referred to as a "ceremony of innocence." As such, presiding over the tea table may be seen as a major instance of what the great modern novelist, Dorothy Richardson, in her *roman-fleuve, Pilgrimage* (the first volume of which was published in 1915), has called women's crowning achievement—"the creation of atmospheres."[2] Like Cassatt, Richardson both yearned for women's emancipation, and, at the same time, honored and cherished her domestic role as creative director and maintainer of the "spaces of femininity." Miriam, the heroine of *Pilgrimage*, in conversation with an enlightened male advocate of women's emancipation, states: "There's no emancipation to be done. Women are emancipated." "Prove it, Miriam," her male suffragist friend challenges. "I can," Miriam replies,

> Through their pre-eminence in art. The art of making atmospheres. It's as big an art as any other. Most women can exercise it, for reasons, by fits and starts. The best women work at it the whole of the time. Not one man in a million is aware of it. It's like air within the air. It may be deadly...So is the bad art of men. At its best it is absolutely life-giving. And not soft. Very hard and stern and austere in its beauty...Just as with "Art"...It's one of the answers to the question about women and art. It's all there. It doesn't show, like men's art. There's no drama or publicity...It's hard and exacting; needing "the maximum of detachment and control." And people have to learn, or be taught, to see it...[3]

Yet Miriam (who is really the authorial voice in the novel), like Cassatt, somehow reveals the paradoxical nature of her defense of women as atmosphere-makers versus

art-makers by admitting at the end of this passage: "Lots of women hold back. Just as men do—from exacting careers. I do. I don't want to exercise the feminine art."[4] And later, in an article, Richardson articulates that divided position vis-à-vis women's domestic role which so unites her with Cassatt, by pointing out that the demands of atmosphere-making offer precisely the greatest obstacles to women's creative achievement:

> Art demands what, to women, current civilization won't give. There is for a Dostoyevsky writing against time on the corner of a crowded kitchen table a greater possibility of detachment than for a woman artist no matter how placed. Neither motherhood nor the more continuously exacting and indefinitely expansive responsibilities of even the simplest housekeeping can so effectively hamper her as the human demands, besieging her wherever she is, for an inclusive awareness, from which men, for good or ill, are exempt.[5]

The article, published under the rubric "Women in the Arts," is entitled, significantly: "Some notes on the eternally conflicting demands of humanity (*not* 'femininity'!) and art."

In a sense, one might speculate that Cassatt, in the painting *Lady at the Tea Table*, sees her sitter's vocation—manipulating the tea things, pouring, arranging her clothing and decor, running her household with a sure grasp, a keen esthetic sense, and long years of experience, of building a seemly and even exquisite atmosphere—as an analogue to her own task of painting a portrait: constructive, subtle, full of choices and decisions, a formal work as well as a social occasion.

And indeed, it is through the knowing manipulation of the formal means of *her* art, the art of painting, that Cassatt has made this portrait into a masterpiece, not merely a likeness. Like Poussin's great self-portrait in the Louvre (1650), it is also a painting about art and the making of art. Like Poussin, Cassatt sets off her sitter's head in a series of enframements which both rivets it in place and calls attention to the relation between the rectangles within the painting (one of which is, indeed, a framed picture itself) and the rectangular shape of the canvas support.

A similar use of the frame to provide compositional stability and self-reference exists in Degas' *The Bellelli Family*, a family portrait of the late 1850s and early 60s, where Laura Bellelli offers a striking analogue to the figure of Mrs. Riddle in both her dignified pose and her dark pyramidal shape; Degas, a friend of Cassatt's, used the painting-within-a-painting motif again, with quite different implications, in his 1868 portrait of another friend, the artist James Tissot.

Yet oddly enough, it is a painter whom Cassatt seems not to have admired strongly whose work offers the best analogy for her sense of the frame-within-a-frame in her work. Cézanne, in his seated portrait of Choquet (1877), locks the figure in place with exactly the same tightly-knit planar grid that Cassatt constructs for her portrait, although he

emphasizes it more through constant reiteration. Cassatt, on the contrary, softens any impression of pictorial geometry through strategies of texture and color, playing the blue-and-white drip patterns of the Chinese export tea set, so strikingly deployed in the foreground, against the differentiated swirls and textures—also blue and white—of the delicate, transparent lace *coiffe* of the sitter. The glitter of the porcelain is picked up, in a different modality, by the subdued glow and coloristic striation of light playing on the sitter's face. Indeed, the painting could, with perfect justice, in a Whistlerian vein, be thought of as a "Symphony in Blue and White." Cassatt also avoids any sense of over-rigidity by playing the asymmetry of pose and carefully deployed china against the slightly off-center position of the figure as a whole, loosening the bonds of would-be symmetry into an interesting off-centeredness.

This sense of a firm skeletal structure controlling the portrait composition is quite different from the looser one used by Berthe Morisot in her portrait of her sister, Mme Pontillon (1871). This firmness of structure is characteristic of all of Cassatt's most distinguished portraits of women, like that of Miss Mary Ellison (1879), where the gilt-edged mirror plays the same enframing role as the picture in *Lady at the Tea Table* and the semicircle of the fan is echoed in the answering curve of the sofa back, or the *Young Lady in Black* (1883), where the striking female figure is doubly enframed by elements of the background.

But although Cassatt can certainly demonstrate her brilliance and formal inventiveness as a portrait-painter of women, it must nevertheless be admitted that it is upon her images of mothers and children that her reputation seems to rest today.

My graduate student who sent an image of the painting *Emmie and Her Child* (1889) [p. 204] as a Mother's Day card to his mom is certainly typical, even if his appreciation is on a higher level, of the perception of Cassatt's work today. For many people, Cassatt is representing the "natural mother" in *Emmie and Her Child*, a maternal image cast in the timeless one of the Madonna and Child of Italian Renaissance painting—say, for example, Raphael's *Madonna del Granduca* (1500)—but made contemporary, secular and intimate.

Yet of course, there is no "natural" way of representing motherhood, any more than motherhood itself can be thought of outside the specificity of a particular historical, social, and imagistic context.

Within Cassatt's own time, representations of the mother and child theme could range from the iconic ferocity of Van Gogh's *Mme Roulin and Her Baby* (1888) to the saccharine traditionalism of William Bouguereau. Other epochs have envisioned motherhood, under duress, as either fierce or alienating, as is exemplified by Goya's *They Are Like Wild Beasts* (c. 1810) or Dorothea Tanning's *Maternity* (1946). And of course not all mothers are "good," nor have they been represented as such—for example, Delacroix's *Medea* (1838) or Max Ernst's *Virgin Spanking Infant Jesus* (1926)—although their transgressive power arises precisely from the memory of the "good mother" images they

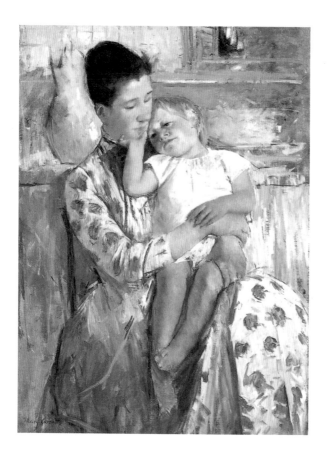

Mary Cassatt,
Emmie and Her Child, 1889.
Oil on canvas,
35½ × 25⅜ in.
(90.2 × 64.5 cm)

violate, in the case of the Delacroix, Andrea del Sarto's *Charity* in the Louvre, in the case of the Ernst, something like the Raphael *Madonna* mentioned above.

And if Cassatt's mother and child images speak openly of the sensual fleshly delights of maternity, as is the case with *After the Bath* (1901)—far more, for instance, than Morisot's more distanced, delicate image, *The Cradle* (1872)—they seem repressed or at least sublimated in relation to Paula Modersohn-Becker's animalistic, earthy carnality in the painting *Reclining Mother and Child* (1907), where the naked maternal body, itself curled into an almost fetal position, seems almost to merge with the naked form of her young.

And certainly, Cassatt never deals with misery, poverty and anguish as conditions of the maternal relationship. She does not represent the tragedy of the proletarian mother who cannot care for or succor her young as does Kollwitz with characteristic expressive power in such images as her etching of *Dead Child and Mother* (1903) or the *Portraits of Misery IV* (c. 1903). Cassatt's is the mother of the cozy, well-provided upper-middle-class bedroom or parlor, in which her curving body can provide shelter and sustenance, not the mother of the back alley or the urban slum.

But there is another kind of mother that Cassatt's art engages with, a very different mother—her own mother, but, perhaps equally importantly, a mother *without* a child. Despite the fact that Cassatt's painting of her mother, *Reading Le Figaro* (1877–78) [p. 206], shares certain formal characteristics with Whistler's, and despite the fact that, from a coloristic point of view, Cassatt's painting, playing on a subtle scale of whites tinged with gray, could, like another famous painting by Whistler, also be called "A Symphony in white," her mother is represented not staring blankly into space, in disembodied profile, an object within a world of objects, but rather in solid three-quarter view. She is represented reading with great concentration, not some fluffy novel, but the rather serious and politically and literarily oriented *Le Figaro*, its title prominent if upside down in the foreground.

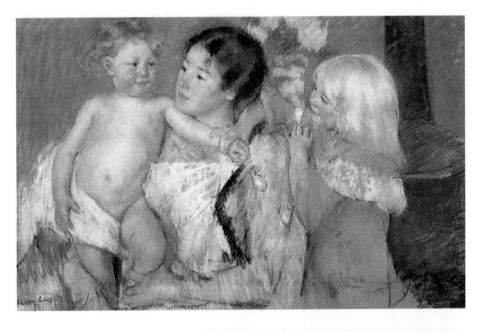

ABOVE Mary Cassatt,
After the Bath, 1901.
Pastel on paper,
25¹⁵⁄₁₆ × 39⅜ in.
(66 × 100 cm)

RIGHT Paula Modersohn
Becker, *Reclining Mother
and Child*, 1907. Oil on
canvas, 32⅝ × 49¼ in.
(83 × 125 cm)

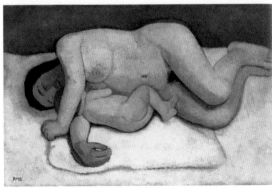

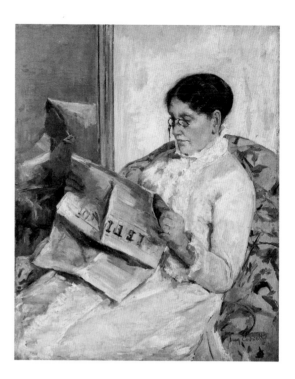

Mary Cassatt,
Reading Le Figaro,
1877–78. Oil on
canvas, 39⅛ × 31½ in.
(99.4 × 80 cm)

In her classic text, "Motherhood According to Bellini,"[6] the French theorist Julia Kristeva meditates on the Virgin's body, its ineffability and the way it ultimately dissolves into pure radiance. In other writings, she and other French, psychoanalytically oriented "feminists" stress the maternal body as the site of the pre-rational, the incoherent and the inchoate. Cassatt's portrait inscribes a very different position vis-à-vis the maternal figure; for this is a portrait-homage not to the maternal body, but to the maternal *mind*. Put another way, one might say that, finally, we have a loving but dispassionate representation of the mother not as nurturer but, rather, the mother as logos. It doesn't really matter whether the real Mrs. Cassatt was an intellectual or not—for all we know, she may have been absorbed in the racing news—it is the power of the representation that counts. Instead of the dazzling, disintegrative, ineffable colorism with which Kristeva inscribes the maternal body according to Bellini, Cassatt reduces the palette of the maternal image to sober black and white—or its intermediate, gray—the colors of the printed word itself. Sight, of course, is the sense most closely allied with mental activity, associated with (usually, but not always) masculine power in the 19th century; and the black-framed pince-nez—the instrument of visual power—is prominent, reiterating the black of the printed page below and the hair above.

Shortly before, in *In the Loge* (1878), Cassatt had associated femininity and the active gaze. Her young woman in black, armed with opera glasses, is all active and aggressive-looking. She holds the opera glasses, those prototypical instruments of masculine

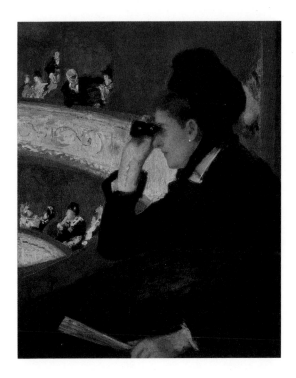

Mary Cassatt,
In the Loge, 1878.
Oil on canvas,
32 × 26 in.
(81.2 × 66 cm)

specular power, firmly to her eyes, and her tense silhouette suggests the concentrated energy of her assertive visual thrust into space. Even in a portrait painted when her mother was sick and visibly older, *Portrait of Katherine Kelso Cassatt* (1889), Cassatt creates an image of power, framing and setting off the head and giving her mother's body a certain amplitude, placing her in the traditional "thinker" pose.

What I am trying to suggest is that, while they might often, in the 19th century, be the antithesis of the spaces of thought and action in the public (and predominantly masculine) sphere, the spaces of femininity might also, for some women, actually serve as sites of intellectual and creative production, and eventually, even of political militancy. Or to put it another way, these spaces can suggest the psychoanalytic maternal position, inscribed in the presymbolic, symbiotic relation of mother-child in a world of their own, apart from a public, patriarchal sphere of reason and power—the symbolic order, to which the (male) child gradually accedes with the acquisition of language, a process brilliantly recorded in Mary Kelly's *Post-Partum Document* (1978–79). This psychoanalytic construction of the maternal position is radically different from the multiple positions historically assumed by actual mothers in the historical world, including such women as Mary Cassatt's close friend, Louisine Havemeyer, a mother who collected the most advanced art of her time and went to jail for the cause of women's suffrage, or Mrs. Potter Palmer, also an active feminist and suffragist and an organizer of the Woman's Building at the Chicago World's Fair of 1892–93. Not that Mary Cassatt's mother was a

political activist, far from it; I am merely saying that for her daughter, she could serve as a powerful if understated metonym of thought, directed attention and intelligence and at the same time inscribe the position of motherhood. This duality might not be without its contradictions—they stay with us today, as any professional or politically active woman who is also a mother knows—but it was a position within the privileged world in which the Cassatts lived, and even within less privileged ones. It is not without significance that Gertrude Stein chose to call her remarkable play based on the life and achievements of Susan B Anthony, later an opera with music by Virgil Thomson, "The Mother of Us All." And as far as the psychoanalytic take on the maternal position is concerned, even that has been recently challenged by Marie Christine Hamon in her book provocatively entitled *Pourquoi les femmes aiment-elles les hommes? et non pas plutôt leur mère?* (1992).[7]

Yet even when Cassatt confronts the more conventional aspects of motherhood—the mother caring for her child, bathing it, as in the painting *The Child's Bath* (1893) or the drypoint *The Bath* (1890–91)—at her best she avoids the sentimentality, the roly-poly clichés of form and conception, including the animalistic "earth-mother" physiognomy, of Renoir's *Motherhood* of the same period.

Mary Cassatt,
The Child's Bath, 1893.
Oil on canvas,
39½ × 26 in.
(100.3 × 66.1 cm)

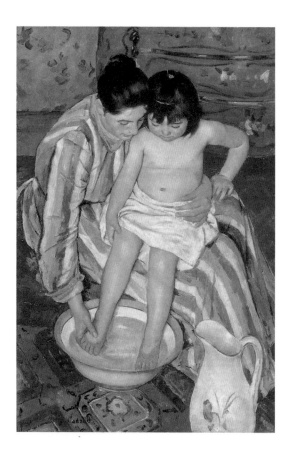

Indeed, it is to another contemporary, Degas, and his adult women "Bathers," specifically *The Tub* (1886) [p. 210], that one must turn for an equivalent to Cassatt's formal boldness in her 1893 painting *The Child's Bath*, which shares with Degas the high horizon, the view from above and the psychological restraint, as well as that sense of the formal demands of the surface, which move our eye up and across the canvas rather than into it. The bold yet controlled use of multiple patterns and sophisticated color relationships in the formal construction of the image, however, is Cassatt's own: the pattern of the wallpaper in relation to that of the bureau in the background; the two different rugs, one at the front and one at the back; the recherché harmony of the dress striped in mauve, olive and white, the stripes picked up differentially by the pattern of the fingers of mother and of child, the folds of the towel and, now circular, in the mauve border of the footbath; all this set into play by the exaggerated scale of the pitcher in the foreground leading the eye up and onto the pictorial surface.

One must not, of course, underestimate the role of the Japanese print, like the 18th-century example by Kitagawa Utamaro, *Young Mother Bathing Her Baby* [p. 210], in mediating and transforming scenes of intimate life, which in the Western art of the 19th century were susceptible to sentimental convention, into works of formal rigor and

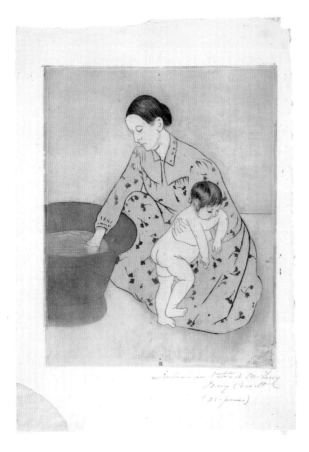

Mary Cassatt, printed with Leroy, *The Bath*, 1890–91. Color drypoint, aquatint and softground etching from two plates, printed *à la poupée*, on ivory laid paper, 12⅝ × 9¾ in. (32.1 × 24.7 cm) (image); 17⅛ × 11¾ in. (43.6 × 30 cm) (sheet)

ABOVE Edgar Degas, *The Tub*, 1886.
Pastel on cardboard, 23⅝ × 32⅝ in. (60 × 83 cm)

RIGHT Kitagawa Utamaro,
Young Mother Bathing Her Baby, c. 1795.
Polychrome woodblock print; ink and color on paper, 14¹¹⁄₁₆ × 9⅞ in. (37.3 × 25.1 cm)

emotional distance. This relationship is particularly noticeable in the print version of the image, and is another predilection that Cassatt shared with Degas, as well as with her friend Louisine Havemeyer from whose collection this print (a trial proof from between the 9th and 10th states) comes.

Yet neither should one underestimate the rich current of sensuality marking Cassatt's treatment of the infant body, her delight in the luscious tactility of baby flesh. I asked a student at a recent doctoral examination which was a more sensual treatment of the naked body, the Cassatt or Degas' pastel, *The Tub* (1886). She was stumped. The two other women professors on the committee agreed that it was a hard decision, but interestingly enough, the solitary male member of the committee confessed that as a man and a father he had been so indoctrinated into the taboo nature of the girl-child's body that he could hardly even look at the image, much less consider it a sensual one! Cassatt transcribes her own impatience with convention in one of her early representations of the child alone, *Little Girl in a Blue Armchair* (1878). How well she has captured the irritation of the nicely dressed child, that particularly annoying quality of wiggliness that afflicts the young when, nearly going mad with boredom, they are forced to sit still for a long time against their will. Against the angular movement of the child, Cassatt has contrasted the immobile form of the sleeping puppy to the left; one can imagine the desperate parent saying to the little prisoner: "See how nicely Fido sits for Miss Cassatt." The young girl's restless pose is in marked contrast to the conventional, dull and angelic manner in which Rudyard Kipling's little daughter sits for Cassatt's contemporary and academic rival, Elizabeth Gardner Bouguereau. This same kind

of sentimentalized innocence marks Angèle Dubos' child-portrait, *Happy Age* (1877). Rather than being an individual feature, it is a convention of the representation of childhood for the academic art of the period.

In a certain sense, Cassatt's *Little Girl in a Blue Armchair* might be said to contain an autobiographical reference as much as the *In the Loge* with her avid glance: a portrait of the artist as an impatient semi-rejector of traditional feminine roles and decorum as well as the conventional representation of female subjects, young or mature; although the real, grown Mary couldn't wiggle like that, a certain amount of spiritual wiggling, and verbal tartness, was permissible—and useful.

Berthe Morisot, a friend of Cassatt's, also takes steps to deconventionalize the child-portrait in her image of her daughter, *Julie and Doll* (1884), both in terms of style and in choice of pose and dress—sagging stockings and rucked up skirt—though the brush-work is far looser and more expressive and the image more benign than Cassatt's. It is, of course, possible for the modern viewer to read a certain undertow of prepubescent sexuality in the sprawling, straddle-legged pose. Again, one might point to precedents in the history of French art. In Théodore Géricault's *Portrait of Louise Vernet as a Child* (*c*. 1818) for instance, also known as *L'Enfant au Chat*, the child is shown with seductively revealed shoulder and knee, gripping a very knowing—or even human-looking—cat with her arm. Courbet's *Portrait of Béatrice Bouvet* (1864), is marked by a perverse, doll-like stiffness, a perversity which surfaces violently in the representations of young girls by Balthus, though his sitters are a little older to be sure; note the presence of the cat and the echo of the seductive pose in the raised arms.

It has rarely been noticed how many of Cassatt's children—babies mostly, but some more than that—are stark naked and sexually identifiable, or if it has been noticed, it has not been commented on as anything out of the ordinary. Nor has it been pointed out how frankly provocative the glances and gestures of mother and infant son are in the aptly named *Baby's First Caress* (1891) [p. 212]. This is partly because of the justify-ing precedent provided by the naked or semi-naked Christ child in the Virgin and Child imagery of the Renaissance; but of course, the myth of the asexuality of these figures was exploded once and for all by Leo Steinberg in his brilliant study of the sexuality of Christ.[8] But we also avoid the issue of the child-nude in Cassatt's paintings because, in the light of psychoanalytic theory, the subject has too many disturbing undertones and overtones. The sexuality of Mary Cassatt is not something we want to think about, just as we prefer to think of the childish body as innocent, prelapsarian in fact, despite evidence to the contrary. The 19th century, like our own, was a time of deep ambiguity about the naked body of the child although the inscriptions of repression are far from identical.

In Cassatt's passionate devotion to the nude child's body, as in the painting *Mother and Child (Mother Wearing a Sunflower on Her Dress)* (1905), one cannot rule out the pres-ence of desire. One might almost speak of Cassatt's lust for baby flesh, for the touch, smell and feel—intimate touching plays an important role here—of plump, naked,

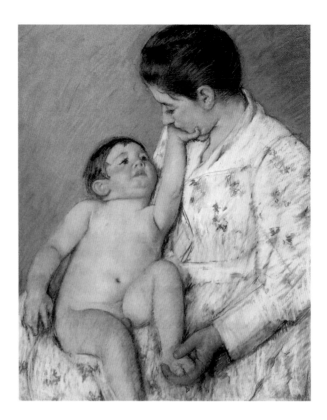

Mary Cassatt,
*Baby's First
Caress*, 1891.
Pastel on paper,
30 × 24 in.
(76.2 × 61 cm)

smooth-skinned bodies, a desire kept carefully in control by formal strategies and a certain emotional diffidence; in some cases, the less successful ones, displaced and oversweetened as sentimentality.

The psychoanalytic terms "displacement," "repression" and "sublimation" inevitably creep into the discourse when the subject of sexuality is broached in relation to the works of Cassatt. Yet we must be wary of anachronistic readings of the mobility of desire and its objects. For the 19th century, the naked bodies of children were often envisioned as simultaneously pure *and* desirable, as is exemplified by the seductively nude or nearly nude photographs of little girls by the Reverend Dodgson, otherwise known as Lewis Carroll, such as his *Portrait of Evelyn Maud Hatch* (1879).

Though it is tempting to see Cassatt's lusciously nude babies, such as the *Mother and Child (The Oval Mirror)*, as examples of Freudian "displacement"—to assert that in the absence, in the representational codes of the time, of socially acceptable *mature* objects of female desire, she simply displaced that desire onto immature ones—this may not be the case at all. Desire takes many different forms at different historical moments and in different situations and we decide what is "normal," what is "displaced" or "repressed" at our peril. Although the Reverend Dodgson might shy away from the adult female

nude, he, his youthful sitters, and their cooperative mothers seem to have felt quite at ease with the child-nude, reserving the sexual fantasies we deem appropriate only to *adult* objects for the realm of childhood.[9]

Why should a nude photograph by Robert Mapplethorpe of the young Jessie McBride of 1976 be considered obscene, or even placed in the category of "child pornography" by some extremists? Why are such images as these, or ones like them, considered—by our postal authority even, officially—dirty pictures? And why are Sally Mann's photographs of her own children considered more than equivocal—offensive, even, by some people (and I'm not saying, in an absolute sense that they don't hover on the dark border of the forbidden)—and Cassatt's not? Is the issue at stake the indexicality of photography? Clearly, Cassatt's youthful sitters sat naked as much as Sally Mann's daughter posed likewise.

Or maybe we should think more about the equivocal sexuality present in both and realize that we are living through an age of almost unparalleled repressiveness and prudery where the child's body and its visual representation is concerned; our much vaunted sense of sexual liberation has gone at least ten steps backward in that area since the time of the Reverend Dodgson and Mary Cassatt.

In the years between 1890 and 1893, Cassatt created two of her major works: one of them, small-scale and private, in the form of a series of prints, was unparalleled for its subtlety, inventiveness and technical daring; the other, a large-scale, public and allegorical mural, alas lost, is known to us only through inadequate black-and-white photos.

Indeed, one might say that Cassatt's masterpiece was the series of color prints she executed in etching, drypoint and aquatint at the beginning of the 1890s, at the height of her career. Prints such as *Mother's Kiss* (1890–91) or *Maternal Caress* (1890–91) encapsulate the undramatic events constituting the daily life of the upper-class woman, the woman of refinement and leisure. These include playing with the baby, the private preparations of the body or clothing, letter-writing, visiting, and riding on the omnibus. Despite the fact that the last two demand venturing into the outside world of a great city, the female subject is always represented existing within a protected and enclosed—even encapsulated—world.

In such prints as *The Coiffure* (1890–91) and *The Fitting* (1890–91) the closed, protected world of genteel womanhood is daringly filtered through the stylized and elliptical rendering of reality characteristic of the Japanese print, whose lessons her friends and fellow Impressionists Degas and Pissarro were also taking seriously at this time; the three artists often shared ideas, technical data and criticism. Cassatt transposes the *yukio-e* idiom into her own modern and Western terms, terms in which feminine experience functions as a complete language system, with its own tropes and inventions. Here Cassatt completely erases the meaningful narrative implications of temporality (traditionally produced by shadow, modeling or deep space, signifiers of the unfolding of time in painting), in favor of surface, presentness and anti-narrative surface in a

Mary Cassatt, printed with Leroy, *In the Omnibus*, 1890–91. Color aquatint with drypoint from three plates, partially printed *à la poupée*, on ivory laid paper, 14½ × 10½ in. (36.7 × 26.8 cm) (plate); 17¼ × 11¾ in. (43.7 × 30 cm) (sheet)

series of subjects, which, because of their very unimportance, their anti-heroic qualities, lend themselves perfectly to the idiom of modernism. The transformation of intimate spaces into formal elegance by means of bold reduction and sophisticated patterning is one of Cassatt's many achievements in these works, as both *The Letter* (1890–91) and *The Lamp* (1890–91) indicate.

Worldly sociability, the tête-à-tête of two fashionably dressed ladies—that "creation of atmospheres" that Dorothy Richardson, and Cassatt herself at times, saw as woman's highest artistic achievement—could serve as the basis of *Afternoon Tea Party* (1890–91), a print of great coloristic and compositional subtlety which plays the black of the visitor's jacket against the white of the hostess' gown, a white of course identical to the white of the paper itself. In *In the Omnibus* (1890–91), a trip into the outside world is represented as so protected that the public vehicle, whose open windows provide an admirable formal scaffolding for the composition, is figured like a traveling parlor for elegant mother, baby and nursemaid, and the city of Paris itself, locus of so much Impressionist attention, functions as a mere backdrop for the domesticated interior.

Cassatt's other major project in the early 1890s was the vast allegorical mural she created for the Woman's Building at the Chicago World's Columbian Exposition (1893). Cassatt's mural, dedicated to the subject of *Modern Woman*, was set across from its pendant, *Primitive Woman*, by Mary Fairchild MacMonnies, another American artist living in Paris. Both of these monumental works seem to have survived into the 20th century, but the last traces of them disappeared shortly after the First World War according to recent archival detective work by Carolyn Kinder Carr and Sally Webster.[10] The murals, set in the tympana of the Hall of Honor of the Woman's Building, were grand in scale—about 60 feet long and 12 to 14 feet high at the highest point—and tripartite in conception.

Cassatt's mural in the south tympanum was divided into three parts by a prominent decorative border: the central panel represented a scene of young women picking fruit in a blooming garden, allegorizing the notion of "Young Women Plucking the Fruits of Knowledge and Science"; to the left, in "Young Women Pursuing Fame," young women were again represented allegorically—and rather humorously—running after what looks like a kite but is actually a little winged figure, with geese nipping at their heels. To the right, "Arts, Music, Dancing" are represented by young women engaged in these activities. "Nothing of St. Cecilia," she specified wryly of the "music" figure.[11]

Despite the loss of the original, a near-contemporary oil sketch related to the theme of the central panel, *Young Woman Picking Fruit* (1892), provides some notion of the brilliance of the color, a brilliance unexpected in the more conventional mural projects of the period, and associated at the time by conservative critics with an assertive modernist stridency of form.

In a recent article in the *Art Bulletin*,[12] Judy Sund critiques Cassatt's mural, *Modern Woman*, on a variety of grounds, both formal and iconographic, summing up her criticism by asserting that "Cassatt, by depicting modern woman in symbolic terms, neglected real women and their actual achievements. Rather than singling out notable individuals," Sund continues, "or even distinctive types—for instance, the sorts of scientists,

Mary Cassatt, *Modern Woman*, 1892–93.
Oil on canvas, 58 × 12 ft (17.6 × 3.6 m). Mural for the south tympanum of the Hall of Honor, Woman's Building, World's Columbian Exposition, Chicago, 1893.

educators, homemakers and suffragists who attended the Women's Congress—in representative domains, Cassatt presented the viewer with clusters of young, resemblant women, homogeneous in class and race..."[13]

While it is certainly true that Cassatt resorts to the types and the class of women with which she is familiar, and while she is far from being "politically correct" in terms of present-day conceptions (a rather anachronistic demand!), Sund's alternative program, though worthy, sounds depressingly familiar: a sort of conventionalized "upward-and-onward" iconography, iterated in various forms, on the walls of public buildings and high-school assembly rooms in particular.

Cassatt, on the contrary, was attempting, if not entirely successfully, to create a really modern allegory, to take up Courbet's *Allégorie réelle*—an allegory in terms of reality—in her own terms, a cultivated, cosmopolitan, *fin-de-siècle* woman's terms. Her work bears the signs of modernity in its very ambiguousness. Like Courbet in his *Allégorie réelle* of 1855—also created for a World's Fair—she may have thought it prudent to conceal her own strongly felt political views, feminist in her case, her high aspirations for women, in the public space of a major monument. *Modern Woman* was light, humorous and up-to-date in its modern if not modish dress.

If Cassatt, in her own words, "tried to express the modern woman in the fashion of our day and...to represent those fashions as accurately and as much in detail as possible,"[14] she did not by any means resort to the frivolities of Parisian haute couture as did Tissot in his allegorical series *The Woman of Fashion* of ten years earlier, which was also devoted, from a very different point of view, to Modern Woman. Cassatt had the dresses made by Doucet and Worth according to her own instructions, and they are neither constrictive or sexy but, rather, modern without being precisely fashionable.[15] In short, Cassatt's is one of the few ambitious monumental allegorical paintings of its time I know that, although serious in its total intent, is not weighed down with deadening solemnity and moralism.

About the central portion of her mural, Cassatt wrote that she intended to demonstrate that in *her* garden the picking of the fruit of knowledge by women was *not* a condemned activity: on the contrary, it was strongly to be encouraged. The promoters of the Woman's Building had stated their purpose as follows: "We [women] have eaten of the Tree of Knowledge and the Eden of Idleness is hateful to us. We claim our inheritance, and are become workers not cumberers of the earth."[16] And, if the theme of fruit picking depicted in the central panel of Cassatt's mural allied her figures more closely to the realm of nature than the realm of culture, as Sund asserts, it is nevertheless true that it was a theme to which many of the most advanced artists of her day turned in the later part of the 19th century, and not necessarily just those who believed in some old-fashioned notion of pastoral beatitude as an alternative to modern reality.

Degas, for instance, turned to the theme of apple-pickers for an unusual bronze funerary monument, while Morisot saw it as a theme of contemporary summer activity

in the country for well-brought-up young girls, as devoid of allegorical implications as possible; and, it must be admitted, Morisot's young women are picking cherries, not apples. Pissarro, at the height of his pointillist period, gives the theme certain specifically moral overtones in *Apple Picking at Eragny-sur-Epte* by centralizing the tree and emphasizing the contemplative gesture of the woman at the right—and these are peasants, not middle-class girls.

Like Cassatt, Gauguin, in his monumental mural-scale painting *Where Do We Come From? Who Are We? Where Are We Going?* (1897), constructs the motif in modernist, in his case primitivist, language, making it the center of a frankly allegorical, and frankly ambiguous, iconographic scheme—either fruit picking unconnected with sin in an island paradise, or the opposite, that even an island paradise may be infected with sin through the plucking of the fruit of the tree of the knowledge of good and evil.

Apple picking offers a theme that is at once decorative and primitivizing in Paul Sérusier's vaguely medievalizing triptych, *Gathering of Apples* (1891), with its Breton and female cast of characters. But here, the conjunction of women and apple picking signifies in exactly the opposite way from Cassatt's modern allegory: in a medievalizing context, it is hard to escape notions of Eve and the Fall.

Cassatt's interpretation of the apple picking theme comes closest in its positive allegorization and the modernity of decor and formal language to Paul Signac's utopian scheme for a mural for the Town Hall at Montreuil (1895), *Au Temps d'Harmonie*. In this anarchist hymn to working-class family values, however, it is of course a man, in the left foreground, who is privileged to pick the transvaluated fruit of the tree of knowledge, not a mere woman.

In refusing to make her allegory grim or moralistic, in rejecting old-fashioned notions of allegory, in her fidelity, above all, to the formal inventiveness of the vanguard of her day, Mary Cassatt was taking big risks in Chicago. In concerning herself with the effects of a large-scale, decorative ensemble, she was participating in one of the major vanguard enterprises of her time. To borrow the words of Carol Zemel: "From mural painting to industrial design, art as *'décoration'* had enormous Currency...in the final decades of the century."[17] By 1891 when "Albert Aurier's essay on Gauguin made *décoration* a major plank of the Symbolist platform, the emphasis was on decoration's ideational force: the unity of surface that guaranteed a picture's immediate...impact and effect. With this embrace of the decorative within the avant-garde, an important shift had taken place. Decorative painting now...had become an important and specifically modern domain."[18]

Cassatt was certainly aware of the various debates about the decorative that engaged so many of the advanced painters and critics of her time. Her correspondence contemporary with the painting of *Modern Woman* makes this evident, be it a rather technical exchange about the role of the decorative border with Mary MacMonnies or a more general discussion with Mrs. Potter Palmer about aspects of form, scale and color in the Woman's Building. Most interestingly, perhaps, in a letter to Mrs. Palmer of

October 11, 1892, Cassatt makes clear her commitment to a specifically *gendered* aspect of the discourse on decoration and the decorative when she states, about the color: "My idea would have been one of those admirable old tapestries—brilliant yet soft."[19] Now in the decorative parlance of the time, especially among the Nabis, tapestry (and stitched work in general) were associated exclusively with the feminine realm. As Laura Morowitz has pointed out, "The tapestry…became a paradigmatic art form during the *fin-de-siècle*, connoting the feminine, private spaces of bourgeois life and was associated with female production."[20]

In the same letter, the artist justifies her omission of men from her mural with some crispness: "An American friend asked me in a rather huffy tone the other day, 'Then this is woman apart from her relations to man?' I told him it was. Men I have no doubt are painted in all their vigor on the walls of the other buildings; to us the sweetness of childhood, the charm of womanhood, if I have not conveyed some sense of that charm, in one word if I have not been absolutely feminine, then I have failed."[21] A modernism which is a specifically *feminine* modernism: that is Cassatt's ambitious goal in her Chicago project. If the contradictions seem apparent to us—an experimental public art extolling private joys and virtues, the equation, perhaps, of feminist with feminine, not by any means the same thing in today's parlance—we must remember that these associations were made by many advanced women of Cassatt's time, and many feminists as well.

For it seems to me that Cassatt was undeniably a feminist. Writing to Sara Hallowell, she declared, "After all give me France. Women do not have to fight for recognition here if they do serious work"; she refers positively to women's determination to "be *someone* rather than *something*."[22] Cassatt was a woman who became increasingly radical in her politics with the passage of time. She was a supporter of Dreyfus at the time of the Affair, and more and more felt herself allied with the cause of feminism.

Indeed, it was Cassatt, according to Frances Weitzenhoffer, who had initially encouraged her friend Louisine Havemeyer to "go in for the Suffrage."[23] In 1914, she wrote from war-torn France to Mrs. Havemeyer, by now a prominent member of the Women's Political Union and more than ever a suffrage activist: "Of course, every question is subordinated to the war, but never more than now was suffrage for women the question of the day—the hope of the future. Surely, surely, now women will wake to a sense of their duty and insist upon passing upon such subjects as war, and insist upon a voice in the world's government!"[24] Cassatt helped Mrs. Havemeyer to organize the important loan exhibition *Masterpieces by Old and Modern Painters* at Knoedler's Gallery, New York, in 1915, and showed eighteen of her own works along with a large selection of Degas' paintings and some old masters for the benefit of women's suffrage.

Yet in the last analysis, it is for her art that Mary Cassatt will be remembered, her production, to borrow the words of Griselda Pollock, of a "body of works about women, an *œuvre* which was both feminine in its fidelity to the social realities of the life of a middle-class woman and thoroughly feminist in the way it questioned, transformed and

subverted the traditional images of Women..."[25] And this transformation was wrought through the language of the most advanced painting movements of her time. It is in this sense that, looking back from the vantage point of a century, we, women art historians, critics, and yes, women artists, can say of Cassatt as Gertrude Stein did of Susan B Anthony (another unmarried, childless woman, incidentally): she was "The Mother of Us All."

Notes

1 Griselda Pollock (1988), "Modernity and the Spaces of Femininity," in *Vision and Difference: Femininity, Feminism, and Histories of Art*, London and New York: Routledge, pp. 50–90.

2 Dorothy Richardson (1967), *Pilgrimage*, vol. 3, New York, NY: Alfred A Knopf, p. 257.

3 Ibid., pp. 257–58.

4 Ibid., p. 258.

5 Dorothy Richardson (1925), "Some notes on the eternally conflicting demands of humanity (*not* 'femininity'!) and art," *Vanity Fair*, 24, May, p. 100.

6 Julia Kristeva (1980), "Motherhood According to Bellini," in Leon Roudiez, ed., *Desire in Language*, trans., T Gora, et al., New York, NY: Colombia University Press.

7 Marie Christine Hamon (1992), *Pourquoi les femmes aiment-elles les hommes? et non pas plutôt leur mère?*, Paris: Seuil.

8 Leo Steinberg (1983), *The Sexuality of Christ in Renaissance Art and in Modern Oblivion*, New York, NY: Pantheon Books.

9 For a discussion of Dodgson's photographs, see Susan H Edwards (1994), "Pretty Babies: Art, Erotica or Kiddies Porn?" *History of Photography*, 18: 1, Spring, esp. pp. 39–40.

10 Carolyn Kinder Carr and Sally Webster (1994), "Mary Cassatt and Mary Fairchild MacMonnies: the Search for Their 1893 Murals," *American Art*, 8, Winter, pp. 52–69.

11 Cassatt to Palmer in a letter of October 11, 1892, cited by FA Sweet (1966), *Miss Mary Cassatt, Impressionist from Pennsylvania*, Norman, OK, p. 131.

12 Judy Sund (1993), "Columbus and Columbia in Chicago, 1893: Man of Genius Meets Generic Woman," *Art Bulletin*, 75: 3, September, pp. 443–66.

13 Ibid., p. 464.

14 Cassatt to Palmer, 1892, cited by Sweet, *Miss Mary Cassatt*, p. 130, and Sund, "Columbus and Columbia in Chicago, 1893," p. 462.

15 Nancy Mowll Mathews (1994), *Mary Cassatt: A Life*, New York, NY: Villard Books, p. 106.

16 Maud Howe Elliott (1893), "The Building and its Decoration," in MH Elliott, ed., *Art and Handicraft in the Woman's Building of the World's Columbian Exposition*, Paris and New York: Goupil and Co., p. 23.

17 Carol Zemel (1997), *Van Gogh's Progress: Utopia, Modernity, and Late Nineteenth-Century Art*, Los Angeles and Berkeley, CA: University of California Press, p. 235.

18 Ibid., p. 237 and note 62, p. 280.

19 Cassatt to Palmer, 1892, cited by Sweet, *Miss Mary Cassatt*, p. 131.

20 Laura Morowitz (1996), "Consuming the Past: the Nabis and French Medieval Art," PhD Dissertation, Institute of Fine Arts, New York, p. 1.

21 Cassatt to Palmer, 1892, cited by Sweet, *Miss Mary Cassatt*, p. 131.

22 Cassatt to Hallowell, cited in a letter of 1864 from Hallowell to Palmer; see Nancy Mowll Mathew, ed. (1984), *Cassatt and Her Circle: Selected Letters*, New York, NY: Abbeville Press, p. 254.

23 Louisine W Havemeyer (1922), "The Suffrage Torch, Memories of a Militant," *Scribner's Magazine*, 7, May, p. 528, cited by Frances Weitzenhoffer (1986), *The Havemeyers: Impressionism Comes to America*, New York, NY: Harry N Abrams, p. 205.

24 From Louisine Havemeyer's unpublished chapter on Mary Cassatt (intended for her *Memoirs*), p. 33, cited by Weitzenhoffer, *The Havemeyers*, p. 220.

25 Griselda Pollock (1980), *Mary Cassatt*, London: Jupiter Books, p. 27.

12

Sylvia Sleigh: Portraits of Women Artists and Writers

Parallel Visions: Selections from the Sylvia Sleigh Collection of Women Artists, 1999

Sylvia Sleigh's work is marked by an inimitable combination of Flemish-primitive detail, Rococo elegance and that intense but idealizing scrutiny of the facts of contemporary existence characteristic of Pre-Raphaelite painting at its best. Out of it all, Sleigh has invented an unmistakable style of her own. Her male portraits, mostly from the late 1960s and 70s, refused the masculine clichés of business suit, shirt and tie, characteristic of official portraiture. Instead, Sleigh revealed her male subjects naked and unashamed, seductive and sensuous in their delectable corporeality. Rather than reducing the nude male body to a series of classical generalizations—the usual procedure in Western art since the Renaissance—she made her men's physiques as idiosyncratic as their faces: variations in complexion and body-hair pattern were more important in this task of individuation than musculature and skeletal structure. The results were embodied in such revolutionary works as *Paul Rosano Reclining* (1974) or *Nick Tischler Nude* of the same year, and perhaps most triumphantly, in the male nude group-portrait of that year, *The Turkish Bath*. In this large painting, freely based on prototypes by Delacroix

Sylvia Sleigh,
*Paul Rosano
Reclining*, 1974.
Oil on canvas,
54 × 78 in.
(137.2 × 198.1 cm)

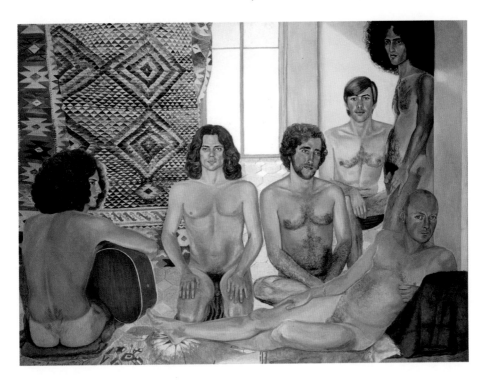

Sylvia Sleigh, *The Turkish Bath*, 1973.
Oil on canvas, 76 × 102 × 2 in. (193 × 259.1 × 5.1 cm)

and Ingres, the wonderful pink and blond tenderness of Lawrence Alloway's recumbent form is played against the piercing blue intelligence of his glance, and his horizontal image against the swarthy, svelte, romantically aquiline verticality of the adjacent figure of Paul Rosano. Contrasts of hair pattern are set off by the richness and coloristic brilliance of the decorative patterns against which the figures are deployed.

Sylvia Sleigh's series of portraits of women artists and writers, ranging in date from the late 1970s to the present, offer once again pictorial proof that realism and loveliness are not mutually exclusive; that "uglification and derision," to borrow Lewis Carroll's immortal words, do not necessarily constitute visual "truth," whatever we may mean by this term. Each of these canvases delights the eye with its decorative plenitude at the same time it convinces the mind of the accuracy of its representation. One would never confuse *Marjorie Strider* (1977), a serene blonde beauty seated in a classically reposeful posture, wearing a simple, clinging red dress, a glowing chrysanthemum emphasizing her corsage, with another work of the same year, the more energetic, tensely posed *Gloria Orenstein*. In the latter portrait, the subject is posed with arms akimbo, her curly black hair forming an electric halo around her face, her dress bristling with pattern and beadwork. Yet both the artist (Strider) and the art historian (Orenstein) are seated against similar decorative backgrounds, a lively fabric patterned with stripes and stylized flowers, which sets off the uniqueness of each sitter's appearance to best advantage.

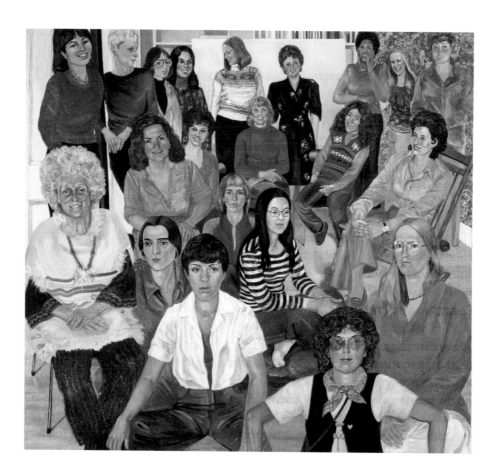

ABOVE Sylvia Sleigh,
A.I.R. Group Portrait,
1977–78. Oil on canvas,
82 × 72 in. (208.3 × 182.9 cm)

RIGHT Sylvia Sleigh,
Howardina Pindell,
1978. Oil on canvas,
90 × 72 in. (228.6 × 182.9 cm)

Two artist-portraits of 1978, those of *Rosemary Mayer* and *Howardina Pindell*, reveal Sleigh's unerring ability to reveal character through nuances of pose, setting, and color, at the same time that she maintains the formal integrity of the pictorial structure as a whole. *Rosemary Mayer* presents the blondish, pink-skinned sitter, dressed in vivid blue, in a slightly off-center pose, a lock of hair providing an asymmetrical accent as it falls over one shoulder. Mayer, wearing large, prominent glasses (a token of her visual trade, perhaps?) is seated on a ladder-back chair against a wallpaper that almost outdoes that of Van Gogh's *Mère Roulin* in its coloristic exuberance. In *Howardina Pindell*, on the contrary, the background is neutralized, the figure dramatically frontal, the simple elegance of the planes of the sitter's face, her carved features and intense dark gaze set off against the sophisticated earth-colored abstract patterning of her costume to create one of Sleigh's most vivid and memorable artist-portraits.

"Motherhood does not preclude creative achievement" might be the message embodied by *Rosalind Shaffer and Marisa* of 1978. The dark-haired young mother, her flower-printed blouse set off by the rich maroon of the chair on which she is enthroned, stares out assertively at the viewer. The tow-headed infant, squirmy but firmly held in place by her mother's hands, confronts the world with an astute and quizzical glance. There is nothing of the bland sentimentality afflicting the traditional mother-and-child portrait here; far from it!

One of the most interesting comparisons to be made within this series is that pairing *Sabra Moore (My Ceres)* (1982) with *Michelle Stuart* (1980) [p. 224]. In the Moore portrait (not illustrated), the artist places her subject within a backyard tondo, the circular

Sylvia Sleigh,
*Rosalind Shaffer
and Marisa*, 1978.
Oil on canvas,
36 × 24 in.
(91.4 × 61 cm)

Sylvia Sleigh,
Michelle Stuart, 1980.
Oil on canvas,
36 × 24 in.
(91.4 × 61 cm)

format enclosing a brick wall, what looks like corn stalks, and a curtain of verdant foliage to the right. The pose is a rather severe, frontal one, the pale austerity of the sitter's head mitigated by the flowing fall of her hair and the animation of her flowered blouse. Flowers also play a major role in the elegant portrait of the artist Michelle Stuart. Whereas pale but intense pastels provided the coloristic keynote in the Moore portrait, here, the major note is black: black for the hair and eyes of the sitter as well as for her outfit. But the black in this case is anything but somber, partly because of the burgeoning flowery appliqué on the borders, cuffs and linings of the sitter's costume as well as the bright red blossoms cascading down the white curtain in the background. The imagery is further enlivened by the charm of the pose—head tilted, one arm gracefully poised on the chair-back, the other on the sitter's knee—creating an image at once decoratively ingenious and psychologically engaging.

Finally, we have an image of the artist and her work: the portrait of *Selina Trieff*, and what seems to be, behind her, a self-portrait *en travesti* as Watteau's *Gilles*. This is, in effect, a double portrait, one of them disguised, of the posing artist herself. The

224

Sylvia Sleigh,
Selina Trieff, 1984.
Oil on canvas,
36 × 24 in.
(91.4 × 61 cm)

presence of the artist's work within the canvas, and the strength and poignancy of the image of its creator, sitting with folded arms in red shirt and gray pants in the foreground of the composition, take us back to one of Sylvia Sleigh's most innovative works, *Philip Golub Reclining* (1971) [p. 90]. In this memorable work—with its witty reference not merely to Veláquez's *Rokeby Venus*, but to the Spanish artist's self-image in *Las Meninas* as well—Sleigh overturned the canon by representing herself, a woman, as the clothed, active artist in the process of recording the nude, passive male model before her.

In the *Selina Trieff* portrait, Sleigh reminds us once again that the woman artist counts, that her work demands serious scrutiny and that its supposed deviations from convention, whether academic or avant-garde, deserve sustained attention. That the sheer loveliness of these works, their decorative richness and powers of formal seduction exist not despite but because of their incisive realist accuracy is what makes Sylvia Sleigh such an original portrait painter, and her work exemplary in its reinvention of a time-honored genre.

13

Deborah Kass: Portrait of the Artist as an Appropriator

Deborah Kass: The Warhol Project, Newcomb Art Gallery, New Orleans, 1999

Imitation is the sincerest flattery. Take Deborah Kass' brilliant takes on Andy Warhol. On the surface, this is appropriation, but it is appropriation with a difference. Whereas appropriation artists like Sherrie Levine, or even Warhol himself in his Brillo boxes, depend on the exactness of the copy, whether it be of Mondrian or a standard commercial design, Kass' redos depend for their originality on their intentional deviation from the model. *Double Blue Barbra* (*The Jewish Jackie Series*) (1992) for instance, or *Triple Yentl (My Elvis)* (1993) depend on the Warholian prototype at the same time that they critique its refusal to engage with ethnicity or sexual preference.

Despite the formal similarities, Kass' oeuvre as a whole refuses Andy's trademark cool in its choice of meaningful subject matter. For Kass' subjects are not universal pop

Deborah Kass, *Double Blue Barbra* (*The Jewish Jackie Series*), 1992.
Silkscreen and acrylic on canvas, 2 panels, each 45 × 36 in. (114.3 × 91.4 cm)

Deborah Kass, *Triple Yentl (My Elvis)*, 1993.
Silkscreen and acrylic on canvas, 72 × 96 in. (182.9 × 243.8 cm)

icons—Marilyn or Mao—but people who mean something to her, who have a personal importance to the artist. Out of Warhol's cool, she makes something hot, replete with the warmth of genuine feeling. Her images of Barbra, Gertrude Stein or her grandmother are not ironic commentaries but heartfelt homages to her culture-heroines. Yet her appropriative strategy, based on the most objectified representational style of our time, keeps such homage from sentimentality. When love is filtered through Warhol's silkscreen icons, it turns into something more complicated. As do the artist's self-images. In the latter case, it is gender that gets problematic: in the case of *Camouflage Self-Portrait* (1994) [p. 228], we can't make out the face, much less the gender of the artist; in *Portrait of the Artist as a Young Man* (1994) [p. 228], we know that the artist in question is a woman, but the images are sexually ambiguous; in *Altered Image #2* (1994–95) [p. 229], a large-scale gelatin silver print, we have the female artist posing like Andy in a famous photo where he is got up like a woman from the head up, a man from the neck down. It gets as complicated as the drag acts in Shakespeare's comedies, where boy actors dressed like girls disguised themselves in men's clothes, thereby titillating audience members of both sexual preferences. Gender is an act, Kass seems to

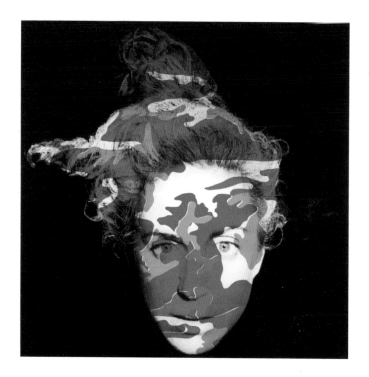

RIGHT Deborah Kass, *Camouflage Self-Portrait*, 1994. Silkscreen and acrylic on canvas, 70 × 70 in. (177.8 × 177.8 cm)

BELOW Deborah Kass, *Portrait of the Artist as a Young Man*, 1994. Silkscreen and acrylic on canvas, 24 panels, each 22 × 22 in. (55.9 × 55.9 cm)

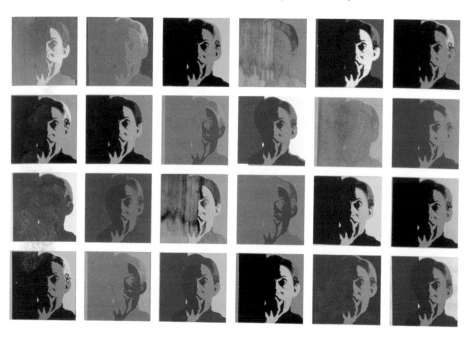

be saying, but it is an act with consequences. For the Jewish lesbian artist who wants to make something of her complex identity, the consequences are particularly interesting.

I admire Kass and her works not only for their formal elegance and their pictorial wit, but for their bravery. It is hard in an era where irony rules, where ambiguity informs every attitude, where coolness is the reigning mode of sensibility, to be warm about what one admires, to identify with people—sometimes women, sometimes specifically lesbians—who have actually done something admirable rather than simply functioning as pop idols. The art world images do something of the same thing: they praise art and the people who make it happen: artists, critics, curators. Never dull, never sentimental, wonderful to look at, always original and straight from the heart. Kass' "appropriations" are more original than many other artists' so-called unique inventions.

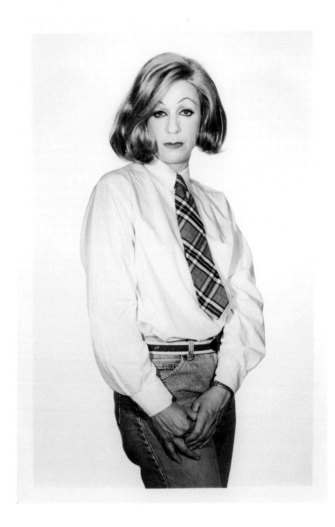

Deborah Kass,
Altered Image #2,
1994–95. Photograph,
gelatin silver print,
60 × 40 in.
(152.4 × 101.6 cm),
edition of 6

14
Jenny Saville: Floating in Gender Nirvana

Art in America, March 2000

Territories was the name given to the recent show of paintings by young British artist Jenny Saville at Gagosian Gallery in New York. The title was an apt one for Saville's mapping of fleshy geography. The immediate visual impact is one of excess: gargantuan naked bodies, mostly female, hurtling away from us or exploding into our space; seductive yet somehow injured flesh extruded onto the picture plane with an uncanny combination of delicate brushwork and brutal slathering of pigment; a perspectival extravagance which at once bespeaks the objectivity of the photograph and the empathic angst of expressionism. However superficially Rubenesque—one of the paintings is actually titled *Rubens' Flap*—and however much they constitute a slap in the face to our waif-obsessed culture, these paintings are after something more than simply the celebration of flesh. Saville's achievement in this show goes beyond mere excess, onto more interesting ground.

Let me hasten to add that this is not the "return to painting" so fervently desired by conservatives and derided by radicals. One might say that Saville's work is post-"post-painterly," to wrench this term out of its original Greenbergian context: painterliness pushed so far over the top that it signifies a kind of disease of the pictorial, a symptom of some deep disturbance in the relation of pigment to canvas. Although the surface and the grid both play an important role in Saville's formal language, both are melted down and sharpened up by the virtuoso yet oddly repulsive brushwork that marks her style. It's helpful, in approaching her work, to think of Thomas Mann's *Doctor Faustus* and the idea, current early in the last century, of art as a kind of fatal spiritual illness.

All of Saville's monumental nudes employ photographic precedents, but not in any simple way. The majority of the figures are based on photographs of Saville herself, but one would, in most cases, no more consider them under the rubric of "self-portrait" than one would think of a Cindy Sherman "Untitled Film Still" in such terms. The situation is further complicated by the photographs of bruises and other injuries which Saville collects from medical textbooks and incorporates into her paintings.

In a provocative lecture at the Ingres portrait symposium held last fall at the Metropolitan Museum of Art in New York, the artist David Hockney presented some startling new material about the use of pre-photographic instruments, like the camera

lucida, in the art of the past. He used examples taken not only from the work of Ingres, but also from that of Caravaggio and Velázquez as well as from his own drawings. Hockney, who has himself created pioneering photo-collages, built on his fascinating historical account by predicting more radical uses for photographic devices in the future. Certainly, Saville's use of photographs—such as those of her own body, in grotesquely enlarged close-up or exaggeratedly foreshortened, or piled atop other bodies—and multiple exposure-like effects lives up to Hockney's predictions with a vengeance.

Of all the work in *Territories*, *Hem*, a gigantesque, foreshortened female nude, seemed to be most closely related to Saville's previous work, such as the canvases included in the *Sensation* exhibition. At 10 by 7 feet, the image climbs upward from a huge pubis articulated with broken fur across mountains of belly and midriff, breasts, and finally to the relatively small but individuated head. It's a late-20th-century Venus of Willendorf seen in ant's-eye perspective. Yet the impact of the gross flesh is deflected by evidence of the pure act of painting itself: the viscous white plane to the left, which extends across the lower belly and crawls up the left breast.

Fulcrum (1998–99), measuring 16 feet in width, deploys across its surface three naked figures, tied together with string on top like butcher's meat. Alive or dead, dreaming or waking, the bodies, in the absence of any visual clues as to place, or even space, occupy the entire canvas with their oddly weightless girth. If one has met Saville or seen photographs of her, it's clear that the topmost figure is the artist, a fact which may or may not carry allegorical meaning.

Jenny Saville, *Fulcrum*, 1998–99.
Oil on canvas, 103 × 192 in. (261.6 × 487.7 cm)

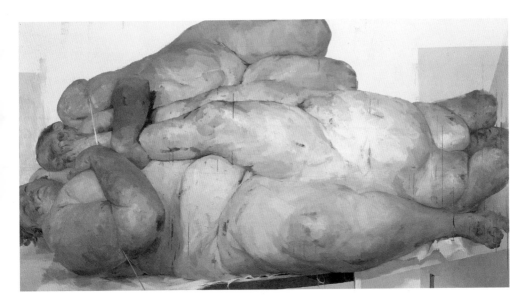

Matrix (1999) involves a graphic crotch shot of a highly ambiguous nude body—in this case, not a photo-collaged construction but an actual transsexual, Del la Grace Volcano, whose mustache, tattoo and clipped hair consort oddly with a pair of pouting breasts and—foregrounded—a richly impastoed pudendum.

The figure floats in that postmodern realm of gender nirvana, brilliantly theorized by Judith Butler as a zone of shifting sexual identities and the rejection of essential difference between male and female. In its aggressive anti-essentialism, Saville's work is as much an intellectual project, a social construction of the body, as it is a neo-Rubenesque orgy or a one-up on Lucian Freud. In the truly ambiguous and hugely disturbing *Matrix*, even the brushwork, juicy as it is, comes across as somehow intellectualized—immensely self-conscious and self-revealing as it goes about its business of welding male to female, making a visual rhyme between problematic genitalia and lusciously rose-slathered, daringly foreshortened thigh.

The conjunction of bloody wound and masculine head brings to mind Sigmund Freud's classic theory of castration, at the same time that it recalls Luce Irigaray's radically anti-phallocratic redefinition of female sexuality in terms of multiple sites of pleasure, endless jouissance. Yet *Matrix* should not be read as a pictorial sermon on a theme by Irigaray, or Judith Butler for that matter, if to do so means negating its esthetic impact. Seeing *Matrix* in *Territories*, I found it hard not to take the work as a painting about the very possibility of painting at the end of the century. The exaggerated foreshortening, the slablike rosy impasto on the thigh that almost seems to leap

Jenny Saville, *Matrix*, 1999.
Oil on canvas, 84 × 120 in. (213.4 × 304.8 cm)

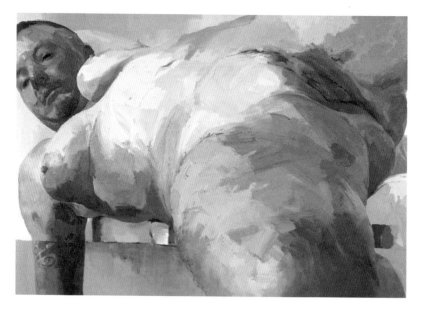

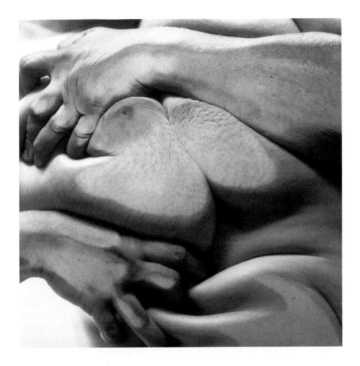

Jenny Saville and Glen Luchford, *Closed Contact #4*, 1995–96.
C-print in Plexiglass frame, 71½ × 71½ × 6¾ in. (181.6 × 181.6 × 17.1 cm)

off the canvas, but above all, the securing of the surface by means of the gray horizontal plane beneath the body and the elegant tattoo on the vertical arm that intersects with it—these are strategies to recall both the traditions of modernism and the anxieties of postmodern representation.

Even the least "bodily" of the images in *Territories* was disturbing: the canvas called *Hyphen* (1999), which represents the heads of two young girls. As I learned, the painting shows Saville (on the right) and her sister. It's an image evidently taken from a childhood photograph. I am not sure why it should be the case, but this painting seemed to me the most shockingly sexual of all the images on view, perhaps because, in the absence of the naked body, all the voluptuous indulgence of the flesh is displaced onto the heads alone and concentrated there, as though the pouting, too-red lips were analogues for sex organs, the childishly rounded cheeks for buttocks.

Ideally, Saville's recent paintings should be seen in company with the sixteen photos of the *Closed Contact* series (not included in *Territories*, though a few examples could be seen in the gallery's back room) created in conjunction with the photographer Glen Luchford. In these large, weirdly abstract, strangely realistic color prints, Saville is seen lying naked on a glass table, as recorded by the photographer shooting from below. The artist's body itself is almost unrecognizable—fleshy bits distorted as though made

of some elastic substance, not human skin at all. Once more, the figure fills the whole space with its uncanny clues—breast, shoulder, belly button. The body is made strange at the same time it is thrown in your face.

"It's just Lucian Freud with feminism," sneered my smart friend who hates painting. But that is just what Saville's work is not. Despite the lush gouts of paint and the evocations of Rubens, Saville is at heart a conceptual artist, whereas Freud is a traditional painter trying to make it look as though he has a concept. Saville's work actually has more in common with feminist performance art and imagery of the photographed body-object than with that of an old-time paint-slinger like Freud.

The power of her brilliant and relentless embodiment of our worst anxieties about our own corporeality and gender is what distinguishes Saville from other paint-obsessed representers of the naked human body. To my eye, no other artist in recent memory has combined empathy and distance with such visual and emotional impact.

The paintings on pages 234–35 were created after this essay was written.

Jenny Saville,
Reflective Flesh,
2002–3.
Oil on canvas,
20⅛ × 96⅛₆ in.
(305.1 × 244 cm)

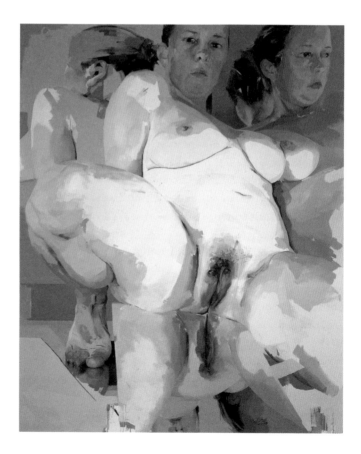

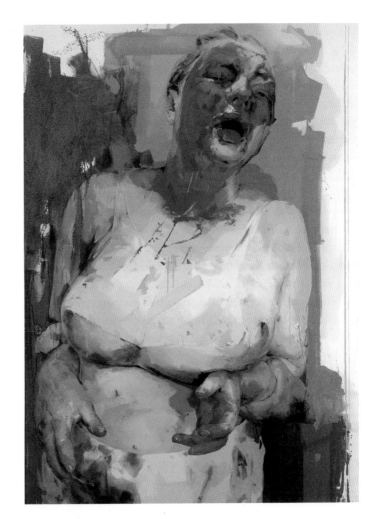

RIGHT
Jenny Saville,
Pause, 2002–3.
Oil on canvas,
120 × 84 in.
(304.8 × 213.4 cm)

BELOW
Jenny Saville,
Suspension, 2002–3.
Oil on canvas,
115 × 178 in.
(292.1 × 452.1 cm)

Mary Frank: Encounters

Mary Frank: Encounters, Neuberger Museum of Art, New York, 2001

In this retrospective exhibition, which focuses on Mary Frank's paintings and works on paper of the last fifteen years, the artist reveals herself as a major figure in American art, a position she has occupied with increasing vigor for many years. Frank's intensity of feeling is matched by her eloquence of expression. How rare it is, at the beginning of the second millennium, to discuss an artist in terms of feeling, of deep emotion. And yet there it is: Frank's work speaks to our deepest and most commonly shared emotions, and does so in ways that are entirely unconventional and original, ways conceived through a lifetime of experience and knowledge, yet palpitating with the vitality of immediate discovery.

Mary Frank established her reputation in the 1970s with an impressive series of large-scale, multipartite sculptural works, made (unusually for works of such ambition) out of clay. *Persephone*, a recumbent ceramic figure in five parts, created later in 1989, beautifully represents this aspect of the artist's work in the current exhibition. In general, a fragmented human figure, while alluding to the gentle metamorphoses wrought by time, also conjures up images of the starkest brutality: in the case of a female figure, rape, dismemberment, the utmost outrage. One thinks of Hans Bellmer's photographs of sexually molested dolls or the transgressive imagery of the Surrealists. But in Frank's *Persephone*, the combination of brutality and tenderness creates a sense of ecstatic empathy with the riven body. The sculptor has rejected the traditional boundaries between sculptural object and background, between woman and nature, so that the outstretched "hand" assumes the flowing striations of a river or stream, and the hair gushes backward like a waterfall. Above all, the body refuses conventional notions of wholeness. It reveals itself as something made, kneaded, shaped, the result of esthetic decision and emotional commitment. *Persephone* evokes a body fallen from the sky—a modern female Icarus, with all the tragic implications of that loss of a young, daring flyer—or a vast flower broken from its roots. The sensual body of the ancient goddess, in its frangibility and its very substance, clay, belongs to the earth, on which the figure is deployed, from which she arose, and to which we are all, ultimately, condemned. And yet the message of the spread thighs, the half-parted lips, the raised breast and flowing hair, the sensual integrity of the piece, in its pieces, is also one of hope, of renewal, the renewal that *Persephone* signified.

Mary Frank, *Persephone*, 1989.
Ceramic, 27 × 73 × 70 in. (68.6 × 185.4 × 177.8 cm)

Despite her reputation as a sculptor, Frank turned more and more to oil painting in the early 1990s. Yet sculpture was still far from forgotten as she made the transition. It appeared, boldly cohabiting with the paint medium, in the form of shrines or votive images that nestled intimately in the niche-like hollows of her canvases or protruded from their surfaces, as though extending the imaginary space of the two-dimensional world of painting into the more literally three-dimensional one of sculpture. Frank's final statement in sculpture, the monumental *Messenger, 1/4* (1991–92) [p. 238], was a single, three-dimensional bronze figure of a leaping woman. This electrifying figure, which would become a familiar one in Frank's increasingly important two-dimensional work, is caught in midflight, suspended over an earth-bound wheel and a small-scale profile horse. Is this a goddess, hugely poised over the distant earth? Iris, messenger of the gods, comes to mind, the disparity in scale between the figure and its accompaniments suggesting the vast distance between the Olympian world and our own. Yet we also feel close to this figure, for its surfaces are lovingly worked, the bronze marked with striation, like those indicating drapery on Egyptian statuary, but here, seemingly incised on the flesh itself. Despite the specificity of pose and gesture, the leaping figure remains

mysterious. The uncanny juxtaposition of small and large in *Messenger* is transposed to the flat surface of the painted images Frank produced during the period, as though the vast, impersonal macrocosm of outer space were reiterated internally within the microcosm of the pictorial world. *At the Point of Waking* (1990–91), is a case in point: the hallucinatory precision of the figures—the dark, Plutonian male at the left, the pale, hovering, angelic female at the right—is echoed more generically in the huge, immeasurable swirls of light and darkness that mark the space they inhabit.

In 1993, Mary Frank embarked on a series of triptychs, a format that was to be important to her creative thinking from that time on. In these large-scale, ambitious paintings, redolent of the sacramental aura of their origins, the artist brought together many of the themes she had explored during the previous ten years, ranging from the smallest manifestations of the natural world—the striae of leaves, runic incisions on stone or wood—to the vastness of Pascal's infinite spaces and their portentous silence.

LEFT Mary Frank, *Messenger, 1/4*, 1991–92. Cast bronze, 68 × 28 × 58 in. (172.7 × 71.1 × 147.3 cm), edition of 4

OPPOSITE Mary Frank, *What Color Lament?*, 1991–93. Oil and collage on board, 70 × 168 in. (177.8 × 426.7 cm)

Although several major productions of the period employ the triptych format, *What Color Lament?* (1991–93), a monumental work in oil and collage on board, is the crowning example. This work inevitably evokes the religious art of the past in terms of its format—a central panel flanked by two wings, the whole comprising thirteen separate panels. Its imagery, incised into the paint-encrusted surface, recalls the briefly glimpsed, half-forgotten newspaper photographs of mourning figures from distant lands, yet at the same time, calls up, with Biblical simplicity and preclassical monumentality, the prophetic lamentations of the Old Testament. A landscape of despair, simultaneously rugged and fragile, establishes an intimate relationship among the images, despite their formal separation into independent quadrants. Color, as the title indicates, raises the question in this piece: all kinds of colors in a wide range of textures and saturations, from the hazy gray of the background to the stark yellow and white of the right wing's center panel (evoking, perhaps, atomic explosion), to the burning focus of the piece, the small, isolated red figure which stands at its heart—dead center.

Mary Frank's complex deployment of the picture space creates poignant ambiguities in the triptych. Where, I ask myself, am I, the spectator, in relation to the space of the painting? I realize, after a period of contemplation—and it takes time to peruse this triptych—that there is no single "space" of the painting, only spaces. These spaces are sometimes connected by a mutual horizon line, as they are in the central portion, where the sides curve as amply as the curve of the earth's surface, making me realize suddenly that what I had at first thought to be a series of separately enframed incidents are actually part of the same continuum. Is this a vision of one or many? *What Color Lament?* plays out a perpetual ambiguity on this question, an ambiguity that is reinforced by variations in the scale of the images. If we read that which is smaller as more distant—as in the case of the central figure in red—then that figure must be preternaturally far away. And yet the red color's being set against the stark black foiling it, as well as its isolated

verticality, stresses its function as a major element—an entity physically close—calling forth a response which can only be thought of as intimate.

What Color Lament? cannot, then, be experienced as a unity, because it is conceived as a multiplicity of separate images deployed across the surface of the support. Yet, by the same token, we cannot accept the primacy of the individual elements, because the lines and forms, such as the jutting, perspectival cliff at the lower left, which runs through two separate quadrants, demand that we see the unified field as primary, the separate rectangles as secondary. *What Color Lament?* is also then "What Space Lament?", a profound pictorial meditation on separation and unity, carried out, it should be noted, in terms of oppositions of clarity and obscurity in the surface treatment, ranging from the linear delicacy of the trees in the foreground to the blurred, densely scumbled mandorla of yellow light at the upper right.

Central to Mary Frank's mode of expression are the motifs, or more accurately, pictoglyphs, produced by stencils, stamps and other means, that she deploys over and over again from picture to picture, which assume new meanings and evoke new connotations within each new context. Most memorable among these are: the hands, the leaping horse, the shrouded figure seen from the back, the wheel set at an angle to imply motion, a small kneeling female figure in profile, a falling female figure, and a soaring bird. These pictoglyphs assume several functions. Most obviously, by their near-obsessive repetitiveness, they produce a certain thematic unity from picture to picture. At the same time, however, and more significantly, they serve to distance the work both from the sentimentality of direct expressionism and from the banality of naturalistic illusion. Mary Frank is constantly constructing and reconstructing new meaning and feeling from this arcane, pre-existing language of visible words. Functioning like the vocabulary of a mysterious, forgotten language, the glyphs work to create new significations in new juxtapositions. Or, to put it differently, meaning arises from the unlimited reconfiguration of the pictoglyph vocabulary: the reiterated stencil of hands, leaping horse, floating or falling female figure, running man, veiled mourner.

The rather simple-minded, unproblematic recourse to nature or the "natural world" as a source of artistic inspiration has become a cliché of the critical discourse on Mary Frank, and is a referent that I would firmly reject. First of all, it must be specified that nature itself is a construct, created by the human need for an unambiguous grounding in the good, the permanent, and the desirable, as opposed to the present vexations of the social order. Next, we must ask just which aspect of "nature" is being referred to: the benign Mother Earth favored by sentimentalists or the ferocious "nature red in tooth and claw" posited by more cynical observers of the natural order. And is there, indeed, anything "natural" about nature at this point in history? More germane to the present exhibition is the wrenching dissonance between the human and the natural order

often found in Mary Frank's recent work. The human creature may be isolated within a dreamscape of desolation or there can be a sense of nostalgic yearning for a natural harmony that has been, equally naturally, destroyed or made unattainable. Some of this sense of the ambivalence of the natural order, for human experience at least, was apparent in the artist's extraordinary series of animal drawings for the book *Shadows of Africa*, a collaborative effort with the writer Peter Matthiessen. There, drawings capturing the touching intimacy of a mother elephant and her calf or the lovemaking of buffaloes were interspersed with nightmare images of the ominous approach of birds of prey or violent moments of savage attack. Mary Frank's celebration of the natural order in her art, then, must always be equivocal, since it involves the rituals of destruction and devastation as much as it does those of creation and nurture. And, in fact, it is this acceptance of darkness as a significant part of the human condition—a condition in which the natural is always filtered through the optic of the creaturely and the social—that gives Mary Frank's work its present grandeur and passionate intensity.

A series of messengers, all somewhat akin to the monumental sculpture with that title previously discussed, make an important appearance in Mary Frank's output of the early 1990s. In *Messenger Series I* (1991–92), it is not immediately clear whether the messenger brings doom or joy. Something dark, forceful, and ominous surges forth from the harshly incised form. The flailing hands, the half-hidden face, the elongated feet, and the jaggedness of the edges make us feel that he is the prophet of a great calamity, as does the wheel flung at his feet. But the richly scumbled rose background, touched with violet and deeper red, could be an announcement of a new dawn as well as a sign of calamity. In both the bronze and the painted messenger figures, it is the unusual dynamism of the poses, especially remarkable in the three-dimensional sculpture, that captures the imagination. In the large, multipartite *Messenger* (1991–92) [p. 238], the running figure, white this time, is combined with hand pictoglyphs, horse figures, a tiny, kneeling supplicant, and a larger, more sketchily painted family group against an indefinite, ethereal background. The ambiguous sense of dark destiny is increased by the spinning, detached wheel at the messenger's feet—spinning out of control, even out of the picture plane itself.

An important exhibition of Mary Frank's work in 1998 was entitled *Inscapes*, and the word served as the title of several of the individual canvases themselves. The term derives from the work of the great 19th-century English Jesuit poet, Gerard Manley Hopkins. The idea of the inscape was central to Hopkins' creative thought. By it, he meant to suggest "individually-distinctive beauty," a sense of the haecceitas or "thisness," of experience. At the same time, the term was meant to indicate "design, pattern—what I'm after in poetry." It referred to landscape particularly, for each landscape, as Hopkins perceived it, combined unity with a uniquely individual quality. "Inscape" could also refer to the outward manifestation of inward essence, in either nature or art. It was

RIGHT Mary Frank,
Knowing by Heart
(closed), 1997. Acrylic,
oil, and collage on
panel, 48 × 48 in.
(121.9 × 121.9 cm)

OPPOSITE Mary Frank,
Knowing by Heart
(open), 1997. Acrylic,
oil, and collage on
panel, 48 × 96 in.
(121.9 × 243.8 cm)

not traditional beauty that the devout Hopkins was after in his poetry, but, rather, the manifestation of the glory of God through the idiosyncrasies of the natural world.[1]

How apt this term, "inscape," is for the work of Mary Frank! Looking at her large-scale triptychs and her smaller pieces as well, one is reminded of the great inscape painters of the past—Matthias Grünewald, Francisco Goya, and Odilon Redon, particularly—although there is nothing derivative about her mysterious and evocative images. Mythic figures and personal experience conjoin to create a sense of disturbing transcendence within the immediate framework of the visual object.

In one of the most ambitious of her triptychs, *Knowing by Heart* (1997), the enigmatic human figures emerge gradually at the center of the composition, as though coming into being from the primal matter of the paint itself. The molten colors glow like crushed gems against the turbulent white background. A large, multicolored male figure springing in from the left joins hands with a leaping owl-headed imp at the right. Behind them is a calmer couple, the female in a pose of vatic dignity, in profile, her arm raised. Are these perhaps dual aspects of a single pair? Further mystery is generated by the paint itself, a sea of pigment in a shiny, waxy mixture of color in the foreground. Here, the depicted terrain is rounded like the edge of the world, the puddled paint taking shape and then melting back into inchoateness to suggest other shapes, and to evoke a variety of emotions as well: pain, anger, the memory of a difficult past. Frozen stillness and feverish dynamism are both there, conjuring up a sense of violence in the composition along with an echo of melancholy. The darkness of this pale "inscape" is more literally articulated on the exterior wings of the triptych, where black is the predominant tone and the composition extremely complex: a painfully contorted branch, rooted nowhere,

twists in on itself, a lone female figure, etched in white, crouching in its arms. Like Goya's *Disparate Rediculo* (Ridiculous Folly or the Dead Branch, 1816–17), with its fatalistic, doomed survivors hovering over the brink of nowhere, this image suggests with dreamlike precision an extremity of isolation beyond which reason cannot penetrate.

In a second triptych, *Voice* (1997), the spatial configuration is quite different, the contrast between near and far more exaggerated. The central figure, once more standing on the arching border of a dreamworld, is much more distant from the spectator than the figures in *Knowing by Heart*, and the startling profile head at the right much closer, stretching almost from the bottom to the top of the panel. The sense of temporal as well as spatial distance is increased by the fact that the imagery to the left of the head seems to emerge from the figure's mouth, as though she is a prophetess calling the scene into being with her words. The white line marking the edge of the world emerges from her mouth as though a function of her breath, her witness. In Frank's imagery, as in that of Matisse's *Dance* (first version) (1909), that curving line, the border between mundane experience and the unknown territory beyond, evokes both terror and exaltation. A rich sky blue, a kind of painterly firmament, variegated in its surface, stretches across all three inner panels, with a rectangular wall and window at the left blocking off the picture space opposite the prophetic head. On the outside of the panels, paradoxically, incandescent poppies bloom against a night sky, suggesting, in relation to the brilliant blueness of the interior, both contrasting times of day and opposing states of the spirit. In talking about the contrast between the exterior and the interior panels of her triptychs, Mary Frank has called for the intervention of the spectatorial will: "People can open them or close them, participate in them." In a way, this is a modern,

free revision of the classic Christian altarpiece: its wings generally remained closed on ordinary days and were opened to reveal their full resplendence only on special Holy Days of the church calendar.

If *Voice* may be thought of, from one perspective, as an inscape of air, then a third triptych, *Destinies* (1997), makes its initial impact as an allegory of fire. Against a fiery red background, an Icarus figure falls from the sky in the center; at the left, an owl flies toward us, breaking through a restraining rectangle (a minicanvas within the painting), and at the right the ever-recurring imp-creature leaps up into the air. Falling, flying, leaping—these are the motifs deployed across the blazing sky. Below, a calm figure on a surfboard plies his way across the synoptic wave lines toward the light glowing on the distant horizon. The compositional movement—upward and downward, inward and outward all at once—plays again on the flexibility of dream imagery, evoking the disturbing music of the unconscious, a memory of explosion, disaster, abandonment, painful yet idiosyncratically beautiful at the same time. The image on the exterior of this triptych offers the starkest contrast to the incandescent glow of the interior: it is a large, richly material, rough-barked tree trunk and branch, looming massively against a gleaming black background. If we were thinking of the four elements in relation to the triptych iconography, this would certainly be the element of earth.

This is the Remembering (1996–97), the artist stated, was actually the earliest of this series of triptychs. The exterior panels are very thickly and rhythmically painted in browns and ocher, setting into relief the brilliant blue tree on the yellow ground at the right and the bent, black-bordered running figure hurtling her way through the painted background at the left. Inside, all is surging, churning, multitonal blueness: in this work, the dominating element would seem to be water, but a water so turbulent, a sea

RIGHT Mary Frank,
This is the Remembering
(closed), 1996–97.
Oil and acrylic on
panel, 48 × 48 in.
(121.9 × 121.9 cm)

OPPOSITE Mary Frank,
This is the Remembering
(open), 1996–97.
Oil and acrylic on
panel, 48 × 96 in.
(121.9 × 243.8 cm)

so violent in its churning, that it is difficult to pick out the dominant motifs. Yet they are there: two figures, uncertain in their temporal status, who may be drowning, swimming, or floating. Tossing limbs emerge and disappear; the foot at the left foreground, for instance, seems to exist on the surface of the panel only for a minute, evoking the body's presence and absence before and after its momentary appearance. The paint itself becomes an independent, incandescent entity in the right panel, and indeed the whole pictorial space vibrates with the sheer physicality of the paint from which the figures come into being. From one standpoint, human life exists here as an emergent form, needing time to develop from its liquid element. Yet from another, more deeply tragic vantage point, this is a terrible hymn to the traditional trope of the Drowned Maiden, given voice historically in the character of Shakespeare's feckless Ophelia and continuing down to Brecht's poignant lyric, *The Drowned Girl*.

During the last two years, Mary Frank has broadened and deepened both the formal range and the emotional impact of her painting. Themes drawn from nature, always a major element of inspiration, have increased in their productive ambiguity and power. Neither positive nor negative, good nor bad, nature and the natural world seem to exert an influence that extends far beyond the human limits of desire and morality. Or perhaps it is a fantasy of natural forces that Mary Frank deploys with such stunning effect: nature as an obsessive trope—a tree, some mountains, a turbulent sea—that exists as much in the mind's eye as in the physical world.

In an ambitious triptych entitled *Migration* (1998–99) [p. 246], the contrast between the exterior of the work and the interior is so extreme as to generate an electrifying perceptual shock. With the shutters closed, we confront barely adumbrated, roughly drawn

RIGHT Mary Frank,
Migration (closed),
1998–99. Acrylic,
oil, and collage on
panel, 36 × 48 in.
(91.4 × 121.9 cm)

OPPOSITE Mary Frank,
Migration (open),
1998–99. Acrylic,
oil, and collage on
panel, 36 × 96 in.
(91.4 × 243.8 cm)

figures on unprimed canvas, those at the left reduced to an abstract dynamic pattern of black, blue, and white squiggles. The effect is one of enormous haste, hence of primitive emotional immediacy. But the inside, by contrast, offers a vast and richly painted panorama of the natural world, stretching across all three panels: mountains and water in reds, yellows, and greens at the left, reduced at the right to pure blue and white with many areas of bare white canvas, which works beautifully with the coloristic opulence of the left-hand side. Scratched into the surface to the left of the center, and dominating the scene just at the point of the richest conjunctions of opposing colors and forms, is a vatic figure with arms raised as though in blessing. And then, one remembers the running figure on the exterior of the piece, and constructs a significant, if ambiguous, relationship between these, the only two human elements in the work.

In another recent triptych, the relation between landscape and graffito-like human figures is reversed: the exterior of *Ever* (1999), is a richly painted panorama, perhaps water or mountain or both, conceived in a mode that can only be called sublime in its distance from mere human concerns or perspectives, the paint freely applied in the foreground in a rich cacophony of impastoed blues, greens, purples, and browns. In *Ever*, it is the interior that is far more schematic than the exterior. The motif of the naked runner that appeared on the outside of *Migration* makes its appearance again at the far right, but this time it is accompanied by curvilinear adumbrations of floral motifs. The entire interior surface has a snowy effect, inflected by footprint-like marks on the surface. It is interesting to note that Mary Frank takes photographs both in color and black and white, of landscape motifs as an aide-mémoire. Asserting her "subamateur" status as a photographer, Frank sees these photos as raw material for her paintings; she assembles them in useful collages, then paints over them or adds to them as she sees fit.

The sublime mountain peaks and/or terrifyingly mountainous waves of *Ever* reappear in an even more colorful, pictorially charged version as the inside of a triptych

called *Geologies* (1999). One of Mary Frank's most powerful depictions of the natural world devoid of any trace of human or animal presence, *Geologies* features on the outside a centrally placed tree trunk with roots that reach out to grasp the globe of the world. This earth is deeply figured with a pattern of rock forms that give the tree trunk a sense of primal embeddedness in the rocky terrain, so different from the swinging, pounding, richly pigmented yet threateningly unstable sea of the interior panels.

Certainly, one of the most important pieces in the show, for its scale, for its iconographic complexity, and, above all, for its creation of formal contrast and emotional connection between interior and exterior is the triptych *Where or When?* (1998–99) [pp. 248–49]. With the wings closed, this ambitious piece suggests an isolation that is as much spiritual as physical: a vast snowfield of the soul, a place of silence and jagged rocks, of tentative pathways. At the left, a single figure kneels; at the right, two transparent Victories or angels, green-winged, dance out their palpitating visitation. In the black sky above shines an important key to the implications of this strange iconography: a palette, resplendent with color, flat, like painting itself, but throbbing with potentiality. Is it this that the little figure at the left kneels before in veneration? Yet the interior of the triptych offers a dramatic change in both scale and location. Here, in a locus red as fire, we are confronted with a female figure, almost a portrait in its specificity, who clings to a rocky ledge, holding on to two tree trunks as though clinging to life itself on the rooflike edge of nowhere. The foreknowledge on her face is perhaps connected to the figures on the exterior and, certainly, the broad slabs of color in the foreground actualize the potential of the palette that appears there. It is as though the artist has drawn on her own memories of loss and trauma—concrete, irrevocable—not so much to transcend them as to transform them into alternate images, using nature—snow, fire, trees, sky, space—as a catalyst.

Ballad (1997–99) [pp. 248–49] offers an alternative view of similar material. Here, the female figure occupies the left-hand wing of the closed triptych, and it is water rather

RIGHT Mary Frank, *Where or When?* (closed), 1998–99. Acrylic, oil, and collage on panel, triptych, 48 × 48 in. (121.9 × 121.9 cm)

OPPOSITE ABOVE Mary Frank, *Where or When?* (open), 1998–99. Acrylic, oil, and collage on panel, triptych, 48 × 96 in. (121.9 × 243.8 cm)

RIGHT Mary Frank, *Ballad* (closed), 1997–99. Acrylic, oil, and collage on panel, 48 × 48 in. (121.9 × 121.9 cm)

OPPOSITE BELOW Mary Frank, *Ballad* (open), 1997–99. Acrylic, oil, and collage on panel, 48 × 96 in. (121.9 × 243.8 cm)

than fire that is the element in question: gorgeously swirling, foam-crested water into which the nude figure strides confidently. This figure makes literal contact with the viewer in that her hand crosses the margin of the left panel, just at the place where Mary Frank puts her hand when opening the wings, and where the viewer is invited to do the same, to participate in the work's meaning. Inside is a vast stretch of winter landscape; the female figure who dominates the exterior is absent. The Persephone legend comes to mind here, with its mythic tale of the death of nature, brought about by the rape and underworld sojourn of the heroine, and the mourning of her mother, the goddess of the earth's fertility. Indeed, this is a sterile, bleak landscape, as elegiac and mournful as

any of Caspar David Friedrich's 19th-century snow scenes, redeemed only by the pres-
ence of the pale, rectangular canvas in the background, which functions as a signifier
of art rather like the palette in the sky of *Where or When*? One of the interesting things
about the recent triptychs is their constant reversal of inside and outside. There is no
particular theme or formal construction that is consistently designated as one or the
other: the spectator is always freshly confronted, invited to enter the painted world
differently each time.

A strange, primitive creature occupies center stage in several of Mary Frank's late works. It is generally a figure on all fours enveloped in a brilliant field of brushstrokes. Part human, part animal, more masculine than feminine, the figure, rather like a cave painting in its mordant simplification, exists within a grassy, paint-streaked setting, sometimes as a sort of negative white element in a sea of assertive paint. The most abstract of Mary Frank's figural inventions, it is a form that either emerges from or disappears into the order of nature—or, paradoxically, from or into the order of artifice, signified by the pure pigmented facture itself.

In *Creature* (1999), this ambiguous and somewhat disturbing being is sharply outlined in bright orange on the picture surface, hovering against and above its colorful setting. In the triptych, *Experience* (1999), the figure, which occupies a position directly in the center of the closed wings, is almost imperceptible, a negative white space where the powerful all-over brushstrokes are absent, a pale shadow echoed by a smaller motif at the upper left-hand corner of the closed panels. In *Dwelling II* (1999), it exists only as a shadowy reminiscence on the frieze-like interior of the piece; two standing graffiti outlined in brilliant orange occupy the dominant position on the foreground stage. This figure conjures up many associations to me, especially in conjunction with its internal or external other. In *Creatures*, in conjunction with the beautiful and suavely painted female nude who occupies the blue, arched exterior shutters of the piece, it brings to mind the traditional trope of the Wild Man of Europe, a prehistoric, pastoral, uncivilized vestige of a golden or silver age, his body covered with leaves, which haunted

Mary Frank, *Creature*, 1999.
Oil on panel, 24½ × 48 in. (62.2 × 121.9 cm)

the imagination of certain medieval and Renaissance thinkers. In the smaller and simpler *Creature*, for some reason I thought of the mad king Nebuchadnezzar, on his knees eating grass. In *Untitled*, the vaguely adumbrated figure seems more associated with the natural realm of grasses and animals, a sort of cool pastoral fantasy, playing against the complex, multifigured interior with its hot red background, its bending and standing female figures, and the ominous owl, with outspread wings, who flies toward the spectator from the swirling surface. But it is in *Dwelling*, a smaller but nevertheless important work, that the figure finally attains an erect position, in conjunction with an exterior that also suggests the human presence in the heart of nature: a kind of pueblo house with windows and doorways carved into the side of a vast mountain.

In her latest triptychs, as well as in her smaller works, Mary Frank reveals herself once more to be the visual poet of the inner life, evoking the pain and the mystery of our human embeddedness in the natural world. She is not afraid of large subjects, nor is she reluctant to deploy her extraordinary skills as a creator of memorable imagery in the service of our grandest, if at times darkest, experiences: love, death, chaos, loss, and fragmentation. Nor does she trivialize tragedy and terror by suggesting some easy redemptive value to be gained from their contemplation. Rather, she confronts this darkness of the spirit and wrestles it into vivid pictorial expression. Perhaps it is the sense of loss above all that inflects these powerful icons with a recurrent pathos. In Mary Frank's work, we indeed come face to face with the deepest meaning of Hopkins' "inscape": the outward manifestation of inner essence through individually distinctive beauty.

Notes

1 WH Gardner, ed. (1948), "Introduction to the Third Edition," *Poems by Gerard Manley Hopkins,* New York and London: Oxford University Press, pp. xiii–xxvi, and *passim.*

16

Seeing Beneath the Surface (Kathleen Gilje)

Art in America, March 2002

In her recent exhibition at New York's Gorney Bravin + Lee Gallery, Kathleen Gilje showed utterly convincing full-scale replicas of nudes by such art-historical super-stars as Rembrandt, Rubens and Courbet. Yet despite an almost frightening technical prowess acquired during years of practice as a conservator of old-master paintings, Gilje is as much a conceptual artist as she is a dyed-in-the-wool painter. Her show revealed the work to be an art of ideas at the same time that it is a tour de force of technical bravura; or, rather, idea and materiality coincide so neatly in Gilje's work that at times we do not know we are being fooled, both visually and conceptually, until the spell wears off. But we are being deceived to some end: the subtle and not-so-subtle alterations Gilje wreaks on the time-honored icons of Western painting make us think and see differently. These new incarnations of old masterpieces, "contemporary restorations," as Gilje calls them,

Kathleen Gilje, *Woman with a Parrot, Restored (after Courbet),* 2001.
Oil on canvas, 51 × 77 in. (129.5 × 195.6 cm)

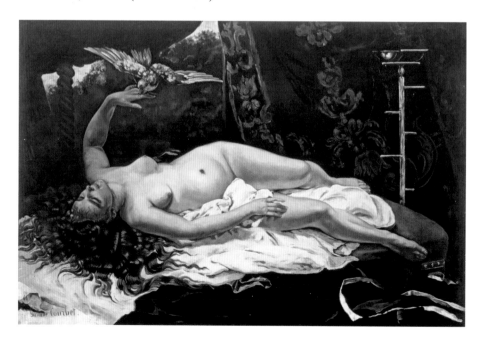

seem to reveal the hidden implications of the works themselves, implications that, for the most part, only a present-day feminist would be privy to.

Yet this is not merely a feminist project. On the contrary, the work provides an answer to a very different kind of question. Can we ever look at the old masters with new eyes, see the great works of the past with virgin vision, as though for the first time? Gilje's thought-provoking "restorations" shock us, gently or blatantly, into doing just that.

Perhaps the most striking work in the show, especially if you happen to be a Courbet specialist, is Gilje's absolutely accurate version of the artist's lush and lascivious nude, *Woman with a Parrot*, one of the treasures of the Metropolitan Museum of Art. Titled *Woman with a Parrot, Restored (after Courbet)* (2001), it is accompanied by an X-ray that reveals a startling pentimento: under the banal vertical of the parrot's perch is another scenario, and a much more exciting one, in the shape of a well-set-up young male nude.

Here Gilje's tongue-in-cheek wall text (which must be considered as much a part of the work as the painting and the X-ray) comes to the fore, transforming the project from mere playful *tricherie* to a more serious undermining of art-historical doctrine. Gilje, in the role of academic scholar, takes seriously Michael Fried's reference to "Courbet's struggle with his own spectatorship." Alluding to the male figure, art historian Gilje argues, "This remarkable presence not only resolves the nagging problem of the painting's composition, but also the problem that has plagued viewers as to the actual orientation of model and painter, Fried insisting that Courbet could not have painted

Kathleen Gilje, *Woman with a Parrot, Restored (after Courbet)*, 2001.
20 sheets of X-ray film mounted on Plexiglass, 50 × 75½ in. (127 × 191.8 cm)

the woman's face without himself having approximated the position of the newly revealed figure." Assuring us that the nude young male is indeed Courbet, the wall text goes on to tell us why he had to disappear in the final version: he realized, perhaps, that "he had *gone too far*" and, "having put himself into the painting, Courbet...took himself out again."

The wall text concludes with a neat nugget of psychoanalytic "theory," complete with a trendy reference to the phallus and the gaze: "In a countervailing act of self-abnegation, Courbet replaced the portrait of himself—an embodiment of youthful virility...with the portrait of a stick. The phallus stands, but desiccated, withered, as if to atone for the imperium of a gaze the painter finds, finally, impossible to shake. The restored painting testifies nevertheless to the extent to which even the most conventional appearing of Courbet's nudes is scarred by the painter's struggle with that most fundamental of painterly problems, the very act of beholding itself." The wall text should no more be taken as a total put-down of contemporary art history than Gilje's replicas should be seen as complete rejections of the art of the past. Far from it. She just uses both to call attention to the generally unexamined assumptions common to both painting and text.

Perhaps the most ambitious effort in this conceptual direction was a 1997 collaboration at the MIT List Visual Arts Center between Gilje and Joseph Grigely, word artist and professor of art and critical theory at the University of Michigan, that involved a "newly discovered" version of Caravaggio's *Musicians*. In a catalogue essay liberally studded with erudite endnotes, Grigely-as-art-historian convincingly supports the existence of another, quite different image beneath the surface of the painting, one that is disclosed in Gilje's X-ray. In the subsurface image, a mirror reveals that the foreground boy is not singing but masturbating. "Instead of grasping a love madrigal in his left hand, he grasps a metonym of this madrigal: his erect penis," declares the scholarly text. Combining art-historical fact and deconstructive fiction, the collaboration works its magic. The show even included a mock reconstruction of the art historian's cluttered office, replete with slide carousels and coffee cups as well as relevant books and articles.

In a solo exhibition at the Williams College Museum of Art, also in 1997, the scholarly apparatus was less prominent although still present in the form of "comparative" reproductions of the originals of the newly "restored" works. Among the memorable images in that show, each of which was constructed with meticulous attention to detail and technique, was a 1994–96 version of Ingres' elegant portrait of the Comtesse d'Haussonville, built up in the layers of glaze habitually employed by this 19th-century artist. But in the mirror behind the comtesse is reflected not the back of the subject, but a startling image of female body-builder Lisa Lyon as photographed by Robert Mapplethorpe, one fetishized image substituting for another. This might suggest a rather different and less passive comtesse, who was, in fact, a productive historian in private life.

Kathleen Gilje,
*Comtesse
d'Haussonville,
Restored (after
Ingres)*, 1994–96.
Oil on canvas,
52½ × 36⅛ in.
(133.4 × 91.8 cm)

Among other works in the Williams College show that more or less speak for them-
selves without accompanying texts are versions of Raphael's suave *La Donna Velata*
with a black eye (1995) and El Greco's famous portrait of the grand inquisitor, Cardinal
Fernando Niño de Guevara, now seated before Andy Warhol's *Orange Disaster*, which
includes multiple images of a photograph of an electric chair (1993) [p. 256]. About
this "restoration," Gilje says in the catalogue, "You see, the electric chair is in exactly
the same three-quarter turned position as the Inquisitor's throne.... Visually, the most
horrifying thing about this painting to me is that there is such calm masking on this
man's destructiveness." Although it is usually a sexual innuendo that is revealed by
Gilje's additions, it may, as this powerful image demonstrates, be a political one as well.

Gilje has "restored" a painting by a woman only once, to my knowledge. Her version
of Artemisia Gentileschi's Old Testament subject, *Susanna and the Elders, Restored (after
Artemisia Gentileschi)* (1998) [p. 257], was recently on view at the National Museum
of Women in the Arts in Washington, DC. The X-ray of what lies beneath the cower-
ing Susanna shows a powerful, shrieking, knife-wielding Susanna, but the didactic
and factual text in the accompanying brochure (authored in this case by critic Laura
Cottingham), far from encouraging us to accept the underlying figure as Artemisia's
own, destroys the X-ray's illusion that a more militant Artemisia is registered beneath

Kathleen Gilje,
*Portrait of Cardinal
Niño de Guevara, Grand
Inquisitor, Restored
(after El Greco and Andy
Warhol)*, 1993. Oil on
linen, 67⅞ × 42⅜ in.
(172.4 × 107.6 cm)

the visible surface. We don't want to know that Kathleen Gilje, modern "restoration" artist, created a furious and vengeful Susanna beneath the conventional image. We want to believe that the victimized Artemisia did it herself, acting out her retribution in pictorial form against the man who raped her. Gilje's images work best in a setting of textual complicity, not scholarly literalism.

In the Gorney Bravin + Lee exhibition, Gilje combined painting and text to great effect in revisions of several other major works besides the Courbet. Most striking is a seductive *Het Pelsken, Restored (after Rubens)* (2001) [p. 258], a version of Peter Paul Rubens' semi-nude portrait of his sixteen-year-old bride (Sir Peter Paul was fifty-three at the time) clutching a fur coat around her, with the addition here of a pair of avid, masculine hands grasping at her rounded body. Gilje's accompanying text maintains that "Helena in *Het Pelsken* is doubly possessed: as wife, *by social man*, by Sir Peter Paul Rubens, Lord of Steen; as sexual body...*by the beast*." This feminist reading is particularly interesting in light of the fact that John Berger, many years ago in his *Looking at Pictures*, selected this nude image as a relatively benign one, demonstrating Rubens' pride in and affection

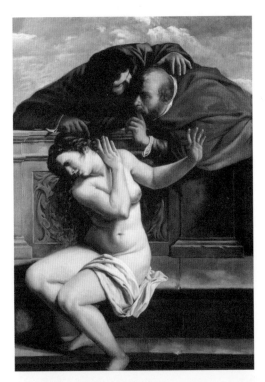

ABOVE Kathleen
Gilje, *Susanna and the
Elders, Restored (after
Artemisia Gentileschi)*,
1998. Oil on canvas,
67 × 47 in.
(170.2 × 119.4 cm)

RIGHT Kathleen
Gilje, *Susanna and the
Elders, Restored (after
Artemisia Gentileschi)*,
1998. 15 sheets of
X-ray film mounted
on Plexiglass,
67 × 47 in.
(170.2 × 119.4 cm)

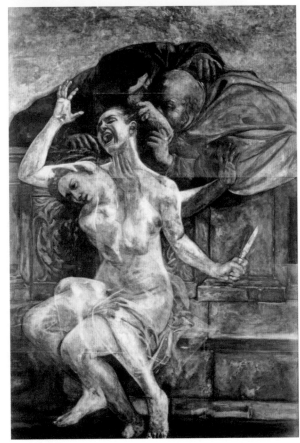

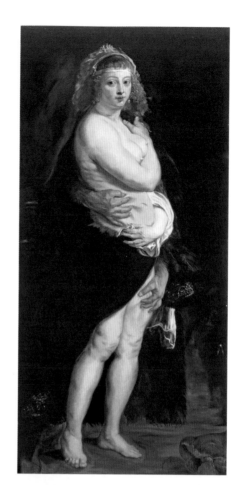

RIGHT Kathleen Gilje,
*Het Pelsken, Restored
(after Rubens)*, 2001.
Oil on wood, 69¾ × 33½ in.
(177.2 × 85.1 cm)

BELOW Kathleen Gilje,
*Danaë, Restored (after
Rembrandt)*, 2001.
Oil on canvas, 72½ × 80½ in.
(184.2 × 204.5 cm)

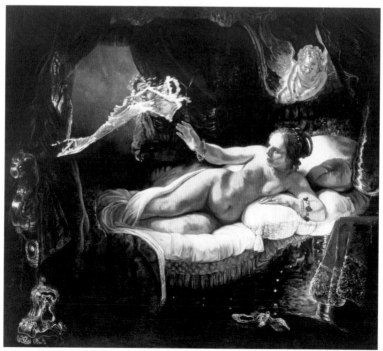

for his young bride. Gilje will have none of it. "The painting says: 'This woman is *universally desirable.*' The painting says: 'She is *mine.*' The painting says: '*I* am Rubens!'" So proclaims Gilje in the wall label. The clutching hands say the rest.

The other large painting with text in the show is a version of Rembrandt's *Danaë* (in the Hermitage), in which Gilje commemorates the 1985 attack on this work by a man who threw acid on it, destroying about 30% of the canvas. An amorphous white blotch, somewhat like ectoplasm, startlingly mars the upper left-hand portion of Gilje's *Danaë, Restored (after Rembrandt)* (2001). The artist astutely comments, "By replacing the painting's 'golden semen' here with the acid that literally and figuratively takes its place, we are also forced to ask whether the arm Danaë raises—and which historically has been seen as welcoming the god—has not from the outset been raised rather to ward off an assault?" Shower of gold or acid, ancient god or modern madman: they are all equivalent in the kingdom of violence toward women.

Lastly, I would like to consider some of the small, textless images at the gallery, representations of individual women that make their point in both visual and conceptual terms. All of them are nudes and convincing as renderings of specific persons. In the touching *Portrait of a Young Lady, Restored (Love)* (2001), a prim and proper Memling sitter with conical hat and wispy, transparent veil is transformed into a Catherine Opie subject by the blood-rimmed word "love" cut into her left arm. For those familiar with Opie's work, the reference helps emphasize the latent androgyny of the original as well as the restoration, the boyishness of the homely face with its pulled-back hair and protruding ear. In still another work from this group, *Portrait of a Lady, Restored (Lady Lisa)* (2000), which replicates a Rogier van der Weyden work, a pair of masculine-looking

Kathleen Gilje, *Portrait of a Young Lady, Restored (Love)*, 2001. Oil on wood, 18⅝₆ × 13⅛₆ in. (46.5 × 33.2 cm)

Kathleen Gilje, *Linda Nochlin in Manet's Bar at the Folies-Bergère*, 2005.
Oil on linen, 37⅝ × 50⅞ in. (95.6 × 129.2 cm)

hands enter the scene, pinching the woman's exposed nipples and, at the same time, suggesting one of Stieglitz's portraits of Georgia O'Keeffe, where the subject is represented grasping her own breasts.

In these single-figure works, it is simply the bodies of women that are at stake—displayed, gripped, wounded—and they may be the images that touch us most with their pathos, even as they startle us with their bluntness. In a rather dismissive review of the show in the *New York Times*, critic Ken Johnson reproached Gilje for remaining "a kind of dutiful daughter," her conceptual interventions not venturing "much beyond the pale of academic respectability," and he urges her to be more like Peter Saul or Robert Colescott. Johnson has it all wrong. Gilje is badder than those overt parodists, because her wickedness is bound up in the very reality of the Great Masterpieces themselves and in the Great Minds who interpret them. These are fierce and often funny paintings, offering intense visual pleasure—at a high price indeed.

17
A Rage to Paint: Joan Mitchell and the Issue of Femininity

The Paintings of Joan Mitchell, 2002

Rage, violence, and anger have often been deployed as heuristic keys in interpreting the work of Joan Mitchell, especially the early work. In her catalogue of a major 1988 retrospective of Mitchell's work, Judith Bernstock tied Mitchell's 1957 painting *To the Harbormaster* to the Frank O'Hara poem from which Mitchell derived her title by referring explicitly to the lines in which water appears as the traditional symbol of chaos, creation, and destruction. Taking account of Gaston Bachelard's theory that "violent water traditionally appears as male and malevolent and is given the psychological features of anger in poetry," Bernstock went on to maintain that both Mitchell's "frenzied painting" and O'Hara's poem "evoke a fearful water with invincible form ('metallic coils' and 'terrible channels') and voice-like anger, a destructive force threatening internal and external chaos." She concluded with a reference to the formal elements in the painting that evoke the menacing mood of the poem: "The cacophonous frenzy of

Joan Mitchell, *To the Harbormaster*, 1957.
Oil on canvas, 76 × 118 in. (193 × 299.7 cm)

short, criss-crossing strokes of intense color...the agitation heightened as lyrical arm-long sweeps across the top of the canvas press down forcefully, even oppressively, on the ceaseless turbulence below."[1] Of *Rock Bottom*, a work of 1960–61, Mitchell herself maintained: "It's a very violent painting, and you might say sea, rocks."[2]

Of the whole group of canvases created from 1960 to 1962—including *Flying Dutchman, Plus ou Moins, Frémicourt*, and *Cous-cous*—the artist asserted: "[These are] very violent and angry paintings," adding that by 1964 she was "trying to get out of a violent phase and into something else."[3] This "something else" was a series of somber paintings Mitchell created in 1964, works that she called "my black paintings—although there's no black in any of them."[4] In their thick, clotted paint application and somber pigmentation they constitute a break from the intensely colored, energetic, all-over style of her earlier production. They also seem to mark an end to the self-styled "violent" phase of Mitchell's work and a transition to a different sort of expressive abstraction.

Issues of intentionality aside, what do we mean when we say that violence, rage, or anger—indeed, any human emotion—are inscribed in a work of art? How do such emotions get into the work? How are they to be interpreted?

In earlier art, when anger or violence is the actual subject of the work itself—as, for example, in Antonio Canova's *Hercules and Lica* (1795–1815)—the task of interpretation may seem easier, the emotion itself unambiguously present, even transparent, despite the smooth surfaces and neoclassical grandeur of Canova's sculpture. Yet even here, in *Hercules and Lica*, with its furious hero and horrified victim, or in the convulsive

Joan Mitchell,
Rock Bottom, 1960–61.
Oil on canvas,
78 × 68 in.
(198.1 × 172.7 cm)

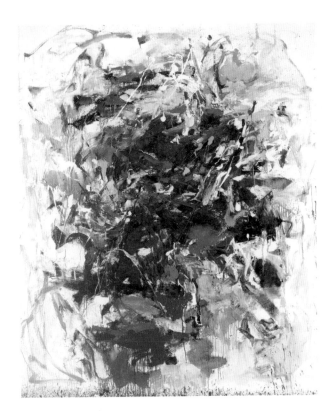

RIGHT Joan Mitchell, *Untitled* (from the Frémicourt era, 1960–62), 1960. Oil on canvas, 98 × 80¼ in. (248.9 × 203.8 cm)

BELOW Joan Mitchell, *Cous-cous*, 1961–62. Oil on canvas, 78¾ × 119¾ in. (200 × 304.1 cm)

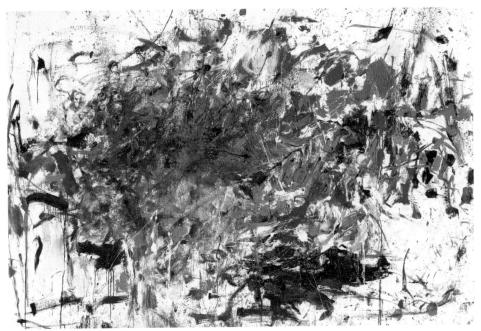

image of hands-on murder in Paul Cézanne's *Strangled Woman* (1870–72), problems of interpretation arise. Is Cézanne's painting a more effective representation of rage than Canova's sculpture simply because we can read a coded message of violence directly from the formal structure of the work, from its exaggerated diagonal composition, its agitated brushwork, its distorted style of figuration?

Clearly the problem of just what constitutes and hence is *read* as rage or any specific emotion in art becomes both more and less complicated when the painting is abstract—that is to say, when there is no explicit subject to provide a basis for interpretation. In the case of abstract expressionist work like Mitchell's, even the titles may prove to be deceptive or irrelevant, appended for the most part after the fact. The task of interpretation is both exhilarating and daunting, the canvases functioning as so many giant Rorschach tests with ontological or, at the very least, epistemological pretensions. Biography, in fact, often looms large in such cases precisely because of the *absence* of recognizable subject matter. The gesture seems to constitute a direct link to the psyche of the artist, without even an apple or a jug to mediate the emotional velocity of the feeling in question.

Yet despite the unreliability of biography as a means to elucidate the work of art, it cannot be altogether avoided, although it certainly must be severed from the naïve notion of direct causality (for example, "Mitchell was sad because of the death of her father, so she made dark paintings"). The role of rage in the psychic make-up of the artist and her production is daunting: anger may be repressed; it may be "expressed" in a variety of ways; it may even be transformed into its opposite, into a pictorial construction that suggests to the viewer a sense of calm, joy, or elegance. In any case, its role is always mediated.

Following the general issues of rage and its expression in abstract painting is the more specific issue of *gendered* rage. For Mitchell, of course, was a *woman* abstract painter, even though, quite understandably, she did not want to be thought of as such when she painted the works under discussion. Indeed, there is an apposite story about Mitchell told by Elaine de Kooning in 1971 involving the phrase "women artists": "I was talking to Joan Mitchell at a party ten years ago when a man came up to us and said, 'What do you women artists think…' Joan grabbed my arm and said, 'Elaine, let's get the hell out of here.'"[5] Mitchell was fleeing from what, at the time, was a demeaning categorization. Like other ambitious young abstractionists in the 1950s and 60s who happened to be women, she wanted to be thought of as "one of the boys"—at least as far as her work was concerned. If she did not want to be categorized as a woman painter, it was because she wanted to be a *real* painter. And, at that time, a real abstract painter was someone with balls and guts.

Mitchell was one of many women trying to make it in a man's world, and on men's terms, even if they were not acknowledged as doing so. These women included painters, writers, musicians, and academics. It seems to me, then, important to examine not merely how rage might be said to get into painting or sculpture but also how it gets into

women. In order to do so, it is helpful to consider the more general conditions existing for the production and valuing of women's work in the 1950s and 60s.

Here I think it is instructive to look again at two photographs that have often been compared, and then at a third. The first is the famous Hans Namuth photograph of Jackson Pollock caught in the dance-like throes of sublime inspiration. It is a dynamic icon of the transcendent authority of (male) abstract expressionist creation. The second image, by Cecil Beaton, has been used to stand for, to put it bluntly, the corruption of the ideal. In it, a beautiful *Vogue* model stands before a Pollock painting, testifying to the transformation (inevitable in late capitalist society) of creative authenticity, which is a momentary illusion at best, into a saleable commodity.[6] As is usual in such visual demonstrations of social corruption—one thinks here of George Grosz's or Otto Dix's trenchant satires of Weimar society or, later, those of RB Kitaj—it is played out on, or with, the bodies of women—inert, passive, lavishly bedecked, sometimes nude or semi-nude. In Beaton's photograph the model functions as a fashionable femme fatale, embodying, so to speak, the inevitable fate of modernist subversion: the relegation of high art to the subordinate role of mere backdrop for (shudder!) feminine fashion, with fashion itself functioning as the easy-to-grasp sign of the fleeting and the fickle, high art's deplorable other.[7] Beaton's fashion photograph transformed Pollock's painting into "apocalyptic wallpaper," to borrow Harold Rosenberg's term, though in this case the wallpaper is not so much "apocalyptic" as merely pricey.

This comparison and its implications make me angry and uneasy because it is hard to side with either of these visions of art or fashion. My anger, and my uneasiness, have to do with the fact that although I was involved in contemporary art in 1951, I was a young woman who was highly invested in fashion as well. And for me, in my early 20s (only a few years younger than Joan Mitchell), a struggling instructor, a graduate student, and a faculty wife at Vassar, being fashionable was one of the things that helped me and my young contemporaries to mark our difference from the women around us in the early 1950s. Being elegant, caring about clothes, constituted a form of opposition to what I called "little brown wrenism," a disease imported from Harvard by Vassar faculty wives and their spouses along with the postwar revival of *Kinder, Küche, Kirche*. It was premised on a "womanly," wifely, properly subordinate look: no make-up, shapeless tweeds, dun-colored twin sets, and sensible shoes. Brilliance and ambition *had* to be marked as different. There were several possibilities: for artists like Joan Mitchell or Grace Hartigan, paint-stained jeans and a black turtleneck could be professional attire and constitute an assertion of difference at the same time. The philosopher Elizabeth Anscombe, a strong-minded British eccentric, insisted on complete menswear: jacket, tie, trousers, and shirt. I am told that a special podium, which hid the offending pants, had to be rigged up when she lectured at Barnard College.

As a woman who followed fashion, I could have told you who the model was in the Beaton photograph, just as easily as I could identify Pollock. And I could have told you

who had designed the splendid gown she wore. My grandmother had given me a subscription to *Vogue* when I was still in high school, and I followed fashion, as I followed art, avidly. I certainly knew they were not the same thing, but my passionate involvement with both art and fashion (and, I might add, anti-McCarthy politics) made the fact that I was a woman, not a man (and a woman who thought of herself as different from many of the women around her), a vital differential in my relation to the elements of the Beaton versus Namuth opposition.

What, then, are we to make of the 1957 Rudy Burckhardt photograph of Joan Mitchell at work in front of her painting *Bridge*? Where should it be placed? In the camp of the original, authentic creator, like the Pollock photograph, or in that of the Beaton model? The sitter here is, after all, like the model, an attractive, slender young woman. I do not know whether Mitchell ever saw the *Vogue* photo, and she was certainly not interested in fashion, but the oppositions offered by the two images were certainly part of the context within which she lived and worked.

Different though they may be as visual objects, the position of the model in the *Vogue* picture is not so different from that of the figure in Willem de Kooning's *Woman I* (1950–52). Both Beaton's photograph and de Kooning's painting implied that woman's place was as the object of the image rather than the creator of it. Her passion was not the "rage to paint," but rather to be "all the rage." The Burckhardt photo of Mitchell, then, is something of an anomaly, the object taking over the subject position, albeit with a difference—and this despite the fact that Mitchell's body, qua body, is an athletic, dynamic, active one—as active in the picture-making process as Pollock's.[8] Yet in terms of the Namuth and Beaton photographs, she is twice "othered": once as the female "other" of the male Jackson Pollock, but once again as the female "other" of the elegant and proper female *Vogue* fashion model.

In other photos taken in front of her work, Mitchell is made to seem less self-assured, less like "one of the boys." But there is one photograph, taken in about 1953, of her with her poodle, George, that brings to mind one of the most famous youthful self-images of the artist as a young subversive, Gustave Courbet's *Self-Portrait with a Black Dog* of 1842.[9] In the photograph of Mitchell and her dog, although she is clearly the "other" of Courbet in terms of gender, she may now be seen as "same" in terms of the chosen elements of the artist's self-representation: like Courbet, she possesses her work and her dog. Mitchell's otherness, in the photograph, swerves back, in this trajectory, to identity; her rage is transformed into mastery, envisioned as a positive vector in the process of creation. For a photographic instant, at least, Mitchell is one of the boys—indeed, a very big boy, Courbet. And yet this is not a completely satisfying resolution to the dilemma of the woman artist. We do not see the brush in Mitchell's hand, after all, as we do in Courbet's in the center of *The Painter's Studio* (1854–55), and we all know, from simplified versions of Freud, if not from various artists and art critics, that the brush is the phallic symbol par excellence. Artists have even been said to paint with their

pricks—and how can a woman do that? As Michael Leja has succinctly put it: "A dame with an Abstract Expressionist brush is no less a misfit than a *noir* heroine with a rod."[10]

What a wholesome emotion rage is—or can be! "Menin aida thea peleadeo Achileus" (Sing, goddess, the wrath of Achilles). The *Iliad* starts on a high note of rage, connecting art itself—the singing of the goddess—with heroic anger. Nietzsche extolled the salutary potential of rage, above all, when it engaged the creative psyche. So did William Blake, who declared, "The tigers of wrath are wiser than the horses of instruction." Yet how unbecoming rage, and the energy generated by it, is thought to be when it comes from women. And all too often women's rage is internalized, turning the justifiable fury they feel against both the social institutions and the individuals that condemn them to inferior status not on others but on *themselves*: cutting up their own work; making it small; rejecting violence and force as possessions of the masculine ego, hence unavailable to the female artist; stopping work altogether; speaking in a whisper instead of a roar; becoming the male artist's support system. Silence has always been a viable, indeed, a golden, alternative for women artists. The fact that Mitchell, though a woman, could take possession of her rage and, like a man, transform it into a rage to paint, was an extraordinarily difficult concept for a male-dominated art world to accept.

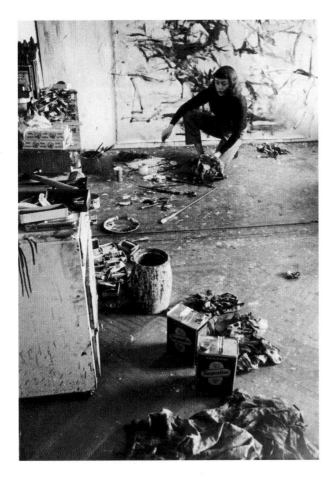

Rudy Burckhardt, *Joan Mitchell I*, 1957. Gelatin silver print, 8 × 10 in. (20.3 × 25.4 cm)

Yet it would seem to me that rage, and its artistic corollary, the rage to paint, are both central to the project of Joan Mitchell. Mitchell herself quite overtly rejected attempts to define her work as feminine, although she came to accept the notion of feminism as a political stance. Her paintings forcefully help establish the notion of a feminine other—energetic, angry, excessive, spilling over the boundaries of the formless, the victimized, the gentle, and the passive—but battling, at the same time, those other familiar demons, chaos and hysteria, with a kind of risky, ad hoc structure.

In a long, rambling, beautifully revealing letter she wrote to me in the late 1980s, Mitchell stated: "I have lots of real reasons to hate…and somehow I can't ever get to hatred unless someone is kicking my dog Marion (true story)…or destroying Gisèle [a friend] etc. and then I'll bite—(I can't get to killing—my 'dead' shrink kept trying to get me there—I have never made it—my how I loved her)."[11] Perhaps Mitchell never thought of herself as angry or enraged. I do not suppose she thought of herself as a heavy drinker either. But, then again, neither did the various male artists who depended on rage and alcohol to stimulate their art—or, at least, to make it possible for them to write or paint and not succumb to darkness and passivity.

Recently, however, women have been discovering the specificity of their rage and anger and writing about it. In 1993, in an article entitled "Rage Begins at Home," literary scholar Mary Ann Caws differentiated rage from anger, asserting: "Rage is general, as I see it, and is in that way quite unlike anger—specific or motivated by something—which can, upon occasion, be calmed by some specific solution, beyond what one can state or feel or see. Rage is…one of the great marvels of the universe, for it is large, lithe, and lasting. I have come to treasure my rage, as I never could my anger. My rage possessed and is still undoubtedly possessing me, from inside, and did not, does not, cannot demand that I control it…. Energy comes from, and is sometimes indistinguishable from this rage." Later Caws ceased to differentiate between the two, for, as she put it, "I believe they have me both."[12]

In 1992, in a special issue of RESearch entitled "Angry Women," Andrea Juno, in an interview with Avital Ronell, declared: "The only way a woman can escape an abusive misogynistic relationship is through full-fledged anger. Anger may also be the conduit by which women in general can free themselves from larger social oppressions." Ronell responded: "Anger must not be confined to being a mere *offshoot* of ressentimental, festering wounds, but must be a channeling or broadcast system that, through creative expression, produces a certain *community*. That image of a mythical, Medusan threat is wonderful."[13]

For Mitchell, rage, or anger, was singular, consuming. When I was with her, I could often feel rage, scarcely contained, bubbling beneath the surface of her tensely controlled behavior. Sometimes it would burst forth, finding as its object a young curator, an old friend. It was icy, cutting, and left scars. Once, when I was staying the night at her house in the country, she had an acrimonious fight with a former partner. It was

terrifying; I have never seen or heard a man and a woman so angry at each other, and it went on and on, mounting in its passion, with physical violence always lurking in the background, though it never actually came to blows. I wanted to hide under the table, but I was called upon as a witness to the iniquity of first one, then the other, by the contending parties, mostly by Mitchell herself. Certainly Mitchell's rage constructed no sense of community or connection between herself and other women.[14] Yet I think we must be aware of the power of individual anger in women's achievement, as revealed in the work of Mitchell and many others of her generation—and after.

Without Mitchell's unerring sense of formal rectitude, however, without her daring and her discipline as a maker of marks and images, her work would be without interest. I would like to look now at a series of images that have often escaped careful examination: the ten original color lithographs, drawn on aluminum plates, that the artist made in 1981 with master printer Kenneth Tyler.[15] These works are in some ways anomalous in the artist's oeuvre in that they are small-scale and are *not* executed in oil paint, Mitchell's preferred medium. And yet for that very reason, because they are, let us say, more approachable, they offer a good starting place to chart the intersection of energy and its articulation in Mitchell's work—the explicit way that meaning comes into being in her imagery. Delicacy, grace, and awkwardness are all present in varying degrees in Mitchell's subtle, nonreferential calligraphy. The constant interplay of same and different is crucial to the production of meaning in these prints, which, though visual in every respect, nevertheless share in the distinctive character of language in the way their images are constructed.

How do visual structures of similarity and difference come into play in a reading of *Bedford I* and *Bedford III*? In both lithographs a bottom layer, which we see as earth or ground, is opposed to an airier, more lightly applied blue "sky" area above. Yet the feeling or mood of each of these prints is very different, the vernal lightness, sprouting bounce, and dancing rhythms of *Bedford I* produce an atmosphere utterly opposed to that of the petulant, indeed outright angry animation created by the more solid facture of the choppy ground element and the fractured sky area of *Bedford III* [p. 270]. In another print from the same series, *Flower III*, a four-color lithograph, the relationship between more densely worked and more open areas is reversed: now it is the upper portion of the image that is filled with color and incident and meshed strokes of crayon, while the bottom is sketchily adumbrated by a series of open vertical strokes that leave plenty of leeway for the white paper beneath.[16] Two polarities of Mitchell's style are demonstrated in a later group of prints she created in conjunction with Tyler Graphics. In *Sunflowers II* of 1992 two related images are juxtaposed to form a diptych. The subject is really the relation of the downpouring energy of the crayon strokes. These dark, congested rectangles have nothing in common with Vincent van Gogh's famous flowers except the palpitating excitement of their facture, and there is something perverse about the title. These are dark sunflowers indeed; the one on the right—with its

Joan Mitchell,
Bedford III, 1981.
Color lithograph on
paper, 42⅛ × 32½ in.
(108 × 82.6 cm),
edition of 70 + proofs

thick, blotchy smears of blue and green pigment and skinny bent supports—is especially ominous. In *Little Weeds II*, of the same date, however, the colors are brighter, the calligraphy dispersed over a broader, emptier horizontal field, the mood more frenetic, and the dynamic more centrifugal rather than contained.

From the very beginning, Mitchell's rage to paint was marked by a very specific battle between containment and chaos. In *Red Painting No. 2* of 1954 a shivering island of agitation is held in check by the composition's central focus, the mazing and amazing dynamism of the brushwork, which pulls together and layers in deep, jewel-colored skeins. A close-up detail of the upper central portion of the canvas reveals something of the complexity of Mitchell's facture, the almost excessive bravado of the gestural center compared with the cool pallor of the gridded margins, as though something wild had escaped from a cage—or needed to be pent up in one.

Mitchell's work has often been compared with that of her contemporaries and immediate predecessors. If we compare Mitchell's untitled canvas of 1956–57 with de Kooning's *Woman* of 1949–50,[17] we see that she accepted the sweep, the slash, the bravura brushwork of his style but rejected what is most striking about his image: the figuration. Comparison, of course, can bring out difference as well as similarity. Much is sometimes made of the "impact" or "influence" of Mitchell's longtime companion, the Canadian-born abstractionist Jean-Paul Riopelle, on her style. Yet I think comparison in this case brings out irrevocable difference: Riopelle's patterning is more regular, less

270

aleatory, more all-over, of equal density throughout, which gives his work a preconceived rhythmic formula utterly opposed to Mitchell's poignant visual searching.

In Mitchell's work, as I am trying to demonstrate, meaning and emotional intensity are produced structurally, as it were, by a whole series of oppositions: dense versus transparent strokes; gridded structure versus more chaotic, ad hoc construction; weight on the bottom of the canvas versus weight at the top; light versus dark; choppy versus continuous brushstrokes; harmonious and clashing juxtapositions of hue—all are potent signs of meaning and feeling. It is this structural freedom and control, this complexity of vision that accounts for the fact that, far from being a one-note painter, Mitchell explored a vast *range* of possibilities in her work, from the spreading, ecstatic panoramas to the inward-curdling "black paintings," from the totally covered canvas to the canvas enlivened only by a few dashes of calligraphy. *Field for Two* (1973) could almost be a Rothko, but a Rothko highly implicated in Hans Hofmann's "push and pull."[18] The gridded planes of color hover over and retreat from the surface of the canvas. And what colors they are: pinks, oranges, a touch of vernal green, and then those streaks of hovering darkness that so often seem designed to disrupt easy comfort or harmony in Mitchell's best canvases.

The diptych and the polyptych formats attracted Mitchell increasingly from the late 1960s on. Of course, the two-part or multipartite format was not her invention. On the contrary, it had had a long history, going back to the religious art of the Middle Ages and the Renaissance, when it often assumed heroic proportions in the traditional Christian

Joan Mitchell,
Field for Two, 1973.
Oil on canvas,
57½ × 44½ in.
(146.1 × 113 cm)

altarpiece. More recently, in the 1950s, Pollock made use of both the diptych and the polyptych in a series of dramatic drip paintings in which strings of pigment jump over barriers and respond to similar formations in their partner paintings.[19]

But Mitchell's multicanvas creations were different from both the religious art of the past and Pollock's more recent essays into the genre. First, they constituted a response to her own need for greater spatial expansiveness, yet an expansiveness that would nevertheless be held in check by the specific dimensions of the individual panels that constituted the object.[20] Secondly, the diptych or polyptych appealed to her because of the more complex relationships it could induce: not just the play of differ-ence and analogy *within* the single canvas, but response and reaction against another related panel, both like and different. The range of interrelated expressions was vast and open-ended.

At times the notion of landscape, and of the topographic, almost inevitably enters the mind of the viewer of Mitchell's work. There are titles—such as *Plowed Field, Weeds, The Lake,* or *River*—that conjure up a topographic or landscape experience. The fact that Mitchell lived for a great deal of her mature life in Vétheuil, on the Seine, with its splendid views already immortalized by Claude Monet (who had lived briefly in the gardener's cottage near her property), increases the temptation to ascribe specific paint-ings to precise locales. But it is important to keep in mind that almost all of Mitchell's canvases were titled *after* the fact, not before. Far from being a painter who worked *sur le motif*, like Monet or Cézanne, one might say that Mitchell was a painter who worked the motif in after. She discovered the analogies to some thing, place, idea or feeling after she had completed the work, not before. Many of the titles are facetious or arcane, like *The Goodbye Door* or *Salut Tom.* Some of them are flatly descriptive, like *Cobalt* or *Bottom Yellow.* But in all of them we are aware of what art critic Barbara Rose denominated the "struggle between coherence and wild rebellion."[21] That, if anything, is what Mitchell's paintings are "about." As such, they constitute a pictorial palimpsest of multiple experi-ences; they are never perfect, finished objects. From their brazen refusal of harmonious resolution rises their blazing glory.

In a wonderfully suggestive article about Virginia Woolf and Duke Ellington pub-lished in the *New York Times*, cultural critic Margo Jefferson turned her thoughts to "the place of beauty and fury in Woolf's work," explaining that "beauty restores and fury demolishes in her novels. The bond between them...is so psychically fraught it remained muted, even subterranean." But, Jefferson continued, "Like grief or longing or moments of transcendence...anger can be changed into something else and made new." She ended her piece by asserting that "elegy and fury [may exist] side by side, beauty and the heart of darkness sharing one language."[22] How apt a description this is of Joan Mitchell's painting at its best, an art in which rage and the rage to paint so often coin-cide and, indeed, share the same ever-questing, always unformulaic pictorial language.

Notes

1 Judith E Bernstock (1988), *Joan Mitchell*, catalogue, New York: Hudson Hills Press, in association with the Herbert F Johnson Museum of Art, Cornell University, pp. 47 and 51.

2 Joan Mitchell, cited in ibid., p. 57.

3 Ibid., p. 60, no. 4.

4 Joan Mitchell (1994), in *Joan Mitchell "My Black Paintings...,"* 1964, catalogue, New York: Robert Miller Gallery, unpaginated.

5 Elaine de Kooning and Rosalyn Drexler (1973), "Dialogue," in Thomas B Hess and Elizabeth C Baker, eds, *Art and Sexual Politics: Women's Liberation, Women Artists, and Art History*, New York: Collier, p. 56.

6 See TJ Clark (1999), *Farewell to an Idea: Episodes from a History of Modernism*, New Haven, CT: Yale University Press, pp. 302–8, figs 177 and 178. Serge Guilbaut used one of the Beaton photographs for the cover of his *Reconstructing Modernism: Art in New York, Paris, and Montreal, 1945–1964* (1990), Cambridge, MA: MIT Press.

7 Although, it must be admitted, fashion was greatly admired by some of high modernism's greatest supporters, beginning with the French poet Charles Baudelaire, who claimed that fashion constituted an essential half of beauty itself and wrote an essay in praise of *maquillage*. Likewise, the poet Stéphane Mallarmé wrote for a fashion journal.

8 Mitchell had been a successful ice skater and always moved with assertive energy and economy. Burckhardt, unlike most of his contemporaries, photographed quite a few women artists. Besides a whole series of images of Mitchell in 1957, he photographed Ann Arnold, Nell Blaine, Elaine de Kooning, Jane Freilicher, and Marisol.

9 See Bernstock, *Joan Mitchell*, p. 212, for the photograph *Joan Mitchell and George*, New York, *c.* 1953.

10 Michael Leja (1993), *Reframing Abstract Expressionism: Subjectivity and Painting in the 1940s*, New Haven, CT: Yale University Press, p. 262.

11 Joan Mitchell, correspondence with the author, undated.

12 Mary Ann Caws (1993), "Rage Begins at Home," *Massachusetts Review*, 34, Spring, pp. 65–66.

13 Andrea Juno, interview with Avital Ronell, "Angry Women," *RESearch*, 1992, p. 151.

14 It is hard to think of any sort of utopian community built solely on the power of rage!

15 These works are reproduced with an essay by Barbara Rose (1981), in *Joan Mitchell: Bedford Series. A group of ten color lithographs*, Bedford, NY: Tyler Graphics.

16 See ibid., p. 15, for illustration.

17 See *Joan Mitchell: Paintings 1956 to 1958* (1996), New York: Robert Miller Gallery, unpaginated (the painting is the third one illustrated). De Kooning's painting is located at the Weatherspoon Art Gallery, University of North Carolina, Greensboro.

18 Mitchell's *Field for Two* is in the collection of Joanne and Philip Von Blon.

19 See, for example, Pollock's *Silver and Black Diptych* of *c.* 1950, or his *Black and White Polyptych*, a five-panel piece of 1950.

20 It is interesting to note, in relation to the concept of spatial expansion, that Mitchell never, to my knowledge, worked on the floor, like Pollock. She and her canvases had a vertical, one-to-one relationship. Although the paint might be freely and broadly manipulated, and it certainly dripped to good effect, this was not a result of the artist standing over the support and "dominating" it, so to speak.

21 Barbara Rose, in *Joan Mitchell: Bedford Series*, p. 6.

22 Margo Jefferson (1999), "Revisions: Fearlessly Taking a Fresh Look at Revered Artists," *New York Times*, November 1, sec. E.

18

Sam Taylor-Wood:[1]
When the Stars Weep

Sam Taylor-Wood: Crying Men, Matthew Marks Gallery, New York, 2004

Sam Taylor-Wood's *Crying Men* is exactly that: a series of large-scale photographs, in color and black and white, of moist-eyed men facing the camera. Just men—except they all happen to be movie stars.

Paul Newman looks at us directly but veils most of the right side of his face with three outstretched fingers. His left eye, though revealed, has to work through a barrier of shadow to reach us. We are aware of the heavy ring, like the lock on a protective gate, circling his third finger, bearing the number 1, and of the network of wrinkles—no actress would ever allow them—that score his beauty with pathos. Willem Dafoe, red shirt blazing, hair tousled, covers his emotion with a diagonal sweep of his arm. Jude

Sam Taylor-Wood,
Paul Newman, 2002.
C-print, 33⅞ × 33⅞ in.
(86.4 × 86.4 cm)

Sam Taylor-Wood, *Jude Law*, 2003.
C-print, 33¹³⁄₁₆ × 43¹³⁄₁₆ in. (86.2 × 111.7 cm)

Law takes to grief passively but tellingly, huddled in a corner, legs drawn up, arms akimbo, a deep crease down his forehead, in a shot that is mostly moodily shaded blank wall. Kris Kristofferson, like Newman, confronts us directly, his wrinkles compressed. His expression is ambiguous, hovering between the serious and the heartbroken; we hardly know he is crying until we glimpse the drops of moisture beading his eyelids.

Benicio Del Toro stands to one side of a curtained window, dark against light, head lowered, hair tumbled, shirt open, eyes lowered, brow furrowed, lips parted, as though experiencing an emotion beyond utterance. Dustin Hoffman's sorrow is stoically withheld. His grief is diffidently contained within the dark silhouette of his naked arms and torso. Hunched over a white table, vulnerable and desolate, he lowers his eyes, as though refusing, or unable, to engage with the spectator. Laurence Fishburne gets into the crying game wholeheartedly: he is centrally and symmetrically planted in his bathroom, clutching the reverse of a brown bathrobe, his head set off by a circular window, like a dark Buddha or a saint with a halo, perceptibly weeping. Robin Williams, scarcely recognizable, his clasped hands masking his mouth, sits facing us, the elbows of his shapely

Sam Taylor-Wood, *Robert Downey Jr.*, 2002.
C-print, 51¾ × 67¹⁵⁄₁₆ in. (131.5 × 172.5 cm)

arms covered with a disconcerting mane of black hair, resting on his knees, the funny man ironically playing the man of sorrows. Robert Downey Jr. doesn't let grief interfere with sensual self-display: he mourns lying down and lightly draped, smooth-skinned and hairless, like a male odalisque or an epicene martyr, his arm raised provocatively over his head, his torso saucily twisted. Two older actors, on the other hand, Ed Harris and Michael Gambon, give their all to the task of sorrow. Their timeworn faces become maps of remembered feeling, sorrow-in-itself, as it were, a self-confrontation rather than a mere posing for an assignment.

As a series, *Crying Men* is brilliant, multilayered, and provocative. Consisting of twenty-eight large-scale photographs, twenty-two in color, six in black and white, it arouses potent desires, both esthetic and personal, in the viewer. At the same time that these images arouse desire, however, they leave it unsatisfied. Or to put it another way: you begin by feeling you can get close to these captivating male stars, but it turns out that you can't. You are always kept at a distance, frustrated in your need for intimacy.

As a series, these photographs raise questions perhaps ultimately unanswerable. Why, for instance, is it "crying men," not "crying women," or "crying men and women"? The gender of the portraits is central to their impact, as is the fact that they

Sam Taylor-Wood, *Michael Gambon*, 2003.
C-print, 36¾ × 43¹³⁄₁₆ in. (93.7 × 111.7 cm) (framed)

are documents of portraiture, not journalism. What does it mean that famous men are doing the crying, not just the man on the street—the man on the street in Baghdad or Sarajevo, for instance, who may have just lost his wife and children, or the soldier who has lost his best buddy? We have seen plenty of those pictures recently. And it certainly must matter that these are famous actors, men whose profession it is to perform a role, to express feelings on command. The mark of a good actor or actress is indeed the ability to cry on command, I am told. These are portraits of men who were told they had to cry in order to have their portraits taken by a famous artist—and all of them rose to the occasion.

For the most part, though, crying never distorts these handsome faces; the sitters may protect the glamor of their famous looks with hands or shadows, but they are always recognizable, and they don't grimace with emotional pain, as people caught by news photographers may do. Deliberately and from the start, Taylor-Wood lets us know that this is not heartrending documentary; these are not men crying over real tragedies, personal losses; these are just good actors obeying the director's orders and performing. The woman artist has control over these powerful males; they weep at her bidding.

Yet the grief portrayed is real, in a way—convincing the way a good film is convincing. Does it matter that the onscreen stuff that makes us blub—Bogart saying goodbye to Bergman at the plane, juicy death scenes—is "only" acting? Aren't these images in many ways more moving, more tear-jerking, than most things we experience in life? That's not because the scenes are real, any more than Paul Newman's sorrow in Taylor-Wood's photograph is real; it's because of the acting. It's acting that makes me share Gambon's assumed pain, that makes me wonder what is touching Newman's heart—that makes me want to give Law a good hug, cheer him up a bit.

Maybe something more than mere sympathy is at stake here? But that's the point with movie actors crying, at any rate for a woman viewer, isn't it? They're so sexy when they're sad, these beautiful men. Their tears make them still more alluring. Their laughter wouldn't be half as seductive. Men crying: that's what's really interesting about this series, what draws us back to the images again and again.

The theme of men crying has resonances in social history, in ideas about gender difference, and most specifically in the context of Taylor-Wood's work in general, an oeuvre in which male vulnerability has played an important role from the start. Men aren't supposed to cry in public, nor too much in private, either. This regulation has eased up a little in recent years, but male weeping is generally viewed with disfavor—it is seen as a sign of moral and psychological weakness, of "effeminacy." The stiff upper lip, the lowered head, the furtive tear, the consolatory handclasp: in the male of the species, these are the substitutes for the outright expression of painful emotion. The past of Hollywood is marked by the ascendancy of the strong silent type: Gary Cooper didn't cry, and a tear-streaked John Wayne is almost unthinkable. Although crying is more permissible in our day than it was in theirs, it is still unusual to see men crying in public, despite the cult of male sensitivity. Men weeping in public are somehow an embarrassment.

Of course it hasn't always been this way. The heroes of the Old Testament and of classical antiquity poured forth buckets of tears on the slightest provocation. Tom Lutz, author of *Crying: The Natural and Cultural History of Tears*, notes that "Odysseus is hailed as a great warrior when he cries in almost every chapter of Homer's *Iliad*. And in the sixteenth century, sobbing openly at a play, opera or symphony was considered appropriately sensitive for men and women alike."[2] Johan Huizinga, the great historian of the late medieval period, points out that in the 15th century

a surplus of tears came not only from great mourning, a vigorous sermon, or the mysteries of the faith. Each secular festival also unleashed a flood of tears. An envoy from the King of France to Philip the Good repeatedly breaks into tears during his address. When young John of Coimbra is given his farewell at the Burgundian Court, everyone weeps loudly, just as happened on the occasion when the Dauphin was welcomed or during the meeting of the Kings of England

and France at Ardres. King Louis XI was observed to shed tears while making his entry into Arras; during his time as Crown Prince at the court of Burgundy, he is described by Chastellain as sobbing or crying on several occasions.[3]

For Lutz, the clandestine nature of manly sobbing is a modern phenomenon. It was the Industrial Revolution, he believes, that dried up the well of masculine tears, making a controlled, efficient, nonexpressive demeanor a necessity for membership in bourgeois society: "Weeping itself became the problem rather than a reaction to a problem. Anger and stress became the substitute for tears—an attitude that persists to this day. Hardheadedness, what psychologists call 'restricted emotionality,' is still the paradigm for businessmen. If you cry you're weak, a bit of a Jessie."[4]

Apparently the same industrial revolution that took away men's permission to wear gorgeous, gaudy, sensuous silks, brocades, and lace, and to show off their well-turned calves in satin breeches, deprived them of the privilege of crying as well.

Taylor-Wood, then, is confronting a subject that has been underground, aberrant, until very recently. Yet *Crying Men* is far from her first engagement with the subject of vulnerable, seductive men—nor will it be her last. The figure of the vulnerable, even abject male is a constant theme in her work, although it takes different forms at different times. Earlier in Taylor-Wood's career, in the perverse and highly original updating of historical prototypes that constituted much of the *Soliloquy* series, dead men played an essential role. *Soliloquy I* (1998) shows its handsome young protagonist dead on a rumpled studio couch, his hair cascading down his forehead, his right arm limply dropping to the floor. The image is of course an updated takeoff on the British Pre-Raphaelite painter Henry Wallis' famous *Death of Chatterton* of 1854 (itself a British genre version of David's neoclassical *Death of Marat* of 1793), representing the young poet's suicide in a miserable attic, a death brought about by artistic failure and a self-administered dose of arsenic. Taylor-Wood's large photograph is far more ambiguous in its implications, an ambiguity reinforced by its accompanying predella, a panoramic 360-degree representation of contemporary men and women in a fantastically baroque interior. (The same "Chatterton" figure, incidentally, appears in a much livelier, multifigured context in Taylor-Wood's *Five Revolutionary Seconds XIII* of 1998.) Another work in the series, *Soliloquy VII* of 1998, is a startlingly foreshortened modern version of Mantegna's late-15th-century *Dead Christ*, using the technology of the modern C-type color print to increase its dramatic rush of linear perspective, and making the image even stranger— and deader—by coupling it with a peaceful landscape predella, so that the corpse's feet, enlarged and creased, seem to hang over the sunny bucolic panorama below.

The dead Christ, universal paradigm of male vulnerability, makes his appearance again in Taylor-Wood's *Pietà* of 2001, a slow-motion film, about two minutes long, in which the artist herself plays the role of the Virgin Mary, lifting and lowering, with some difficulty, the inert body of the actor Robert Downey Jr., partially and inappropriately

clad in un-Christlike trousers but in a pose that might have served as a prototype for his not dissimilar role in *Crying Men*. A more ambiguous work from the same period is a small photograph of a beautiful strawberry-blonde nude in profile, and in a pose descended from Holbein's *Dead Christ* (1521). Teasingly, Taylor-Wood's figure could be either male or female, but in the context of her *Passion Cycle* of 2002 (passion in both the sexual and liturgical sense), in which it was shown, it functioned at least in my eyes as a vulnerable and seductive young male.

Taylor-Wood has captured still another type of vulnerable man with her camera recently, and he is neither crying nor dead, but sleeping. And it is not a still camera that records his slumber, but video. A 1-hour and 7-minute-long moving picture of a man whose only movement is the twitch of an eyelid, or the languorous drift of an arm to shadowy, unseen nether regions, may seem a redundant reversion to outmoded Warholian tactics of overwhelming boredom, but this motionless man is well worth watching asleep over the course of an hour, for he is literally a sleeping beauty. I am referring, of course, to Taylor-Wood's notorious video portrait of the world-famous soccer star and sports idol David Beckham, filmed in one continuous shot, and recently installed in a darkened alcove of London's National Portrait Gallery. Not much happens in this filmic portrait, titled simply *David* (2004), before which I planted myself, seated on the floor, for half-hour segments. But when, for example, the unconscious Beckham moves his right arm to reveal one his most recent tattoos, "Angel II," on his right shoulder and bicep, it is momentous. And of course one constantly wonders what is going on in our hero's unseen nether regions.

Reviewers have criticized *David* for failing to live up to Michelangelo's statue of the same name, or to the video's purported prototype, the same artist's *Night on the Medici Tomb* (1526–33). Taylor-Wood herself opts for realism: "I wanted to create a direct, closely observed study. Filming while he was asleep produces a different view from the many familiar public images."[5] Yet at least two images from the high art of the past are imbricated in Taylor-Wood's image of the sleeping Beckham and his godlike beauty. One is Girodet's *Endymion* (1791) in the Louvre, which plays light and shadow over the ravishing form of the sleeping nude youth with similar effectiveness, and the other is Poussin's painting of Narcissus—dead rather than sleeping—watched over by the adoring nymph Echo (1628–30). According to Ovid, Narcissus was punished for admiring his own reflection too much, but who could blame him? Lying in a position not unlike that of Beckham in Taylor-Wood's video, Narcissus reveals the beauty of his lifeless form to the spectator, as the contemporary artist reveals that of her modern idol. One could even say that the spectator—in this case myself on the floor of the National Portrait Gallery—is given the place of the admiring nymph in Poussin's painting. Is Beckham really sleeping? Does it matter, any more than the fact that the *Crying Men* are faking it? What matters is the work, in the end, and the potent emotional disturbance it gives rise to in those, like myself, who are seduced by the charms of the flesh presented

under optimum conditions. As in so many of Taylor-Wood's works, including the *Crying Men*, little touches of beauty's other—the ugly, animalistic side of the human male— enhance the visceral impact of the image, touches like the bristling black hair covering Beckham's shapely arms (see Robin Williams in the *Crying* series). Apollo and Dionysus are combined in a single mortal man, with shades of Nietzsche's theory of tragedy.

Crying Men is itself a part of a triad of works expressing, it would seem to me, different aspects of the human condition. The other two parts are *Self Portrait Suspended* (2004), showing Taylor-Wood mysteriously suspended above the ground in a series of gravity-defying poses; and a short video, *Ascension* (2003), in which one man lies flat on the ground while another, with Ray Bolger-esque flexibility, tap-dances directly above him, a white dove ludicrously perched on his head and finally taking off for the great beyond. The three pieces together are ripe for allegory, even allegory with spiritual implications.

Surely the crying men represent all that is dark and earthbound, the misery, real or imaginary, tying us to our terrestrial fate. The trio of prone male figure, dancing man, and white dove is a grotesque, Bakhtinian parody of the Holy Trinity, and of would-be creative freedom. Only the artist herself, precariously suspended somewhere between the floor of her studio and its ceiling, between heaven and earth, accepting this intermediary position and its difficulty, attains a kind of freedom, finding, in the words of my student Jovana Stocik, "an uninhabited and uninhibited place—her own studio, but above the ground." Hers is the difficult position of grace.

Notes

1 Sam Taylor-Wood changed her name to Sam Taylor-Johnson in 2012.

2 Tom Lutz (2001), *Crying: The Natural and Cultural History of Tears*, New York: WW Norton, quoted in Stuart Husband (2003), "Big Boys Do Cry," *The Observer*, April 20, online at http://observer.guardian.co.uk/review/story/0,6903,939758,00.htm

3 Johan Huizinga (1996), *The Autumn of the Middle Ages* (1919), J Payton and U Mammitzsch, trans., Chicago, IL: Chicago University Press, p. 8.

4 Lutz, *Crying*.

5 Sam Taylor-Wood, at http://www.paulsworld.co.uk/beckham/news/04042602.htm

19
Alice Neel

Lecture, Victoria Miro Gallery, London, May 2004

It is clear that from the very beginning of her career, Alice Neel was a socially engaged painter. Her early work, expressionist and social realist in style, treated with both sympathy and exacerbation the world around her in the slums of Spanish Harlem and downtown Manhattan. She was what was called a "premature anti-Nazi," that is to say, one of those radicals, including socialists and communists, who protested against Hitler's policies well before the outbreak of the Second World War. This same engagement with the fight for social justice animated much of her later work, although in a different way, in the many portraits she did of leading figures in the women's movement, official or unofficial—like the flamboyant feminist politician, Bella Abzug, or Kate Millet, whose cover portrait she did for *Time* magazine, or artworld feminists like Cindy Nemser, Irene Peslikis, Ann Sutherland Harris—or myself. And in her many

portraits, clothed and naked, of gay men, of which one might aptly say that the personal is political.

At the same time it is equally clear that Neel was always engaged with the contemporary body in all its idiosyncrasies: *Alice and John Rothschild in the Bathroom*, or *Alienation* (both 1935) are straightforward about the body and its basic needs, including the toilet. Indeed, one might say that throughout her career, she was a social critic with and of the body, as in the wrenching image, *T. B. Harlem* (1940), whether clothed or nude. Indeed, she is one of the rare painters of our time to paint nude portraits: more of that later.

In the field of portraiture, women have been particularly active, both in the past and today. This hardly seems accidental: women have, after all, been encouraged, if not coerced, into making responsiveness to the moods, attentiveness to the character traits (and not always the most attractive ones) of others into a lifetime's occupation. What would be more natural than that they should put their subtle talents as seismographic recorders of social position, as quivering reactors to the most minimal subsurface psychological tremors, to good use in their art? For the portrait is implicated, to some degree at least—whether artist, sitter or critic wishes to admit it or not—in "that terrible need for contact," to which Katherine Mansfield makes such poignant reference in the pages of her *Journal*. Unlike any other genre, the portrait demands the meeting of two subjectivities: if the artist watches, judges the sitter, the sitter is privileged, by the portrait relation, to watch and judge back. In no other case does *what* the artist is painting exist on the same plane of freedom and ontological equality as the artist her or himself, and in no other case is the role of the artist as *mediator* rather than dictator

or inventor so literally accentuated by the actual situation in which the artwork comes into being. This is particularly true of the representations of relatives, friends or kindred spirits—rather than commissions—and of course, of self-portrayal.

Alice Neel was one of the most prominent among the portraitists of our time, working in a vein of what one might call incisive or critical realism. Neel's portraits, far from being merely witty or clever—although to be so is itself no mean achievement— form a consistent, serious, and innovative body of work. Progressively, over the years, she invented an idiosyncratic structure of line, color and composition to body forth her vision of unmistakably contemporary character. Almost forty years later, looking back at the exposed thighs, the patent-leather polyphony of the shoes, the world-weary individualism of *The Gruen Family* (1970), or the casual yet somehow startling *rapprochement* of self-exposure and self-containment—of pose, color scheme and personality —achieved in *David Bourdon and Gregory Battcock* (1970), prominent gay critics and art-world figures, we are forced to admit, sighing, blushing or wincing as the case may be, "So that's the way we were!" This was the truth of the realist body, the characteristic posture of our times.

Facing the terrible portrait of *Andy Warhol*—livid, bandaged, trussed, sewn and scarred, visibly drooping yet willing himself to a ghastly modicum of decorum after his near assassination, by far-out feminist Valerie Solanis, one is reminded somehow of Van Gogh's intention, in painting the melancholy Dr. Gachet, to record "the heartbroken expression of our time." Yet it is not so much a question of derivativeness in any of her

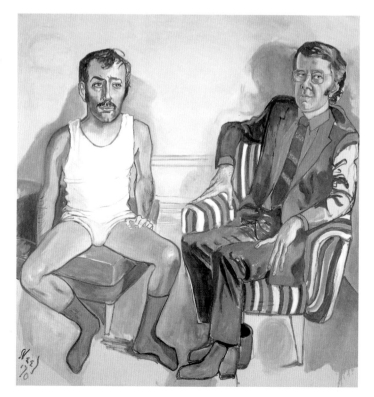

Alice Neel,
*David Bourdon and
Gregory Battcock*,
1970. Oil on canvas,
59¾ × 56 in.
(151.8 × 142.2 cm)

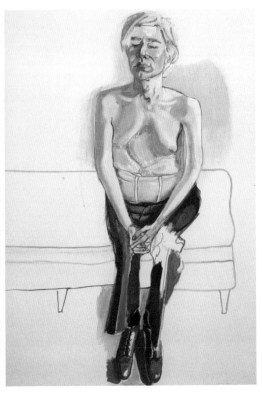
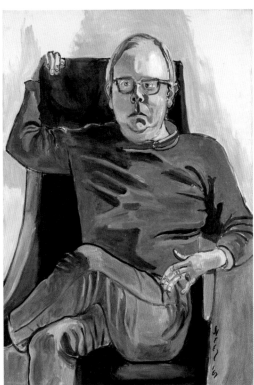

ABOVE LEFT Alice Neel, *Andy Warhol*, 1970.
Oil on canvas, 60 × 40 in. (152.4 × 101.6 cm)

ABOVE RIGHT Alice Neel, *Henry Geldzahler*, 1967.
Oil on canvas, 50 × 33⅛ in. (127 × 86 cm)

work as it is simply a fact that few of her subjects have escaped the inroads of contemporary anxiety—often a peculiarly New York brand of it—each, of course, in his or her own particular fashion.

Nobody is ever quite relaxed in a Neel portrait, no matter how suggestive of relaxation the pose: some quivering or crisping of the fingers, some devouring patch of shadow under the eyes or insidious wrinkle beneath the chin, a linear quirk, a strategic if unexpected foreshortening dooms each sitter-victim to premonitory alertness as though in the face of impending menace.

This lurking uneasiness, a strain of darkness, is not something Neel reads into her sitters, although she had her share of suffering: mental breakdown, rejection, a hard time in the misogynistic art world of her earlier career. Rather, it has to do with her peculiar phenomenology of the human situation. This is how Neel sees us, how we actually exist for her, and so it is there. Or rather, at times, she doesn't so much *see* it that way as record it, in the same way that Courbet once, without realizing what he was painting, is said to have recorded a distant heap of faggots, without knowing what they

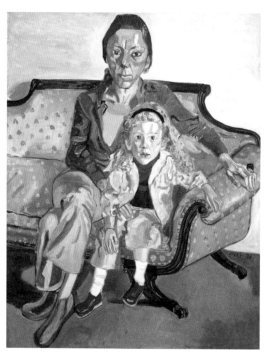

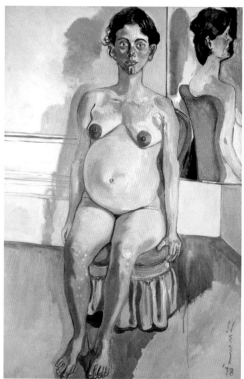

ABOVE LEFT Alice Neel, *Linda Nochlin and Daisy*, 1973.
Oil on canvas, 55⅞ × 44 in. (141.9 × 111.8 cm)

ABOVE RIGHT Alice Neel, *Margaret Evans Pregnant*, 1978.
Oil on canvas, 57¾ × 38 in. (146.7 × 96.5 cm)

were. In 1973, when I was sitting for *Linda Nochlin and Daisy*, Neel said to me, genuinely puzzled, "You know, you don't *seem* so anxious, but that's how you come out." Of course, one might say that a person's exterior, if it is explored and recorded with sufficient probity, will ultimately give up the protective strategies devised by the sitter for facing the world. Neel felt genuine regret, perhaps, that this was the case; nevertheless, since it was, to paint otherwise would have been merely flattering rather than truthful. One may well ask, are the reiterated hands in this picture, and Daisy's coiled-wire posture, merely observation—I was keeping a lively four-year-old in place—or a more general observation about the repressive relationship of mothers and children?

Alice Neel's nudes raise issues both of sexuality and of style. She is not kind to bodies, even the bodies of those she likes—a figure like that of *Annie Sprinkles* (1982) is definitely naked, not nude. Or, take the nude portrait of *Margaret Evans Pregnant* of 1978: the pose is unstable in its balance, the physical disequilibrium presaging that loss of agency and freedom for the woman on the brink of motherhood. This sense of anxiety about the future is veiled over by the sitter's staunch, rather blank expression.

The youthful delicacy of the head and limbs are played against the grotesque if natural bulge of the belly. In fact, Neel really started the portrait with the stomach, according to eyewitness accounts. Even the baby, her grandson Andrew, is violently sexualized—and realistic—in her portrait, *Andrew* (1978).

In Neel's unforgettable nude portrait of the Greenwich Village character, Joe Gould, the eccentric subject is rendered super endowed, sitting upright and glaring at the viewer. This pose may profitably be compared with the more relaxed, indeed classically female recumbent pose of critic and curator, John Perreault, in a portrait of 1972. Both were shown in the pioneering show Perreault curated in 1972, *The Male Nude*. Neel does not flatter her nude subject. John Perreault is no Adonis—just an average man, not terribly muscular. Neel plays up portrait idiosyncrasies of hair and beard, the way

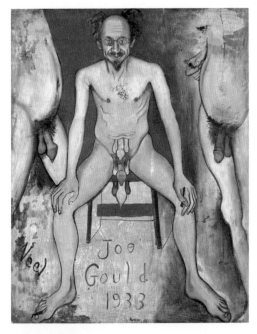

LEFT Alice Neel, *Joe Gould*, 1933. Oil on canvas, 39 × 31 in. (99.1 × 78.7 cm)

BELOW Alice Neel, *John Perreault*, 1972. Oil on canvas, 38 × 63½ in. (96.5 × 161.3 cm)

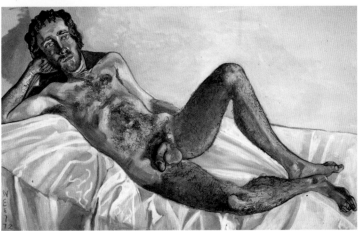

the body hair grows on torso and limbs, the fall of balls and penis, the steady gaze. Just a nice man with no clothes but rather a stunning picture.

The male nude portrait was the innovative genre favored not only by Neel, but by another woman realist of our time, Sylvia Sleigh (chapter 12). Her work also raises the issues involved in a woman artist's representation of the naked male, until recently a rare situation except within the confines of the life class. Sleigh's male nudes, like *Imperial Nude* or *Paul Rosano* (1974), are all portraits, and, so to speak, portraits all the way, down to the most idiosyncratic details of skin tone, configuration of genitalia or body-hair pattern. Sleigh has stated that her interest in male fur and its infinite variety, while partly due to delight in its sheer decorative possibilities, was also determined by a reaction against the idealizing depilation of the nude body decreed by the academic training of her youth.

Finally, I would like to end with a few thoughts about realism and old age, as it is depicted in two nude self-portraits, Neel's *Self Portrait* (1980) and Lucian Freud's *Painter Working, Reflection* (1993). One might almost say that realism and old age were made for each other. The trope of the wrinkle—along with the sag, a token of the ever-increasing pull of gravity on the human frame and flesh—seems admirably suited to the realist eye for detail, realist rejection of generalized beauty, realist attraction to ugliness and the woes the flesh is heir to. Realism is made to trace our mortality, and does so with considerable authority and relish in these two nude self-portraits. But with a difference of course. Despite his token obeisance to the humility of Van Gogh's boots, Lucian Freud seems in this self-portrait literally to "reflect" the mythology constructed about him: heavy with Rembrandtian overtones, this is a portrait of the aging artist as the traditional old master. The imperious claims of the artistic ego have triumphed over the demands of the challenge faced by the realist painter—to transform the visible world into image on surface in an interesting and novel way. In his nude—no, naked—self-portrait, the aging painter reveals "himself" to his audience. His body is presented as softening, even decaying, but still powerful. Armed as he is with palette knife and penis, the pathos of his fading physical strength is allegorically deployed to contrast with his undiminished creative powers.

Alice Neel's portrait is far less confrontational, though it is startling. She sits, looking over her shoulder at what we presume is her reflection in a mirror. She, too, holds the tools of her trade. The brush she holds tells us she is an artist, as does the rag and the resolutely de-glamorizing eye-glasses. Old people need them to see, old artists especially, although they are hardly part of the traditional apparatus of the nude.

"More beautiful than a beautiful thing is the ruin of a beautiful thing," Rodin is said to have proclaimed apropos of *Celle qui fut la belle haulmière* (1885–87). Rubbish! where the human form is concerned, at least. Alice's aging body droops, sags and bulges, it is far from ideal, certainly not beautiful in the pathos-full way that Rembrandt's old

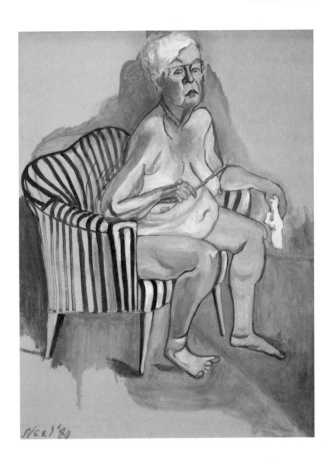

Alice Neel,
Self Portrait, 1980.
Oil on canvas,
53¼ × 39¾ in.
(135.3 × 101 cm)

women are said to be beautiful. But there is nothing tragic about it, it is not meant to represent the ruin of a beautiful thing. What Neel is after in this portrait is what realists have always in their varying ways been after, and that is a certain notion of truth: unflinching, matter of fact, provocative. In a way, one might consider this nude self-portrait as a realist testament, a literal tribute to that naked truth, magic or critical or both, which has always been at the heart of the realist project.

20

Unholy Postures: Kiki Smith and the Body

Kiki Smith: A Gathering, Walker Art Center, Minneapolis, MN, 2005

Standing in front of Stefan Lochner's 15th-century altarpiece of *The Martyrdom of the Twelve Apostles* when I was in Frankfurt recently, I thought of Kiki Smith. I thought of her because Lochner's astonishing panel paintings, although some 600 years older, raise in exacerbated form some of the same basic issues about the body and its representation that Smith's work does with such startling originality today: issues involving art and beauty, art and pain, and above all, the pose of the body and its implications for meaning and feeling. It is to these issues that I will address myself in this essay. I believe that only by locating her work within the context of history—the history of art as well as the history of violence and its representation—can its full meaning, its singular assault upon the eyes and the spirit emerge.

Lochner's panels deal, in excruciating and exquisitely detailed realism, with the body in pain. Each individual torture is laid out for the observer in its crystalline uniqueness and individuality: of means, of victim, of character, of costume. Some of the apostles were executed, some beaten to death, a few crucified in a variety of imaginative ways. Saint John—youthful, nude, and frontal—is being boiled alive in an ingeniously heated bathtub, neatly stoked by a fantastically dressed servant, while another helper pours a ladle of boiling liquid over his head. Most graphic of all is the panel of the flaying of Saint Bartholomew, which is rendered with a kind of medically accurate detachment. The saint lies on a wooden platform, the whetstones for sharpening the tools of his destruction in a bowl at the bottom of the image. In the foreground, an assistant sharpens one of the surgical knives, while the prime torturer holds a knife in his mouth as he vigorously peels back the skin from the saint's shoulder and upper arm. Bartholomew, like an interested medical student, turns his head impassively to watch this operation, his halo partially obliterating the body of an equally impassive assistant holding a flask. Another torturer slices into the victim's thigh with surgical precision. It is almost too horrible to watch, but watch one does, of course.

The first Kiki Smith piece that I remember seeing created a visceral shock—like that produced by Lochner's apostle panels. I still remember the intensity of the feeling, as though the bottom had suddenly dropped out of the sedate world of the gallery and my own place within it; to put it more physically, I felt it in my guts. This work was *Tale*

of 1992, a sculpture in wax, pigment, and papier-mâché. It represents a naked woman, roughly modeled, down on all fours, crawling painfully across the floor, which expands into a desert of difficult-to-navigate space. I don't remember the head or the details of the front of the figure at all, apart from a drooping breast—for good reason. All attention is focused on the looming rear end, the filthy buttocks and the rectum from which emerges a literal "tail" of shit—or perhaps a long, long intestine, or both. The play on words of the title is meaningful: tale or story, and tail or rear appendage. For both are at play in the horrifying power of the image. The *excretory tail* generates, or has been generated by, a *tale*, a story stemming less from the Legends of the Saints or Lives of the Christian Martyrs than from more up-to-date sources such as the accounts of modern torture in Elaine Scarry's *The Body in Pain* or the annals of Amnesty International.

Like the female figure in Smith's *Tale*, Lochner's Saint Matthias is crawling on the ground as the axman's weapon strikes his head; Paul crouches on the bloody turf, headless, after his execution, his hands tied together in front of his decapitated trunk. It is the function of such grounded poses to deny the dignity and the agency of the body. They are the postures of abjection and degradation, what happens, structurally, when the body succumbs to pain or torture and becomes merely the victim of an external force. There are, however, significant differences between Lochner's crawling martyrs and Smith's naked woman. Gender is one difference; nudity is another. Posture, pose, position may mean a lot in the construction of the figure, but it is not everything. Pain, which is inscribed on the flesh of Smith's martyred nude, is not significantly rendered

Kiki Smith, *Tale*, 1992.
Wax, pigment and papier-mâché, 160 × 23 × 23 in. (406.4 × 58.4 × 58.4 cm)

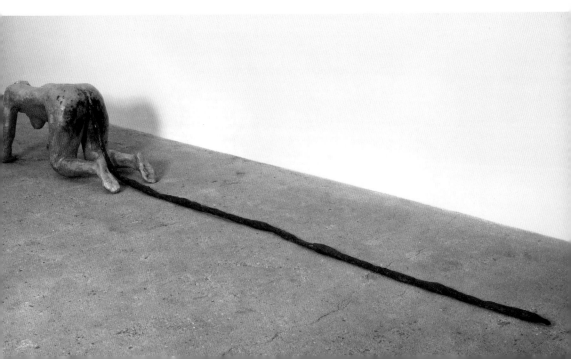

in Lochner's representation of the apostles' tortured bodies, despite the fetishistically realistic representation of these tortures by the artist. Lochner's saints neither wince nor flinch nor grimace. Rather, crouch or crawl though they may, they maintain a steady calm. Instead it is their torturers—in their vile snarls, low jeers, and effortful stabs—who express emotion, who are abject.

What I am trying to say is that it is Smith's isolated, secular body that bears witness to degradation. The saintly flesh, on the contrary, is impermeable to suffering, no matter how abject the pose: for the Catholic believer in the 15th century, it seems that Grace abolishes sentience. Whereas in Smith's crawling woman with her tail of shit the pose—crawling—seems naturally to signify the abject, there is little that is abject about Lochner's martyred apostles no matter how suggestive of humiliation their postures. Of course, they are male figures and dressed in timeless dignified robes rather than shown naked. Yet in 15th-century religious iconography, even a naked female figure crawling on her hands and knees may hover on the border between moral abjectness and pure beauty, as in Rogier van der Weyden's eloquent depiction of a female nude being dragged to hell by her hair in the Beaune *Last Judgment*, one of the loveliest back views in the history of art.

Yet the pose, the posture of the human figure certainly counts, and is in fact of major importance. Posture is of the essence both in the religious tension of Lochner's panels and in the expressive power of Smith's sculptured bodies, and in Western art more generally since classical times. Postures are a necessary if not sufficient condition for the generation of meaning and feeling. And most of the variations on pose and posture we are familiar with are played, consciously or unconsciously, against the precedent of classical art. No matter the strategies developed to mitigate its debasement—stoicism or seductiveness—the crawling body is in the final analysis an abject body. And this abjection is invariably heightened by the residue of ancient precedent lingering on in the modern visual unconscious: Aby Warburg's famous *Nachleben*, or afterlife, of antiquity. It is the memory of those proud marble gods and goddesses, upright and self-sustaining on their pedestals, that still provides the alternative *imaginaire* for the abject body of Smith and many of her contemporaries.

The classical contrapposto stance creates the great precedent for both imitation and rejection. It is contrapposto—the shifting of weight from one foot to the other on a solid base, as in, say, the *Doryphoros* and all its neoclassical descendants down through the nineteenth and early twentieth centuries—that instates agency, the power of the body to move through its internal structure at the bidding of the will. The body, controlled by the mind, may decide to shift its weight from one leg to the other, to raise or lower an arm, to turn the head left or right, up or down. Such a pose, or its variations, is generally accompanied by an idealization of the body in terms of proportions and features: a surface smoothed out, elegant and self-contained. At the opposite end of the positional spectrum are the poses usually selected by Smith for her sculptured bodies, positions

that call to mind the indignities suffered by the Catholic martyrs of Lochner's altarpiece: crawling, kneeling, creeping, hanging. Looking at such poses, one is reminded of the Christian adage: "The flesh must wither that the spirit may flourish."

Hanging is a position favored by Smith for the deployment of the body disempowered, most spectacularly in her untitled installation of 1990 at Temple University in Philadelphia. Here, the ephemerality of the material, ink on paper, and the roughness of the body surfaces increase the uncanny sense of horror created by the weightless dangling figures, as do the blood-red, heavily saturated paper sheets on the walls surrounding them, as though the apparitional quality of the hanging corpses had been attained in part by leeching the blood from their veins.

Yet strangely enough, when you look at these figures for a while, you realize that these are not quite corpses, but rather standing figures suspended, erect male bodies, their necks unbroken, treading on air. Although they may at first call to mind lynch victims or memories of what the Nazis did in Russia to those, male and female, thought to be "spies" or partisans, there are other quite different references involved for the art historian. I am referring to the *boti*, hanging commemorative donor figures, life-size wax effigies "dressed in their own clothes and offered in propitious anxiety or relieved gratitude." According to Aby Warburg, the great historian of 15th-century Florentine art and thought, the churches of Florence were literally clogged with these quite realistic hanging votive effigies, and "their manufacture sustained a thriving industry...The Church of the Annunciation in particular contained a veritable forest of these macabre effigies suspended from its ceiling such that space ran out and parishioners were endangered by their accidental falling to the floor."[1] Like Smith's hanging figures, the *boti*, too, were made of ephemeral material, although unlike Smith's, they were treated realistically.

According to art historian Helaine Posner, "Smith originally conceived these ghostly white apparitions as a tribute to the many lives taken by AIDS."[2] Surely on some level we can read these dangling bodies, positioned between earth and heaven, as it were, as an updated votive offering commemorating AIDS victims. I am not proposing any sort of influence here, but rather a kind of *Nachleben*, to borrow Warburg's term, an afterlife of certain motifs and poses created by similar motivations.

This is hardly Smith's only venture into depriving the figure of firm footing, hence agency, by suspending it off the ground. Striking in this respect is the pair of life-size untitled wax figures, male and female, of 1990, heads bent, eyes closed, feet dangling, lifted off the floor awkwardly on metal stands more appropriate for inanimate objects than for human bodies. And yet these hanging figures are "alive" and human, all too human. With their abraded skin and leaky orifices—her breasts ooze milk, his penis drips semen—they convey an overwhelming sense of visceral shame: that fundamental shame about sex and the sex organs brought about by the Fall of Adam and Eve, a shame that is to be shared by everyman and everywoman, henceforth, as a bodily self-loathing that is quite ordinary but transcendent. According to some versions of the story of

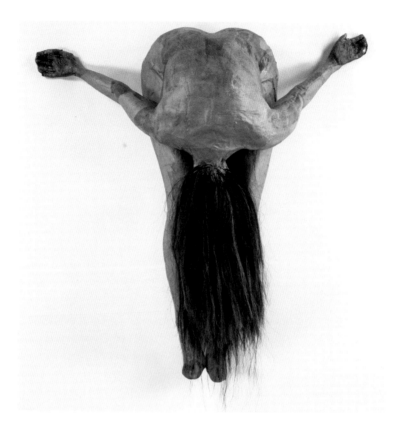

Kiki Smith,
Untitled, 1995.
Brown paper,
methyl cellulose
and horse hair,
53 × 18 × 50 in.
(134.6 × 45.7 ×
127 cm)

the Fall, our bodies were perfect before we had knowledge of good and evil: physical imperfections, leaks, bumps, abrasions, bruises, and the like appeared only after that momentous instant of bad judgment, as sin inscribed itself in the very flesh of human beings. Yet Smith's suspended pair is far from despicable. They are victims, yes, but more than that: they are victims with an inner sense of responsibility for their own victimhood. John Milton felt that this was precisely what differentiated human beings from the rest of the sentient world: we were "sufficient to stand but free to fall." Smith almost literally captures this paradoxical position in these figures and in their pose.

Hanging by the arms of course inevitably brings to mind that ultimate image of bodily torment, the Crucifixion, and its many variations and repetitions in the deaths of martyrs, like those depicted in the Lochner altarpiece. When, however, it is a *female* figure that is suspended by her arms, the meaning of the pose changes considerably. This is certainly true in Smith's version of the crucifixion motif, *Untitled* of 1995, where the head is bowed deeply over the body so that the double arch of the buttocks is on top and a rich mane of dark hair cascades down over the legs, hanging hair falling over hanging body. The pain of the crucified position, arms out, hands apparently nailed to the wall, is either heightened or contravened by the sensual appeal of the female hair

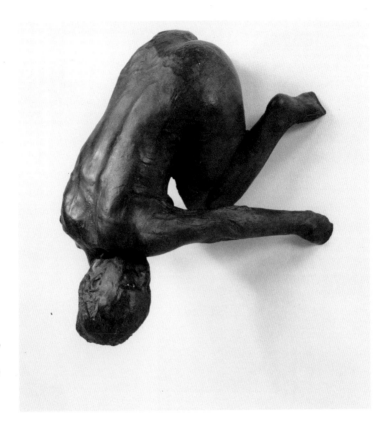

Kiki Smith, *Lilith*, 1994. Silicon bronze and glass, 33 × 27½ × 19 in. (83.8 × 69.6 × 48.3 cm)

and buttocks so vividly conjoined in this hanging body constructed of brown paper, methyl cellulose, and horse hair.[3] The obtrusive hair somehow complicates the simple reading of the piece as woman-as-victim and implies a sort of displaced feminine power. Women's hair is, after all, considered an unholy and powerful weapon of seduction by both Muslims and orthodox Jews: the former demand that women veil the offending locks, the latter that married women shave it off and wear a wig so as not to attract extra-marital attention. At the *fin-de-siècle*, Edvard Munch, among other misogynistic artists, more than once deployed the motif of enveloping female hair to signify a woman's sexual ensnaring of her hapless male victims, as in the painting *Vampire* (1893–94) and, quite explicitly, in the woodcut *Man's Head in Woman's Hair: The Mirror* (1896–97).

Even less equivocal, though unexpected, is the impact of the hanging, upside-down bronze *Lilith* of 1994. In *Lilith*, which was cast from life and has fiercely glaring "real" eyes, obtained from a German doll-maker, the ratio of power to victimization implied by the hanging female figure is raised considerably and explicitly. First of all, there is the story that goes with the name. Lilith, according to Talmudic legend, was the first Eve, a depraved creature who rejoiced in her sexuality and demanded equality from her husband. She has been recast by recent women militants as a feminist heroine—which

295

indeed she was. Lilith was not a vampire-like seducer and murderess of newborn babies, as she had been designated in Talmudic lore, but rather a full human being created by God, like Adam, from dust (not a secondary creature made from male prime rib!). Lilith, according to this new interpretation, insisted on sexual equality, refusing to lie beneath her spouse. Ultimately, she spurned sex "on the bottom" and flew out of Eden into outer space. If, as Nan Rosenthal has brilliantly speculated, the position of the hanging *Lilith*, suspended from the wall by three hooks, ultimately derives from a pose akin to the crouching female in Rodin's sensual *Je Suis Belle* (1882), then Smith has triumphantly reversed not only the conventional implications of the Lilith folklore, but also the implications of the hanging and crawling postures themselves. Her Lilith, upside-down and hanging though she may be, far from being abject, is an ornery feminist heroine, subverting patriarchal hierarchies and the conventions of sculptural decorum at once.[4]

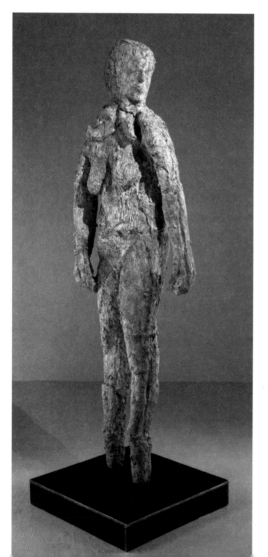

On the rare occasions when Smith represents the Biblical female upright and solidly rooted to the ground, as she does in *Lot's Wife* of 1996, *Virgin Mary* of 1992, or *Mary Magdalene* of 1994, she undercuts their traditional dignity in other ways, by means of weird and startling surface treatments. *Lot's Wife*, caught at the moment she turns to look back at the city of Sodom and is turned into a pillar of salt, has already lost her feet in anticipation of pillarhood and is covered with a scabby rough hide—something between flesh and salt—rather than smooth skin. The Virgin Mary, despite her welcoming gesture, rather like that of the traditional Virgin of Mercy, is bald, nude, and flayed like an anatomical *écorché*; it would be hard to derive comfort from the contemplation of a creature so visibly uncomfortable in her own skin, so close to the condition of meat and tendon, a torture victim rather than a succorer. Mary Magdalene, on the other hand, is too well covered: her skin has grown the legendary hair that marks her saintliness,

OPPOSITE LEFT
Kiki Smith, *Lot's Wife*, 1996. Silicon bronze with steel stand, 81 × 27 × 26 in. (205.7 × 68.6 × 66 cm), edition of 3

OPPOSITE RIGHT
Kiki Smith, *Virgin Mary*, 1992. Wax, cheesecloth and wood with steel base, 67½ × 26 × 14½ in. (171.5 × 66 × 36.8 cm)

RIGHT Kiki Smith, *Mary Magdalene*, 1994. Cast silicon bronze and forged steel, 60 × 20½ × 21½ in. (152.4 × 52.1 × 54.6 cm), edition of 3 + 1 AP

except for on her smooth, protruding breasts, face, and belly—reminders of her once-sinful loveliness. She recalls a mythic animal—perhaps a werewolf—and her head is pulled back in a grimace of animal misery.

One can hardly expect an artist as deeply devoted to investigating the body in all its vicissitudes as Kiki Smith to confine her interest to the exterior of the human figure. Rather, she digs deeper, goes further. Whereas the great male masters of sculpture in the past considered that only the outside of the body was worthy of attention, for Smith, what is inside the body—what is exuded from it, leaks out of it, drips from uterus or bladder—is equally important. In *Pee Body* of 1992, the crouching female figure with head lowered, her femininity and her contemporaneity emphasized by her painted toe- and fingernails, lets loose a bright gush of yellow glass beads from her body onto the floor. The stocky standing female figure in *Untitled (Train)* of 1993 turns back to look at a cascade of blood-red beads streaming from her vagina behind her. For some outraged conservative male critics, this is simply going too far: the artist has degraded art itself by

Kiki Smith, *Pee Body*, 1992.
Wax and glass beads, 27 × 28 × 28 in. (68.5 × 71.1 × 71.1 cm), installation dimensions variable

calling attention to such low bodily functions as peeing or menstruation.[5] Critic Roger Kimball referred to a show of such works as "The Body Repellent" in his review of 1995.[6]

And, of course, he is right to be shocked: no one else has admitted the bodily processes into the confines of art on such a large scale or so overtly before. And yet, after the shock, one begins to think further: not to lessen the transgressive impact of pee, shit, or blood on the gallery floor, which remains considerable, but of the role of transformed substances in Catholicism, Smith's natal religion, itself. The metamorphosis of liquids—inchoate, yucky substances—into shapely jewel-like hardness is, after all, not unrelated to the Catholic doctrine of transubstantiation, in which humble bread and wine are transformed at the altar into the body and blood of Christ. If wine and bread can be changed into flesh and blood, why can't piss and menstrual blood be transformed into jewels by the artistic imagination? Perhaps the miraculous transformation in Smith's case is more akin to the secular practice of alchemy—the magical transmutation of base metals into gold—than it is to Catholic doctrine. At any rate, Smith's conception of the body in this case, too, is profoundly inimical to the classical ideal of sculpture. The classical body keeps the inside hidden. No organs, no liquids appear externally. Tears, pee, shit, menstrual blood, vomit have no part in the ideology of the classical nude, nor does the stomach, the liver, or the heart, all subjects of Smith's sculptural invention. In traditional sculpture, even at its most adventurous, only the outside of the self-supported body is admitted to exist as sculpture, only the integral surface can be represented. There is something scary and taboo about incorporating the bodily functions that Smith engages with so boldly into the work of art, as though revealing them suggests that the body itself *is* only a work in process, as it were: ephemeral, debased, and mortal.

This is not to say that Smith does not, on occasion, engage with the ideal of female loveliness. She does so from time to time, but only to call into question the very idea of feminine beauty as a natural given for art. Sometimes she does this rather lightheartedly, using the artifice of decorative gold disks to articulate the nipples and pubis of a soft cloth torso, or planting an impossibly enormous kitsch butterfly on the shoulder, hip, and knee of the life-cast figure of a mature woman. But the artist calls the female ideal into question most radically and incisively in an untitled work of 1992 made of wax, cheesecloth, wood, and pigment. This is a female figure seen from the back with her hands under her buttocks in a pose vaguely reminiscent of Ingres' classic orientalist back-beautiful nude, the *Valpinçon Bather* of the early 19th century. Or perhaps it would be more accurate, and certainly more appropriate, to associate Smith's torso with Man Ray's photographic spoof of Ingres' back-view beauty, *Le Violon d'Ingres* (1924), where the nude sitter, objectified by the two curved sound holes on her back, is transformed into a literal *violon d'Ingres*, the French idiom for hobby or avocation. How daring of Smith to retransform Man Ray's lighthearted parody into an icon of serious human affliction! The waxen flesh of this woman's back is incised with several long, deep parallel scars,

the result, one might surmise, of premeditated domestic abuse or deliberate political torture. In recorporealizing, thereby literalizing, Man Ray's punning objectification of woman's body, Smith goes far beyond Surrealist pseudo-horror, back to the horror that is reality. One might have to turn again to the Stefan Lochner altarpiece I began with to find such a graphic representation of the body in pain, but in this case, without compensatory redemption. Only in the Catholic Lochner's vision of hell from the same altarpiece does this kind of suffering, deeply inscribed in the human flesh, appear— eternal, unbearable, irredeemable. For Kiki Smith, though, it would seem that hell may be vividly present on earth, here and now, part of the human condition or, more accurately, a construct of the sensitive moral imagination in tune with the vicissitudes of our terrible times.

Notes

1 Thomas Crow (2004), "Moving Picture: Thomas Crow on *Aby Warburg and the Image in Motion* by Philippe-Aain Michaud," Sophie Hawkes, trans., in *Bookforum*, Spring, p. 28.

2 Helaine Posner (1998), *Kiki Smith*, Boston, MA: Bulfinch Press, p. 16.

3 The latter, incidentally, derived from Ann Hamilton's installation *Tropos* (Dia Center for the Arts, New York, 1993–1994), with its wall-to-wall horse-hair floor covering. For further evidence of Smith's involvement with hair, see her *Untitled*, a two-color lithograph of 1990, which represents a dense network of hair spread out to cover almost the entire sheet (pl. 37).

4 I am grateful to Nan Rosenthal for her information about *Lilith*. See her important article about this work, "Kiki Smith: Lilith" (1996), *Metropolitan Museum of Art Bulletin* 54, Fall, p. 66.

5 Of course, male peeing, especially by little boys, is relatively unobjectionable: think of the acceptable, if kitschy, "Manneken Pis" statue in Brussels.

6 Roger Kimball (1995), "Oozing Out All Over (The Body Repellent, Whitechapel Gallery, London)," *Modern Painters* 8, no. 1, Spring, pp. 52–53.

21

Sarah Lucas: God is Dad

Sarah Lucas: God is Dad, Gladstone Gallery, New York, 2005

If God is Dad then God, and Dad his surrogate, are both dead as doornails. Or are they? This seems to be the provocative question posed by Sarah Lucas' new exhibition, titled *God is Dad*, a blatant but apposite misprision of Nietzsche's inflammatory declaration "God is dead," and one that slides neatly into that Freudian and post-Freudian turf Lucas has been reclaiming for women and the irrepressible classes ever since her memorable installation at the Freud Museum in 2000—and before.

There are two installations on view in the gallery. In the first, an assemblage of bedsprings, cement firebricks and stockings, the antique springs' repetitive pattern, enlivened by off-beat irregularities and sudden puncturings of the visual order, lies somewhere between Sol LeWitt and Eva Hesse, but its structure is worked out in terms of actual objects rather than abstract forms.

Less attention has been paid to the formal qualities of Lucas' constructions than they deserve, perhaps because they always incorporate recognizable elements, pulling us inevitably toward interpretation rather than formal analysis. Yet both need to be considered together to get at, not the meaning, but rather the full impact—the pathos, power and visual irony—of these uncanny re-castings of the most ordinary situations. Here, the empty stockings play against the regular patterning of the bedsprings: abject, certainly, as is the ruined bed. Yet for Lucas, the abject is always embodied as entity, usually as a product, part of commodity culture not generalized as base matter, reduced to the unrecognizable yet evocative *informe*, as it is, say, in Louise Bourgeois' works of the 1960s. Lucas' metonymies often take the commodified shape of "container-for-the-thing-contained": pantyhose for female legs, bra for breasts, car for passengers, or, less usually, metaphorized, as in bucket for cunt or cucumber for prick. Or she can suggest new implications by an unexpected shift of direction. In the bed piece, she perversely changes the orientation of the bedsprings from their normal, passive horizontal position to a more assertive vertical. The raddled bedstead, by virtue of its verticality assumes a kind of personhood, or, if not that, a definite if exhausted authority, needing to be propped up against the wall but still holding on. (The death of God? We needn't go that far. Dad losing his stuffing? Maybe.) Combining rusty dignity and satisfying patterning at once, the sheer elegance of the almost accidental circular design re-sublimates the junked and discarded bedstead with the contrapuntal music of intricate wire repetitions, interrupted by abrupt insertions of curling white string.

Sarah Lucas, *God is Dad*, 2005. Nylon tights,
small light bulbs, wire, 47½ × 11½ × 5 in. (120.7 × 29.2 × 12.7 cm)

Yet here, as in all Lucas' best work, there is that titillating hint of violence: the
stockings forced brutally through the curled wire, the clue in the detective story that
makes narrative rise, like a poisonous vapor, from ordinary incongruities. And behind
bedstead and stockings, in contrast to the lyrical circular rhythms of the springs, lie the
stolid, inert rectangles of the cinderblock wall, constituting another kind of suggestive
reality—entrapment, enclosure, the sordid vulnerabilities of class and the housing
estate. The imagery here is ultimately propelled by the death drive, calling up Thanatos
rather than Eros, reminding us that, if God is Dad, then Dad is Dead and Mum hasn't
had too good a time of it, either.

What are the stockings, after all, if not a reminder of feminine vulnerability? Yet
they are ambiguous, depending on who is being reminded of what, but certainly they

are gender specific. For women, discarded pantyhose are notionally abject objects of identification: we feel for them, or whoever wore them, or for what happened to whoever wore them before they were rejected, thrust into bedsprings or whatever; for men, presumably, they are a sexual trophy, a reminder of past conquests, of female legs possessed, enjoyed or brutalized—or all three at once.

Legs, stockings, history

Lucas' hosiery, for the art historian, at any rate, summons up a considerable history of the representation of women's legs as independent bodily fragments, and you don't have to go as far back as the votive offerings—legs, arms, ears, according to the nature of the miraculous cure—of the Catholic Middle Ages to find them. In Manet's oeuvre, fashionably stockinged and shod, legs are on view as provocative parts of women's bodies, advertisements for further, unseen pleasure, hanging over the balcony in *Masked Ball at the Opera* (1873), or glimpsed as delectable sketchy morsels hidden under the table in letter illustrations. And there is a history of stockings, too, especially in erotica, like Courbet's *Woman with White Stockings* (1861) where the woman is caught peeling them off and thereby permitting the viewer a tantalizing glimpse of her casually exposed sex, conveniently located at eye-level for easier consumption.

It is, however, the empty stocking, the stocking without the leg that is most suggestive, for, like the empty glove featured in that most intriguing of print cycles, Max

Sarah Lucas,
Spread Yourself
Little Table, 2005.
Wooden table, nylon
tights, cast concrete
shoes, wire,
30¼ × 28 × 11 in.
(76.8 × 71.1 × 27.9 cm)

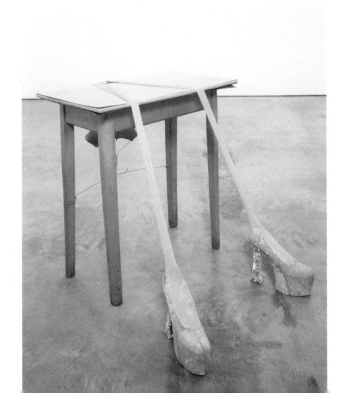

Klinger's *A Glove* (1878–81), women's hosiery assumes an uncanny life and presence on its own, a prime fetish object ripe for representation. In Seurat's *Les Poseuses* (1886–88), a writhing still life of stockings and gloves, presumably freshly peeled from the stately figures of *A Sunday Afternoon on the Island of La Grande Jatte—1884* (1884–86), occupies the foreground of the composition, surely its liveliest point of interest. I am not talking about anything as inert as "influences" or anything as irrelevant as "internationality" here. I am sure, or at least fairly sure, that Lucas never gave a second thought to either Manet, Klinger, or Seurat when she stuck those stockings through the bedsprings. It's just that you can't shake off those resonances, viewer or artist, even if you want to. They cling like Pliofilm to the body fragment or the body container in visual representation, along with their unique, inevitably gendered, individual associations.

Despite such references, in their insistent presence *as* objects—touchable, silky, droopy—Lucas' hosiery rips through the barrier of traditional representation: they are things in themselves, present tense. We could, if we wanted—although we probably don't—rip them free of their "esthetic" context, put them on and wear them home, if we are women or transvestites; just as we (if we are men) could replace Duchamp's urinal in its original location in the lavatory or even pee into it; or, as the artist himself suggested, take Picasso's 1942 *Bull's Head* apart and, restoring it to its origins as bicycle seat and handles, pedal off on it. These maneuvers, I suppose, would be quite literal demonstrations of both use-value and exchange-value embodied in a single artwork!! For besides being, theoretically at any rate, *useable*, Lucas' stockings are *replaceable*, almost infinitely so; if I chose to make off with the particular pair on view, the artist or gallery assistant could easily replace them with another and it would still be the same piece. Thus the work, for all its formal elegance, must be viewed as conceptual as well as materially unique in its typology.

On Freud's couch

It was in her brilliant installation in the Freud Museum in 2000 that I first encountered those permutations of a repertory of ordinary, sex-linked objects that constitutes the heart of Sarah Lucas' enterprise: bras, buckets, beds, pantyhose. Lucas played out her role as bad-girl rebel here with singular relish and inventiveness, slyly decking out Freud's analytic couch with Kleinean part objects, but spoofing Melanie Klein, too, in that these were ghosts of part objects: not the actual breast, object of infantile delight and fury in Klein's canon, but the empty bra; not the actual sex organ, so central to Freud's theories, but the flaccid pantyhose or stretched white briefs; not an actual couch but a suspended futon. As such, they constituted parodies of Freud and his theories, the anti-Oedipal as installation, the snake curled up in the very bosom of Freudianism. Or rather, the commodified skin of the snake. Both the bed, in the form of a suspended red futon mattress pierced by a phallic fluorescent bulb, and the womb-like bucket, featured in Lucas' second installation in the present exhibition, a bucket with the glow

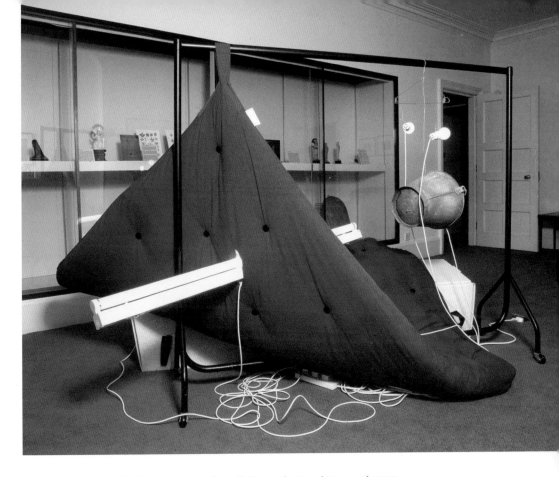

Sarah Lucas, *Beyond The Pleasure Principle* (installation at the Freud Museum), 2000. Mattress, lights, coffin, clothes rail, bucket, 57⅛ × 76 × 85 in. (145 × 193 × 216 cm)

of a light bulb emanating from its depths (the light at the end of the vaginal tunnel?) made their appearance in *Beyond The Pleasure Principle*, the *pièce de résistance* of the Freud Museum installation. Lucas even provided a "Thanatos surrogate" in the form of a cardboard coffin at the base of the piece, literalizing the antagonistic presence of the life and death drives articulated in Freud's eponymous publication of 1920. The bucket as female sex symbol had already, in conjunction with a mattress and a penis surrogate, made its debut six years earlier in conjunction with melon breasts, orange balls and a cucumber erection in *Au Naturel* of 1994 [p. 306], a work that reminds us that the "natural world" plays its role in Lucas' jokey permutations: raw chickens, preferably headless and upside-down, bananas, and in one case, a very large dead salmon have all played their role in the construction of the artist's offensive visual puns.

Downstairs in the dining room of Freud's house, *The Pleasure Principle* showed up as two reconfigured dining-room chairs, one adorned with bikini and bra, the other with underwear vest and briefs, connected with a long, fluorescent light bulb. I must say I laughed out loud when I saw it, with Papa Freud, godlike in his white beard and frontal

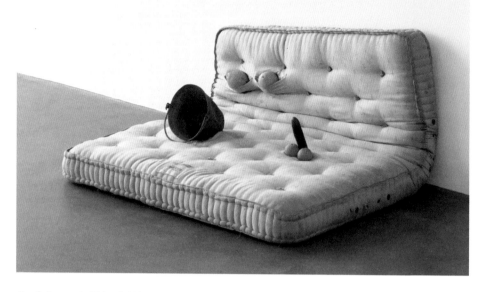

Sarah Lucas, *Au Naturel*, 1994.
Mattress, melons, oranges, cucumber, bucket, 33⅛ × 66 × 57 in. (84 × 167.6 × 144.8 cm)

pose in a photo above the sideboard, looking down on what he had wrought. Perfect, in its way. And of course, disjointed female legs help set the scene in Freud's study. There, as adjuncts to the meaningful couch, topped by a huge photo of the artist, headless but with a nipple protruding through a well-placed hole in her wrinkled gray t-shirt, are two chairs metamorphosed into the gangly, splayed legs, covered in papier-mâché tights, featuring pop cult images of eyes and mouths, scopophilia? Oral fixation? Of—*Hysterical Attack*.

Legs and Lucas

If I have lingered so long over the transgressive, but oh-so-apposite interventions at the Freud Museum, it is because, apart from being my first contact with Lucas' work en masse, the project was so important both as summation and source of her figuration. In terms of personal genealogy, the tights-clad legs in Freud's study look back to an *omnium gatherum* of the theme, in *Bunny Gets Snookered* of 1997 and forward to all sorts of future variations, like the abandoned stockings featured in "God is Dad." *Bunny Gets Snookered*, a multifigured installation in Sadie Coles' gallery had a real snooker (billiards or pool) table in the center, a bevy of splay-legged, stockinged, headless but bent-armed stuffed babes in considerable disarray deployed helter-skelter on office chairs around the floor, an additional stocking fluttering above their bras. The aftermath of a wild party, say, or a souvenir of more brutal violations; two more colorfully clad Bunnies were set right on top of the green-baize covered table, and another group, more realistic, appeared in black-and-white photographs on the wall. Not only Bellmer's dolls but Picasso's surrealist *Large Nude in Red Armchair* of 1929 must be considered as part of the genealogy of

these remarkably funny yet deeply depressing figures. Gender difference is at play here, setting these helpless creatures within, yet against the "masculine" precincts of the billiard parlor. The pathetic bent-noodle arms, lifted in futile protest, in particular, might be compared with other, very different arms in Lucas' oeuvre: the aggressive, overtly realistic ones in *Get Hold of This* of 1994 and similar casts that followed, arms making the challenging, macho "up yours" gesture in gritty plaster or hard, shiny plastic (as in the installation of eight of these pieces at Barbara Gladstone Gallery in 1995), the very opposite of the helpless, dithering, cloth *Bunny* arms.

But lest we accuse Lucas of anything as premeditated as programmatic feminism in this case, or any others, it is illuminating to read excerpts of her own account of the genesis of the *Bunny* figure, as set forth in Matthew Collings' excellent recent monograph:

> The origin of the Bunnies is a long story...I made an octopus out of tights stuffed with newspaper...And I really liked it. I thought, "Tights are so sexy, in a way. So I'll do something else with them." I started making a hare and tortoise out of tights but it never worked out.... But anyway I got some wires inside the tights and I had newspapers in them, too. And then when I abandoned the hare and tortoise idea, there was something about those gray legs, those gray tights. So I held on to them for a while. And years later, I don't know why, I started on them again. I'd made a cage for The Law and I wanted something to go with it,

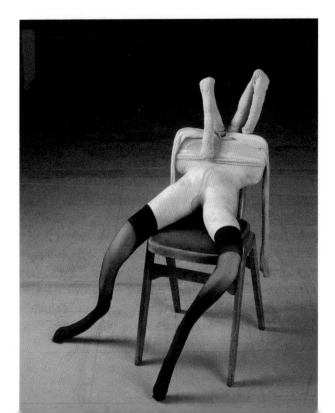

Sarah Lucas, *Bunny Gets Snookered*, 1997. Tan tights, black stockings, plastic and chrome chair, clamp, kapok, wire, 40⅛ × 35⅜ × 25¼ in. (102 × 90 × 64 cm)

something quite sexy. So I got the tights idea out again. But this time I stuck the chair in. I didn't know where I was going with it; I just thought, well, I'll start again with that.... And once I'd got the legs actually stuffed, I wanted to see how they looked, so I just clipped them on the back of this chair and that was it. I added a couple of things, but really that was it. It was brilliant. It doesn't happen very often that you really get that "Eureka" feeling, and you want to grab a beer or suddenly laugh, and smoke fast really fast, and phone people up and say "You've got to get over here!" Which is one of the things you dream about. And funnily enough, people say, "Why's your stuff always about sex?" Or something silly like that, but I often didn't start with that. It doesn't actually turn into anything until it gets there.[1]

Certainly one of the best accounts of the artist's own experience of the creative process on record, Lucas' narrative makes it clear that the final *Bunny* image emerged out of the very process of object-making and not as the result of some pre-ordained concept about sex or gender, or anything else. Which doesn't mean that Lucas doesn't have strong views and feelings about men, women, gender and the social order. It just means that particular forms can metamorphose from unexpected sources, that objects can take on new meanings, spring to novel life under unexpected circumstances and may surprise even the artist herself.

Can we, should we, then think of Sarah Lucas as a feminist, her work as feminist art? It all depends on what, in 2005, we mean by feminist. The implications of the term itself are changing, making it possible to approach more and different artists in feminist terms. Certainly, Mignon Nixon, for example, in her innovative forthcoming book on Louise Bourgeois,[2] makes a strong case for the importance of feminism, both the movement and the theoretical structure, in that artist's revolutionary work, work that is often abstract and which has previously been celebrated as perhaps post-Surrealist or just plain post-modernist. More and more, feminism is being conceived in terms that are at once more inclusive and less doctrinaire than it was at the time of its heroic revival in the late 1970s.

Certainly, Lucas herself, when she was just beginning to be an artist thought of herself as a feminist, propelled by anger at the injustice of the London art world in the early 90s:

One of the reasons I was interested in the feminine was that I wasn't successful. I lived with [the artist] Gary Hume. I was reading a lot of feminist writings and that led to arguments, because I was angry with him for being so successful. And not just him, but lots of other people, most of my good friends...I used to come home furious from openings and fancy dinners, and he'd get the brunt of all that anger.

RIGHT Sarah Lucas,
Jesus Was Married, 2005.
Steel bucket, wire hanger,
three light bulbs,
79½ × 15½ × 10½ in.
(201.9 × 39.4 × 26.7 cm)

BELOW Sarah Lucas,
The Sperm Thing, 2005.
Steel bucket, cast concrete
football, nylon tights,
10 × 76 × 21 in.
(25.4 × 193 × 53.3 cm)

Lucas' first solo show, *Penis Nailed to a Board* of 1992, was a near perfect illustration of how the personal can take shape as the political under the impact of anger, informed by post-Freudian theory and feminism, "without looking particularly theoretical or, even particularly feminist," as Matthew Collings has pointed out.[3] It was the arbitrariness of gender identifications, their sleazy crudeness in modern popular representation that

Lucas was after in this show, the way they could still shock and make the public take notice, the way they could still call attention to the arbitrary structure of power relations both personal and social, especially where sex was concerned.

Much of Lucas' early work was autobiographical and aggressively gendered as "masculine," or at least, deliberately "anti-feminine" and androgynous: a series of photographic self portraits like *Self Portrait with Skull*, where she confronts the viewer head on in shapeless jacket, heavy sneakers and jeans, legs open in a strong masculine thrust—so different from the weak-kneed sprawl of the Bunnies. In one self-portrait, she poses memorably in a contemplative attitude on a toilet-seat, legs raised, cigarette in hand. She could be either a boy or a girl in the absence of precise sexual indicators, but the image itself calls up, if distantly, Duchamp's provocative insertion of a urinal into the sacred precincts of the art gallery many years back, and along with it, his scandalous gender-play as Rrose Selavy. In still another photograph, Lucas slouches in a chair in the wide-legged "masculine pose" she favors but defies specific gender identification with two fried egg "breasts" plastered to her chest. In these, as in so many of her works, femininity and masculinity are represented as masquerade, constructions rather than essences.

Cigarettes played a big role in her earlier iconography: male identified and transgressive at once, they might be thrust into a sneering wax jaw—*Where Does It All End?* (1994–95) or used, craftsman-like, to construct complex popular objects, like *Nobby* (2000), a cigarette-covered garden gnome, or more recently, in an ultimate act of kitschy transgression, in the giant crucifix displayed in the Tate's three-person (two men, one woman) show, *In-A-Gadda-Da-Vida*, where the suffering Christ (perhaps a homage to a friend whom she accompanied and recorded when he had himself ritually crucified in a ceremony in the Philippines), is literally constructed of "coffin nails," the most popular commodified sign of death in our own times.

The present show, "God is Dad," distills some of the thematics of her previous work in more muted, contemplative form, combining pathos with a certain harsh insistence on the melancholy persistence of old objects, old attitudes. Part of its power lies in its critique of a gendered world where the sexes are still anything but equal and certainly far from harmoniously at one. Women may have won the vote, gained a presence in the art world, and much else besides, but, ironize as you will God is still Dad, and a brutal Dad in too many places, in too many situations. The stocking, the fallen bucket say it all.

Notes

1 See Matthew Collings (2002), *Sarah Lucas*, London: Tate Publishing, pp. 89 and 92.

2 Mignon Nixon (2005), *Fantastic Reality: Louise Bourgeois and a Story of Modern Art*, Cambridge, MA: MIT Press.

3 Collings, *Sarah Lucas*.

22

"Why Have There Been No Great Women Artists?" Thirty Years After

Women Artists at the Millennium, 2006

I'd like to roll the clock back to November 1970, a time when there were no women's studies, no feminist theory, no African American studies, no queer theory, no post-colonial studies. What there was was Art I or Art 105—a seamless web of great art, often called "The Pyramids to Picasso"—that unrolled fluidly in darkened rooms throughout the country, extolling great (male, of course) artistic achievement since the very dawn of history. In art journals of record, like *ARTnews*,[1] out of a total of eighty-one major articles on artists, just two were devoted to women painters. In the following year, ten out of eighty-four articles were devoted to women,[2] but that includes the nine articles in the special Woman Issue in January, in which "Why Have There Been No Great Women Artists?" appeared; without that issue, the total would have been one out of eighty-four. *Artforum* of 1970–71 did a little better: five articles on women out of seventy-four.

Things have certainly changed in academia and the art world, and I would like to direct my attention to those changes, a revolution that no one article or event could possibly have achieved, but that was a totally communal affair and, of course, over-determined. "Why Have There Been No Great Women Artists?" was conceived during the heady days of the birth of the Women's Liberation movement in 1970 and shares the political energy and the optimism of the period. It was at least partially based on research carried out the previous year, when I had conducted the first seminar at Vassar College on women and art. It was intended for publication in one of the earliest scholarly texts of the feminist movement, *Women in Sexist Society*,[3] edited by Vivian Gornick and Barbara Moran, but appeared first as a richly illustrated article in the pioneering, and controversial, issue of *ARTnews* edited by Elizabeth Baker and dedicated to women's issues.[4]

What were some of the goals and aims of the women's movement in art in these early days? A primary goal was to change or displace the traditional, almost entirely male-oriented notion of "greatness" itself. There had been a particular and recent historical reconsecration of the cultural ideal of greatness in the United States in the 1950s and 60s, a reconsecration that, I must admit, I was not consciously aware of when I wrote the article, but which surely must have colored my thinking about the issue. As Louis Menand pointed out in a recent *New Yorker* article dedicated to the Readers'

Subscription Book Club, initiated in 1951, "What dates the essays [used to preface the book club selections and written by such certified experts as Lionel Trilling, WH Auden, and Jacques Barzun] is not that they are better written or less given to 'the Theoretical' than contemporary criticism. It is their incessant invocation of 'greatness.' It is almost a crutch, as though 'How great is it?' were the only way to begin a conversation about a work of art."[5] Tied to the idea of greatness was the idea that it was immutable and that it was the particular possession of the white male and his works, although the latter was unstated. In the post-Second World War years, greatness was constructed as a sex-linked characteristic in the cultural struggle in which the promotion of "intellectuals" was a cold war priority, "at a time when a dominant strategic concern was the fear of losing Western Europe to Communism."[6]

Today, I believe it is safe to say that most members of the art world are far less ready to worry about what is great and what is not, nor do they assert as often the necessary connection of important art with virility or the phallus. No longer is it the case that the boys are the important artists, the girls positioned as appreciative muses or groupies. There has been a change in what counts—from phallic "greatness" to being innovative, making interesting, provocative work, making an impact, and making one's voice heard. There is less and less emphasis on the masterpiece, more on the piece. While "great" may be a shorthand way of talking about high importance in art, it seems to me always to run the risk of obscurantism and mystification. How can the same term "great"—or "genius," for that matter—account for the particular qualities or virtues of an artist like Michelangelo and one like Duchamp, or, for that matter, within a narrower perimeter, Manet and Cézanne? There has been a change in the discourse about contemporary art. Greatness, like beauty, hardly seems an issue for postmodernism, with whose coming of age "Why Have There Been No Great Women Artists?" coincided.

The impact of theory on art discourse and especially feminist and/or gender-based discourse is another change. When I wrote "Why Have There Been No Great Women Artists?," theory in its now accepted form did not exist for art historians, or if it did, I was not aware of it: the Frankfurt school—yes; Freud—up to a point; but Lacan and French feminism were little dots on the horizon, as far as I could tell. Within academia, and in the art world to a certain extent, that impact has since been enormous. It, of course, has changed our way of thinking about art—and gender and sexuality themselves. What effect it has had on a feminist politics of art is, perhaps, more ambiguous, and needs consideration. It has certainly acted to cut the wider public off from a great deal of the hot issues discussed by in-the-know art historians and critics.

If the ideal of the great artist is no longer as prominent as it once was, there have nevertheless been some extraordinary, large-scale, and long-lasting careers in art to be dealt with, some old-style grandeur that has flourished in the work of women artists in recent years. First of all, there is the career of Joan Mitchell. Her work has sometimes been dismissed as "second-generation" abstract expressionism, with the implication that she

was not an inventor or that she lacked originality, the cardinal insignia of modernist greatness. Yet why should it not be possible to consider this belatedness as a culmination, the culmination of the project of painterly abstraction that had come before? Think of Johann Sebastian Bach in relation to the baroque counterpoint tradition; the "Art of Fugue" might have been created at the end of a stylistic period, but surely it was the grandest of grand finales, at a time when originality was not so highly prized. Or, one might think of Mitchell's position as parallel to Berthe Morisot's in relation to classical Impressionism: a carrying farther of all that was implicit in the movement.

In the case of Louise Bourgeois, another major figure of our era, we have quite a different situation: nothing less than the transformation of the canon itself in terms of certain feminist or, at least, gender-related priorities. It is no accident that Bourgeois' work has given rise to such a rich crop of critical discourse by mostly theory-based women writers: Rosalind Krauss, Mignon Nixon, Anne Wagner, Griselda Pollock, Mieke Bal, Briony Fer, and others. For Bourgeois has transformed the whole notion of sculpture, including the issue of gendered representation of the body as central to the work. In addition, the discourse on Bourgeois must confront two of the major "post-greatness" points of debate of our time: the role of biography in the interpretation of the artwork; and the new importance of the abject, the viscous, the formless, or the polyform.

Bourgeois' work is characterized by a brilliant quirkiness of conception and imagination in relation to the materiality and structure of sculpture itself. This, of course, problematizes the viewing of her pieces. Indeed, as Alex Potts (whom I will take as an honorary woman in this situation) has stated, "One of the more characteristic and intriguing features of Louise Bourgeois' work is the way it stages such a vivid psychodynamics of viewing." And he continues, "There seems to be an unusual attentiveness on her part to the structure of a viewer's encounter with three-dimensional art works in a modern gallery setting as well as to the forms of psychic phantasy activated in such interactions between viewer and work."[7]

It is important to realize that although Bourgeois had been working since the 1940s, she did not really come into prominence and recognition until the 70s, in the wake of the women's movement. I remember walking to my seat with her at one of the early, large-scale women's meetings and telling her about my plan to match a 19th-century photograph, *Buy My Apples* [p. 195] with a male equivalent—well, maybe, *Buy My Sausages*. Louise said, "Why not bananas?" and an icon was born—at least I think it happened that way.

A younger generation of women artists often engages with ways of undermining the representational doxa that may be subtle or violent. Not the least achievement of Mary Kelly, for example, in her innovative *Post-Partum Document* [p. 314], was the way it desublimated Clement Greenberg's famous dictum, that the final step in the teleology of modernist art is simply the stain on the surface of the canvas, by reducing that stain to a smear of baby's shit on the surface of a diaper. Cindy Sherman, to take another

Mary Kelly,
Post-Partum Document:
Documentation I,
Analysed Faecal Stains
and Feeding Charts, 1974.
Perspex unit, white card,
diaper linings, plastic,
sheeting, paper, ink,
1 of 31 units, 11 × 14 in.
(28 × 35.5 cm)

example, sent up the movie still, making strange this most conventional of genres, and later shattered the idea of the body as a whole, natural, coherent entity with an imagery characterized by grotesquery, redundancy, and abjection. Yet, I would venture that Sherman's photographs also create a fierce new anti-beauty, making Bellmer look positively pastoral, but in particular pulling the carpet out from under such admired painterly subverters of canonical femininity as de Kooning or Dubuffet.

Another profound change that has taken place is that of the relation of women to public space and its public monuments. This relationship has been problematic since the beginning of modern times. The very asymmetry of our idiomatic speech tells us as much; a public man (as in Richard Sennett's *The Fall of Public Man*) is an admirable person, politically active, socially engaged, known, and respected. A public woman, on the contrary, is the lowest form of prostitute. And women, historically, have been confined to and associated with the domestic sphere in social theory and in pictorial representation.

Things certainly began to change, if at a slow pace, in the 20th century, with the advent of the "New Woman": the working woman and the suffrage movement, as well as the entry of women—in limited numbers to be sure—into the public world of business and the professions. Yet this change is reflected more in literature than in the visual arts. As Deborah Parsons has demonstrated in her important study of

the phenomenon, *Streetwalking the Metropolis: Women, the City and Modernity*, novels like Dorothy Richardson's *Pilgrimage* or Virginia Woolf's *Night and Day* or *The Years* represented women engaging with the city in newer, freer ways—as watchers, walkers, workers, denizens of cafés and clubs, apartment dwellers, observers and negotiators of the public space of the city—breaking new ground without the help of tradition, literary or otherwise.

But, it was not until the late 1960s and early 70s that women as a group, as activists rather than mere *flâneuses*, really took over public space for themselves, marching for a woman's right to control her own body as their grandmothers had marched for the vote. And, not coincidentally, as Luc Nadal points out in his 2000 Columbia dissertation, "Discourses of Public Space: USA 1960–1995: A Historical Critique," the term "public space" itself began to be used by architects, urban designers, historians, and theoreticians at just this time. Says Nadal, "The rise of 'public space' in the 1960s corresponded to a shift at the center of the discourse of planning and design." Nadal connects this project with the "vast movement of liberatory culture and politics of the 1960s and early 70s." It is within this context of liberatory culture and politics that we must consider woman not merely as a visible presence in public space, but in her practice as a highly visible and original shaper and constructor of it. For women today play a major role in the construction of public sculpture and urban monuments. And, these monuments

Cindy Sherman,
Untitled #261, 1992.
Chromogenic color
print, 68 × 45 in.
(172.7 × 114.3 cm),
edition of 6

are of a new and different sort, inassimilable to those of the past, often centers of controversy. Some have called them anti-monuments. Rachel Whiteread, for example, recreated a condemned house on a bleak plot in London, turning the architecture inside out and creating a storm of reaction and public opinion. A temporary anti-monument, it was later destroyed amid equal controversy. Whiteread's recent *Holocaust Memorial* in Vienna at the Judenplatz also turns both subject and form inside out, forcing the viewer not only to contemplate the fate of the Jews, but to rethink the meaning of the monumental itself by setting the memorial in the heart of Vienna, one of the major sites of their extermination.

Jenny Holzer, using both words and traditional and untraditional materials, also created scandals in Munich and Leipzig with her provocative public works. Her 1997 *Memorial Café to Oskar Maria Graf*, a German poet, exists as a functional café at the Literaturhaus in Munich. This is, to borrow the words of doctoral student Leah Sweet, a "conceptual memorial [that] refuses to present its subject...through a likeness or a biographic account of his life and work." Rather, Graf is represented through excerpts of his writing selected by Holzer and scattered throughout the café. Shorter excerpts appear on dishes, place mats, and coasters—an ironic use of what one might call the domestic-abject mode of memorialization!

Maya Lin is probably the foremost and best known of these women inventors of new monuments with new meanings and, above all, with new, untried ways of conveying meaning and feeling in public places. Lin's own words best convey her unconventional intentions and her anti-monumental achievement in this most public of memorials: "I imagined taking a knife and cutting into the earth, opening it up, an initial violence and pain that in time would heal. The grass would grow back, but the initial cut would remain a pure flat surface in the earth with a polished mirrored surface...the need for the names to be on the memorial would become the memorial; there was no need to embellish the design further. The people and their names would allow everyone to respond and remember."[8] Still another unconventional public memorial is Lin's *The Women's Table* [p. 318], a water table created in the heart of Yale's urban campus in 1993, commemorating with words, stone, and water the admission of women to Yale in 1969. It is a strong but gentle monument, asserting women's increasing presence at Yale itself, but also commemorating in more general terms women's emergent place in modern society. Yet, despite its assertive message inscribed in facts and figures on its surface, *The Women's Table* is at one with its surroundings. Although it constitutes a critical intervention into public space, its effect vis-à-vis that space is very different from that of a work like Richard Serra's controversial *Tilted Arc* of 1981. Lin's Yale project, like her Vietnam memorial, establishes a very different relationship to the environment and to the meaning and function of the public monument than Serra's aggressive confrontation with public space. I am not coming out for a "feminine" versus a "masculine" style of public monument with this comparison. I am merely returning to the theme of

ABOVE Rachel Whiteread, *Holocaust Memorial*, 2000. Judenplatz, Vienna.
Concrete, 150 × 276 × 394 in. (380 × 700 × 1000 cm)

BELOW Jenny Holzer, *Memorial Café to Oskar Maria Graf*, Munich, 1997

Maya Lin, *The Women's Table*, 1993.
Yale University, New Haven, Connecticut

this session and suggesting that now, as in the 19th century, although in very different circumstances, women may have—and wish to construct—a very different experience of public space and the monuments that engage with it than their male counterparts.

I would next like to consider very briefly the dominance of women's production in a wide variety of media that are not painting or sculpture in the traditional sense, and above all, the role of women artists in breaking down the barriers between media and genres in exploring new modes of investigation and expression. These are all women artists who might be said to be inventing new media or, to borrow a useful phrase from critic George Baker, "occupying a space *between* mediums."[9] The list would include installation artists like Ann Hamilton, who has made the wall weep and the floor sprout hair, and the photographer Sam Taylor-Wood [pp. 274–81], working with the enlarged and/or altered photo, who produces "cinematic photographs or video-like films."[10] This list of innovators would include innovative users of photography like Carrie Mae Weems, video and film inventors such as Pipilotti Rist and Shirin Neshat, performance artists like Janine Antoni, or such original and provocative recyclers of old practices as Kara Walker, who has created the postmodern silhouette with a difference.

Finally, although I can only hint at it, I would like to indicate the impact, conscious or unconscious, of the new women's production on the work of male artists. The recent

318

emphasis on the body, the rejection of phallic control, the exploration of psychosexuality, and the refusal of the perfect, the self-expressive, the fixed, and the domineering are certainly to some degree implicated, however indirectly, with what women have been doing. Yes, in the beginning was Duchamp, but it seems to me that many of the most radical and interesting male artists working today have, in one way or another, felt the impact of that gender-bending, body-conscious wave of thought generated by women artists, overtly feminist or not. William Kentridge's films, with their insistent metamorphoses of form, fluidity of identity, and melding of the personal and the political, seem to me unthinkable without the anterior presence of feminist, or women's, art. Would the work of male performance and video artists, abjectifiers, or decorative artists have been the same without the enormous impact and alteration of the stakes and the meanings of art production in the 1970s, 80s, and 90s that were produced by women's innovations?

Women artists, women art historians, and women critics have made a difference, then, over the past thirty years. We have—as a community, working together—changed the discourse and the production of our field. Things are not the same as they were in 1971 for women artists and the people who write about them. There is a whole flourishing area of gender studies in the academy, a whole production of critical representation that engages with issues of gender in the museums and art galleries. Women artists, of all kinds, are talked about, looked at, have made their mark—and this includes women artists of color.

Yet, there is still, again, a long way to go. Critical practice must, I think, remain at the heart of our enterprise. In 1988, in the introduction to *Women, Art and Power*, I wrote,

> Critique has always been at the heart of my project and remains there today. I do not conceive of a feminist art history as a "positive" approach to the field, a way of simply adding a token list of women painters and sculptors to the canon, although such recuperation of lost production and lost modes of productivity has its own historical validity and...can function as part of the questioning of the conventional formulation of the parameters of the discipline. Even when discussing individual artists, like Florine Stettheimer or Berthe Morisot or Rosa Bonheur, it is not merely to validate their work...but rather, in reading them, and often reading them against the grain, to question the whole art-historical apparatus which contrived to "put them in their place"; in other words, to reveal the structures and operations that tend to marginalize certain kinds of artistic production while centralizing others.

The role of ideology constantly appears as a motivating force in all such canon formation and has, as such, been a constant object of my critical attention, in the sense that such analysis "makes visible the invisible." Althusser's work on ideology was basic to

this undertaking, but I have never been a consistent Althusserian. On the contrary, I have paid considerable attention to other ways of formulating the role of the ideological in the visual arts.

Or to put it another way: when I embarked on "Why Have There Been No Great Women Artists?" in 1970, there was no such thing as a feminist art history. Like all other forms of historical discourse, it had to be constructed. New materials had to be sought out, theoretical bases put in place, methodologies gradually developed. Since that time, feminist art history and criticism, and, more recently, gender studies, have become an important branch of the discipline. Perhaps more importantly, the feminist critique (and of course allied critiques including colonialist studies, queer theory, African-American studies, etc.) has entered into the mainstream discourse itself: often, it is true, perfunctorily, but in the work of the best scholars, as an integral part of a new, more theoretically grounded and socially and psychoanalytically contextualized historical practice.

Perhaps this makes it sound as though feminism is safely ensconced in the bosom of one of the most conservative of the intellectual disciplines. This is far from the case. There is still resistance to the more radical varieties of the feminist critique in the visual arts, and its practitioners are accused of such sins as neglecting the issue of quality, destroying the canon, scanting the innately visual dimension of the artwork, and reducing art to the circumstances of its production—in other words, of undermining the ideological and, above all, esthetic biases of the discipline. All of this is to the good; feminist art history is there to make trouble, to call into question, to ruffle feathers in the patriarchal dovecotes. It should not be mistaken for just another variant of or supplement to mainstream art history. At its strongest, a feminist art history is a transgressive and anti-establishment practice meant to call many of the major precepts of the discipline into question.

I would like to end on this somewhat contentious note: at a time when certain patriarchal values are making a comeback, as they invariably do during periods of conflict and stress, women must be staunch in refusing their time-honored role as victims, or mere supporters, of men. It is time to rethink the bases of our position and strengthen them for the fight ahead. As a feminist, I fear this moment's overt reversion to the most blatant forms of patriarchy, a great moment for so-called real men to assert their sinister dominance over "others"—women, gays, the artistic or sensitive—the return of the barely repressed. Forgetting that "terrorists" operate under the very same sign of patriarchy (more blatantly of course), we find in the *New York Times*, under the rubric "Heavy Lifting Required: the Return of Manly Men," "The operative word is men. Brawny, heroic, manly men." On it goes: we need father figures—forget heroic women, of course. What of the murdered airline hostesses—were they feisty heroines or just "victims," patriarchy's favorite position for women? Although the female writer of the article admits that "part of understanding terrorism...often involves getting to the root

of what is masculine," and that "the dark side of manliness has been on abundant display as information about the lives of the hijackers, as well as Osama bin Laden himself comes to light, revealing a society in which manhood is equated with violent conquest and women have been ruthlessly prevented from participating in almost every aspect of life," and, in quoting Gloria Steinem, contends that "the common thread in violent societies is the polarization of sex roles," and even though the *Times* felt uncomfortable enough about "The Return of Manly Men" to append at its base an article, "Not to Worry: Real Men Can Cry," the implications of the piece ring out loud and clear.[11] Real men are the good guys; the rest of us are wimps and whiners—read "womanish."

In a similar but more specifically art-oriented vein, a recent *New Yorker* profile of departing MoMA curator Kirk Varnedoe brings the call for the return of manly men directly into the art world—Varnedoe is described as "handsome, dynamic, fiercely intelligent and dauntingly articulate."[12] He made himself into a football player. At Williams College, whose art history department would shortly become famous as an incubator of American museum directors, he found that what his remarkable teachers, S Lane Faison, Whitney Stoddard, and William Pierson, did "in the first place, was to take the curse of effeminacy off art history."[13] Stoddard went to all the hockey games and came to class on skis in the winter—a sure anti-feminine qualification in an art historian. At the Institute of Fine Arts, "legions of female students fell in love with him. One of them wrote him a love letter in lieu of an exam paper."[14]

Of course, this description is over the top in its advocacy of masculine dominance in the art world. It is not, alas, totally exceptional. Every time I see an all-male art panel talking "at" a mostly female audience, I realize there is still a way to go before true equality is achieved. But I think this is a critical moment for feminism and women's place in the art world. Now, more than ever, we need to be aware not only of our achievements but of the dangers and difficulties lying in the future. We will need all our wit and courage to make sure that women's voices are heard, their work seen and written about. That is our task for the future.

Notes

1. *ARTnews* 68, March 1969–February 1970.
2. *ARTnews* 69, March 1970–February 1971.
3. Vivian Gornick and Barbara Moran, ed. (1971), *Women in Sexist* Society, New York, NY: Balk Books.
4. *ARTnews* 69, January 1971.
5. Louis Menand (2001), *New Yorker*, October 15, p. 203.
6. Ibid., p. 210.
7. Alex Potts (1999), "Louise Bourgeois—Sculptural Confrontations," *Oxford Art Journal*, 22, no. 2, p. 37.
8. *New York Review of Books*, November 20, 2000, p. 33.
9. *Artforum*, November 2001, p. 143.
10. Ibid.
11. *New York Times*, October 28, 2001, section 4, p. 5.
12. *New Yorker*, November 5, 2001, p. 72.
13. Ibid., p. 76.
14. Ibid., p. 78.

23
Women Artists Then and Now: Painting, Sculpture, and the Image of the Self

Global Feminisms: New Directions in Contemporary Art, 2007

Looking back at the catalogue of *Women Artists: 1550–1950*,[1] the first big show of women artists at the Brooklyn Museum that I curated with Ann Sutherland Harris in 1976, I was struck by the great differences separating it from the Museum's present exhibition of women artists. Some of these differences are obvious. The first show was historical rather than contemporary. From this it followed that it consisted almost entirely of drawing and painting; even sculpture was omitted in the interest of consistency. Clearly, back then, the word "artist," female as well as male, implied that the individual was primarily a painter. In the present show, however, painting and traditional sculpture take a backseat to the less traditional media: photography, video and the moving image, installation, and performance have gained center stage. Clearly, *what* the work is made of is now very different. But *where* the work comes from, the nationality and ethnicity of the artists who made it, is equally important in establishing the difference between *Women Artists: 1550–1950* and the present exhibition. Exciting and innovative as it was, the Brooklyn show of the 1970s consisted almost without exception of work by women from Europe and America. Today's exhibition includes a plethora of women artists from non-Western countries, women from all over the world, in fact. These contemporary women artists, not just from Europe, Britain, and the United States, but from Africa, Asia, Australia, and Latin America, have insisted upon the validity of their own experience, both personal and artistic, creating new formal languages that often incorporate national and ethnic traditions in surprising or nontraditional ways. They are included in the exhibition not only out of a benign desire to expand the field in the interest of justice, but because non-Western women artists are among the most influential movers and shakers in the international art community, acknowledged creators of the most original and influential art that reaches the public. Women artists were among the stars of the 2005 Venice Biennale, for example, and names like Shirin Neshat, Mona Hatoum, Miyako Ishiuchi, and Regina José Galindo were as prominent as those of major male artists participating in the Venice show.

Yet the path to public recognition and professional success has been a long and arduous one, and both the goals and achievements of women artists during the thirty-five years since the beginning of the Women's Liberation movement in art, as embodied in the work of such pioneers as Judy Chicago, Miriam Schapiro, Martha Rosler, Hannah Wilke, Eleanor Antin, Joyce Kozloff, Carolee Schneemann, Lynda Benglis, and many others, need to be acknowledged. Indeed, the work of women artists well before the momentous 1970s needs to be examined with specificity and critical insight in order to provide a meaningful historical context for the work and ambitions of younger women artists today. For contemporary women artists, sometimes consciously, but often unconsciously, incorporate, modify, and struggle against the examples of the past, their putative foremothers. It is only in the light of historical precedent that the achievements of the present assume their full meaning: as fulfillment, transformation, or resolute deconstruction, as may be the case.

Women and painting

Setting the stage

History and mythology part ways, as they so often do, when it comes to the issue of women painters. In mythology, women were associated with the very origins of painting. According to the charming legend of the Corinthian Maid, it was a young woman, Dibutades, who, dismayed by the impending departure of her lover, traced the outline of the shadow he cast upon the wall and, with Cupid guiding her hand, thereby invented painting.[2] If we turn from allegory to historical reality, however, we find that women have, for the most part, had a hard time of it in the field of painting, as in all the realms of high art. The dramatic fate of the 17th-century painter Artemisia Gentileschi has recently been revealed in serious art history, in novels, and in film, as has the more recent but no less discouraging story of the talented Lee Krasner, doomed to painterly obscurity by the brilliant career of her painter husband, Jackson Pollock. From the Renaissance onward, women were denied access to the proper training and preparation afforded their male contemporaries: free access to the art schools, prize contests, travel abroad, and, no less important, to the nude models whose forms provided the very basis of the elevated genre of history painting. Even when they were allowed to work and exhibit as painters, women were generally consigned to the less ambitious realms of portrait and still life, especially flower painting, art forms that were believed to accord better with feminine lack of imagination, intelligence, and ambition.

There were, however, noteworthy exceptions to this general rule of exclusion and denigration. As is so often the case, women painters sometimes found ways of gaining fame, or more precisely, notoriety, by *being* exceptions, by forcing public attention. There were a rare number of women painters who, for a variety of reasons, achieved fame and fortune on a major level at least in part *because* they were women rather than in spite

of their sex. One might, for example, think of the glamorous Élisabeth Vigée Le Brun (1755–1842), portrait painter to the stars in the late 18th century, whose fame and ability to create ravishing portraits of aristocratic ladies and gentlemen made her a favorite all over Europe as far as the distant reaches of Russia. Later, in the 19th century, Rosa Bonheur might have claimed to be the best known, if not the most critically acclaimed, painter in Europe and America. Bonheur specialized in the painting of animals, and engravings after her famous *The Horse Fair* adorned the walls of middle-class parlors and humble cottages all over the world. When *The Horse Fair* was sent on tour in the United States, huge crowds swarmed to see the phenomenon: it was certainly the *Star Wars* of its time. The same sort of notoriety has marked the career of the 20th-century modernist painter Georgia O'Keeffe (1887–1986), who must certainly be one of the most popular artists of the last hundred years, her admirably reproducible work adorning the covers of innumerable calendars and memo books, and, in the form of posters, decorating countless walls from restaurants to college dorms. But what interests me in this essay is not the relative success, or lack of it, of women painters historically, but rather what painting has meant to women, as a medium, a project, a mystique, especially in more recent times.

What of the medium, of painting itself? For most of the history of painting, from the Renaissance to the 19th century, painting has, so to speak, been taken for granted, as it was in our exhibition *Women Artists: 1550–1950*. One could be a smooth, finished painter, working with almost invisible brushstrokes to create a surface of almost photographic transparency, like Jan van Eyck or Jean-Auguste-Dominique Ingres; or one could emphasize bravura brushwork and densely applied impasto, like Peter Paul Rubens, or Eugène Delacroix, or the Impressionists in the 19th century. But the notion that painting itself was in some way *anti*-avant-garde, regressive, and hence inimical to revolutionary practice in the visual arts—especially inimical to the goals of feminist artists in particular—did not become an articulate position until the 1980s.

Of course, anti-painting had been in existence before the women's art movement, starting with Dada after the First World War, reaching its most coherent statement in the work of Marcel Duchamp, whose signed anti-art-object, the notorious urinal he titled *Fountain*, appeared as early as the Armory Show in 1913. Collage and papier collé in turn challenged the supremacy of oil on canvas, as did the application of foreign materials like sand, coffee grounds, or other non-art matter in the work of the Surrealists. The increasing importance of photography, both documentary and manipulated, also called the supremacy of the painterly media into question as the 20th century progressed, despite photography's bad reputation with critics like Charles Baudelaire, who felt that it failed the test of imagination and individuality. But one might say that it was just these qualities that feminist artists of the 1980s, and before, strenuously rejected—individualism and personal expression—associating them with male-dominated creativity and the cult of personality they felt dominated the art world at the expense of women and

minority artists. Photography, video, installation, and performance were associated with feminist refusal of the patriarchal reign of the painted masterpiece. Only by rejecting the tyranny of painting, traditional medium of heroic male self-expression, could women establish their own independent territory. Artists like Mary Kelly, working in installation, Valie Export or Joan Jonas in performance, Cindy Sherman or Eleanor Antin in photography, or Martha Rosler in video, to name only a few who worked and are still working outside the realm of the painted object, are cases in point.

Indeed, taken from this oppositional standpoint, Mary Kelly's most famous work, her *Post-Partum Document*, can be seen as a willfully parodic rejection of painting itself. For Kelly's work—while it may be a Lacanian "argument for the social construction of subjectivity in a striking indictment of essential femininity," to borrow the words of Kate Linker, or "one of this century's most significant and influential artistic statements on identity," representing "the ultimate merging of feminism and minimalist performativity,"[3] to borrow those of Maurice Berger—is at the same time, physically, a series of canvas-like "supports" hung on the gallery wall with the infant's nappies substituting for canvas, and her son's ever-evolving shit taking the place of paint.

The return of radical painting

Recently, however, many women artists with feminist inclinations have returned to painting—with a difference. Painting, with all its historic resonances, may for that very reason lend itself brilliantly to a postmodern rejection of the epistemological baggage it traditionally carried. Painting could re-/de-construct itself as a kind of antithesis of heroic individualism, a visual rejection of the macho self displaying his phallic dominance on canvas. Using paint and canvas as their medium, women artists recently have forged multiple modes of pictorial—and anti-pictorial—expression. I will analyze several of these innovative bodies of work as case studies, in no sense attempting a chronological order or textbook completeness.

Angela de la Cruz is one of the women artists in the exhibition who has made the phenomenology of painterliness the entire point of her oeuvre. In a series of works of surprising sensuousness and potent abstract beauty, she wrenches giant paint surfaces free of their supporting stretchers, to make ambiguous objects that are neither "paintings" nor "installations" but something of both. "Painting" in her conception is both freed from its traditional passivity, a flat surface hanging on a wall, yet openly subjected to the artist's esthetic agency in terms of color, scale, and deconstructive inventiveness. In a work such as the beautifully sensual, meltingly modulated (and plainly titled) *Flop* (1999), the canvas unrolls in lazy furls on the floor, like a fallen and lassitudinous Rothko; in *Torso* (2004), a work in oil on canvas and metal, the large, squarish shape, metallic black, blossoms into a tantalizingly organic form suggestive of the human body; in *Ashamed* (1995), a work in the present exhibition, the pale canvas folds modestly back into itself, enacting, in abstract form, a ritual of female self-protection. Recently,

in an exhibition titled *Larger than Life* at the Andalusian Center for Contemporary Art (2001), de la Cruz expanded her scale to that of the truly architectural, occupying the large interior space with shaped, multi-angled forms that emphasized the supporting, usually hidden, skeleton of painting as much as the canvas itself.

There is still another, perhaps more tragic and ambiguous aspect of Angela de la Cruz's powerful pieces. Are these crumpled, torn, ravaged structures really paintings? Or are they beat-up, paint-covered ruins, moving in their abjection? Combining rage and elegance—a new, particularly female hybridity of today—de la Cruz's work reminds us that art has a lifespan, and gorgeously brutalized work like the monumental *Ready to Wear (Red)* (1999), where the voluptuously pigmented stuff is literally torn off its stretcher, or *Loose Fit III (Large/Orange)* (2000), in which the violated canvas cloth hangs as elegantly as a dead Zurbarán monk's habit, are evidences of the fact that art itself can suffer and die, whether it be painting or some other, unnamable genre.

Another painter, Elizabeth Murray, different both in her generational affiliation and her nationality from de la Cruz, has chosen a very different way of reviving the art of painting in her energetic, large-scale, often erratically shaped canvases. Several basic questions are posed by Murray's work. How can painting be a flat entity on the surface of a canvas yet at the same time exist in space? How can a painted object at once iterate its essential rectangularity yet contest it? Or, to put it still another way, how can painting maintain its apparently inherent opticality while being pulled into a kind of goofy play with tactility, involving canvas both bent and shaped? And what of the painted marks on such a canvas, painted marks that refuse to stay flat on the surface but move all around the canvas, which no longer has a proper front or back but has been transformed into virtually a giant Möbius strip? Murray's best work often references both the means and the history of painting, at the same time resorting to a vocabulary of form and color that specifies both "high" and "low" art without discrimination. *Painter's Progress* (1981), for instance, speaks directly to the history of modern art implicit in its title, in its replay of Cubist fragmentation as well as its self-reference to the artist in the imposed palette with brushlike forms thrust into the hole. Yet the colors (black, raw green, shimmery pinkish violet) and the strangely suggestive shapes (organic, sexual?) have more to do with the comic book or the advertisement than with Analytic Cubism's neutral shades, nor do the fierce angular splits and borders that deregularize the canvas itself belong to any time but our own. The motif of the ordinary table, favored by both Cézanne and the Cubists, becomes a major preoccupation in a series of works from the 1980s. In what Robert Storr has aptly called "a tug of war between dissolution and cohesion,"[4] the exuberant table-in-space motif is still going strong as late as 1995, when it involves an overtly recognizable subject, granted in a sort of simplified "anime" form.

Both de la Cruz and Murray are primarily concerned with the structural problematics of painting. Other women artists have been involved with the way the painted *matière* creates form on a relatively traditional, rectangular support: both Jenny Saville and

Elizabeth Murray,
Painters Progress,
1981. Oil on canvas,
nineteen panels,
116 × 93 in.
(294.5 × 236.2 cm)

Cecily Brown exploit the painterly surface to their own, extremely different, ends. In the work of neither of these two artists is intensely painterly facture treated in a parodic, hip, post-mod way. That both of these brilliant pictorialists are women thickens both the plot and the paint, because the cliché of the great male brush-wielder, from Rubens to Renoir to Pollock or de Kooning, implies that female artists, those without the requisite penis, can't do really big-time painting: a chaste little flower or a nice Impressionist landscape, perhaps, but not the big, luscious, sexy stuff.

For Cecily Brown, it is as though the swirling, violently animated surface existed before the piecemeal figuration—a breast here, a penis there—that emerges from the welter of pigment. *Performance* (1999) [p. 328] is a completely readable but highly agitated scene of erotic action, a virtual orgy evoked by swirls of pink, cream, blue, green, or pinkish flesh color. Brown's work makes constant reference in both its iconography and its formal language to the connection between the act of fucking and the act of painting, a trope previously reserved for male artists but rarely so explicitly articulated in the material facture of the imagery itself. Brown borrows unapologetically from the painterly traditions of the 19th century, especially the French Romantics. In some smaller paintings, reminiscences of Géricault and Delacroix, little islands of historical reference congealed in the midst of free-flowing brushwork call up the specter of *The Raft of the Medusa* or *The Massacres at Chios* from the whirlpool of vibrant abstraction.

Heroic in both scale and ambition, contemporary in emotional complexion, is the painting of British artist Jenny Saville. Dwelling almost equally on sex and gender, pain

RIGHT
Cecily Brown,
Performance, 1999.
Oil on linen,
100 × 110 in.
(254 × 279.4 cm)

BELOW
Jenny Saville,
Passage, 2004–5.
Oil on canvas,
132⅛ × 114⅓ in.
(335.5 × 290.4 cm)

and fleshly injury, Saville uses photographs, medical journals, advertisements, and crime scene reportage in the construction of her subjects. Distancing herself from direct contact with her "models"—often herself—she builds up surfaces in slathers and slabs of molten pigment, playing aggressive corporeal volume against attention to the surface grid, balancing gorgeous effects of brilliant impasto with almost unbearable images of bodies torn, injured, and suffering. Gender ambiguity is the topic she explores in *Passage* (2004–5). The figure itself is confrontational, the face staring out at us, the breasts prominent, the legs dramatically splayed and foreshortened, the better to display the startlingly explicit balls and penis that at once contradict yet set in relief the explicitly feminine head and body of the figure. The paint application is as bold and in-your-face as the hermaphroditic sexuality of the model. We are as aware of the painterly energy and formal self-consciousness of the artist as we are of the presence of the constructive sweep of the brushstrokes in a de Kooning.

The local and the cosmopolitan

One of the most important innovations of the women painters in this show is their engagement not only with the problematics of painting, but also with the various and novel ways in which painting interacts with local traditions and national histories. Here, I think, is the most unprecedented creative explosion of women who use paint as their medium. In the show, for example, Shahzia Sikander, who was born in Pakistan but has lived in New York since 1997, and whose work includes many other media—installation, murals, video, and performance—does paintings that are based on the tradition of the miniature in India from the 17th century onward, some of the most complex and inventive painting the world has ever known. Far from being oppressed by Islamic tradition, Sikander is obviously empowered by it, using the gorgeous and flexible repertoire of the Indian miniature to forge new meanings, often with subtle, or not so subtle, feminist overtones. Ambreen Butt, another Pakistani artist working in the United States, takes over the tradition to create a saga of contemporary feminine heroism couched in the language of the miniature. In an untitled watercolor enhanced with gouache and gold leaf on wasli paper from the *I Need a Hero* series, her female protagonist, clad in contemporary workout clothes, ultimately snares a rather traditional-looking demon. The format is circular, the action terrific, the pictorial detail enchanting. Ghada Amer, born in Cairo and working in New York since 1996, simultaneously engages with and undermines traditions that are both local and gender-specific. Amer quite literally sees the personal as political: "What is going on now politically is like a mirror of what has always gone on in myself, because I am a hybrid of the West and the East," she asserts.[5] Her particular "transgression" is to stitch pornographic imagery into what at first sight appear to be completely abstract paintings [p. 330]. By introducing thread into her paintings, she blatantly transvaluates what has always been regarded as a particularly feminine and a particularly local, Egyptian craft tradition, importing a very

Ghada Amer, *Trini*, 2005.
Acrylic, embroidery and gel medium on canvas, 79 × 66 in. (200.7 × 167.6 cm)

untraditional sensual piquancy into the prim and pristine realm of women's stitchery. The introduction of sewing and embroidery into the sacrosanct realm of high-art painting has a special, often transgressive, meaning for contemporary women artists. In the early days of the women's movement in art, painters like Miriam Schapiro introduced lace handkerchiefs and other "feminine" collage items into their canvases to assert women's presence in the field of art. Today, however, painters like Amer and Israeli-born American Orly Cogan are using stitchery in an entirely new, "perverse" way: to assert women's right to the pleasures of pornography through the traditionally "feminine" medium of embroidery.

Yet even without the addition of a foreign element like thread or wool into the body of the painted object, contemporary women artists throughout the world are reconfiguring the look, the *matière*, and the implications of the time-honored medium in a variety of ways. Béatrice Cussol of France, for instance, in a series of small, viciously playful watercolors, de-sanctifies and de-beautifies the medium with sexy, cartoon-like

figures in explicitly feminist critical situations, including one in which a cartoonish female is vividly depicted with a chain around her leg and a house up her nose, in an updated parodic version of Ibsen's *A Doll's House*. Sardonic feminist critique can assume racial overtones, as it does in Wangechi Mutu's provocatively titled *A Passing Thought Such Frightening Ape* (2003). The artist, born in Kenya but working in the United States, employs new materials (ink and collage on Mylar polyester film) to produce images in which translucent beauty of color and surface is combined with weirdly hybrid body-types—human figures with rapacious bird-claw legs or an ape-like head atop a naked body and sporting stiletto heels; such works create a grotesque new reality of the Other, at once repellent and attractive. The same ecstatic hybridity marks the work of a young Chicago artist, Mequitta Ahuja, in her ambitious, large-scale canvas *Boogie Woogie*, where the dancing female figure, part human, part animal—a kind of horned werewolf, perhaps—lumbers wildly through a field of red poppies, in a canvas marked by sophisticated "primitivism" of form and content.

Wangechi Mutu,
A Passing Thought Such Frightening Ape, 2003.
Collage, ink and contact paper on Mylar, 59⅞ × 42½ in. (152 × 108 cm)

Parastou Forouhar, *Thousandandone Day*, since 2003.
Detail from wallpaper

The mural or, rather, wall painting as it is usually called today, is another reincarnation of a traditional subcategory of the painter's art. Claudia and Julia Müller of Switzerland and Parastou Forouhar, originally from Iran, now working in Germany, reject the uplifting harmony of theme and formal language that so often marked the mural painting of the past—the pastoral nationalist verities of the French 19th-century painter Pierre Puvis de Chavannes, for a prime example—in favor of a language both deconstructive and deliberately fragmented. In the Müllers' *Destroyed Family Album*, the artists suggest, even if they don't directly represent, the violence and destruction of ordinary life that have been experienced by so many people caught up in the massacres and diasporas of the 20th century. Parastou Forouhar, in her wallpaper drawings titled *Thousandandone Day*—a sardonic reference to Scheherazade's *Thousand and One Nights?*—uses the benign all-over decorative medium of wallpaper to record events that are anything but benign: the savage murder and destruction of anonymous civilians, many by hanging, at the hands of equally anonymous executioners.

If contemporary women artists, of all countries and in a wide range of styles and mediums, have indeed returned to painting, then, it is less a "return" than a "reinvention" of that time-honored artistic practice, refusing the harmonious for the

problematic, the universal for the local, the traditional for the daring and aggressive. National traditions play a major role in this reinvention of the painted image, but it is not necessarily a direct or overtly positive one. Indeed, sometimes the feminist problematic is played directly against the tried-and-true formulae of traditional national styles, with startling effect. The intention is not to reject ethnic source or stereotype, but to deploy it differently, in formal structure and in implicit or explicit meaning.

Women artists and sculpture

A look at sculptural history

Before there were performance artists, installation art, or body art, the human body was the subject of sculpture. From the earliest times, and in many disparate cultures, artists have worked with the variability of human flesh, hacking, hewing, or molding inert material to create their versions of the (usually idealized) human form. Women began seeking careers as sculptors in the 19th century in both Europe and the United States. In the realm of sculpture, as in that of painting, they achieved reputations, and, in some cases, notoriety, against the grain, as it were, relying upon social connections as well as talent and technical skill. Such was the case of the aristocratic sculptor who went by the name of Marcello, who made a considerable reputation for herself as a portraitist and as a creator of figures from classical mythology. "Woman. Artist. The Duchess of Colonna (Marcello was an assumed name) seems to have constantly oscillated between these two tendencies," declared her biographer, who realized the difficulties involved in trying to pursue a serious career under such circumstances.[6] Nevertheless, Marcello the artist created such works as the technically accomplished and sensually appealing *Pythia*, created for her friend Charles Garnier's new Paris Opéra in 1870. Then there was the group of artists half-facetiously dubbed "The White Marmorean Flock" by Henry James, women who did their monumental carving mostly in Rome but also in the United States, where some of them received important commissions. In the realm of painting, women could manage without confronting the un-ladylike scandal of the naked body by sticking to the lesser realms of domestic portraiture, still life, or landscape; in sculpture, however, the body, ranging from the classical nude to the clothed contemporary heroic portrait, was de rigueur, and women plunged into the fray.

Edmonia Lewis, a black, lesbian member of the White Marmorean Flock, created the impressive monument *Forever Free* in 1867, a work commemorating the freeing of the slaves at the end of the Civil War. High purpose, as well as social realism, justified the semi-nudity of the protagonist, who lifts his cast-off shackles above his head to indicate his redemption while a black woman companion kneels at his feet. Lewis was not the only black woman sculptor of note in American history. Closer to our own time, the almost forgotten black woman sculptor Augusta Savage created a very different memorial to black achievement in her imaginative *The Harp* of 1937, commissioned for

Harriet Hosmer, *The Sleeping Faun*, modeled 1864, carved *c*. 1870.
Marble, 50 × 60 in. (127 × 152.4 cm)

the New York World's Fair of 1939. Based on James Weldon and Rosamond Johnson's inspiring anthem to black achievement, "Lift Every Voice and Sing," the work was in essence a monumental harp made of human bodies—black bodies—their voices raised in song.

Another member of the 19th-century White Marmorean Flock, Harriet Hosmer, created a highly esteemed *Sleeping Faun*, a male nude in marble that sold for five thousand dollars, an extremely good price at the time. Hosmer's sleeping male figure indirectly references Anne-Louis Girodet's notorious *The Sleep of Endymion* of 1791 (transmitted in sculptural form via Antonio Canova's *Sleeping Endymion* of 1819–22); although lacking the sensuality and erotic abandonment of Canova's statue and Girodet's canvas, it is nevertheless a creditable sculptural performance and certainly bears witness to its creator's awareness of all the latest trends in the academic mainstream.

In our own time, the photographer and video artist Sam Taylor-Wood has shown an affinity for similar subject matter, turning for inspiration to the beautiful male nude several times in the course of her production. Most apposite to the subject, even

Sam Taylor-Wood, *David*, 2004.
DVD, duration: 1 hour 4 minutes 7 seconds

though it is not a piece of sculpture but an hour-long film, is Taylor-Wood's provoca-
tive portrait of an Endymion figure for our time, the soccer player David Beckham. Her
David, in the National Portrait Gallery in London, clearly references the same sleeping
Endymion figure that inspired Harriet Hosmer 140 years earlier. Nor is this almost
motionless, statue-like figure Taylor-Wood's only venture into representing sleeping
beauty, the nude male version; far from it. In *Soliloquy VII* (1999), she created a startlingly
foreshortened modern version of Andrea Mantegna's *Dead Christ*, and the seductive
movie actor Robert Downey Jr. has appeared more than half naked in at least two of
her recent pieces: *Pieta* (2001) and in the series *Crying Men* [pp. 274–277]. That series
of photographic portraits of movie stars includes a C-print of *Daniel Craig*, not nude,
alas, but beautiful nevertheless.

Women sculptors such as Evelyn Longman (later Batchelder) and Janet Scudder
(1869–1940) continued the tradition of the academic nude well into the 20th century,
when it was deemed especially appropriate for public commissions, among them
Scudder's Donatello-inspired *Frog Fountain* (1901), featuring a dancing circle of
chubby, cheery nude boys, versions of which were bought by Stanford White and the
Metropolitan Museum of Art. Far more substantial and impressive is Longman's colos-
sal allegorical male nude *Spirit of Communication*. In 1914, Longman, a student and
assistant of the renowned Daniel Chester French, won the national competition for this
work and received the commission destined for the top of the AT&T building in New
York City. One of Longman's best-known works, *Spirit of Communication* is a towering

ABOVE Malvina Cornell Hoffman, *Bacchanale*, 1917. Bronze, 68 × 54 in. (172.7 × 137.2 cm)

LEFT Camille Claudel, *The Waltz*, 1893. Bronze

figure, 24 feet high, cast in bronze and gilded, a winged male of impressive physique, brandishing lightning bolts in his left hand and encircled by what looks like a telephone or telegraph cable.

Toward the end of the 19th century and the beginning of the 20th, a change is discernable not merely in the world of artists, but in the realm of cultural production more generally. Physical passion came to be artistically presentable, at least by a small elite of women writers and artists. Indeed, in some cases, the representation by women of women's erotic experience and sexual feeling was deemed especially authentic, rising as it did from their actual engagement with passion rather than from male imagination.

Although more than twenty years separate the birth date of the French sculptor Camille Claudel from that of the American Malvina Hoffman, I feel justified in considering them together insofar as both were students of Auguste Rodin and both were personally involved with the master. In addition, both were highly unconventional in their lives, experimenting with their passions and attempting to create material equivalences for them in their sculpture. Both women created highly charged sculptures of frenetically dancing couples. Hoffman's *Bacchanale* represents the famous ballerina Anna Pavlova (Hoffman's onetime lover) and her partner, Mikhail Mordkin, entwined in a vigorous Isadorian prancing movement. Claudel's scandalous *The Waltz* was originally rejected from the Salon because the male and female dancers were nude. In later versions, they were clothed but still palpitating.

The 20th century bore witness to a radical change in the nature of the sculptural enterprise, involving the evacuation of the traditional human body, nude or clothed, from the sculptural arena and, in some cases, the rejection of representation. Barbara Hepworth (1903–1975), certainly the most prominent woman sculptor of the earlier 20th century, worked in a generally abstract style, although her abstractions often suggested natural forms or human presences. The change in the nature of sculpture, which of course affected women sculptors as well as men, might be said to have occurred in two ways: first, the dematerialization and abstraction of the sculptural object; and second, the substitution of the found object for the carved or modeled one, the replacement of the traditional nude with the most ordinary objects, like the notorious urinal of Duchamp, or his bicycle wheel or bottle rack.

Goodbye to all that: contemporary women and the sculptural object

Women sculptors may be numbered among the most radical of the vanguard artists of the 20th century.

Among the most memorable are Eva Hesse, Louise Nevelson, Lee Bontecou, and Louise Bourgeois, the latter two still creating and showing their art. All four of these remarkable creative figures conspicuously altered the very notion of what sculpture might be: Hesse, by choosing new, sometimes soft and dangling sculptural materials,

hanging and grouping organic entities in irregular anti-architectonic compositions; Nevelson, by transforming humble bedposts and banisters into monumental iconic painted assemblages; Bontecou, by creating evocative, roughly stitched canvas or burlap constructions stretched over metal frames and suggesting war-torn turf and shell craters to some, scary female sex organs to others.

Bourgeois' production has been so varied that it is almost impossible to summarize, consisting as it does of object-filled, cage-like pavilions, menacing, metallic spiders, deliberately "formless," meltingly abject, and gooey sculptural deposits and hangings, and, on the other hand, finely articulated marble hands, torsos, or other body parts. Whatever she has done, her work has marked the shape of sculpture and installation today.

Revising sculptural tropes

Recently, the British sculptor Rachel Whiteread has completely revised the notion of sculptural form, the independent object conceived in relation to space, by substituting the container for the thing contained, a time-honored rhetorical strategy. She has done this most notably in her full-scale cast of a house slated for destruction in London, but also in many other projects involving casting. Substituting the shell of a house or a room for the people who occupied it, or the chair for the person who sat on it, is a metonymic strategy with a strong potential for evoking human aura in the total absence of the actual figure. Whiteread's series of bathtubs in various materials, cast from the actual objects but lacking specific definition, have a precedent in the artistic practice of the past. In the 19th century, a simple chair might evoke a missing presence. In the drawing of Charles Dickens' empty chair that appeared in the London journal *Judy* in 1870, at the time of the beloved author's death, the famous chair Dickens wrote in appeared woefully bare in front of the author's abandoned desk, still covered with manuscript, surrounded by subordinate sketches of scenes from his stories and novels. Vincent van Gogh obviously resorted to this rhetorical figure, and probably this very source, when he painted the two famous chairs, his and Paul Gauguin's, at the time of the fateful visit of his friend to Arles in 1888. Whiteread, however, has departicularized and depersonalized the motif in her multiple works, referencing human absence in general rather than that of a specific person.

In the present exhibition, an artist like Sarah Lucas goes a step further, bringing gender conflict into the mix, evoking a fallen and abject female body by means of an empty wash bucket and a pair of discarded pantyhose in her sardonic *The Sperm Thing* [p. 309]. In the Italian Monica Bonvicini's installation *Bonded Eternmale*, it is the association between modernist decor, male bonding, and power that is brought to the fore, by means of two 1954 standard-issue Willy Guhl leather chairs and a side table with a whiskey bottle painted in black. The gender issue asserts itself without resort to representations of men and women. In a similar way, we immediately define as feminine

the little situation evoked by two chairs, two pairs of slippers, and a sort of lumpy TV screen in Tracey Emin's *The Interview*. The basic chairs, the slippers, the whole decor is deliberately scruffy, sub-ordinary, unsettlingly domestic. Are the pathetic chairs supposed to stand for interviewer and interviewee? Are they supposed to evoke housewives watching an interview? You can use your imagination to create an apposite narrative.

These works by contemporary women artists raise another issue for the skeptical viewer: can multipartite installations like these even be considered sculpture?

I would say that some contemporary installation art may indeed be thought of as a kind of expanded sculptural field, in which several objects coexisting in space, coherently and meaningfully related, constitute a postmodern version of the traditional heroic sculptural group or monumental public complex. Installations like Pinaree Sanpitak's *Temporary Insanity*, made out of silk, synthetic fiber, a battery, motor, propeller, timer, and sound device, can evoke emotional dissonance and extreme disarray as effectively as the flailing and lamenting marble figures in the classical Niobid group. The seemingly endless procession of empty children's shoes constituting Leung Mee Ping's *Memorize the Future* evokes the national destiny of 21st-century China as effectively as François Rude's *La Marseillaise* could invoke the heroic post-revolutionary future of 19th-century France.

Yet women sculptors have not completely abandoned the human figure in recent years. Kiki Smith has created memorable examples of the male and female nude that evoke the sculptural precedents of the past and at the same time break away from the constraints of both the classical and the medieval traditions. The first Kiki Smith piece that I remember seeing created a visceral shock like almost no other. I can still summon up the intensity of the feeling, as though the bottom had suddenly dropped out of the sedate world of the gallery and my own place within it; to put it more physically, I felt it in my guts. This work was *Tale* [p. 291], a sculpture in wax and papier-mâché. It represents a naked woman, roughly modeled, down on all fours, crawling painfully across the floor, which expands into a desert-like stretch of difficult-to-navigate terrain. I don't remember the head or the details of the front of the figure at all, apart from a drooping breast—for good reason. All attention was focused on the looming rear end, the filthy buttocks and the rectum from which emerged a literal "tail" of shit—or perhaps a long, long intestine, or both. The play on words of the title is meaningful: "tale," or story; and "tail," or rear appendage. For both are at play in the horrifying power of the image. The excretory "tail" generates, or has been generated by, a "tale," a story stemming less from Legends of the Saints or the Lives of the Christian Martyrs than from more up-to-date sources, like the accounts of modern torture in Elaine Scarry's book *The Body in Pain* or the annals of Amnesty International.

The human body—or its regressive mutation—is the subject of Patricia Piccinini's part-endearing, part-repulsive piece *Big Mother* [p. 340], a work in "silicone, fiberglass, human hair, leather, and diapers"—hardly the *matière* of classical nudity! Piccinini's

work raises the question of just what constitutes the human itself. What is the boundary line between the human and the animal species? Still today, this question perplexes scientists and laypersons and raises the specter of racial difference as well, by implication. In another sculptural group by this inventive artist, *The Young Family*, the startling realism of the pinkish, naked hide of the represented creatures suggests a kind of counter-Darwinian slippage of *Homo sapiens* back down the ladder from which mankind ascended, in which cute, puppyish babyhood assumes the pathetic guise of beastly monstrosity when full grown. At the opposite end of the evolutionary ladder, as it were, is the South Korean artist Lee Bul's *Cyborg W5*, in which technology has imperceptibly taken over the realm of the organic, producing an artificial, futuristic monster-humanoid, neither creature nor thing but something of both, complexly modeled in white polyurethane.

Patricia Piccinini, *Big Mother*, 2005. Silicon, fiberglass, leather, human hair, 68⅞ × 35⅜ × 33½ in. (175 × 90 × 85 cm)

Lee Bul, *Cyborg W5*,
1999. Hand-cut
polyurethane panels on
FRP, urethane coating,
59 × 21⅝ × 35⅜ in.
(150 × 55 × 90 cm)

The subject of death, so often dealt with in sculptural form in the memorials of the past, still occupies contemporary women working in the medium. Iskra Dimitrova of Macedonia has created a new kind of memorial in the tellingly titled *Thanatometamorphosis*, casting her own body in black wax to evoke mortality—a "death transformation" in the most literal sense—and setting the body afloat in a glass pool, eerily evoking the context of mortality by means of light, liquid, and the sound of the artist's voice. A very different kind of metamorphosis takes place in the Iranian artist Mandana Moghaddam's *Forty Braids of Hair II*, in which women's braided hair assumes unwonted power by suspending a concrete block 27 inches above the floor: a kind of monument to feminine muscularity from an unexpected source. More explicitly connected to the funerary monument, and deliberately politically provocative, is the Mexican artist Teresa Margolles' *Burial*, a small, simple block of cement encasing a human fetus, paradoxically memorializing a single potential life and, at the same time, challenging the repressive legal systems that prevent women from having control over their own bodies. The fact that the fetus itself is invisible, merely suggested, makes the work all the more powerful in its silent evocation of pain and injustice.

341

Traditional distinctions between sculpture, painting, and architecture are rejected by Adriana Varejão, a Brazilian artist, in her *Linda da Lapa*, a powerful and heterogeneous work in which the architectonic, the decorative, and the organic are melded in a hybrid of surprising emotional intensity. At once evoking the destructiveness of war in its ruined walls, and the murder of human victims in the hyper-realistic blood and guts dripping over the brightly painted tiles, Varejão's work is a monument to modern social and political violence, recalling the intensity of William Blake's "London," in which the 18th-century English poet calls up "the hapless Soldier's sigh / [that] Runs in blood down Palace walls" to evoke the heartless cruelty of his own day.

Adriana Varejão, *Linda da Lapa*, 2004.
Oil on aluminum and polyurethane, 157½ × 66⅞ × 47¼ in. (400 × 170 × 120 cm)

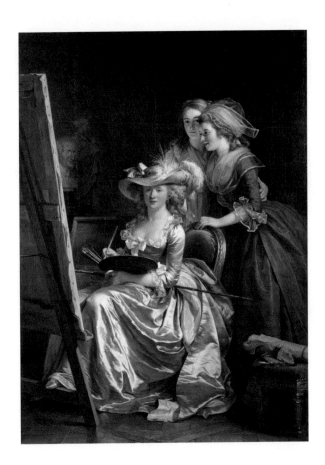

Adélaïde Labille-Guiard,
*Self-Portrait with Two
Pupils, Mademoiselle Marie
Gabrielle Capet (1761–1818)
and Mademoiselle Carreaux
de Rosemond (died 1788)*,
1785. Oil on canvas,
83 × 59½ in.
(210.8 × 151.1 cm)

Contemporary women artists and the self: identity and masquerade

"Je est un autre" proclaimed the adolescent Arthur Rimbaud in one of his infamous "Letters of a visionary" in 1871. "The 'I' is another" might be the theme song for contemporary women artists invested in the realm of self-representation. It is obvious that Cindy Sherman, in her revolutionary *Film Stills*, conceived of the "I" as "an other"—many others, in fact—in a remarkable series that used the self to eradicate selfhood in favor of perpetual masquerade. Yet even in the traditional female self-portraits of the artist of the 18th, 19th, and early 20th centuries, the "I" of the woman artist is a problematic one. Women artists, from the 18th century, were confronted by a dilemma, conscious or not, when they turned to self-representation. If, on the one hand, they emphasized their mastery, their technical prowess, and their artistic prominence, they might be condemned as "unwomanly"; if, on the other hand, they insisted on their feminine vulnerability and charm in constructing a pictorial alter ego, they might be scorned as inadequate artists. Compromises and clever solutions abounded in the realm of the female self-portrait. Adélaïde Labille-Guiard, a brilliant technician of the 18th century, turned to elegant clothing (satin and a hat to die for!) as well as a bevy

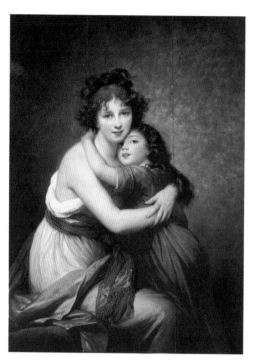

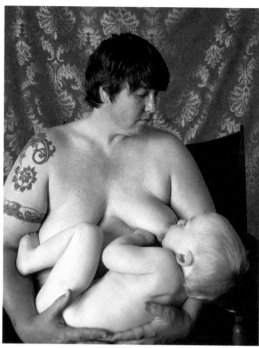

Élisabeth Louise Vigée Le Brun,
Self-Portrait with Daughter, 1789.
Oil on canvas, 51⅛ × 37 in. (130 × 94 cm)

Catherine Opie,
Self Portrait/Nursing, 2004.
C-print, 40 × 32 in. (101.6 × 81.3 cm), edition of 8

of ancillary female students to create an appropriately "motherly" context, which at the same time stressed her ability to convey artistic know-how to a group of followers; Mme. Vigée Le Brun, one of the most popular portraitists of the late 18th and early 19th centuries, posed embracing her daughter; and Berthe Morisot represented herself in the company of her daughter Julie. Motherhood has always served as an obvious guarantee of femininity for aspiring women artists. It is precisely around the issue of motherhood that the contemporary photographer Catherine Opie makes her powerful intervention into conventional gender identity. Opie rejects the time-honored connection of maternity with normative femininity. Instead, she creates an image of butch, tattooed madonnahood that, in its plangent physicality and formal elegance, gets right to the heart of the matter. It is precisely because the maternal image is so tightly entwined with stereotypical femininity that Opie's self-image as a nursing mother so brilliantly forces us to reconsider our preconceptions.

The pregnant body, another seemingly unqualified signifier of femininity, is viewed head-on and without reverence in Yurie Nagashima's photographic self-image, in which the artist as potential mother exposes her crotch, her bulging belly, and her scorn for rules of health and decorum by smoking and blatantly giving the finger to the viewer, to the guy who got her into this state, and presumably to the whole concept of

motherhood. Nor in these days, when digital alteration of the photograph plays such an important role, can the pregnant body be considered an unqualified guarantee of feminity: Hiroko Okada's *Future Plan* #2, a jokey Lambda print of two half-nude, big-bellied young men grinning at their undeniably pregnant condition, makes the point that even in this indexical medium, motherhood, or potential motherhood, is no longer gender-specific.

Yet it is not just the signs of maternity that inflect the female self-portrait with salutary feminine overtones, either today or in the past history of the genre. A simple "Portrait of the Artist" like that of Hortense Haudebourt-Lescot, alone at her easel, facing the spectator, brush in hand, manages to evoke a double source, accounting both for artistic prowess *and* feminine allure in a single image. The rich, subdued palette, the shadowy ambience, the black velvet beret, the gold chain, and the expressive pose, at once self-contained and vulnerable, all recall Rembrandt's self-portraits. Yet at the same time, the delicate impasto of the pearl earrings, the evocative mood, and the feminine details of the costume are reminiscent of that master's portraits of women, especially his *Hendrickje at the Window* (1656–57). It is tempting to think that Haudebourt-Lescot fused the two Rembrandtian prototypes to create an image that is a portrait of the artist and, at the same time, the portrait of a woman.[7] The doubleness inherent in the project of self-representation for the woman artist could later be deployed in the service of vanguardism, as when Paula Modersohn-Becker daringly depicted herself naked in 1906 in

Yurie Nagashima, *Expecting-Expected*, 2001.
Chromogenic print, 68⅞ × 85¾ in. (175 × 218 cm)

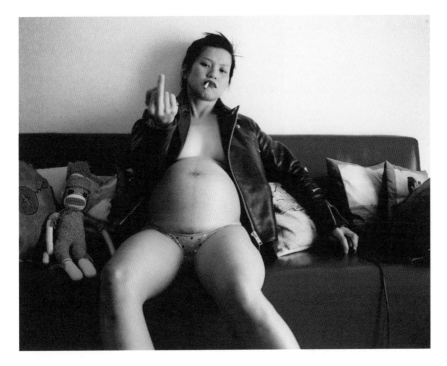

a "Portrait of the Artist as a Female Nude," as it were. The German artist combines two time-honored genres—that of the self-portrait and that of the alluring female nude— in a single startling image. Inspired both by Cézanne's Bathers and Gauguin's primitivizing Tahitian *vahines*, the artist's intelligent, individuated head challenges the spectator and contrasts with the rather abstract, decorative conception of her naked body. Adorned with a string of beads and holding a flower rather than a brush, the setting a garden rather than the traditional atelier, Modersohn-Becker nevertheless suggests her profession by pointing toward her breast meaningfully, in a distant echo of Albrecht Dürer's self-aggrandizing gesture in his engraved self-portrait of 1500. It was rare enough for a male artist to depict himself in the nude, as it is still today, despite notable exceptions such as Lucian Freud or John Coplans' photographs of his own body parts; but for a woman artist to do so was particularly transgressive. It is as though women artists had no right to their own bodies: the female nude "belonged" by right to the male painter. A good measure of this transgression remains in Alice Neel's nude *Self Portrait*, here with the added scandal that the woman artist's body in question is an old one, depicted with all its sags and wrinkles, rather than being young and alluring.

For today's young artists, the naked self-image is standard practice but one that appears more often in the context of performance, photography, or video rather than in painting (and often in a narrative situation). Of course, the tradition of naked women performance and video artists goes back to the work of such pioneers as Carolee Schneemann, Valie Export, and Marina Abramović, as well as to the provocative photographic self-images of Hannah Wilke with her bubblegum wounds. Today, the tradition

Paula Modersohn-Becker, *Self-Portrait (Semi-Nude with Amber Necklace and Flowers II)*, 1906. Oil on canvas, 24 × 19⅝ in. (61.1 × 50 cm)

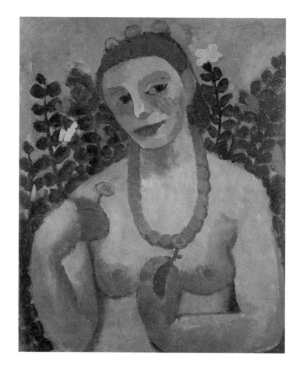

continues in renewed form, often with political overtones, in works like Tanja Ostojic's Internet project *Looking for a Husband with an E.U. Passport*, or Milica Tomic's single-channel video *I Am Milica Tomic*.

The ambiguity and instability of gender identity haunts many contemporary women artists' self-images, as does the deliberate contravention of the social order such gender-bending instates.[8] Sometimes, gender ambiguity is expressed forthrightly and with clear overtones of sacrilegious mockery, as in the Israeli Oreet Ashery's *Self-Portrait as Marcus Fisher I*, a Lambda print in which the rabbinical-looking figure, complete with the felt hat, beard, and side curls of the Orthodox Jew, gazes down in astonishment at the naked female breast that has unaccountably sprouted through his white shirt. In other cases, like the British artist Gillian Wearing's *Self-Portrait as My Uncle Bryan Gregory*, from the *Album* series, the male relative has simply taken over the portrait-image. One can hardly talk about ambiguity in this instance, since the signs of the feminine author have been entirely occluded by successful masculine masquerade. But in other photographic self-portraits by women artists, the transformation of the sitter-artist into a boyish male has overtones of political contestation, as it does in the Moroccan Latifa Echakhch's *Pin-Up (Self-Portrait)*, in which the young woman poses confrontationally on an Oriental carpet wearing a man's shirt and jeans in an uncompromisingly "masculine" pose. Nothing could be further from the conventional sexy pin-up here, although a certain gender ambiguity is betrayed by the tentativeness of the glance and the slight swelling of the breasts beneath the manly shirt. These elements become more telling if they are contextualized within the setting of a Muslim culture in which the wearing of the veil is a hot issue for young women. Cass Bird's *I Look Just Like My Daddy* raises similar questions in an all-American setting. The identity problem is written right across the boyish young sitter's hat. Of course, this is probably not a self-portrait at all, but the unflinching directness of the gaze suggests that it might be. Still, ambiguity, gendered or otherwise, is not the only strategy that has been and continues to be deployed in the construction of meaningful female self-representation. Romaine Brooks, for instance, an American artist living in Paris in the early 20th century, stages herself unequivocally as a lesbian in her memorable self-portrait. Yes, her outfit is mannish, her expression severely contained, but she does not try to make you think she is actually a man, rather insisting upon her specifically lesbian elegance and identity as a member of the cosmopolitan community of creative women living in Paris at the time. More recently, a performance artist, Pilar Albarracín [p. 348], unequivocally pillories popular stereotypes of Spanish womanhood by first assuming the role of the passionate flamenco singer (who ultimately stabs herself in the belly in a wild frenzy of exuberant *duende*), and then transforms herself into a housewife who literally takes the clothes off her back to create her perfectly cooked frittata. Is the self in a self-portrait singular or plural? This is the unexpected question raised by Amy Cutler, who literalizes and proliferates Rimbaud's "Je est un autre" in her gouache *Army of Me*. In this work, the artist confronts an endless

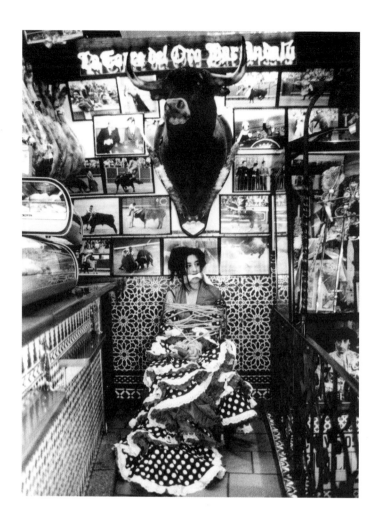

Pilar Albarracín, *Prohibido el cante*, 2001–13. Black-and-white photograph, 67⅞ × 49¼ in. (172.5 × 125 cm), edition of 5 + 1 AP

array of women just like herself—but different in pose and clothing. If "je" is really an other, why can't the "I" in question be many others, not merely one? This proposition is staged in very different form, with different implications, in the Japanese artist Tomoko Sawada's *ID400 (#201–300)*, a series of one hundred gelatin silver prints created between 1998 and 2001 in which the artist assumes an entirely different, and unrecognizable, identity in each little group of ID photos. Sawada's work suggests not so much that "I" is another but, as in the case of Cindy Sherman's many untitled images, that "I" does not exist at all, or if it does, it exists *only* as Other. Carey Young, on the other hand, suggests, tongue in cheek, that an identity can be constructed by corporate training programs. In her brilliant and frustrating video *I Am a Revolutionary*, she attempts, unsuccessfully, it must be admitted, to repeat the words establishing her credentials as a revolutionary with sufficient conviction to please her male coach. It is clear he will never be satisfied with her performance, her "revolutionary" identity never established in the Baudrillardian world of corporate simulacra.

Yet the self-portrait of the woman artist *qua* artist is still a viable proposition. Take, for example, Elke Krystufek's *Space Cadet*, in which the Austrian artist creates a confrontational image in acrylic on canvas, combining words and a self-image, of her situation as an artist. Eyes staring, blood trickling from her nose, her hair in wild disarray, she notes on the background of the canvas a number of contemporary paradoxes, like, "the disappearance of the body in cyberspace but in fact one is still dragging that sucker around all the same." And to her left is inscribed the impossible question: "How can one be an artist without being an artist?" and then "the silent artist—a dinosaur in the digital age." Or, in a very different vein, there is Angela de la Cruz's version of the self-portrait, in which the representational aspect has disappeared in favor of the materiality of the objects of representation: paint, stretcher, canvas. Our old friend, the metonymic chair, makes its appearance once again, this time as the signifier of the artist herself, who is no longer a necessary presence. Only what the artist produces counts, and The Work, independent and authoritative, hangs on the wall in its solitary splendor. In *Self*, a multipartite work, de la Cruz is metaphorically and materially asserting that the work is the self, and the self the work. She does not think it necessary to specify the gender of the self in question.

Angela de la Cruz, *Self*, 1997.
Oil on canvas and armchair, 39⅜ × 39⅜ in. (100 × 100 cm)

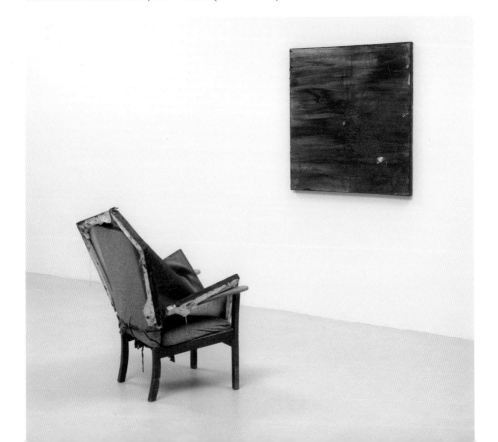

Returning to the comparison I began with, between the exhibition of thirty years ago and the one of today, I think I am entitled to use the forbidden word "progress." To say that there has been progress in the art world is almost a kind of blasphemy. Aren't things getting more and more commercialized, hasn't art lost its aura completely, hasn't art-making simply become a money-making venture like any other? I would say no to all these critiques, especially where women artists are concerned. Never before have women assumed such prominent positions in the arena of the visual arts, both as producers and as curators. Women artists can be said to have succeeded only when their presence in the art world assumes the dimensions of a critical mass, not simply a rare, if admired, aberration. Although that goal has not yet been achieved globally, there has been significant movement in that direction, including the present exhibition, to a degree never before achieved. Even if it were for just this reason alone, the Brooklyn Museum show would be an occasion of celebration.

Notes

1 Ann Sutherland Harris and Linda Nochlin (1976), *Women Artists: 1550–1950*, Los Angeles, CA: Los Angeles County Museum of Art; New York, NY: Alfred A Knopf.

2 See Robert Rosenblum (1957), "The Origin of Painting: a Problem in the Iconography of Romantic Classicism," *Art Bulletin* 39, pp. 279–90; George Levitine (1958), "Addenda to Robert Rosenblum's 'The Origin of Painting'," *Art Bulletin*, 40, pp. 329–31; and Frances Muecke (1999), "'Taught by Love': the Origin of Painting Again," *Art Bulletin* 81, pp. 297–302, for accounts of this fascinating theme. It is noteworthy, however, that according to the terms of this allegory, it was love that led a woman to create a painted image, rather than innate ability: without the guidance of Cupid, it would not have happened.

3 Kate Linker and Maurice Berger (1999), quoted on the web page devoted to "Mary Kelly: *Post-Partum Document*," University of California Press website, http://www.ucpress.edu/books/pages/8495.html

4 Robert Storr (2005), *Elizabeth Murray*, New York, NY: The Museum of Modern Art, p. 63.

5 Ghada Amer, quoted in Hilarie Sheets (2001), "Stitch by Stitch, a Daughter of Islam Takes on Taboos," *New York Times*, November.

6 Henriette Bessis (1980), *Marcello* Sculpteur, Fribourg: Musee d'Art et d'Histoire de Fribourg, p. 8.

7 I have resorted to my own text of almost half a century ago on this work; see Nochlin, *Women Artists: 1550–1950*, catalogue no. 75, p. 219.

8 Judith Butler's (1990) *Gender Trouble: Feminism and the Subversion of Identity*, New York, NY: Routledge, is almost required reading for some of this work.

24
Cecily Brown:
The Erotics of Touch

Cecily Brown, 2007

It is the facture that immediately strikes one in looking at a retrospective of the paintings of Cecily Brown. That, and the seriousness and ambition of her production as a whole. Her work, far from being a sort of fluffy Abex lite spiced up with some titillating erotic details, as some of the critics would have it at the beginning of her career, has assumed the status of a complex and stimulating meditation on the nature of painting and the place of the human figure within it. The erotics of pigment has a place within this purview, but it is hardly the whole point of it.

Certainly, her paintings make reference to the act of painting, painting as a process. And within this process, the sex act serves as both an analogy and a specific referent. Male artists have often made the explicit comparison between painting and fucking: Renoir, for instance, said that he painted with his prick. Brown has made it possible for critics to speak of sex in relation to a woman artist—and it's about time.

Less noticed has been the importance, indeed the centrality, of *touch* in Cecily Brown's painting practice. Here, I think the specter of Cézanne and his insistence on touch as the constitutive element of pictorial creation arises, whether or not Brown specifically acknowledges it.

Touch is, of course, the primary sense at play in the throes of lovemaking, an activity that often takes place in the dark. Although the sense of sight may ignite desire, the latter rarely finds its consummation in broad daylight. In many of Brown's paintings, it seems as though she is retaining a pictorial equivalent of that haptic ardor consuming the partners in the throes of sexual pleasure: touching, squeezing, rubbing, stroking, roiling the thick gobs of paint onto the canvas. The sense of touch, then, is at once transformed into visual equivalents in Brown's work, but at the same time remains present to it, untransformed, in the actual, material pigment traces deposited by the forceful or subtle touch of the artist's brush or knife on the linen canvas, so crucial to her formal and expressive enterprise.

In terms of evolution, it is tempting to see Brown's work "progressing" from the graphic specificity and crowded spatial stage of pictorial orgies like *The Gang's All Here* of 1997, with its multiple penises and intertwined bodies awhirl in a cyclone of vivid color, or the intensely embodied pleasure panorama of *Seven Brides for Seven Brothers* of

351

1997–98, in which two large-scale nude bodies, male and female, dominate the scene, surrounded by erect penises and welcoming cunts, to the more abstract but no less eroticized compositions of later date. It is interesting, in view of Brown's own pictorial self-awareness, not to speak of her consummate knowledge of the history of painting itself, that she returns to her own earlier work only to dismember it and recreate its sexual energies in terms of abstract broken planes and coloristic bravura, in the significantly titled *Gangbusters* of 2001, surely a reference to the 1997 *The Gang's All Here*.

In *Lady Luck*, a large canvas (over 8 feet by over 9 feet, 254 × 279.4 cm) painted mainly in tones of red and pink, the agitated brushstrokes set off the large-scale head dominating the heart of the linen support. It is a woman's head, and it is upside down, suggesting (pace Bazelitz) a female subject, a surrogate self, perhaps at the height of sexual ecstasy. The de Kooning-like activation of the surrounding canvas at once calls up the intensity of the emotion and the disintegration of self that takes place during orgasm. The upside-down parted lips may evoke the vaginal lips and the shape of the face is indeed womblike, but at the same time, Brown unites the signs of sexual ecstasy with those of death. The open-mouthed head is also a skull, its heart-shaped glasses— although the nearest thing to a "still center" in the painting, reflecting both artist and viewer on their surfaces—also intimate the hollow eye sockets of the classical death's head. Brown's paintings often make reference to this confluence of sex and death, a traditional motif much favored by Elizabethan lyricists, for example, where "to die" is a euphemism for having an orgasm.

Yet it would be a mistake to see Cecily Brown's evolution as an artist in terms of a simple passage from greater naturalism to dominant abstraction. No more than Picasso does Brown feel obligated to submit to outmoded Greenbergian teleology. Two quite

Cecily Brown,
Lady Luck, 1999.
Oil on linen,
100 × 110 in.
(254 × 279.4 cm)

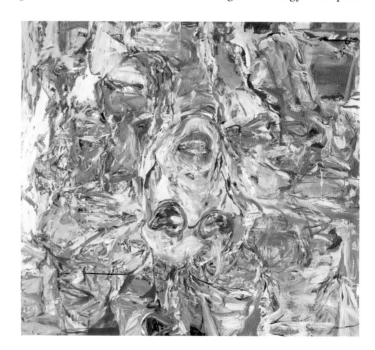

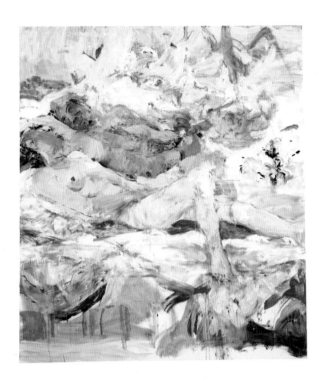

Cecily Brown, *These Foolish Things*, 2002. Oil on linen, 90 × 78 in. (228.6 × 198.1 cm)

readable nudes, male and female, dominate the canvas in *These Foolish Things* of 2002. The scenario seems companionable rather than conventionally erotic: each figure seems to be pleasuring him/herself while turning to his/her partner appreciatively, as though sharing notes. Erotic excitement is transferred to the surrounding white sheets and drapery: drippy, liquescent, oozy, suggesting literally the aftermath of a sexual encounter. Harking back to a tradition originating in the red-figure vase painting of ancient Greece and moving down through the Renaissance to the nude nymphs and satyrs of Watteau in the 18th century, Brown paints the male figure a dark bronze, the female figure a seductively creamy, paler tone. Yet one would never, for this reason, mistake Brown's couple for one by Boucher or Fragonard. It is precisely the willed difference from precedent that makes this, and many of her other canvases, so forcefully of the present.

Cecily Brown's painting reveals a deep awareness of the Western tradition throughout the course of her career. And, of course, the representation of sex and violence forms an integral part of that tradition, indeed, lies at its very heart, as Louvre curator Régis Michel so convincingly revealed in his revolutionary exhibition *Possess and Destroy: Sexual Strategies in the Art of the West*, which took place at the Louvre in 2000 and included work dating from the 16th century to the present. *The Quarrel* of 2004 may first strike the viewer as a Cézannesque amalgam of nudes, green leafage, and space, conjured up by bold variations in the touch and density of pigmented strokes on the surface of the canvas [p. 354]. But to the knowing eye, memories of Titian's lusty *Bacchanal*, various Renaissance and Baroque *Rapes of the Sabines*, with their lusciously

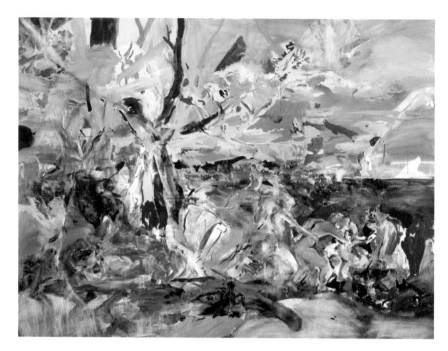

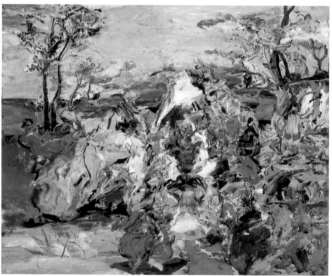

churning female nudes and fiercely grappling warriors, or even Degas' *Incident from the Middle Ages*, with mounted soldiers shooting at naked female victims, come to mind. It is surely no accident that Brown herself painted a Titianesque *Bacchanal* in 2001, but a *Bacchanal* that suggests rather than depicts the violent encounter of the sexes proffered by the traditional prototypes.

Brown herself has stated that her painting is about painting, in this sense, a modernist project. "The more I look at paintings," she asserts, "the more I want to paint, the more engaged I become and the deeper and richer it gets."[1] Certainly this is true, but there is more to be said about her relationship to the art of the distant and more recent past. A work like *Quarrel*, or many of the works in the present show—such as *Figures in a Landscape 2* of 2002 or the aptly titled *I Will Not Paint Any More Boring Leaves 2* of 2004— constitute a quarrel with the past, or at least a violent engagement with it. Looking at paintings, for an artist as ambitious and talented as Brown, whether it be the precedent of Titian, of Cézanne, or more recently and recognizably that of de Kooning, must be a fraught and difficult experience; it is by no means the calm incorporation of a benign "influence" into one's own work. It is precisely this sense of struggle, of grappling with the problems of painting and the ever-present challenge of painting's past, that gives so much vitality to Brown's work—and provides surprises as well.

Recently, in *Aujourd'hui Rose* of 2005, the artist has turned to the startling theme of the *memento mori*, the metamorphic skull, reminiscent of the skull hidden at the heart of Holbein's monumental *Ambassadors* at the National Gallery in London. Yet perhaps one should not be surprised at the emergence of this topic in Brown's work, which has always had its dark side, most explicitly in the "Black Paintings," like her Goyaesque *Black Painting 1* of 2002 [p. 356], where the nude figure sensuously outstretched on a bed, executed in grisaille, seems to be tormented by a host of dimly adumbrated demonic creatures emerging from the sinister darkness above his head. Or one might even turn

Cecily Brown, *Black Painting 1*, 2002.
Oil on canvas, 80 × 90 in. (203.2 × 228.6 cm)

back to the apparently pleasure-riven orgasmic head of the brightly painted *Lady Luck* for a precedent for this intermingling of life and death in a single image. I first saw *Aujourd'hui Rose* at the recent Frieze Art Fair in London, and was immediately struck by its poignant evocation of various stages of feminine life in a single image, muted in color, vivid in its dark implications. Despite its wide-ranging thematic scope and stylistic variety, or perhaps because of it, Brown's work displays an admirable consistency of theme and purpose throughout. The body of work she has produced in a relatively short time makes Cecily Brown a major figure to contend with in the contemporary revival—or revivification—of the ambitious field of oil painting, a medium that, despite all the publicity about its demise, has never really died.

Notes

1 Robert Enright (2005), "Paint Whisperer: an Interview with Cecily Brown," *Border Crossings*, no. 93, February, p. 40.

25

Existence and Beading:
The Work of Liza Lou

Liza Lou, 2008

> Pleasure and pain are my themes.
>
> <div align="right">LIZA LOU</div>

My first critical response to Liza Lou's classical installation *Kitchen* (1991–96) [p. 359] was far from critical: more on the order of "Wow!" a kind of mindless, astounded gasp, my brain unable to credit the testimony of my eyes. So many beads! So many years of toil! So much glitter! So big, yet in terms of its surface marquetry, so small! So contemporary yet so absolutely Byzantine! California pop embroidered by a feminist maniac! Keinholz's dark social critique seen through the eyes of the Wizard of Oz! Primitive Technicolor filmed in all its primal glitz by a mad housewife!

All this is by way of saying that my first verbal response could not be literal description; it had to be metaphoric in order to bear the sheer *excessiveness* of the conception. Lou blithely mingled the "true" with the "false," the naively imitative with the blatantly commercial. The idea of a "natural" substance had lost its meaning: water, the fluid element was frozen into decorative, curvilinear patterns while the stable wood-grain of the cabinets had assumed an uncanny dynamism. Lou played with her phenomenological contradictions the way late capitalism plays with commodities themselves, refusing the natural and accepting the deceptive, the artificial, the blatantly gaudy as the way things are, especially in suburban California at the end of the 20th century.

Yet, after being overwhelmed by the totality of the beaded kitchen, the life-size thing-in-itself of the piece, I automatically zoomed in to enjoy the details. All the richness, kitschiness and seductive pleasure of the work lies in the details: *Kitchen* is the sum of its parts and Lou's esthetic here, briefly described, is simply *horror vacui*. There are no spaces in this installation—no neutral backgrounds where the beleaguered eye can take its rest, no cranny where the artist's maniacal decorative impulse has failed to work its will.

Take the concept of water; or better yet, think of water as it is usually represented in naturalistic art: a substance defined by its evanescence, transience, foaminess, and insubstantiality. Courbet's cresting, impastoed waves or Monet's thinly brushed lily ponds come to mind. Now look at Liza Lou's water, "pouring" glitteringly from the kitchen spout: the artist insists that we see it as both artificial and real at once. Twisted,

irregular strands of blue and crystal beads emerge "formlessly" from the spout and then gradually assume a regular pattern of repeated spirals, darker blue enlaced with green, as the water levels off in the sink itself and assumes the circular shape of the artsy-craftsy pottery plates immersed in the glittery grasp of its implacable swirls. The sink is one of my favorite places in the *Kitchen*: it is so rich in contradiction, so gorgeous in its beady plenitude, so earnestly effortful in its attempt to fake reality and so honest in its refusal to do so.

Of course, there are other almost equally seductive bits in the *Kitchen*: the open oven, for instance, with its glittery cherry-filled pie—and hidden within its blazing red maw, some comic Barbie soft-porn pin-ups. The suburban oven as the Mouth of Hell? Barbie as a damned soul, consumed by General Electric flames? Why not? But we turn away, as we are meant to, to the everyday stability of the beaded Cap'n Crunch box on the checkered tablecloth, the convincingly random bits of refuse in the green-handled dustpan. The initial "Wow!" turns into "ooh" and "ahh" as we come upon ever more enchanting feats of beaded persiflage. It is rather like our childhood reactions to that perfect dollhouse in the shop window, the one we could never have, the one with *everything*. *Kitchen*, among other things, is a vision of unattainable utopian plenitude.

Brilliant and original though *Kitchen* and its plein-air pendant *Back Yard* (1996–99) may be, they did not rise full-blown from the head of Liza Lou, like Athena from the head of Zeus, but came into being within a certain geographic and temporal context: California in the 1970s and 80s is the background, pop the sensibility, feminist the gender. Think *Womanhouse* (1970), a Los Angeles project under the direction of Judy Chicago and Miriam Schapiro, with its domestic rooms: bathroom, bedroom, kitchen, memorable for its fried-egg/breast decor or, on a more ambitious level, Judy Chicago's *Dinner Party*, with its roots in women's craft and creative communality and cooperation. Think of Keinholz's bitterly socially critical installations of the same period. Despite the difference in intention, the playing down of specific gender or social advocacy, and the totally different esthetic results, it is important to remember such sources in approaching Lou's early installations.

Given the colorful gorgeousness and glitter of much of Liza Lou's earlier production, and its generally domestic subject-matter, the artist's major exhibition at White Cube in London two years ago came as something of a shock. In these installations—the life-sized prison *Cell*, the ragged *Comfort Blanket* or the stark bucket and noose of *Stairway to Heaven*—the decorative material (the signature glass beads) previously deployed to enliven surfaces in scenes of hyper-domestic tranquility have metamorphosed into the dreadful grunge of the prison cell, the overt threat of barbed wire, or the bare appurtenances of a prison suicide. A sinister neutrality of color and stifling of formal prolixity defines these objects as the furniture of absolute social constraint. By a sort of reverse alchemy, the colorful glitter of hysterical consumerism is transmuted into absolute dispossession, overabundance into total lack.

Liza Lou, *Kitchen*, 1991–96.
Glass beads, wood, wire, plaster, artist's used appliances, 2016 × 2016 in. (5120.6 × 5120.6 cm)

The constricted cubic space of the prison cell is of course the obverse of the world of conspicuous consumption and the spurious plenitude of *Kitchen* or *Back Yard*.[1] A terrible coldness, like a poisonous vapor, is projected from these unexpectedly somber bead-created objects. Indeed, the texture and color of the beads themselves have suffered a sea change. The interior of *Cell* (2004–6) is a case in point. The crude, rough cement blocks are water-stained and broken, their harsh surfaces created by thousands and thousands of *vertically* inserted glass beads. Patterning has been abandoned for uneven breaks and blemishes; the scarred, dirty floor, in its turbulent puddles of lighter and darker beads looks like a Jackson Pollock in a close-up photograph but is utterly persuasive in its illusionism when seen in context.

The prison toilet—*Loo* (cast resin and glass beads, 2006)—is a point of particularly malevolent focus. Not since Duchamp's *Urinal* has a simple bathroom fixture been forced to bear such a freight of evocation. Yet the point of Duchamp's piece was that it was a simple found object, transformed only by signature and site into a "work of art." Liza Lou's *Loo*, on the contrary, is the product of the most artful illusionism, deceptive

to its core. The ordinary disgust one would feel for the stained interior of a stark, filthy prison toilet is undercut almost immediately by our recognition of the extreme technical prowess of the piece—she has done all this with tiny, softly glowing glass beads! The shit stains, the irregular rust marks are—let's face it!—gorgeous! Through the transformatory power of craft, this most abject of objects is transmuted into a political shrine for our times. Indeed, to push the analogy even further, *Loo* can be read as a kind of religious object, a reminder of the tortured body that used it, like the reliquaries of the Christian martyrs. It is, however, secular, political torture—South Africa immediately springs to mind, but it could be Guantánamo or Abu Ghraib or any other political prison—that is the referent here. This subliminal reference to events that we know about is what makes the object a contemporary one, directly moving rather than nostalgically sentimental.

For premonitions of the dark mysteries of these later installations, one must turn to another medium, performance, and Liza Lou's intense performance piece, represented in the video *Born Again*. There is, of course, a relation between installation and performance as media through their contemporaneity, their apparent rejection of the conventions of traditional art forms as irrelevant or outdated, and their insistence on the idea of *presence*, spatial or corporeal, as a guarantor of authenticity. Both genres seem to reject the constrictions of traditional art practices like painting or sculpture with their formal canons. For the performance or installation artist, immediacy implies honesty. Yet, paradoxically, in both installation and performance, presence is often mediated by photography or video. In the case of Liza Lou's installations, it is photography that most often records the actual piece. When I write about the installations, what I am talking about is memory and photography, and most often, scintillating details rather than totalities, since it is the fantastic, glittering details that are most convincingly captured in reproduction, the individual bead-patterns making their most striking artificial/naturalistic effects in close-ups.

In the case of Liza Lou's unforgettable performance piece *Born Again*, or rather its video presentation, the carefully framed headshots impart a seeming irrefutability to the life-story recounted on screen. The blond, angelic head, in close-up almost throughout, the hypnotic voice, throbbing with folksy pathos and sincerity, the script, retailing a Gothic tale of sudden conversion, transformation, personal belief, maternal piety, paternal brutality and abuse, but above all, through the detailed sub-story of the fate of the beloved pet, taken away, disciplined, tortured, lost forever—surely an avatar of the child-victim herself and a guaranteed tear-jerker—all this is inscribed on the video screen as absolute autobiographic truth. The sheer intensity of the artistic performance and its documentation overwhelm the spectator's critical faculties: presence in this case, seems to serve as a guarantee of reality. No more than *Kitchen* or *Back Yard* is *Born Again* "real." But unlike them, its goal is to convince the viewer that this is unedited, unscripted personal history. The performance piece, with its emphasis on human suffering, leads indirectly to the three-dimensional work from exhibitions at Galerie Thaddaeus Ropac

Liza Lou, *Born Again* (film still), 2004.
DVD, duration: 50 minutes

and White Cube, pieces like Adam and Eve (*The Damned*) or Christ Carrying the Cross (*The Vessel*), in that the artist is able to enter, convincingly, into the pain of others while exploring the physical dimensions of suffering inscribed in the beaded body. These works, like the performance piece, suggest an ambiguous relationship to the heroes of Biblical history and to faith itself. Her Christ figure, *The Vessel*, kneeling under the weight of a single bar of the cross, is provocatively headless. *The Damned* (2004) clearly derives from the Adam and Eve of Masaccio's *The Expulsion from the Garden of Eden*. Seen from the vantage point of this shame-bent couple, ousted from the Garden of Eden, their gold-beaded bodies bulging with the muscles of trained athletes (the modern equivalent of classical perfection?), the earlier *Back Yard* and *Kitchen* lose their optimistic sparkle and *assume* the forlorn status of Paradises Lost and irrecoverable.

In her most recent work, Liza Lou returns to brilliant color, pattern and decoration— but with a shocking difference. Instead of suggesting California plenitude or American glitz, these large-scale bead-works (reliefs rather than installations) evoke the disasters of war through the incursion of violence into formal pattern. The subliminal referent is always, it seems to me, warfare and military oppression: the agony of the Middle East, of South Africa, or our own sequestered prison camps in Guantánamo and elsewhere.

In the first of these large-scale relief "tapestries," *Axis Defeat* [2] [p. 362], the complex, multicolored Persian ruglike pattern, a pattern which is also multilayered with differ- ent areas of beads projecting further into space than others, is savagely interrupted by irregular areas of red, suggesting fierce gouts of blood dripping down over the tender blue support. At the same time, the very formal structure of the piece gives way to encroaching barbarity, chaos and destruction. The brilliant red color, which exists as

part of a controlled, repetitive pattern at the top of the relief, gradually escapes from its decorative, ceremonial constrictions, soaks into the support and then flows downward in untrammeled, formless malevolence as it reaches the base, itself eroded, the blue replaced by irregular, muzzy white bead formations. Little hints of disintegration are provided throughout by filmy intrusions blurring clear contours, effacing the decorative bead-structure of the whole. One thinks of Yeats' memorable lines from "The Second Coming:" "...Mere anarchy is loosed upon the world,/The blood-dimmed tide is loosed, and everywhere/The ceremony of innocence is drowned...."

A work of similar ambition, *Offensive/Defensive* suggests both a richly patterned rug and, at the same time, an architectural ground plan or an aerial view of a sacred building with an elongated apse. Incursion rather than destruction seems to be the thematic key here. Irregular black networks of protruding beads, sometimes closely grouped, sometimes loosely strewn and scattered, seem to emerge from the top of the building,

Liza Lou,
Axis Defeat, 2007–8.
Glass beads on
aluminum panel,
108 × 66 in.
(274.3 × 167.6 cm)

Liza Lou,
Offensive/
Defensive, 2009.
Glass beads on
aluminum panel,
72 × 36 in.
(182.9 × 91.4 cm)

moving out from an initial entry-point. Dry rot? Termites? Or, more aptly, an invading army, as seen from the air, taking over with their sinister, dark anonymity, desecrating the beautifully articulated, multicolored, lozenge-patterned integrity of a sacred space. If one looks closely, one can actually see the individual, black verticals of each inserted bead pricking up aggressively from the vividly colored elements of the resplendent field.

Quick, Cheap, Overwhelming Victory [p. 364] allegorizes its arrogant martial message with precious metal. The 24-carat gold-plated beads that construct most of the surface of the piece, each area differentiated by length and complicated by varying depths of raised and sunken relief, are anything but "cheap"—extremely costly, in fact: both literally, as artistic material, and figuratively, in that the victory in question costs enormously

in terms of lost lives and destroyed environment. The irony of the "quick, cheap, over-whelming victory" is reinforced by the blood red, irregularly intrusive margins of the piece. Yet the handiwork here, the sheer brilliance, complexity and inventiveness of the artist's deployment of red and gold beads to create a counterpoint of depth, regularity and resonant deviation from pattern is so compelling, so esthetically satisfying that, in detail, allegory fails (or fades away) and we are engulfed in pure pleasure.

Gold beads, 24 carat, are also the precious material deployed in a work of total simplicity, *Barricade*, a large-scale, free-floating construction suggesting both the men-acing interruption of free access to space and an assertion of power, and at the same time the ultimate vulnerability of all such protective strategies, large or forceful as they may appear to be. Even more ambitious is the multi-storied *Tower*, a series of cages 30 feet high, constructed of glass beads, razor wire and steel, installed to great effect in the stairwell of L&M Arts. Liza Lou confided to me that she was distressed by some minor

RIGHT Liza Lou,
*Quick, Cheap,
Overwhelming
Victory*, 2008. Gold-plated beads on
aluminum, 72 × 36 in.
(182.9 × 91.4 cm)

OPPOSITE Liza Lou,
Tower, 2008. Steel,
razor wire, glass beads,
355 × 30½ × 30½ in.
(901.7 × 77.5 × 77.5 cm)

imperfections in the corner joinings of the individual cages, which to me seemed almost invisible. Here, to me, is the craftsman or woman's dilemma: is imperfection a flaw or a positive element in the handcrafted, or would-be handcrafted object? There are several ways of considering these revealed, or over-emphasized joinings: for the modernist, they might be deemed necessary articulations of the boundaries of the individual cage-elements within the totality of evenly criss-crossed horizontals and verticals, "form following function," as it were. For Ruskin, and the 19th-century proponents of the craft esthetic, these imperfections, roughnesses and deviations from mechanical perfection constituted the presence of the human touch, the very touchstone of good craftsman-ship itself. Imperfection breathed life into the crafted object, and was therefore a moral as well as an esthetic desideratum.

Security Fence replicates in steel and glass beads those threatening barbed-wire-topped enclosures designed to keep intruders out and enemies in—imprisoned, that is.

Eight feet square by 8 feet tall, the structure is chillingly human in its scale, shining with the mock-menace of silver-lined glass beads. The details of the encircling barbed wire at the top are reiterated with painstaking accuracy, like serial crowns of thorns, every bolt and brace clearly articulated. *Maximum Security*, a large, cross-shaped wire pen installed at Lever House belies the religious implications of its form and the shifty moiré patterns of its wire structure. It recalls the 19th-century Panopticon, described by Michel Foucault in his classic *Discipline and Punish: the Birth of the Prison*, a vision of hapless prisoners subjected to ceaseless surveillance under the eye of the watchful guard stationed at the center of their radiating cells. Both *Security Fence* and *Maximum Security* can fruitfully be compared with more particularized visual images in which barbed wire plays an esthetic and expressive role, works like the South African photographer David Goldblatt's highly specific *Shoemaker on Raleigh Street, Yeoville, Johannesburg, 14 September 2006*, in which the entire subject—human figures and scrawled graffiti—is seen through and partially obliterated by the repeated swirls of barbed wire on the protective chain-link fence running parallel to the picture plane. Says Tamar Garb, organizer of *Home Lands-Land Marks: Contemporary Art from South Africa*, the brilliant show in which this black-and-white photograph appeared: "It is through cages and grilles that many South African structures must now be viewed, but this creative jumble of grids and fencing provides its own unique patterns and shapes...."[3] As is the case in Goldblatt's photographs, there is a certain esthetic of the documentary at work in Liza Lou's installations which underpins their formal elegance with a sturdy, factual eloquence.

Liza Lou, *Maximum Security*, 2007–8.
Steel, glass beads, 282 × 80 in. (716.3 × 203.2 cm)

Liza Lou speaks about constructing these works in her studio in South Africa near Durban. Her assistants are South Africans, mostly women, who have a long, robust heritage of bead-craft, and she acts as a choreographer of the project, directing skilled and experienced craftspeople who often sing as they work, and sometimes question her about the crazy effects she wants to achieve with her beads, outcomes so different from those of their traditional patterns. Yet one has a vision of harmony and teamwork, of the empowering psychic energy produced by demanding craftsmanship well done. One thinks back to the craftsmen's shops of the Middle Ages, to the hopeful and productive ateliers of the talented and ambitious women in the Arts and Crafts movement in this country early in the 20th century, of *Womanhouse* with its fried-egg kitchen and menstruation bathroom, of Judy Chicago and her band of volunteers working together to create that pioneering feminist installation, *The Dinner Party*, in the early days of the Women's Art Movement, or of the group cooperation involved in the creation of Liza Lou's own, earlier large-scale installation, *Back Yard* in the late 1990s. The term "obsessive" has been used to describe the incredible, detailed, repetitive work that went into the beading of *Kitchen*. Of course, one could also speak of Seurat's relentless application of small, evenly spaced dots of color to the surface of *La Grande Jatte* or *Le Chahut* as "obsessive" too, or the demanding work of lace-makers or embroiderers. There are ample satisfactions to be found in cooperative creative repetition, akin to those obtained by musicians or dancers who are often called on to repeat sounds or steps.

The critic, Peter Schjeldahl, reminisces about his participation in *Back Yard*: "Then there is the collective labor that went into the *Back Yard*. Many afternoon parties of volunteers gathered to produce blades of virtual grass for the piece's tousled lawn. (As the creator myself of twenty-one of the finest blades, I can tell you how it's done. With tiny pliers, crimp an end of a four-inch wire, slip on one round bead—a drop of dew, dig—and enough cylindrical beads to fill the wire, and then crimp the other end. Presorted by Lou, your beads' colors occupy some part of a grassy spectrum from lush green to withered yellow.) This aspect of the work," Schjeldahl continues, "suggests a participation mystique or communitarian agenda like that of Christo's public-art circuses,"[4] or, he might have added, Judy Chicago's righteous feminist collective creation. Schjeldahl rejects such an agenda on Lou's part, attributing to her instead "the fearsomeness of the true artist's ruthless drive." Is one creative position necessarily so different from the other? Can't there be some overlap, some fruitful contradiction at play? In any case, Liza Lou's practice, like Seurat's, is vastly different from the art of "personal signature" of an artist like Monet or Van Gogh or Jackson Pollock, where the marking of the surface seems directly linked to the ambitious hand and extruded emotion of the maker.

Craftsmanship also implies that the work is handmade, by the craftswoman or craftsman him or herself or with the aid of willing assistants. We don't expect craftsmanship from Jeff Koons or Donald Judd, who send their work out to fabricators; they spurn the craftsmanly presence, as it were, the monotonous making of the same

gesture over and over again. Yet a certain rapport with the repetitive is the very mark of much craftsmanship: weaving, embroidery, stitchery—feminine crafts traditionally. Like Seurat's dotted surfaces, Liza Lou's beadwork at once implies the human presence, the all-important decision of the artist at each point in the process of creation—yet is impersonal. It is very different from Monet's or Jackson Pollock's touch, which is recognizable as the trace of the artist's brush, the signature of a powerful individual.

Liza Lou's project, like that of all artists, involves both pain and pleasure. When asked by an interviewer whether her work process, with all its difficulty, tedium, and at times, apparent impossibility of completion provided a kind of catharsis for her, the artist replied: "Catharsis would suggest an end in sight. I like to keep the wound fresh, and so I keep working."[5] Fortunately for us, her audience, there is no end in sight.

"It's agonizingly slow work. I became interested in finding the perfect circle, the perfect bead. Each tip needs to be perfectly smooth, no jagged edges. The beads are balanced onto their tips one at a time with tweezers, in a very precise, exact method. The diameter of each bead is quite slender, necessitating a specially trained crew of people to perform this very slow balancing act."[6]

This unexpected resuscitation of contemporary abstraction was hinted at in the artist's exquisite drawings of minute bead sequences translated into lithographs, such as the diptych *Analogous Mountain*, scaled-down agglomerations of what Eva Hesse, cued by mathematical definition, called "Tori" in her sculpture of 1969.[7] Liza Lou renders the adhesion of such tiny shapes as disrupted unities suggestive of pullulating landmasses and breakaway peninsulas.

These kinds of "discovered" shapes and forms, when scaled up again, also suggest the often jagged disruptions which sprawl across the rug's initial pattern, but now raised in slightly higher but still shallow relief, the thinness of a second layer of beads upon the first. While these tossings suggest torn or tattered passages in the original rug they are really abstract counter-movements across the basic patterns, superposed "interruptions" predicated solely on taste and felt necessity.

Esthetic agreements taken for granted have long been up-ended. Replacing abstraction's purity-think Robert Ryman, Mark Rothko or Ad Reinhardt (their art, that is, not their politics)—the feminist politics of the 1970s are now fundamental to contemporary studio practice. What was once a supposedly gender-blind abstraction (provided you were ignorant of the sex of its creator) is now explicitly gender-coded, and abstract painting—marginalized by conceptual and deconstructive strategies—has been relegated to but a narrow toehold in the making of contemporary art. Hence, the recourse to eccentric, signature substances has become standard operating procedure and the use of beads, to mention only one possibility, is an artistic option that, even if rarely exercised, is nonetheless perfectly natural.

In the hands of Liza Lou the bead becomes a speck akin to a stitch, a dot—recalling Georges Seurat's pointillist dot, Roy Lichtenstein's Ben-day dot, or Paul Klee's dot

that takes a walk, the *spaziergang* of the tiniest visual impulse that leads to drawing and its immense consequences, as Klee reminds us in the opening of his *Pedagogische Skizzenbuch* (1924).

Forty years ago, Eva Hesse showed that gender did not have to be constructed iconographically—through images of things—but abstractly, through gender-coded processes (knitting, weaving, etc.) or through the use of eccentric materials. Such substances, owing to their frequently human associations—blood, say, or hair—were often keyed to the female "blood mysteries"—blood into milk, say—a transubstantiation normative to "tribal" culture, hence marginalized when not wholly taboo in the West. Thus, the tribal fetish also became a source for the eccentric materials so congenial to Feminist art. Still, while the bead is also an index of craft, it is hardly craft we think of when speaking of Liza Lou, but rather of a complex of ironies regarding "beadwork" specifically and "women's work" generally.[8]

The works that first brought Liza Lou to renown are two room-size environments. The first, *Kitchen* (1991–96) [p. 359] is replete with sink brimming in soaking dishes surrounded by a surfeit of household appliances and brand-name comestibles, all fashioned from intensely colored, glistening beads. When installed at the New Museum, *Kitchen* caused enormous consternation. Who was this unknown "girl" who undertook a project lasting more than five years, one that fell stylistically between pop art and feminist theory?

Kitchen was followed by *Back Yard* (1996–99),[9] a work also "obsessively" beaded, though the artist finds the adverb off target. "I reject the word obsessive. It's more clichéd, insensate, shallow, folksy, dumb psychobabble. My work is not the result of a mental disorder. It is serious, determined work. The closest thing I can relate it to in terms of process is sitting Zazen,"[10] she writes, referring to the form of Buddhist meditation marked by strictly prescribed sitting and hand positions. The experience of losing oneself in a working process is not uncommon when small repetitive, focused and incremental steps made over long periods of time are the central creative focus. Think Brancusi. He also experienced such a "loss of self" when at work. It helps clarify the often lofty, spiritually-associative titles of his sculptures. The method is a kind of litany.

In *Back Yard*, a picnic table laden with food-filled paper plates is set amidst a swath of lawn, the grass formed of hundreds of thousands of hand-threaded single blades. The threading of these myriad blades of grass—its uncanny allusion to Walt Whitman's "Leaves Of Grass" a value-added plus—was realized in a Californian community effort, an early model for Liza Lou's subsequent collectivist working method.

These famous installations are almost "awkward" when compared to the sophistication of the present work, so much so as to demarcate an early, "ungainly" pictorialism supplanted by a suppler, virtuoso mode indicative of the recent phase of the artist's stylistic development.

Both *Kitchen* and *Back Yard* exemplify processes of attraction/repulsion, a fetishization that, for Freud, inhabits an angst-ridden mental space spanning the anger at the loss of the penis he attributed to women and, perhaps, his own terror of the vagina, one he adumbrated as a boy's petrifying first glimpse of his mother's genitals. Such unnerving insights into the functioning of the mind have been radically revised when not wholly rejected by subsequent psychoanalytic and feminist theory. Today, the fetish is open to less luridly dramatic, not to say malign interpretation, and is seen as a prime expression of tribal culture. The latter is a point of honor for Liza Lou since her hugely labor-intensive work is made in KwaZulu-Natal, South Africa, capital of the most skilled of the Zulu bead-workers.

Still, for all the stringing and threading to be found in Liza Lou's work, there is scant work on the loom—the weaving of beads into patterns associated not only with South African but with Native American beadwork too. In Liza Lou's work, the bead covers every surface like hoar frost or a crystallized sugar coating, a tenacious shimmering sprawl; but very little of what is conjured by the bead-weaving germane, for example, to the belts and wampum of the indigenous Americans, nor the vast collars and necklaces of the Zulu nations, is present.

An important power reversal has taken place. Except for the affinity to the material, it is Liza Lou who is bringing a new technique to the South Africans and not the other way round. In so doing she eludes a colonialist exploitation of the methods of a subjugated people. Through an admixture of time, imagination, labor intensiveness and communal life, Liza Lou has found a way to work beads, basically a familiar material, and to transmit this new method to her associates. In this intimate exchange her work remains political, rooted in feminist thought, and still speaking truth to power.

While Liza Lou's work may bring the elaborate studio systems of Jeff Koons, Damien Hirst or Takashi Murakami to mind, her "low-tech" specialization and "hands-on" connectedness to her work and her college of workers is utterly at odds with the "state of the art" techno-fetishization that marks the "first-world" sense of accomplishment and its obsession with capitalist/individualist ends—a fall-out quite the reverse of Liza Lou's collectivist aspirations. The world of Koons, to take a glaring example, is the consumerist fetish—extreme perfection of execution expended upon objects of profound ambiguity—think *Hanging Heart* (1994–2006). There is nothing "touch-sensitive" there, that formal index so inextricably associated with feminist method, and one still typical of Liza Lou's work for all its recent refinement. Her continuity is with postminimalism's absorption of feminist principles. It is no stretch to affiliate a work like *Continuous Mile*, with its mile-long cord woven out of glass beads and cotton, to Eva Hesse's progenitive, infinitely coiled *Hang Up* (1965–66) or to Jackie Winsor's *Double Bound Circle* (1971), both exemplary postminimal masterworks.

Why the bead in the first place? Why should that curious, punctured glass seed be used as the artist's primary medium? Several replies to this question have already been

suggested above. But, responding to the direct question, the artist replies, "Well, why not? I am very interested in labor, in the accrual of time and material, pattern and repetition. The material satisfies a tendency that I have to work in a methodical and slow way. But it seems I bring this tendency to my work no matter what the métier. Drawings, for instance. Scale is very important to me. The macrocosm and the microcosm."

Still, that Liza Lou's sculpture gives one pause to ponder the age-old imposition of subservience upon women or, by extension, the new, putative independence of South African women is, in itself, no guarantee of its being enduring art; for that, one need but wait. But to place it there by critical fiat is also an anachronistic assumption denied by the deconstructive and feminist biases that animate Liza Lou's art—so opposed is she to the sexist drift of pre-conceptual art with its age-old, eroticized objectification (and implicit denigration) of women.

Since one deconstructs ideologies through an inversion of the forms used to bolster the ideology in the first place (for example, the use of advertising as an anti-capitalist conceit), the principles on which Liza Lou's artistic strategies ultimately rest (apart from the belief in the possibility of pure beauty) are deconstructive tactics aimed at the demolition of institutionalized sexism (and racism) by a politically sophisticated artist who, at the same instant, creates fetishized objects of intense desirability.

Inhumane incarceration, for example, establishes the literal dimensions of *Cell* (2004–6) as it recreates an inquisitorial claustrophobia rendered exquisite by beaded shimmer. Ditto, *Security Fence* (2005) with its tiara of razor wire—like a crown of thorns seemingly transformed by glistening beads into magical branches of icicles. And this braiding of attraction/repulsion with a strand of deconstruction also remains true of the chain-link holding pen, *Maximum Security*.

Liza Lou loves and hates the consumerist signs of the objects upon which her celebrity rests—and through which she deconstructs consumerist ideology. Indeed, to conjure beadwork today, in the US, at least, one doesn't necessarily think of art; luxury objects also come to mind—*étuis* and *minaudières*, the *pavé* of tiny crystal beads set upon gold or silver compacts or evening clutches. But all that is far too easy. Actually Liza Lou's work implicitly argues against the facile appeal to beauty—the kind, say, registered in Damien Hirst's *For The Love Of God* (2007)—that notorious platinum and diamond-encrusted skull. True, while a *memento mori*, its tragic consciousness is compromised by the artist's congenial embrace of the commercially viable, something that, as yet, has not tainted Liza Lou's work and against which she is ever vigilant. Indeed, one could say that, in Damien Hirst's case, the very proof of its status as a work of art is coeval and congruent with its monetary worth. It is art because it is valuable. Which is less an indictment of current social values than it sounds; it is merely a statement of contemporary *Realpolitik*, our "facts on the ground."

Still, the contrasts, as have already been drawn in this essay, are neither qualitative nor moralistic, however much—arguably—there is a touch of the "politically correct"

and the "culturally diverse" in Liza Lou's work (and far more in her reception). For this critic, art exists beyond the assertions of quality and, possibly, even those of morality, however much morality and quality (those permeable terms) may be spurs to decisive artistic action. As *Rezeptiongeschichte* demonstrates (that is, the history of the early criticism of an artist's work), the terms by which an artist is appreciated are set early in his or her career. In Liza Lou's case, while her ideas may flatter the political consciousnesses of a liberal audience, these ideas are also the ones that will redeem her work after the reactionaries have done their worst.

To be sure, Liza Lou's project is antithetical to fetishized consumerism. Or, perhaps, it is better to say that the artist is twin-minded about this association, as appalled by its commercialism and as she is drawn to the pretty and the feminine as an ironical tactic. Liza Lou is both mesmerized and traumatized (other manifestations of attraction/repulsion) by the fetishized appurtenances of the privileged European or American woman as she reproduces them as class and social indictment, if not even as bitter comedy. And, in so doing, she creates startling, glamorous works of art whose secret treachery illuminates their disturbingly subversive desirability.

Notes

1 Although, see the more masculine interior installation, *Trailer* (1999–2000) which, in its sinister grungy decor and darker tonalities, as well as masculine boots and guns, provides a kind of linkage between the domestic scenes and the later prison thematic.

2 The titles are derived from the names of strategic army operations. The work, glass beads on aluminum panel, measures 108 × 66 in. (274.3 × 167.6 cm).

3 See Tamar Garb, *Home Lands-Land Marks*, catalogue, London: Haunch of Venison, 2008, p. 19.

4 Peter Schjeldahl (1992), "Splendor in the Grass: Liza Lou and the Cultivation of Beauty," in P Schjeldahl and M Tucker, *Liza Lou*, Santa Monica, CA: Smart Art Press, p. 21. The book contains a long list of helpers acknowledged by Liza Lou in a section called "The Dignity of Labor."

5 Tim Marlow, interview with Liza Lou in *Liza Lou* (2006), catalogue, London: White Cube, p. 12.

6 All direct quotations from the artist come from an email from Liza Lou to Linda Nochlin, June 11, 2008.

7 Webster's Dictionary defines the term in geometry: "A surface, or its enclosed solid, generated by the revolution of a conic section, especially a circle, about any axis in its plane

other than its diameter: also tore." With regard to the Hesse sculpture, Lucy Lippard notes that "Hesse chose the geometrical definition of the word, which she heard from Robert Morris..." See L Lippard (1976), *Eva Hesse*, New York, NY: New York University Press, p. 156.

8 Irony demands an awareness of two things: the first is knowledge about that which the irony is being ironical; and second, an appreciation of its new ironical representation. In time, this dual appreciation is lost and the ironical representation becomes the new paradigm admired for its fresh formal properties, and a new style has been reified.

9 The year the artist was awarded a MacArthur Grant, the so called "genius" grant.

10 Even granting the return to a murderous tribal xenophobia in South Africa under a compromised President Mbeki fully complicit in Robert Mugabe's reign of terror in neighboring Zimbabwe—the source, I might add, of many concerned emails between this writer and the artist. Fearing for her safety, I press her to leave. Instead, she chooses sisterhood and solidarity with her cooperative and remains there.

26

Black, White, and Uncanny: Miwa Yanagi's *Fairy Tale*

Heavy Light: Recent Photography and Video from Japan, 2008

If there is a single thread tying together the highly variable stylistic strands in the work of the young Japanese artist Miwa Yanagi since the appearance of her memorable series *Elevator Girls* in 1998, it is its unremitting concentration on women and their situation. The *Elevator Girls* series, staged in glowing Technicolor, grew out of performance and involved female models standing or sprawling in exaggeratedly postmodern settings enhanced by elevators, escalators, and other hoked-up appurtenances of luxe cosmopolitan consumption. Carefully groomed women impersonated the Barbie-like hostesses paid to take care of visitors to Japanese department stores. Digitalized to increase the uneasy sense of the vast, depersonalized commercial spaces of international consumerism—Pascal's memorable "Le silence de ces espaces infinis m'effraie" might serve as their logo—the series nevertheless focused on the Japanese particularism of the black-haired, red-uniformed protagonists, who stand rigidly at attention or fall pathetically in dainty heaps on the tilting pavements.

Despite Yanagi's critical attitude toward contemporary social mores embodied in these prints, they clearly reject the documentary sensibility associated with traditional photography of social critique. Artifice, demonstrated artifice, is the name of the game, and "revealing the device"—making evident the constructed nature of the photographic environment—is a prime strategy of her project, and remains so in all her work.

Yanagi's next series, *My Grandmothers*, begun in 2000, is both more dynamic in style and less pessimistic in sentiment than *Elevator Girls*, although equally self-conscious in its strategies. Here she used her models' conceptions of what they might be doing and how they might be looking in fifty years as the basis of a series that posits old age as a site of dramatic feminine liberation. *Yuka*, the most memorable image of the series, has become a poster girl for the joys of (imaginary, of course) female postmenopausal self-determination and pleasure. Here, the heroine, her ostentatiously dyed red hair streaming in the wind behind her, opens her mouth in a cry of triumphant exultation as she speeds past the Golden Gate bridge in the sidecar of her much younger and much dimmer boy toy's motorcycle. Still other works from this series, all modeled by much younger women in masks and make-up, represent an embracing lesbian couple, an elegant older woman traveling first-class in a luxurious airplane, and still another

steering her own glider with great self-assurance. Perhaps Yanagi is suggesting that for women, always remaking their appearances to accord with social expectations in their youth, old age itself is a kind of benign disguise, the open sesame to a magic kingdom of self-determination.

Between 2003 and 2006, Yanagi created her most recent series, a group of highly finished black-and-white photographs, square in format, dealing, for the most part, with the narratives of traditional Western fairy tales.[1] The *Fairy Tale* series includes many grandmothers, too, or rather, young girls disguised as grandmothers; the whole series is staged by children *en travesti*. But the *Fairy Tale* old women are hardly the benign and self-determining senior powerhouses-of-the-future envisioned in Yanagi's earlier series: on the contrary, they are a sinister lot of old crones, ruthless and scary hags, going far beyond the boundaries of decorum established by traditional illustrations of the genre in their equivocal grotesquery. Included in the core of the *Fairy Tale* photographs are two images of Eréndira, not a traditional fairy-tale girl at all, but the inspiration of the series as a whole, as she appeared in Gabriel García Márquez's eccentric short story, itself inspired by traditional folklore, *The Incredible and Sad Tale of Innocent Eréndira and Her Heartless Grandmother*.[2]

I would first like to make some remarks about the series as a whole, then focus on some individual images, and finally locate this group of works within the larger context of recent fairy-tale investigation by scholars and fairy-tale representation by contemporary women artists, concentrating particularly on a single tale, "Little Red Riding Hood."

The *Fairy Tale* series as a whole is calculated to construct an aura of the uncanny, both in its formal structure and in its willed perversion of the moral edification of the familiar 19th-century renditions of this time-honored folk genre in the hands of Grimm or Andersen, not to speak of the totally kitchified and sugarcoated versions offered by Hollywood in the form of the Disney epics. Here, in Yanagi's images, within the shadowy, spatially ambiguous, at times indecipherable stage sets constructed by Yanagi for the playing out of her perverse mini-dramas, the figures glow with a sinister pallor: spooky illumination and its natural sources are foregrounded—candles, daylight, fire-light—and youth and age, the latter signified by scary masks worn by equally youthful figures, battle it out for empowerment. I could not help but think of the masks of Noh theater in relation to Yanagi's practice.

The deliberate choice of black-and-white film is, of course, highly meaningful today, when much large-scale constructed or staged "art" photography is recorded in color film.[3] In the case of the *Fairy Tale* images, black-and-white serves several functions. First, it suggests the *inwardness* of these bizarre interchanges, the fact that they take place in the realm of the artist's and the viewer's imagination; in short, that they are fantasy images, connected with the strange displacements and condensations of the dream world rather than with everyday life. We are, after all, said to dream in black-and-white. In a sense, too, the reversion to black-and-white reduces the indexicality of these

ABOVE Miwa Yanagi,
*Fairy Tale Series: Little
Red Riding Hood*, 2004.
Gelatin silver print,
39⅜ × 39⅜ in.
(100 × 100 cm)

LEFT Gustave Doré,
Little Red Riding Hood,
1862. Engraving.

images: these days, we unconsciously expect reality to produce its trace in full color for full veracity. Yet at the same time, black-and-white may allude to the historical past of fairy-tale illustration, in particular to some of the best known and most highly charged illustrations of the 19th century, the marvelous engravings of Gustave Doré for "Little Red Riding Hood," which expose, albeit without premeditation, the sexual subtext of the moralistic good-girl story.

Miwa Yanagi,
*Fairy Tale Series:
Snow White*, 2004.
Gelatin silver print,
39⅜ × 39⅜ in.
(100 × 100 cm)

Each individual print in Yanagi's series recasts and reinterprets a familiar tale in a highly idiosyncratic way. In *Snow White*, the protagonist and the wicked stepmother—mirror images of each other—confront each other in an arm wrestle for the fatal apple, a large, plastic number, as phony as the realistic old-hag mask sported by Snow White's wrinkly opponent. "Come on, eat up," suggests the text on the facing page. "No thank you," Snow White replies like a polite little girl. "Then have half with me." The stepmother here is illogically conciliatory, thereby presumably killing off both of them. There are simply times, Yanagi suggests, when compromise won't work.

In Yanagi's revisionist version of the Snow White tale, our heroine has wrestled the authority figure—the Bad Fairy? Grandma? A combination of both?—to the floor in a multi-windowed room filled with the appurtenances of spinning, a traditional occupation of the good woman: piles of uncarded wool, spools of yarn, a phallic distaff prominent in the foreground and another, discarded, on the floor to the right. Youth decidedly has the upper hand in this wrestling match of the generations, and the accompanying text bears out this message. "Time for bed." "I am not sleepy." "It is time to sleep." "Then you sleep first, Grandma."

One of the most memorable of the *Fairy Tale* images is a close-up portrait of Gretel, the heroine of "Hansel and Gretel." Significantly, brother Hansel is missing: there is simply no place for the male sex in this revisionist charade of the traditional tale. The

young girl playing Gretel lies on a rug, leaning toward the spectator, her face illumi-
nated by the light of a single candle. She gnaws tentatively on the desiccated finger of
a withered arm thrust through the chalkline bars indicating an adjacent cage. Clearly,
the wicked old witch does not have the upper hand in Yanagi's recasting of the story.
Who is supposed to be eating whom? The side panel reinforces the disturbing ambigu-
ity of the image.

"You look like a dry twig. Why don't you fatten up?"
"So I will never be eaten by you."

Hasn't Yanagi reversed the parts of Gretel and the witch? Wasn't it Gretel, in the
traditional story, who cleverly proffered a chicken claw instead of her arm to the witch
when the latter demanded to see if her victim was plump enough for consumption?
Who is keeping whom captive in Yanagi's version? Is youth getting the better of age once
more? Yet surely, Yanagi's Gretel, if dominant, doesn't look very happy. This ambiguity,
if not actual role reversal, continues in the most parodic staging of the series, *Cinderella*
[p. 378]. Set in a nocturnal chamber before a blazing fireplace filled with the requisite
cinders—Cinderella/cinders, get it?—the tableau features two wistful, small-footed
"sisters" to the left and a decidedly large-footed, boyish "Cinderella" to the right, a
gangly teenager who throws herself back into the arms of a masked "older" character,
her wicked stepmother, also barefooted, holding a candle. This unstably posed heroine,

Miwa Yanagi,
Fairy Tale Series:
Hansel and Gretel,
2004. Gelatin silver
print, 39⅜ × 39⅜ in.
(100 × 100 cm)

her jaunty legs revealed by the firelight gleaming through her transparent skirt, seems to be muttering an aside to her grotesque partner: "Compared to your huge feet, look how dainty ours appear." Perhaps the underlying message here is that sisters, even evil stepsisters, should stick together and resist the unreasonable demands of their elderly caretaker. Once more, the divisions are generational and Yanagi leaves the interpretation open to viewers.

The *Fairy Tale* photographs, powerful, puzzling, phantasmagoric, and ultimately highly disturbing, although meaningful in themselves, appear even more provocative when examined both within the context of recent investigations of the fairy-tale genre outside the realm of visual representation, within the disciplines of psychoanalysis, anthropology, and literary studies, where there has been a proliferation of what one might call "Fairy Tale Studies," as well as within the framework of fairy-tale images by other contemporary women artists. Examination of a fairy tale favored by women artists and pictured by Yanagi herself, "Little Red Riding Hood," is particularly apposite for this purpose.

As Jack Zipes, professor of German and doyen of contemporary fairy-tale studies, has pointed out, the fairy tale has the potentiality for spearheading a radical reexamination

Miwa Yanagi, *Fairy Tale Series: Cinderella*, 2005.
Gelatin silver print, 39⅜ × 39⅜ in. (100 × 100 cm)

of dominant cultural values at the same time that it serves, in its standard 19th- and 20th-century versions, to maintain the social order by punishing deviation.[4] Feminist criticism in particular, has revealed both the conscious and unconscious assumptions about female passivity, helplessness, and reliance on masculine assistance implicit and explicit to the plots of such old favorites as "Cinderella," "Snow White," and "Little Red Riding Hood." The latter tale has attracted the particular attention of scholars of folklore, literary scholars, and, last but not least, women artists.[5]

In a recent article, "Visualising Little Red Riding Hood," Sarah Bonner sets the stage for a full-scale examination of women artists' varied approaches to this fairy-tale theme. At the outset, she declares: "In recent years contemporary artists have been appropriating and re-inventing traditional fairy tales. Subverting and interrogating received meanings, artists are challenging the traditional parameters of tales which convey ideas of gender role and racial identity. The fairy tale is being translated from literary text into visual culture. The artists recoding the tales address shifts in cultural attitude, engaging predominantly with issues of identity and discrimination...The text and image are intimately related, yet I propose that the image contains qualities that release interpretation from the strictures of tradition, making them more relevant and immediate in contemporary society."[6] There is a plethora of Red Riding Hood illustrations, beginning in the 19th century and continuing more or less unabated until the present day, a history made partially available in a rather helter-skelter fashion by reproductions in several publications[7] and easily viewable by Googling "Little Red Riding Hood" images online. These include a series of brilliant lithographs by Doré, drawings by Walter Crane, and myriad plates illustrating various episodes—Red Riding Hood Meeting the Wolf, the Wolf in Bed, the Wolf Captured by the Brave Huntsman are favorites—by many little-known or anonymous draftsmen. Yet it is far more interesting to situate Miwa Yanagi's work, and in particular her version of the Red Riding Hood theme, within the context of contemporary art than simply to see it as part of a historical continuum. I have chosen to make a comparative examination of two very different contemporary interpretations of the theme by women artists: Paula Rego's *Little Red Riding Hood Suite*, six images in pastel, executed in 2003, and Kiki Smith's complex reinvention of the raw materials of the tale, taking inspiration from "recent literary subversions of the tale that promote the complicity of the girl and wolf, in a cultural climate that is concerned with alienation and difference."[8]

Rego's series of six pastels is relatively straightforward, if quirky. The artist hews closely to the traditional story, beginning with Red Riding Hood sent off to visit her grandmother, but violently disrupts and confounds the traditional narrative with dark irony in which her feminist revisionism shines forth with sardonic insistence. In Plate 4, we meet the Wolf, a fading hipster clad in skimpy, figure-revealing exercise clothes, the sort of aging male narcissist one would dread running into at a cocktail party. In Plate 3, *The Wolf Chats up Red Riding Hood* [p. 380], we have our protagonist sitting with

LEFT Paula Rego,
*The Wolf Chats up
Red Riding Hood*, 2003.
Pastel on paper,
41 × 31⅛ in.
(104 × 79 cm)

OPPOSITE Kiki Smith,
Daughter, 1999. Nepal
paper, bubble wrap,
methyl cellulose,
hair, fabric and glass,
48 × 15 × 10 in.
(121.9 × 38.1 × 25.4 cm)

the Wolf and staring up at his laughably inadequate Grandma disguise, as he stares down at her with an unpleasantly possessive leer. We now fast-forward to Plate 5, *Mother Takes Revenge* [p. 434], in which the maternal figure, armed with a pitchfork, spears the bloated, postprandial Wolf, who lies on her daughter's abandoned red cloak after eating her and presumably her grandmother as well. Mother obviously doesn't need the help of the traditional woodcutter or any other male do-gooder, thank you very much. In the final frame, *Mother Wears the Wolf's Pelt* [p. 427], Red Riding Hood's mother, clad in a chic red suit and matching hat, makes a solo appearance, swathed in her cherished wolf-skin stole. She crosses her excellent legs and looks up to the right slyly, as though flirting with an invisible figure. Throughout, Rego insists on the power, autonomy, and sexual viability of the mature female ego, to which both the little girl and her grandmother are, so to speak, sacrificed. The male seducer is, of course, utterly defeated.

Nothing could be more different from Rego's sardonic narrative of empowerment through female agency than Kiki Smith's variegated group of variations on the Red Riding Hood theme. There is no overt violence in Smith's multiple interpretations of the tale. Rather, the artist envisions complicity between girl and wolf, in that both are positioned as outsiders, nonconformists. In one statue, *Daughter* (1999), the red-cloaked figure of the young girl, immediately associated with the classical Red Riding Hood, confounds such simple identification by sprouting a beard, morphologically identifying

with her traditional predator and suggesting some of the uncanny, antisocial outsider-ness of the werewolf as well. In another, a bronze work titled *Rapture* (2001), a full-grown, mature woman steps forth confidently from the split belly of the wolf, lying recumbent on the floor beneath her. Gender identify itself is confounded, for the paradigmatically male wolf of tradition has morphed into a maternal figure. Or perhaps he has remained male and the woman has simply erupted from his carcass.

Miwa Yanagi, in her revision of the Red Riding Hood story, chooses neither alterna-tive: neither violent destruction nor accepting complicity with the wolf. The Red Riding Hood image from the *Fairy Tale* series is a strange one, at first glance repellent and frightening. We are looking down, as from a great height, at a gigantic, riven wolf skin, clotted with unspecified muck, from whose open belly emerge two figures: Little Red Riding Hood and her grandmother, wrapped in each other's arms, their faces framed by the mighty back paws of the fallen beast. Their faces and bodies are stained with unspecified dark fluid, their expressions noncommittal. The accompanying text con-firms their newfound status: "The two, rescued from the wolf's stomach, were newly born twins." The little girl and her grandmother, old and young women, figured as competing, often physically struggling entities in many of Yanagi's other prints from

the *Fairy Tale* series, are here seen as compassionate equals, redeemed to live anew in companionship. On closer inspection, it would seem that the wolf skin that shelters them was not violently cut apart by a woodsman's axe or any other weapon, but rather was zipped open like a sleeping bag. In fact, that is what it is in this contemporary version of the tale: a zippered, cuddly, if somewhat equivocal wolf-skin sleeping bag, not the corpse of a ravening monster at all.

Things are often not what they seem in Yanagi's evocative transformation of traditional fairy tales. Using the framework of the time-honored coming-of-age stories for young women as a starting point, the artist completely dislocates and subverts the meanings of her texts, encouraging girlish rebellion against the sinister forces of a decrepit authority that would keep her instincts repressed, her agency unexercised. Within the gloomy, ill-lit purlieus of a factitious unconscious, a shadowy and ambiguous dream world, Yanagi summons her forces and, on the whole, overcomes the enemy. Only through rebirth, a sea change wrought within the belly of the beast, can reconciliation be achieved, and if the expression of the little girl inside the charmed circle is any indication, this reconciliation is, at best, provisional.

Notes

1 The series of photographs exhibited and then published by Yanagi under the title *Fairy Tale: Strange Stories of Women Young and Old* (2007), Kyoto: Seigensha, includes other material as well. I will be focusing on the twelve central images in the series referencing the well-known fairy tales of Charles Perrault, the Brothers Grimm, Hans Christian Andersen, et al. It is in a sense ironic that the Japanese artist Miwa Yanagi concerns herself with the European fairy tale, whereas it was a Westerner, Lafcadio Hearn, who rescued the Japanese fairy tale from oblivion early in the 20th century. Hearn later adopted Japanese identity.

2 Atsuo Yasuda (2005), *Miwa Yanagi: The Incredible Tale of the Innocent Old Lady and the Heartless Young Girl*, Tokyo: Hara Museum of Contemporary Art, p. 7.

3 This is not always the case. See, for example, the recent show of Jeff Wall at White Cube, Piccadilly (2008) in London. There are many other exceptions, but I believe that most of them exclude the representation of the human figure. Wall is concerned mainly with slum architecture and urban decay.

4 See Jack Zipes (2002), *Breaking the Magic Spell: Radical Theories of Folk and Fairy Tales*, revised edition, Lexington, KY: University Press of Kentucky.

5 The literature on "Little Red Riding Hood" is extensive. I can only suggest some of the major contributions, many of them gathered in compendia of various authors' research and interpretation: see Alan Dundes, ed. (1989), *Little Red Riding Hood: A Casebook*, Madison, WI: University of Wisconsin Press, and Jack Zipes, ed. (1993), *The Trials and Tribulations of Little Red Riding Hood*, New York, NY: Routledge. The latter volume contains poetry and prose on the subject; some of the more recent contributions have a decided feminist edge, and the prologue, "Framing Little Red Riding Hood," is invaluable. Zipes returns to the theme in "A Second Gaze at Little Red Riding Hood's Trials and Tribulations" (1983–84), *The Lion and the Unicorn*, 7–8, pp. 78–109. The wide-ranging study by Catherine Orenstein (2002), *Little Red Riding Hood Uncloaked: Sex, Morality, and the Evolution of a Fairy Tale*, New York, NY: Basic Books, has an up-to-date bibliography.

6 Sarah Bonner, "Visualising Little Red Riding Hood," http://www.ucl.ac.uk/english/graduate/issue/2/sarah.htm, accessed November 15, 2007.

7 See, for instance, the volumes by Zipes and Orenstein cited in note 5.

8 Bonner, "Visualising Little Red Riding Hood."

27

Old-Age Style: Late Louise Bourgeois

Louise Bourgeois, 2008

What is an "old-age style"? Is it the same as a "late style"? Although the two terms are often used interchangeably, they are not synonymous in all cases. The late style of a Van Gogh or a Seurat, both of whom died in their thirties, is obviously not an "old-age style," but it does have characteristics that differ noticeably from the artists' earlier works. And the work of some artists in their old age is not different enough from their earlier work to constitute a separate category.

Traditionally, an old-age style was held to provide an elegiac climax to the earlier style of the master in question. In the case of the late Titian, the aged Rembrandt, the late Monet or the late Michelangelo, old age enabled an expansion of previous achievement, a style more unified, harmonious and universal, lacking in hard edges or petty detail, characterized in painting by a luminous softening of boundaries and expansion of brushwork, a generalized glow of colour rather than specific local tonalities.[1] In the later 19th century and the earlier 20th, the lauding of the late style, or the old-age style—the two terms were used almost interchangeably—became an automatic critical reflex in the face of failing faculties. Many critics and scholars, especially those who were getting on in age themselves, didn't want to think of the mental and physical losses that occur late in life, that happen to artists as well as the rest of humanity, to face up to the failures of the human system that accompany advanced years—the trembling hand, the fumbling brushstroke, the filmy eye, the cloudy brain. In denial, they transvalued weakness into strength, proclaiming old-age styles grander, deeper and more universal than youthful or mature ones. These critics never considered the fact that the "film upon the eye," to cite Emily Dickinson, might not be a means to transcendent achievement, but as the poet so nicely put it, "mortality's old custom/Just locking up to die." The running down of the human machine, fraught with pathos though it may be, is hardly a guarantee of moral or esthetic superiority—on the contrary.

More recently, the literary theorist Edward Said challenged this traditional view of the late style. In his last work, *On Late Style* (2006), dealing mainly with music and literature, but certainly relevant to a consideration of the visual arts, Said asks the pertinent, or impertinent question: "What of artistic lateness not as harmony and resolution but as intransigence, difficulty, and unresolved contradiction? What if age and ill health

don't produce the serenity of 'ripeness is all'?" He considers the case of the old Ibsen, whose final plays, far from offering resolution, "suggest an angry and disturbed artist for whom the medium of drama provides an occasion to stir up more anxiety, tamper irrevocably with the possibility of closure, and leave the audience more perplexed and unsettled than before."[2] Late style, he declares, is likely to be anachronistic and constitutes a form of exile, coming as it does when the artist who is fully in command of his medium nevertheless abandons communication with the established social order of which he is a part, and achieves a contradictory, alienated relationship with it. For Said, commenting on Theodor Adorno's analysis of Beethoven's late style, the composer's "late works remain unreconciled, uncoopted by a higher synthesis; they do not fit any scheme and they cannot be reconciled or resolved, since their irresolution and unsynthesized fragmentariness are constitutive...Beethoven's late compositions are in fact about 'lost totality', and are therefore catastrophic."[3] In short, late styles abandon all the comforting segues and esthetic connections that hold the art object together, dealing instead with disconnects, abysses, unyielding dislocation and unresolved contradiction.

The old-age work of Louise Bourgeois conforms to neither of these paradigms for late styles. Although certainly the products of extreme old age, they are far from elegiac. Yet they could hardly be more unsettling than what had come before: they don't mark a dissonant break with her previous achievement. I will be dealing with two aspects of the late work: first and foremost, the "soft work," mainly stuffed pieces with a hand-sewn look; crude but sophisticated, constructed from common, used, worn materials, assertive and droopy at once, reminiscent of children's stuffed toys, but fully sexual, often, like the aging body itself, the prey of gravity, sometimes scary. Against this multifarious soft production of Bourgeois' extreme old age, I will posit the singular and much less well-known "hard work," namely *The Institute* [p. 392], an architectural model in silver that the artist created in 2002 for the Institute of Fine Arts of New York University, where her husband Robert Goldwater had taught for many years.[4] It is almost as if *The Institute*, expertly cast in precious metal, erect, architectonic and precise, was conceived to be the perfect antithesis of the abject, sagging, childish but oh-so-grown-up stuffed pieces. In my imagination, it is their dolls' house, the empty rooms waiting for stuffed bodies. It is this contradiction, the two types together, that in a sense constitutes the old-age style of Bourgeois, making it impossible to summarize the work of her latest years in any coherent way.

Soft stuff

Before making any of the stuffed pieces, Bourgeois created several installations that were a prelude to the work in cloth. *Untitled* (1996), a work in cloth, bone, rubber and steel is like a *memento mori* cast in the language of fashion, a memorial to Bourgeois' own lost, youthful, sexy body. It consists of the artist's cast-off clothing—undergarments

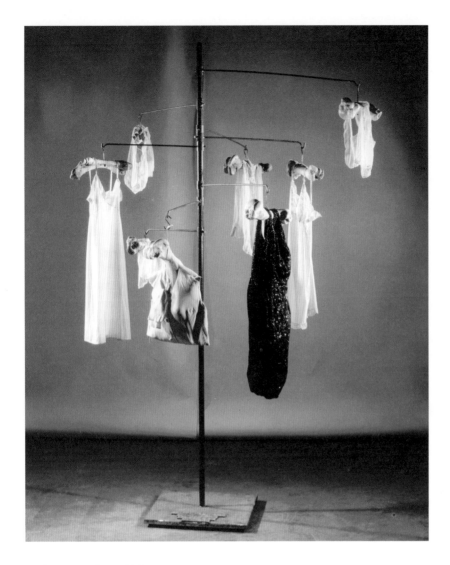

Louise Bourgeois, *Untitled*, 1996.
Cloth, bone, rubber and steel, 118¼ × 82 × 77 in. (300.4 × 208.3 × 195.6 cm)

in silk and satin, a beaded dress, filmy stockings—hanging from bone hangers on the branches of a metal tree. "Clothing is a metaphor of the years that pass. For me fashion is the experience of living in this dress, in these shoes," she declares.[5] Hanging garments, especially lacy, transparent slips, chemises and girdles, have recently been used to memorial effect by the Japanese photographer Miyako Ishiuchi. In her exhibition, *Mother's*, at the 2005 Venice Biennale, photographs of her aged mother's seductive panties, nightgowns and slips, as well as her less seductive false teeth, wigs and withered breasts, created an unforgettable metonymic "portrait," the subject always absent yet forever present in the imaged objects bearing the stamp of her bodily occupation. If for

Bourgeois, "fashion is the experience of living," then discarded fashion invokes the premonition of dying that lurks in every old person's imaginaire. That these seductive garments are suspended from bone hangers, reminders of the skeleton beneath the surface, adds an ironic emphasis to this somber memorial wrought from the frivolous elements of fashion. For Bourgeois, as for most women, old or young, fashion carries a heavy freight of implication, despite its apparent frivolity.

Bodies, soft and stuffed

Regression, desublimation, abjectness: these are the terms that immediately spring to mind when confronting the soft figures of Bourgeois' old age. Hanging, lying, sprawling, alone or intertwined—these often small-scale figures are after all, more akin to children's beloved toys, especially their fuzzy, hug-worn, shabby yet comforting stuffed animals, than to the pristine solidity of bronze or marble sculpture, or even Bourgeois' more malleable and formless productions in latex. Yet how comfortless most of these works are; how disturbing their existence in our space! Of course, there is a modern tradition of stuffed, sewn sculpture. Claes Oldenburg immediately springs to mind. But his soft telephones, egg-beaters or typewriters got their shock value both from the ordinariness of their iconography as objects of daily use, and, even more, from the transformation of these useful objects into utterly useless yet touchingly vulnerable soft equivalents. Bourgeois does not go in for this kind of witty metamorphosis in her output of human bodies in cloth: there is always some overtone, strong or weak as the case may be, of horror, at the very least, of the uncanny, hovering about these works. These sculptures, before they make us chuckle, make us uncomfortable in our skin, our human skin, which, these works remind us, is only a temporary covering, after all, and a highly vulnerable one. One of the early cloth works, *Three Horizontals* (1998), a massive multipartite piece in fabric and steel, presents three outstretched women's bodies ranged on a utility table, in descending order of size and completeness. The topmost body, the largest, is armless, the next is smaller, armless and less articulated; the third and lowest is hardly a body at all, but a kind of phallicized stump that is in turn feminized by bulging breasts and not much else. The pink cloth creating their bodies is coarse, cheap, roughly basted together so that the joins of the fragments of stuff suggest scars. Together, they evoke the victims of some mass misogynist atrocity of our time: Dafur or Serbia immediately spring to mind. But to those in the know, they also recall a "tradition" of female soft sculpture in the service of estrangement. I am thinking particularly of the work of the Swiss artist, Eva Aeppli, Jean Tinguely's first wife, born in 1925, who created a group of scary, evocative textile sculptures in the early 1970s—grotesque, powerful, full-scale figures (see the collection in the Tinguely Museum in Basel). Even more significant are the stuffed sculptures of Dorothea Tanning, also the work of old age, Surrealist in inspiration, harking back to some of

Tanning's earlier and better known paintings. Stuffed cloth works like *Tragic Table* from the *Hotel du Pavot* series (1970) and the multipartite installation of stuffed bodies and furniture, *Hotel du Pavot, Chambre 212* (1989), are connected to Bourgeois' work in both spirit and form. I am not speaking about anything as trivial as "influence" in this case, but rather of mutual interest in sewn, stuffed work and its rapport with concerns both feminine and geriatric—not to speak of its power to shock and unsettle conventional ideas about the sculptural object.[6] For these works of Bourgeois are, despite their rejection of conventional notions of sculpture, nevertheless volumes that exist in space, that respond to gravity, that may be walked around by the viewer—in other words, share certain essential properties with conventional sculpture in bronze, clay or marble.

Yet it is precisely the departures from the niceties of the traditional media that mark the most powerful examples of the stuffed work, like *Arch of Hysteria* (2000), a hanging piece in coarse pink fabric that takes up a theme once executed in purest marble or shiny bronze, displayed on the ground, with masculine sexual attributes. Although the stitched work generally has often been linked to Bourgeois' childhood involvement in her mother's craft of tapestry restoration, pieces like this offer material evidence against this sort of over-determined psychobiography. Bourgeois' grotesque handiwork in much of the stuffed sculpture is hardly in the tradition of professional tapestry conservation. On the contrary, its power lies in the deliberate ferocity of its bad sewing—basting, more accurately—the large, clumsy stitching both suggesting old age, which cripples virtuosity, or regression to childhood, the time before it is acquired. The deliberateness of this effect of crudeness becomes even more apparent when, on closer inspection, you see that in certain areas the big stitches are quite deliberately even and controlled, while in others, the torn-off bits of thread tremble in the ambient air as though bitten off by an unskilled sewer. Helpless, awkward, lumpy, floating in space, *Arch of Hysteria* comes to rest nowhere, rather like one of those anonymous, falling figures in a medieval altarpiece of the Last Judgment, not yet settled in either heaven or hell.

Totally different in scale and effect is *Endless Pursuit* (2000), a small patchwork globe executed in ribbed blue fabric, with a nasty open-mouthed head and two pancake breasts popping up at one end [p. 388]. Bourgeois has often revealed herself to be a literary person, both in her own copious writing and her knowledge of literary antecedents, from ancient mythology to vanguard texts. What else could *Endless Pursuit* be but a blue-balled riff on Samuel Beckett's *Happy Days*, one of that pessimistic author's darkest meditations on human self-deception in the face of creeping old age and mortality? Surely this is a version of Beckett's mindless anti-heroine, Winnie, buried in sand up to her neck but determined to put a good face on the situation. Beckett's sand pile, however, in Bourgeois' version has expanded into the whole world, and the feckless Winnie into Everywoman.

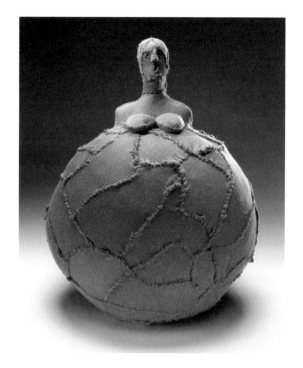

RIGHT Louise Bourgeois, *Endless Pursuit*, 2000. Blue fabric and thread, 18 × 12 × 12 in. (45.7 × 30.5 × 30.5 cm)

BELOW Louise Bourgeois, *Femme Couteau*, 2002. Fabric, steel and wood, 9 × 27½ × 6 in. (22.9 × 69.9 × 15.2 cm)

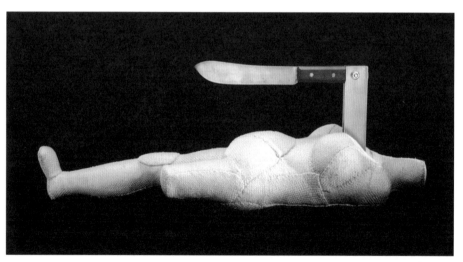

Other stuffed female figures are both more threatening or more overtly erotic, often recalling pieces from Bourgeois' earlier production, recast in more ad-hoc materials, becoming both more startling and more literally ephemeral in their implications. Such is the case with *Femme Couteau* (2002), a work in coarsely woven fabric, almost like a heavy bandage, a steel-bladed knife with a wooden handle, and a connecting flange,

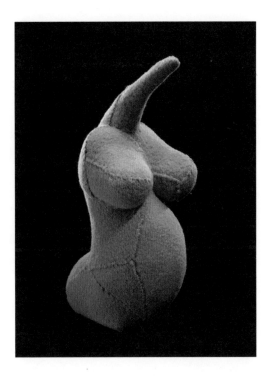

Louise Bourgeois,
Fragile Goddess, 2002.
Fabric, 12½ × 5 × 6 in.
(31.8 × 12.7 × 15.2 cm)

springing from the recumbent, headless, one-legged female torso. Threat, mutilation, violation: all three are evoked in a single two-part sculptural image. In earlier versions of the theme—the one in luscious pink marble of 1969, in the Spiegel Family Collection—the other in gleaming black marble of 1982—the two elements, woman and knife, merge in a single part-object, encapsulating female and male mutilation anxiety.[7] In Bourgeois' own words, "the woman turns into a blade."[8] In the much later cloth version, the two elements of the theme are separated and literalized. The female *is* mutilated; the knife *is* poised ominously over her dismembered body like a guillotine, not phantasmally incorporated into it. While Bourgeois' mature style may have evoked psychosexual anxieties in the form of the impermeable marble part-object, her old-age style presents outrages wrought on the vulnerable, cloth-embodied female subject itself.

Eroticism reverting to the primitive is the motif exploited in *Fragile Goddess*, a smallish pink fabric work of 2002. Here too, an earlier conceit of Bourgeois' is recalled: the Paleolithic-inspired *Harmless Woman* (a pun on "armless," of course), a bronze work of 1969. This assertively feminine torso with its large breasts, bulging belly almost popping its heavy seams and its snaky, phallic head is far from "fragile." On the contrary, the topos refers to the very origins of sculpture itself, those enduring Stone Age "Venus" figurines that were among the most durable and lasting ever produced. To re-create such a figure in bronze—certainly with modifications, as Anne Wagner has pointed out—is one thing; to do it up in fuzzy cloth is quite another. And in pink

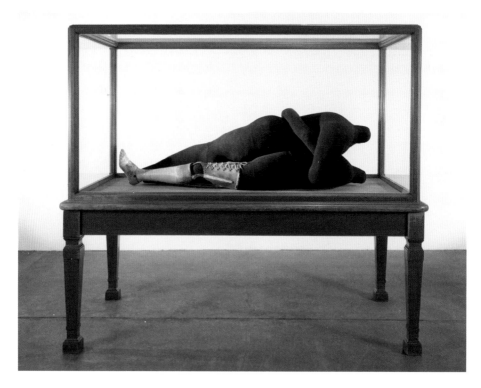

Louise Bourgeois, *Couple IV*, 1997.
Fabric, leather, stainless steel and plastic, 20 × 65 × 30½ in. (50.8 × 165.1 × 77.5 cm)

fabric, it also summons up reference to penis and testicles, a gender reference thereby complicating the question of its fragility still further.[9]

Not merely the "erotic" but actual physical coupling between a man and a woman— or several of each—also make their appearance in recent cloth works by Bourgeois. *Couple IV* (1997) may be said to explore the dubious joys of the prosthetic-erotic: one of the two sinister, enlaced, black-cloth bodies has a fully articulated, laced up, neatly-carved wooden leg strapped on to his/her thigh. Neither has a head, and the blatant perversity of the piece is enhanced by its presentation in a wood and glass Victorian vitrine, as though these were specimens of some exotic, vanished, more brutal race of beings. *Couple* (2001), a hanging piece in fuzzy light blue plush is as close as Bourgeois ever gets to sentimentality, despite the fact that the happy pair hang mid-air, suspended from a wire. Think Rodin's *Kiss* done over in the *matière* of worn-out bedroom slippers. More serious fun and games are afoot in *Seven in Bed* (2001), a multifigured work in pink fabric, employing seven overheated, sexually ambiguous figures going at each other on a white mattress. The heads, however, don't quite add up—some lucky creatures seem to have more than one and are kissing in two directions at once. Certainly, *Seven in Bed*

incarnates a utopian dream of the old and the post-sexual: all you can get, all at once, all in the same bed. What could be more spectacular evidence of the sexually powered inventiveness of Bourgeois' old-age style? Only Renoir, in the series of late *Bathers*, beached, blubbery whale-women, nudes he created in the years before his death in 1919 at the age of seventy-eight, put so much frustrated, displaced desire into pink, naked bodies. Only in his old age did Renoir allow himself to go literally over the top, into a visceral dreamland of loosened brushwork and pneumatic bliss. Bourgeois permitted herself the erotic pleasures of the *informe* well before she got old; but the stuffed-cloth medium allowed her to deploy them with uncommon verve and humor.

Hard, cold and empty

Most of Bourgeois' late work does not aspire to the architectonic. There are, it is true, a series of untitled towers in fabric and stainless steel of 2001, composed of an aggregation of small, heaped-up cushions that depend on an architectural upward trajectory for their effect. These tower-like forms proceed, against the grain, from smaller base to larger crown in what might be considered either a tongue-in-cheek reference to Constantin Brancusi's *Endless Column*, or a reference to her own earlier wooden stacked poles with their totem-pole evocations. But there is one major exception to the lack of the architectural in Bourgeois' late production, and that is the work that stands in the Great Hall of my own place of work, New York University's Institute of Fine Arts. As such, it is an object, or perhaps, more accurately, a shrine, which I pass several times during the week, often more than once a day. Because I see it so frequently, I have become increasingly intrigued by its mysterious presence, its obsessive accuracy of detail, its blind, mirrored windows and above all, the way in which, from the outside, it lets nothing, nobody, in or out. Cast in silver,[10] *The Institute* [p. 392] is majestically isolated, like a sacred reliquary, in a wood and metal cage/case designed by the artist herself. In the words of the publicity brochure devoted to this sculpture, it is characterized as: "Part found object, part memory work, it distills the Institute's inhabitation of what was once a residence. Below its roof, the five floors of the Duke House can be uncovered one by one, shifting in character from the lucid to the labyrinthine. Three mirrors offer shifting views of the complexity of this space and its uses."[11]

Bourgeois herself explained why she made the piece: "The Institute played an important part in my life. For many years my husband Robert Goldwater taught there. The four o'clock Friday lectures and tea were events I enjoyed. The best parts were the questions from the students." I was one of those students; in fact, Goldwater was my teacher and directed my dissertation. I can actually, if I want to, take the silver model apart, floor-by-floor and find my own little office perched in the highest part of the building, near the corner. It was probably one of the servant's rooms when James B Duke built his mansion in 1912, with the architect Horace Trumbauer. Now it is filled with my books,

files and papers, and with my own memories as well. Bourgeois' miniature version is, paradoxically, far more evocative than the actual building, which has, over the years, simply become my place of work. It brings back my vanished youth in the time of my old age in an extraordinarily literal way. I am not sure how I feel about this; not completely happy, to be sure. It is unsettling to inhabit a doll's house, even in imagination. And the sculpture is so relentlessly hard and unyielding, so hermetic in the guardianship of its secrets.

Houses and house-imagery have played a major role in Bourgeois' iconography, from her earliest days as an artist to her most recent work. One might say that the house stands either for too much connection with her family, and her past, or too little. In the early work, the series of *Femme Maison* drawings created in about 1945 to 1947, the female body is literally taken over by the house, which occupies the place of her head or

Louise Bourgeois, *The Institute*, 2002.
Silver, 12 × 27¾ × 18¼ in. (30.5 × 70.5 × 46.4 cm)

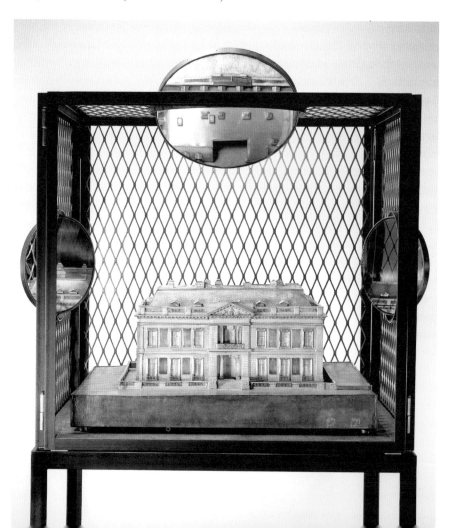

her upper body in a drastic conjunction of anatomy and architecture. In a late work, like *Cell (Choisy)* (1990–93), a guillotine blade rises over a scale model of her family home, a building not unlike the mansion represented in the silver *Institute*, cutting off access to the childhood site and the memories it represents: the house either smothers or is severed; there seems to be no compromise in Bourgeois' vision.

Yet *The Institute* is a different sort of building. Its space is institutional and public, despite its origin as a private mansion. As such, it represents for me a masculine building type, not one associated with the female realm of domesticity, but with its opposite: the "male" space of scholarship, rigor, discipline: the realm of reason. Perhaps that is why it is so closed, mysterious and harsh, its argent surfaces so hermetically sealed off from the world and its temptations. Not for *The Institute* the squirming, perverse, excessive pleasures of the sewn and stuffed *Seven in Bed*. Hard, cold, shiny, above all, empty—it is the other side of Bourgeois' remarkable old-age style, the other aspect of the experience of old age, or perhaps of life itself. I realize, now that I am old, that I tried as a young Institute student who was also a wife and mother to cope with these two aspects of experience—soft and hard—as best I could. It was difficult, but not always so—at times, the struggle itself was exhilarating and energizing. Bourgeois' late work, among other things, reminds me of these contradictory aspects of a vanished past.

Painting

Between 1938 and 1949, Bourgeois made a small number of paintings before giving up pictorial art in favor of sculpture. In 1945, her first solo exhibition at the Bertha Schaefer Gallery in New York comprised twelve paintings. The schematic division of the picture-space was matched by their symbolic content, mostly linked to Bourgeois' recent move to New York and her relationship with France. Subsequently her painting evolved toward a very personal form of figuration in which the influence of Surrealism was clear. During her second solo exhibition, at the Norlyst Gallery in September 1947, she showed seventeen paintings, including *Regrettable Incident in the Louvre Palace* (1947). This painting is undoubtedly connected with her memories of the Louvre, where, having obtained her diploma from the École du Louvre, she worked as a guide during the Universal Exposition of 1937. Several paintings, notably the four *Femme Maisons* of 1945–47, include themes that she later developed in both sculpture and drawing.

On March 18, 1947, she wrote, "Even though I am French, I cannot think of one of these pictures being painted in France. Every one of these pictures is American, from New York."

Notes

1 Says Thomas Crow: "The signs along this particular path of interpretation read 'elegiac' and 'autumnal': its goal is a consoling view of old age as a repository of ultimate wisdom and truth. These examples (Titian, Rembrandt, et al.) may indeed exemplify just such qualities, but the story is suspiciously the same in each instance, and there is a lurking anachronism in all such retrospective judgments, given the strong modern esthetic preference for ambiguity in the painterly process." Karen Painter and Thomas Crow, eds (2006), *Late Thoughts*, Los Angeles: Getty Publishing, p. 55.

2 Edward W Said (2006), *On Late Style: Music and Literature Against the Grain*, New York, NY: Pantheon, p. 7.

3 Ibid., pp. 12–13.

4 Bourgeois was assisted in this project by both an architect and a model-maker, basing the work on the plans and elevations of the James B Duke mansion, in which the Institute of Fine Arts is housed.

5 Bourgeois, cited from an interview in 1996, in Susan L Stoops, *Louise Bourgeois: The Woven Child* (Worcester, MA: Worcester Art Museum), p. 20 and no. 24, p. 34. See also Griselda Pollock's suggestive analysis of this work and of Bourgeois' earlier "old-age" style: Griselda Pollock (1999), "Old Bones and Cocktail Dresses: Louise Bourgeois and the Question of Age," in *Oxford Art Journal*, vol. 22, no. 2, pp. 71–100.

6 For an early consideration of the subject of women and fabric art, or soft sculpture, see Aline Dallier (1974), "Le Soft Art et Les Femmes," *Opus International*, no. 52, September, pp. 49–53. Among the artists considered are Patsy Norvell, Harmony Hammond, Eva Hesse, Sheila Hicks and Barbara Chase Riboud. I am grateful to my doctoral student, Kalliopi Minioudaki, for bringing this article to my attention. I would also like to take this opportunity to thank Jovana Stokic for her help in preparing this essay, as well as Jerry Gorovoy and Wendy Williams at the Louise Bourgeois Studio, who went beyond the call of duty in supplying me with photographs and information.

7 See Mignon Nixon (2005) *Fantastic Reality: Louise Bourgeois and a Story of Modern Art*, Cambridge, MA: MIT Press, p. 233 and fig. 6.16, p. 231. Nixon's whole chapter on the part-object is informative on this theme; see "*Femme Couteau* (Knife Woman): Art Objects as Part-objects," pp. 165–208.

8 Then, in the next breath, according to Nixon, Bourgeois asserts that the "woman has become a girl who feels vulnerable because she can be wounded by the penis," and so "tries to take on the weapon of the aggressor," ibid., p. 233.

9 See Anne M Wagner's interesting analysis of the bronze work, its relation to Paleolithic sculpture, and Bourgeois' titles for this work: "Bourgeois' titles for such figures are steeped in denial," Wagner (1999), "Bourgeois Prehistory, or the Ransom of Fantasies," *Oxford Art Journal*, vol. 22, no. 2, pp. 5–23.

10 In an edition of six, with one artist's proof.

11 Geoffrey Glick (2002), *Louise Bourgeois: The Institute, NYU*, pamphlet, Institute of Fine Arts, New York University, unpag. The pamphlet also informs us that Bourgeois donated all six copies of *The Institute* to the school, and that all proceeds from the sale of the casts is destined to support Institute programs.

28
Sophie Calle: Word, Image and the End of Ekphrasis

Previously unpublished

Walking into Sophie Calle's most recent installation in the Church of the Heavenly Rest, a show called *Rachel, Monique: I Couldn't Capture Death*, I realized how ambivalent, indeed hostile, I felt about much of the artist's work. "It's an elegiac but frustratingly oblique meditation on the life and death of Ms. Calle's mother, Monique Sindler," as Ken Johnson summarized it in a review in the *New York Times*.[1] I would say that through the use of film, photographs and read-aloud diaries, Calle, in the name of (dubious) filial piety, reveals her mother as the narcissistic drama queen she was. According to the evidence of the diaries, to borrow Ken Johnson's words, Calle's mother was "feckless, vain, over-privileged, alcoholic, sexually promiscuous, pretentious, self-pitying," a woman who "whines about having accomplished nothing consequential during her life time and complains that her children don't pay attention to her."[2] Of course, in this piece, Calle pays maximum attention to her mother, going so far as to record the last eleven minutes of her expiration on film in an extraordinary and tedious death-bed scene, attempting but failing to capture her last moment: hence the subtitle, *I Couldn't Capture Death*. In other words, this is the record of a highly ambiguous relationship: a piece both making up for the mutual antipathy, and, in the guise of "completeness" and "paying tribute," a palpable act of revenge.

It is hard to categorize the work of Sophie Calle. It generally involves both text and pictures, sometimes sharing the qualities of detective fiction, at other times, those of the documentary film, at still others, the diary. Both annoying and provocative, seductive and boring, dependent often on personal narrative but refusing emotional closeness, Calle in her work is, as Robert Storr asserted many years ago, "downright annoying, the embodiment of the unreliable narrator."[3] Although her work is usually presented on the walls of a museum or gallery, this is not always the case. She has had a hand in filmmaking and one work appeared as a series of articles in a major French newspaper. Some of her exhibitions have been published in the form of elegant, illustrated books, by Actes Sud. And it is not accidental that the photos she uses are often lacking in esthetic value; snapshots, utilitarian indexical images—a device used by documentary photographers from the time of Jacob Riis onward as proof of factual authenticity—the less "esthetic" the "realer," as it were.[4]

I am now going to focus on what interests me most in her work: the group of series in which Calle focuses on the direct relation between words and images, such series as *The Blind* (1986); *Ghosts (1989–1991)*; *Last Seen* (1991); the revisitation of *Last Seen* at the Isabella Stewart Gardner Museum, Boston, in 2012; *Last Seen* of 2014, which brings together the two latter groups of works; and finally, *Purloined,* a group of works involving text and image shown at the Paula Cooper Gallery, New York, in 2014. All of these involve a series of missing images and a matching series of attempts to "remember" or "recreate" these missing images through verbal description.

The attempt to make a text capture, reduplicate or bring to life a visual image, a rhetorical strategy known as "ekphrasis," has had a long and complicated history, going as far back as Homer, flourishing in the Renaissance and continuing through the 19th century, when Keats wrote his ekphrastic "Ode on a Grecian Urn," and the 20th, in such works as WH Auden's "Musée des Beaux Arts" (1938), in which the poet considers both the details and the wider implications of Pieter Bruegel's painting, *Landscape with the Fall of Icarus*, in the Musée des Beaux Arts of Brussels; John Ashbery's famous encounter with Parmigianino, "Self-Portrait in a Convex Mirror," published in 1974, or more recently, Alfred Corn's long, colloquial narrative poem, "Seeing all the Vermeers" (2002), which is literally about the poet seeing all the Vermeers in existence and necessarily involves a great deal of ekphrastic description and commentary.

It is my contention that all of Calle's series involving missing or non-present images and the words—other people's—that she uses to attempt to describe or "recreate" them are a variety of ekphrasis, or more precisely, a kind of anti-ekphrasis, and that to understand what she is doing we need to examine the ekphrastic tradition itself in some detail. (What does she keep, what does she reject?)

I will begin by asking: how have we, how can we, how do we speak about pictures? How do we get words to wrap themselves around, indeed capture, that most elusive prey, the work of art or visual image? This has existed as a problem almost from the beginning—of both images and language.

Among the most ancient and famous of ekphrastic descriptions is that of the Shield of Achilles from Book 18 of Homer's *Iliad,* probably dating from the 9th century BCE. Although artists of a far later age, like John Flaxman in 1821, attempted to create a pictorial image of the famous shield, it originated as a purely verbal invention: Homer's lengthy and complex description of the shield and its richly varied vignettes—the earth, the sun, the stars, the life of two cities: a wedding celebration in a peaceful city and a bloody battle in a city at war; the ocean surrounding the shield—was originally meant to be a *spoken*, not a written text. It was often publically disseminated by professional reciters and interpreters of Homer, called *rhapsodes*.[5] Created in catchy dactylic hexameter, filled with repetitions and epithets, it lends itself to sonorous, professional recitation; there is nothing either casual or personal about it. It is well worth keeping in mind that the earliest relationship between words and images sprang from an oral tradition.

Jumping ahead a few thousand years to the Renaissance and after, words and pictures were closely intertwined in esthetic theory, referred to as "sister arts." In Renaissance discussions, the Horatian phrase *ut pictura poesis*—as in painting so is poetry—is often reversed, "as is poetry so is painting," indicating an analogy, if not an exact identity, between the two media. The poet was supposed to make his audience *see* the object, and the painter or sculptor make his viewer understand or read the meaning as well as imagine the action taking place in his canvas or sculpture. Renaissance and baroque critics were also doing a more practical task for the artists whose work they wrote about: likening the visual arts to poetry was an important way of raising painters and sculptors from the status of mere craftsmen, humble guild members, to high-minded creative geniuses like poets.[6]

Well into the 19th century, poets were using ekphrasis to conjure up works of art—and much more. This is what John Keats does in his famous "Ode on a Grecian Urn," written in 1819 and published anonymously the year after. Whether Keats was looking at a specific piece of Greek pottery or not when he wrote the ode,[7] he both resorts to ekphrastic description yet moves far beyond it to consider more general issues of temporality and beauty, passion and its extinction. At the beginning of the poem, though, he is specifically considering the relation of words to image in his address to the urn. "Thou still unravish'd bride of quietness/Thou foster-child of Silence and slow Time/Sylvan historian, who canst thus express/A flowery tale more sweetly than our rhyme." And clearly, it is the object—the visual object—that wins out in terms of the *ut pictura poesis* relationship, although one might very well find this paradoxical, given the splendor of the verse in which Keats admits defeat.

In the 20th century, in WH Auden's poem, "Musée des Beaux Arts," equally based on close observation of a work of art, the relation between words and image is quite different. In the first place, it is definitely a specific painting that Auden is confronting, Bruegel's *Landscape with the Fall of Icarus* of *c.* 1558, in the Musée des Beaux Arts in Brussels. In the second place, it is not elevation and transcendence that the poet seeks in the work of art, but its opposite: a confirmation of nature's indifference to human fate in the work of the old masters. Auden's very language is self-consciously pedestrian, wonderfully and deliberately earthbound:

About suffering they were never wrong.
The Old Masters; how well they understood
Its human position; how it takes place
While someone else is eating or opening a window or just walking dully along:
...That even the dreadful martyrdom must run its course
Anyhow in a corner, some untidy spot
Where the dogs go on with their doggy life and the torturer's horse
Scratches its innocent behind on a tree.

Now Auden goes in for a passage of pure ekphrasis—description taken directly from the painting itself—but this acts simply as a concrete affirmation of his more general thesis of universal indifference—cool, offhanded, specific in its lucid detail:

> In Bruegel's Icarus, for instance: how everything turns away
> Quite leisurely from the disaster; the ploughman may
> Have heard the splash, the forsaken cry,
> But for him it was not an important failure; the sun shone
> As it had to on the white legs disappearing into the green
> Water; and the expensive delicate ship that must have seen
> Something amazing, a boy falling out of the sky,
> Had somewhere to get to and sailed calmly on.

But aside from poetry, where the sister act of *ut pictura poesis* may be said to have continued down to the present day, both in terms of modernism and postmodernism, images and writing in some sense have become more and more alienated. By this, I don't mean to say that people stopped writing or talking about pictures. On the contrary: more and more people made it their business to criticize and analyze works of art in classrooms, scholarly tomes and the press. But the terms of the engagement have changed radically. "Literary painting"—painting that tells a story, evokes an emotional response, has a moral—was no longer looked on with favor. And writing about painting was supposed to be more objective, "scientific" even, in its rejection of personal feeling or literary reference.

In academia, largely under the influence of German art-historical scholarship, a would-be scientific model came into use in the discussion of the work of art: one thinks back to founding fathers of the discipline of art history like Heinrich Wölfflin and his stringent historico–formal analysis of Renaissance and Baroque works—art history without artists—but any art history text book still depends largely on an empirical–analytical method of a sort. This is by no means the same as the simple, or complex, descriptive practice of ekphrasis, although it may resort to description to support its claims. At its worst, scholarly analysis can sink to the dullest automatic-pilot academicism; at its best, it can reveal both the manifest and the latent content of an image to the viewer. And at its very peak, analytic art-historical writing can rise to the heights of the best ekphrastic description, in the work of such art historians as Meyer Schapiro or Leo Steinberg.

There is still another category to be considered in terms of the relation between words and images, an extremely important one, and that is art criticism. The point of criticism—and what distinguishes it most sharply from both ekphrasis and art-historical analysis—is its propagandistic mission, its power of persuasion. Bluntly stated, criticism attempts to convince the viewer through the sheer power of rhetoric that the

work, works, or artist in question, are either good—even superlatively good—or bad, even abysmally bad. With the growing power of the press in the 19th and 20th centuries, the role of critical writing, and the critic, became ever more prominent. Critics like Ruskin or Baudelaire, or Roger Fry or Clement Greenberg could change the taste of nations with the force of their observation and the eloquence of their prose. Words and pictures mutually depended upon each other in the critical enterprise. Critical language could set about the task of enlightening or convincing the public in a variety of ways, some of them ekphrastic to the highest degree.

Here, for instance, is Albert Aurier, a prominent French Symbolist critic at the end of the 19th century, attempting to capture the effect of his first confrontation with the then unknown Vincent van Gogh, in "The isolated ones: Vincent van Gogh," published in *Mercure de France* in January, 1890: he is discussing *The Sower* and *Starry Night*, among other works.

Beneath skies that sometimes dazzle like faceted sapphires or turquoises, that sometimes are molded of infernal, hot, noxious, and blinding sulfurs; beneath skies like streams of molten metals and crystals, which, at times, expose radiating, torrid solar disks; beneath the incessant and formidable streaming of every conceivable effect of light, in heavy, flaming, burning atmospheres that seem to be exhaled from fantastic furnaces where gold and diamonds and similar gems are volatilized—there is the disquieting and disturbing display of a strange nature, that is at once entirely realistic, and yet almost supernatural, of an excessive nature where everything—beings and things, shadows and lights, forms and colors—rears and rises up with a raging will to howl its own essential song in the most intense and fiercely high-pitched timbre: ...gardens, and rivers that seem sculpted out of unknown minerals, polished, glimmering, iridescent, enchanting...flowerbeds that appear less like flowers than opulent jewelry fashioned from rubies, agates, onyx, emeralds, corundums, chrysoberyls, amethysts, and chalcedonies; it is the universal, mad and blinding coruscation of things; it is matter and all of Nature frenetically contorted...raised to the heights of exacerbation; it is form, becoming nightmare; color becoming nightmare, color, becoming flame, lava and precious stone; light turning into conflagration; life, into burning fever.[8]

Here is ekphrasis carried to a fever pitch at the end of the 19th century, in the Symbolist critic's attempt to create an equivalent of the artist's torrential brushwork and expressive color in an unleashed flow of exotic verbiage.

Having provided a sketchy historical background for the word/image relationship, I now want to turn to the work of Calle herself. I would like to begin with one of the earliest word/image pieces, the one based on Bonnard's *Nude in the Bath* of 1936 [p. 401].

Here is what Calle has to tell us about the origin of this piece:

In June 1989 I was invited to participate in an exhibition at the Musée d'Art Moderne in Paris. The Bonnard painting *Nude in the Bath* was out on temporary loan. I asked the curators, guards, and other staff members to describe and draw the painting that once filled the empty space. I replaced the missing painting with these memories.[9]

Bearing this in mind, we might ask ourselves several questions: how is Sophie Calle's project in this piece different from previous word/image relationships? Are there still traces of these? What is she foregrounding, what is she obliterating? In other words, what either connects Calle's work to, or sharply differentiates it from, the ekphrastic tradition?

And here is the group-text substitute for the painting out on loan: a text dispersed, fragmentary, often flat and boring, extremely repetitious, with some people really trying to remember the painting, some vaunting opinions, even negative ones, some showing a bit of erudition, some clearly out of touch with this sort of thing, drawing on faulty memory, trying to make present through words what is materially absent; not exactly a group ekphrasis but close to it: a rejection, on Calle's part, of the premises of the old, subject-centered ways of writing about art in certain terms.

Nude in the Bath, Bonnard

It is horizontal, as the hooks show. It shows a woman lying in her bath. She is relaxed, an arm along her body, blond wavy hair in a harmony of blue. I think you can see the upper part of her body and her legs, the rest disappears into the water. She seems weightless, inert. ◆ There is a woman lying in the bath. She fills the entire length of the painting and a quarter of the height. I saw blues, yellows, oranges, greens and this woman, a bit out of focus, like a mermaid. I can't remember the rest at all. ◆ It's a long bath with a woman in it. ◆ I see most colors: orange, purple. I clearly see a body lying in a bath, a woman's body without a face, the head would be on the right side, the rest I can't remember. ◆ I think there is a kind of a bath with a woman in it, lying. The colors are a bit sad, grays and blues, and a gold-plated frame. Like the painting on the left. ◆ It is a completely blurred painting, in a fire of colors you can distinguish a bath, seen quite close, and a person bathing in the water in about the diagonal of the painting. In this blur, some places, the real substance of the object appears: the corner of a carpet, a piece of flesh, come transparent water. ◆ I see colored spots, pink, blue, purple. A woman lying too flat, long like a wire. She is Marthe his wife. She was depressed and spent her time in the bath. She was thin and weak and came from Aubervilliers. ◆ The woman was stretched out, lying in those grays and

ABOVE View of the exhibition *Histoires de musée* at ARC, Musée d'Art Moderne de la Ville de Paris, France, 1989, showing Sophie Calle, *The Ghost (Pierre Bonnard, Nu dans le bain/Nude in the Bath)*, 1989. Text silkscreened by transfer, synthetic polymer oil, color photographs, 38⅝ × 61 in. (98 × 155 cm)

BELOW Pierre Bonnard, *Nude in the Bath*, 1936.
Oil on canvas, 36⅝ × 57⅞ in. (93 × 147 cm)

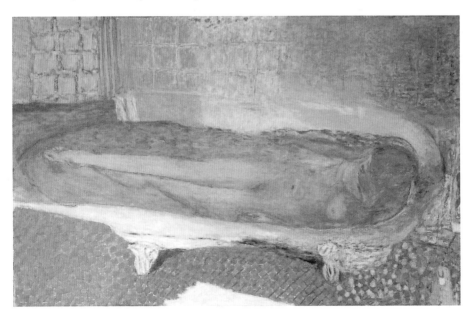

browns. I remember mostly gray and the white body. ◆ The woman is sketched, whitish. She is bathing, diaphanous, surrounded by water lilies, I think. ◆ I have walked past for the last seven years. I think she is dead, she doesn't move anymore. That is probably why I don't look at her anymore. ◆ I would describe her as a source of light, coming from within, sensual. But the idea is missing. It is only a sensible colorful emotion. A certain blue, a certain kind of color formed by superimposed blended colors. You contemplate the color, it is nice, gentle. The woman herself seems comfortable in the water, she is happy, and he is happy to show this. ◆ Nothing special. It's a nude in a bath in the water. Color tones similar to those on the painting on the right. A not very esthetic form, nice superimposed colors in an awful mixture. It's a splendid painting but I don't like it. ◆ It's a naked woman in a bath with yellow, purple and pink tiles in the background. The bath has feet. The woman is orange in coloring. The head seems to be bowed. ◆ A woman is lying in the water. She seems feeble. Her hands are positioned on the edge of the bath. She is dreaming, her head bowed. Her body is not a normal color. ◆ Light plays like small electrons wandering round. It is velvety, like gold dust. What is less lively is her in the bath. Stiff. It's as though he has had to put her flat. I remember two forms which clash, the large oval of the bath and the rectangles all aligned. I see gold, ivory, music by Ravel, a powdery perfume. ◆ It is a naked woman in the bath, as the title says.[10]

Out of these diverse memory fragments and scraps of commentary, Calle has constructed a kind of hybrid: a text-image to be *read* from up close but *viewed* from a suitable distance as a decorative image.

What might we point out as specific to this piece, as opposed to the traditional work of ekphrasis? First of all, that Sophie Calle herself is not the poet, the art historian, the critic, the describer, but rather the *deus ex machina* who sets the descriptive action in motion. Secondly, the work itself is not present for the various writers' contemplation; it is (temporarily) absent: the writers are obliged to work from memory. (Question: in our age of easy access to reproductions, didn't some of them cheat? Or was it stipulated that they write from memory alone?). Thirdly, the final memory is not, like traditional ekphrastic writing, the product of a single consciousness but of an anonymous group of writer/remember-ers, people of different levels of training, expertise, social classes, and degrees of familiarity with the work and with the current language of art discourse itself. Fourth, as a group text, the piece probably works better as an art object hanging on a wall than as a literary achievement. A product of Calle's manipulative rejection of the premises of the old, subject-centered ways of writing about art, the text certainly qualifies as postmodern.

Is this just a parlor trick or a serious text, an experiment with implications of more democratic theories of reception, of opening up the field, of rejecting a single patriarchal

authority, of creating a new art discourse with a certain (pseudo) naïveté and freshness? Douanier Rousseau doing a stint as an art-critic? To explore these questions, I think we have to proceed to later versions of the project.

In 1991, Calle and her cohort confronted another series of works-that-weren't-there in the series titled *Ghosts*. She explains their genesis in these words: "I was invited to participate in an exhibition at the Museum of Modern Art in New York. Five paintings (Magritte, Modigliani, de Chirico, Hopper, Seurat) were out on temporary loan, I asked the curators, guards, and other staff members to describe and draw the paintings that once filled the empty spaces. I replaced the missing paintings with those memories."[11]

The work in the 1991 *Ghosts* series, compromising empty spaces plus wall texts commemorating five paintings by Magritte, Modigliani, de Chirico, Hopper and Seurat, out on temporary loan, is interesting because the wall texts are more sophisticated, detailed and often accompanied by sketches, as requested: here, for example, is part of the text recalling the missing Modigliani, *Reclining Nude*, of 1919:

The title helps. It's a reclining nude, a painting of a rather voluptuous lady, stretched out across the canvas, lying on her right side, very pale and serene. Her name is Anna Zborowska. Her body fits the entire scene from one end to the other. Maybe the feet are missing. Her head is on the left. She has a long, skinny nose and a beautiful little mouth. The background is nondescript, so you just focus on the nude. I remember that my three-year-old grandson took one look at her and said he recognized her breasts, which is what he pointed out. ◆ Gorgeous painting. It's a naked woman resting on a yellow pillow, a blend somewhere between an Italian Mannerist and a Matisse. I remember dark earth colors surrounding the figure. She has auburn hair in a bun and that oval Modigliani face. Her blank eyes remind me of ancient sculptures. They become an entrance, rather than just an eye looking at you. ◆ (...) I don't like her. I wouldn't call this a beautiful woman. She looks like a caricature. There is something awkward about her proportions. I remember the unusual length of her torso, her elongated face. If you want to see a beauty, you look for a normal size. Some people might think of her as elegant, I don't. She seems uncomfortable, as if she was lying on a piece of wood. But she does look better than the Magritte, at least she looks alive. ◆ (...) It's like any other nude. It's a horizontal painting of a female lying naked.[12]

The first and second contributions sound as though they were made by a curator, or a docent, or someone familiar with the verbiage of art history or criticism. "Somewhere between an Italian Mannerist and a Matisse...", "dark earth colors," the reference to ancient sculptures—these are not the memories of an ignorant viewer. Another participant overtly expresses distaste, still another finds the nude ordinary, "like any other nude."

At almost the same time, however, Calle's attention turned to a different variation of the missing-picture situation, a far more serious one: the notorious thefts of old master paintings at the Isabella Stewart Gardner Museum in Boston. Calle's various Gardner series of words and images were created under more sinister circumstances than her previous ones, and engage not with a benign case of temporary absence, but with the more devastating and permanent disappearance of artworks resulting from theft—in a roundabout way, perhaps, related to her earlier "detective works." In other words, these lost paintings cut from their frames are permanently rather than temporarily absent: dead rather than missing-in-action. The difference between a project that involved writing about works that had been stolen and perhaps destroyed and those merely out on loan might be likened to the difference between going on a brief vacation and being kidnapped, raped, and murdered.

Here is what Calle has to say about her first Gardner series, *Last Seen* (1991):

On March 18, 1990, five drawings by Degas, a vase, a Napoleonic eagle, and six paintings by Rembrandt, Flinck, Manet, and Vermeer were stolen from the Isabella Stewart Gardner Museum in Boston. Isabella Stewart Gardner expressly stipulated in her will that nothing in the display should be changed after her death. After the theft, I photographed the empty spaces that the paintings and objects had occupied and I asked the curators, guards, and other staff members to describe their recollections of the missing works.[13]

I will focus on the missing Vermeer, partly because Vermeers are relatively rare, partly because I have a certain antipathy to his work, but partly because his paintings have given rise to so much ekphrastic writing ever since his rediscovery/recreation in the mid-19th century by Courbet's friend, the critic and scholar, Théophile Thoré, exiled for his radical views by Emperor Louis Napoleon.

The most famous of these, of course, is Proust's memorable passage in *À la récherche du temps perdu,* in which the elderly writer, Bergotte, visits an exhibition of Dutch art, falls ill and dies while examining a "petit pan de mur jaune" in Vermeer's *View of Delft*—a "little patch of yellow wall," the subject of serious discussion and argument for Proustians ever since.[14] More recently, in Alfred Corn's long narrative poem, "Seeing All the Vermeers," there is a stanza of ekphrasis on the *View of Delft*:

By train to Den Haag, to see the *View of Delft*'s ink-black
medieval walls and bridge, barges anchored on a satin
water more pensive than the clouded blue above,
where one tall steeple took its accolade of sun.
(Proust's "patch of yellow wall" I couldn't find, though.)

Sophie Calle, *Last Seen... (Vermeer, The Concert)*, 1991.
One framed color photograph and one framed text photo, 66¾ × 50¾ in. (169.5 × 129 cm);
text: 33⅞ × 30¹¹⁄₁₆ in. (86 × 78 cm)

The Gardner Vermeer is left undescribed, although the visit to the Gardner is noted:

I was one of the visitors tiptoeing
through Isabella Gardner's house in Boston
decades before the heist, which to this day
remains unsolved....[15]

Here, then, against these exemplary ekphrastic texts, is Calle's group text for the stolen Gardner Vermeer, *The Concert* of *c.* 1664–67 [p. 407].[16] It is to be noted that the contributions here are a bit meatier, more detailed and more personal than some of the previous ones.

The Concert, Jan Vermeer

I'll always remember this painting because I couldn't see it. It was displayed at waist height, behind a chair, covered with glass but next to the window so that the glare caught the glass. ◆ I remember there was a painting there but I couldn't describe what was in it. I remember it had a gold frame, very thin,

carved, ornate. ◆ In the foreground, there was a dark shape, I believe it was a piano, with a large textile, an oriental rug covering it and an instrument, like a cell, partly tucked under the rug. In the middle ground were the three figures. One was a girl playing the harpsichord and she wore this yellow bodice with puffed sleeves and a white skirt. Then there was a man playing the lute, with his back to you, sitting in a chair, wearing a red coat, I think. On the right, the woman singing was in blue. She looked pregnant and held her hand just above her swollen belly. There were two paintings hanging in the background. One of them was a wild, dark, savage picture of a forest. The other, just above the head of the singer, was *The Procuress* by Van Baburen. It's a picture of an older woman, who is sort of a pimp, selling this young woman with a lot of cleavage to a distinguished businessman who is looking very salaciously at her, and it's such a rude counterpoint to this very pristine, demure scene of the concert. You had this dark shadowy corner that was somewhat ominous, then this lovely afternoon concert, and then this very lusty, bawdy picture within this very sedate and sensitive one. ◆ It's a peaceful thing. I used to look at it every morning before work. ◆ I used to come here at night, late at night and just to go up there and stand. ◆ The was a woman sitting at the harpsichord. She is so lost in her world of ideas that she's not even present. The other one, who is holding this ethereal scrap of paper, is exquisitely homely. And turning his back to us, sits the mysterious individual, this long-haired gentleman whom we will never know. He plays a guitar-like object and it's almost sort of phallic, especially since this pregnant woman is standing there. ◆ It seemed like a very innocent painting although the scholars would say that it had a lot of sexual energy in it. But I just heard the piano and the woman's voice. ◆

These memories range from the literally descriptive and the circumstantial to the poignant and would-be transcendental. Some of them certainly go beyond the bare description and recollection suggested by Calle in her statement of intentions.

But Calle was not finished with the Gardner: she returned to the site of the theft in 2012. "She learned that in 1995, after her initial work, the museum had reinstalled the empty frames of the missing artwork from the Dutch Room. Fascinated and intrigued by this visually organized absence, Calle made an additional body of work called *What Do You See?* The outcome is a portrait of absence that might, or might not, take shape through collective memories."[17] Here is how Calle herself describes this later project:

In 1994, after being restored, the empty frames were hung back in place, further emphasizing the painting's absence. I asked the curators, guards, and other staff members, and visitors to tell me what they saw within these frames.[18]

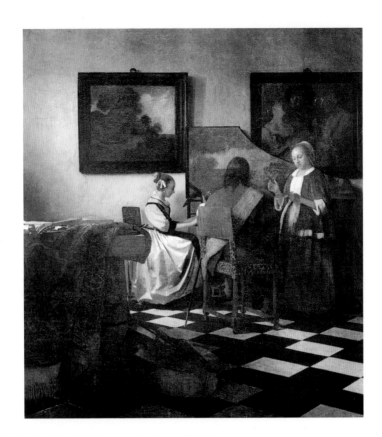

RIGHT Vermeer,
The Concert,
c. 1664–67.
Oil on canvas,
28½ × 25½ in.
(72.4 × 64.8 cm)

BELOW Sophie Calle, *What Do You See? (Vermeer, The Concert)*, 2013.
One Lambda print and one lithograph on Rives BFK paper, two panels, each:
26⅞ × 39⅞ in. (68.2 × 101.2 cm)

When I stand in front of this empty space, I see a woman deep in concentration playing the harpsichord, and the woman on the other side just about to emit a note from her body. And I hear music playing ♦ I see a very old wooden frame with no picture in it, and behind it a brown background, a velvet cloth. That's all there is. There's no reason for this frame to be here. What am I supposed to see? This empty space represents space, just space ♦ The picture arises. I contemplate a painting stronger than its absence. If you know this work, you see it better in the velvet than in a reproduction. I see people making music. You are looking at this silent picture but you're aware of music being made in the painting. A lute player with his back to you, a woman at a harpsichord and a woman singing, palpable. In my dreams I mostly see her. I am so attached to her that I should be able to know where she is ♦ I don't see much of anything. I see an empty frame, and behind the frame is this very dark fabric. I certainly see a solemn space. A little bit reproachful ♦ I see colors. On the left, the yellow sleeve of the woman, the trapezoidal red shape of the back of the chair and then that blue... I see the luxurious jacket the singer is wearing and the shadowy foreground with that rich, oriental carpet over the table. I see three colors, that sort of dance across the surface. It's red, yellow, blue—it's Mondrian ♦ I see flashes of what is supposed to be there. I see *The Concert*. When I give people a tour, I point and I say: this is *The Concert*. But there is nothing there. Except a framed space that represents frustration ♦ I see a black fabric, a little bit spooky. It says I could put anything I wanted inside the frame, but the blackness seems to be fighting against my desire to imagine something in there ♦ I've never seen this picture in person, so I see crime-scene pictures. The frame lying on the floor, in the middle of the room, with broken glass contained within. The chalk they put around the body—that's what this frame is to me. But it never goes away; you see the body every day ♦ It's a sad and nostalgic image. I see textures and nuances. I see this soft light washing over the velvet. I see this dark shadow to the right, and this very pale horizontal line across the center. I see this tiny layer of dust, especially on the lower left-hand edge. And of course, because the velvet is so spare and simple, I focus on the frame, the gold-etched outlines of flowers and the larger floral shapes, almost like sunflowers, around the edges. The outside is very charged and the inside very quiet. And, for whatever reason, I have this slight feeling that the frame is looking at me ♦ I see a frame that shows an absence. I see something everyone is denied the pleasure of seeing. I see a loss that is just indescribable. I see my impossibility to ever see the real thing ♦ Today I just see velvet, but of course there's much more ♦ My job is to bring it back, so I see my failure. I see this void even in my nightmares. There is a car, and, in it, a painting with a plastic bag over it. I take the bag off and it's not the painting that I want. But I know that one day, in the middle of the night, I'll receive a telephone call: *Vermeer is back*.

Here are some excerpts from *What Do You See?*, the show of empty frames. Some of them are far more emotional, disturbed and disturbing, than any of the previous group texts, even those about the same disappeared paintings. Many contributors comment on the impact of the physical presence of the frames themselves, the sense of emptiness, of lack created by them. Some of them openly mourn the lost paintings as they would a dead friend.

The Concert, Jan Vermeer

When I stand in front of this empty space, I see a woman deep in concentration playing the harpsichord, and the woman on the other side just about to emit a note from her body. And I hear music playing. ◆ I see a very old wooden frame with no picture in it, and behind it, a brown background, a velvet cloth. That's all there is. There's no reason for this frame to be here. What am I supposed to see? This empty space represents space, just space. ◆ The picture arises. I contemplate a painting stronger than its absence. If you know this work, you see it better in the velvet than in a reproduction. I see people making music. You are looking at this silent picture but you're aware of music being made in the painting. A lute player with his back to you, a woman at a harpsichord and a woman singing, palpable. In my dreams, I mostly see her. I am so attached to her that I should be able to know where she is. ◆ I don't see much of anything. I see an empty frame, and behind the frame is this very dark fabric. I certainly see a solemn space. A little bit reproachful. ◆ I see colors. On the left, the yellow sleeve of the woman, the trapezoidal red shape of the back of the chair and then that blue...I see the luxurious jacket the singer is wearing and the shadowy foreground with that rich, oriental carpet over the table. I see three colors, that sort of dance across the surface. It's red, yellow, blue—it's Mondrian. ◆ I see flashes of what is supposed to be there. I see *The Concert*. When I give people a tour, I point and I say: this is *The Concert.* But there is nothing there. Except a framed space that represents frustration. ◆ I see a black fabric, a little bit spooky. It says I could put anything I wanted inside the frame, but the blackness seems to be fighting against my desire to imagine something in there. ◆ I've never seen this picture in person, so I see crime-scene pictures. The frame lying on the floor, in the middle of the room, with broken glass contained within. The chalk line they put around the body—that's what this frame is to me. But it never goes away; you see the body every day. ◆ It's a sad and nostalgic image. I see textures and nuances. I see this soft light washing over the velvet. I see this dark shadow to the right, and this very pale horizontal line across the center. I see this tiny layer of dust, especially on the lower left-hand edge. And of course, because the velvet is so spare and simple, I focus on the frame, the gold-etched outlines of flowers and the larger floral shapes, almost like sunflowers, around the edges.

The outside is very charged and the inside very quiet. And for whatever reason, I have this slight feeling that the frame is looking at me. ◆ I see a frame that shows an absence. I see something everyone is denied the pleasure of seeing. I see a loss that is just indescribable. I see my impossibility to ever see the real thing. ◆ Today I just see velvet, but of course there's much more. ◆ My job is to bring it back, so I see my failure. I see this void even in my nightmares. There is a car, and, in it, a painting with a plastic bag over it. I take the bag off and it's not the painting that I want. But I know that one day, in the middle of the night, I'll receive a telephone call: *Vermeer is back.*[19]

In a recent interview, Melissa Harris asked Calle about the stolen-painting pieces in general: "Does it make any difference that *Last Seen* and *What Do You See?* address something that has been stolen, as opposed to out on loan?" Sophie Calle replied: "Yes, there is more feeling—like when somebody dies as compared to just leaving for the month. I did not compare the texts, but I think there is more nostalgia when the work is stolen. It is more intense."[20]

Finally, I should like to turn to a small show of stolen-painting pieces recently exhibited at the Paula Cooper Gallery in New York. Titled *Purloined*, it includes stolen works by Turner, Titian, Picasso and Lucian Freud and the texts generated by these purloined paintings, most of which were subsequently returned.

Tucked into a corner was a particularly striking piece, based on a small, early portrait of Francis Bacon by Lucian Freud [p. 410], painted in 1952, owned by the Tate but stolen from a British Council retrospective of Lucian Freud's work in 1988, showing at the Neue Nationalgalerie in Berlin. The small size of the portrait, 7×5 in. (18×13 cm, painted on copper) made it particularly vulnerable.

Here is the text generated by the stolen portrait; it was placed next to a photograph of the yellow filing cabinet in which the postcard-sized painting had been stored at the Tate [p. 410]:

It was small. Small and vulnerable, seven inches by five. So tiny. A jewel, a miniature. Precise. Compact. Meticulous. Withdrawn. The expression on the face was melancholic. The mouth was just as if he had some little secret of his own. I believe his eyes were blue...I think of it as "the Bacon." I have to force myself to think that it's a Freud painting rather than a Bacon self-portrait. It shows Bacon's little sort of chubby face, looking down, very closed, very reserved...It is the portrait of an outsider. When I heard it had gone, this mysterious, downcast look, those compelling but disturbing eyes immediately came back to me. Haunted eyes, as though there were thoughts in the mind of the sitter that were hard to dispel. It's uncomfortable. It reminds you of thoughts that we would much rather not have, the kind that make one look pale and clammy. I think this is

the most tender portrait I've ever seen of Bacon. I remember the long eyelashes, the look, hair casting a shadow, a bit like Hogarth's self-portraits. It seemed more like a private image than public property. An iconic object of domestic size. Unusually small, unusually pale, and with an extraordinary intensity that seemed out of proportion with its size. At that scale you tend to paint more tightly, more precisely, more lovingly perhaps...A very existential painting that gives the impression the sitter has gone through extreme experiences. It is Genet and Sartre. But it is difficult to disentangle whether this is because the image conveys that impression or because one already knows that it is Francis Bacon.[21]

RIGHT Lucian Freud, *Francis Bacon*, 1952. Oil on copper, 7 × 5 in. (17.8 × 12.8 cm)

BELOW Sophie Calle, *Purloined (Lucien Freud, Portrait of Francis Bacon)*, 1998–2013. Ilfochrome color print (photograph) and lithographic print on BFK Rives paper (text), framed photo: 26⅟₁₆ × 17⅜ in. (66.2 × 44.2 cm), framed text: 11¹³⁄₁₆ × 9⅞ in. (30 × 25 cm), introductory text: 5¹³⁄₁₆ × 8⅜ in. (14.8 × 21.3 cm)

Clearly, the people asked to write about the stolen painting had been familiar with it, had tender feelings about it, had responded to its smallness and its status as a "private" image rather than public property, as though to the loss of a personal friend.

But this is not the end of the writing about the portrait; or rather, there had been a text with a picture of the stolen painting published in 2001 by the artist himself! Freud decided he needed the painting for his upcoming show at the Tate. He created 2,000 "Wanted" posters, in German, offering a reward of 300,000 deutsche marks (about $160,000) for the return of the painting, no questions asked. Neither the artist's name nor that of the sitter is mentioned on the poster; only the request: "Would the person who now has possession kindly consider allowing me to show the painting in my exhibition at the Tate next June?" To cite art-blogger Jim Lane: "To date, the portrait and its heister are still at large...Oh, and another problem, many of the 'wanted' posters were stolen as collectors' items and none of them were ever recovered either."[22] One can imagine the thief, or his client, in some secret villa in the jungles of Brazil, gloating over it with a glass of brandy every evening, or like the fictitious possessor of Jan van Eyck's "Just Judges" panel from the Ghent Altarpiece (the panel stolen in 1934 and never recovered) in Camus' novel, *The Fall* (1956), brooding over the existential meaning of his plunder near a canal in Amsterdam.

In the course of writing this text, I asked myself why, beyond its enormous intrinsic interest, I was so deeply involved, indeed obsessed by the issue of ekphrasis, in both its broad and its narrow senses, and in the destruction or deconstruction of the traditional ekphrastic mode in Calle's word/image pieces. The obvious answer is, that as an art historian and sometimes critic, I have been an ekphrasticist for most of my life, without even realizing it.

My earliest publication, a slim volume titled *Mathis at Colmar: A Visual Confrontation*, published by Red Dust Press in 1963, had been ekphrastic in the strict sense of the word. It was the product of a trip to Colmar to see Matthias Grünewald's Isenheim Altarpiece. I sat in front of the work in question for five days and looked and thought and felt and wrote. It is not in any sense a traditional example of art-historical writing and it is one of my favorite creations, more akin to poetry than scholarship. Thirty years later, in an article for *Artforum* about a Philip Pearlstein portrait of my husband and myself, I commented on the necessarily subjective outlook of my take on the artwork, writing:

Philip Pearlstein's *Portrait of Linda Nochlin and Richard Pommer* ties together the personal and the intellectual strands of my life like no other work of art. It was commissioned in 1968 as a wedding portrait, and we are both wearing more or less the clothes we were married in...We are represented sitting in Philip's studio in Skowhegan, illuminated by the cold light of dentist's lamps, sweating in the heat of a Maine summer, though this latter condition is not recorded.[23]

The piece, then, begins objectively enough, but it ends with a kind of deep personal feeling, as in so many of Calle's texts based on absence, but in this case absence based not on the fact of a picture going missing but, rather, the disappearance of one of its subjects. My husband, Richard Pommer, one of the major subjects of this large-scale portrait, had died two years before I wrote the article. In writing the piece, I was engaged in a different kind of retrieval, retrieval from within, as it were.

Then, in 1998, I really allowed myself to go overboard in a piece on Bonnard's bathers I wrote for *Art in America*, on the occasion of the big Bonnard retrospective of that year. Originally presented as a lecture in a symposium on the exhibition at the Tate Gallery, my ekphrastic exuberance was rejected by my fellow panelists—all male—as "negative"—I think they meant "too personal, too feminist, in bad taste"—and it is all of that. Here it is:

It is the sign of death, not dynamism, however, that marks Bonnard's last great series of bathers, created in the 1930s and 1940s, in which the bathing figure, seen from a high viewpoint, is simply stretched out horizontally in the long tub. Passivity is the essence of the pose in the 1925 version. The image is somber and austere, reduced in color. Indeed, the most intense tonalities are reserved for a narrow area of red floor in front of the bath and the four rectangular tiles on the wall behind the bather. Marthe herself, and her bathwater, are thinly painted in low-keyed blue-green: her funny face emerges from the surrounding opaque water with a startling, almost caricature-like vividness. The whole composition creates a sense of expansion and constriction at once: expansion in the elongation of the forms; constriction in the tomb-like isolation of the tub-shape itself.

Tomb/womb: the bath as a motif is both constricting and sheltering, suggesting at once the beginning and the ending of life, inter-uterine bliss (or the baptismal font) and the coffin...In the case of the outstretched female bather, woman and water, however, it is hard to avoid the association of sensual enjoyment with its eventual punishment—or self-punishment...But it is Ophelia that one thinks of as a general precedent: Ophelia in her watery grave represented as variously as in the bronze version by Auguste Préault (1876)...or the minutely painted Ophelia by John Everett Millais (1852)...There is something abject and sinister about Bonnard's late bathers: the force impelling them is not desire itself but the memory of desire, the ghost of desire, desire as a revenant come back to haunt the still, tepid surface of the bathwater. "Get out of the tub or you'll melt away," my mother used to say. The associations of sensual indulgence and subsequent punishment cling to such images, but that's obvious. What is perhaps less obvious is that Bonnard's women *have* in fact melted away, pictorially speaking. They have indeed suffered a sea change into something rich and strange,

the coral and pearls of the painter's pigment, and the meltdown demanded by his sexual fantasy. The metamorphosis may be gorgeous, but it is also a kind of elegant *pourriture*, exquisite rot, *la pourriture terrestre,* canvases shimmering with the iridescence of putrification, glowing with the disintegration of the loved object as it oozes into the *informe.* It is significant that Bonnard's work is its most provocative best when he kills off or mutilates his subject: Marthe dismembered or floating in death-like passivity is the heroine of his most exciting canvases. Did he love her or hate her, or, as is so often the case, feel some combination of both? Surely, there must have been some resentment felt about this woman, who, though little seems to be known about her character, seems to have drawn him into her own reclusion, her apparent lack of interest in anything but the care of her own body. At the same time, he may have felt gratitude towards Marthe for sharing his life, for lending herself so willingly, and frequently, it seems, to the demands of his art.... I deeply admire, indeed at times, am passionately seduced by the pictorial rhetoric of Bonnard's bathers; yet at the same time, and with equal intensity, I am also repelled by so much transformation of woman into thing, such melting of flesh-and-blood model into the molten object of desire of the male painter...That I hold Bonnard's bathers in admiration, that they afford me so much visual pleasure while, at the same time, causing me such instinc-tual pain, is a token of the divisions coexisting in the woman-as-art-lover...It is precisely that edge of irony, of sardonic destruction and self-consciousness that makes Bonnard's bathers so interesting...and accounts for their intense visual and expressive complexity.[24]

Despite the fact that most of the text was devoted to objective analysis and positive judgment, this flight of ekphrasis was viewed as "daring" by some and outrageous by others. The root of the trouble might well be that I am trying to express a very mixed emotional reaction to a work of art—something that Calle's texts, by their very nature, are designed to do, but that "normal" critical writing avoids.

Now I would like to sum up: what is the result of this lengthy investigation into Sophie Calle's word/image pieces? I think there are several conclusions to be drawn, apparently contradictory but not mutually exclusive:

1. In a certain sense, these are the fruit of a democratizing impulse, although I say this with tongue in cheek. We can, if we like, all do our own "Sophie Calles." They take no particular skill or expertise. In the 19th century, we might have ordered a hand-painted copy of the Bonnard or the Vermeer from a skilled copyist at considerable expense; even today, we can go online and find a plethora of line-for-line copies on sale, in a variety of media and sizes. But we are too sophisticated for that; we know such consumer prod-ucts are kitsch at best, schlock at worst. As good postmodernists, if we are (as is likely!) unable to afford our own Vermeer or de Chirico or Bonnard, we, like Sophie Calle, can

create our own ekphrastic equivalent, a sort of "School of Calle" substitute, by getting a group of friends or museum workers or total strangers to create a verbal substitute for the absent object of our desire.

2. On the other hand, however, these Calle installations serve to remind us of the irreplaceable value of the work of art itself, in all the uniqueness of its presence. How melancholy all these texts are, in their effortful attempts to recreate the absent artwork, whether it be benignly visiting another site or tragically abducted. Try as we might, we cannot recreate the inimitable aura, which, as Walter Benjamin pointed out in his classic 1936 article, "The Work of Art in an Age of Mechanical Reproduction," was the very essence of the great creation: aura and presence were one. But with the coming of film and photography, and even more today with digital media, the value of the unique object would seem to disappear in a welter of mass reproductions, available to all, often omitting or distorting some of the essential elements of the original: scale, texture, touch. In some ways, of course, Benjamin could be considered irrelevant, indeed archaic, if we look at the art world today. In terms of cash value and auction prices, one might say the aura is working its magic, with contemporary works constructed by machines or assistants going for millions. And we might even speak of the "aurification" of precisely those media that are born for democratic consumption, like photographs, which theoretically are open to unlimited editions, and which now have limited editions, *catalogues raisonnés* and rare heritage prints available for collectors: works not perhaps born with the aura, but which have had the aura thrust upon them, so to speak.

3. But, confronted by Calle's work—texts and absences—we realize what an unrelenting hold the aura has on the imagination of the beholder of the work of high art, the rare, unique, time-honored masterpiece. There simply is no substitute for its presence, as these texts, empty frames and meaningless draperies demonstrate over and over again. Try as we may, nothing can really take the place of the lost Vermeer or Rembrandt, and we mourn its departure as we would that of an irreplaceable human being. Or, when, as sometimes happens, lost works are rediscovered, we rejoice as though the dead had been revived. I remember taking a weekend trip to St Petersburg to see the lost and newly recovered Degas, *Viscount Lepic and his Daughters at the Place de la Concorde*, and felt it well worth the effort; if someone came up with Courbet's *Stonebreakers*, destroyed during the Second World War, I would go to the ends of the earth to see it. Cynical though I may be about certain aspects of expertise, connoisseurship and the snobbish elitism that corrupts the relation of art and its audiences, and especially tired of the present sentimental adulation of Vermeer, nevertheless my heart goes out to old Bergotte, sick and exhausted, but dying with the image of the little patch of yellow in his mind's eye.[25] Or to Géricault, one of the greatest artists of the 19th century, who, when he first confronted the Sistine Ceiling in those reproduction-free days—1817, I think—is said to have fallen to the floor in a kind of faint or paroxysm and not to have recovered for several days. And it is precisely this paradoxical opposition, engaging with

Benjamin's pronouncements on the aura, which Sophie Calle raises so brilliantly and yet with such seductive understatement in her word/image series.

There is still another issue that Calle's "ekphrastic" work raises, and that is a feminist one. There is not a single missing work by a woman artist that Calle engages with; no Mary Cassatt, no Berthe Morisot, no Georgia O'Keeffe painting leaves a space on the wall or an empty frame. In a sense, one might say that the missing masterpiece and the ekphrastic replacement for it create a kind of genealogy in the act of substitution, not unlike that proposed by Harold Bloom for the strong poets of history: Milton vying with Shakespeare, who enabled Wordsworth who "begat," so to speak, Keats and Shelley, who begat Browning, who begat Yeats. It is through the act of emulation/competition that something new, innovative, and independent is created. Women writers are, of course, omitted from this genealogy and the competitive energy that constructs it, as are women artists from the emulative/competitive chain that constitutes the grand genealogy of art history, in which Cézanne vies with Manet, Picasso with Cézanne and Jackson Pollock with Picasso. Women's art is completely omitted from this history of struggle and success: it is indeed the "empty space" on the wall that remains empty, that no ekphrastic substitute will ever fill. Sophie Calle, by creating her *Ghosts*, ensures the failure of ekphrasis by refusing a grand verbal recreation of the lost image, and instead reducing it to a series of lapsed memories, speculations, broken phrases, regrets, varied opinions, including negative ones, by ordinary people rather than a single brilliant consciousness. In so doing, she is, unintentionally, creating an unconscious feminist response to the Great Art of the museum and its authorized discourses.

Notes

1 Ken Johnson (2014), "As Maman Lay Dying, Her Spirit Became Art: in 'Rachel, Monique,' Sophie Calle eulogizes her Mother," *New York Times*, May 15.

2 Ibid.

3 Robert Storr and Marianne Grove (2003), "Sophie Calle: La femme qui n'était pas la/ the woman who wasn't there," *Art Press*, 295, November, pp. 23–28.

4 For further sources of information about Calle and her work, I recommend the large Prestel volume that accompanied the major Calle exhibition, *M'as-tu vue?*, curated by Christine Macel in 2004 at the Centre Pompidou, and the compact, convenient little book *Sophie Calle: The Reader* (2009), London: Whitechapel Art Gallery, with excellent essays by Yve-Alain Bois, Robert Storr, Sheena Wagstaff, Iwona Blazwick and many others.

5 Lattimore, 11.

6 For the most complete discussion of this topic, see Rensselaer Lee (1940), "Ut Pictura Poesis: the Humanistic Theory of Painting," *Art Bulletin* 22, pp. 197–269.

7 Keats made a tracing of an engraving of the Sosibios Vase in the Louvre.

8 Albert Aurier (1890), "The Isolated Ones: Vincent van Gogh," *Mercure de France*, January, http://www.vggallery.com/misc/archives/aurier.htm (accessed December 1, 2014)

9 Sophie Calle (2013), *Ghosts*, Arles/Paris: Actes Sud, p. 7.

10 This English translation of the French text is taken from Calle, *Ghosts*, pp. 10, 11 and 14.

11 Ibid., p. 17.

12 Ibid., pp. 28, 29 and 32. For a reproduction of this wall text, showing the individual sketches, see pp. 30–31.

13 Ibid., p. 63.

14 "At last he came to the Vermeer which he remembered as more striking...and finally, the precious substance of the tiny patch of yellow wall...he fixed his gaze, like a child upon a yellow butterfly that it wants to catch, on the precious little patch of wall.... I ought to have...made my language precious in itself, like this little patch of yellow wall..." Bergotte, already mortally ill, falls down and dies while contemplating the yellow patch in the Vermeer. The incident occurs in Volume 5 of Proust's *In Search of Lost Time: The Captive* (1993), originally published in 1923, CK Scott Moncrieff et al., trans., New York, NY: Modern Library, pp. 244–45. When I went to see the painting in the museum of Delft, there was a crowd of viewers gathered around it trying to find that patch of yellow in order to repeat the Proustian experience, just as I was.

15 Alfred Corn (2002), "Seeing all the Vermeers," *Contradictions*, Port Townsend, WA: Copper Canyon Press, p. 71.

16 First exhibited in the show *Last Seen* at the Carnegie International, Pittsburgh, PA, in 1991, and later at the Isabella Stewart Gardner Museum in 2012.

17 Statement from the brochure (2013), "Sophie Calle: *Last Seen*, October, 2013–March 2014, Isabella Stewart Gardner Museum, Boston, MA." This show brought together both series of works relating to the Gardner thefts.

18 Calle, *Ghosts*, p. 151.

19 Ibid., pp. 145–47.

20 "What Do You See? Sophie Calle in conversation with Melissa Harris" (2013), *Aperture*, #212, Fall, p. 13.

21 My transcription of the wall text at Paula Cooper Gallery.

22 Jim Lane (2013), "Wanted Art," *Art Now and Then* (blog), Friday, January 25, pp. 1–2.

23 Linda Nochlin (1993), "State of the Art: Philip Pearlstein: *Portrait of Linda Nochlin and Richard Pommer*," *Artforum* 32, no. 1, September.

24 From a text Linda Nochlin sent to Suzanne Page in October 2005, much of which was published as "Bonnard's Bathers" (1998), in *Art in America*, July, pp. 63–67 and 103.

25 See above for discussion of this incident in Proust's *Remembrance of Things Past*, p. 404.

29

Ellen Altfest: A New, New Realism

May 2014, previously unpublished

A dog's sense of smell is up to 100,000 times more acute than a human's

NATIONAL GEOGRAPHIC MAGAZINE, JUNE 2014

What is realism? Or, to be more accurate, what are realisms? For there is not a single realism, but many. Early in the 15th century, Jan van Eyck, painting in oil, proudly proclaimed "Johannes van Eyck fuit hic"—"Jan van Eyck was here"—on the wall in the back of *The Arnolfini Portrait* (1434); and indeed he was, visible in the background of the mirror behind the married couple [p. 418]. Jan's acute brush engages with every surface, captures every gleam, and differentiates every nuance of texture as witness to the event. See how many different kinds of wood he distinguishes: floor, clogs, picture frame, window frame; or fur: the fur edging of Arnolfini's garment is markedly different from that on the border of his wife's sleeve, or the coat of the dog in the foreground. Yes, as scholar Erwin Panofsky pointed out many years ago, each of these objects bears a hidden religious or moral meaning that, in a sense, justifies their tangibility, but it is their visible manifestation that Van Eyck cares to get just right, indeed is enamored with. A great deal of detail is required to establish the veracity, the "I-was-thereness" of the image.

Michelangelo would have never have said, or wanted to say, that he was there in the *Creation of Adam* from the Sistine Ceiling. In fact, he belittled Flemish art, according to Francesco da Hollanda, for its unselective imitation of nature, declaring: "It will appeal to women, especially to the very old and the very young, and also to monks and nuns and to certain noblemen who have no sense of true harmony. In Flanders they paint with a view to deceiving sensual vision.... They paint stuffs and masonry, the green grass of the fields, the shadows of tree, and rivers and bridges, which they call landscapes with many figures on this side and many figures on that. And all this, though it pleases some persons, is done without reason or art, without symmetry or proportion, without skillful selection or boldness, and, finally, without substance or vigor...."[1] Roger Fry, one of the founding fathers of modernism early in the 20th century shared this opinion, albeit more elegantly: while admitting the Northern artists' extraordinary control of the medium, the richness and glow of their colors and the precision and accuracy of their outlines, Fry nevertheless finds the early Netherlandish painters "lacking in those principles of plastic design which mark the great European tradition founded by Giotto," and thus esthetically inferior. "If," he continues, "we consider a minute and detailed verisimilitude a great pictorial quality then the Flemish primitives stand

Jan van Eyck,
*The Arnolfini
Portrait*, 1434.
Oil on oak,
32⅜ × 23⅝ in.
(82.2 × 60 cm)

almost unrivalled.... The vision of these painters was so little removed from the vision we employ for buying stuffs in a shop that it required no effort of reflection to recognize its accuracy and effectiveness." (This is obviously a dig at the taste of the materialistic British art lover in 1927.) But, adds Fry—and the but is at the heart of his esthetic judgment—"this everyday vision has not been the concern of the greatest painters; they have sought to place themselves at a greater distance from the phenomena of nature, to view them with a more detached eye, to be less entangled in their immediate references and implications. They have sought...to discover those more universal truths which escape the untrained vision, distorted as it is from infancy, by the needs of the practical and instinctive life."[2] Fry does not go as far as his friend and fellow critic Clive Bell, who declared that "detail is the heart of realism and the fatty degeneration of art."[3]

Yes, detail is the heart of realism. But far from being a sign of degeneration it can be a sign of vigor, of vitality, of presence. In Van Eyck's *Portrait of a Man in a Red Turban*, (1433), the viewer is made aware of the sitter's unique pattern of beard stubble, his wrinkles, and can follow the magnificent, complex swirls of the red headdress that provides texture, space, and dynamic vitality all at once to the portrait. Compare the

simple geometric hats, the *mazocchi*, favored by Florentine artists of the period. It is indeed the detail at the heart of realism that constitutes the uniqueness of this image.

The naked human body has always been a testing ground for realist intervention. The 19th century made many bold assaults on the hairless, marble-smooth classical nude surface, a surface that demanded relentless omission. Things inevitably present but just as inevitably omitted from the traditional naked body, or nude, began to appear on the fleshly surface: cellulite in the case of Felix Vallotton's little canvas of nude buttocks; or body hair under the naked armpit or on the crotch of Courbet's naked women. Strange and unusual angles of vision were pursued by Degas in his representations of women bathers; he, like other realists of the 19th century, wanted to see the body, and to make viewers see it, differently from the way it had been seen before. Degas preceded the Russian formalists by some decades when he proposed seeing and depicting the world from unexpected angles of vision, such as from above and below. The body is made strange—to his contemporaries, grotesque and upsetting; he was accused, of course, of misogyny for his lack of conventional idealization, his inclusion of the knobs of the spine, the splay of the feet, the jut of the hip, for the debasement of the head.

In the 20th century, Philip Pearlstein extended the possibilities of realistically reconfiguring the genre of the nude, defamiliarizing the body with strange folds of flesh, cast shadows, revealed wrinkles, and disturbing partial views, including headless ones [p. 420]. The late Sylvia Sleigh included the reality, and shocking decorative potential, of masculine body hair and the effects of suntan, a bit tongue-in-cheek. But she maintained she was only painting what she saw and that artists of the past had automatically self-censored.

Altfest's *The Butt* of 2007 [p. 420] brings something decidedly new to this engagement with detail, body coloration and textural exploration. Overtly estheticized, tongue-in-cheek, the classical torso has been revivified, clamped into a limiting frame like a Georgia O'Keeffe flower, rich in the immediacy of body hair, paint-splotched stool and perspectival floor plane. These are textures we may not want to touch, though built on haptic modes of vision, but we do want to absorb them through sight.

When it comes to plants, fruit or vegetables, Altfest gives herself a challenge that previous landscape or still-life painters, however attached to things as they are in the real world, have never given themselves: the weeds in *Tumbleweed* (2005) [p. 421] seem designed to drive a painter crazy, with their highly differentiated monotone prickles and countless branching outgrowths. As a painting it represents them as no photograph could, for the swirls, curves, interlacing nests of linear elements were created over time, as process, not photographed as immediately available product. In its resolute avoidance of "form," despite its modest scale, Altfest's painting calls to mind the grand ambition of Jackson Pollock's drippy swirls in abstract expressionist masterpieces like *Autumn Rhythm* of 1950, while at the same time, given its small size and concrete subject matter, asserting its realist difference.

ABOVE
Philip Pearlstein,
*Female Model on
Eames Stool*, 1978.
Oil on canvas,
48 × 60 in.
(121.9 × 152.4 cm)

LEFT
Ellen Altfest,
The Butt, 2007.
Oil on canvas,
13 × 13 in.
(33 x 33 cm)

It is impossible to discuss realism without its social implications. Realism seems almost to have been invented as a way of indicating class difference. In the Middle Ages, irregularities, sordid details and lack of decorum were reserved for the representation of peasants, contrasting their low status with the elegantly idealized or decorative styles favored for aristos or heavenly figures. From the 19th century on, realistic detail was used for scenes depicting social issues, though often overlaid with the heightened emotion we tend to associate with sentimentality. But as early as the 13th century, stylistic difference comes to the fore to distinguish the annunciating angel from the lowly shepherds in the reliefs of Chartres' west portal. The shepherds have attained a far greater degree of individuation than the sacred figures around them, their earthy coarseness immediately setting them off as representatives of that lowest order of humanity that benefited from the birth of Christ. Stiff-legged and slack-jawed, with blunt features and dumb expressions, the figures express a kind of dawning realization of an imminent miracle. The costumes seem amazingly accurate, down to the sags and wrinkles of different kinds of woolen homespun: the hose are more regular in their patterns of folds than the sleeves. One can find a vivid paradigm of realism as indicator of low social status in the way the blunt, plebian features of the left-hand shepherd, and the irregular wrinkles of his garments, are deliberately played against the stylized scallops

Ellen Altfest, *Tumbleweed*, 2005.
Oil on canvas, 42 × 52 in. (106.7 × 132.1 cm)

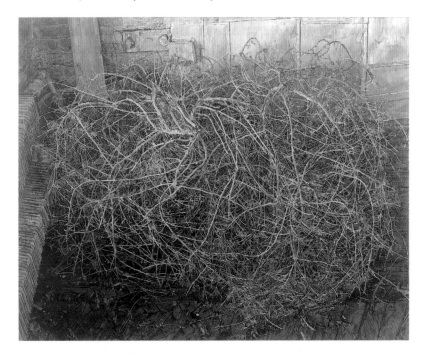

of the angelic wing behind him. The contingent irregularities of the natural world are contrasted with the sublime regularity of the world beyond time; the angel is planted in a pose of eternal — classical — harmony, while the shepherds are caught in the midst of more momentary physical and emotional transactions.

Realist vision was essential to the socially critical art of the 19th century. Artists like Géricault and Courbet used realist detail for a purpose. Anti-idealization carried a political charge for Courbet (and for Géricault) in his English works, even earlier. Documentary photography, a direct descendent of 19th-century realism, often played the "witness role"—Jan van Eyck's "I was there"—in the case of the down-and-out: New York immigrants or deprived Appalachians. Both Jacob Riis and Walker Evans depended, in different ways, on anti-idealized detail and a kind of anti-composition to ensure the "reality effect," to borrow Roland Barthes' term—in their black-and-white prints.

Riis, in particular, a journalist totally untrained in the art of photography, deliberately strove for an "uncomposed," anti-esthetic look to make his images seem more indexical, hence more truthful, and by so doing increase their political effectiveness. Evans at once manages premeditated composition and shocking realist evidence of destitution.

Given this history, it is interesting to observe the nearly complete lack of interest in social critique, the class struggle or overt political commitment in the work of most of the major "new" realists from the 1950s on. Alice Neel, a major figure, who was certainly engaged with the issues of class, race and politics in her early work, turned almost completely to the idiosyncrasies of the individual in her later, more famous portraits; neither Pearlstein in his nudes, nor Sylvia Sleigh in hers, was interested in traditional social context, much less the class struggle, although one could certainly say that Sleigh, in her decorative male nudes, was making a feminist statement.

And this rejection of realism's historic tie to social commitment is certainly the case for Ellen Altfest. Indeed, one might almost call her style "esthetic realism," a realism that makes a kind of strange and quirky beauty out of the offbeat cut of her imagery, but even more, an eye and hand able to see and record what the ordinary person represses, or elides as "extraneous." What is striking about the realist painting of recent years and the present is its resolute rejection of the social consciousness with which, in the recent past, it was almost invariably connected. One might say that for a painter merely to engage with realism (outside its "natural" realm of video, film, photography) constitutes a political act. After abstraction, Minimalism, conceptual art, pop, etc., a realist painting is, inherently, a kind of outsider art, and an artist like Altfest intensifies this identity by insisting on her work as an esthetic rather than a social project. But I am using the term "esthetic" in a very special sense: the esthetic of realism, Alfest's esthetic, has little to do with conventional beauty, good drawing, luscious painting, Roger Fry's eternal truths, or Clement Greenberg's criteria for "strong" art. For Altfest, beauty in the conventional or even vanguard sense has been abandoned for a quirky esthetic that encompasses

both reduction and plenitude. She may reduce the visual field to an armpit but once the motif is chosen, it is a question of getting everything in, of excluding nothing. It is an esthetic of non-rejection; no one part is better than another. And in a certain sense, one might say it is at once an esthetic of amazing reduction—so that is what a single nipple is like!—and an equally astounding expansion of the visual field. Looking at *Tree* (2013) [p. 425], I realize that there are tiny protrusions, lines, mini-shingles, curving lobes, cracks, rough spots, which, although there in the tree trunk itself, no one would ever have noticed, or if they had noticed, would have rejected as extraneous, unnecessary. Walking home from the beach, I looked at a piece of driftwood much more carefully, scanned it with a probing eye, after looking at Altfest's tree trunk.

Alfest, however, does not rely on a single esthetic, or follow a pre-ordained formula. In *The Butt*, for example, one might say that the male torso is highly estheticized, a symmetrically positioned rear view transformed into a kind of vase or double-curved urn, its right edge embellished with a line of light. Yet the outer curves of the "urn" are distinguished as fleshy bulges, not smooth ceramic curves, and the all-over patterning of body hair, with its multiple variations, thickening around the anus, distracts from less human readings, bringing us back to the bare factuality of the butt, seated on a paint-spattered stool and a more sparsely paint-stained studio floor.

Yet in *The Bent Leg* of 2008 [p. 424], the artist chooses an asymmetrical close-up view for the male body—the bent leg framing the penis, scrotum and part of the back thigh. Here, the edges are less important, the interior massing of hairy elements and the always-dominating penis are the point of the composition, tightly interlocked and contained, making the decorative felicity of *Butt* far less prominent. When I say "always-dominating penis" in the male nudes, or fragments of nudes, by Altfest, I do not mean to imply that she is making a deliberate statement about the importance of the male organ or a political comment on the centrality of male domination, as did some feminist artists who specialized in representations of the male organ in the 1970s. No, that is not the point. In works like *Reclining Nude* of 2006–7 or *The Bent Leg*, it is simply that the penis, after centuries of discreet veiling—students at the French Académie des Beaux-Arts were advised to have some "chance" element, like a sword, a bit of drapery, or in one case, a large roast of beef, come between the offending organ and the eye of the beholder—is now accorded full attention. In *Reclining Nude*, for example, the penis and the scrotum, topped by a mat of dark curls, are the first things to meet the viewer's gaze. And there is a lot to see: veins, sags, textures, shades of lighter and darker rose attract the eye and keep it probing; in *The Bent Leg*, one has to push back a bit farther in space, but the penis is alluringly framed by the V shape of the leg, peeping inquisitively out in three-quarter view, its perky shape contrasting with the sagging weightiness of the balls beneath. *Penis*, of 2006, is a head-on confrontation of the subject, with only a thin slice of belly, a few fingers and a glimpse of hairy, parted thighs to provide context. The delicate irregularities of the asymmetrical organ itself are symmetrically framed on

the same paint-swirled studio stool that supported *The Butt*. One suspects that they are a back and front view of the same subject, but there is no proof offered by the images themselves.

There is still another aspect of Ellen Altfest's realist esthetic that is rarely discussed, and that is scale. Many of Altfest's oil paintings with human-derived subjects are quite small—*The Butt* is 13 × 13 in. (33 × 33 cm), *The Bent Leg*, 12 × 8 in. (30.5 × 20.3 cm) and *Penis*, 11 × 12 in. (28 × 30.5 cm). The masculine fragments offered by her series of watercolors of 2011 are equally small and give the impression of being even smaller because of the extreme reduction of their subjects and the delicacy of their handling: a tiny area where part of an arm meets a fragment of chest (*Arm and Veins*, watercolor on paper, 8 × 9 in. (21.1 × 23 cm)); an ear, or a nipple and a close-pressed arm. Here, the cut is absolute: there is no background, no suggestion of place, nothing but the minimal if variable minutiae of flesh and hair. Interestingly enough, a few of the still-life subjects are somewhat larger: *Tumbleweed* is 42 × 52 in. (106.7 × 132.1 cm), but *Green Gourd* of 2007, admittedly a color woodblock print on paper rather than an oil painting, is only $16\frac{7}{10}$ × $17\frac{1}{10}$ in. (42.4 × 43.4 cm) and the recent *Tree* (oil on canvas) of 2013,

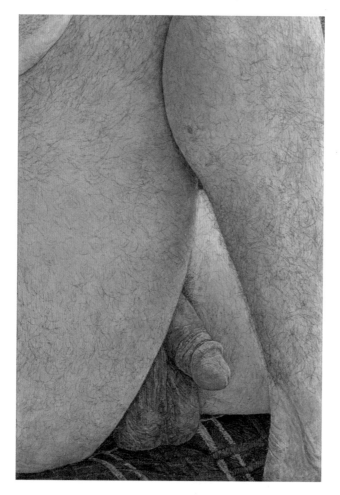

Ellen Altfest,
The Bent Leg, 2008.
Oil on canvas,
12 × 8 in.
(30.5 × 20.3 cm)

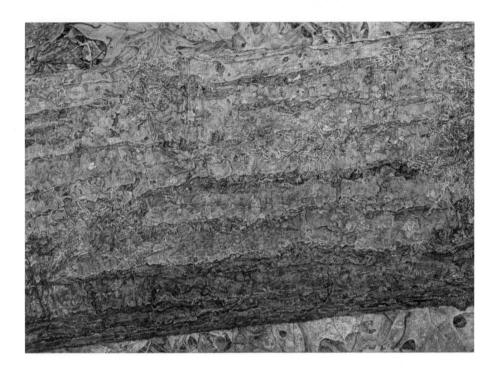

Ellen Altfest, *Tree*, 2013.
Oil on canvas, 8⅛ × 11¼ in. (20.6 × 28.6 cm)

over which Altfest worked doggedly out of doors for more than a year, is 8⅛ × 11¼ in. (20.6 × 28.6 cm),[4] about the size of a sheet of typing paper. Small scale seems exactly right for intense detail. One has to come in close, or bring the image close with one's hands, as one would for the miniatures in a medieval prayer book; backing away, as one tends to do with a Jackson Pollock, or a Velázquez or Titian, is counterproductive. In a work as small as many of Altfest's, intimacy is a demand of the visual field itself. Yet perhaps "intimacy," with its implications of emotional as well as physical closeness, is the wrong word; or "visual intimacy," not the emotional kind, must be specified. In an art world where grandeur of scale has for a long time been associated with importance of achievement, Ellen Altfest's production suggests that there is plenty of room for an alternate vision and a different kind of evaluation.

Notes

1 See Francesco da Hollanda (1966), in R Klein and H Zerner, eds, *Italian Art: 1500–1600: Sources and Documents*, Englewood Cliffs, NJ: Prentice-Hall, pp. 34–35. See also L Nochlin, "The Realist Criminal and the Abstract Law," Part I, *Art in America,* September–October 1973, pp. 54–61, for a more extensive discussion of realist critique.

2 Roger Fry (1927), *Flemish Art: A Critical Survey*, London: Chatto & Windus, cited in L Nochlin (1973), "The Realist Criminal and the Abstract Law," Part II, *Art in America* 61, no. 6, p. 97.

3 Clive Bell, *Flemish Art*, cited in ibid.

4 See Randy Kennedy (2013), "Warming to Painting in the Cold," *New York Times,* June 9, p. AR21.

425

Natalie Frank: The Dark Side of the Fairy Tale

Tales of the Brothers Grimm. Drawings by Natalie Frank, 2015

"Why," to borrow the words of the most famous scholar of the subject, Jack Zipes, "do fairy tales stick?"[1] Why do they still have the power to attract us, to seduce us, to lure us, to stir our imaginations? And by "us," I mean children, their intended audience, and the adults who immediately took them over. The answers are of course multiple and often contradictory, and I plan to speculate about them throughout the course of this essay. The fairy tale's radical irrationality seems to demand psychoanalytic interpretation, yet its rigorous social logic ensures—as the dream does not—that proper rewards and punishments, that is to say, socially sanctioned ones, are meted out to the protagonists at the end.

Fairy tales, especially those collected and published by Charles Perrault in France in the late 17th century and the Brothers Grimm in Germany in the early 19th, have been perennial favorites, not just with readers but with illustrators.[2] If no modern illustrator can quite match the elegant perversity of Gustave Doré's black-and-white bedroom scene from Perrault's *Petit Chaperon Rouge* (Little Red Riding Hood) featuring the sardonic allure of the wolf decked out in granny's nightgown and the pre-nubile provocation of Little Red Riding Hood herself, 1862 [p. 375] many contemporary women artists have come close in their versions of the Little Red Riding Hood theme, with which I will be primarily concerned in this essay. The Portuguese/British artist, Paula Rego, has constructed the tale as a feminist farce, with Red Riding Hood's mother flaunting the wolf's pelt as a stole at the end; the American Kiki Smith has envisioned the Red Riding Hood theme as one of startling metamorphoses, one version with the starkly naked figure of the young woman emerging from the wolf's belly, another with the caped figure of Red Riding Hood sprouting a scary wolf-beard [p. 381].[3] The Japanese photographer, Miwa Yanagi, in her recent *Fairytale* series of 2005, created large-scale images enacted by children and adolescents, in which playfulness and cruelty, fantasy and realism merge.[4] Yanagi shows Red Riding Hood and her grandmother clinging together, still enclosed in the wolf's belly—a furry zip-up sleeping bag.[5]

Natalie Frank's fairy tale project, *Tales from the Brothers Grimm: Drawings* (2011–14), a book of drawings in gouache and chalk pastel on rough Arches paper, stands out. It is unusual not only for the scope of the artist's ambition—there are seventy-five images

RIGHT Paula Rego,
*Mother Wears the
Wolf's Pelt*, 2003.
Pastel on paper,
33⅛ × 26⅜ in.
(84 × 67 cm)

BELOW Kiki Smith,
Rapture, 2001. Bronze,
67¼ × 62 × 26¼ in.
(170.8 × 157.5 × 66.7
cm), edition of 3 + 1 AP

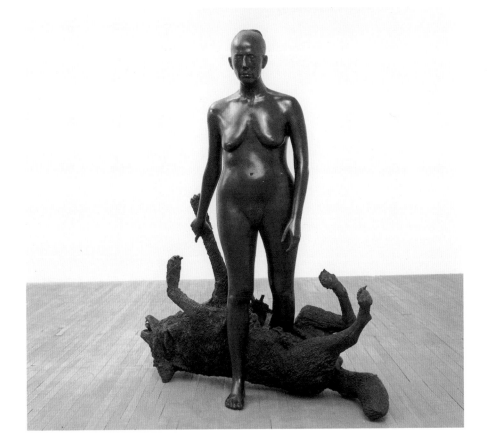

Natalie Frank, *The Stammerer*, 2007.
Oil on canvas, 72 × 62 in. (182.9 × 157.5 cm)

in the book, one to five drawings measuring 22 × 30 in. (56 × 76 cm) for each of thirty-six fairy tales—images in all—but for the complexity of her technique and thinking alike. These are Grimm's fairy tales before the PC censors got ahold of them, although even the good brothers themselves could hardly have envisioned them as Frank does, living as they did before the era of psychoanalysis or Surrealism. Frank's versions of the familiar and not-so-familiar tales are un-syrupy, anti-Disneyesque and sometimes gruesome. Cruelty and crude eroticism, magic and bizarre fantasy mark their folkloristic roots; weirdness and irrationality distance them from both everyday life and the moralism of happily-ever-after.

One might say that Frank has a natural affinity for the dark side of the fairy tale, the dark side of life in general. Her earlier monumental, large-scale oil paintings are marked by an uncanny ominousness. Their alluring richness of coloristic and graphic virtuosity is always offset by a transfiguring realist gloom. Women, especially, are marked for physical or mental misfortune, their naked or half-clad bodies fated for the worst. In *The Stammerer*, for instance, a large-scale 72 × 62 in. (182.9 × 157.5 cm) oil on canvas of 2007, a richly painted blond nude, her sexiness enhanced by lace bikini underpants, lies amid rumpled draperies, including a flowered shawl, her body tipped up toward the spectator (shades of Manet's *Olympia!*) in the foreground, while behind her, silhouetted

before a window, a sinister couple—a nude, middle-aged man grasping a young girl by the throat—is reflected in a mirror. The complexity of this sentence is generated by the structure of the artist's imaginative invention, with its strange variations of light and shadow revealing realistic bodies and seductively detailed textile patterns, yet suggesting scarcely concealed violence and terror. In the even larger *Leftover Girls* of 2006, two forlorn young women, one black, one white, sit on the ground in the foreground, the white girl clad in a bedraggled wedding gown, complete with veil and gloves. Mystery lurks in the vigorously brushed setting behind them: in the spooky house with its curtained window; in the strange half-figure of a nude woman crawling into the lighted square to her left, in which other, half-adumbrated figures seem to loom; in the staring head encased in a cellophane bag silhouetted before the lighted area; and in the row of discarded bouquets to the left. A red and white pole connected to a hand emerges startlingly from the ground to the right. Ambiguities intentionally scar the abstract beauty of the virtuoso facture throughout: is the dark "girl" a girl or a boy? What is going on inside the house, and is it really "inside" that the lighted square is meant to represent? The uncanny scene is designed to disturb our equilibrium—and it does.

Frank's engagement with the dark side reaches a climax in the complex iconography and monumental scale 192 × 74 in. (487.6 × 188 cm) of *The Czech Bride* of 2008.

Natalie Frank, *Leftover Girls*, 2006.
Oil on canvas, 108 × 54 in. (274.3 × 137.2 cm)

Natalie Frank, *The Czech Bride*, 2008.
Oil on canvas, 192 × 74 in. (487.6 × 188 cm) (triptych)

Allegorical in its tenor, intensely personal in its references, *The Czech Bride* features the artist herself as participant–observer, literally connected to yet separated from her protagonist, whose heavy braid of blond hair she grasps at the borderline of tragedy. Veiled references suggest both the tragic past of the Shoa and less veiled ones—the ever-present outrage of the violation of women's bodies. Violence and sex are clearly linked in the ominous central scene, the headless figure in a striped shirt holding a hammer over the inert, bound figure of the Czech bride, and to the far right, where a diabolically ardent male nude enters the naked female, her hands clasped as though in prayer, from behind. The fairy tale images, in turn, foreground the violence and eroticism embedded in their purportedly child-centered narratives: they are definitely not meant for children, even contemporary ones, inured to the carnage of video games. In some cases, even faint-hearted adults may turn their heads away. At the same time, as works of art, these drawings are so truly resplendent, so seductive in the plenitude of their coloristic and narrative layering, so intriguing in their evocative ambiguities that they indeed "stick," to borrow Jack Zipes' terminology. They cannot be ignored!

I will now turn to the single Grimm's fairy tale that will be the focus of this essay: the time-honored fable of Little Red Riding Hood, also known, as Natalie Frank titles it, as Little Red Cap.[6] Frank devotes three of her most captivating pages to Little Red Cap, starting with the entry of our heroine into grandma's bedroom, where the wolf, having swallowed the old lady and decked himself out in her nightclothes, waits to greet and eat Little Red Cap. In the words of the artist: "The wolf dresses up in grandma's clothing. Little Red Cap walks into grandmother's house to find her in bed. Little Red Cap's reflection is in the mirror. The statuary watch her."[7]

In this opening image, Little Red Cap, nude, childishly plump, knock-kneed and red all over, seen from the rear, dominates the foreground, where she stands transfixed, staring at the unmistakably lupine granny figure in the bed before her. The wolf/granny's head partially obscures the startlingly expressive and disproportionately large head of Little Red Cap reflected in the mirror on the wall behind—a Little Red Cap dressed, bonneted, quite grown up and decidedly distressed. The wolf, big-eared, bug-eyed and sharp-toothed, grins in anticipation, clutching the picnic basket of goodies in one clawed hand, his brownish balls clearly revealed below the pink weave of the basket in his lap. He seems more of a devil than a naturalistic wolf, and his satanic grotesquery is picked up by the animalistic vase to the left with its naturalistic bouquet, and contrasts with the strange, surreal dog and cow viewed through the half-open brown shutters in the stippled blue out-of-doors, a blue-and-white stippling penetrating the interior space, and also picked up in the blue-and-white patterned bedspread. The room itself is mainly colored an acid, striped yellow; one of the gratuitous elegancies of the composition is the flowing pattern of brown and differing shades of muted green created by the blankets over the wolf's hairy knee.

Natalie Frank,
Little Red Cap I
(Grimm's Fairy Tales),
2011–14. Gouache
and chalk pastel on
paper, 22 × 30 in.
(55.9 × 76.2 cm)

Natalie Frank,
Little Red Cap II
(Grimm's Fairy Tales),
2011–14. Gouache
and chalk pastel on
paper, 22 × 30 in.
(55.9 × 76.2 cm)

To say that this version of Little Red Riding Hood is unexpected is an understate-ment, and yet, on second thoughts, each deviation from the usual rendering of the tale is motivated. Yes, a naked Red Riding Hood is startling, but the body in question is red, just like her traditional cape; yes, a wolf who shows not only his teeth but his balls wouldn't have a chance as a stand-in for grandma, but the beast's hypocritical, moony expression is a wonderful parody of more successful masquerades of this stereotypical role, and the strangely voluptuous and anguished mirror reflection of the child foiling the wolf's head sets up the terrifying tensions of the situation, as well. In addition, we the viewers are clearly *entering* the drama. By placing the heroine with her back to us on a delicate platform of shadow in the foreground, we, to some extent, identify with her, are identical with her. What happens to her happens to us.

The second drawing in the series is described by the artist as follows: "The wolf devours Little Red Cap and grandmother whole. So when the farmer comes in to find the wolf, he can cut him open and deliver the two women intact. Limbs come out of every orifice." This is an image of unprecedented ferocity, the blue-eyed, gaping-mawed, sharp-toothed head of the ravening wolf, a highly detailed human hand within its jaws, dominating the upper left-hand portion of the image. Below, we confront what seems to

Natalie Frank,
Little Red Cap III
(Grimm's Fairy Tales),
2011–14. Gouache
and chalk pastel on
paper, 22 × 30 in.
(55.9 × 76.2 cm)

be the bent torso of the red-clad heroine with her staring head, and, to her left, curled into fetal position, what is perhaps the granny figure in her white nightgown, pre-digested, as it were. Red Cap's torso is encompassed by her own red-clad leg on the left (or is this the wolf's leg, the hairy pelt torn off and dangling?) and the wolf's unmistak-able, masculine, hairy one on the right. The mattress is now bare and lumpy, the bed supported by a wolf paw in the foreground. The mirror in the background now shows a gnarled tree trunk against a blue sky; the striped, acid-yellow wallpaper background remains, as does a touch of the blue-and-white stippling beneath the bed. The violence of the scene is iterated in the sharp diagonal of the composition and the fragmentary bodily presences it encompasses.

In the third, and final, episode of the tale, *Little Red Cap III*, the wolf is killed and Little Red Cap saved. In the artist's words: "Little Red Cap fills up the wolf with stones and looks at him face to face. She has been inside him and now faces him, cheek to cheek. Their faces meld together and the picture falls away into abstraction."

In more conventional versions of the tale, the ending is heavily moralized: Little Red Riding Hood has been punished for disobeying her mother's command not to stray from the straight and narrow, even to pick flowers for her grandmother. The wolf is

punished for his duplicity and savagery by being killed and stuffed with stones, instead of the delicious human flesh he craved. The savior (male) is the virtuous woodsman or hunter who cuts open the wolf and releases his prey (female) from gruesome death and/ or captivity. Little Red Cap is incorporated into the society of dutiful, obedient women necessary to keep the wheels of civilization turning.

In Frank's version of the tale the outcome is more ambiguous. The wolf and Red Cap confront each other in the center of the piece, more or less as equals amid a tangle of body parts; only the wolf's body is clearly specified as his own with its dangling balls and muscular thighs. Red Cap's bodily apparatus is more ambiguously described: is that her body clothed in crisscrossed pink that hovers in the air behind her face, clutching an ear of the wolf, or is it an avatar of her grandmother, identified by the partial aged head at the far right? Or has the granny figure been transmuted into the almost-abstract smiling angel raising her hand in blessing at the upper right, the compositional counterfoil to the faithful dog raising his head in the left foreground. The rest of the image indeed "falls away into abstraction," as the artist specifies, although there is a hint of the male figure of the savior huntsman looking superior in the left-hand margin, and other figures, heavily impastoed, partially emerging in the background. The figure of the wolf still dominates: his muzzle covers some of Red Cap's face and his body is assertively thrust forward. On second viewing, I realized his figure shared some of the sleazy lupine narcissism of Paula Rego's lounge-lizard version of the same character.

Paula Rego,
*Mother Takes
Revenge*, 2003.
Pastel on paper,
41 × 31⅛ in.
(104 × 79 cm)

Despite the triumphant rescue of Little Red Cap and her grandmother, the arrogant masculinity represented by the ballsy wolf dominates every scene in which he appears, even the one depicting his purported death and downfall. This, of course, has a great deal to do with the dynamic energy of the massed pastel strokes radiating from the wolf's skull, the hypnotic stare of his blue, blue eye, the reiterated patterning of his sharp teeth, and the assertive diagonal at which his body is pitched in the last two scenes, or the equally assertive frontal pose in which he confronts us in the introductory one. Natalie Frank's formal language lies at the heart of her narrative project, her novel take on the time-honored story. Her color scale is breathtaking throughout: acid yellows, smoldering reds, contrasting, chilly, and dappled, atmospheric blues. Sharp black outlines often deny or conflict with the volumetric *rondeurs* of the objects or bodies they articulate; meltingly fuzzy areas collide with stark planar ones. Everywhere there are daring structural dissonances, contrasts, antinomies, but they are held together by Frank's unerring visual rectitude. The entire corpus of Frank's *Tales* bears close examination, scrupulous attention to its sophisticated layering, a mind open to the power of her transformative imagination that can make the Grimm's far-from-timeless stories into new and provocative experiences for today.

It is not surprising that Natalie Frank's most recent work should bear the impress of her formal and iconographic experiments in the *Tales* series. A sculptural "portrait," *Anne* (2014), with its realistic profile set off by uncanny blue drops backed by the displaced yellow silhouette of an arm, certainly brings to mind some of the fantastic imagery of the Grimm cycle. A kind of sculptural bust, supported on a stick, Anne combines realistic modeling with colorful decorative flatness; the presence of the red hood and collar specifically relates to the artist's almost contemporary imagery of Little Red Cap in the fairy-tale series. But an added element of grotesquerie marks this "portrait bust": it can be viewed with portions "open" or "closed," suggesting active viewer participation.

Even more complex and disturbing is the recent two-dimensional work, *Woman with Bugs* (2014) (what a title!), which raises the surreal contradictions of flat decoration and modeled flesh to a striking pitch of disharmony. Yes, there are bugs in this image, as promised in the title, but whether they are protagonists or intruders is purposely left unclear. The effect of gorgeous creepiness is enhanced by the fact that the picture can be viewed either open or closed, suggesting, like the entire Grimm series, hidden or ambiguous interior spaces to be explored by the viewer. Natalie Frank's *Tales* illustrations are important not merely because they inventively reinterpret the material of the time-honored, one might almost say, "time-worn" fairy tales, but because their creation demanded that the artist find new sources and resources of imagination, daring, and formal experimentation. Her most recent work bears the imprint of their achievement.

Notes

1 See Jack Zipes (2006), *Why Fairy Tales Stick: The Evolution and Relevance of a Genre,* New York: Routledge.

2 Charles Perrault published his *Histoires ou Contes du Temps passé* (Tales and Stories of the Past with Morals), subtitled *Les Contes de la Mère l'Oye* (Tales of Mother Goose) in 1697; the brothers Jacob and Wilhelm Grimm first published their *Kinder-und-Hausmärchen* (Children's and Household Tales), known in the Anglophone world as *Grimm's Fairy Tales,* in 1812.

3 Smith herself explains: "It's a resurrection/birth story; 'Little Red Riding Hood' is a kind of resurrection/birth myth. And then I thought it was like Venus on the half shell or like the Virgin on the Moon. It's the same form—a large horizontal form and a vertical coming out of it." Kiki Smith cited in http://www.pbs.org/art21/images/kiki-smith/rapture-2001?slideshow=1 (accessed December 1, 2014).

4 Miwa Yanagi, "Fairytales" (large black-and-white photographs), 2005.

5 For other highly original versions of the Little Red Riding Hood theme by contemporary women artists, see the work of Ghada Amer and Nicole Eisenman.

6 For a relatively succinct account of this tale and its many variants, see Jack Zipes, ed. (1993), "'Little Red Riding Hood' by Charles Perrault" (1697); and "'Little Red Cap' by Jacob and Wilhelm Grimm" (1812), in *The Trials and Tribulations of Little Red Riding Hood,* London: Routledge, pp. 91–93 and 135–38. There are many recent studies of the Little Red Riding Hood tale and its illustrations. For an extensive bibliography, see my "Black, White, and Uncanny: Miwa Yanagi's Fairy Tales," no. 26, in this volume.

7 *Little Red Cap (Grimm's Fairy Tales)* is Natalie Frank's own title for the first of these images.

Bibliography: Linda Nochlin (1931–)

* Reprinted in *Women, Art, and Power*
† Reprinted in *The Politics of Vision*
†† Reprinted in *Representing Women*

1963

The Development and Nature of Realism in the Work of Gustave Courbet: A Study of the Style and Its Social and Artistic Background, Ph.D. Thesis, Institute of Fine Arts, NYU. Published as *Gustave Courbet: A Study of Style and Society* (1976), New York: Garland Publishing. See also "Summaries of dissertations" (1962–64), *Marsyas* 11, pp. 79–80.

Mathias at Colmar: A Visual Confrontation, New York: Red Dust, Inc.

1964

"Joseph C Sloane, *Paul Marc Joseph Chenavard*," book review, *The Art Bulletin* 46, pp. 113–16.

1965

† "Camille Pissarro: The Unassuming Eye," *ARTnews* 64, April, pp. 24–27, 59–62; revised version was published in Christopher Lloyd, ed. (1986), *Studies on Camille Pissarro*, London and New York, NY: Routledge & Kegan Paul, pp. 1–14 (this is the version reprinted in *The Politics of Vision*).

"Innovation and Tradition in Courbet's *Burial at Ornans*," *Marsyas* suppl. II ("Essays in Honor of Walter Friedlaender"), pp. 119–26; reprinted in Petra ten Doesschate Chu, ed. (1977), *Courbet in Perspective*, Englewood Cliffs, NJ: Prentice-Hall, pp. 77–87.

1966

Ed., *Realism and Tradition in Art, 1848–1900: Sources and Documents*, and *Impressionism and Post-Impressionism, 1874–1904: Sources and Documents*, Englewood Cliffs, NJ: Prentice-Hall.

1967

"Gustave Courbet's *Meeting*: A Portrait of the Artist as a Wandering Jew," *The Art Bulletin* 49, September, pp. 209–22.

1968

"Introduction," in *Realism Now*, Poughkeepsie, NY: Vassar College Art Gallery; reprinted in *ARTnews*, January 1971; and in G Battcock, ed. (1975), *Super Realism: A Critical Anthology*, New York: EP Dutton, pp. 111–25.

"The Invention of the Avant-Garde: France, 1830–1880," *ARTnews Annual* 34 ("The avant-garde"); reprinted as *Avant-garde Art* (1971), New York: Collier/Art News.

1970

"The Art of Philip Pearlstein," in *Philip Pearlstein*, Athens, GA: Georgia Museum of Art, University of Georgia.

"Metropolitan Museum: The Inhabitable Museum," *ARTnews* 68, January, pp. 36, 45, 58.

"Ugly American: The Work of Philip Pearlstein," *ARTnews* 69, September, pp. 55–57, 65–70.

1971

Realism, Harmondsworth, UK: Penguin Books.

* "Why Have There Been No Great Women Artists?", in Vivian Gornick and Barbara K Moran, eds, *Woman in Sexist Society*, New York and London: Basic Books, pp. 344–66; reprinted in *ARTnews* 69, no. 9, January 1971, pp. 22–39, 67–71; reply RL Leed, 69, February 1971, p. 6; in Thomas B Hess and Elizabeth C Baker, eds (1971), *Art and Sexual Politics*, New York: Newsweek Books, pp. 1–39; and in *ARTnews* 91, November 1992; abridged version translated into Russian as "Pochemu ne byvaet velikikh khudozhnitz?" (1992), *Heresies* 7, no. 2, pp. 38–42.

"Gustave Courbet's *Toilette de la mariée*," *Art Quarterly* 34, no. 1, Spring, pp. 30–54.

"Museums and Radicals: A History of Emergencies," *Art in America* 59, July–August, pp. 26 39; reprinted in Brian O'Doherty, ed. (1972), *Museums in Crisis*, New York, NY: George Braziller, pp. 7–41.

1972
* —— and Thomas B Hess, eds, *ARTnews Annual* 38 ("Woman as Sex Object: Studies in Erotic Art, 1730–1970"); reprinted as *Woman as Sex Object*, New York, NY: Newsweek Books; includes "Eroticism and Female Imagery in Nineteenth-century Art," pp. 8–15.
"Albert Boime, *The academy and French art in the nineteenth century*," review, *The Burlington Magazine*, 114, August, pp. 559–60.

1973
"The Realist Criminal and the Abstract Law," *Art in America* 61, no. 5, September–October, pp. 54–61, and no. 6, November–December, pp. 96–103.
"Miriam Schapiro: Recent Work," *Arts Magazine* 48, no. 2, November, pp. 38–41.
"Oh, Say Can You See?," review, *New York Times Book Review*, December 2, pp. 4–5, 24, 30, 36, 40, 44, 48, 50.
"Matisse Swan Self," poem, *Hudson River Anthology* 1, Winter, p. 6.

1974
"The 19th Century: French Nineteenth-Century Sculpture and American art," in Lerner, ed., *The Hirshhorn Museum & Sculpture Garden,* New York: Harry N Abrams, pp. 25–96.
* "Some Women Realists," *Arts Magazine* 48, no. 5, February, pp. 46–51, and 48, no. 8, May, pp. 29–33; reprinted in G Battcock, ed. (1975), *Super Realism: A Critical Anthology*, New York: EP Dutton, pp. 64–78.
"Paterson Strike Pageant of 1913," *Art in America* 62, May–June, pp. 64–68; reprinted in BA McConachie and D Friedman, eds (1985), *Theatre for Working-class Audiences in the United States, 1830–1980*, Westport, CT, and London: Greenwood Press, pp. 87–96.
"By a Woman Painted: Eight Who Made Art

in the 19th Century," *Ms. Magazine*, July, pp. 68–75, 103.
"How Feminism in the Arts Can Implement Cultural Change," *Arts in Society* 2, nos 1–2, Spring–Summer, pp. 80–89.
"Formalism and Anti-formalism," *Quadrille* 9, no. 1, Fall, pp. 35–42.
"TJ Clark, *The absolute bourgeois: artists and politics in France, 1848–1851*, and *Image of the people: Gustave Courbet and the Second French Republic, 1848–1851*," review, *Art in America* 62, no. 5, September–October, p. 15.
"Herbert Read, *Education through art*," review, *New York Times Book Review*, October 13, section 7, p. 36.
"Dorothea Tanning at C.N.A.C.," *Art in America* 62, no. 6, November–December, p. 128.

1975
"Introductory Essay: The Recent Work of Miriam Schapiro," in Miriam Schapiro, *The Shrine, the Computer and the Doll House*, San Diego, CA: Art Gallery, University of California San Diego.
"Statement," in *Works on Paper: Women Artists*, New York, NY: Women in the Arts Foundation and Brooklyn Museum, p. 5.
"Grandes Femmes Petits Formats at Iris Clert," *Art in America* 63, no. 1, January–February, p. 90.
"Ellen Johnson of Oberlin: Mainstream in Middle America," *Art in America* 63, no. 2, March–April, pp. 27–29.
"Forum: What is Female Imagery?," *Ms. Magazine*, May, pp. 62ff.

1976
—— and Ann Sutherland Harris, *Women Artists: 1550–1950*, Los Angeles County Museum of Art, CA, and New York, NY: Alfred A Knopf; translated into French as *Femmes peintres, 1550–1950* (1981), Claude Bourguignon, Pascaline Germain, Julie Pavesi, and Florence Verne, trans., Paris: Des Femmes; selections reprinted as "Women Artists in the 20th Century: Issues, Problems, Controversies" (1977), *Studio International* 193, May–June, pp. 165–74;

and "Excerpts from 'Women and the decorative arts'" (1978), *Heresies* 1, no. 4, Winter, p. 43.

"Rackstraw Downes," *Art in America* 64, no. 1, January–February, pp. 101–2.

"Leslie Torres: New Uses of History," *Art in America* 64, no. 2, March–April, pp. 74–76.

"Teddy Brunius, *Mutual aid in the arts from the Second Empire to fin de siècle*," review, *The Art Bulletin* 58, June, pp. 308–10.

1978

Henry A Millon, eds, *Art and Architecture in the Service of Politics*, Cambridge, MA, and London: MIT Press.

"The Changing Vision: Women Artists of the 19th and 20th Centuries," in Ann B Steir, ed., *Women on Women*, Toronto: York University, pp. 45–65.

"Courbet, die Commune und die bildenden Kunste," in Klaus Herding, ed., *Realismus als Widerspruch: die Wirklichkeit in Courbets Malerei*, Frankfurt: Suhrkamp Verlag, pp. 248–61, 316–18.

Contribution to "Late Cézanne: A Symposium," *Art in America* 66, March, pp. 90–91.

* "Lost and Found: Once More the Fallen Woman," *Art Bulletin* 60, no. 1, March, pp. 139–52; reply with rejoinder, TJ Edelstein (1979), 61, September, pp. 509–10.

"Débat sur l'exposition 'Courbet' au Grand Palais," *Histoire et critique des arts*, May, pp. 123–38.

1979

"Meyer Schapiro's Modernism," *Art in America* 67, March–April, pp. 29–33.

"Germaine Greer, *The Obstacle Race: The Fortunes of Women Painters and Their Work*," review, *New York Times*, October 28, section 7, p. 3.

1980

"The *Cribleuses de blé*: Courbet, Millet, Breton, Kollwitz and the Image of the Working Woman," in K Gallwitz and K Herding, eds, *Malerei und Theorie: das Courbet-Colloquium 1979*, Frankfurt, pp. 49–73.

"Introduction," in Joyce Baronio, *Forty-second Street Studio*, New York: Pyxidium Press.

"Feminism and Formal Innovation in the Work of Miriam Schapiro," in Thalia Gouma-Peterson, ed., *Miriam Schapiro: A Retrospective, 1953–1980*, Wooster, OH: College of Wooster.

Essay in *New York Realists 1980*, Sparkill, NY: Thorpe Intermedia Gallery.

* "Florine Stettheimer: Rococo Subversive," *Art in America* 68, no. 7, September, pp. 64–83; reprinted in Elisabeth Sussman and Barbara J Bloemink, *Florine Stettheimer: Manhattan Fantastica*, New York, NY: Whitney Museum of American Art and Harry N Abrams, 1995.

"In Detail: Courbet's *A Burial at Ornans*," *Portfolio* 2, no. 5, November–December, pp. 32–37.

† "Léon Frédéric and *The Stages of a Worker's Life*," *Arts Magazine* 55, no. 4, December, pp. 137–43.

"Picasso's Color: Schemes and Gambits," *Art in America* 68, no. 10, December, pp. 105–22, 177–83.

1981

"Introduction," in *Real, Really Real, Super Real: Directions in Contemporary Realism*, San Antonio, TX: Witte Memorial Museum, pp. 25–35.

† "Van Gogh, Renouard, and the Weaver's Crisis in Lyons: The Status of a Social Issue in the Art of the Later Nineteenth Century," in Moshe Barasch and Lucy Freedman Sandler, eds, *Art the Ape of Nature: Studies in Honor of HW Janson*, New York, NY: Harry N Abrams, pp. 669–88.

"Realist Tradition at The Brooklyn Museum; traveling exhibit," review, *The Burlington Magazine* 123, no. 937, April, pp. 263–69.

"Edward Hopper and the Imagery of Alienation," *Art Journal* 41, no. 2, Summer, pp. 136–41.

"Maurice Agulhon, *Marianne au combat: l'imagerie et la symbolique republicaine de 1789 à 1880*," review, *Oxford Art Journal* 4, July, pp. 62–64.

"Return to Order," *Art in America* 69, no. 7, September, pp. 74–83, 209–11.

1982

"The De-politicization of Gustave Courbet: Transformation and Rehabilitation Under the Third Republic," *October* 22, Fall, pp. 64–78; reprinted in Michael R Orwicz, ed. (1994), *Art Criticism and Its Institutions in Nineteenth-century France*, Manchester and New York: Manchester University Press.

1983

"The Telling Detail: What it Reveals About Painting," *House and Garden* 155, no. 1, January, pp. 136–43.

"Visions of Languor: Paintings by John Singer Sargent and John Alexander," *House and Garden* 155, no. 4, April, pp. 124–29.

† "The Imaginary Orient," *Art in America* 71, no. 5, May, pp. 118–31, 187–89, 191.

"Fantin-Latour: Beyond Fruit and Flowers," *House and Garden* 155, no. 6, June, pp. 130–37, 190–97.

"A Ceramic Sculptor's Art about Art: The Work of K Sokolnikoff," *House and Garden* 155, no. 7, July, pp. 154ff.

"Masterpieces in the garden," *House and Garden* 155, no. 9, September, pp. 170–77, 181–82.

"The Stylish Art of Louise Dahl-Wolfe," *House and Garden* 155, no. 9, September, p. 194.

† "A Thoroughly Modern Masked Ball," *Art in America* 71, no. 10, November, pp. 188–201.

"Revolution Out of Bounds: Ronald Paulson, *Representations of Revolution (1789–1820)*," review, *Art in America* 71, no. 11, December, pp. 11–12.

1984

"Introduction," in *American Women*, Evanston, IL: Terra Museum of American Art.

"Crystalline Fantasies," *House and Garden* 156, no. 6, June, pp. 38, 42, 48, 50.

"Joan Mitchell: Art and Life at Vetheuil," *House and Garden* 156, no. 11, November, pp. 192–97, 226, 228, 232, 236, 238.

"Malvina Hoffman: A Life in Sculpture," *Arts Magazine* 59, no. 3, November, pp. 106–10.

1985

"Introduction," in *Catherine Murphy: New Paintings and Drawings 1980–1985*, New York, NY: Xavier Fourcade Gallery.

Entries for works by Jack Beal, Henri Matisse, Pablo Picasso, and Joe Shannon, in Karl Kilinski II, *Classical Myth in Western Art: Ancient through Modern*, Dallas, TX: Meadows Museum and Gallery, Southern Methodist University, pp. 44–45, 64–67, 78–79.

† "Courbet, Oller and a Sense of Place: the Regional, the Provincial and the Picturesque in Nineteenth-century Art," *Horizontes*, no. 56, vol. 28, pp. 7–13.

"Paris Commune Photos at New York Gallery: an Interview with Linda Nochlin," *Radical History Review* 32, pp. 59–74.

"Watteau: Some Questions of Interpretation," *Art in America* 73, January, pp. 68–87.

"High Bohemia: G.V. Whitney's Long Island studio," *House and Garden* 157, September, pp. 180–89.

1986

"Introduction," in Debra Bricker Balken, ed., *Nancy Graves: Painting, Sculpture, Drawing, 1980–1985*, Poughkeepsie, NY: Vassar College Art Gallery.

"Paintings New Public: Thomas E Crow, *Painters and Public Life in Eighteenth-Century Paris*," review, *Art in America* 74, no. 3, March, pp. 9, 11, 13, 15.

"Renoir's Men: Constructing the Myth of the Natural," contribution to "Renoir: A Symposium," *Art in America* 74, no. 3, March, pp. 103–07.

"Courbet's *L'Origine du monde*: The Origin Without an Original," *October*, no. 37, Summer, pp. 76–86.

"Second Impressions: The New Painting: Impressionism 1874–1886," review, *House and Garden* 158, July.

"Art: Portraits in Prints," *Architectural Digest* 43, no. 8, August, pp. 128–33.

"Degas' *Young Spartans Exercising*," letter, *The Art Bulletin* 58, no. 3, September, pp. 486–88.

"Courbet," contribution to "What Would You Ask Michelangelo?," *ARTnews* 85, no. 9, November, p. 100.

1987

† "Degas and the Dreyfus Affair: a Portrait of the Artist as an Anti-Semite," in Norman L Kleeblatt, ed., *The Dreyfus Affair: Art, Truth, and Justice*, Berkeley, CA: University of California Press, pp. 96–116; reprinted in Maurice Berger, ed. (1994), *Modern Art and Society: An Anthology of Social and Multicultural Readings*, New York, NY: Icon Editions.

"Art: A Sense of Fashion," *Architectural Digest* 44, no. 2, February, pp. 110–15.

"The Political Unconscious in Nineteenth-century Art" (guest editor), *Art Journal* 46, no. 4, Winter, includes "Editor's Statement," pp. 259–60.

1988

†† ——— and Sarah Faunce, *Courbet Reconsidered*, New York, NY: Brooklyn Museum, and New Haven, CT: Yale University Press; includes "Courbet's Real Allegory: Rereading *The Painter's Studio*," pp. 17–42.

"Judy Pfaff, or the Persistence of Change," in *Judy Pfaff: 10,000 Things*, New York, NY: Holly Solomon Gallery, pp. 6–13.

Women, Art, and Power and Other Essays, New York, NY: Harper & Row; Chinese translation, 1995; title essay reprinted in N Bryson, MA Holly, and KPF Moxey, eds (1991), *Visual Theory: Painting and Interpretation*, Cambridge, UK: Polity in association with Blackwell, pp. 13–46; title essay translated as "Les femmes, l'art et le pouvoir" (1988), *Cahiers du Musée national d'art moderne*, no. 24, Summer, pp. 44–61.

"Morisot's *Wet Nurse*: the Construction of Work and Leisure in Impressionist Painting," in C Beutler, P-K Schuster and M Warnke, eds, *Kunst um 1800 und die Folgen: Werner Hofmann zu Ehren*, Munich: Prestel Verlag; reprinted in TJ Edelstein, ed. (1990), *Perspectives on Morisot: Essays*, New York, NY: Hudson Hills Press, and in Norma Broude and Mary D Garrard, eds (1992), *The Expanding Discourse: Feminism and Art History*, New York, NY: Icon Editions.

"Success and Failure at the Orsay Museum, or Whatever Happened to the Social History of Art?," contribution to "A Symposium: the Musée d'Orsay," *Art in America* 76, no. 1, January, pp. 85–88.

"En plein air," *Interview* 18, no. 4, April, p. 122.

"La Révolution française de Zuka," in *Zuka: The French Revolution through American Eyes*, Paris: Mona Bismarck Foundation, pp. 3–7; reprinted as "Zuka's French Revolution: A Woman's Place is Public Space" (1989), *Feminist Studies* 15, no. 3, Fall, pp. 549–62.

1989

The Politics of Vision: Essays on Nineteenth-century Art and Society, New York, NY: Harper & Row.

"*Le chêne de Flagey* de Courbet: un motif de paysage et sa signification," *Quarante-huit/ Quatorze*, no. 1, pp. 15–25.

† "Seurat's *Grande Jatte*: an Anti-utopian Allegory," *Museum Studies* 14, no. 2, pp. 132–53.

"Fragments of a Revolution," *Art in America* 77, no. 10, October, pp. 156–67, 228–29.

1990

"Introduction," in *Mujer en Mexico/Women in Mexico*, New York, NY: National Academy of Design.

"Pornography as a Decorative Art: Joyce Kozloff's Patterns of Desire," in Joyce Kozloff, *Patterns of Desire*, New York, NY: Hudson Hills Press, pp. 9–13.

1991

†† "A House is Not a Home: Degas and the Subversion of the Family," in Richard Kendall and Griselda Pollock, eds, *Dealing with Degas: Representations of Women and the Politics of Vision*, New York, NY: Universe, pp. 43–65.

"Bathtime: Renoir, Cézanne, Daumier and the Practices of Bathing in Nineteenth-century France," Groningen, The Netherlands: Gerson Lectures Foundation.

"Foreword," in Abigail Solomon-Godeau, *Photography at the Dock*, Minneapolis, MN: University of Minnesota, pp. xiii–xvi.

1992

"Delacroix's *Liberty*, Daumier's *Republic*: Gender Advertisements in Nineteenth Century Political Allegory," in *XXVIIe Congrès international d'histoire de l'art*, Strasbourg.

"Responses," *The Yale Journal of Criticism* 5, no. 2, Spring, p. 119.

1993

"Mary Frank," in *Mary Frank: Messengers*, New York, NY: Midtown Payson Galleries.

"'Matisse' and its Other," *Art in America* 81, no. 5, May, pp. 88–97.

"State of the Art: Philip Pearlstein, *Portrait of Linda Nochlin and Richard Pommer*," *Artforum* 32, no. 1, September, pp. 142–43, 204.

1994

The Body in Pieces: The Fragment as a Metaphor of Modernity, London: Thames & Hudson.

"Cora Cohen: Recent Paintings," in *Cora Cohen*, New York, NY: Jason McCoy Gallery.

"Issues of Gender in Cassatt and Eakins," in Stephen F Eisenman, ed., *Nineteenth Century Art: A Critical History*, London: Thames & Hudson, pp. 255–73.

"Starting from Scratch," in Norma Broude and Mary D Garrar, eds, *The Power of Feminist Art: The American Movement of the 1970s*, New York, NY: Harry N Abrams; reprinted in *Women's Art Magazine*, no. 61, November–December, pp. 6–11.

Contribution to Paul Gardner, "Who Are The Most Underrated and Overrated Artists?," *ARTnews* 93, no. 2, February, pp. 113–14.

†† "Body Politics: Seurat's *Poseuses*," *Art in America* 82, no. 3 March, pp. 70–77, 121, 123.

"Flesh for Phantasy: Lucian Freud—Frayed Fraud," *Artforum* 32, no. 7, March, pp. 54–59; reply and rejoinder, 33, no. 3, November, pp. 7–8.

†† "Géricault, or the Absence of Women," *October* no. 68, Spring, pp. 45–59; reprinted in R Michel, ed. (1996), *Géricault*, Paris: La Documentation française, pp. 403–22.

"Vassar, Art and Me: Memoirs of a Radical Art Historian," *Vassar Quarterly* 90, no. 2, Spring, pp. 20–24.

Conversation with Thierry Mugler, in Holly Brubach, "Whose Vision Is It, Anyway?," *New York Times*, July 17, section 6, pp. 46–49.

"Jill Johnston, *Secret Lives in Art; Essays*," review, *Artforum* 33, no. 3, November, supplement, pp. 2, 6.

Contribution to "The Best and Worst of 1994," *Artforum* 33, no. 4, December, p. 66.

1995

—— and Tamar Garb, eds, *The Jew in the Text: Modernity and the Construction of Identity*, London: Thames & Hudson; includes "Starting with the Self: Jewish Identity and its Representation," pp. 7–19.

"'Sex is so Abstract': the nudes of Andy Warhol," in *Andy Warhol Nudes*, Woodstock, NY: The Overlook Press, n. p.

"Learning from 'Black Male'," *Art in America* 83, no. 3, March, pp. 86–91.

"Forest Ranger: Simon Schama, *Landscape and Memory*," *Artforum* 34, no. 2, October, pp. 15, 114.

1996

Cézanne's Portraits, Geske Lectures, Lincoln, NB: College of Fine and Performing Arts, University of Nebraska.

Margarett Sargent: A Modern Temperament, Wellesley, MA: Davis Museum and Cultural Center, Wellesley College.

"Cézanne: Studies in Contrast," *Art in America* 84, no. 6, June, pp. 56–67, 116.

"Art and the Conditions of Exile: Men/ Women, Emigration/Expatriation," *Poetics Today* 17, no. 3, Fall, pp. 317–37; reprinted in Susan Rubin Suleiman, ed. (1998), *Exile and Creativity: Signposts, Travelers, Outsiders, Backward Glances*, Durham, NC: Duke University Press.

"Francis Bacon," review, *Artforum* 35, no. 1, October, pp. 109–10.

Contribution to "The Best and Worst Exhibitions of 1996," *Artforum* 35, no. 4, December, p. 87.

1997

—— and Joelle Bolloch, *Women in the 19th Century: Categories and Contradictions*. New York, NY: The New Press.

"Foreword," in Kathy O'Dell, ed., *Kate Millett, Sculptor: The First 38 years*, Catonsville, MD: Fine Arts Gallery, University of Maryland Baltimore County.

"Impressionist Portraits and the Construction of Modern Identity," in Colin B Bailey, *Renoir's Portraits: Impressions of an Age*, New Haven, CT, and London: Yale University Press, pp. 53–75.

Essay in *Rupert Garcia*, catalogue, San Francisco, CA: Rena Branston Gallery, n. p.

"The Vanishing Brothel: John Richardson, *A Life of Picasso, vol. 2: 1907–1917*; Norman Mailer, *Portrait of Picasso as a Young Man*; and *Picasso and the Spanish Tradition*," review, *London Review of Books* 19, no. 5, March 6, pp. 3–5.

"Kelly: Making Abstraction Anew," *Art in America* 85, no. 3, March, pp. 68–79.

"Robert Hughes, *American Visions*," review, *London Review of Books* 19, no. 21, October 30, p. 10.

"Objects of Desire: the Modern Still Life," review, *Artforum* 36, no. 2, October, pp. 91–92.

Contribution to "Top ten x 12," *Artforum* 36, no. 4, December, pp. 90–91.

1998

"Mary Frank *Inscapes*," in *Mary Frank: Inscapes*, New York, NY: DC Moore Gallery.

"Bonnard's Bathers," *Art in America* 86, no. 7, July, pp. 62–67, 105, also published in *Tate* 14, Spring, pp. 22–30.

"Signage Infection: Marjorie Garber, *Symptoms of Culture*," review, *Artforum*, Fall, p. 4.

"Painted Women," review, *Art in America* 86, no. 11, November, pp. 106–11, 141.

1999

Representing Women, London: Thames & Hudson.

——— Joy Episalla and Michael Cunningham, *Inside/out*, New York, NY: Debs & Co.

"Portrait of the Artist as an Appropriator," in Michael Plante, ed., *Deborah Kass: The Warhol Project*, New Orleans, LA: Newcomb Art Gallery.

Essay in *Ellsworth Kelly: Drawings 1960–1962*, New York, NY: Matthew Marks Gallery.

"Miriam Schapiro: Life Work," in Thalia Gouma-Peterson, *Miriam Schapiro: Shaping the Fragments of Art and Life*, New York, NY: Harry N Abrams.

"Griselda Pollock, *Mary Cassatt: Painter of Modern Women* and Judith Barter, *Mary Cassatt: Modern Woman*," review, *London Review of Books* 21, no. 8, p. 9.

"Matisse and Picasso: a Gentle Rivalry," interview with Yve-Alain Bois, *Artforum* 37, no. 6, February, pp. 70–77, 114–15.

Contribution on Chuck Close, *Nancy* (1968), to "Four Close-ups (and one nude)," *Art in America* 87, no. 2, February, pp. 66–69, reply and rejoinder 87, no. 4, April, p. 25.

"Irritating Women," *New York Times Magazine*, May 16.

"Mama Dada: Naomi Sawelson-Gore, *Women in Dada: Essays on Sex, Gender, and Identity*," review, *Artforum*, Summer, p. 4.

Contribution to "Best of the '90s: Books," *Artforum* 38, no. 4, December, p. 136.

"Issues & Commentary: Saluting 'Sensation'," *Art in America* 87, no. 12, December, pp. 37, 39.

2000

The Feminist Turn in the Social History of Art: Linda Nochlin Interviewed by Richard Cándida Smith, Los Angeles, CA: The J Paul Getty Trust.

"Mary Frank: Encounters," in *Mary Frank: Encounters*, New York, NY: Harry N Abrams, Inc. and Neuberger Museum of Art, pp. 9–24.

"Floating in Gender Nirvana," *Art in America* 88, no. 3, March, pp. 94–97.

"The Naked and the Dread," Special Issue, *Tate: The Art Magazine* 21, May, pp. 66–71.

"Issues: a Visit with Linda Nochlin," interview by Jean Martin, *The Art Book* 7, no. 3, June, pp. 16–18.

"Of Self and History: Exchanges with Linda Nochlin," interview by Moira Roth, *Art Journal* 59, no. 3, Fall, pp. 18–33.

——— and Abigail Solomon-Godeau, "Sins of the fathers: 'Posséder et Détruire,' Louvre, Paris," review, *Art in America* 88, no. 12, December, pp. 92–101, 135.

"Molly Nesbit, *Their Common Sense*," review, *Artforum* 39, no. 4, December, p. 34.

2001

"Afterword," in Aruna d'Souza, ed., *Self and History: A Tribute to Linda Nochlin*, London: Thames & Hudson, pp. 201–05.

The Body in Pieces: The Fragment as a Metaphor of Modernity," Twenty-Sixth Walter Neurath Memorial Lecture, London: Thames & Hudson.

"Uncertain Identities: Portrait of the Artist as a Young Jew," in *Ken Aptekar: Painting between the Lines, 1990–2000*, Kansas City, KA: Kemper Museum of Contemporary Art, 2001, pp. 31–47.

Essay in Amy Ingrid Schlegel, ed., "*An Unnerving Romanticism": The Art of Sylvia Sleigh and Lawrence Alloway*, Philadelphia, PA: Philadelphia Art Alliance, n. p.

"I, too, am an artist: Mary Ann Caws, *Dora Maar with and without Picasso: A Biography*," review, *London Review of Books* 23, no. 1, January 4, pp. 21–22.

"Death and Gender in Manet's Still Lifes: 'Manet: The Still-Life Paintings'," review, *Art in America* 89, no. 5, May, pp. 128–35.

"The Anatomy of the World: the First Anniversary (When Words Don't Fail)," *Artforum* 40, no. 3, November, p. 46.

"Desire, American Style: Jonathan Weinberg, *Ambition and Love in Modern American Art*," review, *Art in America* 89, no. 12, December, pp. 27–29.

2002

"The Art of Honoré Sharrer," in *Honoré Sharrer*, New York, NY: Spanierman Gallery, pp. 4–7.

"Joan Mitchell: a Rage to Paint," in Jane Livingston, ed., *The Paintings of Joan Mitchell*, New York, NY: Whitney Museum of American Art; Berkeley, CA: University of California Press, pp. 49–59.

"Love in a Cold Climate," contribution to "Vincent van Gogh's *Parc Voyer d'Argenson*: four scholars, four views," *Van Gogh Museum Journal*, p. 63.

Contribution to "Whither the Field of Nineteenth-century Art History?," *Nineteenth-Century Art Worldwide* 1, no. 1, Spring, online.

"Seeing Beneath the Surface," *Art in America* 90, no. 3, March, pp. 118–21. Reprinted in *Revised & Restored: The Art of Kathleen Gilje* (2013), Greenwich, CT: Bruce Museum and Wilmington, MA: Kirkwood Printing Company.

"Don't You Cut Up Your Lunch When You're Ready to Eat It?: Mieke Bal, *Louise Bourgeois's 'Spider': The Architecture of Art-Writing*," review, *London Review of Books* 24, no. 7, April 4, pp. 12–13.

"Mirroring Evil: Nazi Imagery/Recent Art," review, *Artforum* 40, no. 10, Summer, pp. 167–68.

"Size Matters," *Tate: The Art Magazine* 29, Summer, pp. 48–53.

"Documented Success," review, *Artforum* 41, no. 1, September, pp. 161–63.

"Sam Taylor-Wood: The Passion," review, *Contemporary* 45, November, pp. 76–77.

Contribution to "Best of 2002: Books," *Artforum* 41, no. 4, December, pp. 44–45.

2003

"Foreword," in Peter R Kalb, *High Drama: The New York Cityscapes of Georgia O'Keeffe and Margaret Bourke-White*, New York, NY: Midmarch Arts Press, pp. 1–2.

"Migrants," in *Jenny Saville: Migrants*, New York, NY: Gagosian Gallery.

"The World According to Gober," in *Robert Gober: Displacements*, Oslo, Norway: Astrup Fearnley Museum of Modern Art, pp. 85–92.

"The Darwin Effect: Introduction," Special Issue, *Nineteenth-Century Art Worldwide* 2, no. 2, Spring, online.

"Christian Schad and the Neue Sachlichkeit," review, *Artforum* 41, no. 10, June, p. 179.

"Less than More: Venice Biennale," review, *Artforum* 42, no. 1, September, pp. 178–79, 240, 246.

Contribution to "Feminism & Art: Nine Views," *Artforum* 42, no. 2, October, p. 141.

"New Tricks for an Old Dog: the Return of Painting," *Contemporary* 58, December, pp. 18–23.

2004

"When the Stars Weep," in *Sam Taylor-Wood: Crying Men*, New York, NY: Matthew Marks; London: White Cube; Göttingen: Steidl;

reprinted in Margo A Crutchfield, ed. (2008), *Sam Taylor-Wood, 1995–2007*, Cleveland, OH: Museum of Contemporary Art, pp. 52–55.

"Different Strokes: Turner, Whistler, Monet: Impressionist Visions," review, *Artforum* 42, no. 9, May, p. 86.

2005

"Sarah Lucas: GOD IS DAD," in *Sarah Lucas: God is Dad*, New York, NY: Gladstone Gallery, pp. 4–15.

"Unholy Postures: Kiki Smith and the Body," in Siri Engberg, ed., *Kiki Smith: A Gathering, 1980–2005*, Minneapolis, MN: Walker Art Center, pp. 30–37.

"Women Artists: the Japanese Impulse," in Barbara Rich et al., eds, The Second Chino Kaori Memorial "New Vision" Lecture, Heidelberg, with interview of Linda Nochlin by Midori Yoshimoto (2004), Kyoto, Japan: Center for the Study of Women, Buddhism and Cultural History and Medieval Japanese Studies Institute.

Contribution to "The New Modern: Itineraries," *Art in America* 93, no. 3, March, pp. 51–54.

"Picturing Modernity, Then and Now: 'Faces in the Crowd'," review, *Art in America* 93, no. 5, May, pp. 124–29, 180.

"Venice Biennale: What Befits a Woman?," *Art in America* 93, no. 8, September, pp. 120–25.

2006

Bathers, Bodies, Beauty: The Visceral Eye (2004), Charles Eliot Norton Lectures, Harvard, Cambridge, MA: Harvard University Press.

"Bonnard's 'Bathers,'" in Suzanne Page, ed., *Pierre Bonnard: The Work of Art, Suspending Time*, Paris: Musée d'art moderne de la ville de Paris, and Ghent: Ludion, p. 205, adapted from "Bonnard's Bathers," (1988), *Art in America* 86, no. 7, July, pp. 62–67, 105.

"Cecily Brown: the Erotics of Touch," in Ellen R Feldman, ed., *Cecily Brown*, Des Moines, IA: Des Moines Art Center; Boston, MA: Museum of Fine Arts, pp. 55–59.

"'Why Have There Been No Great Women Artists?' Thirty Years After," in Carol Armstrong and Catherine de Zegher, eds, *Women Artists at the Millennium*, Cambridge, MA: MIT Press, pp. 21–32.

2007

Courbet, London: Thames & Hudson.

—— and Maura Reilly, eds, *Global Feminisms: New Directions in Contemporary Art*, New York, NY: Brooklyn Museum, and London: Merrell.

"Foreword," in Eleanor Heartney et al., *After the Revolution: Women Who Transformed Contemporary Art*, Munich, Germany, and New York, NY: Prestel, pp. 7–8.

"Zuka's birds and other creatures," *Zuka*, catalogue, Paris: Galerie Darthea Speyer, n. p.

"Old-Age Style: Late Louise Bourgeois," in Frances Morris, ed., *Louise Bourgeois*, London: Tate and Rizzoli, Paris: Centre Georges Pompidou, pp. 188–227.

Contribution to "Revisionary History: Robert Rosenblum," obituary, *Artforum* 45, no. 7, March, pp. 65–66, 69–70, 339, 341.

2008

"Black, White, and Uncanny: Miwa Yanagi's *Fairy Tale*," in Christopher Philips and Norkio Fuku, eds, *Heavy Light: Recent Photography and Video from Japan*, New York, NY: International Center for Photography, and Göttingen, Germany: Steidl, pp. 232–41.

"Existence and Beading: the Work of Liza Lou," in Robert Pincus-Witten, ed., *Liza Lou*, New York, NY: L & M Arts, pp. 12–19.

"The Garden of Infantile Delights and Adult Perversions," in James Putnam, ed., *Polymorphous Perverse*, London: Other Criteria, pp. 36–41.

"A Life of Learning" (2007), Charles Homer Haskins Prize Lecture, Montreal, New York, NY: American Council of Learned Societies.

"My Life with Heels," in Elizabeth Semmelhack, *Heights of Fashion: A History of the Elevated Shoe*, Toronto, Ont.: Bata Shoe Museum and Pittsburg, PA: Periscope Publications, pp. 2–3.

"On *Triptych—May–June 1973*," *Tate Etc.* 14, Autumn, pp. 62–63.

2009

"Rules of Abstraction: Grace Hartigan records her experience as a lone woman among male painters: *The Journals of Grace Hartigan, 1951–1955*," review, *Artforum* 47, no. 8, April, p. 36.

2010

"Courbet and the Representation of 'Misère': a Dream of Justice," in Klaus Herding and Max Hollein, eds, *Courbet: A Dream of Modern Art*, Frankfurt, Germany: Schirn Kunsthalle; Ostfildern, Germany: Hatje Cantz, pp. 76–83.

"Living with Courbet: Fifty Years of My Life as an Art Historian," in Mathilde Arnoux et al., *Courbet à neuf!: Actes du colloque international organisé par le musée d'Orsay et le Centre allemand d'histoire de l'art à Paris, les 6 et 7 décembre 2007*, Paris: Maison des sciences de l'homme, pp. 11–22.

"Running on Empty: Women, Pop and the Society of Consumption," in Sid Sachs and Kalliopi Minioudaki, eds, *Seductive Subversion: Women Pop Artists 1958–1968*, Philadelphia, PA: University of the Arts; New York and London: Abbeville Press Publishers, pp. 12–17.

"The Social Body," in *Historias* 76, May–August, pp. 3–14.

2011

"Foreword: Representing the New Woman—Complexity and Contradiction," in Elizabeth Otto and Vanessa Rocco, eds, *The New Woman International: Representations in Photography and Film from the 1870s through the 1960s*, Ann Arbor, MI: University of Michigan Press, pp. vii–xi.

"Interview with Linda Nochlin by Ken Silver, August 31, 2010," in Kenneth E Silver, *Cindy Sherman: Works from Friends of the Bruce Museum*, Greenwich, CT: Bruce Museum, pp. 20–39.

"The Ballets Russes and the Parisian Avant-garde," in Special Issue, *Experiment: A Journal of Russian Culture* 17, no. 1, pp. 214–30.

"Leo Steinberg, 1920–2011," obituary, *Art in America* 99, no. 5, May, pp. 38, 40.

2012

"Against the Grain: Representing the Working Woman in Nineteenth-century Painting," in Claire Barbillon, Catherine Chevillot, and François-René Martin, eds, *Histoire de l'art du XIXe siècle (1848–1914): bilans et perspectives: actes du colloque École du Louvre–Musée d'Orsay, 13–15 septembre 2007*, Paris: École du Louvre, pp. 253–56.

"Géricault, Goya y la representación de la miseria tras la Revolución industrial," in Francisco Calvo Serraller et al., *El arte de la era romantic*, Madrid: Fundación Amigos Museo del Prado; Barcelona: Galaxia Gutenberg: Circulo de Lectores, pp. 199–218.

"I Couldn't Make it to the Poor Farm," in Michelle Grabner and Annika Marie, eds, *All Over the Map: A Festschrift Celebration and Exhibition Honoring Moira Roth*, Manawa, WI: Poor Farm Press, pp. 29–31.

"Misery, Beauty, and Other Issues: Linda Nochlin in Conversation with Dan Karlholm," interview, *Art Bulletin* 94, no. 2, June, pp. 187–98.

2014

"L'Intervista: 'Ma il successo di una pittrice costa più fatica'," *La Repubblica*, December 7, 2014.

2015

"Ellen Altfest: A New, New Realism," May 2014, previously unpublished.

"Natalie Frank: The Dark Side of the Fairy Tale," *Tales of the Brothers Grimm. Drawings by Natalie Frank*, 2015.

Artists' Biographies

Ellen Altfest (b. 1970)

An observational painter who works exclusively from life, Ellen Altfest has developed a meticulous approach that reflects intimate and intense engagement with objects. By exploring various iterations of "the other," she seeks to understand her subject and control it through prolonged scrutiny.

Since receiving a Master's degree at Yale School of Art in 1997, Altfest has gravitated toward nature as subject matter. Working in oil paint, but with photographic precision, she captures the minutiae of selected objects with a hyperrealism that approaches abstraction. In works such as *The Log* (2001), for example, the object retains its integrity, but simultaneously seems to dissolve into a field of color and texture. Similarly, in *Little Rock* (2002), the variegated rock surface is striking for both its abstraction and surface tactility. Altfest's first solo exhibition in 2002, entitled *Rocks and Trees*, focused on this corpus of paintings.

In 2003, Altfest began a series that juxtaposes natural objects in the industrial space of her studio, such as *Driftwood (Studio Floor)*, which explores effects of light on the undulating surface of the wood set against the speckled plane of the artist's workplace. The close cropping of the work, and the concentrated, head-on viewpoint, create a dizzying effect derived from the intensity of its colors and textures.

In 2004, Altfest traveled to the southwest of the US, where in works such as *Desert Flower* and *Small Cactus* she embraced the forms and colors of the desert environment. One of her most famous paintings, *Tumbleweed* (2005), in which the plant takes on an almost animal-like potency, emerged from this encounter. Each of the paintings in this series takes from three to fifteen months to complete, reflecting the artist's time-consuming meditation on her subject.

The element of change can prove profoundly problematic for Altfest. Her objects often transform during the creative process: house plants grow, models quit, and vegetables decay. In 2007, with works such as *Rotting Gourd*, Altfest began deliberately to incorporate these natural metamorphoses into her art.

More recently, Altfest has turned to a different form: the male body. Beginning in 2006 with her precise exploration of the flaccid male penis, Altfest has since progressed to the fragmented male body. In works such as *The Back* (2009), the model's body becomes a landscape, where curves of flesh and hair-growth patterns assume an importance they lack in daily life. Works such as these were the centerpiece of Altfest's solo exhibition at The New Museum, New York, in 2012, and at the 2013 Venice Biennale. DB

Louise Bourgeois (1911–2010)

Louise Bourgeois was a printmaker, sculptor, and painter whose work employed evocative biomorphic imagery to explore psychosexual themes. Born in Paris, Bourgeois spent time as a girl in her parents' tapestry restoration workshop, helping to rework passages in historic textiles. In 1938, after studying at the École des Beaux-Arts, the École du Louvre, Atelier Fernand Léger, and other notable French art schools, she moved to New York with her husband, American art historian and curator Robert Goldwater. In New York she spent two years studying painting at the Art Students League with renowned instructor Václav Vytlačil, and, through Stanley William Hayter's Atelier 17 printmaking workshop, began to associate with Joan Miró, André Masson and other European expatriates.

Although Bourgeois did not garner widespread critical acclaim for her work until 1982, when she received her first museum retrospective, she was a member of the New York avant-garde from the early

1940s. During the 1940s and 50s Bourgeois developed a strong interest in abstraction, despite the fact that many themes in her work—such as sexuality, violence and fear—were more commonly associated with the Surrealists than the abstract expressionists with whom she began to exhibit. Like her peers, she believed that art-making served as a way to cut to the core of human vulnerability and express complex and deep-seated feelings.

In 1945 Bourgeois gave up painting to focus solely on sculpture, initially in the form of tall totemic sculptures crafted from wood. By the 1960s her sculptures had begun to employ explicitly sexual references, such as protuberant and fleshy forms to evoke misshapen genitalia. Through such sexual imagery, Bourgeois sought to plumb the depths of male–female relationships and to work through her own troubled upbringing, wherein her father conducted a decade-long affair with her governess. During the years 1967 to 72, the artist also traveled frequently to Italy and began exploring the sensuous possibilities of marble.

Bourgeois gained new audiences in the 1970s, when hailed as a forerunner to feminism. At the same time she returned to an early interest in printmaking while experimenting with new media and forms of practice, such as performance art and monumental sculptural installations. *Confrontation* (1978) was an installation-cum-performance, where models—close friends of the artist—wore latex garments decorated with breast-like protrusions and paraded around a room full of stretchers laden with latex objects. These ideas would be recast in *Cells* (1990s), a series of enclosed environmental sculptures that visitors were invited to enter or simply consider the structure and evocative objects inside.

As an octogenarian in the 1990s, Bourgeois discovered her most iconic subject yet—the spider—which she viewed as a protective creature and employed as a tribute to her mother, a weaver and inspirational figure in her life. In 2000, *Maman* (1999), a monumental steel and marble spider with an overflowing egg sac, was exhibited at the opening of Tate Modern's colossal Turbine Hall.

Toward the end of her career Bourgeois was awarded solo exhibitions by institutions such as Tate Modern, the Hermitage, the Museum of Modern Art, New York, and Brooklyn Museum. Her many accolades included induction into the Order of Arts and Letters by the French Minister of Culture (1983); receipt of the first Lifetime Achievement Award from the International Sculpture Center in Washington, DC (1990); nomination to represent the US at the Venice Biennale (1993); and receipt of the Golden Lion for Living Master of Contemporary Art, and the National Medal of Arts (1997). KW

Cecily Brown (b. 1969)

Cecily Brown is a British painter based in New York, whose work explores themes of sexuality in a highly tactile style that bridges abstraction and figuration. Raised by her mother, a novelist, Brown discovered while in art school that her father was the well-known art critic David Sylvester. She knew Sylvester as a family friend who had already introduced her to the London art world, most memorably Francis Bacon, and their relationship became closer on learning of Sylvester's paternity.

Brown completed her training at the Slade School of Fine Art, London, in 1993. The following year, she moved to New York, in part to distance herself from the predominant Young British Artists who were identified with conceptual art and were unsympathetic to painting. While working as an animator in a commercial studio, she created her short film, *Four Letter Heaven* (1995), a graphic watercolor illustration of a sexual encounter set to cha-cha music, which was shown at film festivals across the US and Europe. She describes her first mature works as her vibrant paintings of rabbits engaged in frenetic orgies (1996–97), where the bunnies stand in for humans, and toy with associations from German children's books, as well as from Disney and *Playboy*.

Brown's next series featured fragmented

human figures performing a medley of sex acts. With their complex layers of dense oil paint and writing brushstrokes, these paintings implicate the viewer as voyeur and reclaim the traditionally male gaze. In other works, such as *Puttin' on the Ritz* and *Father of the Bride*, she selects titles from popular culture to inject humor into potentially disturbing images. The large scale and vigorous physicality of Brown's technique recall abstract expressionism, and she has acknowledged the influence of painters like Arshile Gorky and Willem de Kooning, as well as her freedom, as a female English artist, to adopt and adapt their style in a way that fellow male artists could not.

Since 2000, Brown has experimented with her palette, incorporating a broader range of hues into some works and restricting herself to grisaille in others. Her subject matter has also diversified into landscape and the *memento mori*, while more recent paintings have brought the figure back into the foreground: large groups of nudes stare out at the viewer, instigating a contest of gazes yet eluding definitive form. Brown has distanced herself from the pornographic scenes of her early work but there remains an underlying tension of sexuality throughout her oeuvre. LC

Sophie Calle (b. 1953)

French writer, conceptualist, installation artist and photographer, Sophie Calle discovered art at a young age through her father, a renowned oncologist, who maintained close friendships with prominent artists Arman and Christian Boltanski. Calle's own artistic practice deals with oppositional themes such as absence and presence, and public-versus-private identity, with a particular focus on voyeurism and intimacy. Conceptually driven, her work mainly takes the form of performance and documentary photography, the latter in a style reminiscent of surveillance photos or crime scene imagery.

After traveling the world in her youth for seven years, Calle returned to Paris and channeled the loneliness she felt into artistic investigations of the lives of people around her. Her first major work, *Sleeper* (1979), entailed inviting forty-five people—acquaintances, neighbors, and strangers—to sleep in her bed. Documented with photographs and descriptive texts, *Sleeper* represented Calle's initial experimentation with the boundaries of privacy and intimacy. She would later revisit these themes with *Sleeper Room with a View* (2002), in which she invited members of the public to read stories to her while she slept in a bed atop the Eiffel Tower.

Other early works tested human vulnerability further, by employing the tactics of voyeur or stalker. Having spent months observing and trailing strangers on the streets of Paris, in *Suite Venitienne* (1980) she followed a man she met at a dinner party—"Henri B"—around the city of Venice, recording his activities through photographs and captions. *Detective* (1980) involved her mother hiring a detective to follow the artist on a tour of personally significant places, documenting her every movement. Both works call into question preconceived notions of trust and the sanctity of personal boundaries.

Calle continued to explore the issue of personal privacy in works such as *Hotel* (1981), in which she impersonated a maid so she could survey and photograph the habits and belongings of guests; and in *Address Book* (1983) she built up a detailed portrait of a stranger from an address book found on the street, even calling the owner's friends and family listed inside. She then published these transcriptions, along with illustrations, in a series of twenty-eight articles for the French daily newspaper *Libération*. *Address Book* proved so controversial that the subject threatened to sue Calle for invasion of privacy.

Calle's recent projects seek to explore a more romantic perspective on loss and intimacy. In 1996 she collaborated with American photographer Gregory Shephard on the autobiographical film *No Sex Last Night*, about a road trip they took together across the US, which culminated in their

wedding in Las Vegas. The film offers intimate access to the fears, problems and desires that accompanied their relationship. In 2007, Calle showed *Take Care of Yourself* in the French pavilion at the Venice Biennale, a multi-media work inspired by the last line of a breakup message sent to her by a lover. The work consisted of photographs, films and texts representing different interpretations of the text by 107 women, based on their individual experiences.

Since 2005, Calle has served as a professor of film and photography at the European Graduate School in Saas-Fee, Switzerland, and in 2010 she received the Hasselblad Award for her achievements in photography. KW

Mary Cassatt (1844–1926)
Mary Cassatt was an American painter and printmaker who became an integral member of the French Impressionist circle, and is best known for her pictures of women and children. Although not a mother herself, she created some of the most touching images of maternity in the history of art.

Cassatt was born into a wealthy family in Allegheny City (now Pittsburgh), and spent five years in Europe with her family in the 1850s, which opened her eyes to the work of artists such as Ingres, Delacroix, and Courbet. After enrolling in the Pennsylvania Academy of Fine Arts in 1860, she returned to France in 1865 to supplement her training in the studio of the French academic painter Jean-Léon Gérôme, spending regular sessions copying works at the Louvre. In 1868 her painting *The Mandolin Player* was accepted at the Paris Salon.

In 1877, after meeting Degas and other members of the Impressionist circle, Cassatt joined the group and, under their influence, began to move away from more generic portraiture and genre painting to explore bolder techniques in paint, pastel, and print media. She also heightened the instantaneity of her compositions with effects of asymmetry, cropping, and loose brushwork, focusing mainly on the subject of women at the theater or in domestic

settings. Family members were favored models, as in *Reading Le Figaro* (1878), which depicts her mother reading the newspaper, and *The Cup of Tea* (*c*. 1880–81), a portrait of her sister Lydia in a fashionable pink dress. Cassatt participated in the Impressionist exhibitions of 1879, 1880, 1881, and 1886.

In the late 1880s, Cassatt began to refine her style, placing greater emphasis on line and pattern and a stronger palette, while images of mothers and children that captured the innocence of childhood and tenderness of motherhood came to dominate her subject matter. A show of Japanese prints at the École des Beaux-Arts in 1890 inspired a series of colored drypoints and aquatints featuring women in scenes from their daily lives; another ambitious project was her mural *Modern Woman* designed for the Woman's Building at the 1893 World's Columbian Exposition in Chicago. One of the most explicit representations of her feminist views, and now lost, the picture featured a large-scale allegory of women in contemporary dress, seen picking fruit from the tree of knowledge and participating in the arts.

Cassatt continued to produce work, mainly depicting friends and family, until 1915, when failing eyesight forced her to retire. Despite spending her entire adult life in France, she actively supported the suffrage movement in the US and helped disseminate the art of her circle to American collectors. LC

Mary Frank (b. 1933)
Working in sculpture, painting, drawing, printmaking, and encaustic, and focusing mainly on the human figure, Frank is deeply engaged with the ways in which art can heal and awaken the human spirit. Her artworks explore archetypal and mythological themes, as well as the poetics of her internal, emotional world, even at its darkest moments.

Frank came to the US from the UK as a child during the Second World War, accompanied by her mother, the painter Eleanor Lockspeiser. Initially trained as a dancer, she honed her acute awareness of

spatial concerns in early studies, particularly the way the human form occupies space. Though figuration was relatively unfashionable during her formative years, she resisted the trend toward abstraction, focusing instead on moments of internal emotional transformation.

During the 1950s and 60s, Frank worked primarily as a sculptor, exploring the female form in a variety of media—clay, terracotta, wood, wax, plaster, and ceramic. Works such as *Arching Woman* (c. 1978) accentuates the sensuality of the female body, while the pose highlights her immateriality, her hollowness. Other sculptures, such as *Small Lover* (c. 1977), are multi-part arrangements that tell a narrative through formal and compositional interplay. Often fragmented, Frank's sculptures recall discoveries in archaeological dig sites, eliciting the viewer's compassion and curiosity. In her wood sculptures, Frank was particularly interested in the interplay of textures, and in conveying erotic expression through effects of rough carving.

In the later 1960s, Frank began to create large assemblages that incorporated clay, drawings, prints, and photographs. Beginning in the late 1980s, she increasingly used drawings and prints to develop a personal vocabulary of forms steeped with spiritual connotations. In the 1990s, painting became Frank's primary medium, though she continued to experiment with a variety of supports—panel, canvas, metal, glass, and ceramic—which provided an opportunity to explore tones, colors, and textures. The natural world is central for Frank, with tropes such as winding trees, glaring owls, and mountainous landscapes recurring regularly. Many of her paintings also evoke religious art, particularly in terms of format—the triptych—which she uses to create a stark juxtaposition between demure panels when closed, and powerful evocative colors when open.

The 2014 documentary, *Visions of Mary Frank* by filmmaker John Cohen, offers a window into Frank's creative process, and explores numerous photographs of her by renowned photographers, including Walker Evans, Edward Steichen, Ralph Gibson, and her ex-husband (1950–69) Robert Frank. DB

Natalie Frank (b. 1980)

The work of the American artist Natalie Frank focuses mainly on female figures, and is fundamentally preoccupied with narrative and memory, and with reconciling figuration with abstraction.

Trained at the Slade School of Art in London, at the École des Beaux-Arts in Paris, and at Yale and Columbia universities, Frank investigates power dynamics and how they influence relationships and identity, through narrative scenes or psychologically potent portraits such as *Dorian* (2009). Her figures often occupy a liminal space between fantasy and reality, and are dreamlike yet concrete, in a way that she likens to the character of memory. Many of Frank's paintings have a theatrical or macabre quality, and she often includes an "overseer" figure who supervises, or choreographs, the scene. Women figure prominently; their function is to test the boundaries of the female role and womens' ability to impose their desires on the outside world, but the scenes are often complicated by violence. By contrast, male figures are frequently left featureless—an indicator of their supporting role. An ongoing interest in transformation and transfiguration has also led Frank to investigate the ways in which the human interior, physical and psychological, can be "taken apart" and recombined, by addressing such subjects as autopsies and exorcisms.

Frank paints wet on wet to bring a dynamic quality to the surfaces of her large-scale canvases, and often bases her images on her own photographs of scenes she has staged, as well as on historical art. A work such as *Study for an Exorcism* (2012) remains closely linked to the photograph, but many depart dramatically from staged sequences. Frank also produces smaller works in other media, mainly gouaches and chalk pastels on paper or board, which often explore the same subjects as her paintings and serve as investigations into texture and facture.

In 2012, Frank was diagnosed with a condition that prevented her from seeing the world in three dimensions, one that affected a number of famous artists in the past. Following treatment, her works now consider space differently, and recently she has begun making hinged panel paintings. In works such as *Little Girl with Lamp* (2014), shaped panels stand out from the wall, silhouetting the subject, while in others, such as *Figure I (hinged)* (2014), the use of hinges allows different planes to move and transform a cut-out figure into a more sculptural form. By these means, Frank continues to find new ways to explore her ongoing interest in the fragmentation of the female body. DB

Kathleen Gilje (b. 1945)

After studying at the City College of New York, Kathleen Gilje spent four years training as an art conservator at the Museum of Capodimonte in Naples, an experience that launched her long career conserving Old Master paintings in institutions such as The Metropolitan Museum of Art, New York, and the Thyssen-Bornemisza Museum, Madrid.

Gilje has exhibited her own work since 1972, and in the mid-1990s became known for her "contemporary restorations." These paintings highlight the illusion of objectivity in conservation and art history and use humor to bring issues of feminism and politics to the surface. For example, *Portrait of Cardinal Niño de Guevara, Grand Inquisitor, Restored* (1992) juxtaposes El Greco's study of *c.* 1600 with Andy Warhol's *Orange Disaster* (1963); in 1995 she gave Raphael's *La Donna Velata* (1515) a black eye.

In the new millennium, Gilje began to take a greater interest in the female nude. Her *Woman with a Parrot, Restored* (2001) is a recreation of Courbet's picture painstakingly built up in layers of paint, including pentimenti, and displayed alongside an X-ray image of a bare male torso. An accompanying wall text written by the artist identifies the figure as Courbet and emphasizes the problematic gaze of the male painter. In other cases, she removed

garments, as in Hans Holbein's *Christina of Denmark* (1538; Gilje's version, 2002), while in *48 Portraits: Sargent's Women, Restored* (2007–8) a series of half-length portraits reimagine Sargent's wealthy female subjects stripped of status symbols.

In 2004 Gilje began a series of portraits that substitute prominent figures from the art world, including collectors, art historians, and critics, for historical subjects. For example, Linda Nochlin becomes the barmaid in Manet's *A Bar at the Folies-Bergère* (1881–82; Gilje's version, 2005), Professor Robert Rosenblum appears as Ingres' *Comte de Pastoret* (1826; Gilje's version, 2005), and critic Michael Kimmelman stands in for Thomas Eakins' *The Thinker* (1900; Gilje's version, 2006).

Gilje's most recent works incorporate herself into imagined scenes of attacks on and by women: Bouguereau's *The Assault* (1898; Gilje's version, 2012) and Artemisia Gentileschi's *Judith Slaying Holofernes* (*c.* 1620; Gilje's version, 2012). Other works feature current technology, such as *The Text Message after Pieter Pourbus's Portrait of a Married Lady of Bruges and Images from Keith Haring* (2013). Gilje's oeuvre helps viewers question contemporary interventions into Old Master paintings and brings a modern perspective to historical works. LC

Nancy Graves (1939–1995)

American artist Nancy Graves was a post-Minimalist sculptor, painter, printmaker, and filmmaker, who combined abstraction with an exacting naturalism. Along with her colleagues Eva Hesse, Bruce Nauman, and Richard Serra (to whom she was married from 1965 to 1970), Graves sought to challenge the rigid formulas of Minimalism by emphasizing process and chance elements.

After studying at Yale University, Graves came to prominence in the late 1960s with her groundbreaking series, *Camels* (1965–69)—a group of life-size sculptures constructed of wood, steel, burlap, polyurethane, animal skin, hair, wax, and oil paint that resembled the animals in

natural-history displays. In 1969, Graves became the fifth woman artist to be given a solo exhibition at the Whitney Museum of American Art, when she presented a selection of these works.

In the early 1970s, Graves turned her attention to creating large sculptures and installations that continued her interest in paleontology and natural forms. Handmade Pleistocene camel skeletons, legs, and bones were dispersed over the floor or hung from ceilings, as in *Variability of Similar Forms* (1970). Working in fiberglass, latex, marble dust and other unorthodox materials, she also began fabricating artificial replicas of beetles, berries, bones, butterflies, twigs, vines, cowrie shells, and feathers, and welding them to steel shafts.

In 1972, after producing a series of films in Morocco, two of which recorded repeated sequences of camel herds, Graves began painting expressionistic, irregularly shaped, colored canvases based on a wide range of maps and weather charts, including those of the ocean floor and the surfaces of Mars and the moon. When she returned to sculpture in the late 1970s, she learned the lost-wax process and a method of patinating bronze by coating it with chemicals sealed with a gas torch. By the early 1980s, the two- and three-dimensional sides of her practice came together in colorfully painted, playfully disjunctive assemblages of found objects cast in bronze, including flowers, fish, seedpods, sardines, human skeletons, as well as human-made objects like fans, colanders, and tools. The resulting arrangements were marked by an elegant linearity that recalled the "drawing in space" sculptures of David Smith—an artist she greatly admired.

Graves' paintings of the mid-to-late 1980s became increasingly sculptural, while her three-dimensional work demonstrated an interest in Alexander Calder's kinetic structures, as well as Picasso's Cubist still-life paintings. Toward the end of her life, Graves was experimenting with poly-optics, a synthetic glasslike material, and incorporating hand-blown glass into her sculptures. MR

Deborah Kass (b. 1952)

The American painter Deborah Kass has dedicated her career to examination of the politics and history of the art world. Refashioning canonical works by male artists to represent a female perspective and subject matter, Kass' paintings question our tacit acceptance of masculine hegemony over contemporary culture.

As a high-school student, Kass took classes at the historic Art Students League in New York, and at the prestigious Whitney Museum Independent Studies Program alongside fellow painter Julian Schnabel, before taking a degree in painting from Carnegie Mellon University. During the late 1970s and early 80s, Kass' work focused on what one reviewer called "feverish landscapes"—vivid, painterly depictions of pastoral scenes, often populated with farm animals and farm houses. By the late 80s, she had begun to extrapolate vertical passages from these scenes and position them alongside bright strips of color and pattern, creating monumental canvases that recall Robert Rosenquist's alternately illusionistic and abstract paintings.

However, Kass still struggled to receive critical recognition, despite the success of like-minded male contemporaries such as David Salle and Eric Fischl. Feeling marginalized because of her sex, in 1989 she began a series called the *Art History Paintings*, which called into question the presumption that artistic genius and masculinity were inherently linked. Building on the painted collage technique she had developed earlier, Kass created patchwork canvases that combined the painting styles and iconography of artists such as Jackson Pollock, Robert Motherwell and Jasper Johns with pop culture imagery from Disney cartoons and Hollywood blockbusters.

A few years later, in *The Warhol Project* (1992–2000), Kass substituted images of herself and her own personal female heroes for those in Warhol's paintings. By "partnering with Andy," as she called it, Kass immortalized her own likeness and that of figures such as Gertrude Stein and Barbra

Streisand, demonstrating her determination to assert a female presence in art.

Since 2000, Kass has continued to explore issues of gender, race and socio-cultural identity through paintings that reference popular culture. *Sing Out Louise* (2002), alludes to a song from the musical *Gypsy*, in celebration of Broadway show tunes, and a recent series she calls "feel good paintings for feel bad times" (2007) features nostalgic references to musicals, movies and Yiddish vernacular, in brilliantly colored compositions that mirror the style of famous male artists. For example, *Nobody Puts Baby in the Corner* (2007) draws its title from the 1987 cult film *Dirty Dancing*, but appropriates the colorful concentric rings of a Kenneth Noland target. KW

Joyce Kozloff (b. 1942)
Joyce Kozloff has spent her artistic career questioning assumptions about what constitutes "high art." In the early 1970s, after realizing that most of the woven textiles and painted pottery she had long admired had been produced anonymously by women, she began creating pattern paintings inspired by Islamic, Asian, and Pre-Colombian cultures. She once remarked: "The feminist revelation—that the decorative arts were largely created by anonymous women and people of color, and therefore degraded in the eyes of historians and critics—forever changed my thinking."

Kozloff's commitment to the revival of ornament led her, in 1975, to join Miriam Schapiro, Robert Zakanitch, Valerie Jaudon and others to establish the Pattern and Decoration movement, as an alternative to the 1960s formalism championed by Clement Greenberg. For Kozloff this resulted in a series of patterned paintings, but eventually she moved off canvas into installations composed of hand-painted, glazed ceramic tiles and pieced silk wall hangings—most notably, *An Interior Decorated* (1979).

During the 1980s, Kozloff concentrated on ambitious public art commissions, many in transportation centers, executed in ceramic tile and/or glass and marble mosaic (with iconography based on local sources), completing sixteen between 1979 and 2003. Simultaneously, she continued producing "private work," including watercolors reproduced in her book, *Patterns of Desire* (1990), which feature pornographic imagery appropriated from Eastern and Western sources—high art, textile design, decorative arts, architecture, and maps.

Since the 1990s, Kozloff has utilized maps to make political statements about imperialism, warfare, and gender. *Targets* (2000) is a 9 ft (2.75 m) walk-in globe in twenty-four sections, each painted with an aerial map of a place bombed by the US between 1945 and 2000. *Voyages* (2006) was an installation of masks and hanging works created for the Arsenale in Venice about the history of navigation and European colonialism during the Age of Discovery. Other cartographic pieces have incorporated antique cosmological and terrestrial maps, overlaid with galaxies and satellites tracks from the Internet. Most recently, she has been creating mural-scale paintings that bring the maps and patterns together.

A lifelong activist, Kozloff was a founding member of the Los Angeles Council of Women Artists, which organized the 1971 protest of LACMA's white-male-dominated exhibition record; a participant in the Ad Hoc Committee of Women Artists in New York during the early 1970s, a co-founder in 1976 of *Heresies: A Feminist Publication on Art and Politics*; and a co-founder of Artists Against the War, 2003. MR

Liza Lou (b. 1969)
The American artist Liza Lou is best known for creating intricate installations of glass beads. Born in New York to evangelical Christian parents who subsequently moved to Minnesota, Lou attended Baptist schools but later found a teacher at Palomar College in California, who initiated her formal training in art and art history. After visiting cathedrals, monuments, and exhibitions in Europe as a student, she studied painting at the San Francisco Art Institute, but left soon

afterwards sensing a lack of support for her new interest in beadwork.

Lou moved to Los Angeles in 1990, where she created her first major work, *Kitchen* (1991–96), in which every surface of a life-size kitchen—replete with Lay's potato chips on the counter and dishes soaking in the sink—was covered with brightly colored beads. The mundane domestic setting is thus transformed into a glittering, psychedelic installation that questions ideas of craft and the decorative, commodification and kitsch, hyperrealism and illusionism. In 1996–99 she produced *Back Yard*, which applies the same treatment to an outdoor environment.

Moving on from installations, Lou created her *American Presidents* series (1995–2000) depicting the first forty-two presidents and a blank-faced forty-third, intended as "a rogue's gallery." From this she progressed to making beaded sculptures, including *The Damned* (2003–4) inspired by Masaccio's *Expulsion from Paradise*, and *The Heretic* (2003–4), a female nude contorted into a yogic pose with exposed genitalia. More recently, Lou's work has evolved toward darker, more political themes. *Security Fence* (2005) juxtaposes a surface of shimmering beads with the threat of a barbed-wire enclosure, while *Cell* (2004–6) turns beads on their ends to convey a stained cement-block prison cell.

In 2010 Lou exhibited a collection of drawings at Galerie Thaddeus Ropac in Paris, in which black and red ink stand in for beads in an increasingly abstract arrangements of dots. Other two-dimensional works have featured woven and striated patterns of beads in subdued neutral tones—a stark contrast to the *horror vacui* of *Kitchen* and *Back Yard*.

In 2005, Lou established a collective in KwaZulu-Natal, South Africa, where she works with Zulu artisans on her projects to deepen her engagement with the cultural tradition of beadwork. Lou was granted a MacArthur Foundation Fellowship in 2002 and received an Anonymous Was a Woman Artist award in 2013. LC

Sarah Lucas (b. 1962)

A prominent member of the Young British Artists (YBA) who emerged in the 1990s, Sarah Lucas uses a wide variety of media—photography, collage, sculpture, and installation—to engage with questions of gender, identity, and sexuality. She also regularly employs cliché and lewd humor to draw attention to the construction, both social and personal, of masculinity and femininity.

After graduating from Goldsmith's College, London, in 1987, Lucas began exploiting everyday objects—tables and chairs purchased from thrift stores, stained mattresses and sofas, food items—to address the inherent misogyny of tabloid journalism. In her first solo exhibition, *Penis Nailed to a Board* (1992), she described this process as a feminist impulse and as the manifestation of a "schism" in her feelings toward men. Following this, Lucas turned to the photographic self-portrait to explore her own identity as artist and subject. Despite stating that she "like[s] to be androgynous," Lucas nevertheless incorporates female tropes into her portraits and sculptures. For example, fried eggs regularly represent breasts in sculptures such as *Two Fried Eggs and a Kebab* (1992), and in photographs such as *Self-Portrait with Fried Eggs* (1996).

Lucas' use of everyday materials to create witty anthropomorphic assemblages also intentionally blurs the boundaries between readymade objects and handcrafted sculptures, exploiting their gendered connotations. For example, in the *NUDS* series (2010) stuffed women's tights take on a decidedly feminine corporeality, while splayed "legs," with the stitched crotch exposed, as in various iterations of *Bunny Gets Snookered*, suggest feminine vulnerability.

In 2008, Sarah Lucas embarked on a series entitled *Penetralia*, which explores in a more direct way the phallic imagery examined in many of her projects. Using plaster, concrete, and fiberglass to represent the male phallus on different scales, these works scrutinize the penis as both banal body part—an

everyday object of sorts—and cultural icon. The series marked a conceptual shift in her work from selecting objects to represent the phallus, including perishable food items such as eggplants, or found objects such as beer cans, to representations of the penis itself.

More recently, Lucas produced her first public sculpture, *Perceval* (2011), a life-size enlargement in bronze of a childhood knickknack, depicting a shire horse pulling a cart loaded with large-scale concrete zucchini and eggplants. The work references both her preoccupation with vegetables and foodstuffs, and with traditional English culture; the latter interest has increased partly as the result of her move from London to a rural environment. Lucas was recently selected to represent the UK at the Venice Biennale 2015. DB

Joan Mitchell (1925–1992)

Joan Mitchell was a leading abstract expressionist painter of the second generation. Raised in Chicago, where her mother was co-editor of *Poetry* magazine and her father a prominent doctor, she studied at Smith College, The School of the Art Institute of Chicago, and Columbia University.

In 1948–49 Mitchell spent a year in Paris and Provence, where her pictures became increasingly abstract. Her first mature works produced after returning to New York reveal the influence of Arshile Gorky, Philip Guston, and Willem de Kooning. Vigorous brushwork was used to apply primary colors, and black and white, but unlike those of her male peers Mitchell's paintings were never covered edge to edge. In 1951, she was included in the Ninth Street Show organized by the Artists' Club and Leo Castelli, and had her first solo show at the New Gallery in New York the following year.

After moving permanently to France in 1955, Mitchell produced a series of "violent" paintings in 1961–62, and "black" paintings in 1964. At the same time her brushwork and palette became more delicate and lyrical, and she began work on multi-panel compositions. In 1967 she moved to a new studio outside Paris, where she worked on an even larger scale, applying thicker passages of impasto and sometimes covering the whole canvas.

Her "territory" paintings of the early 1970s reflect her quest for light and incorporate rectangular elements, and in the late 1970s and early 80s she began experimenting with more densely worked canvases and hastier execution. Her later work, such as the *Grande Vallée* series (1983–84), is frequently interpreted in relation to personal tribulations, including the deaths of close friends and family members and her own battles with cancer, while simultaneously evoking the lush French landscape. Her last works before her death in Paris convey a final burst of energy in quick strokes of vibrant colors.

According to her biographer Patricia Albers, "Joan was never a true action painter, never a subscriber to the notion that one finds a picture intuitively. Aiming to define a feeling, she proceeded from a mental image or images, adjusted, and readjusted, as her picture caught fire." She was inspired by poetry, nature, color, and synesthesia, as well as by particular sites that were often referenced in her titles. In addition to oil paintings, she also made pastel drawings, prints, and illustrations to accompany poetry. LC

Berthe Morisot (1841–1895)

Berthe Morisot was a French Impressionist painter whose work explores themes of femininity and female identity in the late 19th century. Her family supported her artistic endeavors from a young age, although her education was intended to foster her aptitude as a female amateur rather than a professional artistic. She and her sister Edma copied Old Masters at the Louvre and took lessons with Joseph-Benoît Guichard, who recognized the girls' talent. Guichard also introduced them to Corot, whose influence is apparent in the subdued tenor of Morisot's early work. Two of her landscapes were accepted into the Salon of 1864, marking her public debut.

By the late 1860s, Morisot's style had begun to evolve away from Corot's, although she continued to paint *en plein-air*. She met Manet and became his colleague, model, and eventually sister-in-law on marrying his brother Eugène, in 1874. In the same year, Morisot became one of the founding members of the Impressionist group, and participated in every exhibition except the fourth in 1879, which took place shortly after the birth of her daughter, Julie. Her work from the 1870s reveals her interest in direct observation, especially of women outdoors or in intimate interiors.

Morisot frequently illustrated scenes of motherhood, particularly with the infant Julie, who became her most significant subject. The *Wet Nurse* of 1879, featuring Julie as a nursing baby, is remarkable for its tender treatment of breastfeeding as paid labor. As Julie matured, she was represented in a variety of settings at home, such as with her father—the rare male subject—in gardens, playing violin, and with the family dog.

In the late 1870s and early 80s, Morisot created a series of women at their toilette, which raises questions of the male gaze, blossoming sexuality, and the artifice of beauty, and after 1886 she started painting nudes, but grappled with resolving these compositions. In 1891 she undertook her arcadian *Cherry Trees* series, which drew on both historical and contemporary imagery of women picking fruit, and also painted still lifes and landscapes, especially of the Bois de Boulogne.

Unlike the large panels of the *Cherry Trees,* the majority of Morisot's paintings are on a small, domestic scale, and contemporary critics often remarked on the feminine quality of her graceful, loose brushwork and blonde palette. In the 1880s she began to incorporate areas of bare, unprimed canvas into certain compositions, while in the 1890s she became more deliberate in planning her works with preparatory drawings, which in some cases contributed to a greater linearity; others paintings of this time display some of her most fluid handling. She also experimented with printmaking techniques, particularly in the years around 1890, and created watercolors and pastels throughout her career.

Morisot had her first solo exhibition in 1892, at Boussod, Valadon et Cie in Paris. After her death from pneumonia in 1895, a retrospective was staged at the Durand-Ruel gallery, for which the poet Stéphane Mallarmé wrote a lyrical tribute praising Morisot's work as bringing a magical charm to images of daily life. LC

Alice Neel (1900–1984)

The American painter Alice Neel was a trailblazer for women artists, and pivotal in championing figuration during the rise and reign of abstraction. Renowned for her psychologically perceptive portraits, Neel once said she was interested in painting "people torn apart by the rat race of New York."

After studying at the Philadelphia School of Design for Women (now Moore College of Art) in 1925, Neel emerged as a social realist. During time spent in Havana, Cuba, with her Cuban husband, painter Carlos Enriquez, she focused on quotidian scenes and figures of the underworld, revealing her preoccupation with social injustice and poverty in works such as *Beggars, Havana, Cuba* (1926), or the seminal *Well Baby Clinic* (1928).

Back in the US, Neel was one of the first artists to partake in the Works Progress Administration program during the Great Depression, producing urban scenes and landscapes. Living in New York in the late 1930s, she withdrew from the wider art world to focus on recording the Puerto Rican community, whose marginalization and precarious status is highlighted in works such as *The Spanish Family* (1943).

With the rise of feminism in the 1960s and 70s, and Neel's reintegration into the art world, she was finally acknowledged for her earnest observation of life and dedication to portraiture and figuration. In the 1970s, she began a major series of nudes, which played with conventions of eroticism and

underscored the fundamentally female gaze of the artist.

Around the same time, Neel developed a fascination with the pregnant female body, and tropes of motherhood appeared in her work regularly. This interest was undoubtedly provoked by the death of her first daughter from diphtheria and the abduction of her second child (by her father), leading to Neel's suicide attempt in 1930 and subsequent year-long hospitalization. Works such as *Nancy and Olivia* (1967), or *Linda Nochlin and Daisy* (1973), explore the tension between emotional connection and physical protection/restraint in the mother-daughter relationship, while two versions of *Nancy and the Twins* (1971) further highlight the role of the mother as protector and provider. In other works, Neel focused on the voluptuous curves of the pregnant female body, as in *Pregnant Woman* (1971), or *Pregnant Maria* (1964). These works subvert standard tropes of the reclining nude by making women visible—and desirable—at a moment of physical and emotional transformation. Rather than objectifying the female nude, Neel's observations convey empathetic respect.

In 1974, the Whitney Museum of American Art held a major retrospective exhibition of Neel's work, and in 1979 President Carter awarded her the National Women's Caucus for Art's award for outstanding achievement. A documentary (2007) made by her grandson, Andrew Neel, captures her struggles as a female artist, single mother, and painter who resisted conventions. DB

Jenny Saville (b. 1970)

An English painter, draftsman and photographer best known for her female portraits, Jenny Saville creates work focused on gender, sexuality, violence and the body. Her compositions transform the subjects' zaftig physiques into monumental agglomerations of flesh, which countermand the art-historical tradition of the idealized female nude into radical representations of women's bodies as substantial, fallible, peculiar or unsightly.

After graduating from Glasgow School of Art in 1992, Saville was awarded a six-month scholarship to the University of Cincinnati, Ohio, where she drew inspiration from obese American women and plastic surgery procedures, such as liposuction, observed in New York. These experiences, combined with the influence of painters like Courbet and Velázquez, helped stimulate Saville's fascination with the boundaries between corpulent and grotesque form.

As a young artist in the early 1990s, Saville strove to capture the tactility and weightiness of the human body by experimenting with extreme viewpoints, expansive canvases and a sensuous oil painting technique involving thick, variegated strokes. Her figures are often marred by indentations, such as from confining undergarments in *Trace* (1993–94), inscriptions as in *Branded* (1992), where the subject's torso bears the words "decorative," "delicate" and "supportive," or incisions as in *Plan* (1993). This early group of works was purchased by the British art collector Charles Saatchi, who exhibited them under the auspices of the Young British Artists.

From 1995 to 1996 Saville turned to her own body as source material, collaborating with British fashion photographer and film director, Glen Lutchford. The resulting photographic images depict Saville's nude figure pressed against a sheer pane of glass, distorting her body into arbitrary passages of pooled flesh. By the late 1990s, Saville had begun incorporating multiple figures into her paintings, as in *Fulcrum* (1999), which portrays three naked models stacked on top of each other, creating a vast tangle of limbs and fleshy forms.

During the early 2000s, Saville expanded her painting to include transgender models. Presenting the full spectrum of gender identity through incongruous genitalia and facial features, these works confront the viewer with an outlandish odalisque for the modern day, perhaps best seen in *Passage* (2004), where the figure's masculinity in the

bottom half of the canvas is complicated by her seductive femininity in the upper half. Seeking to highlight the juxtaposition in these works, Saville cultivated a technique of broad, angled brushstrokes that direct the viewer's gaze across the body.

Saville's most recent series, a set of large-scale drawings grouped under the title *Reproduction,* represent Saville's distinctly somatic reinterpretation of Renaissance Madonna and Child paintings. Focusing on the Virgin's pregnant form as a body at "human capacity," these works use gestural pencil marks and scumbles to convey the physical closeness and emotional energy shared by mother and child, and expand Saville's fascination with corporeal female form into more nuanced, cerebral realms. KW

Miriam Schapiro (b. 1923)
Miriam Schapiro was one of the leading artists of the women's movement in the 1970s. The child of an artist and industrial designer, she began by making abstract paintings while living in New York in the 1950s with her husband, the artist Paul Brach. In the 1960s she produced *Shrines* (1961–63), a series of icons of womanhood confined to geometric compartments: a gold panel on top like an altarpiece, a silver mirror at the bottom, an egg and a variable fourth object in the middle.

After moving to San Diego in 1967, Schapiro began to engage more directly with the burgeoning feminist movement. Her *Ox* paintings of the later 1960s are bold abstractions of the female form in the shape of an X with a central opening—an example of what she and Judy Chicago called "central core imagery," in which artists appropriate the vagina as a symbol for feminist purposes.

From 1971 to 1975, Schapiro and Chicago collaborated on an innovative Feminist Art Program at the California Institute of Arts, where they fostered dialogue about the status of women in the art world. Aside from *Womanhouse* (1971–72), a derelict mansion in downtown Los Angeles that Schapiro,

Chicago, and their students transformed into spaces representing women's fantasies of the home, Schapiro also collaborated with Sherry Brody on *The Dollhouse*, which aimed to elevate the trappings of domestic female life into a higher art form.

In 1975 Schapiro became a principal figure in the Pattern and Decoration movement, incorporating textiles, particularly those that allude to women's work like samplers and quilts, into her paintings, in a technique she called "femmage." For her signature work of this period, the monumental *Anatomy of a Kimono* (1976), she designed a gallery-size installation based on the Japanese kimono as a ceremonial dress for the "new woman." At the same time Schapiro also started her series of "collaborations" with historical female artists, including Mary Cassatt and Berthe Morisot, incorporating images from their works into her compositions.

In the 1980s and 1990s, much of Schapiro's work became figurative and often included a dancer motif, such as her Matisse-inspired cutouts and her 34 ft (10.5-meter) outdoor sculpture, *Anna and David* (1986). Paintings such as *Blue Angel* (1987) question our judgment of female subjects in seductive poses by portraying the strong individuals behind them. She also expanded the "collaborations" series with Frida Kahlo and avant-garde Russian artists, and returned to the shrine concept with works like *My History* (1997), which positions symbols of Schapiro's Jewish heritage alongside those of other women's work. LC

Sylvia Sleigh (1916–2010)
Sylvia Sleigh was a prominent realist artist intimately involved with bringing feminist principles into the art world during the 1970s. Born in Wales, Sleigh came to the US in 1961, following her marriage to the prominent art critic Lawrence Alloway, who later became a curator at the Solomon R Guggenheim Museum. Sleigh was particularly known for her unapologetically frank representations of the male nude body.

Frequently representing fellow artists and friends, Sleigh's paintings sought

to capture the dignity, humanity, and beauty of the subject, regardless of gender, and to undermine the male gaze of the art-historical canon. For example, *The Turkish Bath* (1973) subverts art-historical precedents by depicting a cast of male nudes offering themselves to the gaze of the viewer. Similarly, in works such as *Imperial Nude Paul Rosano* (1977), Sleigh challenged one of the standard tropes of Western art, by positioning the male figure as reclining odalisque.

Sleigh rejected idealization of the body, seeking instead to bring individuality and realism to the human figure. In doing so, she sought to remove not the element of desirability but of objectification, and to call into attention the values associated with traditional representations of women. Sleigh applied the same approach to portrayals of herself, as in *Sylvia Nude* (1963), where the undulating curves of the artist's body are presented with honesty and detachment. Rather than as an artist surrounded by the trappings of her profession, Sleigh depicts herself above all as a woman, with her back turned but looking back confidently at the viewer.

The realism of Sleigh's depictions—the attention lavished on body hair or the changes in tone on tanned skin—highlights her observational acuity, as well as her sympathy toward her subjects. Aware of the difficulties that hindered female artists, Sleigh also collaborated with colleagues on group portraits of women's cooperatives, such as *A.I.R. Group Portrait* (1977–78), and worked closely with women's art organizations including the Ad Hoc Committee of Women Artists and Women's Caucus for Art. In 1999, she completed her most ambitious work, a fourteen-panel, 21-meter panorama inspired by Watteau, entitled *Invitation to a Voyage: The Hudson River at Fishkill* (1999), which illustrates the artist's friends relaxing in an arcadian setting cut through by a prominent railroad.

In 2008, Sleigh received the Distinguished Artist Award for Lifetime Achievement from the College Art Association, and in 2011 a Lifetime Achievement Award from the Women's Caucus for Art. DB

Kiki Smith (b. 1954)

Chiara Lanier Smith, better known as Kiki Smith, is an American artist whose work deals with subjects such as race, gender, sexuality, the body, mythology, religion, and nature, in a wide variety of media, including sculpture, drawing, textiles, printmaking and multi-media installation. Born in Nuremburg, Germany, Smith was raised in New Jersey by an opera singer mother and sculptor father, though she claims that she drew most of her inspiration from female artists such as Louise Bourgeois, Lee Bontecou and Eva Hesse.

After studying briefly at the Hartford Art School in Connecticut in the 1970s, Smith left to pursue her career in New York, where she became a member of the artists' collective Collaborative Projects Inc., or "Colab." By the mid-1980s, she found herself drawn to visceral subjects, and in 1985 trained briefly as an emergency medical technician before realizing her interest in the body had more to do with phenomenology than medicine.

Fascinated by the internal workings of the body and seeking a depersonalized means of representing the figure, Smith focused in the 1980s on reproducing human organs in materials such as plaster, glass and wax; examples include *Glass Stomach* (1985), *Ribs* (1987), and a cast of a pregnant woman's torso entitled *Shield* (1988). Smith also used her depictions of the body's interior to pursue political ends, addressing the AIDS crisis in the bottled blood work *Game Time* (1986), and abortion rights in the bronze *Womb* (1986).

By the early 1990s, Smith had progressed to explore the body in its entirety, addressing the way women's bodies serve as sites of political, social and religious debate by showing the female figure as mutilated. In sculptures such as *Virgin Mary* (1992) and *Mary Magdalene* (1994), flayed skin is used to refer to the subjects' sufferings. Other works—such as the woman defecating on all

fours in *Tail* (1992)—consider the abjection of the female body more generally through base actions.

During the late 1990s, Smith's focus turned to the natural world, with many works employing motifs from the cosmos, the landscape or the relationship between man and animal, to explore the human condition. For example, in *Jersey Crows* (1995), dead crows cast in bronze were scattered across the gallery floor as a tribute to poison victims in her home state, New Jersey. Smith's latest projects deal with childhood, violence and storytelling through dolls and marionettes, in works such as *Io* (2005) or *Miss May* (2007).

Smith was nominated to represent the US at the 2005 Venice Biennale, and, in the same year, was inducted into the American Academy of Arts and Letters. Other notable honors include the Women in the Arts Award from the Brooklyn Museum in 2009, and the US State Department Medal of Arts from Hillary Clinton in 2012. KW

Florine Stettheimer (1871–1944)
Florine Stettheimer was an American painter, poet and set designer, whose deeply personal and idiosyncratic style is characterized by vivid color, a purposeful naïveté, and a camp sensibility, often in the service of wry social commentary.

Stettheimer trained in painting at the Art Students League in New York City, from 1892 to 1895. From 1898, the Stettheimer family spent extended periods of time in Europe, where she was exposed to the work of the Impressionists, Post-Impressionists, and Symbolists. With the outbreak of the First World War, the family returned to New York, where they regularly hosted extravagant dinners and salons. Among frequent guests were the artists Marcel Duchamp, Marsden Hartley, Charles Demuth, Gaston Lachaise, Elie Nadelman, and Alfred Stieglitz, as well as critics like Carl Van Vechten and Henry McBride. These guests, as well as her sisters and mother, became Stettheimer's primary artistic subjects, whom she featured in single and group portraits.

In 1916 Stettheimer exhibited some of her Post-Impressionist and Symbolist-inspired paintings at M Knoedler & Co., recreating a domestic environment for the occasion within the gallery, but she sold no work and the reviews were mixed. She never showed her work in a commercial gallery again, and only sporadically in public—participating, for instance, in the Independent Society of Artists' annual exhibitions from 1917 to 1926, and in group shows at the Carnegie International, the Whitney Museum of American Art, and Museum of Modern Art, through the 1930s and early 40s.

Throughout her lifetime, Stettheimer remained intensely private about her art, even stipulating in her will that she be buried in a mausoleum with her paintings. However, her freedom from financial restraints and public reception allowed the works' eccentricities to blossom. While early works demonstrated a commitment to her academic training, after 1917 her palette brightened, figures became increasingly schematic, and portraits transformed from realist to symbolic presentations of the subject. Her compositions also changed dramatically: no longer dependent on traditional Renaissance perspective, Stettheimer's figures and objects float in space, as if on a fantastical stage.

In addition to painting, Stettheimer designed costumes and sets for the theater, such as for the Gertrude Stein–Virgil Thomas opera, *Four Saints in Three Acts* (1934), and sent satirical poems to friends, which were published posthumously in a collection entitled *Crystal Flowers*.

In 1946 the Museum of Modern Art mounted a posthumous Stettheimer exhibition, for which Marcel Duchamp served as guest director. In the catalogue he described his friend as one of the first artists of the "School of New York," in possession of a "metropolitan style" specific to art between the wars. Duchamp particularly admired the paintings from the teens, which he "described as *multiplication virtuelle*, where characters and colors are repeated and represented sequentially in a single picture."

Stettheimer's most ambitious work was a series of four large-scale canvases in which she glorified and critiqued the "cathedrals" of the modern city: the financial district, theater, department stores, and art museums. Stettheimer was still working on *Cathedrals of Art* when she died in 1944. MR

Samantha, "Sam" Taylor-Wood (b. 1967)
Originally trained as a sculptor, the English artist Sam Taylor-Wood has worked primarily in photography, film, and video since the early 1990s. Her principal interest lies in exploring the split between the interior and external self, and in subverting gender stereotypes.

After graduating from Goldsmiths' College, London, in 1990, Taylor-Wood began investigating the possibilities of time, space, and reality in a series of photographs and early films, many of which featured the body—either her own or those of dancers—in carefully constructed and orchestrated scenes. One of her most persistent tropes is that of the body floating in mid-air, as in *Bram Stoker's Chair I* (2005), a photograph that captures her own figure balancing on the back of a falling chair. Similarly, in the series *Falling* (2003), she juxtaposes the athletic grace of acrobats with lavish architectural settings. In video work, on the other hand, she has used devices such as time-lapse photography to capture processes too slow to be perceived by the human eye: *Still Life* (2001) captures the gradual decay of a plate of fruit, in a modern-day version of a *memento mori*.

In other photographic works Taylor-Wood has focused on emotional boundaries and the relationship between absence and engagement, inhibition and display: *Crying Laughing* (1997), shows a woman either laughing, or crying, or both. In 2002, she was commissioned by the National Portrait Gallery, London, to make a video portrait of the footballer David Beckham, whom she chose to portray sleeping; and in her photographic series *Crying Men* (2004), she captured Hollywood figures such as Sean Penn, Robin Williams, and Paul Newman,

in tears. All these works sought to examine the constructed nature of celebrity and masculinity. In other film work Taylor-Wood has experimented with the split-screen as a way of investigating interpersonal relationships. *Travesty of a Mockery* (1995) shows a couple having an argument on separate screens, while in *Atlantic* (1997) three screens represent different facets of the same scene.

Taylor-Wood was awarded the Illy Café Prize for Most Promising Young Artist at the 1997 Venice Biennale, and the following year was nominated for the Turner Prize. In 2009, after directing an award-winning short film, *Love You More* (2008), she made her debut as a feature film director with the widely-acclaimed *Nowhere Boy*, based on the childhood of John Lennon. It was while working on this film that the artist met her second husband, Aaron Johnson, whose name she took, becoming Sam Taylor-Johnson in 2012. DB

Miwa Yanagi (b. 1967)
A Japanese photographer and video artist, Miwa Yanagi questions the stereotypical roles and expectations—of beauty, purity, youthfulness and propriety—of women in the patriarchal and consumerist society of Japan. Yanagi studied crafts and fine art at Kyoto City University of Arts, focusing mainly on fiber-based sculptures and installations, but soon discovered an interest in photography after using it to document her work. Today, Yanagi is known for her evocative, dramatic and often haunting photographs.

Yanagi's first, and perhaps best-known photographic series, *Elevator Girls*, begun in 1994, drew attention to the paths open to young Japanese women, by presenting the repetitive daily lives of elevator attendants, a traditionally female role in Japan. Originally staged as a performance piece, the series, which depicts beautiful uniformed women sequestered in commercial buildings, later adopted photography to ensure greater artistic control. The images examine social expectations of Japanese women by showing

the consequences: demure, homogeneous young females going up and down but getting nowhere.

In 1996, Yanagi's images were exhibited at the Kunsthalle in Frankfurt, Germany, alongside the work of prominent photographers such as Jeff Wall and Cindy Sherman, bringing the artist international recognition. In 2000 she began a new series, *My Grandmothers,* consisting of visions of young Japanese women imagined fifty years into the future, free from the strictures of present-day society. Using Photoshop and captioned with the womens' statements, the images show the subjects digitally aged and in contexts that range from airplanes and libraries to apocalyptic landscapes.

Yanagi's next major project, *Fairy Tale* (2004–6), a series of large black-and-white photographs, presents a vision of girlhood restaged through traditional folk tales and stories. Drawing on Greek mythology and the writings of Hans Christian Andersen and the Brothers Grimm, the images use film-noir lighting and theatrical costumes—including masks and make-up that transform the subjects into wizened witches—to problematize the relation between innocence and evil, youth and old age, reality and fiction.

Yanagi's work has been exhibited across the world, including at the Deutsche Guggenheim (2004), the Museum of Fine Arts, Houston (2007) and the Tokyo Museum of Photography (2009). In 2009 she represented Japan in the Venice Biennale with *Windswept Women: The Old Girls' Troupe*, a set of life-sized black-and-white scenes of corpulent, bare-chested women dancing ecstatically in barren landscapes, their legs and breasts digitally aged to suggest atrophy and distortion. Ornately framed and seen in the "dying" city of Venice, the works explore the insidious creep of the human organism toward decay. KW

Zuka (b. 1924)

Zunaida Booyakovitch Mitelberg, more commonly known as Zuka, is an American painter and collagist best known for painting

tableaux vivants, which place women at the center of important historical events. Her oeuvre is characterized by vivid color and a simplified figurative style akin to folk art.

Born in Los Angeles to parents who left Russia to escape the 1917 revolution, Zuka studied art at the University of Southern California. In the late 1940s she traveled extensively across Europe, eventually settling in Paris, where she studied at the Alliance Française and the prestigious Académie de la Grande Chaumiére in Montparnasse. In 1950 she married French political cartoonist Louis Mitelberg.

Beginning her career as a café and street-scene painter, Zuka focused her first major series (1952–58) on the patterns generated by cars on the roads of postwar France. She won acclaim, however, with what she called the "ripe subject" of historical imagery, when in the 1970s she began making paintings about the American War of Independence, depicting iconic figures such as George Washington, Benjamin Franklin and Buffalo Bill. The bright colors, sharp, planar forms, and flat, cutout simplicity of these works recall the cultivated naïveté of American folk art.

During the 1970s, Zuka also became acquainted with Miriam Schapiro, an artist involved in the Pattern and Decoration movement. Schapiro's work inspired Zuka to begin incorporating collage elements into her paintings, a practice she first employed in her paintings of the French revolution (1972–90), in which she set out to portray historical events from the perspective of women. As the artist explained, "[F]ew people ever mention the key role that women played in the movement...history bears out that they fuelled the fires of liberty and then paid dearly for it." Early works in the series recall the vivid, planar style of her American pieces, through epigrammatic compositions that mimic children's book illustrations, but by the 1980s Zuka had begun channeling her love of drama into illusionistic scenes overflowing with riotous figures.

In the same period, Zuka also developed a collage series depicting the spiritual

rituals of American Indians, conveyed through layering of boldly patterned papers. More recently, she has drawn inspiration from nature, painting brilliantly colored landscapes with cows, portraits of birds against floral backdrops (2002–9), and scenes of pigeons overtaking sculptural reliefs on Romanesque churches (2011).

In 1990, Zuka was made a Chevalier of Arts and Letters by the French government. She continues to live and work in Paris. KW

Contributors: Daniella Berman, Laura D Corey, Maura Reilly, Katherine J Wright

Acknowledgments

The two authors would like to thank their colleagues at Thames & Hudson for their support, assistance, and belief in the project from its commencement through its completion, including Jacky Klein, Sophy Thompson, Roger Thorp, Celia White, Alexandra Boalch, Sarah Hull, and Davina Thackara. They would also like to thank Laura Dickey Corey, Katherine Wright, Daniella Berman, and Thea Smolinski for their assistance with the artist biographies.

Linda Nochlin also wishes to thank the artists in the book, who were always helpful and enthusiastic in the writing of the texts. Special thanks go to her friends and colleagues Tamar Garb, Abigail Solomon Godeau, Ewa Lajer Burchardt, Moira Roth, Anne Higonnet, Jongwoo Kim, the late Paula Harper, and her husband, the late Richard Pommer. She is grateful, above all, to Maura Reilly, her former doctoral student, colleague, and dear friend, who has carved out a distinguished career as a feminist art historian and curator, and without whose unwavering commitment this book would not have been possible.

Maura Reilly would like to acknowledge her deep gratitude to Linda Nochlin, whose friendship she cherishes, and whose lifelong commitment to women artists and feminism has been, and will continue to be, a constant source of inspiration.

Picture Credits

17 Courtesy Brooklyn Museum, New York; 21 Courtesy Cheim & Read, New York; 23 Courtesy the artist and Luhring Augustine, New York. © Janine Antoni; 25 © Nancy Graves Foundation, Inc/Licensed by VAGA, New York, NY. Photo Anne-Gerard Flynn; 26 Courtesy Cheim & Read, New York; 29 and 30 Courtesy the artist and Metro Pictures, New York; 32 © 1994 Kara Walker; 33 Photo Jason Wyche. © 2014 Kara Walker; 45 Pinacoteca Nazionale, Bologna. Photo Scala, Florence—courtesy the Ministero Beni e Att. Culturali; 51 National Portrait Gallery, London; 54 Hermitage Museum, St. Petersburg; 55 Adolph D and Wilkins C Williams Fund, 75.22. Virginia Museum of Fine Arts, Richmond; 59 Private Collection, New York. Photo Adam Rzepka. © The Easton Foundation/VAGA, New York/DACS, London 2015; 60a Tate, London; 60b Musée des Beaux-Arts— Palais Longchamp. White Images/Scala, Florence; 62 Galleria degli Uffizi, Florence; 66 Gift of Cornelius Vanderbilt, 1887, 87.25. Image 2015 Metropolitan Museum of Art/Art Resource/Scala, Florence; 70 Collection the artist; 71 Museum of Contemporary Art, San Diego, Gift of Harry Kahn; 73 Photo Smithsonian American Art Museum/Art Resource/Scala, Florence; 75 Gift of Lucille Bunin Askin, 81.38. Everson Museum of Art, Syracuse; 79 Photo Lucienne Bloch; 81 Metropolitan Museum of Art, Alfred Stieglitz Collection, 69.278.1. Photo Malcom Varon. Image 2015 Metropolitan Museum of Art/Art Resource/Scala, Florence. © Metropolitan Museum of Art; 82 Courtesy the artist and DC Moore Gallery, New York; 83 Courtesy Alexander and Bonin, New York. Photo Jason Mandella; 90 Private Collection, Dallas, Texas. Estate of Sylvia Sleigh; 96 The Mary Frick Jacobs Collection, Baltimore Museum of Art; 99 Musée National du Chateau de Versailles. DeAgostini Picture Library/Scala, Florence; 100 Musée du Louvre, Paris; 106 Leeds Museums and Galleries (Leeds Art Gallery)/Bridgeman Images; 111 Musée d'Orsay, Paris; 114a Pinakothek der Moderne, Munich. © DACS 2015; 114b Collection SFMOMA, Albert M Bender Collection, gift of Albert M Bender. © 2015 Banco de México Diego Rivera Frida Kahlo Museums Trust, Mexico, D.F./DACS; 123 Galleria Degli Uffizi (Uffizi Gallery), Florence. Photo akg-images/De Agostini Picture Library/Bardazzi; 125a Gift of Robert H Tannahill. Detroit Institute of Arts; 125b Käthe Kollwitz © DACS 2014; 133 Digital image, Museum of Modern Art, New York/Scala, Florence; 135 Collection Columbia University, New York. © Geoffrey Clements/Corbis; 137 Gift of Ettie Stettheimer, 1947.242. Wadsworth Atheneum Museum of Art, Hartford; 141a Collection of halley k harrisburg and Michael Rosenfeld, New York. Courtesy of Michael Rosenfeld Gallery LLC, New York, NY. Photo Joshua Nefsky; 141b Given by Fania Marinoff Van Vechten in memory of Carl Van Vechten to the Yale Collection of American Literature, University Library, 1973.95.13; 144 53.24.3. Image 2015 Metropolitan Museum of Art/Art Resource/Scala, Florence; 145 Gift of Ettie Stettheimer, 1953, 53.24.2. Image 2015 Metropolitan Museum of Art/Art Resource/Scala, Florence; 154 National Gallery of Canada, Ottawa, Gift of Allan Bronfman, Montreal, 1969 (Camels, VII, VIII).

© Nancy Graves Foundation/VAGA, NY/DACS, London 2015; 156a and 156b Collection of the Nancy Graves Foundation, New York. © Nancy Graves Foundation/ VAGA, NY/DACS, London 2015. Photo Peter Moore; 157 Museum Ludwig, Köln. © Nancy Graves Foundation/ VAGA, NY/DACS, London 2015; 158 Akron Art Museum, Purchased with funds from the Mary S and Louis S Myers Foundation, the Firestone Foundation, National Endowment for the Arts, and the Museum Acquisition Fund, 1981.15. Courtesy Akron Art Museum. © Nancy Graves Foundation/VAGA, NY/DACS, London 2015; 160 Collection Mitchell Shaheen. © Nancy Graves Foundation/VAGA, NY/DACS, London 2015; 162 Private Collection, Washington, DC; 165 Ny Carlsberg Glyptotek. Copenhgen. Album/Superstock; 167 Museum of Fine Arts, Boston; 169 Private Collection, Paris; 170 Musée Marmottan, Paris; 175–79 Courtesy Zuka; 183 Courtesy of the artist and DC Moore Gallery, New York. Photo Eeva-Inkeri; 184–85 Private Collection. Courtesy of the artist. Photo Eeva-Inkeri; 186–87 Private Collection. Courtesy of the artist and DC Moore Gallery, New York. Photo Eeva-Inkeri; 195l Photo courtesy Linda Nochlin; 195r Photo Linda Nochlin; 200 Gift of Mary Cassatt, 1923, 23.101. Image 2015 copyright The Metropolitan Museum of Art/Art Resource/Scala, Florence; 204 Roland P. Murdock Collection. Wichita Art Museum, Wichita, Kansas, M109.53; 205a Cleveland Museum of Art, Gift of JH Wade, 1920.379; 205b Ludwig Roselius Collection; 206 Private Collection, Washington, DC; 207 The Hayden Collection—Charles Henry Hayden Fund. Museum of Fine Arts, Boston; 208 The Art Institute of Chicago, Robert A Waller Fund, 1910.2; 209 The Art Institute of Chicago, Mr. and Mrs. Martin A. Ryerson Collection, 1932.1287; 210l Musée d'Orsay, Paris; 210r Private Collection/Photo © Boltin Picture Library/Bridgeman Images; 212 New Britain Museum of American Art; 214 The Art Institute of Chicago, Mr. and Mrs. Martin A Ryerson Collection, 1932.1289; 220 Estate of Sylvia Sleigh; 221 The David and Alfred Smart Museum of Art, The University of Chicago, Purchase, Paul and Miriam Kirkley Fund for Acquisitions. Estate of Sylvia Sleigh; 222a Estate of Sylvia Sleigh; 222b Collection Margret Chisholm, New Haven, CT. Estate of Sylvia Sleigh; 223 Collection Cynthia Mailman, New York. Estate of Sylvia Sleigh; 224–25 Estate of Sylvia Sleigh; 226–29 Photo courtesy Deborah Kass/Art Resource, NY. © ARS, NY; 231–32 and 234–35 Courtesy Gagosian Galley. © Jenny Saville; 233 Courtesy Gagosian Gallery. © Jenny Saville and Glen Luchford; 237 Metropolitan Museum of Art, Gift of Seavest Private Investments, 1997, 1997.452.a–f. Courtesy the artist and DC Moore Gallery, New York; 238–50 Courtesy the artist and DC Moore Gallery, New York; 252–53 Collection the artist; 255 Collection Ethel and Elie Romano; 256 Collection David Wilkinson; 257a and 257b Addison Gallery of American Art, Phillips Academy, Andover, MA; 258a Collection of Bass Museum of Art, Miami Beach, FL; 258b Collection the artist; 259 Private Collection; 260 Collection the artist; 261 Private Collection. © Estate of Joan Mitchell; 262 Blanton Museum of Art, The University of Texas at Austin, Gift of Mari and James A Michener, 1991. Photo Rick Hall. © Estate of Joan Mitchell; 263a Private collection. © Estate of Joan

Mitchell; **263b** Currier Museum of Art, Manchester, New Hampshire. Gift of Sam and May Gruber, 1992.2.1. © Estate of Joan Mitchell; **267** Estate of Rudy Burckhardt. © ARS, NY and DACS, London 2015; **270** Printed and published by Tyler Graphics, Ltd., Mt. Kisco, New York. © Estate of Joan Mitchell; **271** © Estate of Joan Mitchell; **274–77** Courtesy White Cube; **282l** © The Estate of Alice Neel; **282r** © The Estate of Alice Neel. Courtesy David Zwirner, New York/London; **283** National Museum of Women in the Arts, Washington, DC, gift of Wallace and Wilhelmina Holladay, 1983.24. Courtesy David Zwirner, New York/London. © The Estate of Alice Neel; **284** Blanton Museum of Art, The University of Texas at Austin, Archer M Huntington Museum Fund, 1983.13. Courtesy David Zwirner, New York/London. © The Estate of Alice Neel; **285l** Whitney Museum of American Art, New York, gift of Timothy Collins. © The Estate of Alice Neel. Courtesy David Zwirner, New York/London; **285r** Anonymous Gift, 1981, 1981.407. Image 2015 Metropolitan Museum of Art/Art Resource/Scala, Florence; **286l** Museum of Fine Arts, Boston. Seth K. Sweetser Fund, 1983.496. Courtesy David Zwirner, New York/London. © The Estate of Alice Neel; **286r** Private Collection. Courtesy David Zwirner, New York/London. © The Estate of Alice Neel; **287a** Private Collection, on loan to Tate Modern, London. Courtesy David Zwirner, New York/London. © The Estate of Alice Neel; **287b** Whitney Museum of American Art, New York. Courtesy David Zwirner, New York/London. © The Estate of Alice Neel; **289** National Portrait Gallery, Smithsonian Institution, Washington, DC © The Estate of Alice Neel. Courtesy David Zwirner, New York/London; **291** Photo courtesy the artist and Pace Gallery; **294–96** Courtesy the artist and Pace Gallery. Photo Ellen Page Wilson; **297** Courtesy the artist and Pace Gallery. Photo Herbert Lotz; **298** Photo courtesy the artist and Pace Gallery; **302** Courtesy Sadie Coles HQ, London, and Gladstone Gallery, New York. Copyright the artist; **303** Private Collection. Courtesy Sadie Coles HQ, London, and Gladstone Gallery, New York. Copyright the artist; **305** Tate, London. Courtesy Sadie Coles HQ, London. Copyright the artist; **306** Murderme, London. Courtesy Sadie Coles HQ, London. Copyright the artist; **307** Murderme, London. Courtesy Sadie Coles HQ, London, and Gladstone Gallery, New York. Copyright the artist; **309a** The Heithoff Family Collection; **309b** Murderme, London. Courtesy Sadie Coles HQ, London, and Gladstone Gallery, New York. Copyright the artist; **314** Collection Art Gallery of Ontario; **315** Courtesy the artist and Metro Pictures, New York; **317a** Image courtesy the artist. © Rachel Whiteread; **317b** Literaturhaus Munich. Photo © Kay Blaschke; **318** Courtesy the artist and Pace Gallery. Photo Norman McGrath; **327** Digital image Museum of Modern Art, New York/Scala, Florence. © 2015 The Murray-Holman Family Trust/Artists Rights Society (ARS), New York/DACS; **328a** Courtesy Gagosian Gallery. Photo Robert McKeever. © Cecily Brown; **328b** Image courtesy Gagosian Galley. © Jenny Saville; **330** Courtesy Cheim & Read, New York; **331** Courtesy the Artist and Susanne Vielmetter Los Angeles Projects. © Wangechi Mutu; **332** Copyright the artist; **334** Cleveland Museum of Art, OH/Leonard C Hanna, Jr. Fund/Bridgeman Images; **335** Courtesy White Cube; **336a** Cleveland Museum of Art, OH/In memory of Julia K Dalton by her nephews, George S Kendrick and Harry D Kendrick/Bridgeman Art Library; **336b** Musée Rodin. White Images/Scala, Florence; **340** Photo Graham Baring. Courtesy the artist, and Tolarno and Roslyn Oxley9 Galleries; **341** Collection National Museum of Contemporary Art, Korea. Courtesy Studio Lee Bul. Photo Rhee Jae-yong; **342** Courtesy the artist and Victoria Miro, London. Photo Vincente de Mello. Copyright Adriana Varejão; **343** Gift of Julia A. Berwind, 1953, 53.225.5. Image 2015 Metropolitan Museum of Art/Art Resource/Scala, Florence; **344l** Musée du Louvre, Paris. De Agostini/SuperStock; **344r** Courtesy Regen Projects, Los Angeles. © Catherine Opie; **345** © Yurie Nagashima/Courtesy Scai The Bathhouse; **346** Kunstmuseum Basel; **348** Courtesy the artist and Galerie GP and N Vallois, Paris. © Pilar Albarracín; **349** Courtesy Lisson Gallery, London. © the artist; **352–56** Courtesy Gagosian Gallery. © Cecily Brown. Photo Robert McKeever; **359** Photo Tom Powell; **361** Single take solo monologue written and performed by Liza Lou. Directed by Mick Haggerty; **362–64** Photo Tom Powell Imaging NY, Dean Elliot, Studio 24, South Africa; **365** Photo Tom Powell Imaging NY; **366** Photo Dean Elliot; **375a** Courtesy the artist; **376–78** Courtesy the artist; **380** Courtesy Marlborough Fine Art; **381** Courtesy the artist and Pace Gallery. Photo Ellen Page Wilson; **385** Collection The Easton Foundation. Photo Allen Finkelman. © The Easton Foundation/VAGA, New York/DACS, London 2015; **388a** Collection Ursula Hauser, Switzerland. Photo Christopher Burke. © The Easton Foundation/VAGA, New York/DACS, London 2015; **388b** Photo Christopher Burke. © The Easton Foundation/VAGA, New York/DACS, London 2015; **389** Private Collection, Germany. Photo Christopher Burke. © The Easton Foundation/VAGA, New York/DACS, London 2015; **390** Collection The Easton Foundation. Photo Christopher Burke. © The Easton Foundation/VAGA, New York/DACS, London 2015; **392** Collection Institute of Fine Arts, New York University. Photo Christopher Burke. © The Easton Foundation/VAGA, New York/DACS, London 2015; **401a** Courtesy Galerie Perrotin. © ADAGP, Paris and DACS, London 2015; **401b** Musée d'Art Moderne de la Ville de Paris. © ADAGP, Paris and DACS, London 2015; **405** Courtesy Sophie Calle and Paula Cooper Gallery, New York. © ADAGP, Paris and DACS, London 2015; **407a** Isabella Stewart Gardner Museum, Boston (stolen 1990); **407b** Courtesy Sophie Calle, Paula Cooper Gallery, New York, and the Isabella Stewart Gardner Museum, Boston. Photo Clements Photography and Design. © ADAGP, Paris and DACS, London 2015; **410a** Tate, London/© The Lucian Freud Archive/Bridgeman Images; **410b** Courtesy Sophie Calle and Paula Cooper Gallery, New York. Photo Steven Probert. © ADAGP, Paris and DACS, London 2014; **418** National Gallery, London; **420a** Image Metropolitan Museum of Art/Art Resource/Scala, Florence; **420b** Courtesy White Cube. Photo Bill Orcutt, New York; **421** Courtesy White Cube; **424** Courtesy White Cube JJ37594. Photo Todd-White Art Photography; **425** Courtesy White Cube JJ48370. Photo Cary Whittier; **427a** Courtesy Marlborough Fine Art; **427b** © Pace Gallery. Photo Richard-Max Tremblay. © Kiki Smith; **428–33** Courtesy the artist; **434** Courtesy Marlborough Fine Art

Index